GREAT
CARPETS
of the world

GREAT CARPETS
of the world

Chapters by
Valérie Bérinstain, Susan Day,
Élisabeth Floret, Clothilde Galea-Blanc, Odile Gellé,
Martine Mathias, Asiyeh Ziai

Introduction by Yves Mikaeloff

Prefaces by Daniel Alcouffe
Conservateur Général
Department of Objets d'Art, Musée du Louvre

and
Marthe Bernus-Taylor
Conservateur Général, Islamic Section,
Department of Oriental Antiquities, Musée du Louvre

THE VENDOME PRESS

The publishers extend their warmest thanks
to Yves Mikaeloff, who not only helped us
assemble this group of remarkable authors
but also gave us generous access to his archives
of photographs and historical documents.

In addition, the publishers wish to express their gratitude to
Carmen Garcia, Lunwerg Editores, Madrid;
Joëlle Lemaistre, Institut du Monde Arabe, Paris;
Mary-Jo Ostea, Sotheby's, New York;
Marie-France Vivier, Musée des Arts d'Afrique et d'Océanie, Paris.

Graphic design: Bela Vista, Paris
Picture research: Odile de Laurens
Advisory Editor, English edition: Susan Day

Readers will find slight variations, from chapter to chapter,
in the spelling of names and technical as well as cultural terms,
a consequence of preferences on the part of the seven contributing authors,
often reflecting the special linguistic practices in the various aspects
of the subject covered in this book.

First published in the USA in 1996 by The Vendome Press
1370 Avenue of the Americas, New York, NY 10019

Distributed in the USA and Canada by Rizzoli International Publications
through St. Martin's Press, 175 Fifth Avenue, New York, NY 10010

Library of Congress Cataloging-in-Publication Data
Great carpets of the world / by Susan Day . . . [et al].
p. cm.
Includes bibliographical references and index.
ISBN 0-86565-980-X
1. Rugs. I. Day, Susan.
NK2795.074 1996
746.7'5--dc20
Printed and bound in Italy

Contents

The carpet is a complex work of art, at the same time vulnerable and, unlike tapestry, difficult to display and to view. Trod upon, it suffers by virtue of its very purpose, from the beginning of its existence. A cumbersome object, it is often for that reason cut down and otherwise mutilated. Hung on the wall of a museum, a carpet becomes a vision without logic. Spread over the floor in the home of a collector, a fine rug is covered with furniture, which, of course, keeps it from being seen entire, with the result that it gets trampled on and taken for granted, even forgotten.

A cause for restraint on the part of a curator, a worry for the collector, the carpet, with its wonderful texture, colors, and design, is nevertheless a source of many pleasures. This is what the authors of the present book have so enthusiastically undertaken to demonstrate – to help us see. They explain the techniques involved, recapitulating their genesis and development; they also present the unresolved enigmas and mysteries, such as the origin of the so-called 'Salting' carpets, and raise issues ripe for further research, among them the rugs of eastern Anatolia. Our hope is that the book may inspire new vocations dedicated to patient inquiry and ultimately new collectors as well. It has been my pleasure to know one of the latter, M. René Grog, a generous patron of the Louvre, who first assembled a beautiful collection of Oriental carpets, which in turn led to an interest in 18th-century French furniture and objects, a passion he cleverly harmonized with his first love, the rugs. Despite the rarity of examples made before the 15th century, the carpet represents one of the very oldest disciplines among what we customarily designate as the decorative arts, which, with greater justice, should be called the art of the object. The book here before us will surely make everyone more aware of the important role the carpet has played in certain civilizations, for which it was sometimes the sole article of furniture. Rugs have functioned as prayers, poems, and even political statements.

It is most unusual that a book dedicated to a given medium dares to cover the subject in both the East and the West, an approach that happens to be especially important in the case of rugs. The genre developed in Europe precisely because of inspiration from Oriental works, whose colors and patterns fascinated a number of European painters from the end of the Middle Ages right into the Renaissance. To such a degree was this true that early connoisseurs began naming the various types of patterns after the artists who depicted them. In France, the art of the carpet – one of the last to join the family of decorative arts – took root for the declared purpose of competing with the Oriental imports. Soon the French product would come so utterly into its own that it reversed the tide and began influencing Turkish and Persian carpets woven in the 19th century.

The Louvre is a great carpet museum, as will be clear to anyone visiting the new Islamic galleries and the Department of Objets d'Art. Reading this book, one begins to dream of something even more, a great exhibition of all the surviving pieces, arranged in proper order side by side, from the series of ninety-three carpets commissioned by Louis XIV for the Grande Galerie at the Louvre, one of the most megalomaniac gestures ever made by a monarch. This would truly place us in the presence of the eighth wonder of the world.

Conservateur Général
Department of Objets d'Art
Musée du Louvre

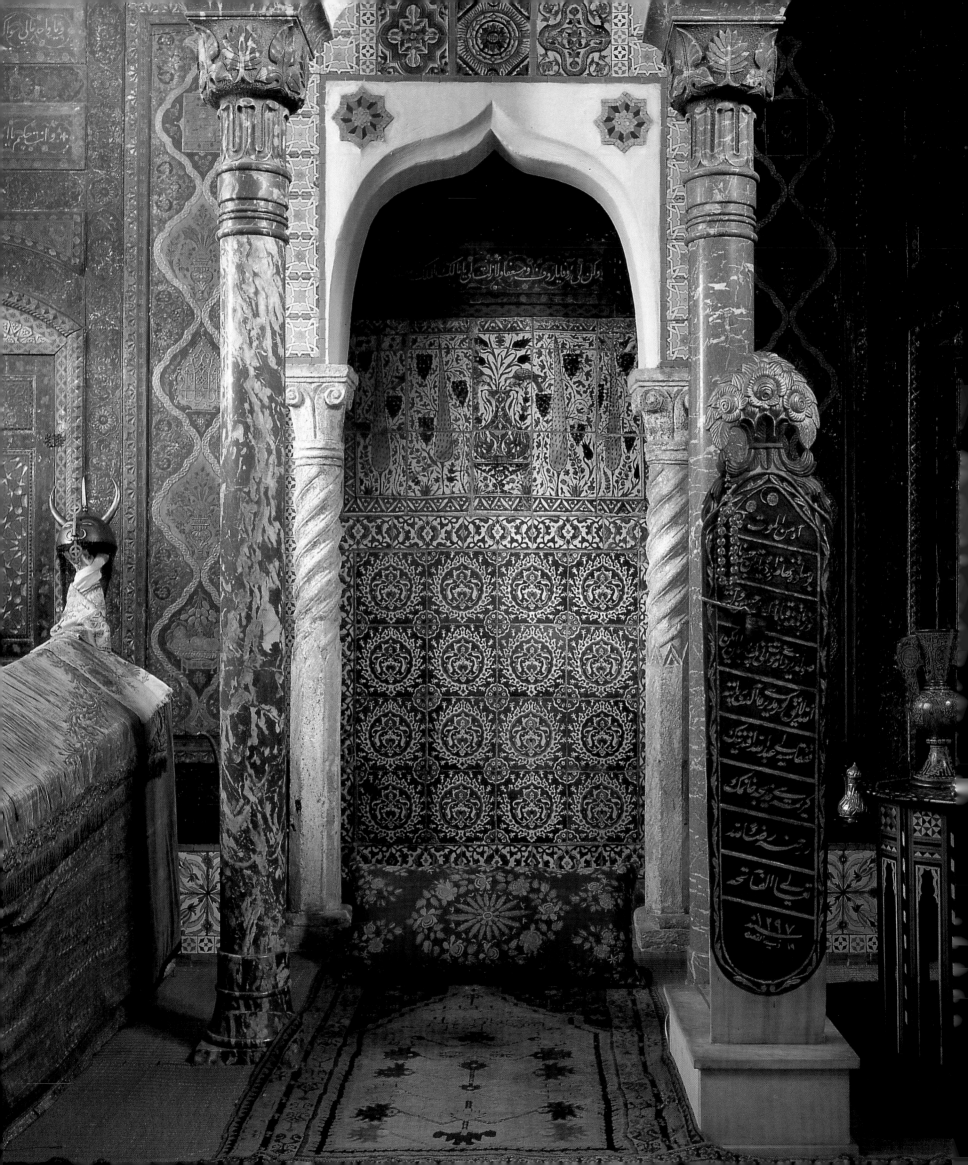

preface
MARTHE BERNUS-TAYLOR

The carpet, or rather the Oriental carpet, enjoys a special place in the collective imagination. It is the stuff of tales, of magic, and its very presence is enough to create a certain atmosphere. From the Ballets Russes sets for *Schéhérazade* through Hollywood films to the patterned runner, the carpet conjures up an image of the mythic Orient, of luxury, of soft, velvety texture, even voluptuousness. It may also generate an air of the sacred, setting a divine or mortal being apart from the rest of humanity. One has only to think of the altar carpet in churches, the carpet under the Virgin's throne or the throne of a king, the prayer rug on which the Muslim prostrates himself in worship. Even today, the carpet is humanity's constant companion, in every aspect of life, from cradle to grave, especially among nomads. Knotted, woven, or embroidered, in silk, wool, cotton, or felt, large or small, whatever shape, it takes the place of furniture and yet is readily transportable. It decorates tents, serves as a mattress, as a tapestry, but also as a bag or carpetbag, a saddle on a horse, or an ornament for the camel's hump during processions.

The carpet is unquestionably Oriental in origin, which dates back to antiquity, although little evidence survives of this remote past. The Scythian tombs excavated in 1949 at Pazyryk, in the Altaï region of Outer Mongolia, yielded felt carpets with appliquéd decorations, as well as one extraordinary woven rug, all preserved in ice since the 5th century before our era. Friezes of elks and horses frame a central field, whose checkered pattern recalls certain carpets relief-carved on the thresholds of the palace in Nineveh. More than a thousand years later, commentators would go into raptures over the 'Spring of Chosroes', that gold and silver, jewel-studded tapestry which once ornamented the walls of the great *iwan* in the palace at Ctesiphon, the capital of the Sassanian monarchs conquered by the Arabs in 638. The very name of this wall hanging evokes a flowering garden, which is understandable given the current habit of likening a spring meadow to a 'tapestry of flowers'. Certain Iranian tapestries bear names that are just as evocative – 'water tapestry', 'garden tapestry', 'hunting tapestry' – all of them implying imagery from nature. It is important to remember as well that, in the Oriental mind, the garden signifies not only wealth and luxury but also an analogue of Paradise.

Literature or written accounts, like 15th-century Flemish and Italian paintings, attest to the great favor that Oriental carpets found in Europe at an early date. They lie before the very altar in *The Mass of Saint Giles* (page 72), hang from balconies signaling the festivities that accompanied the vicissitudes depicted by Vittorio Carpaccio in his marvelous Saint Ursula cycle, brighten the austere portraits of important German or Dutch personages, and, with their colors, rival the fruit-laden silver vessels set out on groaning boards. Most of these carpets are Anatolian, which is hardly surprising in view of the well-known role played by Venice in Europe's trade with Ottoman Turkey. The names of certain painters – Lotto, Holbein, Memling – remain forever identified with these types of carpet, the oldest known examples of which are those represented in their paintings.

These Turkish carpets, like the first pieces found in the mosques of Konya and Kayseri, share certain general characteristics, features found as well in the Turkoman rugs of Central Asia, which would remain distinctive until late in their history, when finally they came under influence from Iran. The chromatic range, always narrow, is dominated by red, while composition, governed by strict laws of geometry, tends towards medallions, often star-

1. An interior designed by the French writer Pierre Loti (1850-1923) at his home in Rochefort. Naval officer as well as writer, Loti spent much of his life in the Orient, which he loved and attempted to evoke not only in his colorful, exotic novels but also in the décor of his private environment.

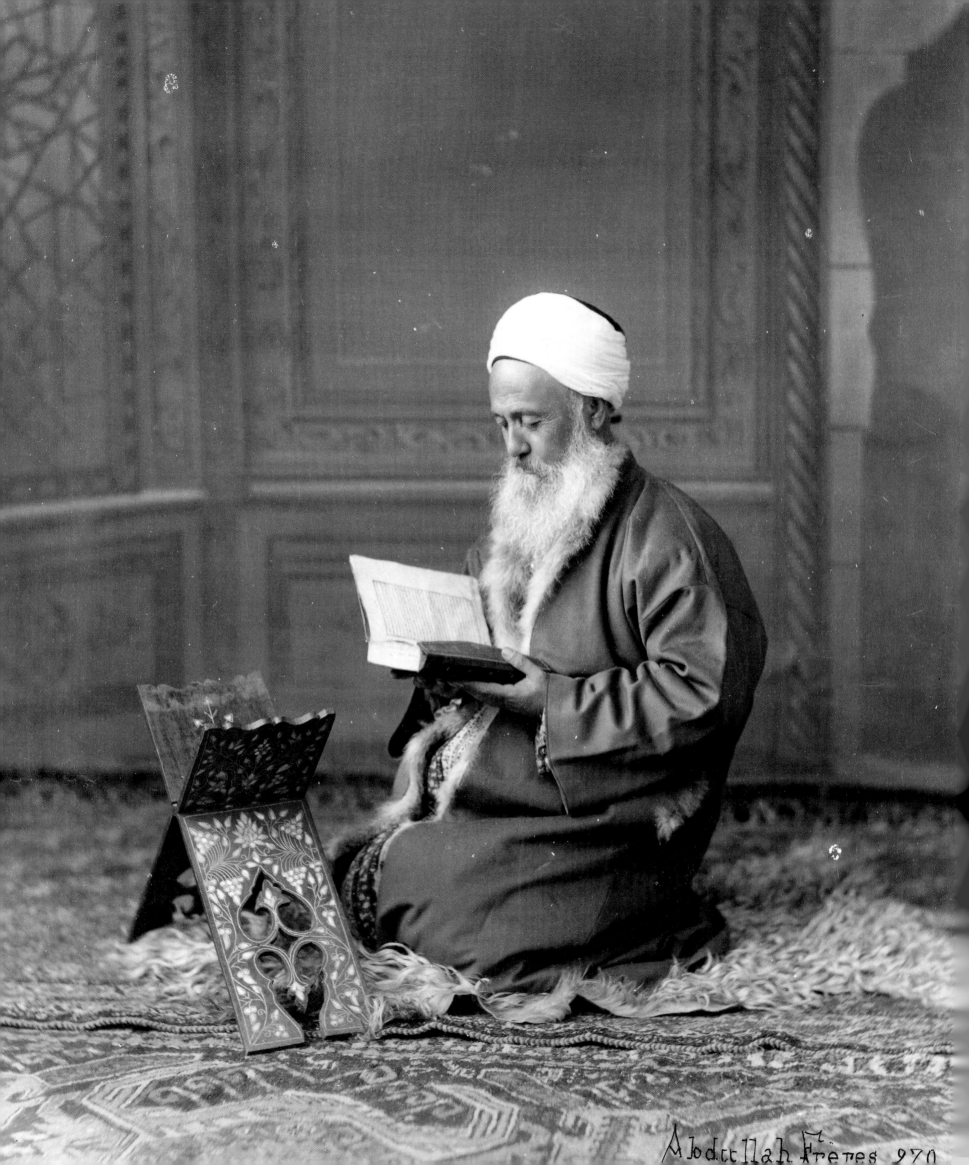

shaped. Decorative elements – arabesques and highly stylized, angular vegetal motifs – also contribute to the overall, very particular look of the carpets. In the 16th century, however, large, flowing bouquets of both real and composite flowers spread across so-called 'court' carpets, in keeping with the *saz* style developed by designers at the imperial *nakkashane*.

The masterpieces produced by the Iranian and Moghul workshops are of a totally different character. Almost invariably, it is nature – blossoms, trees, and animals, but also human figures – which takes over the space. It fairly burgeons with floral arabesques in complicated patterns, rows of blooming clumps growing straight out of planters, but also marvelous gardens where flowering trees, streams and sometimes even waterfalls, naturalistic beasts and creatures borrowed from the mythic bestiaries of China, hunters and angels all mingle together amongst the cypresses.

Some carpets resemble miniature paintings translated into silk, and they may even illustrate literary texts such as the love novels featuring Chosroes and Shirin, Leila and Majnoun, or yet myths like that of the *rûh*, the fabulous Indian beast and enemy of elephants. The Muslim taste for ambiguous motifs expresses itself in countless borders, where feline masks sometimes lurk amongst the flowering peonies.

As noted above, the European love of Oriental carpets is well known, not only from the evidence of paintings but also from literature. By the early 13th century, carpets woven in the Moorish Kingdom of Murcia were being exported to Egypt, and in October 1255 the streets of Westminster were hung with a great many Spanish carpets to celebrate the arrival of Eleanor of Castile, bride of the future Edward I of England.

Pope John XXII bought Oriental carpets, woven with his armorial bearings, for the Papal Palace in Avignon. As for Persian carpets, we know that in the spring of 1602 the Polish King Sigismund III Vasa dispatched an Armenian merchant to Kashan for the purpose of ordering carpets made of gold and silver in addition to silk. It is also established that Shah Abbas sent carpets to the Doge of Venice in 1603, and then again in 1622, this time a collection which is still preserved in the treasury at Saint Mark's. During the 17th century several travelers, among them the Chevalier Chardin, recalled the vitality of the workshops in Isfahan.

2. A master of theology. On the floor in the foreground, a Caucasian rug.

Fine examples of Oriental carpets destined for European clients still survive in several collections: 15th-century Spanish carpets displaying the arms of Aragon and Castile, 'Lotto' rugs with the arms of the Doria and Centurione families of Genoa, and Persian carpets featuring the armorial bearings of Poland's Prince Czartoryski or King Sigismund III Vasa.

It is into this magic realm of carpets that the superb book now before us promises to lead its readers. The journey will be one of discovery, passing through the technical and stylistic highroads of each broad region of that immense Islamic world, while, along the way, as if in counterpoint, developing a vision of an art transposed by the West.

<div style="text-align: right">

Conservateur Général, Islamic Section,
Department of Oriental Antiquities,
Musée du Louvre

</div>

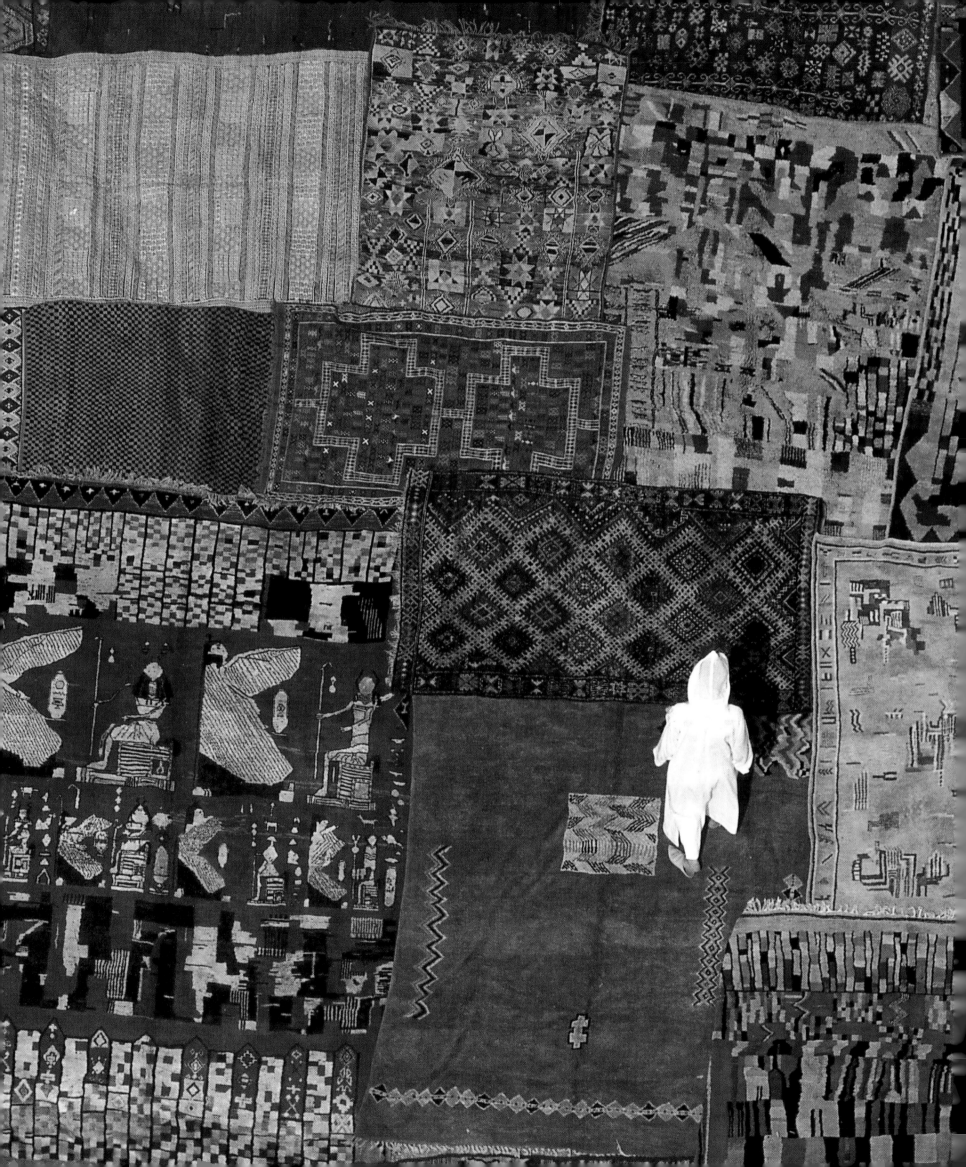

The Carpet, an Art Simple or Complex?

An apparently simple art, the carpet soon reveals itself to be remarkably complicated. Utilizing an elementary gesture fundamental to the medium, each ethnic group endowed the carpet, for generations to come, with the characteristics of its existence. This gesture is the result of various traditions related to wool – and silk – growing, the love of forms and colors, and, often, tastes, since dyes and spices are inextricably mixed together in the history of humanity's never-ending search for survival, comfort, pleasure, and spiritual fulfillment.

A Sacred Art

The carpet is also a sacred art, not only in its role as a votive offering or as a prayer rug, but also in its very principles, in the ritual of its birth. The knot ties the vertical of the warp to the horizontal of the weft and thereby makes a cross, the arch symbol for many different religions. It is a sign of life born at the intersection, the life of humble beings, most often anonymous, who weave the carpet, nimbly fingering its knots as if they were prayer beads. These simple beings transcend their human condition by accepting to become the receptacle of forces beyond themselves. Thanks to them, works are born which reflect the universe and which the 'little person' is utterly astonished at having created. Carpets therefore unite, through the senses and through art, the two aspects of humanity: the profane and the sacred. Given this, one can appreciate why the carpet dealer has always been the friend of princes, but for the people, more often than not, an object of contempt.

The First Uses of Carpets

The genesis of carpets is deeply inscribed upon humanity's collective memory. Carpets have offered protection, served as matting, lined the walls of tents, and decorated homes. Most of all, they have been an extraordinary gift from the East to the West. As early as the 7th century, for instance, precious relics of the Christian saints were wrapped in costly materials for shipment at great expense from the Middle East. This was the Merovingian age, when European abbots, on pilgrimage from Rome, never failed to procure holy relics, while simultaneously acquiring fabrics worth their weight in gold. From the High Middle Ages onward, therefore, Western artists were familiar with Oriental motifs, primarily Sassanian in origin, but progressively enriched by a formidable mélange of Asiatic, Early Christian, Byzantine, and then Islamic cultures.

The Expanding Taste for Carpets

The motifs passed from the Iranian palaces conquered by Islam into Christian Armenia, into the lands under the Calif of Baghdad, and finally into the other Islamic monarchies: the Fatimids of Cairo and the Umayyads of

3. A man walking across a field of carpets, spread out near Marrakesh, Morocco.

4. A rug merchant's stall in Morocco.

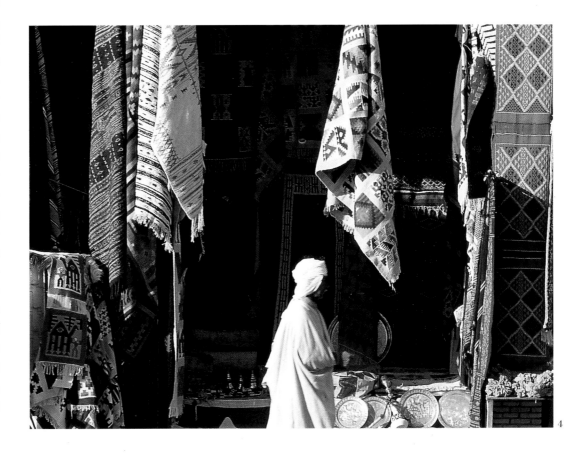

4

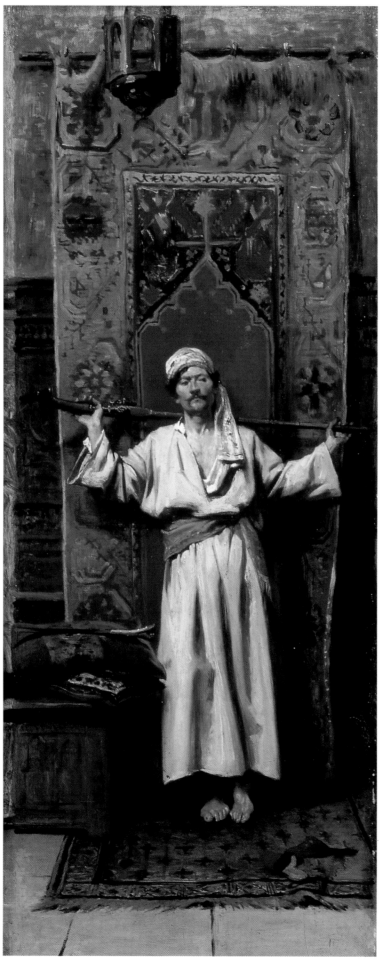

5

Córdoba. In Europe, however, the zoomorphic and floral nature of Iranian art, as well as the hermeticism of its representations, made it easy for the religious meaning of it all to be forgotten. What did survive was a sense of something sacred embodied in those powerful images, which allowed everyone – Muslims, Christians, and even Buddhists – to use them without violating any particular dogma. Thus, the bones of Saint Bernard could be wrapped in a cloth decorated with griffons. Later, the Crusades would generate further exchange between East and West.

Now Oriental carpets captured the imagination of European painters, who, aware of their sacred content, included them in paintings as suitable, eye-catching presences within religious scenes. Many of these carpets are still known by the names of the painters who introduced them to the West. For the society of that period, Oriental rugs clearly served as a bridge between Orient and Occident, revealing a common thirst for the sacred. In a period before new hostilities developed, carpets bore witness to the cross-fertilization between two worlds which had long been locked in mutual conflict. The source of this enrichment had been Spain, one of Europe's privileged zones, where the cultural interpenetration of East and West gave birth to marvelous things of great originality which otherwise would never have seen the light of day.

The Role of Spain

This was Spain before the reign of Isabella the Catholic, a reign often characterized as disastrous, inasmuch as it destroyed that exemplary coexistence of East and West, an harmonious multicultural world which would never return. One cannot help being dumbfounded at the expulsion of such an achieved society, with all its civilization and refinement, an exile brought about by a political power dedicated to blindness. What survives of it links us to another realm, proving that cultural eclecticism can be more than a mere dream. The dream is made manifest in the Great Mosque in Córdoba, a masterpiece of

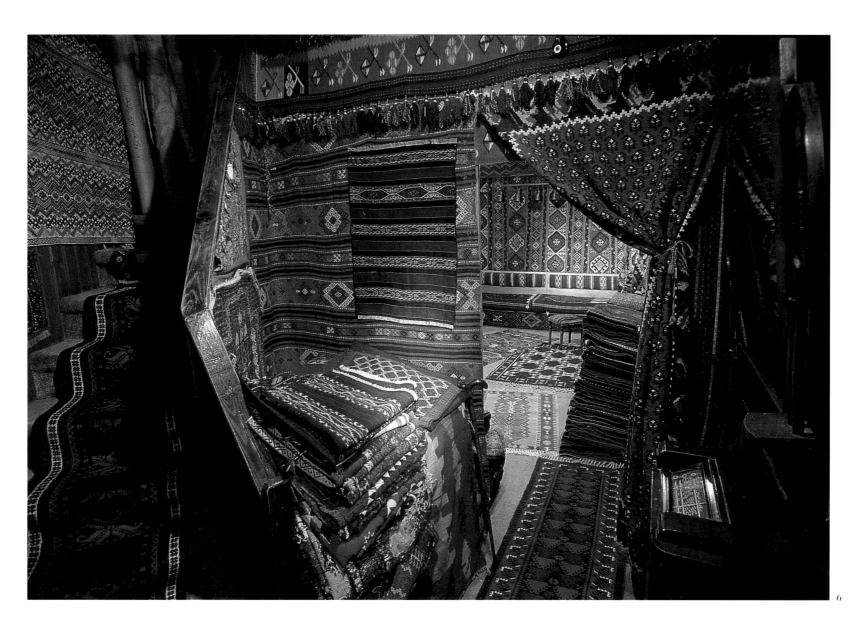

6

Umayyad architecture erected between 785 and 987 in the Alhambra, the seat of the Moorish kings at Granada. Carpets were woven at Cuenca, where they came forth as the fruits of a peaceful life among different communities, societies with a taste for spices and redolent of their sweet odor. In design, the rugs captured the repetitious rhythm of a mosaic organized about a central fountain or crystal, overall safran in color and earthily alive to the touch.

The Importance of Great Britain

It was in Scotland, thanks to the reign of Mary Stuart, that Great Britain continued the tradition of magnificent embroideries, a tradition that remains vital in our own time. The hapless, French-bred Queen embroidered even during her imprisonment. At this time, the distinction between a carpet, a tapestry, and a table cover was not so precisely drawn as today. Needlework such as petit-point made it possible to exploit motifs inspired by the Orient, to utilize the symbolic system of plants and animals, or to illustrate moral stories and the lessons of religion. But if the carpet is a universal art, it cannot be a simple object of consumption. Rather like the situation at a Spanish inn, he who wishes to partake must contribute something of himself. It is the quality of the gift that will determine the rate of exchange. Thus, some may view the carpet as an illustration, others as a didactic scene, and still others as an expression of political thought or the politics of prestige, while equally interested parties seek the real meaning of the plants and animals depicted in the

5. *Émile Delpree (1850-1896). The Warrior. Oil on cavnas, 60 x 95 cm. Collection Berko, Knokke-le-Zoute, Belgium. Note the Turkish prayer rug in the background, very likely a work from the Konya region.*

6. *Kilims and knotted-pile carpets. The shop of Siska Osman, rug merchant established in Istanbul's Grand Bazaar.*

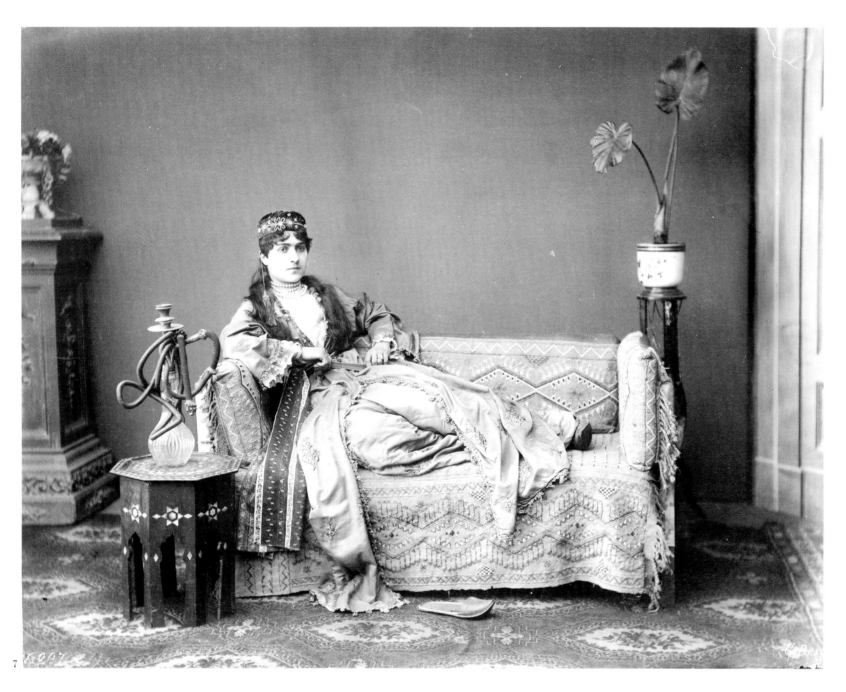

7. *Turkish woman on a sofa, with a so-called 'Smyrna rug' spread over the floor, its pattern composed of medallions framing roses treated in the European manner.*

decorative borders, convinced of the immutable value of symbols.

This tradition survived, even as it moved away from its Oriental roots and became more decorative. Carpets, sometimes precious gifts and often flamboyant in their color, brought richness, warmth, comfort, and gaiety into late-medieval Europe's austere interiors. However, as they traveled into the future, away from the period of discovery, rugs lost much of their primary substance. Needless to say, the power of English maritime commerce, at work on every sea and in every nation, allowed carpet lovers to acquire superb examples, which, in turn,

served to discourage creativity and production at home.

A marvelous period of renewal arrived in the 19th century, however, triggered in England by William Morris, Edward Burne-Jones, and Dante Gabriel Rossetti.

The Birth of Carpets in France

By the 13th century France had imported quantities of Oriental objects, ivories, and fine fabrics, adding wealth to the treasuries of cathedrals and monasteries while also introducing beauty into many a princely dwelling. Oriental carpets had also been wel-

comed, as we know from a contemporary manuscript register with an entry for a 'Saracen tapestry'. From these carpets were born the so-called 'millefleurs' tapestries, Europe's earliest response to the power of the imports. Like the English, the French did not distinguish particularly between tapestries, carpets, and table covers. Later, the carpets of the Louis XIII period drew on the same sources as those used in Oriental rugs. In the second half of the 17th century, Louis XIV made French carpets and tapestries instruments of his grandeur and the brilliance of his reign. The monarch began by appropriating the remarkable team of artists assembled by Nicolas Fouquet, after which he commissioned the Savonnerie workshop, founded in 1601, to weave ninety-three carpets for the Grande Galerie at the Louvre. Delivered in 1689, these works were the largest contribution the Savonnerie factory would ever make to the embellishment of the royal palaces. Like the grandiose buildings erected for the Sun King, the carpets helped assure that sense of *gloire* Louis so determinedly sought for himself and for France.

From Grandeur to Refinement

In the course of the 18th century tastes changed quite dramatically. A Louis XV carpet is less baroque but also much more refined, meant to join with furniture, tapestries, and even clothing in an ensemble of extraordinary elegance. This, after all, was the Age of Enlightenment, which meant that wit had to be present even in the life of forms.

After the French Revolution, Napoleon reactivated and encouraged the manufacture of carpets, by organizing exhibitions, such as those at the Louvre in 1804 and 1808, by granting subsidies, and by commissioning numerous works for the imperial palaces. This meant that the very best artists would be called upon to participate in the program, among them Percier and Fontaine.

Napoleon III revived this policy, restoring and furnishing numerous palaces, which meant ordering a great many carpets for them. Indeed, the carpet was about to enter a

Golden Age, a high period of creativity whose leading exponents would be Sue and Marc, arch symbols of the new *art de vivre*. From this encounter of an architect and a painter was born the so-called 'decorative arts'. All the arts, in fact – music, dance, and fashion, as well as architecture, furniture, and objets – surged on a veritable wave of invention and achievement. New, immensely rich patrons came forward and placed vast orders, supplanting crowned heads as the Maecenases of the modern era. From this context came exceptional carpets, now too rare, whose quality reflected the opulence of a period in which creative individuals managed to endow the arts with new forms.

Today the carpet has lost none of its evocative power or its prestige. It draws the eye at the same time that it also engages the spirit. Let us confirm this in the pages which follow.

8. The house of Sadullah in the Istanbul Grand Bazaar. Draped over the stair banister is a saph, *a prayer rug designed for collective worship.*

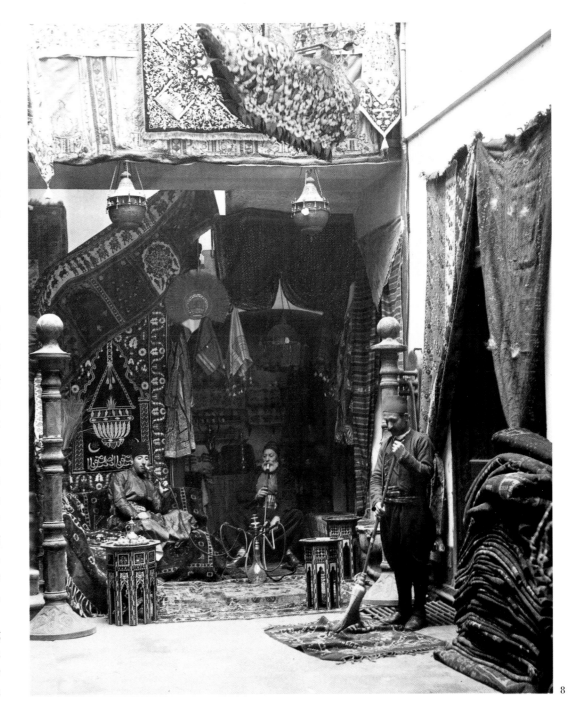

8

CHAPTER
I

THE ORIGINS
OF THE
KNOTTED CARPET

Clothilde Galea-Blanc

It is not known with certainty either where or when pile rugs were first made. The knotted or pile carpet very likely came into being sometime between the 4th and the 2nd millennium BC, somewhere in Asia, probably Mongolia or Turkestan. Nomads may have tried weaving a fabric similar to animal fleece so as to protect themselves from the rigorous climate of the steppes. Yet, there is always the possibility that knotted textiles sprang from the technical skill of settled societies living in Persia or the Armenia of today. According to another theory, advanced by Udo Hirsch,[1] the beginnings of that skill should be sought in Mesopotamia during the 3rd millennium BC.

A Long Evolutionary Process

The technique of the knot, as we presently know it, is the fruit of a very long evolution, the point of convergence and synthesis of various processes and kinds of know-how far removed in time and space, or else developed collaterally. However, apart from the so-called 'Pazyryk carpet' from the end of the 5th century BC, the Seljuk rugs of the 13th century, and a Spanish rug from the 14th century, the earliest preserved carpets date only from the 15th century. Thus, the genesis of the pile carpet can be understood only through a study of ancient literature and archaeological fragments.

THE LITERATURE

From the 19th Century BC

The writers of the Mediterranean basin and, to a lesser extent, those of China who mention carpets do not always indicate whether the pieces were knotted or flatwoven.

Clay tablets used by Assyrian merchants during the 19th century BC bear various words (*kutanum*, *sudna*, etc.) attesting to the commercialization of pile rugs or of textiles meant to serve as floor coverings. During the first half of the 2nd millennium BC, moreover, the Babylonians employed two words signifying the artisan who fabricates knotted-pile

THE FIRST TRACES OF THE EXISTENCE OF CARPETS

Words found on Assyrian clay tablets attest to the use of knotted carpets and textiles as floor coverings as early as the 19th century BC. By the first half of the 2nd millennium BC, the Babylonians had a word – *kasiru* – to designate the knotter craftsman. His existence is a clear sign of the presence of carpets during this epoch in Mesopotamia. The oldest discovered carpet, however, dates only from the 5th century BC. Unearthed during the excavations of a Scythian tomb in Pazyryk, at the heart of the Altaï Mountains, it is the so-called 'Pazyryk carpet'. The place of its manufacture is the subject of considerable debate.

rugs: *kasiru* and *kamidu*, meaning 'knotter' or 'knot-tier'.[2]

From pharaonic Egypt there is no text which mentions either the manufacture or the utilization of carpets, despite the variety of woven products known there. Yet, according to M.T. Barrelet,[3] fabrics decorated with knots are depicted in several bas-reliefs and wall paintings, and similar materials, dating from the 15th century BC, have been preserved. Much later, in the era of the Ptolemies,[4] the luxury of the court at Philadelphia (285-247 BC) attained such dazzling heights that five centuries later it would still haunt the Greek writer Athenaeus[5]: 'In front of the beds lay deep-pile rugs made of fine wool and dyed purple. They alternated with flatwoven rugs from Persia, decorated with animal figures and other representations. . . .'

Traces of Greece

The Greeks of Homeric times were expert at weaving and dyeing, but no evidence survives to suggest they engaged in rug weaving, despite their knowledge of carpets made in Persia and Babylonia. The *Iliad* and the *Odyssey* are full of references to thrones covered with light veils, mantles of purple wool, and soft carpets. In a perfumed room at his palace, Priam kept locked away a great many carpets made by slaves in the Phoenician city of Sidon and seized by Paris (*Iliad*, VIII, 288). Aeschylus, in the *Oresteia*, writes that Agamemnon, upon his return from Troy, refused to tread upon the carpets which Clytemnestra had laid before him: 'A mortal walking on richly embroidered purple! For

myself, I would not dare. It is as a man that I should be honored, not as a god.' Xenophon[6] and later Athenaeus[7] report that Sardis, a city in Asia Minor, was known for its flatwoven carpets on which only the King of Persia had the right to walk.

Latin writers and poets who celebrated the art of textiles, mainly Sassanian, are legion: Pliny in his *Natural History*, Plautus, Silius Italicus, and Martial, among other.

Persian Workshops

The workshops of Sassanian Persia developed woven materials of various and valuable kinds as well as woven and pile rugs, the latter known to the Greeks and discovered in fragmentary form at Dura-Europas, a Greek colony on the Euphrates. There is also a Sassanian carpet depicted in a 7th-century bas-relief at Taq-i-Bustan. Arab writers record the legend of the famous 'Baharestan' carpet which Chosroes I had made in the 6th century for his colossal palace at Ctesiphon in Mesopotamia. Embellished with gold and silver threads, precious stones and pearls, it represented a Paradise Garden. In 638, during the sack of Dastagird, the palace of Chosroes II, the Byzantines carried away woven fabrics and clothing made of silk, in addition to flat, pile, and embroidered carpets.

Abundant Anatolian References

Literary sources from Constantinople mention that in the 6th century carpets covered the floors of Haghia Sophia as well as those of the state rooms within Justinian's palace. The

factories of the Byzantine capital produced wool rugs with motifs based on floor mosaics.[8] In the 9th century a Peloponnesian lady ordered a rug from one of the workshops for presentation to the new church erected by Basil I in Constantinople.

Accounts left by Arab travelers, geographers, and historians provide evidence of incalculable value. Their descriptions of ceremonies, ateliers, and rugs are as rich in information as the later representations of Oriental rugs painted by Crivelli, Lotto, Holbein, and others. To summarize all relevant Arab writings would require an entire volume, but we must at least cite Al-Khatib, who, in his *History of Baghdad*,[9] tells us that the palace of the Abbasid Caliph of Baghdad was decorated with innumerable fabrics for the reception of the Byzantine ambassadors in 917. There were 22,000 rugs and mats disposed about the corridors and courts and the portals leading to the throne. In other rooms the carpets were laid in a manner, often one on top of another, so that they could be admired without being trod upon.

From Chinese accounts[10] we know that felt rugs were fulled for centuries in eastern Turkestan, and that from the 9th century through the 13th the Uigurs made wool carpets in what today is Mongolia. The city of Hoten was producing rugs in the 12th century, and at Khocho, the Uigur capital, wall paintings included images of rugs decorated with arabesques and palmettes.

ARCHAEOLOGICAL FRAGMENTS

Fragments of rugs and the earliest rug discovered in archaeological digs constitute a few links from a long but still incomplete chain, which runs from methods of weaving with or without knotting (whose relevance for the pile rug is still not proven) to the achievement of modern tufting techniques.

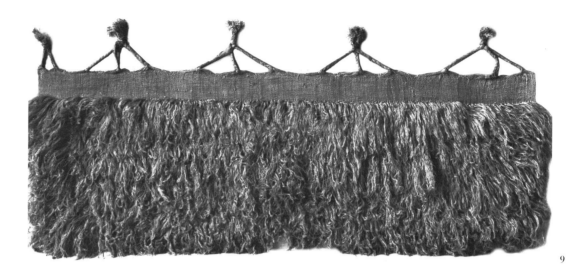

9

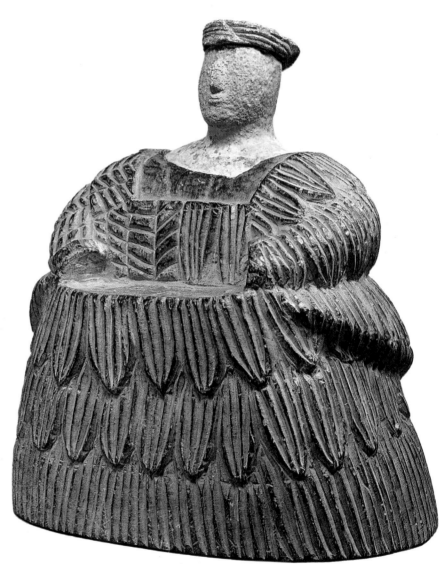

10

10. *'Bactrian Princess', statuette of a woman wearing a kaenakes. 2nd century BC. Chlorite and limestone. Louvre, Paris. The robe resembles textiles characterized as 'imitating goatskin', dated by some experts to the 3rd millennium BC.*

9. *Linen textile embellished with wool pile. Egypt, Deir al-Medina, c. 1450 BC. Louvre, Paris. Many experts believe that linen textiles embellished with long knots anticipated the invention of pile weaving. It is also thought that such textiles were used for clothing as early as the 3rd millennium BC, although none has survived.*

The Near East

In the Near East there are numerous fragments of rugs and textiles attesting to the diversity of the techniques which ultimately yielded the Oriental carpet. The first attempts at knotting can perhaps be detected in undyed linen fabrics embellished with knots, such as the specimens from the 2nd millennium BC found at Deir al-Bahari, Egypt, in the tomb of Pharaoh Horemheb, who reigned from 1379 to 1358 BC. Udo Hirsch[11] supports this theory, advanced earlier by E. Riefstahl[12] and M.T. Barrelet,[13] and maintains that these linen textiles decorated with long knots, as well as those found at Deir al-Medineh or at Deir al-Bahari (Louvre), or yet the ones from the tomb of Kha (two bed covers and two throne covers from around 1400 BC [Museo Egizio, Turin]), prefigured the knotted-pile carpet. Hirsch, Riefstahl, and Barrelet believe, moreover, that such knotted textiles were already being produced in Mesopotamia in the 3rd millennium BC, not one example of which appears to have survived. They were used as clothing and imitated, according to Hirsch in particular, the fleece of a goat. The technique is already well developed, but it has not produced pile rugs properly speaking.

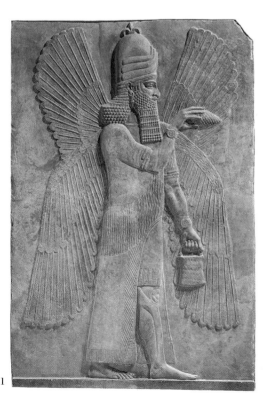

11

12

The Oldest Carpet Yet Discovered

Meanwhile, the oldest of the rugs discovered in a princely Scythian tomb in the Pazyryk Valley, at the heart of Central Asia's Altaï Mountains, dates from the end of the 5th century BC. This was the celebrated find made in 1949 by a Soviet team under the leadership of Rudenko. The technique employed (symmetrical knots, a density of 3,600 knots per square decimeter), the quality of the execution, and the complex symbolism of the ornamentation[14] make the Pazyryk carpet a highly evolved piece, the exact origin of which is the subject of considerable debate. Schürmann,[15] by comparing the Pazyryk carpet with objects found in the vicinity of Lake Van, concludes that it came from Armenia, the hereditary region of the ancient Urartian

THE PAZYRYK CARPET

The 'Pazyryk carpet'. Central Asia (Siberia), 5th century BC. Wool pile, warp, and weft; symmetrical knots; 1.98 x 1.83 m. Hermitage Museum, Saint Petersburg, Russia. Discovered in 1949 by a Soviet team at the heart of the Altaï Mountains, this work is the earliest nearly intact carpet preserved. It dates from the end of the 5th century BC. The technique used, the quality of the execution, and the complex symbolism of the ornamentation make it a highly evolved piece.

kingdom whose population consisted of various tribes among which figured Scythians. According to Dimand and Mailey,[16] however, the Scythians did not make pile rugs but, rather, felt rugs, such as those represented on the Pazyryk piece and the ones discovered in the *kurganes* (tombs) of the Altaï Mountains. In Scythian art, furthermore, the muscularity of the depicted animals is quite marked, which is not the case in the Pazyryk carpet. And, as Rudenko[17] has shown, the Pazyryk riders leading horses by their bridles or mounted are comparable to figures in the Achaemenid friezes of Persepolis. Too, the griffons resemble those in the Susa frieze, while the floral motifs filling the central squares can be found as well in the paving stones of several palaces, such as those of Sennacherib (r. 705-681 BC) and Assurbanipal (r. 668-616 BC) at Nineveh. Moreover, the paving stones, which decorated the passage through the entrance portals, serve as a

frame surrounding a central field identical to the one in the Pazyryk rug as well as in those of later Oriental carpets. If we are to believe Dimand and Mailey, the Pazyryk piece may well be a work of Achaemenid Persia.

Other Textiles

The sophisticated Pazyryk carpet is not an isolated example, since a small fragment from the 5th century BC has been found by Rudenko in another *kurgane*, this one located 200 kilometers from Pazyryk at Bashadar. Here, the asymmetrical knot was employed and a greater density realized: 4,900 knots per square decimeter.

The At-Ta caverns, situated 110 kilometers southwest of Baghdad and host to, among other things, Parthian and Sassanian burial sites (from the 3rd century BC to the 7th century AD), have yielded up a group of some 4,000 pieces of textiles, among which are 40

piled fragments.[18] They are dated, by Carbon-14, between the 3rd century BC and the 3rd century AD. The fragments offer three types of knot: the symmetrical knot (also known as the Ghiordis knot), the asymmetrical knot (often referred as the Senneh or Persian knot), and the single-warp or 'Spanish' knot. Together, they constitute the three

11. *Blessing spirit, sculptural relief from the citadel of Sargon II at Dur-Sharrukin (today Khorsabad). 713-706 BC. Louvre, Paris.*

12. *'Pazyryk carpet', from a Scythian tomb in the Pazyryk Valley, Altaï Mountains (Siberia). 5th century BC. Wool pile, warp, and weft; symmetrical knot; 1.98 x 1.83 m. Hermitage Museum, Saint Petersburg, Russia.*

13. *Threshold, alabaster gypsum, Palace of Assurbanipal, Nineveh. c. 645 BC. Louvre, Paris. The central squares or compartments patterning the Pazyryk carpet contain floral motifs like those incised on this paving stone from ancient Nineveh.*

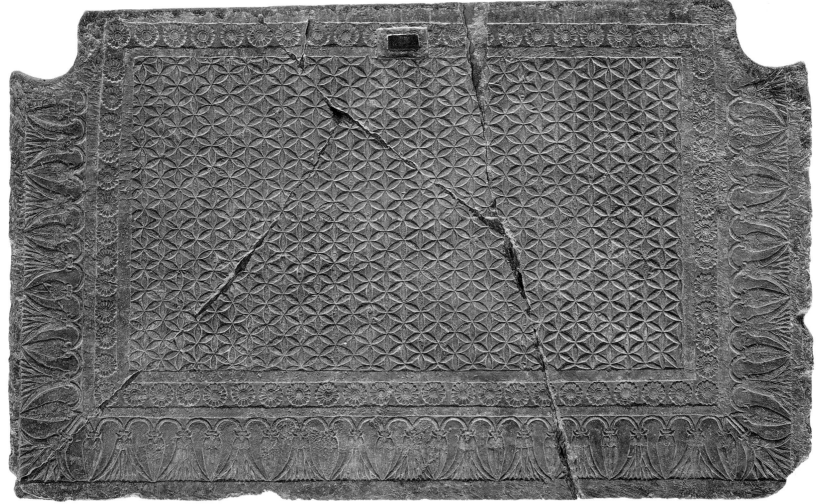

13

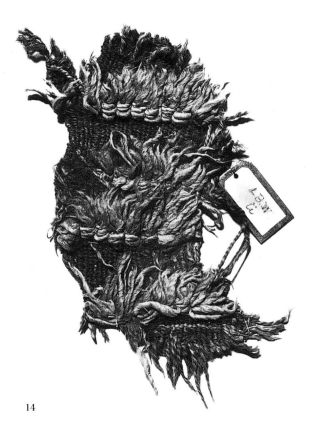

14

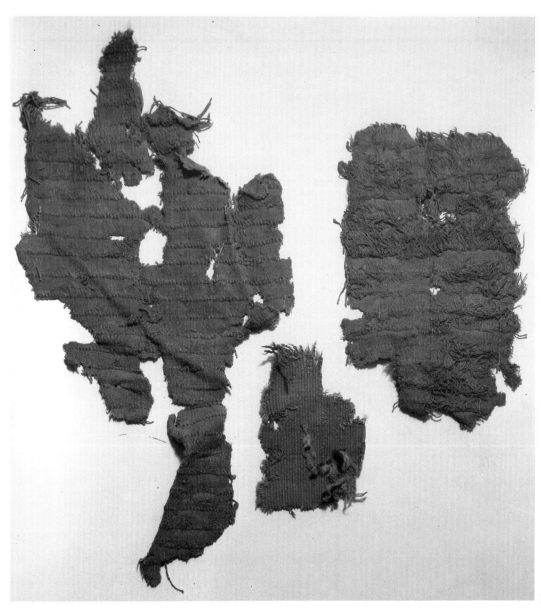

15

basic techniques for making Oriental carpets. Considerable irregularity in the craftsmanship – in the thickness of the threads, the distance between knots – is typical of these textiles made from the wool of sheep and goats. The ornamentation is simple and geometric: stripes, wavy lines, squares, stepped motifs, grids. Very likely the rugs were woven locally and not imported. Comparable to the fragments found at Dura-Europas, Palmyra, and in Nubia, they prove the vitality of the craft at this time, especially in Iraq and Syria.

Evolution of Styles and Techniques

Rug fragments with symmetrical knots, with knots wound about a single warp strand, and woven bands ornamented with knots were discovered by Sir Aurel Stein at Lulan in Chinese Turkestan. They were made between the 1st and 3rd centuries of our era. Their motifs are geometric (wavy lines, lozenges, grids), like those in fragments taken from the Lop Nur site (Sven Hedin excavation) and dated to the same period. In China's Sinkiang province, recent excavations of a Han tomb

have uncovered two pile rugs from the 1st and 2nd centuries of our era. From Kyzyl in Chinese Turkestan comes a 5th- or 6th-century fragment whose knots are looped about a single warp (Albert von Le Coq excavation).

The Copts of Egypt progressed from woven fabrics embellished with knots, utilizing dyed woollen yarn on a linen foundation, to entirely knotted works made with wool. There are at least two fragments attesting to this: a 4th- or 5th-century piece from Karamis (Museum, University of Michigan) and a 7th- or 8th-century vestige featuring the face of a saint and discovered in the ancient Fostat quarter of Cairo.

At the outset of the Islamic era, the technique of weaving and knotting was still the

14-15. Knotted-pile rug fragments. Lulan, Chinese Turkestan, AD 1st-3rd century. Victoria and Albert Museum, London. The knot is symmetrical and the patterns geometric, composed of wavy lines, lozenges, and diaper grids. The fragments came from an archaeological excavation carried out by Sir Aurel Stein.

16. Rug fragments. Egypt, 7th-8th century. Wool pile, warp, and weft; single-warp knot. Metropolitan Museum of Art, New York. Carpet fragments dating to the beginning of Islam come essentially from excavations carried out in Egypt, a country that acquired textiles from production centers as far away as India and Spain. This, in turn, makes the provenence of the fragments seen here difficult to determine. What does appear evident is that both the knot types and the iconography characteristic of the Orient were falling into place.

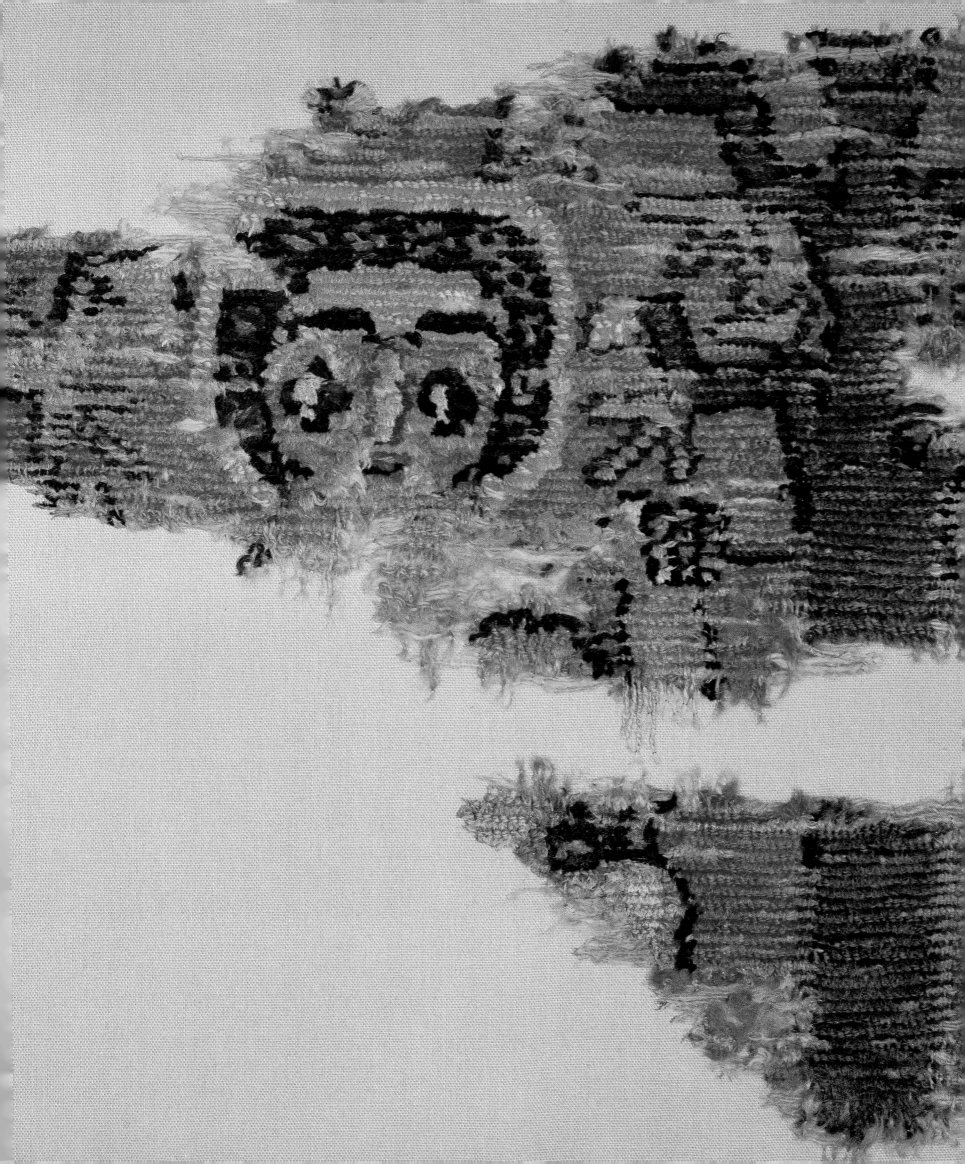

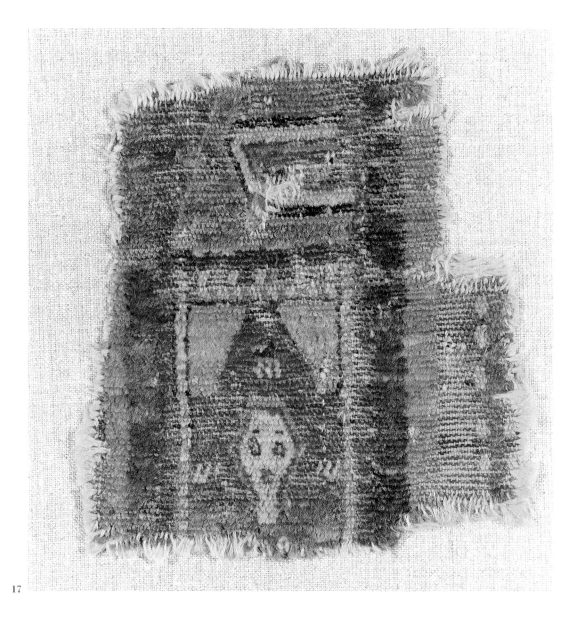

17

17. Carpet fragment depicting an orans (praying figure) within an architectural setting. Egypt(?), 9th century (?). Wool pile, warp, and weft; single-warp knot; 18 x 89 cm. Bouvier collection, Geneva. Although found in Egypt, this fragment has been assigned by some scholars to Spain, because of the single-warp, or 'Spanish', knot used for the pile. It would follow, therefore, that the knotted-pile rug may have arrived in Europe in the 10th century through Spain, where it could have been introduced by Coptic weavers.

same as that utilized by Egyptian, Syrian, Persian, and Mesopotamian artisans. Very likely the types of knots and the iconography characteristic of the Oriental carpet became established in the producing countries during the period which stretched from the 8th century to the 12th.

Egypt: A Mine of Information

Medieval Arab literature contains frequent references to the carpet-producing centers of Iraq, Persia, and Armenia, but only seldom does it mention those in Egypt. Paradoxically, however, carpet fragments from early Islam have come to light primarily through excavations carried out in Egypt. The oldest examples are those uncovered at Fostat, the first Islamic settlement in Cairo, and they are from knotted rugs. Today the vestiges are preserved in a variety of collections, such as those in Cairo's Museum of Islamic Art, the National Museum of Stockholm, and the Textile Museum in Washington, D.C. The current state of research makes it difficult to fix a place of origin for all the surviving bits, since Egypt bought textiles from a variety of

countries, some of them as far away as India and Spain. Several pieces, dated between the 11th and 14th centuries, are made in such a way – with the single-warp Spanish knot – as to identify them as Hispano-Islamic (see Chapter 10). Could this type of knot have been imported into Spain in the 10th century by Coptic weavers who, in turn, would have acquired it in the East? Is it possible to justify such a thesis by the existence of a single fragment, in the Bouvier collection, with a knot tied on a single warp thread? This example[19] should actually be dated to the 9th century, and, given the characteristics of its decorative style – an *orans*, or praying figure, within an architectural setting – and the exclusive use of wool, the piece could very well be of Egyptian provenance.

Various Techniques

Two other fragments discovered in Egypt[20] also confirm the diversity of techniques practiced before carpets achieved their full flowering. Made with a symmetrical knot, these bits have, in one instance, seven or eight shoots of weft between each row of knots and, in the other, from four to six, characteristics found in certain fragments recovered at Dura-Europas and Lulan. In one of the rugs the weft is shot under two warps and over one, a trait that is far from novel and can be seen in a symmetrically knotted fragment from Dura Europas and in several pieces found on the Cairo market, among them a fragment at the Metropolitan Museum in New York.

A fragmentary rug in the San Francisco Fine Arts Museum also came from Fostat. The field seems to be decorated with a stylized lion surrounded by geometric borders suggestive of Roman mosaics and Coptic textiles. The motif of foliage with clusters of grapes, inherited from the Greco-Roman world, reappears in Islam, notably in Umayyad art and in the so-called 'desert' castles, such as those at Khirbet al-Mafjar or at Qusayr'Amra. Carbon-14 dating places the fragment somewhere between the second half of the 7th century and the end of the 9th century. It is made entirely in wool and with the symmetrical knot.

Cut-Loop Textiles

There were also various weaving methods capable of producing textiles which may have been used as rugs. In the Islamic world, we should remember, the use of textiles as furnishing is both flexible and varied, since a fabric could serve alternatively as a wall hanging, a bed cover, or a rug. Having developed cut-loop or velvet fabrics, the Copts and the Christian Syrians could 'copy' knotted rugs. Several such fragments, among them one at the Metropolitan Museum and another in the Keir collection in London, present ornamental schemes derived from Roman and Early Christian mosaics.[21] Mamluk carpets continued these overlapping, geometric figures. In the example owned by the Metropolitan, strong polychromy, cross motifs (the inside border), and vine branches (the outside border) are characteristic of Coptic art from the 5th century. A comparable fragment is the one in the Keir collection, which, in addition, has stylized human faces (in the border) and eagles (in the field). According to E. de Unger,[22] the textiles in this series could also have been the work of Copts during the Fatimid era (967-1271), thus later and Islamic.

Relationship to Islamic Art

With the advent of Islam, the Copts seem to have become even more influential, thanks to their numerous ateliers (Tinnis and its five hundred looms, Damiette, Alexandria, Fostat, etc.), as well as to the variety of textiles produced, among them the famous *tiraz*. The geometricization of ornament also became more common. Kufic inscriptions, geometric forms, floral and sometimes zoomorphic motifs appear in fragments of cut-loop rugs dating from the 9th and 10th centuries held by the Museum of Islamic Art in Cairo, the Textile Museum in Washington, D.C., and the Metropolitan Museum in New York.

Until the 13th century, fabrics woven from wool and used as rugs, wall hangings, and cushions constituted the main production of Egypt, an industry which had arrived there only in the 3rd century AD. Already ably practiced in the countries of the eastern

THE FIRST ISLAMIC CARPETS

Geometric Decoration

In terms of ornamentation, the work reproduced below may reflect the period during which the decorative scheme of the first Islamic rugs was being developed. The geometric motifs used in carpets, such as the octagon, and their characteristic organization and imbrication are common to an iconography already well established at the end of the Roman Empire, from the beginning of both Christianity and the art of Islam. They show up particularly in late Roman mosaics, as well as in the 8th-century Umayyad mosaics in the mosque at the Khirbet al-Mafjar castle located north of Jericho, or in the *opus Alexandrinum* long practiced in Christian lands, such as the work executed in 1268 in Westminster Abbey. From literature we know, moreover, that the same mosaics served as models for certain carpets made in Constantinople between the 6th and 9th centuries. Mamluk artisans would have also utilized such models during the 15th and 16th centuries in order to create their famous compartment-patterned rugs.

A Link in the Chain of History

Although unable to prove that the first Islamic rugs systematically reproduced motifs from mosaics or that every textile displaying such ornamentation may be a rug, we conclude that the piece seen here, by partaking of the influential stylistic current, may very well constitute a link in the chain leading to the still obscure origins of the pile carpet.

The technique employed is worth noting: the supplementary wefts essential to brocaded decoration pass under every other warp and over every fourth warp.[23] The warps are made of linen and the brocaded wefts of colored wool and cotton. This technique and the S-spun yarn constitute the distinctive traits of Egyptian production. The colors used – brown, bright orange, vivid yellow, indigo, and green – are also characteristic of Coptic textiles as well as of fabrics from the beginning of Islam.

In design, this piece is comparable to several known textiles. The closest parallel is a fragment in the Davids Samling in Copenhagen (no. 12/1988), which originated in Egypt or Palestine at the end of the 7th century or sometime during the 8th century.[24] A cut-loop fragment from the 5th century is preserved at the Metropolitan Museum.[25] There is another similar fragment at the Victoria and Albert Museum, this one made of silk and inscribed with the name of the Umayyad Caliph Marwan. A third piece, in the Keir collection,[26] shares the same ornamental spirit.

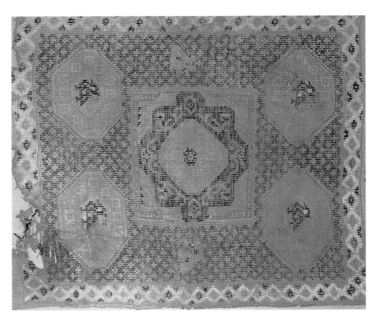

18. *Brocaded linen ornamented with birds, Egypt, c. 9th century. c. 112 x 77.5 cm. Linen warp, wool and cotton brocade wefts. Private collection, Paris.*

18

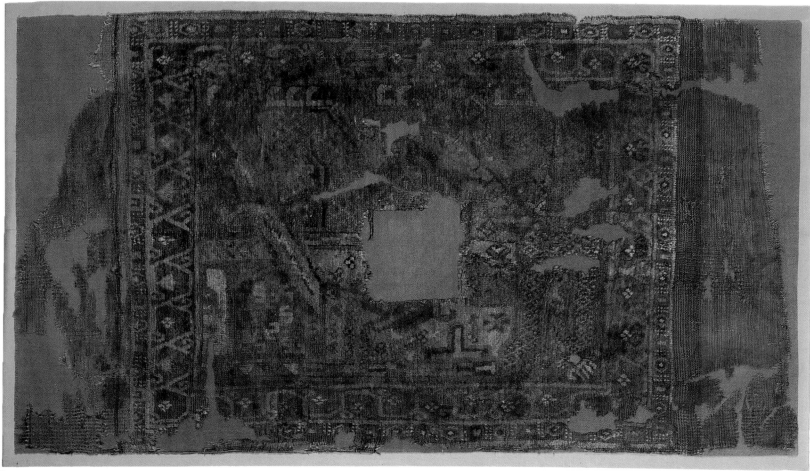

19

Mediterranean, the technique, which arose along with sheep husbandry in Egypt, gradually replaced linen weaving, essentially a pharaonic process. Fragments now at the Textile Museum in Washington and the Metropolitan Museum exhibit floral and geometric ornamentation, or a combination of Coptic motifs and Islamic style, or purely Islamic patterns. The decorative features are varied: birds (Metropolitan no. 27.170.73), lozenges or hexagons containing 'Coptic' crosses (Metropolitan no. 27.170.76), rosettes or fleurons, trilobate palmettes, and epigraphic inscriptions (Metropolitan no. 27.170.79). Light blue on dark blue, deep maroon, brown, and red appear together in a characteristic palette of colors.

History Ignored

That the weaving processes just cited shared a common history with knotted-pile carpets appears certain. It is impossible, however, to establish precisely how these processes fig-

ured in the origin of the carpet or how they contributed to its evolution and its establishment within various cultures. The technique of the knot, already in use sometime between the 4th and 2nd millennium BC, formed part of humanity's collective baggage and would have been utilized in a more or less continuous manner in various regions and periods.

The carpet arose from an art mastered by weavers over a wide region, from China to Islamic Spain. Still, apart from the Pazyryk rug woven at the end of the 5th century and the Anatolian Seljuk carpets of the 13th century, no complete rug or carpet is known to have survived from those early times. Does the lack signify something which still eludes us? Research has often been focused upon Egypt, in part because of the number of fragments found on Egyptian soil, even though knotting techniques originated in the East and decorated fabrics woven from wool in the countries of Asia Minor and the eastern Mediterranean. The art of the carpet, a legacy from the diverse peoples of the Ori-

ent, has been carried to the summit of achievement by Islamic civilization whose symbol it unquestionably constitutes. Between the 8th-9th century and the 12th-13th century, the knotted-pile technique and the iconography of the Oriental carpet took hold and sank deep roots in the societies of Anatolia, Persia, and Spain, without the process through which all this occurred being fully evident to us.

19. Fragmentary carpet with a border based on floor mosaics. Egypt(?), 7th-9th century (Carbon-14). Wool pile, warp, and weft; asymmetrical knot; 115 x 89 cm. Fine Arts Museum (Roscoe and Margaret Oakes Income), San Francisco. Discovered during archaeological excavations in Fostat, an ancient quarter of Cairo.

20. Cut-loop carpet fragment. Egypt, 5th century(?). Wool warp and weft pile; cut-loop or 'velvet' technique; 1.11 x 1.02 m. Metropolitan Museum of Art, New York. The Copts and Syrians, having developed a technique for weaving velvet fabrics, could easily 'copy' or mimic knotted-pile rugs.

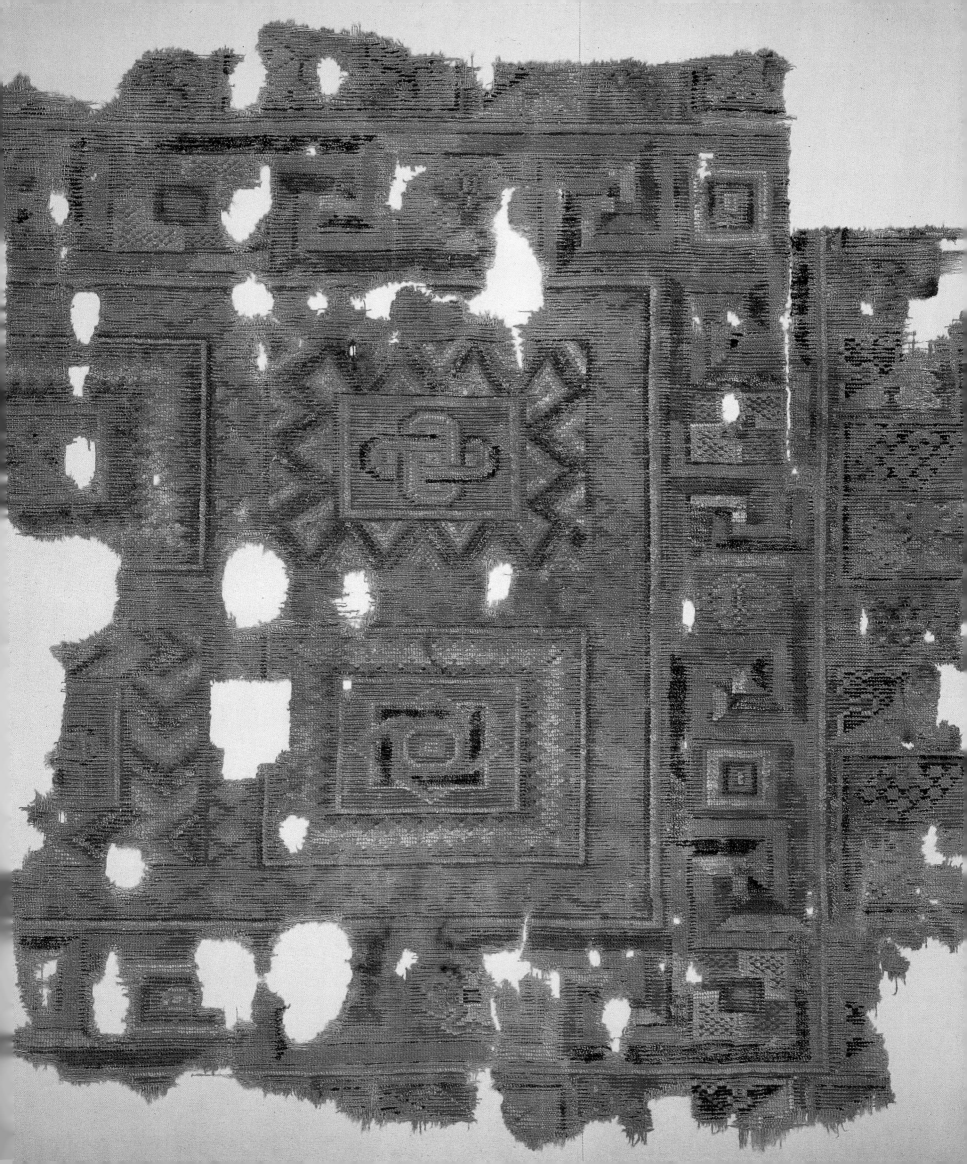

CHAPTER
II

THE MANUFACTURE,
RESTORATION,
AND
CONSERVATION
OF CARPETS

Odile Gellé

There is something mysterious about a fine carpet, a work of human craft with the power to endow whatever space it inhabits with life and soul. The material, the texture, the sparkling colors, the motifs and their composition – all combine to create a unique object, a remarkable presence. The handmade quality of rugs, provided the work has been done according to a precise, codified technique, engages our spirit, our feelings and emotions. Yet, despite the rigorous, systematic methodology, artisans enjoy great freedom of execution and can easily prove their ingenuity through carefully elaborated creative procedures.

The carpet is a colored textile whose structure, or warp and weft, yields a surface that is flatwoven, piled, or embroidered. The several techniques and their materials are sometimes combined within the same piece, thereby enriching the ornamental repertoire. The terms employed in this chapter are those we have found to be the most exact, but while the following list is quite inclusive, it does not, by any means, exhaust the subject.

MATERIALS

The visual and tactile sensations produced by carpets differ, of course, according to the materials employed. Vegetable and mineral matter, for instance, has an inert character, while material obtained from animals tends to be alive and elastic. Light affects both, bringing out the qualities of fibers – their brilliancy, softness, or matteness.

Cotton From its origins along the banks of the River Indus, cotton cultivation spread to China, Persia, and Anatolia before fanning out all over the world. Beginning in the 19th century, industrial spinning contributed enormously to the wide-spread use of cotton. Supple but robust, largely inelastic, and thus capable of holding its shape, cotton plays an important role in carpets mainly as foundation, as the structural warp and weft. But the material is also used for its whiteness in both pile weaving and flatweaving. Mercerized cotton thread, with its wonderful sheen, is utilized mainly in embroidery.

Linen Although Egyptian in origin, linen is cultivated almost entirely in northern climes. Its contribution to carpets is not great, serving primarily as warp and weft in European-made rugs. The plainwoven foundation – the canvas or toile – of embroidered and needlepoint rugs is often made with linen.

Jute and hemp Jute, a substance native to India, and hemp, found everywhere in temperate climates, were once employed relatively little in the fabrication of carpets. The fragile fibers of the former and the shorter ones of the latter made them difficult to spin or twist into yarn. With the arrival of industrialization, however, came a viable method of spinning jute into strands suitable for structural warp and weft, sometimes even for pile. By the same token, hemp became available for use as structure in flatwoven or needlework rugs. The two materials are spun in their natural state or mixed with cotton or linen.

Metal threads These materials show up mainly in court carpets. To create them, fine strips of gold, silver, or copper are wrapped around a strand – a 'soul' or core – of silk, linen, or cotton. Brocaded onto the fabric, the metallized threads enrich and brighten the carpet's design.

Wool The earliest known woollen yarns appeared in Mesopotamia. Soft, pliant, springy, and lustrous, wool is widely and overwhelmingly favored as the primary material of carpets, especially knotted-pile carpets. Its irreplaceable characteristics of suppleness, elasticity, and thermal insulation make wool agreeable both to work and to live with. What wool lacks is great tensile strength, which means that a carpet knotted on a woollen foundation is much more likely to stretch and otherwise lose its shape than one made on a foundation of cotton. In so-called 'tribal carpets', goat hair, because of

21. *At the Manufacture des Gobelins in Paris, drawers filled with wool samples, as arranged during the second half of the 19th century, when the workshop was under the direction of Chevreul.*

22. *The dyeing atelier at the Manufacture des Gobelins. This particular room is reserved for drying wools following their immersion in a vat filled with colorant. The dye shop at the Gobelins functions as a division of the Mobilier National. It serves the Gobelins but also the Beauvais and Savonnerie manufactures, as well as the Gobelins's restoration shop.*

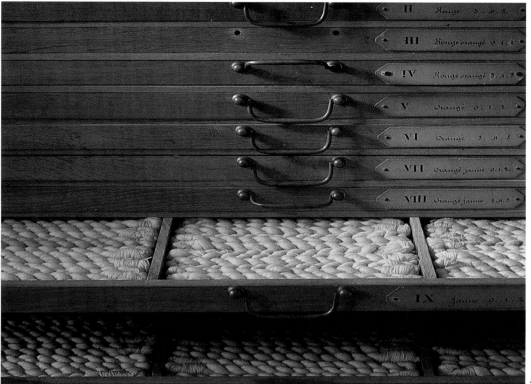

21

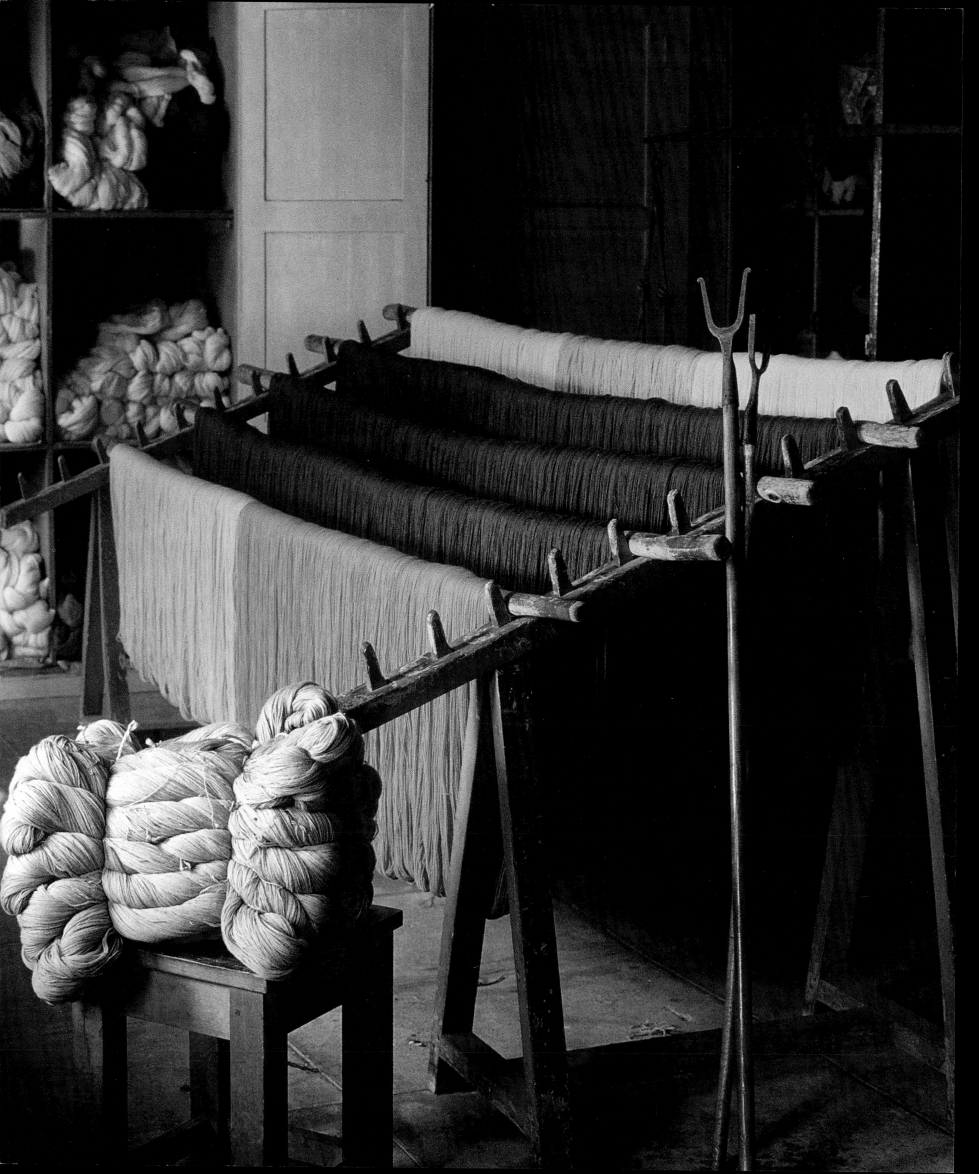

its toughness and stability, is sometimes used, in combination with sheep's wool, for the warp threads, or for the selvedge, but only rarely for the pile, where it would yield a prickly rather than a soft texture.

Silk In China, silk appears to have been known from the time of the earliest recorded civilizations. For centuries the Chinese kept the techniques of silk making a secret even while exporting both the thread and silk fabrics. Silk is the only continuous fiber known to exist in nature, and a strand can run as long as 5,000 feet (1,520 m). Triangular in section, the filaments yield light-reflecting facets that give silk its unique brilliance. And while the lightest of natural fibers, silk possesses

23. *Interior of the Bay Frères spinning mill in Turkey.*

24. *Jars filled with natural and chemical colorants in the dyeing atelier at the Manufacture des Gobelins during the period under Chevreul.*

great tensile strength. This makes silk a favorite material for the warp in densely knotted carpets; it is less frequently used for weft, except where finish and suppleness are particularly desired. In certain pieces, the ornamental motifs are knotted in silk, while the ground is piled in wool. The compact knotting made possible by fine silk yarn brings out the material's iridescence, transforming the carpet into a shimmering pool of light.

THE TREATMENT OF FIBERS

Spinning Techniques

Spinning involves a series of operations through which a primary textile material is transformed into usable yarn: arranging (drafting) the fibers parallel to one another, joining them so that they become continuous, and imparting a twist to the resulting yarn.

Before it is twisted, however, the textile fiber must be prepared in several ways. Wool and cotton are first scoured (washed), carded, and then sorted. Linen, hemp, and jute fibers, which come bundled together within the plant, must be separated from the stalk (the base material) by fermentation and scutching (beating or hacking). Next, the fibers are combed so as to align them in parallel order and then roved – that is, rolled or pulled into long, loose yarn. For spinning – a manual process of twisting the yarn – a drum reel or a spinning wheel may be used, but the simplest and the oldest tool is the hand spindle. Spindle-spun wool rarely has a consistent texture; thus, when woven, it gives the rug a lively, iridescent look.

The simplest yarn consists of a single ply or strand. Several strands plied or spun together make a multi-ply yarn. Yarn can be twisted or spun in two directions, generally identified as S-spun and Z-spun. They can be

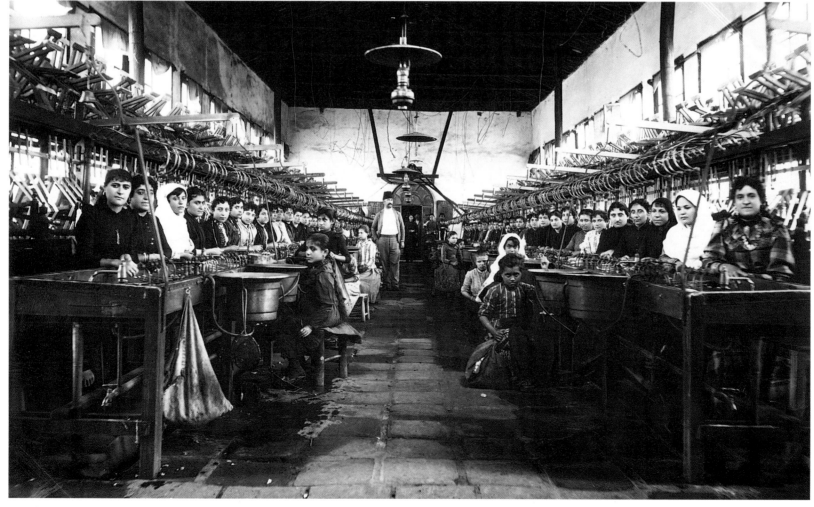

23

distinguished by holding the yarn vertically. If it is plied from right to left, the yarn is said to be S-spun (twisted clockwise); if plied from left to right, it is Z-spun (twisted counterclockwise). Two or more strands twisted together produces the much stronger multiply yarn, but this second spinning must be done in a direction opposite that of the component yarns. Hence the term Z3S, for example, denotes a yarn composed of three Z-spun strands plied together by S-spinning – by twisting in an S-direction.

Silk is processed in a different manner, because a silk filament, unwound from the cocoon, is not a short staple like the other natural fibers but extremely long; moreover, it consists naturally of two strands. The filaments are bundled together in groups of three to nine, after which a twist may be imparted to round off and soften the yarn.

Reeled yarn can also be made by combining the shorter brins, or filaments, but the weakness of the resulting twist makes the fiber supple though less strong. Cabled yarn is composed of several tightly twisted yarns combined together like cord. An example would be four or more Z3S yarns retwisted together. Cabled yarn is particularly sturdy and thus often utilized for the warps.

Dyes

The extraction of colorants from dyestuffs and the preparation of dye baths, both long and delicate processes, are normally carried out by professional dyers and only rarely by weavers.

NATURAL DYESTUFFS Since antiquity, natural dyestuffs – valuable merchandise and the subject of considerable trade throughout the world – have been exported to the carpet-producing countries. In the Middle Ages, red *lac* dye stood in lieu of payment. The colors of Oriental carpets, obtained with the help of natural dyestuffs – that is, from animal or vegetable sources – are both vivid and luminous. The quantities or the compounds, the length of immersion, and the number as well as the temperature of the baths determine the intensity of the resulting color. Woad, indigo, and purple are the oldest of the vat dyes.

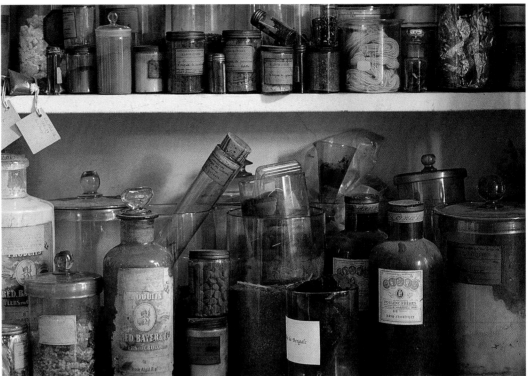

24

Mordants are used to make fast colors that would not be otherwise, owing to the incompatibility of the pigment and the material to be dyed. The most frequently employed mordants are alum (potassium aluminium sulfate) and iron sulfate. Mordanting increases the capillarity of the fibers and thus their ability to absorb and fix the colors. Mordants also make yarns more resistant to light, as well as to washing and wear. Yarn is usually mordanted prior to dyeing, since mordants can affect the colors, rendering them a bit darker. Too much mordant in the solution could, over time, cause the dyed yarns to deteriorate.

Red A wide range of reds can be obtained by soaking the crushed roots of the herbaceous plant known as madder, wild or cultivated. Another prime source of red is cochineal, a parasite insect, many varieties of which have been used by dyers for centuries: kermes from the Mediterranean countries and Armenia, lac from the Far East, and Mexican cochineal. The parasites secrete a pigment that colors their shells, which, once dried and ground into powder, serve as the foundation of the dye bath, whence comes a deep vermillion bluish in tone.

Certain mollusks, among them the murex, yield shades of red and purple that were much prized in the ancient Mediterranean world. Known as royal purple, their tones range from deep brownish red to violet.

Sources of a red running the gamut from rose to brown are woods from Brazil and Campeche, Mexico.

Yellow Yellow dye is extracted from a great variety of plants, among them curcuma, saffron, and reseda or weld. In the case of reseda, the entire plant is ground up to obtain the matter for the dye bath. To make yellow dyes fast, mordanting is normally done prior to dyeing, a procedure not required for indigo.

Blue Indigo, a shrub first known in the Far East, is cultivated in warm climates. Woad, which grows in Europe, gives shades of blue that are less intense than those of indigo. The tonal range of natural indigo is wide, from pale blue to dark blue, with violet or reddish overtones along the way. Fixing these blues to fiber requires a number of subtle and precise operations. Traditionally, blue indigo, which is not water soluble, had to be fermented for several weeks in a vat alkalinized with urine. Wool was then dipped into the heated vat and exposed to the air. Today, these ancient procedures have been supplanted by the use of concentrated sulfuric acid, which, like air, serves as an oxidizing

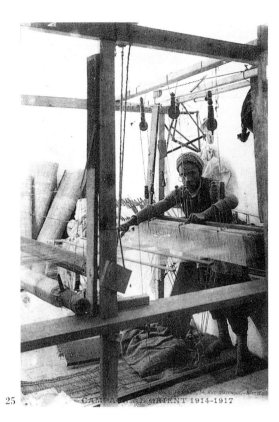

25

25. *Salonique, an Oriental carpet weaver photographed around 1914-1917.*

agent that turns the color from pale yellow to deep blue in a matter of seconds. When mixed together two at a time in successive baths, these three primary colors – red, yellow, and blue – can deliver all the secondary colors: violet, orange, and green. The greens which have come down to us emerged from a yellow bath followed by a blue one.

Browns Nut gall, rich in tanin, chestnut leaves, and walnut hulls as well as the leaves of walnut trees are all dyestuffs capable of yielding beiges and browns. Black may be obtained from sequential immersions in red, yellow, and blue. The brown-black produced by iron oxide is sufficiently corrosive to destroy fibers, slowly over time.

Vegetable dyes, with their capacity to offer colors of remarkable intensity, are still utilized by today's artisans, by nomadic societies, and even by certain large workshops.

SYNTHETIC DYES The discovery of aniline, a coal tar derivative, gave rise to the first synthetic chemical dye, developed in 1856.

Although widely used, aniline colors proved unsound, with a marked tendency to fade after prolonged exposure to light, and even noxious. Azo dyes, from a compound of artificial alizarin and indigo, entered the market in the 1880s and contributed further to the use of chemical dyes. Those based on potassium bichromate or 'chromatic' colors come in a wide range of hues; moreover, they are stable and thus widely utilized today.

ABRASHES, CHINÉS, AND PIQUÉS Abrashes are, for the most part, the variations in tonality, from knotted row to knotted row, within a field of solid color derived from natural dyes. They represent an uneven absorption of the colorant by various parts of the fiber or the inevitable differences among dye batches, as when yarns are hand-dyed progressively in the course of the weaving process. They could also be deliberate improvisations undertaken by artisans seeking to break the monotony of a continuous surface. But whether random, intentional, or the consequence of different dye baths, abrashes give the rug vitality and beauty. And they tend to grow more pronounced with age as well as with each new washing.

Differently colored yarns plied together and then woven, knotted, or embroidered to create nuanced effects are called *chinés* and *piqués*. Chinés result when the plied yarns are in chromatically close tones. Piqués, on the other hand, spring from plied yarns whose tones are markedly different and contrasted.

LOOMS

The simple structure of looms has evolved little in the course of centuries. In its essentials, a loom is still two parallel cross beams – usually made of wood but sometimes of metal and generally round in section – on which the warp is strung and held in tension. Nomadic tribes use horizontal or low-warp looms, which can be easily dismantled and transported on the backs of pack animals, even when a weaving project is still under way. The two cross beams are secured to the ground with pegs driven in at the corners,

and a set of cords or belts installed to hold the near or breast beam taut in relation to the warps. Another approach involves securing the ends of the transverse beams atop a pair of posts laid flat on the ground, thereby forming a stable frame. The dimensions of the rug are of necessity less than those of the loom. The weaver, sitting on the woven section of the rug, under which a board has been slid, moves forward to keep up with the work as it progresses.

The more widely used vertical or high-warp loom – a sturdy rectangular frame made of two posts as well as the two cross beams – exists in four types. (The diagrams provide a sectional view of the looms – their cross beams and the position of the warps.)

The loom with fixed cross beams (fig. 1). Here, the length of the carpet can never exceed the height of the loom. As the work progresses from the bottom up, the weaver must constantly raise the adjustable bench higher.

The loom with roller beams (fig. 2). Also known as the Tabriz loom, on which the warp is continuous and looped about the two cross beams to form two separate sets of warp, front and back. Once the piece has been woven to a height beyond easy reach, the completed fabric is wound towards the bottom and up the back. In this way it is possible to weave a rug almost twice as long as the loom's height. On the two looms just described, the tension of the warps is maintained by wedges slotted into the transverse beams.

The loom with a movable lower beam (fig. 3). The rug is rolled onto the lower beam while the upper beam, lashed to the upper part of the loom by strong ropes, descends bit by bit. The ropes hold the warps under the proper tension.

The loom with mobile beams (fig. 4). The most complex of the four types, this loom has two roller beams, each with a cog wheel at either end controlled by a winch. The weaver releases these mechanisms to wind the finished part of the rug onto the lower beam while simultaneously bringing the unwoven warp within reach of the weavers. Tension is guaranteed by a system of endless screws installed in the vertical beams. The warps are therefore considerably longer than the rug,

including the fringes left over after the piece has been woven and dismounted from the loom. This kind of loom is widely used in both Oriental and Western ateliers. It can also be adapted for horizontal weaving, with strong supports placed at the four corners of the rectangular frame. The rear roller beam, being a bit higher than the front one, gives a slight incline to the warps.

WARPS

The warp is the complete set of equally long parallel threads strung or wound onto the two transverse beams of a loom. This structural base or foundation, composed of durable, tightly twisted pairs of yarns, must be kept under firm tension, a factor essential to weaving.

The number and diameter of the warp threads, as well as their spacing, which must be regular and consistent, are essential factors determining the structure of the rug. An extremely fine carpet may have as many as thirty silk warps per centimeter.

Warp threads generally are not dyed, mainly because in a finished rug they are visible only as fringe at either end.

Weaving begins with warping. A process of assembling yarns of precisely the same length, warping is most often accomplished away from the loom, with the aid of a warping frame, which may be vertical, with its sticks planted in the ground at established intervals, or horizontal (fig. 5). For looms with fixed cross or transverse beams, warping is done directly on the loom, as it is also for looms with continuous, sliding warps. In this instance, the warp is wound about the two beams, thereby creating two separate sets of warps (fig. 2). During the warping operation, the weaver must guard against knots in the warp where they could weaken the rug's structure. All knots should fall on the extreme right side of the warping device, where the beam corresponds to the upper beam of the loom. A warping device also makes it possible to control the cross, the point at which wraps or segments of the same continuous yarn intersect from opposite directions as they are wound back and forth. The warp has been properly wound when every other wrap or

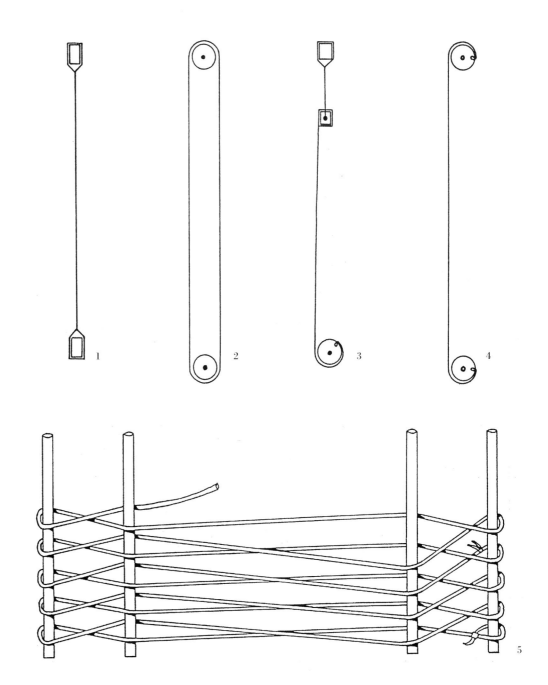

yarn is crossed and when each has been placed next to the previous one, with no overlapping. Once the warp has been completely wound onto the warping device, the closely aligned, parallel strands are tied at strategic intervals with tough cord to hold them in proper sequence for removal to the loom.

Next, the loops of warped yarns are placed either directly around the loom's transverse beams or around adjustable warp bars made of metal and grooved into the wooden beams.

The warp must be divided into two alternating sets of yarns whose separation allows the weft, guided by a shuttle, to be picked – shot,

thrown, or passed through. On simple horizontal looms and vertical looms alike, a removable rod known as a shed stick is slipped into the warp above and below alternate yarns the full width of the piece, selecting odd-numbered threads into one set and even-numbered threads into a second set. The effect of this first division is to push the even or second set of warps towards the back, below the shed stick. Within the shed or space thus created the weaver can introduce and pull across a strand of weft yarn. A second separation of warps is obtained by means of the heddle, another transverse rod, this one made of wood drilled

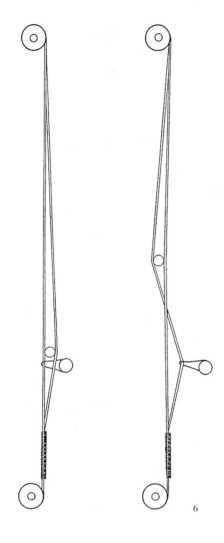

6

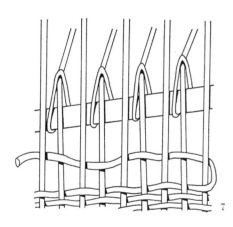

7

with holes for loops of cotton yarn tied one by one to every thread in the even set of warps. The heddle can be movable, attached to the loom's lateral posts, or, in the case of nomad looms, held by a tripod. When pulled by one hand, the heddle brings its set of warps through and above the first set, opening a second shed which allows for the return passage of the weft in the opposite direction. The heddle and its loops, installed once the warp has been mounted on the loom and made taut, slides up and down the warp as required (fig. 6).

More sophisticated low-warp looms mounted on sturdy, rectangular frames are utilized mainly in large workshops in both Europe and the Orient. The weaver sits facing the lower cross beam and separates the two sets of threads by pressing down on treadles linked to movable heddles located under the warp. The preparation of the warp prior to mounting it on the loom differs somewhat from the method employed for vertical looms. The loops at one end of the warps are cut on the warping device, after which the warps are mounted on the loom and the loops at the beginning of the warp are placed in the warp bar on the lower beam. Then comes the task of securing the heddle loops to the individual warps, with even- and odd-numbered loops and warps matched right across the piece (fig. 7). Next, the ends of the warp yarns are tied two by two and placed in the warp bar on the upper cross beam. The warp is thus divided into odd and even sets by means of paired heddles. Working the treadles, the weaver alternates the height of the two sets of warps and passes the wefts through the shed. To facilitate this operation, the width of the heddles is kept to 60 centimeters or less, which means that several sets are needed to span the entire warp and an equal number of paired treadles installed under the loom.

FLATWEAVE CARPETS

Flatwoven rugs – rugs without knotted pile – are made by an ancient process, which is essentially the same as the technique used to weave tapestries, whether on a horizontal loom or on a vertical one. The method is also identical to that employed by kilim weavers and the Aubusson ateliers which make the weavings known as *tapis ras*. In its simplest form, the product scarcely differs from the foundation of warps and wefts that forms the structure a knotted-pile carpet. In other words, it is the most basic kind of weaving. The warps and wefts are interwoven perpendicularly to one another in the following manner: The shuttle holding the weft yarn is passed over and under alternate warps corresponding to the motif, and once the weaver has opened a new shed, the weft is passed under and over alternate warps, and so on.

Passing a weft thread through a set of warps is known as a pick, a throw, a shot, or even a shoot. The wefts must all be of the same thickness if they are not to distort the shape of the woven fabric.

Once a weft has been shot through the warps and then packed or beaten down with a comb hammer, the vertical warp ceases to be visible below this level, covered as it now is by the woven horizontal wefts. The pattern therefore emerges from the colors of the weft threads, a situation that allows the designer considerable freedom. Put differently, a motif is drawn by means of the weft, even as this element serves as a fundamental part of the structure. The design of a 'weft-faced' plainweave comes into being through a series of juxtaposed elements, an interface of contrasting color areas.

Slit-tapestry weave (fig. 8). If the line or edge separating two areas of color is parallel to a warp thread, a slit may result, because the wefts have been turned back – relayed – around adjacent warps at the boundary between the two colors. When the slits are not too long – no more than a half-centimeter – they can be left unsewn, thereby endowing the piece with greater suppleness. Longer slits, however, could weaken the structure. Designs with diagonal lines or edges tend to minimize the length of the gaps in slit-tapestry weaves (also known as 'kilims'). To eliminate the slits altogether, weavers can sew them together once the fabric has been 'liberated' from the loom. Two alternative techniques are interlocked wefts and shared warps.

Interlocked wefts By this method, discon-

tinuous wefts from adjacent color areas are interlaced or wrapped around each other, forming a secure join between two warp threads. If one weft wraps around the corresponding weft from the adjacent color area, they are single-interlocked wefts (fig. 9). A rug woven in this fashion is reversible, that is, the same on both sides. When doubly interlocked, however, the wefts wrap around each other in pairs, producing joins that are smooth on the front and ridged on the back (fig. 10). The result could be a rug that does not lie entirely flat once rolled out on the floor.

Shared or common warps By this process, discontinuous wefts from adjacent color areas are wrapped about the same warp so that they dovetail one another to create a very secure join as well as a sharp demarcation between the two areas. The wrapping can be single-dovetailed for a 'comb-tooth' effect (fig. 11), stagger-dovetailed for a 'zigzag junction' (fig. 12), or dovetailed 2/2 for a 'sawtooth' edge (fig. 13).

Looping or wrapping The weft is wrapped around two warps and then back under one warp (fig. 14), creating a slight ridge on the back of the rug. This decorative technique is sometimes called '2/1 soumak'. The weft wrapping can also engage two warps at a time and be slanted or angled to the left or the right. Moreover, the looping can be done on a diagonal axis as well as on a horizontal one. If woven on the back, looping produces the effect of a clean contour line on the front. Once beaten down with a hammer comb, the loops cover the warp threads left exposed by the last shot of weft. On the face of the rug, the loops may serve a decorative purpose, contouring and emphasizing the shape of a motif. If done at the start of weaving, the loops compensate for the division of warps into alternate, odd and even sets, while at the end the same loops help 'stop' or 'block' the warps.

Curved color junctions Here, the wefts are woven along a curving line (fig. 15), rather than at strict right angles to the warps. The technique makes it possible to reproduce an arabesque pattern, but only over a limited area, lest the result be a rug with a buckled surface instead of a flat one. Curved wefts, with their woven 'sockets' and wedge-shaped

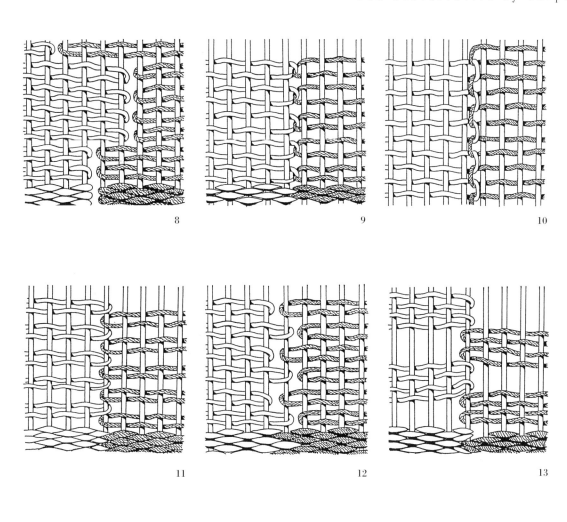

8 9 10

11 12 13

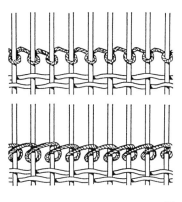
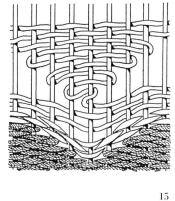

14 15 16

inserts, may adversely affect the parallelism of the strung warps.

Diagonal weft lines Woven irregularly and on the diagonal, diagonal weft lines – sometimes called 'lazy lines' – break up the surface of a napless rug (fig. 16). On a field of solid color, they vary the rhythm of the wefts. They also help prevent shrinkage. Diagonal weft lines can enliven the ground and thus serve a design purpose; for the same reason, they can also emphasize or take advantage of variations in color batches. For a still more dramatic effect, 'lazy lines' may be woven

with different materials. In pile carpets, this technique is visible only from the back. Finally, the process allows several weavers to work on the same piece, each of them responsible for only part of the whole. Indeed, the term 'lazy lines' arose from the fact that workers need not move from side to side while weaving diagonal weft lines.

Soumak An elaboration of the looping or wrapping technique, soumak is worked from the surface, generally by passing the weft yarn over four warps, back under two warps, over four more, back under two more, and so

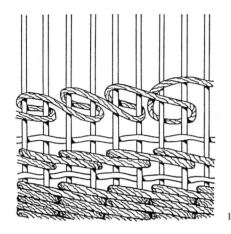

17

18

19

20

on. The row of looping weft slants in one direction (fig. 17), either left or right (fig. 18). When the soumak is worked alternately from left to right and right to left, a herringbone pattern is created; when all the rows are wrapped in the same direction, a twill results. In some cases, the structural wefts are shot after one, two, or even three rows of soumak wefts. On occasion, the structural weft shoots may be omitted altogether.

Supplementary wefts A cousin of soumak, this technique, known as 'cicim' or 'jijim', consists in wrapping the extra wefts around a few warps within the body of the work to create a pattern, woven progressively along with the structural weft (fig. 19). For every pick of structural weft there is a supplementary weft worked in relief so that the pattern is visible on both sides of the piece. The motifs thus served are usually small in scale, and the warps remain exposed in certain places.

Weft-float technique A variant of brocading, this technique involves supplementary

wefts which are passed or 'floated' over two or as many as five warps, then under a single warp, and once again over the same number of warps as in the preceding float (fig. 20). On the reverse side, the auxiliary wefts are barely visible, since on the right side they pass regularly under the same single weft, thereby creating a ribbed effect. The method is particularly suitable for weaving stiff metallic thread.

SELVEDGES Along the lateral edges of the woven piece are the selvedges, formed of clustered warps or of heavier, cord-like yarns. They reinforce and strengthen the left and right borders. Generally composed of two or three warps, the selvedges are woven with the structural wefts.

WEBS AND FRINGES After the fabric has been woven, the warp ends may be finished off in a variety of ways. The two most common techniques are the same as those used in weaving the body of the piece: plainweaving and knotting. They will be discussed below.

KNOTTED-PILE CARPETS

A step beyond plainweave is a knotted surface. It is the rows of knots, held in place by one or more picks of structural weft, that form the surface of a piled carpet. For purposes of knotting, a supple, lightly twisted wool works best, whereas the weft yarn, passed after each row of knots and then beaten down with a hammer comb, should be tightly twisted but flexible. The weft, which does not show on the piled surface of the rug, is sometimes colored, and, in some cases, it may not be shot until after two or three rows of knots have been tied.

The artisan works from the bottom to the top – that is, from one finishing web to the other. If several people are weaving together on the same piece, they may utilize the process known popularly as 'lazy lines' (fig. 16).

The structural weft may be thrown from one to ten times after each row of knots, although the usual number of shots is two. The diameter of the thread is not always constant. If the shoots are held in equal tension throughout the weaving process, the reverse side of the finished rug is flat. But when the first pick of weft is taut, a thinner yarn may be used for a second, looser pass. Where the taut and loose or 'sinuous' wefts alternate throughout the weaving, one set of warps is displaced, in which case the lower set is said to be 'depressed'. This 'two-plane' structure creates a ribbed effect on the reverse side (figs. 22 and 25, shown in section). When the wefts are pulled very taut they may cause the two sets of warps to overlap. This permits extremely dense knotting, which in turn lends itself to the weaving of more complex motifs. On the back of the carpet, only one of every two warps used to tie the knot is visible.

After the knot has been tied, usually on two warps, the weaver pulls the two ends of the yarn to tighten the knot and then cuts the extraneous wool with a knife. Throughout the weaving process, the knotted yarn is also scissor-trimmed in order to make the woven pattern easier to verify. When the finished carpet is 'freed' from the loom – when its warps have been cut at both ends – the pile is shaved or

clipped to achieve a uniformly smooth, velvety soft surface. This work is often done by master specialists. The height of the pile depends upon the density and fineness of the knotting. By convention, density is computed as the number of knots per square decimeter, first vertically and then horizontally. In a loosely knotted piece the pile is generally left long, whereas a finely knotted carpet is normally shaved to leave a short pile. The finished rug is then washed in clear water.

A knotted-pile carpet has an almost magical look, its rich texture shot through with light penetrating deep into the colored fibers. This is not light reflecting from the surface of cut yarns but, rather, light absorbed by matter and resonating from within. As a result, the color of a knotted-pile carpet is more intense than that of a flatwoven rug. Still, the colors appear pure and clear when viewed from the direction of the nap, that is, the pile direction. The reflection of light on the length of the piled fibers brings luminosity to the whole. The colors may even vary within a complete range of values according to the position of the observer, a phenomenon that becomes even more pronounced in silk carpets.

The symmetrical knot (fig. 21). Also known as the Turkish or Ghiordis knot, the symmetrical knot is tied by placing a length of yarn over two adjacent warps, looping it about the warps, and drawing the ends through at the center below the overriding loop. If one of the structural wefts on either side of the knotted row is tauter than the other, the warp will lie on two planes (fig. 22).

The asymmetrical knot (figs. 23, 24). This knot also has two other names: Persian and Senneh. And it too engages a pair of adjacent warps but loops completely around only one of them, after which it passes open behind the adjacent warp. Thus, while the first end is drawn through the center space, the second one is drawn up on the far side of the warp it has passed under, leaving the two ends side by side but separated by one warp. This knot, although easier and faster to tie, is not as solid as the symmetrical knot.

The two types of knot are sometimes used on the same piece, the asymmetrical knot for the field and the stronger symmetrical knot for

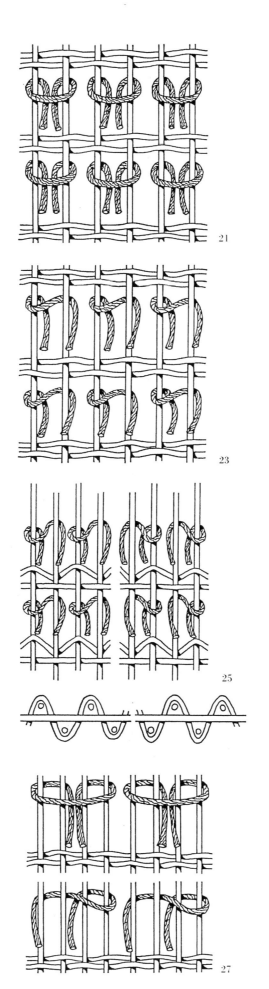

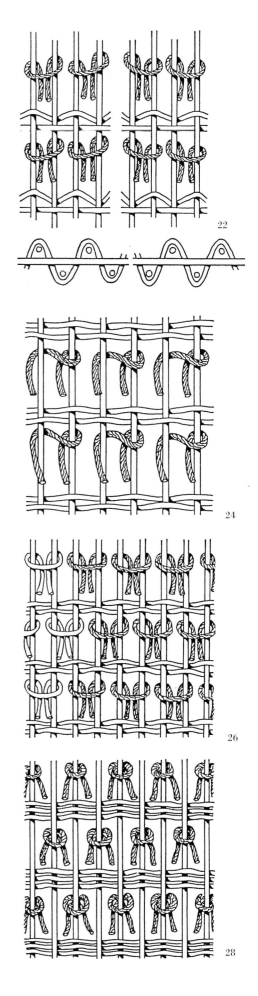

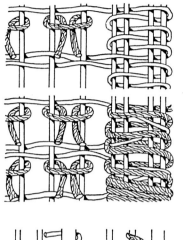

29

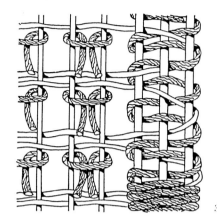

30

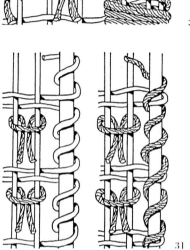

31

THE FRINGES

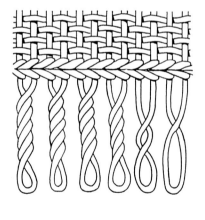

32

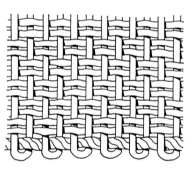

33

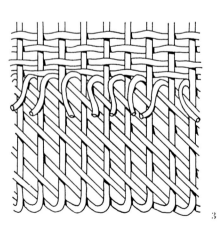

34

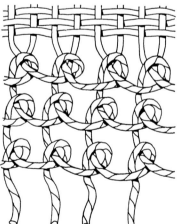

35

the borders. The asymmetrical knot can be open to the right (fig. 23) or to the left (fig. 24). Again, one of the two weft shots may be taut and the other sinuous, the effect of which is a denser rug with a ribbed back (fig. 25).

Staggered symmetrical knots (fig. 26). This technique makes it possible to achieve less jagged edges in the curved or oblique parts of a woven pattern. Arabesque motifs require great knotting density. When the density is not great, the weaver has recourse to a strategy involving the introduction of supplementary knots. In this case, the wefts may be thrown after two rows of knots.

The Jufti knot (fig. 27). Symmetrical or asymmetrical, the Jufti knot is tied around four warps, sometimes even six, which makes it a faster process than either the Turkish or the Persian knot. By the same token, it also produces a rug with a relatively weak structure.

The Spanish knot (fig. 28). Perhaps the weakest of all the knotting techniques, the Spanish knot is looped about single alternate warps, with the two ends brought forward on either side. On the reverse side of the rug, the 'free' or 'untied' warps are clearly visible.

THE SELVEDGES The most vulnerable parts of the carpet, selvedges must be handled with care. The lateral selvedges can be flat or round. In the case of flat selvedges, known as cords, the lateral warps are thicker fibers or grouped by pairs of two or more. The selvedge is woven relative to the height of the knot, either with the weft or, more often, with the aid of supplementary, protective wefts, inasmuch as the structural wefts have been passed only after each row of knots (figs. 29, 30). The round selvedge consists of a single, thick yarn or cord or yet of several warps grouped together. The rug's structural wefts may be reinforced by supplementary, reinforcing wefts looped about the selvedge warp or warps, or oversewn after the fabric is removed from the loom (fig. 31). Auxiliary wefts make it possible to have a selvedge that is colored, monochrome, or polychrome.

The webs – the warp selvedges – at the extremities of the carpet are normally flatwoven to whatever length may be desired. These protective bands are generally the same color

as the warp, but they may also be dressed up with small motifs or stripes. When there is a great density of warps, the wefts cannot entirely conceal the warp, which thus becomes visible, particularly on pile rugs with highly depressed warps. The web may be turned back and sewn under like a hem on certain rugs, particularly those of European origin.

LOW WARP
AND HIGH WARP

Flatwoven carpets are most often made on low-warp looms, whereas knotted-pile carpets tend to be woven on high-warp looms, where the thickness of the finished piece rolled onto the lower beem can be substantial. There are exceptions, however, as in the case of village weavers, who use the horizontal loom for both pile and pileless rugs. Technically, it is not possible to tell whether a piece has been made on a vertical loom or on a horizontal one, unless a human hair woven with a weft, by a weaver bending over her or his work, could be taken as proof of low-warp weaving!

In Oriental practice, the village or nomadic weaver shoots the wefts and ties the knots without tools. Once the heddle or shed stick has separated the warps, the weaver simply passes the weft or ties the knots manually, the balls of wool, kept within arm's reach, unwinding as the work progresses. In the West or in large Oriental workshops, shuttles are used to shoot the wefts. For high-warp weaving, the shuttles may be pointed at one end in such a way as to help beat down the wefts and rows of knots. Otherwise the beating is done with the aid of a small comb, usually made of metal but sometimes of wood.

Weaving proceeds more rapidly on a horizontal loom than on a vertical one, because in the latter case, the weaver must pull the warps with one hand and introduce the wefts with the other. On a low-warp loom, both hands remain free to pass and beat down the wefts.

STITCHES USED IN NEEDLEWORK CARPETS

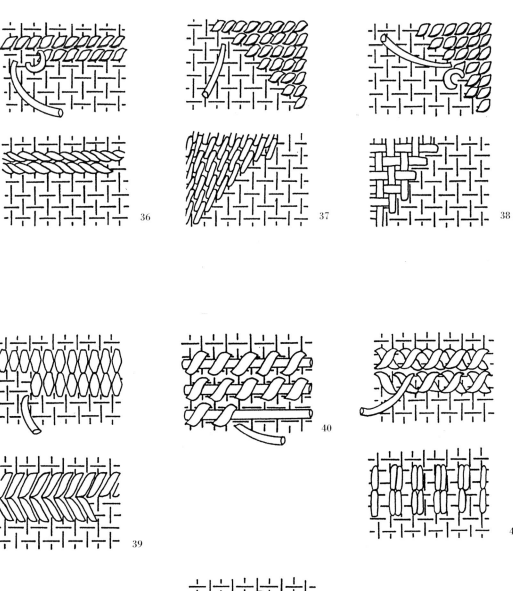

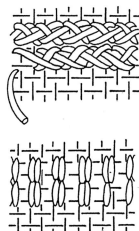

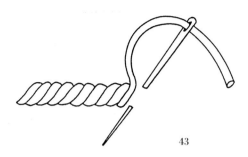

43

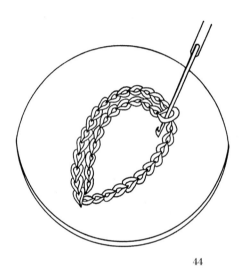

44

THE FRINGES There are many different ways of finishing the fringes once the carpet has been woven. They can be tied in clusters or braided. When the loops at the extremities are not cut, they may simply be left to twist into spirals on their own (fig. 32). But the fringes can also be dressed in a variety of complex ways, sometimes flatwoven to become a compact and solid band (figs. 33, 34, 35).

CARPETS WORKED WITH A NEEDLE

Needlepoint Rugs

'Embroidery' is a generic term designating all manner of needlework applied to a plainwoven foundation or 'canvas'. The stitches are many in kind but occur in a regular and repeating fashion. The canvas is usually an undyed fabric or 'tabby' made of loosely and perpendicularly interlaced warps and wefts spun from hemp, linen or cotton, and, sometimes, jute. There are three kinds of canvas. Plain mono canvas – a simple balanced tabby – has a single-mesh structure formed by the intersection of a single lengthwise thread and a single crosswise thread. With interlocked mono canvas, the threads are actually two thinner strands plied together to produce a 'locked' single mesh. 'Penelope' canvas, introduced around 1850, has a double-mesh construction of paired warps and wefts.

The surface of a needlepoint rug looks like a grid, because each stitch covers a precise number of canvas threads. The only way to determine the kind of stitch employed is to examine the reverse side. The basic needlepoint stitch, worked in a complex manner, yields a strong fabric, the bottom of which discloses a honeycomb-like array of cross stitches.

Tent stitch (fig. 36). Tent stitches, the most basic of all needlepoint techniques, are diagonal and worked from left to right and back again. This tent stitch is also known as the 'continental stitch'.

Diagonal tent stitch (fig. 37). The tent stitches are generally slanted to the right and embroidered along an oblique line.

Basketweave stitch (fig. 38). This tent stitch is worked diagonally first down and then up along a diagonal line, alternately skipping every other cell within the mesh. On the bottom of the canvas, the finished needlework looks like basketweave.

Gobelin stitch (fig. 39). Gobelin stitches are larger than basic tent stitches. They are always worked vertically over two or more cells in the mesh, from right to left and back again.

Gros-point on 'weft' yarn (fig. 40).

Cross stitch Large tent stitches, slanted right to left, are worked across and then reworked from the opposite direction, this time slanting left to right (fig. 41).

Greek stitch A cross stitch with one thread longer than the other, the slant alternately left and right row by row along the horizontal axis (fig. 42).

Embroidered Rugs

Embroidery gives form to imagery on a foundation fabric that remains visible. The support may be constituted of many different materials, but the usual ones are linen, cotton, silk, or felt.

Stem stitch (fig. 43). The stem stitch is a variant of the backstitch, which requires that the needle be moved a step backward before a step is taken forward along the row. Unlike backstitch, which is straight, the stem stitch is slanted and overlapped, which makes it ideal for outlining curved shapes.

Chain stitch (fig. 44). On a support stretched over a small circular loom or hoop, the embroidery is done with a small fine hooked needle. The needle stabs the fabric to catch the thread guided below by the embroiderer's left hand. The motif is first contoured and then filled in little by little, stitching back and forth. The stitch is also known as 'Beauvais point'.

The artisan, weaver or embroiderer, may work from memory. However, when the pattern is complex, a cartoon or model is normally used. Yet even when this is in hand, the artisan cannot rely on any established method for drawing the exact contour of motifs. Oddly enough, repetitive gestures, far from dulling the imagination, actually liberate the weaver or needleworker to deal with the demands of both design and color. Indeed, this constitutes the very reason for viewing a handmade rug as a sensitive and original work of art.

Flatwoven rugs are normally executed on a horizontal, or low-warp, loom, whereas knotted carpets are more often woven on a vertical, or high-warp, loom, where the thick, piled fabric can be wound onto the lower tension or roller beam. Such generalizations, however, may obscure reality, given that nomads, for example, weave both kilims and knotted rugs on low-warp frames. Technically, it is impossible to distinguish high-warp weaving from the low-warp variety.

In the Orient, the weaver in a small workshop, as well as the village or nomad weaver, passes the wefts and ties the knots without the aid tools. After pulling the heddle to separate the two sets of warps, the weaver manually shoots the weft through the shed or ties the knots, using yarns drawn from balls or skeins

GLOSSARY

Abrash Tonal variation within an area of solid color, often caused by differences among dye batches and evident as streaks or stripes from knotted row to knotted row.

Beams Parallel cross beams or rollers, generally made of wood, on which the warp is strung or wound and held in tension; the primary elements of a loom. See also Roller beam.

Brin Fiber, sometimes employed synonymously with strand.

Brocading A general term for various techniques used to embroider or 'float' supplementary, decorative wefts onto the surface of flat or weft-faced rugs.

Canvas A loosely woven grid of plainweave fabric used as a support in embroidery and hooked rugs.

Cartoon The graphic model or pattern, including the position of individual knots, used as a guide by weavers as they make the carpet.

Chiné A multi-play yarn, composed of several yarns of different but closely harmonized colors or values plied together.

Flatweave, flatwoven Napless carpets and textiles. See Kilim, Tapestry.

Foundation The web-like interlacing of warps and wefts that structure a carpet and hold it together, especially a knotted piece whose pile completely covers the foundation. Synonyms: structure, armature.

Heddle A rod with holes through which threads are looped and tied to an alternating set of warps, so that when pulled the heddle brings its set of warps above the first set, thus creating a shed or space through which to shoot the shuttle holding the weft yarn.

High-warp loom (haute lisse) A generic term for vertical looms.

Kilim A napless rug or textile made in the same way as tapestry, that is, solely of the warps and wefts. Supplementary wefts are sometimes introduced. Also spelled kelim, gelim, giglim, gileem, and geleem. The wefts, once beaten down with a comb in the course of weaving, completely cover the warps, and their colors give effect to the pattern. Where two colors meet along a vertical line and wrap around adjacent warps, a slit is formed. The term often used for this characteristic is 'slit tapestry'. Also known as flatwoven or plainwoven rugs.

Knotting A process by which yarns, usually colored, are tied individually to the warps to create a piled surface.

Low-warp loom (basse lisse) A generic term for horizontal looms.

Mordant A chemical substance that enhances the absorption of dyestuffs by fibers and makes the color fast.

Multi-ply yarn Several strands or single-ply yarns plied or spun together; the opposite of single-ply yarn.

Pick See Shot.

Pile A dense, velvet-like surface created by the accumulation of yarns knotted or otherwise attached to a foundation.

Piqué An optical effect created by a combination of several yarns of highly contrasted colors plied together.

Plainweave A napless fabric composed of interwoven warps and wefts.

Ply The method by which several strands of spun yarn are twisted and thus held together.

Selvedge The lateral edges of the carpet.

Shed stick A flat stick threaded above and below each alternate warp yarn across the loom; when rotated on its side, the stick separates the warps into upper (odd-numbered) and lower (even-numbered) sets, opening between them a space or shed through which a weft can be passed. A rod-like shed stick creates the shed without being rotated.

Shed The space created, by shed stick or heddle, between the alternate sets of warps through which the shuttle holding the weft yarn is passed.

Shot or shoot A passage of weft yarn through the shed, the later a space created by separating alternating sets of warps. Frequently used synonyms: pass, pick, and throw.

Spin The process of drawing out and twisting loose fiber to form a continuous strand of yarn. Spun yarn is normally plied in several strands.

Tapestry A flatwoven, weft-faced textile in which the wefts are exploited through various techniques, including soumak and slit-tapestry weaving.

Twist See Spin. Spun yarn is generally twisted together with other strands in an opposite direction to the spin.

Warp ends Warp yarns left over at either end of the carpet; when cut, they 'free' the carpet from the loom and become the terminal fringes.

Warp The set of parallel yarns of equal length strung or wound onto transverse beams and held in tension by the loom.

Weft Yarn that is passed transversely across the loom, over and under successive warps. The weft can be a pattern weft, as in tapestries and kilims, floated as in brocading, or serve as the foundation in pile rugs. Synonym: woof. See Weft-faced carpet.

Weft-faced carpet See Kilim and Tapestry.

Yarn A continuous strand of material spun from fibers. Synonym: thread.

kept within arm's reach. In the West or in large Asian factories, the artisan weaving on a low-warp loom employs shuttles – small elongated wooden bobbins loaded with yarn. On a high-warp loom, the worker utilizes spindles – shuttles with a tapered or pointed tip designed to help facilitate the weaving process. Beating down or compacting the wefts is done with the aid of a small hammer comb, made of metal or wood. Usually weaving is faster on a horizontal loom. This is because on a high-warp loom the warp must be held with one hand while the other hand shoots the weft, whereas on a low-warp loom both hands are free to pick and beat down the weft.

For all their beauty and value, carpets are fragile artifacts whose organic fibers and colors deteriorate over time. Growing awareness of the problem has prompted a broad reconsideration of all such preventive measures as conservation, cleaning, and restoration.

CONSERVATION

Conservation attempts to slow the process of decay by eliminating its causes. The most serious threat comes from long exposure to light and high or variable humidity. But damage wrought by insects, micro-organisms, rodents, and atmospheric pollution can be almost equally devastating. Finally, there is the mischief done by folding, especially where the piece has been left folded or creased throughout a long period.

Light, particularly ultraviolet radiation, weakens natural fiber, impairing its molecular structure through harmful photochemical effects. There is, in addition, the fading brought on by energy from light and the chemical reactions it triggers. The noxious character of light, however, can be neutralized considerably through a system of filters capable of absorbing ultraviolet radiation. Another important defense is controlling luminosity, which should be maintained at a level no higher than 50 lux.

Variations in the amount of humidity in the air undermine the tautness of the warps and wefts and thus the carpet's very structure. A level of humidity lower than 35 percent dries the fibers, making them brittle and crumbly, whereas at a level above 75 percent they swell and become all the more vulnerable to destructive bacteria. The ideal level of relative humidity lies between 45 and 60 percent, which can be measured with an hygrometer and maintained with either a air-conditioner or a humidifier, as the case may be.

A valuable rug should be inspected regularly to make certain it has not become host to insects, larvae, or micro-organisms (fungus). Vacuum cleaning and preventive treatment with pesticide, by bath or by fumigation, will rid the infested rug of its parasites.

Pollutants such as anhydride sulfate (SO_2) and ozone (O_3) attack the fibers of a rug chemically. The best defense against them is an air-conditioning system with good filters. Frequent vacuum cleaning can also check the baneful effects of atmospheric pollution.

Furthermore, a rug should never be left folded, given that hard creases will eventually break the fibers and cause the foundation yarns to unravel. The best solution is to place the rug on heavy paper covered with a light sheet of old linen or with an acid-free paper and roll the whole up in the direction of both warps and pile, leaving the reverse side outside. If the carpet is lined, it should be rolled up on site with the lining inside. The lining may rumple slightly, but the carpet will remain smooth. The rug should then be wrapped and protected with one of the materials discussed below.

CLEANING

The restorer, before doing anything to a carpet, should make a thorough study of its materials, its history, and the state of its deterioration. Every piece has its own structure and thus requires its own particular kind of care. Suctioning or beating away grit, removing stains, and dry cleaning or washing help to retard the process of degradation to which all rugs are subject. But even prior to these operations, the carpet must first be prepared. Linings, for instance, or any later pieces of applied fabric should be unstitched and removed. Splits, large holes, or patches of serious weakness should then be closed and/or strengthened with temporary mending. To rid the piece of grit and dust, it can be gently vacuum cleaned or lightly beaten with soft brushes while rolled out face down. Vacuum cleaning is sometimes done on site, wherever the carpet normally lies, and for a knotted carpet, the machine should be run back and forth in the direction of as well as against the nap, that is, from side to side. Then, before deciding whether to wash the piece in water or to dry clean it with solvent, the restorer would be well advised to carry out a series of tests with each of the products

considered for the task, since fibers and colors can react in different ways. It is particularly important to know whether any of the colors are likely to run.

Washing is done with the aid of neutral or no more than slightly alkaline, non-ionic detergents preferably derived from fatty acids of organic origin. Rugs washed out flat on the spot should be saturated with a solution of demineralized water and detergent, and then blotted as well as cleaned with brushes until all dirt-laden moisture has been soaked up or discharged. It is important that pressure never be excessive so as not to damage fibers softened and weakened by water. Delicate rugs and fragments need to be protected on either side with sheets of gauze throughout the washing/rinsing process. A filter, such as a flat slatted wooden base, placed under the rolled-out rug helps to reduce the amount of friction required for the cleaning operation. Next comes a series of rinsings, first on one side of the carpet and then on the other, always with demineralized water. This is followed by a fresh-water rinse, which will detect any traces of detergent by making them foam. Finally, the job can be finished off in one last rinse with demineralized water. Drying also proceeds while the rug is flat, ideally at a normal or medium temperature, with plenty of air circulation, and away from strong light.

Washing, of course, removes spots and stains, but it also offers the benefit of making the rug lie properly flat and reinforcing its strength and stability.

Dry cleaning with solvents should be undertaken rarely, and then only for pieces too fragile to be soaked with water. Whenever this delicate operation is needed, specialized cleaners, thoroughly grounded in the relevant chemistry, should be consulted.

RESTORATION

The restorer has an obligation to consider the rug's origin, intrinsic value, and current function, but also its future in order to make sure the piece will have a long life. After thorough cleaning, the carpet should be reviewed for two types of restoration. The first consists of

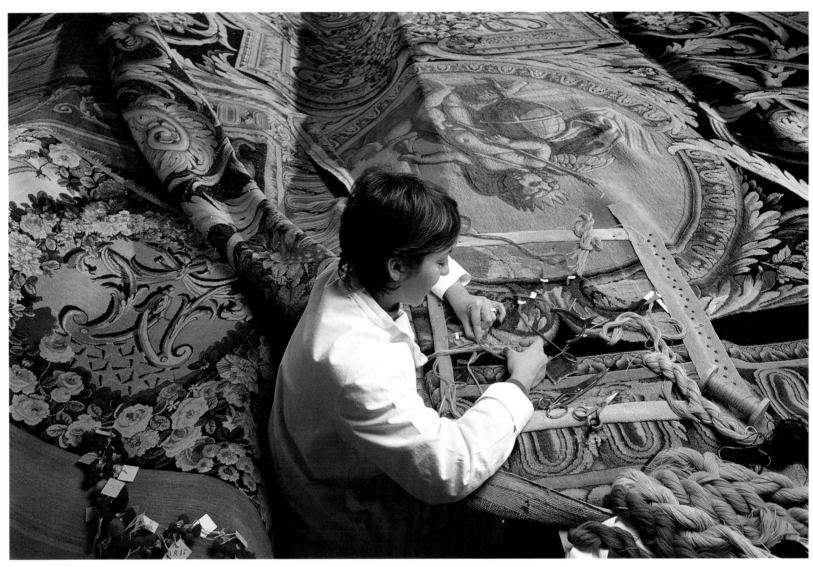

26

conserving the rug as it is, without modification or reconstitution. In this case the restorer merely preserves the carpet and presents it backed by a neutral support. The second approach involves recapturing the original look of the carpet, restoring the foundation, and reconstructing deteriorated or missing parts, all undertaken with great care for the purpose of allowing the piece to function as originally intended. It is absolutely essential that the restorer and the owner determine together whether the piece should be merely preserved or rigorously restored. But whatever the course decided upon, every intervention should be reversible and undertaken with this in mind; it should, moreover, be aimed at preserving the piece as a whole.

Restoration/Preservation

Whenever feasible, the first approach – restoration/preservation – should be chosen over the second. Indeed, a fine period rug no longer strong enough to be used on the floor does not need to be rewoven and reconstructed. The fragment or fragile old piece, displayed and treated like a document, has transcended domestic use and entered the realm of archaeology. Generally, museum curators and some collectors take the restoration/preservation approach, which requires mounting the textile on a support.

Once cleaned, the rug is stitched to a natural, unfinished piece of fabric, finish being a lure to insects. Around any holes, the warp and weft yarns should be realigned in their perpendicular relationship and then, along with all broken yarns, held until sewn to the

26. The Mobilier National's atelier for carpet restoration. The piece being worked on is 'Autumn', carpet no. 58 from the series of ninety-three rugs woven for the Louvre Grande Galerie during the reign of Louis XIV.

fabric support. The latter, chosen for its compatible color and texture, is sometimes applied to deteriorated areas. In the case of a truly damaged rug, it may be necessary to begin consolidating the remains with an overall lining, from which a small square can be cut as a window through which to observe and analyze the structure from the carpet's underside. The effectiveness of the lining should be reinforced with 'quilting', a technique whereby the carpet and its lining are stitched together along the oblique lines of a diamond or diaper pattern. Thus sewn on the bias, the piece retains its suppleness and elasticity. Needless to say,

45

46

47

the thread as well as the fabric chosen for the lining must be from organic sources and carefully tested for material, texture, and color.

The mounted carpet can be presented lightly stretched on a frame, itself covered with cotton flannel, or attached so that the piece hangs a bit loosely. For this effect, a good technique is to hand sew a band of velcro along the upper edge, which allows the weight of the piece to be evenly distributed throughout its width. Exhibited vertically, the rug plays a role similar to that of painting. In this way, it discloses the whole of its decorative splendor, while also offering a chance to appreciate both the composition and the surface in all their detail.

Restoration/Reconstruction

The decision to undertake this second, more radical kind of restoration should be dictated by the original state of the rug and by the importance of the alterations. Once tears, holes, and weakened or worn areas are beyond quick repair, the restorer runs a much greater risk of damaging the very structure of the piece. Hence, the restoration process should begin with a thorough study of the method by which the carpet was made: the type of weave, the knotting technique or stitch, the relative density, the number of warps and wefts, and the quality of the yarns, their material, twist, and color. Not only must the restorer take all these elements into account; it is also imperative that he or she work in a manner entirely consistent with them.

SAMPLING AND TESTING Whatever the type of intervention, it should be launched only after preliminary examination and choice of yarn samples, a task best accomplished under daylight conditions. The success of the restoration depends upon the results of this early exercise, since the materials should match or be compatible with those already woven into the carpet. Ideally, the new yarns would be dyed with colorants from natural or organic sources. Without involving a master dyer, however, it is difficult and very time-consuming to determine the proportional relationships within any given mixture and to develop

a dye precisely like the one under study. Even the vast range of commercial colors now on offer – chemically constituted but very reliable – does not include every possible nuance and variation. As a consequence, the skilled restorer resorts to optical mixtures or effects known as *chinés*.

Chiné is the effect of several yarns twisted together in close, carefully harmonized colors whose combination yields a new shade. For maximum results, the restorer may have to untwist and then recombine the strands in a weight or thickness corresponding to that in the rug being restored. Once the yarns have been respun in the opposite direction and woven into the carpet, the resulting chiné looks smooth, homogeneous, and well integrated into the rest of the piece. When the shades involved are contrasting rather than close, the effect is called *piqué*, and it should be avoided. The chiné technique endows the surface with an optical sheen, whereas the piqué method leaves it looking patchy.

Every material has its unique qualities of consistency, texture, etc. This makes it imperative that one material not be substituted for another at the risk of unfortunate consequences, as when a cotton warp is replaced with a woollen warp yarn, whose fiber is much more elastic than cotton and thus more subject to distortion if pulled overly taut. Light also affects material, bringing out its essential character – velvety, flat, or shiny.

Restoration, as we have seen, can check or slow the process of deterioration. The most exposed or vulnerable parts, such as the edges and the fringes, are frequently the first to suffer, and thus should be reconstructed so as to keep wear and tear from affecting the piece's structure or its knotted pile.

LATERAL SELVEDGES Joined to the body of the rug by structural wefts, the selvedges attached to the outer lateral warps play a crucial role in reinforcing and strengthening the piece. They are sometimes supplemented with a protective extra weft yarn. In a troubled carpet, these may be partly or entirely compromised or indeed gone altogether. In the former case, the intact warps and struc-

tural wefts make it possible to repair the damaged or fragmented edge with a new protective weft and reweave or darn it to the piece with a needle. Where broken structural wefts have caused the side cord to pull away, the restorer has no choice but to reweave the edge using new wefts. And these must be solidly integrated into the body of the piece in order for the edge to be resecured. In the event the selvedge is seriously compromised or even lost, two solutions are possible, once all remaining fragments and fibers have been eliminated. The first involves blanket-stitching the body of the rug completely along its lateral edges, doing so in a tight but invisible manner (fig. 45). The restorer stretches the rug along the edge of a table and aligns a tautly pulled cord parallel with the remaining outer warps. The next step is to bind the cord to the rug's foundation by blanket-stitching the edge with new protective wefts as deep into the body of the rug as the second or third warp thread. The technique just described, which produces a rounded but restored edge, is the quicker of the two methods cited above; however, it has the disadvantage of sacrificing the visual presence of two or three warps.

The second, more radical procedure involves reconstructing the edge to its original state. Again the rug must be stretched flat on a table, this time so that one or two cords can be pulled taut along the rug's lateral edges, the number of these new threads dependent upon the original number of warps. Then, with the aid of fresh weft yarn, a new selvedge can be woven and secured with a supplementary protective weft.

WEBS AND FRINGES The protective band of plainweave at each end known as the 'web' preserves the rug's very constitution. When the web begins to fray, the restorer lays the carpet flat and stabilizes the situation with chain stitches, making sure from time to time to insert the needle into the main body of the piece (fig. 46). This kind of reinforcement is feasible only when the web and fringes are long enough. In the event they have been partially or totally destroyed, the repair will require blind-stitching (fig. 47). This done, it should be possible to reconstruct the missing

fringes by introducing into the body of the rug a set of supplementary warps, which, once pulled out, can be cut to the desired length. The operation sometimes burdens the web with a dense mass of new threads, which could end up looking inelegant, especially if the rug is a delicate one. To finish off the job, the restorer further secures the new fringes by weaving a fine thread horizontally through the foundation of the fabric, thereby blocking the warps. Another row of chain stitching will give the reconstruction its finishing touch.

RECONSTRUCTING DETERIORATED OR MISSING ELEMENTS Wear and tear, moths, excessive mordanting, and corrosive dyes can sometimes destroy not only pile but also flatwoven and brocaded surfaces even while leaving the foundation or underlying structure intact. In such cases, the restorer stretches the carpet flat, removes the damaged fibers, and reconstructs the motifs, using the same technique employed by the original weavers. The knots of pile carpets can be reconstructed with a hook or a needle, after which the rewoven parts should be clipped or shaved, steamed, brushed, and sometimes even ironed. For flatwoven or embroidered rugs, darning is the best technique, with one hand on the upper surface and the other hand working from the reverse side. The needle must be inserted vertically so as not to damage the fibers of the intact stitches surrounding the weakened area. Sometimes it may be necessary to patch the underside of problematic zones with basted bits of fabric, which, along with the restorative darning, help to reinforce structures that have become fragile. The piece should then be lined and quilted.

To repair holes and tears in pile carpets, a structural foundation must be devised on the reverse side of the piece, which means stringing warp yarns, threading the wefts through them, and incorporating this new 'canvas' into the rug's main body. Between each group of wefts a temporary thread of synthetic material is inserted, its thickness sufficient to simulate a row of knots, and once the number of mock rows is correct, the design can be re-created. Gradually, as the fresh knotting progresses, each of the provisional threads is

easily pulled out and removed.

Flatwoven rugs with missing parts must also be rebuilt from a new foundation, after which the repair is made by reweaving with a needle or by meticulous restitching. Embroidered and needlepoint rugs can be restored either by reconstructing the 'canvas' – the structural foundation of warps and wefts – or by applying a piece of ready-made 'canvas' matching the original one. On this base the needlework is re-created stitch by stitch.

REWARPING When several warp yarns are broken or on the verge of breaking, restoration means rebuilding the very base for weaving – in other words, rewarping. With their ends tied, the new warps are threaded through alongside the old ones for several centimeters in order to establish a strong foundation. The number of replacement yarns must be exactly the same as that in the damaged area; otherwise, it would be impossible to re-create the structure and design as they were originally. Once the task of restoration has been completed, the knots tied at the outset can be cut.

The various methods of reconstruction should be undertaken only after the piece has been attached to and stretched upon a frame or a horizontal restoration loom. Indeed, the tension so essential to weaving prevents distortion and makes it easier to control materials so that they do not become too compact. Tweezers are sometimes needed to pull the needle through particularly dense areas. Moreover, a strong needle which is also fine slips more easily through the dense texture of closely woven carpets.

A rug not only bears tangible witness to culture; it also invites reflection on values both aesthetic and historic. Judicious restoration preserves a carpet from the ravages of time; meanwhile, it leads as well to rediscovery, triggering the enchantment which these precious artifacts sometimes work upon our jaded eyes.

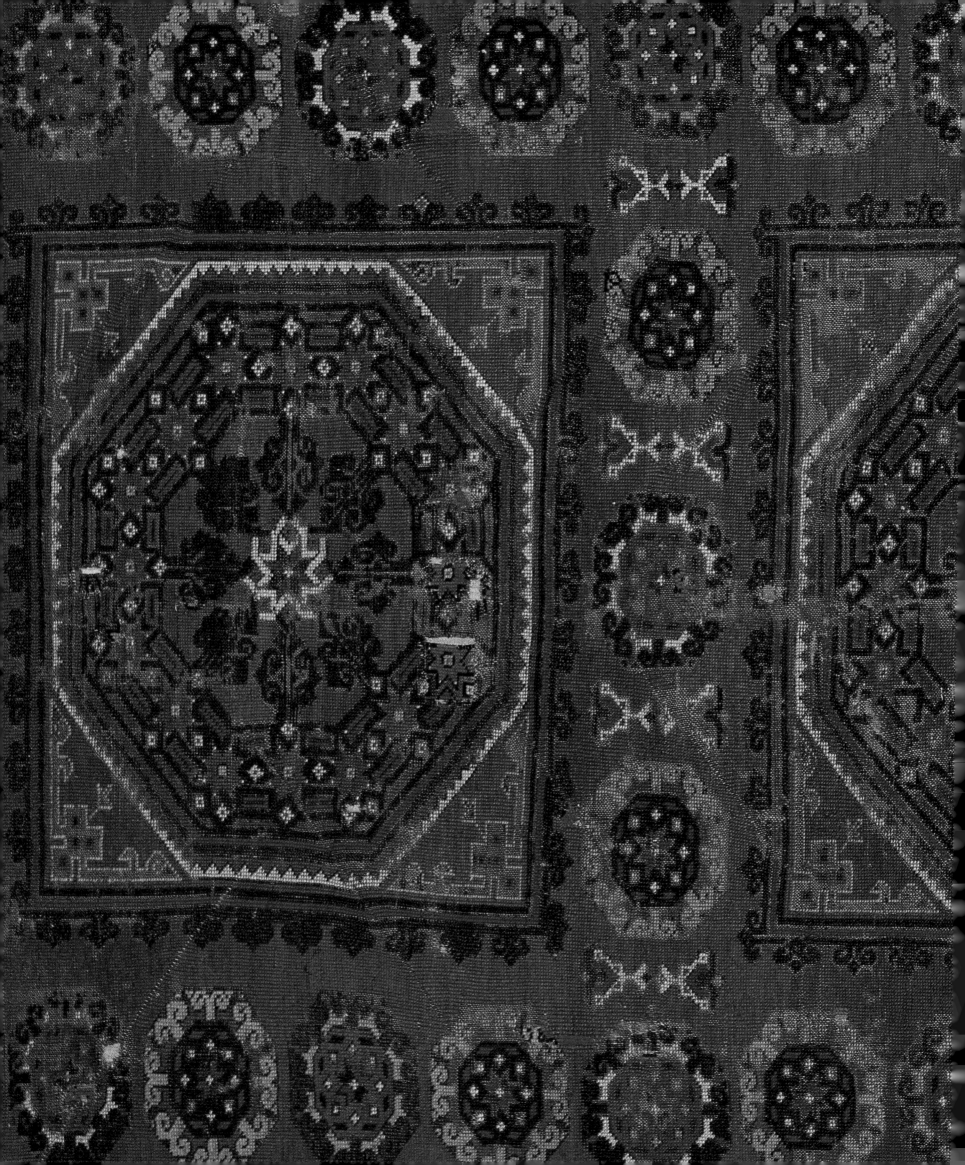

CHAPTER III

BETWEEN A TRIBAL AND A COURT ART: THE TURKISH CARPET

Susan Day

It was some seven centuries ago that Europeans began their love affair with the Oriental carpet, an essential element of Middle Eastern comfort discovered by the Crusaders during their presence in the Holy Land. Saint Louis (1248-1270), who led the Seventh Crusade, is known to have held his famous audiences while seated upon a throne placed in the garden at the Château de Vincennes. On the ground about him were rugs spread for the use of his court, a typically Oriental practice introduced into France by the *bon roy*, who had spent several years as a prisoner of the Saracens. It bore the seeds of a commerce that would soon come into full bloom.

Turkey was the first country to respond to the new European taste for this soft and luxurious floor covering, which even today remains the Oriental art form most appreciated throughout the West. By the 16th century, when the Persian rugs were still largely unknown, 'Turkey' carpets had already become a prized novelty among the furnishings in the houses of the aristocracy. This is borne out by the known collections of King Henry VIII and his Lord Chancellor, Cardinal Wolsey, who owned dozens of rugs imported from Turkey. Less finely knotted, less delicately designed, and less subtly colored than Persian pieces, the Anatolian rug captivated Europeans by its often enigmatic and mysterious designs, which were thought to embody an ancient symbolic system.

According to literary accounts, the Byzantines, the Greeks, and the Armenians[27] of Asia Minor were weaving carpets even before the advent of Christianity. However, the oldest known pieces date back only seven hundred years, by which time the region had fallen under the Turkish yoke.

AN ETHNIC AND CULTURAL MOSAIC

Any narrative about Oriental rugs should begin with an attempt to introduce a bit of order into the tangled history of a region shaped by a long series of migrations and conquests.

The Seljuk Dynasty

In 1038, the Seljuk Turks, having swept in from the steppes of Central Asia, with a motley horde of tribes in their wake, made themselves the masters of Iran, there establishing the Great Seljuk dynasty. Their defeat of the Byzantines at Manzikert in 1071[28] opened the gates of Anatolia to a veritable wave of Turkomans, whose ranks were a mixture of nomad shepherds and warrior tribes. The heart of Anatolia would then be unified by

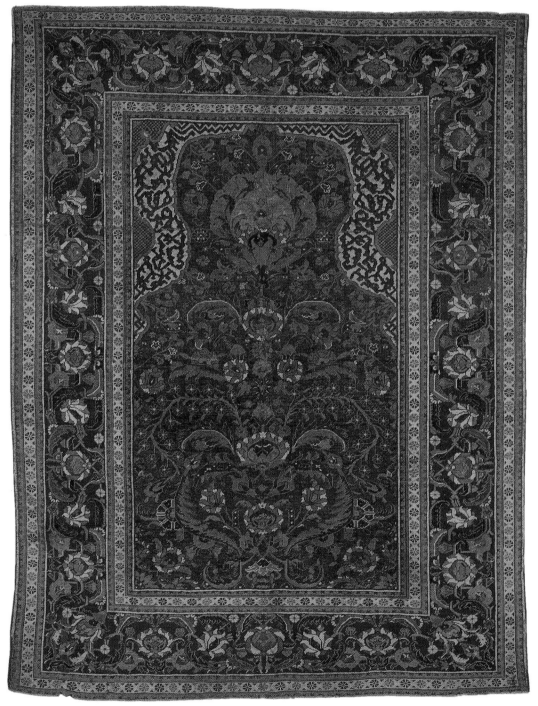

the Great Seljuk Alp Arslan, which marked the beginning of the Seljuk Sultanate of Rum (from the *Bilad al-rum*, or 'land of the Romans', meaning the Byzantines).

The Sultanate of Rum, whose capitals were in Isnik (Nicaea) and Konya (Iconium), succeeded in keeping the more turbulent tribes at bay and thus entered a long period of relative peace and prosperity, which lasted until the eruption of the Mongols in the 13th century. These new invaders vassalized the shattered empire of the Great Seljuks, which became the Il-Khan dynasty of Iran (1215-1353), and then went on to impose their suzerainty on Anatolia.

The Emergence of the Ottoman Empire

In the mid-14th century, meanwhile, the Seljuk dynasty was fading, even as the Turkoman tribes of Anatolia were beginning to lift their heads. Indeed, they organized themselves into some twenty small emirates (*beylik*), each of which proclaimed its independence. The most powerful of the tribes were the Karamanids, established in the

HISTORICAL CHRONOLOGY

The Seljuks In 1038, the Seljuk Turks from Central Asia made themselves the masters of Iran, where they established the Great Seljuk dynasty. By defeating the Byzantines at Manzikert in 1071, they opened Anatolia to a veritable wave of Turkomans. The dynasty collapsed in the 13th century under the onrushing horde of Mongol invaders, who then vassalized the shattered empire of the Great Seljuks, including Anatolia.

The Ottomans In the mid-14th century, the Turkoman tribes of Anatolia began to organize themselves into small emirates. Among the most powerful of the tribes were the Osmanlis, or Ottomans, who expanded until, in 1453, they took Constantinople, the capital of the Byzantine Empire. At its zenith, the mighty Ottoman Empire would extend as far as the Austro-Hungarian frontier, throughout the Middle East, and into North Africa.

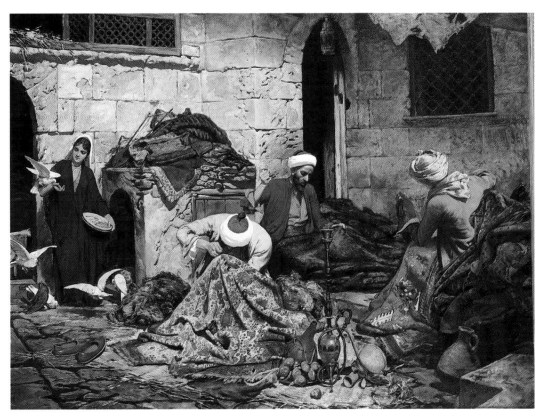

28

27. *Ottoman prayer carpet. 17th century. Private collection. Woven throughout Islam, the prayer rug is a particularly important item in Turkey's carpet production. According to the Koran, a good Muslim must pray five times a day, always following ritual ablutions and in a clean place. The niche motif designed into the field pattern resembles the* mihrab, *which serves to orient the faithful towards Mecca. The Turkish prayer rug will be considered in detail further along in the present chapter.*

28. *Rudolf Swoboda.* Carpet Menders in Cairo. *Oil on canvas. Mathalf Gallery, London.*

southern region of Karaman, and the Osmanlis (so-called for their leader, Osman) or Ottomans in western Anatolia.

The Ottomans, as the world knows, would enter a long period of near invincible power and expansion. In 1326 they made Bursa, a Byzantine city, their first capital (which remained the burial place of the Sultans until they captured Constantinople in 1453). Next they penetrated into Europe, subjugating the Bulgars and the Serbs simultaneously as they absorbed the *beylik* of Anatolia. In 1365 the Ottomans moved their capital to Adrianopole (Edirne). Finally, they laid siege to Constan-tinople, which this time managed, barely, to hold its own. In fact, the Ottomans' advance was only momentarily arrested, by the sudden arrival of a new conqueror, Timur Lang (Timur the Lame, or Tamerlane), who stormed in from his capital at Samarkand by way of Persia. After the death of Tamerlane in 1405, the Ottomans renewed their campaign of conquest even more aggressively, and in 1453 they took Constantinople, thereupon ending the thousand-year-old Byzantine Empire and assuring their own hegemony over the whole of Anatolia. The Ottoman Empire would subsequently extend from the Austro-Hungarian frontiers throughout the Middle East and even into North Africa.

A Tolerant Social Context

With the stage thus set, let us return to our rugs and the Sultanate of Rum. Following the arrival of the Seljuks, who were strict Sunnite Moslems, the peoples of Anatolia gradually converted from Orthodox Christianity to Islam. Henceforth the region would be host to three distinctly different groups: the ruling elite composed of Persian-speaking Seljuks; a settled, urban population of Armenians and

Greeks dedicated to commerce and the crafts; and tribes of Turkoman descent who, though living as nomads on uncultivated lands, would gradually sedentarize, as we know from the many villages with Turkoman names. Rather than force conversion to Islam, the Seljuks imposed taxes on non-Muslims, and as late as the 13th century, Christianity remained the country's dominant religion. Relatively tolerant in religious matters, the Seljuks succeeded in maintaining peaceful coexistence among their subjects' various races and religions. Moreover, this delicate balance continued until the arrival of the Mongols.

FLATWEAVE, EMBROIDERED, AND 'SOFT CARPETS'

We know that, prior to the Turkish presence in Anatolia, the Byzantines were making flatwoven, embroidered, and 'soft', or pile, carpets, although the precise technique they used remains a mystery. Were the pile rugs knotted or merely velvet, that is, textiles with looped and cut wefts? A Byzantine rug from Coptic Egypt (Metropolitan Museum, New York) is a cut-loop fabric, suggesting that the pile rugs of Asia Minor would have been made in the same manner. There are no surviving fragments, however, to support this hypothesis. The Anatolian carpets which have come down to us are either kilims, flatwoven by a technique identical to that used for tapestry, or knotted pile.

Technical Features

Apart from a few regional variations, the structure of the knotted rugs made in Anatolia is relatively consistent. The nomads, who were also shepherds, have ready access to wool from sheep, and occasionally from goats or camels. Sheep's wool was the material most frequently used, for warps and wefts as well as for the pile. Cotton and silk are rarely found in the oldest examples. Normally, the warps consist of two strands of yarn, each of them spun to the left and then twisted together to the right (Z2S). Sometimes they are dyed, more often than not at the extremities so as to have colored fringes. After every row of symmetrical knots, generally composed of two strands (Z2), there are two or three picks of weft; that is, two or three strands of weft have been shot through the warps. They too are often dyed, with red as the color of choice. Frequently the weaver has recourse to diagonal picks, systematically shooting a weft back before it has been entirely passed through the shed. The result is visible on the reverse side of the piece in the form of diagonal lines. The technique, so basic to kilim weaving, is also used in pile carpets. Diagonal picks may be linked as well to changes of color in the central field,[29] or to the fact of several weavers working together on the same piece, each of them at his or her own pace without having to change positions. For designs with white details, small amounts of cotton are occasionally used, the whiteness of this material being much brighter than that of wool. Along the lateral edges, short wefts known as selvedge cords are woven or wrapped around the last warps, row by row as the work on the rug progresses.

Given that we possess not one fragment of pile carpet woven in Asia Minor before the 13th century, Erdmann hypothesizes that knotting must have been introduced into the region by the Seljuk Turks.[30] Meanwhile, the extensive research in Byzantine sources carried out by Jenny Housego has enabled her to demonstrate, quite persuasively, that pile rugs were indeed made in Anatolia well before the appearance of the Rum Seljuks, even if no vestige of such work has ever been found on Anatolian soil.[31]

A TURNING POINT IN THE RESEARCH

An Approximate Science

For more than a century the history of Oriental rugs had to be written with a minimum of means, primarily stylistic analysis comparing pieces found in Western collections, often with nothing more to go on than black-and-white reproductions. Provenance was established on the basis of oral inquiries carried out in Middle Eastern bazaars, and the antiquity of the motif determined by the date of its appearance in European painting. Lacking sure knowledge of where the different groups of rugs originated, the first researchers named them for the painters in whose pictures they appeared, or for the places in which they had been discovered, or yet for the collectors or even the dealers who handled them. These names, moreover, are still used.

Until recently, no research had been done in the archives of producing countries. And despite the many excavations undertaken since World War II, it has to be admitted that, given the fragility of floor rugs, our knowledge may very well remain forever incomplete. One has only to examine old paintings to realize that a great many types or patterns have disappeared, never to be recovered.

New Research Tools

In the last thirty years new research tools, of a technical, scientific, and ethnographic nature, have made it possible to enlarge the scope of our knowledge. In the 1960s, May Beattie and Charles Grant Ellis developed an improved system for analyzing structure. Thanks to their research, we now understand that the methods and materials in common use can vary from country to country, even from one region to another. These tireless scholars have therefore been able to show that, contrary to former assumptions, pieces with the same design may very well not originate in the same place of manufacture. We have learned, for example, that certain

29. *Charles Robertson.* Selling Carpets in Cairo. *Watercolor. Mathaf Gallery, London.*

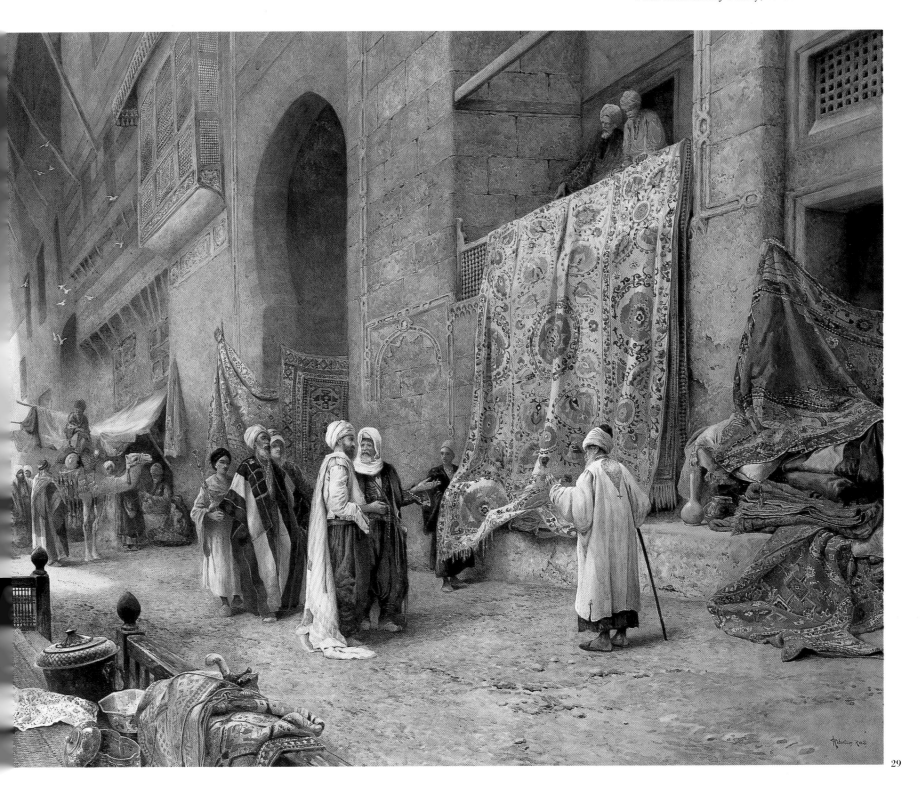

antique rugs, such as the Ushak with the star medallions in the collection of the Duke of Buccleuch and Queensberry, are copies of works from an earlier period, their English manufacture revealed by the presence of linen warps and wefts.[32] Since then structural analysis has emerged as an indispensable tool for determining provenance.

The Turkish tradition of the pious donation prompted the government in Ankara to order an inventory of the antique rugs owned by mosques. To the delight of Oriental carpet fans, the project has uncovered numerous types until then unknown in the West and now preserved in the Türk ve Islam Eserleri Müzesi as well as in a museum dedicated to them, the Vakiflar Museum.[33] At the Ulu Djami, the Great Mosque of Divrigi, Walter Denny and Charles Grant Ellis[34] discovered another group of old carpets, in addition to which there are the important collections of Anatolian rugs recently assembled by Christopher Alexander and Heinrich Kirchheim. Altogether, the new research efforts have not only overturned a good many preconceived ideas but also revolutionized the history of Anatolian carpets.[35]

Discovery of the Tribal Carpet

Along the way, it became evident that the Oriental rug trade had in some way distorted our perspective. Focused as this production was on pieces of a certain quality woven for the court, or made in quantity at the workshops of large manufacturers, it is inevitably better represented in Western museums than tribal rugs, woven in small quantities, sometimes as one of a kind. This explains why, for many years, until the publication of Brüggemann and Böhmer's work,[36] the study of tribal and village rugs, so essential for understanding the evolution of the Oriental carpet, was traditionally neglected in favor of prestige pieces.

Colors as a Guide to Attribution

In addition to their exhaustive study of Anatolian dyes, Brüggemann and Böhmer disclosed the importance of color schemes and their breakdown by region. As a general rule, the dominant hues in the rugs of western Anatolia are blue and red, with green or yellow playing a secondary role. In central Turkey, weavers use more yellow, mauve, and apricot, whereas in the eastern part of the country, taste leans towards a darker palette. Apart from a few experimental projects undertaken at Kavadjik, near Istanbul, and the DOBAG project at Yuntdag, south of Bergama, synthetic colorants have now replaced natural dyes in most of the rugs made in Anatolia.

Finally, Carbon-14 testing, which allows old objects to be dated within a 200-hundred-year margin for error,[37] has demolished an array of theories, notably those related to rugs from the Seljuk period, about which we will comment later on.

SEARCHING THE ANATOLIAN CARPET

Court and mosque rugs, tribal and village rugs, prayer rugs, rugs from the east, the west, and the center – so many examples and so little space, which leaves us no choice but to be selective and to concentrate on the most important aspects of the Anatolian carpet.

The Tribal Inheritance

Anatolia's nomadic peoples are ethnically quite diverse. The Turkish-speaking Yürük ('nomads' in Turkish) are Turkoman in origin, whereas the Kurds descend from the Medes and speak a language related to Persian. Kurdish territory extends from eastern Anatolia into Iran and Iraq. The Yürük of today, even though sharing the same roots as the other Turkomans, are diverse in sociocultural ways. The economy of Anatolia's nomads, who live on the margins of urban society, has long depended on livestock, caravan transport, and the manufacture of felts and rugs, sold in bazaars at the ancient heart of Turkish cities.[38]

Before migrating westward, the tribes of the Asian steppes roamed over a vast territory extending from the Altaï Mountains to the confines of China. Until their conversion to Nestorian Christianity or to Buddhism, and finally to Islam, they were shamanists who practiced totemism. For these societies, signs and emblems stood in lieu of writing. Members of the clan identified themselves with totems, with emblems or *göl*,[39] or yet with the brand sign, the *tamgha*, symbolizing the tribe. These *göl* and *tamgha* sometimes show up in Turkish and Turkoman rugs. Plants, and occasionally even anthropomorphic figures, but, most of all, animals of every sort have served as totems, which are associated with rites and taboos.[40] Once established in Anatolia, certain Turkoman tribes clung to their old customs, which meant that their conversion to Islam long remained superficial.[41] The carpet, woven

for everyday use by nomadic peoples who lived in tents, took the place of furniture, serving as a floor cover, of course, but also as a blanket, a cushion, a receptacle, a saddle, and even a cradle. Woven by women on small, easily dismantled looms, these nomad rugs are generally modest in size and their designs, handed down from mother to daughter, relatively little touched by outside influences. Even today, Yürük carpets can be recognized by their long pile and their repertoire of decorative themes reflecting the Turkoman heritage.

Walter Denny was one of the first to make detailed analyses of the connection between the *göl* in Turkoman rugs from Central Asia and the motifs in old rugs made by the Turks of other regions.[42] The complexity of the patterns makes it impossible to argue for an independent development. Even while acknowledging that the Turkoman examples are clearly later than the Turkish ones, Denny contends that the analogies between the motifs are owing to a common patrimony dating back many centuries and not to stylistic exchange.[43] Tribal rugs from long ago are rare, because when worn out they are thrown away, unlike luxury items made in urban workshops.

Village Rugs

The term 'village rug' signifies the work of a settled or sedentary rather than a nomad weaver. As in tribal rug-making, village methods of fabrication remain those of the craftsman, unlike the sophisticated techniques used in urban workshops or in the manufacture of rugs for the court. Today, virtually the whole of Anatolia's population lives in villages or in an urban environment, settlement having been encouraged, or indeed forced, by the Ottomans, who were eager to stabilize the roving and sometimes turbulent tribes. Woven on modest looms by women at home and sold by their husbands in the bazaar, village rugs are of necessity limited in size. Sometimes villagers join together in a guild-like group which acts collectively to ensure a certain quality and to facilitate distribution. Since the mid-19th century, production has often been controlled by enterprises dedicated to satisfying foreign demand.

30

30. *A recent photograph of two Turkoman women from the Sulaïman-Dolch tribe weaving a carpet on a low-warp or horizontal loom. This tribe, once nomadic in the region of Afghan Turkestan, has now sedentarized. Some members still, on* *occasion, return to their yurts. The photograph was taken at Nakhshrabat near Daulat Abad. Note the resemblance between the göl featured on this rug and the one on the Turkish carpets known as 'large-pattern Holbeins'.*

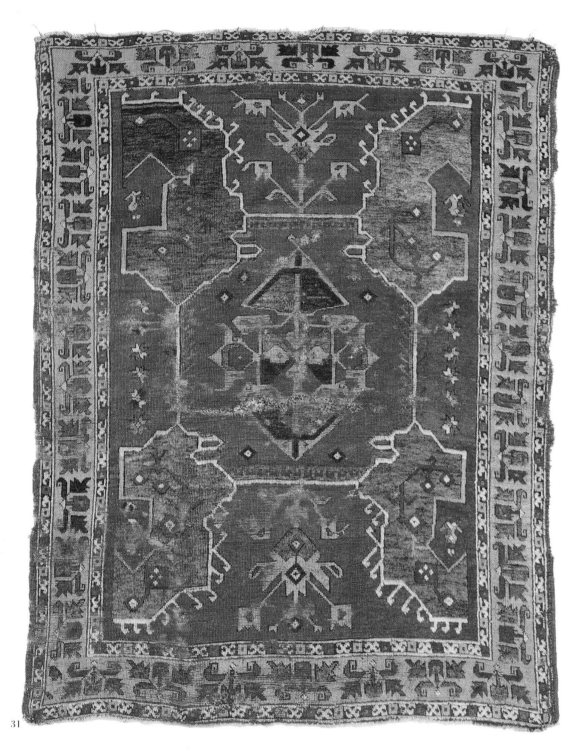

31

31. *Village carpet. Western central Anatolia, 19th century. Wool pile, 1.91 x 1.47 m. Private collection, Paris. Although woven by villagers, this rug was inspired by a 17th-century Ushak model.*

32. *Study of the Koran at the Ulu Djami in Bursa.*

in the mosques of the surrounding area and current production sold in the local bazaar.

Village rug production can be divided into three large regions, located in the west, at the center, and in the east of Anatolia, each with its own technical and chromatic tendencies.

The Importance of Color

The dominant colors of Turkish rugs are the primaries – red, yellow, and blue – with the other hues playing a secondary role. Rarely are there as many as ten colors, which means that Anatolian rugs typically have a narrower chromatic range than the carpets of Persia. In Turkey, as elsewhere in the Orient, indigo furnishes the blue tones, while madder yields the reds, pinks, oranges, and violets, their shades dependent upon the mordant used. Cochineal, which supplies a bluish red, is not unknown, albeit an imported product, which makes it expensive and therefore rare, particularly in rugs made before 1840. The yellows are derived from weld, sumac, saffron, and the skins of onion and pomegranate, sometimes as well from grape leaves. Green requires two immersions, first in yellow and then in blue, rendering it an expensive color, generally used in small amounts or in luxury pieces. Once aniline dyes became available beginning in 1856, synthetic colors replaced colors from vegetable or animal sources. Alas, the first anilines, such as mauveine and fuchsine, which produce tones of mauve and red magenta, proved unstable when washed or exposed to light. By the end of the 19th century they had been abandoned in favor of synthetic products of higher quality.

There are affinities between the palette characteristic of Turkish rugs and that of Turkoman pieces. Color, in fact, plays an important symbolic role in Turko-Mongol societies. Red, for example, is the color of the bride who weaves her trousseau. It is predominant in the carpets of Central Asia, where, moreover, a tribe's name often includes the color of the banner that symbolized it. Thus, the tribe of Genghis Khan was called the Golden Horde because its flag was yellow. Colors were sometimes associated with beasts, possibly the tribe's totem; thus, the

Determining the exact place of manufacture for a village rug is easier than for a tribal rug. Village pieces reveal more influence from designs found in court carpets or in rugs woven by urban workshops, even if the interpretation is sometimes a bit rudimentary. A well-known example is the decorative repertoire inherited from the Ottoman court atelier and used throughout Anatolia by generations of weavers. The evolution of a pattern can sometimes be traced by researching the link between antique examples preserved

Kara Koyunlu were known as the 'Black Sheep' and the Ak Koyunlu as the 'White Sheep'.[44] Green, like red, bore symbolic import but of a different order, signifying as it did the Prophet, which explains why the color is one common in prayer rugs.

Sources of Decorative Motifs

Anatolian weavers take their motifs from many different sources. Byzantium, for example, remained influential, most notably in the geometric design of borders, reminiscent of floor mosaics. Whether Byzantine or Sassanian in origin, geometric and floral compositions, like the medallion filled with affronted or addorsed animals, have been ongoing themes in the Oriental world for millennia, often found in textiles made prior to the Turkish occupation of Anatolia. From the genius of Muslim artists came the calligraphic art, particularly the angular Kufic script first used for inscriptions on monuments but then adapted to the decorative borders of carpets. As the name implies, Kufic was invented in the village of Kufa, shortly after the Muslim conquest. Muslim artists also created the floral and leafy arabesque patterns based on a grid composition which spread in such profusion over every form of Islamic art.[45]

It is important to note the links between Turkish rugs and the pieces depicted in painting from the Turko-Mongol period in Persia – that is, the 14th and 15th centuries – all of which reflect an older heritage. The linkage has already been cited in relation to color, but similarities can also be found in the realm of pattern and decoration. Among them are the Turkoman-like rows of large or small medallions arrayed across the carpets depicted in miniatures painted during the Ilkhanid and Timurid periods. There is, furthermore, a whole repertoire of affronted, addorsed, or combatant beasts, as well as a fantastic bestiary, sometimes heraldic in appearance, that possibly harks back to the ancient art of the steppes and forms part of the Turko-Mongol tradition. The emblems of the Turkoman tribes, in the form of the brand sign or *tamgha* are reproduced in the *Djami al-Tavarikh* (*Universal History*), a work com-

THE DECORATIVE REPERTOIRE OF TURKISH CARPETS

Anatolian weavers took their motifs from many different sources:
- Byzantium offered a model for the geometric design of borders, especially those reminiscent of floor mosaics.
- Islam provided the *mihrab* or prayer niche motif, the art of calligraphy, and a floral repertoire, which included the arabesque.
- The Turko-Mongol past yielded the emblems, brands, and signs – the *göl* and *tamgha* – of ancient tribal identity.
- From China, transmitted through Persian art, came the lotus, the cloudband, the infinite knot, the phoenix, the unicorn, and the dragon, as well as such Buddhist iconography as the flaming aureole and the *tchintamani* ('Buddha's lips' or 'balls-and-stripe').

piled between 1307 and 1314 by the Persian historian Rashid ed-Din,[46] would have been transmitted to Anatolia by their descendants, among them the Salor and the Afshar.

The Turkish rug bears as well the mark of influence from China. With the advent of the Yüan dynasty in the 13th century, the Silk Route was once more open to traffic, thanks to the *pax mongolica*. The Emperor Kublai Khan was in fact the grandson of Genghis Khan, and the Il-Khanate of Iran, founded by his brother Hülagu, owed him fealty. As a result, an increased quantity of luxury items, silks, silver, and porcelain made its way westward. Embellished with lotuses, cloudbands, infinite or endless knots, fantastic birds such as the phoenix, with or without a combatant dragon, and symbols from Buddhist iconography, among them the flaming aureole and the so-called *tchintamani* ('Buddha's lips' or 'balls-and-stripe' motif), these Chinese objects would become fertile sources of inspiration for generations of Persian and Turkish artists.[47]

From the 15th century to the 16th, the refinement of the Timurid and Safavid courts caught the covetous eyes of the Ottomans, among whom Persian literature was very much in vogue. Ottoman courtiers spoke Osmanli, a mixture of Turkish and Persian. Turkish art of the period reflects the influence of Persian masters invited to the Ottoman court or seized as war booty.

32

33

Finally, we should mention a kind of rug fabricated throughout Islam but most especially in Turkey. According to the Koran, a good Muslim must pray five times a day, always following ritual ablutions, and in a clean place. This explains the importance of the prayer rug. While the poor rely on mats, the more fortunate unroll woven carpets or *sedjadeh*. When these are decorated with a niche resembling the *mihrab*, which serves to orient the faithful towards Mecca, they are called *namazlik*. Among the many other motifs regularly found on prayer rugs are the mosque lamp, a symbol of Allah, the ablution fountain, the *mimbar* or pulpit, the *Kaaba* or sacred Black Stone of Mecca, and the 'footprints' identifying where the pious should stand. A rug with multiple niches meant for collective prayer is called a *saph*.

Seljuk and Beylik Rugs

In terms of pattern and design, the oldest Anatolian carpets can be grouped in two dif-

ferent categories, one with geometric motifs and the other with animal themes. An ensemble of very old rugs, three of which are whole, was discovered in the Ala ed-Din Mosque in Konya, a Seljuk building completed at the end of the 13th century. Logically enough, for want of a better name, the collection, now preserved at the Türk ve Islam Eserleri Müzesi in Istanbul, is known as the 'Konya carpets' or the 'Seljuk rugs'.[48] Shortly after this find, other pieces came to light in the Esrefoglu Mosque, built around the same time in Beyshehir, a neighboring city.[49] All but a few are now housed at the Mevlana Museum in Konya. Several fragments of Seljuk carpets turned up during excavations carried out at Fostat in the suburbs of Cairo.[50]

The central field in these earlier pieces is filled with rows of small motifs such as stars, hexagons, lozenges, and octagons, organized for the most part into staggered rows. One carpet, decorated with hexagons sprouting hook motifs, was probably based on a textile from the Yüan era. Another rug, this one from Beyshehir, is exceptional for having been inspired by flowers, evident in the stylized foliage motifs.[51] The equally geometric design of the borders no doubt had its source in Kufic script.

The palette, with its limited range of colors, tends towards *ton-sur-ton* shades, with red tones offset by pink and indigo blue by pale blue. Although not identical, this chromatic vocabulary recalls the Turko-Mongol rug reproduced in Ilkhanid painting, a sub-

ject to be considered further along. Meanwhile, Rudolph Riefstahl and, most recently, Jenny Housego have pointed out the link between this repertoire of geometric forms or floral lattice and the Romano-Byzantine tradition. Housego, with some justice, reminds us that these pieces were woven during a period when the region's majority population was still Greek and Armenian.

Among the oldest prayer rugs there are two of the *saph* variety in Istanbul's Türk ve Islam Eserleri Müzesi. One of them is decorated with three mosque lamps and two *mimbar* within an angular niche whose ogival arch culminates in a motif known as *gotchak*

('ram's horn'). In the view of Nazan Olçer, its archaic appearance suggests a date in the 13th century, not the 15th as had been thought.[52]

ANIMAL CARPETS

When Kurt Erdmann published his study of the Turkish carpet, few examples with animal themes were known to exist, apart from those represented in European painting. Among the rare examples was the so-called 'Marby carpet' in the Stockholm's National Museum and a rug in the Islamisches Museum in Berlin. In

33. *A so-called 'Seljuk' or 'Konya carpet'. Central Anatolia, 13th-14th century. Wool pile. Türk ve Islam Eserleri Müzesi, Istanbul. Discovered at Konya's Ala ed-Din Mosque, a structure completed at the end of the 13th century, this carpet, and others found with it, are believed to date from about the same period or slightly later.*

34. *Saph carpet with multiple niches for collective prayer. 13th-14th century. Wool pile. Türk ve Islam Eserleri Müsesi, Istanbul. Made for a place of worship, the relatively large saph features rows of niches recalling the qibla wall of a mosque.*

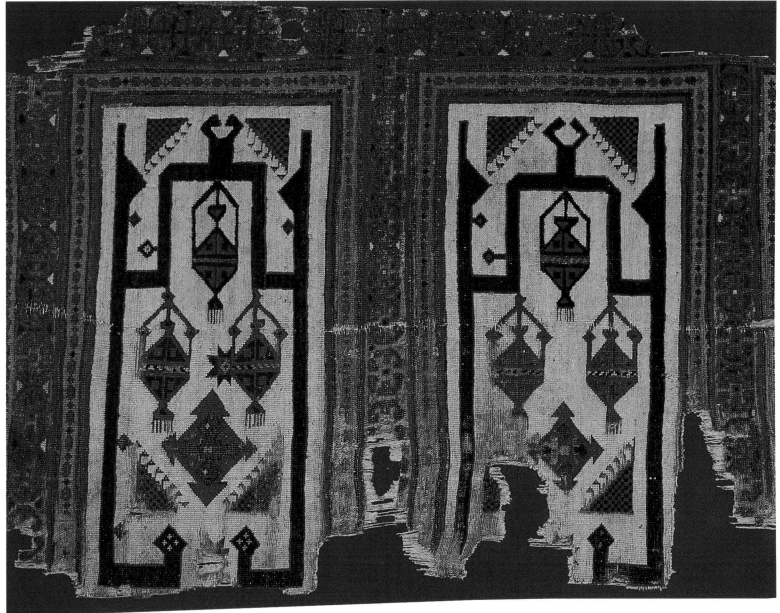

34

both cases the field is divided into compartments each of which houses two large octagonal medallions. At the center of the medallions on the first carpet are two affronted birds flanking a tree of life. On the second piece, the medallions are occupied by a combatant phoenix and dragon theme. A fragment analogous to that of the Marby rug is in the collection of the Metropolitan Museum in New York.[53]

Painting as a Witness

Another group, named for Carlo Crivelli, the Venetian master who included such carpets in a pair of pictures painted in 1482 and 1486, features a star medallion with paired birds and fantastic beasts nestled in its points. A fragment owned by the Museum of Decorative Arts in Budapest belongs to this period, whereas the example in the Kirchheim collection is probably later. Further along we will encounter a set of related pieces, also called Crivellis, which are completely devoid of animal motifs.[54]

Sometimes, too, the animals are simply aligned in rows, without frames, as found in fragments excavated at Fostat[55] and on a rug in Konya's Mevlana Museum, whose dragon pattern resembles the one featured in a mid-15th-century painting by the Spanish master Jaime Huguet.[56]

CARPETS WITH ANIMAL THEMES

The oldest known rug with an animal theme has been dated by Carbon-14 analysis to the period running from the 7th century to the 9th. Of uncertain provenance but undoubtedly found during excavations in Fostat (an ancient quarter of Cairo), it is ornamented with a single fantastic animal. On Anatolian carpets birds and beasts are frequently affronted or addorsed and convey a heraldic feeling. They remind us of the weavers' totemic past, before their ancestors converted to Islam. The earliest Anatolian carpets embellished with animal motifs date from the 13th-15th centuries.

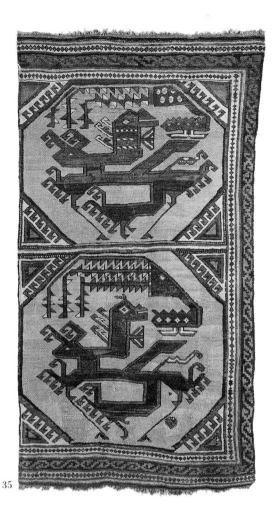

35

35. *Carpet with a combatant dragon and phoenix theme. Anatolia, 15th century. Wool pile. Islamisches Museum, Berlin. With its theme inherited from China, thanks to Turko-Mongol tribes moving into Anatolia, this type of carpet often appeared in 15th-century Italian paintings.*

36. *A so-called 'Crivelli carpet'. 15th century. Wool pile. Iparmüvészeti Museum, Budapest. Named for Carlo Crivelli, the 15th-century Venetian master who included such carpets in two pictures, the group to which this work belongs displays a star medallion with paired birds and totemic animals nestled in the points.*

37. *Carpet with animal themes. Anatolia, 13th-14th century. Wool pile. Metropolitan Museum of Art, New York. This enigmatic design, with its rather heraldic and fabulous bestiary, may be related to the ancient art of the steppes, as well as to shamanism, which was still practiced by certain Turkoman tribes when they first settled in Anatolia. Once thought to be a work of the 15th century, the piece seen here has been redated by Carbon-14 analysis to the 13th-14th-century period. It probably originated in eastern Anatolia.*

Recent Discoveries

Happily, four newly discovered pieces have expanded our knowledge of this group, while also complicating its history even further. One of the rugs, a tribal-looking example ornamented with a single fantastic animal and very likely unearthed from a Fostat tomb in the suburbs of Cairo, has been Carbon-14-dated to a period ranging from the 7th cen-

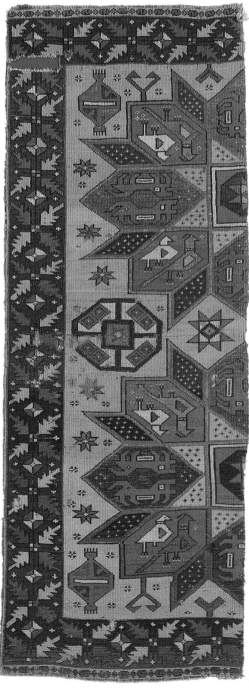

36

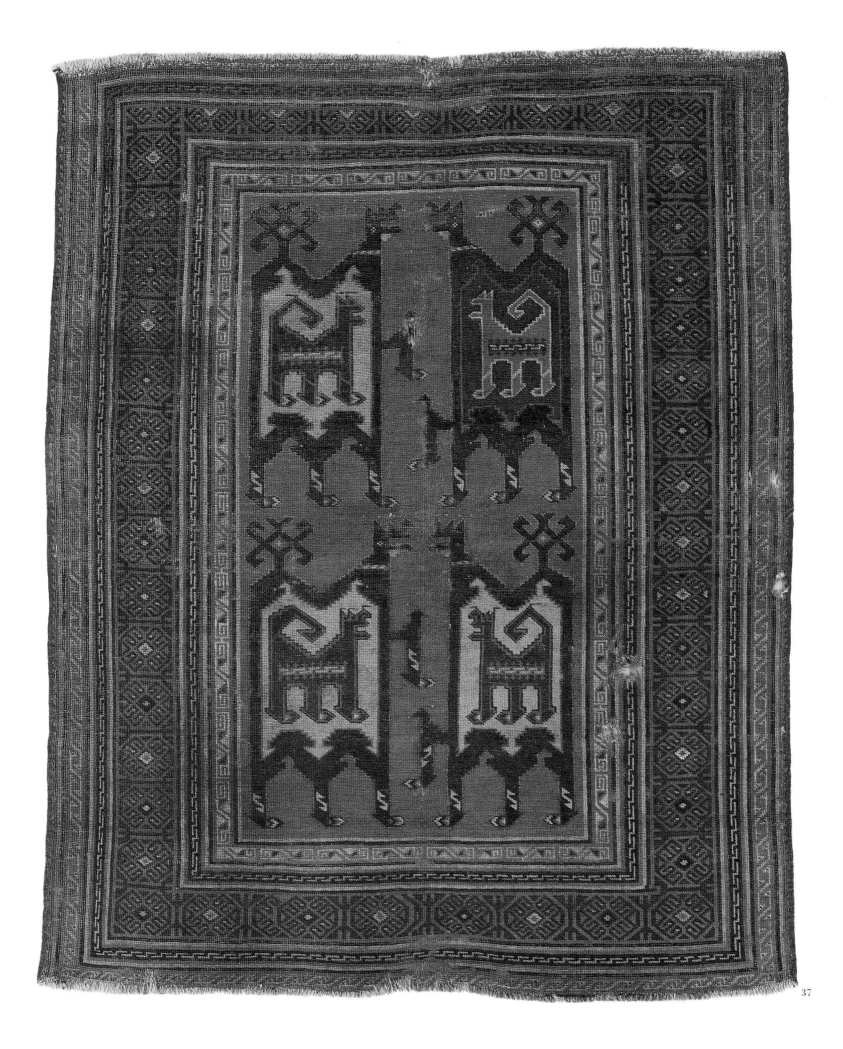

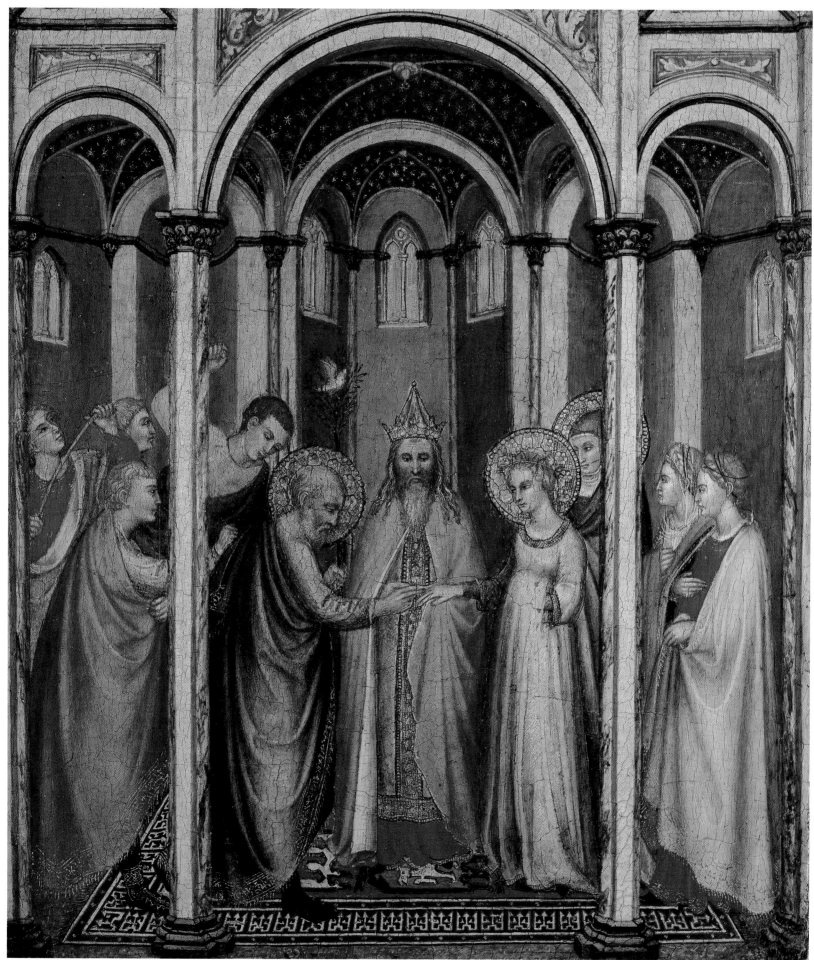

tury to the 9th. At the moment, however, it is not known whether the carpet was woven locally or imported.[57] Three other pieces, these decorated with fantastic pairs of affronted creatures containing smaller beasts, have survived in ancient Tibetan monasteries. Two examples with small formats are preserved in the Bruschettini collections in Genoa and at the Metropolitan Museum in New York,[58] while a third one, larger in format, has been acquired by Heinrich Kirchheim.[59] For these pieces the Anatolian provenance is virtually certain. Carbon-14 analysis makes it possible to date the works between the 13th and 14th centuries, which overturns the 15th-century dating formerly given the group. This new finding meshes better with other findings, notably the animal carpets of Mongol Persia, to which we shall return, and one of the oldest of the European representations, a rug featured in a fresco of 1346 painted in Avignon's Papal Palace by Matteo di Giovanetti, whose design includes two checkered roundels each of them sheltering a swan.[60]

Animals as Totems

This corpus of rugs allows us to formulate a better typological synthesis, especially when viewed in the light of John Mills's valuable study of animal carpets depicted in Western painting.[61] Most often the imagery involves birds and fantastic beasts arranged in rows or in pairs, frequently framed by medallions of various forms. In addition to their beast motifs, these pieces convey a certain heraldic feeling. The relationship between affronted animals and addorsed animals as represented in carpets reminds us of the weavers' totemic past. The duality of opposing good and evil forces – a notion so central to shamanist spirituality – is worth remembering, along with the fact, already mentioned, that the Turkomans newly converted to Islam had yet to give up practices inherited from their ancestors.[62]

38. Sienese school. The Marriage of the Virgin. Early 15th century. Tempera on panel. National Gallery, London.

Today, the provenance of these pieces remains uncertain. It cannot be denied, however, that large-format carpets, such as those discovered in the mosques of Konya and Beyshehir, could not have been woven by nomads or even by villagers. Requiring big looms, they must necessarily be considered the creations of urban ateliers. For the present, we know nothing of the production for export, which was already under way at this early date. All that we can propose is that the oldest Turkish pieces were very likely manufactured in one or several workshops located in central or eastern Anatolia.

Marco Polo's Testimony

When the merchant Marco Polo, en route for China, traveled across 'Turcomania' around 1270-1271, the region was populated by nomads of Turkoman origin and by urban-dwelling Armenians and Greeks engaged mainly in commerce and the crafts. This social organization, as we have seen, is confirmed by research done in the Turkish archives by Halil Inalcik. For Marco Polo, 'the most beautiful carpets in the world, and the most magnificent colors' were produced in five cities within the region. Of these, Konya, Kayseri, and Sivas made the most remarkable examples.[63] The other two cities were probably Karaman and Aksaray. A century later, Aksaray was cited by the Arab traveler Ibn Battuta for the unequaled quality of the woollen rugs it exported to the Middle East, Egypt, and even faraway China.[64] Certain experts, having concluded that the pieces observed by Marco Polo must be similar to those found in the Konya and Beyshehir mosques, have questioned whether the famed voyager, accustomed as he was to the refinement of Venetian life, could actually have thought such carpets the most beautiful in the world. Yet, as witnessed by the representations in painting, the animal carpets were highly esteemed by the Italians. It is not impossible, given the new Carbon-14 dating, that this type of rug did figure among those which so pleased Marco Polo.

The future certainly holds further surprises, especially in regard to the production

of urban ateliers. Evidence suggests, however, that we have scant chance of ever being able irrefutably to establish the exact provenance of all the Anatolian carpets. In those days, after all, very few weavers were sedentarized, which meant that the ornamental repertoire of Turkish weavers moved about just as they did.

39

THE OTTOMAN CARPET

The Seduction of Safavid Court Art

Beginning in the 15th century, Ottoman art underwent considerable influence from the Persian court, first during the reign of the Timurids and again during that of the Safavids following the sack of Tabriz by Selim I in 1514. Let us start, then, by examining two monuments built in Bursa at the outset of the 15th century, both of which represent an important landmark in the evolution of Ottoman art: the Green Mosque and the Green Tomb or Yeshil Türbe. So-called for their ceramic cladding, these structures figure among the oldest examples of the *hatayi* style ('after the manner of Cathay') in Turkey. A complex network of interlaced arabesques around oval medallions enlivened with foliage motifs, rosettes, and lotus blossoms (often but incorrectly called palmettes), and cloudbands, the *hatayi* style became one of the glories of Turkish art. Inscriptions on the interior of the mosque tell us that the tile revetment finished in 1424 was 'the work of master artisans from Tabriz.' One of the artisans, 'Ali ibn Ilias 'Ali, a Bursa painter seized by Tamerlane, had spent many years

in Samarkand, where he had mastered the art of tile revetment in the Timurid manner.[65] However, it took several more decades before the influence of this innovative work could be reflected in the design of carpets.

An Increase in Trade

The Ottomans revitalized the manufacture and export of rugs, a process henceforth aided by commercial and diplomatic relations with the Genoese and Venetian trading posts established on the Bosphorus since the early Crusades. For evidence of this development, we have only to look at the increased number of identical large-format examples in Western collections, which signifies the use of wide looms within an urban setting. Laboring within the context of a guild and supervised by a master weaver, the workers produced each piece from a cartoon furnished by a painter. The city of Konya remained, as in the past, one of the principal centers of rug manufacture. Accounts by European travelers, such as Bertrand de la Brocquière and Giuseppe Barbaro, confirm the existence of workshops in Iznik and Bursa in the 15th century. The western part of the country, along the River Gediz, saw the emergence of another group of important workshops. This region is known for its alum mines, its soft water, so essential in dyeing, and the excellent quality of its madder. A variety of outstanding workshops was located in this region, among them Ghiordis, Kula, Demirci, Selendi, and the most important, Ushak. Contemporary sources also refer to an atelier in Istanbul.[66]

Crivelli Carpets

At first, there was little aesthetic difference between the Ottoman carpet and its predecessors. For the reasons already cited, many types of Ottoman rug bear the names of the painters who depicted them in their pictures, a case in point being the 'Crivellis' mentioned earlier for their zoomorphic themes. Yet, most of the rugs in this group display no such imagery. Usually, the design consists of star medallions with eight points each, subdivided

into geometric motifs serving as enframements for other geometric figures. Four examples consistent with this pattern have been indexed; a fifth is related to them; and a sixth has recently come on to the market. Among the truly significant pieces is the one in the Vakiflar Museum, discovered in the mosque at Sivrihisar.[67] The design would continue to be woven at least until the 17th century, when it shows up in a painting by Gerrit Horst.

The Memling Göl

Another family of rugs, contemporary with the Crivellis, proved to be just as successful. It is characterized by rows of small medallions with hooked contours called the 'Memling *göl*' after the 15th-century Flemish painter Hans Memling. The design of this carpet has evolved little over the centuries, being identical to the pieces woven in the 20th century by the Yürük. The principal motif, moreover, was not unique to Turkish carpets,

40

41

39. *Yeshil Türbe, or Green Tomb, Bursa. 1421. Photograph by Walter Denny. Inscriptions inside the mosque tell us that the ceramic cladding was 'the work of master artisans from Tabriz.' One of them, the Bursa painter 'Ali ibn Ilias 'Ali, had mastered the art of tile revetment in the Timurid manner while a 'guest' of Tamerlane in Samarkand. However, it would take several decades before this innovative work could influence the design of carpets.*

40. *'Memling carpet'. 15th century. Wool pile. Iparmüvészti Museum, Budapest. Named for the Flemish master who depicted such patterns in his paintings, this rug and the family to which it belongs are characterized by rows of small medallions with hooked contours called the 'Memling göl'. The theme has evolved little over the centuries and is woven today by the Yürük.*

41. *'Small-pattern Holbein'. Anatolia, 16th century. Wool pile. Musée des Arts Décoratifs, Paris. Named for the 16th-century German painter Hans Holbein the Younger, small-pattern Holbein rugs feature staggered rows of nearly circular medallions containing octagons bordered by interlace alternating with quadrilobate medallions. The pattern today survives in rugs woven by the Yürük tribe.*

since it is found as well on works of Turkoman or Caucasian origin. The Museum of Decorative Arts in Budapest and the Kirchheim collection both own examples of the 'Memling' rugs. A more recently made series, with a yellow ground, has been attributed to the region around Konya.

Holbein Carpets

While the names Crivelli and Memling designate each a single kind of design, the name of the German painter Hans Holbein the Younger (1497-1543) signifies rather more broadly, characterizing as it does several different patterns. In a further complication, the term 'small-pattern Holbein' identifies one particular pattern, whereas 'large-pattern Holbein' embraces a good number of variations. The terminology is made all the more confusing by the fact that Holbein was neither the only nor even the first painter to depict 'small-pattern Holbeins' in his pictures.

In Holbein's famous portrait of the Hanseatic merchant Georg Giesze, a small-pattern Holbein covers the table. It appears to be one of the 'wheel' rugs mentioned in European archives and inventories beginning in the 13th century. Staggered rows of approximately circular medallions containing octagons bordered by interlace alternate with quadrilobate medallions. In the earliest paintings the small-pattern Holbeins generally have borders enlivened with 'pseudo-Kufic' script. It is also characteristic for the ground color to be a uniform blue, green, or, especially, red. However, the field is sometimes divided into compartments with alternating colors. A commercial product, the small-pattern Holbein can be found in many Western collections. Its principal motif, which resembles the *göl* of the Central Asian Salor tribe, serves as a secondary motif in the large-pattern Holbein. The small-pattern Holbein family first appeared in European painting about halfway through the 15th century and then disappeared therefrom some 150 years later.[68] Yet the pattern proved long-lasting, and it survives today in the repertoire of the Yürük tribe.

The most frequent version of the large-pattern Holbein comprises a field usually divided into rectangular compartments framing large, variously shaped medallions inscribed within octagons. Triangular 'spandrels' or 'quadrants' at the four corners complete the rectangle. Like the small-pattern Holbein, the oldest specimens of the large-pattern frequently have border friezes emblazoned with pseudo-Kufic. Occasionally, as on the example in Berlin's Islamisches Museum, the intervening spaces between the large motifs in the field are activated with pairs of small medallions. On the rug in the Türk ve Islam Eserleri Müzesi the intervals are flanked by pairs of medallions in a quincuncial arrangement, which recalls the Egyptian rugs woven by Mamluk artisans. As with the

42. *Anonymous master.* The Conference at Somerset House. *1604. National Portrait Gallery, London. This painting includes a detailed depiction of a small-pattern Holbein carpet spread over the table.*

42

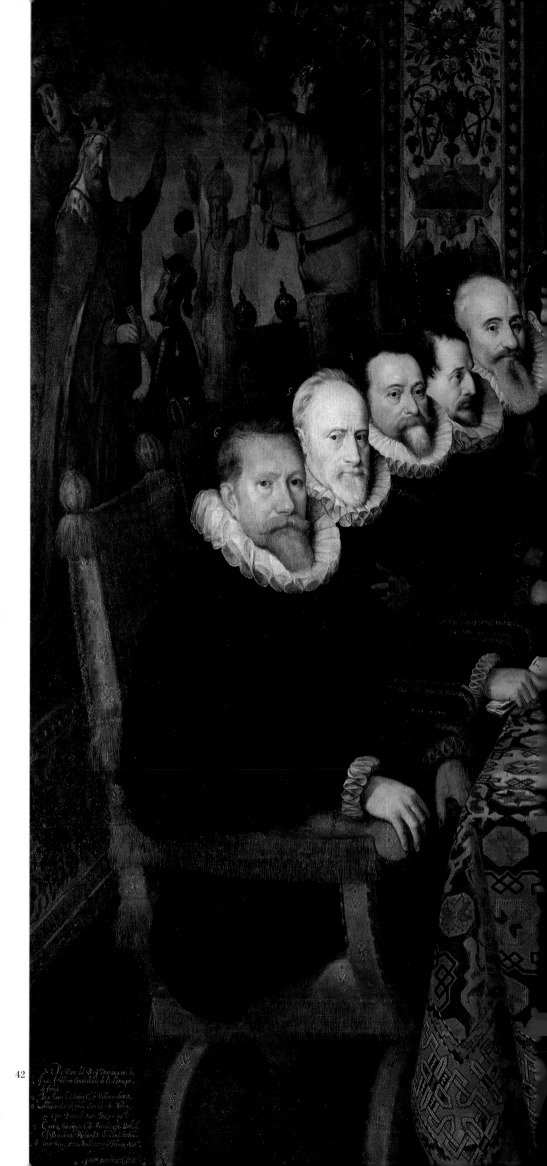

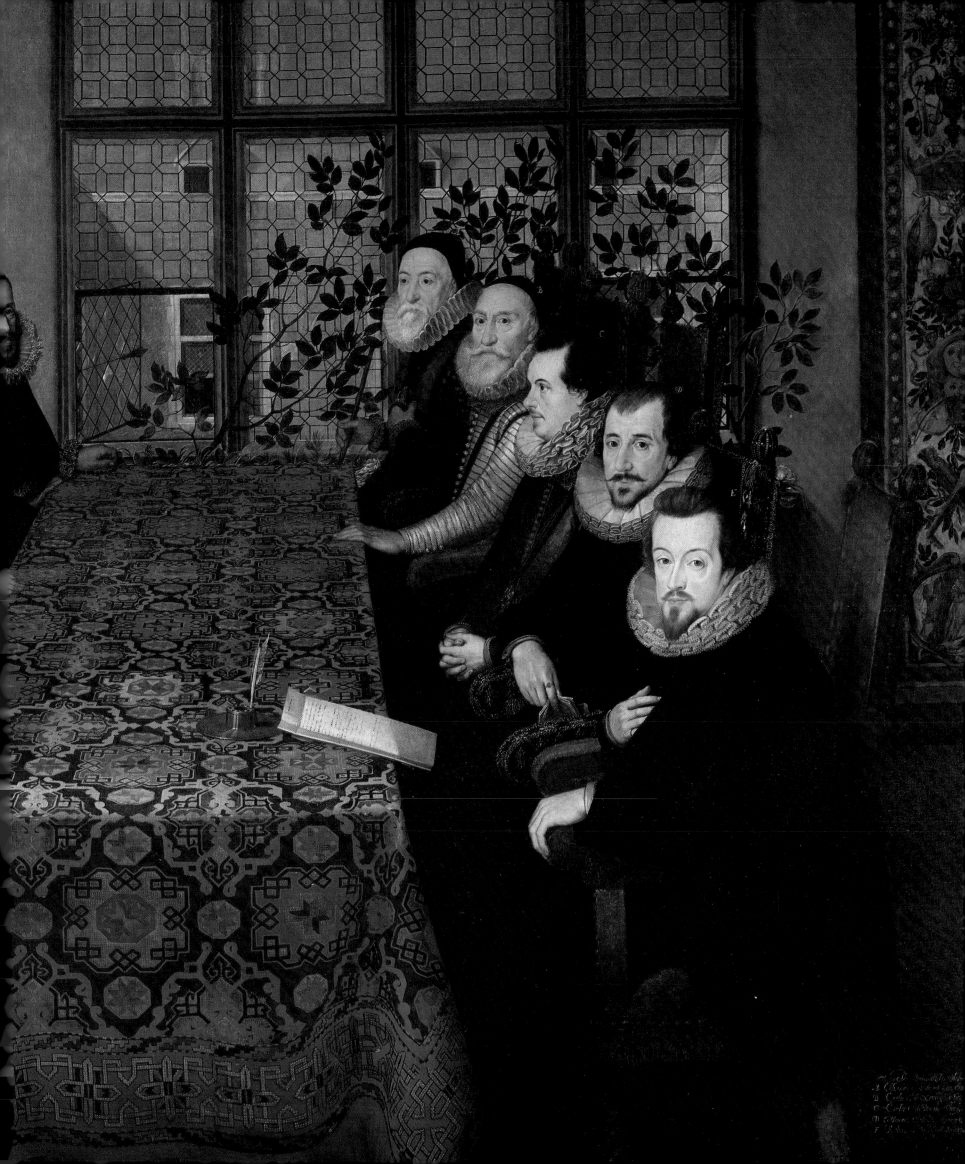

animal rugs, the origin of this composition goes far back in history. Pieces with a similar pattern show up in Chinese miniatures depicting a Mongol encampment at the beginning of the 13th century.[69]

The Holbein palette, predominantly red, blue, and yellow, suggests that the two groups originated in the same workshop. For decades, these rugs were attributed to Bergama, a city in western Anatolia, because of undeniable similarities between antique

43. *The Story of Madame Wen-chi (episode 10, the birth of a child). China, Ming Dynasty (1368-1644). Painting on silk. Metropolitan Museum of Art, New York. The design of the rug depicted in this Ming painting, which represents a scene in a Mongol camp, is similar to the one reproduced opposite.*

44. *'Large-pattern Holbein carpet'. Anatolia, c. 1500. Wool pile. Islamisches Museum, Berlin. One of numerous Anatolian carpets named after the German painter who depicted them in his portraits, the piece seen here displays a pattern of octagonal medallions framed within squares. It has, in addition, small geometric motifs that are identical to imagery found on Mamluk rugs, which leads to the assumption that the carpet was woven in the Karaman, a region briefly dominated by Mamluk Egypt around the turn of the 16th century.*

THE HOLBEIN CARPETS

The name of the German painter Hans Holbein the Younger (1497-1543) is associated with several different geometric patterns, which, however, are generally grouped under two subtitles:

Small-pattern Holbeins present staggered rows of almost circular medallions containing octagons bordered by interlace alternating with quadrilobate medallions. The borders are often inscribed with pseudo-Kufic writing.

The small-pattern *göl* serves as a secondary motif in the large-pattern Holbein.

Large-pattern Holbeins usually comprise a field divided into rectangular compartments framing large, variously shaped medallions inscribed within octagons. Sometimes the spaces between the large motifs are activated with pairs of small medallions. The border may contain pseudo-Kufic script. The Holbein palette is predominantly red, blue, and yellow.

pieces and the area's recent production. This argument, however, collapses in the light of equally valid comparisons with carpets woven elsewhere in Anatolia, or even in the Caucasus. Subsequently, the cities of Ushak and Konya have also been proposed.[70] As for the large-pattern Holbeins in the collections of Berlin's Islamisches Museum, Friedrich Spuhler falls back on Bergama as the place of manufacture.[71] Finally, Walter Denny has examined the presence in the oldest Holbeins, including the Berlin collection, of small kaleidoscopic motifs in the Mamluk manner and concluded that they may have originated in

the region around Karaman.[72] The large-pattern Holbeins in Berlin can be dated with relative precision, thanks to an identical piece depicted in *The Mass of Saint Giles* (National Gallery, London), painted around 1500 by the so-called Master of Saint Giles. Indeed, it was in this very period that the Karaman dynasty was briefly controlled by Egyptian Mamluks.

43

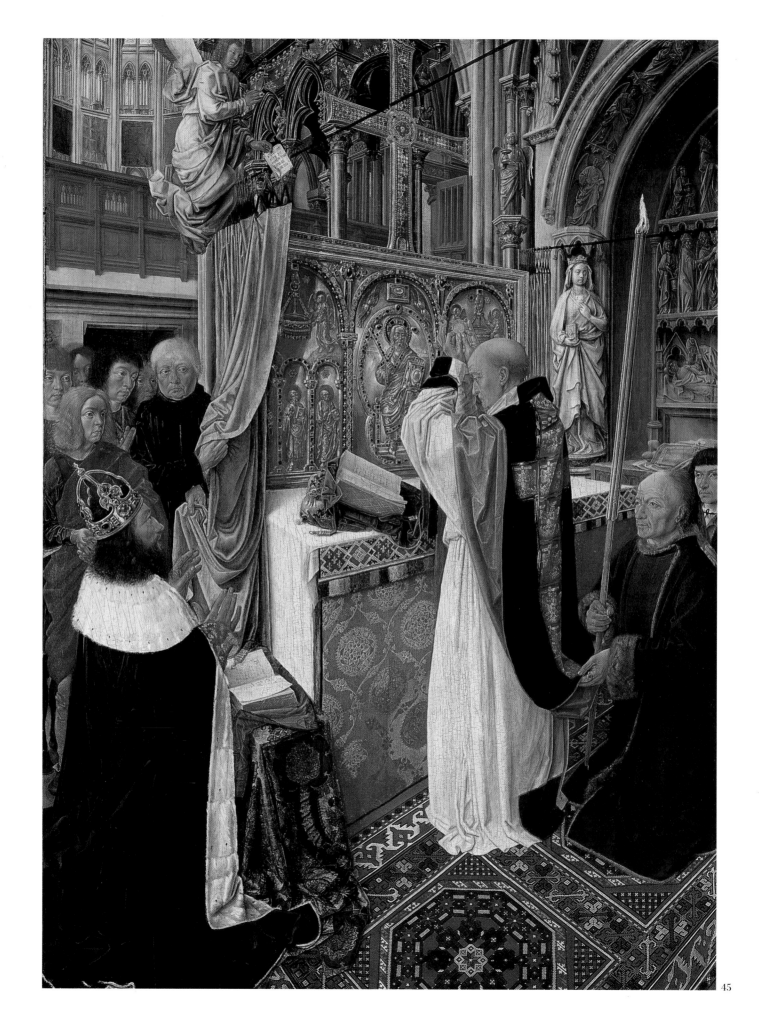

An Egyptian Parenthesis

The Egyptian connection is worth exploring further. Under the Mamluks, who had seized power in 1250, Egypt was an independent state, and until subjugated by the Ottomans in 1517, the country maintained close commercial ties with Turkey. According to numerous travelers who praised the 'Kairin' rugs throughout the 15th, 16th, and 17th centuries, Cairo was known for its fine carpets. The Ottomans even sent their cartoons to be woven in the Egyptian city's workshop. Mamluk carpets, such as the one at the Metropolitan Museum, are normally decorated with large octagonal medallions, polylobate or star-shaped and surrounded by constellations of small 'snow flake' medallions, the whole set off by an abundance of kaleidoscopic and vegetable motifs. Needless to say, the Mamluk rug begs comparison with Turkish carpets, but also with the decorative programs on Islamic architecture, so replete with the *horror vacui* principle common to Muslim artists. Yet there are distinguishing differences between the Mamluk rug and its Anatolian cousins, such as the asymmetrical knot used for the pile and the palette, in which the dominant hue is lac red, derived from an insect originating in India.[73] According to several specialists, it was the Turkoman dynasty of the Kara Koyunlu, which sought refuge in Egypt after having been driven out the Azerbaijan, that introduced pile weaving into this country.[74] Without excluding the hypothesis, we should bear in mind that the Mamluks often were themselves onetime slaves with roots in Turkestan.

Para-Mamluk Carpets

Also worth mentioning is a so-called para-Mamluk group of rugs, which share certain traits with Turkish and Mamluk carpets. The para-Mamluk rug is occasionally floral, as in the case of the lotus-flower design seen in a piece formerly owned by the Zadah Gallery in London. More often, however, a geometric pattern dominates the field, sometimes with a large principal medallion set off by pairs of smaller medallions in a quincunxial relationship, as in the example at the Philadelphia Museum of Art, or it may be divided into squares framing octagons, as in the so-called 'checkerboard' carpet in Vienna's Österreisches Museum für angewandte Kunst. Related to Mamluk art through its pairs of cypress trees and kaleidoscopic motifs, this group also recalls the Turkish carpet, particularly in the arrangement of its decorative elements and in its 'pseudo-Kufic' border. A similar ambiguity emerges from the technique used to weave para-Mamluk rugs. Their pile is made with asymmetrical knots, but the warps are of ivory wool spun Z2S and the wefts are dyed red. Thus, the attribution of these pieces to Damascus appears plausible, given the city's centuries-old reputation as a center for the manufacture of luxury textiles. Furthermore, their overall look accords with that of the *damascini* rugs described in old texts.

The importance of analyzing structure is clear, since many of these pieces, despite their common repertoire of decorative motifs, may very well have originated in production

45. *Master of Saint Giles. The Mass of Saint Giles. c. 1500. National Gallery, London. The large-pattern Holbein reproduced on page 71 can be dated precisely because it matches the rug depicted in* The Mass of Saint Giles, *a work painted at a time when the Karaman dynasty was briefly controlled by Egyptian Mamluks.*

46. *Egyptian carpet from the Mamluk period. Cairo, 15th-16th century. Wool pile. Metropolitan Museum of Art, New York. Mamluk carpets are normally decorated with large octagonal medallions, polylobate or star-shaped and surrounded by constellations of small 'snowflake' medallions, the whole set off by an abundance of kaleidoscopic and vegetable motifs.*

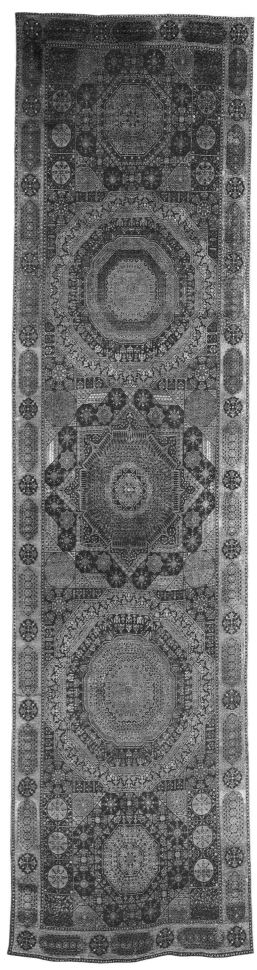

46

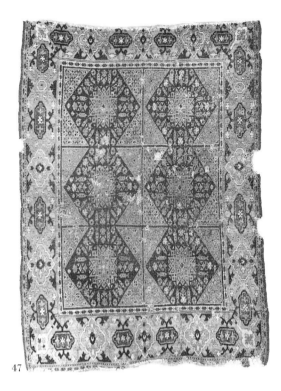

47

47. *A 'para-Mamluk' or 'chessboard' carpet. Damascus(?), 15th-16th century. Wool pile. Österreichisches Museum für angewandte Kunst, Vienna. The group to which this work belongs often presents a field divided into squares framing octagons, but the pattern is also related to Mamluk art through its pairs of cypress trees and kaleidoscopic motifs. Given that the warps are made of ivory wool spun Z2S and the wefts are dyed red, certain scholars, quite plausibly, attribute the group to Damascus, a city long known for its manufacture of luxury textiles.*

48. *Carpet with star medallion. Eastern Anatolia, 15th-16th century. Wool pile. Vakiflar Museum, Istanbul. Despite its Mamluk-like motifs, this piece has colors dark enough to warrant an attribution to eastern Anatolia. It was discovered in the mosque at Divrigi, a city near Sivas highly reputed for its carpet production, the quality of which impressed Marco Polo.*

centers quite distant from one another. We have only to compare the light-colored rug in a quincunxial medallion pattern in the Kirchheim collection, attributed to western Anatolia,[75] with the identically patterned dark-toned carpet in the Vakiflar Museum. The latter was discovered in the mosque at Divrigi, an eastern Anatolian city near Sivas known for its carpet production, the quality of which had impressed Marco Polo. Also from Divrigi, the Vakiflar Museum owns two other rugs which are attributed to a workshop in the region. One is ornamented with an octagonal medallion and the other with a six-pointed star. The latter's design, based on the Turkoman vocabulary of ornamental motifs, echoes the Salor *göl*.[76]

Variants on Holbein Patterns

Among other variants stylistically related to the large-pattern Holbein family are rugs ornamented with star, lozenge, cruciform, and 'keyhole' medallions. One of them, the Wind carpet, which probably dates from the 16th century,[77] is rare indeed, despite the closeness of its palette and its Mamluk vocabulary, especially the four star medallions brightened with clusters of kaleidoscopic motifs, to the Berlin carpets. For the moment, this piece, other than a fragment in Munich's Bavarian National Museum, is the sole witness to the group it once formed part of. As a type, the pattern survives today in village rugs. A 17th-century example from the Kirchheim collection is decorated with an eight-pointed star medallion on a field with a regular, all-over, Turkoman-like pattern of repeating *göl*. Particularly noteworthy are the complexity and unusual, but not unknown, form of the *göl*, each of which is composed of four octagons disposed about a square.[78]

The 'keyhole' rugs were also woven in several different regions of Anatolia. So-called for the small niche at one end of the field (and sometimes at two ends), the keyhole type appears in numerous pictures painted between the 15th and 17th centuries. One of the paintings was by Gentile Bellini and another by his son Giovanni. In both

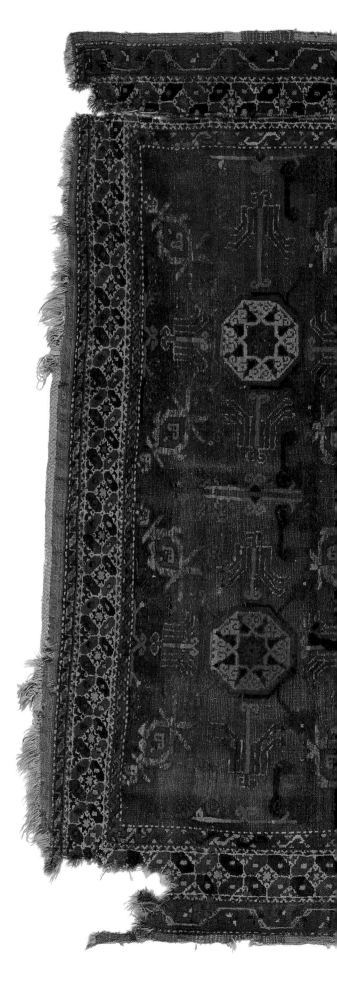

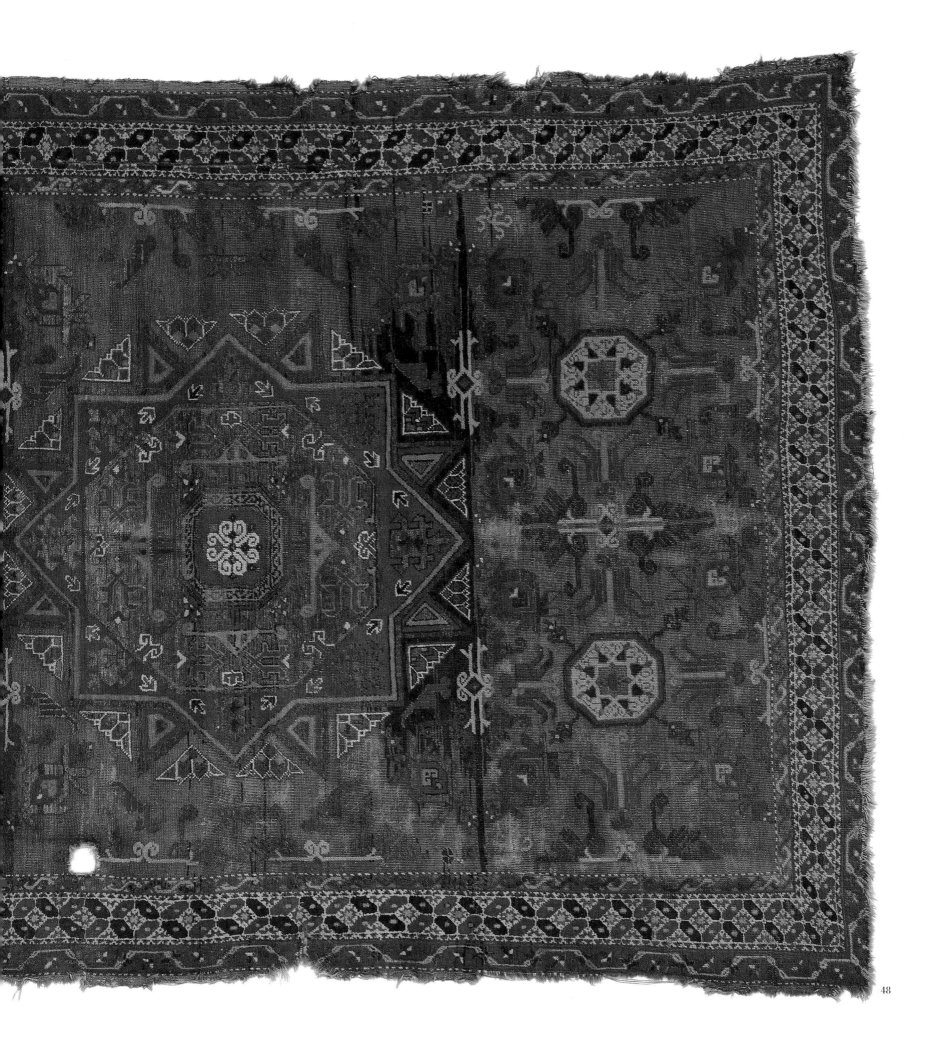

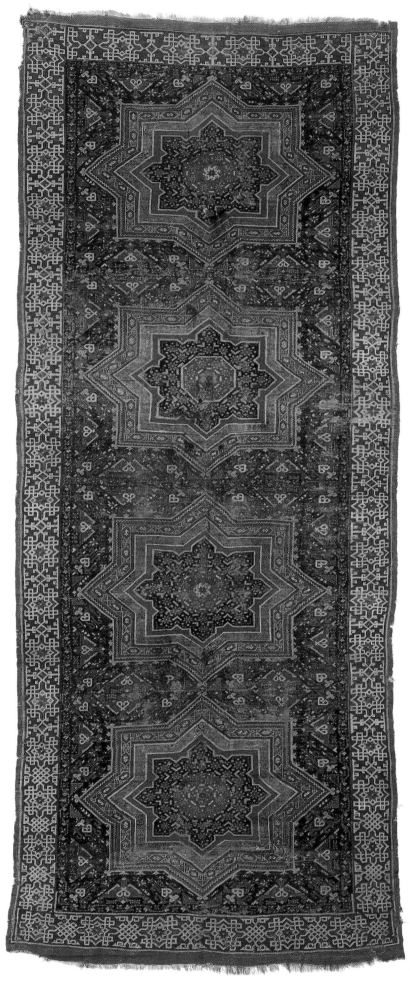

49

49. *The 'Wind carpet' with a star medallion. Western Anatolia, 16th century. Wool pile. Christie's sale, 10 October 1994. Another variant on the large-pattern Holbein/Mamluk scheme, the 'Wind carpet' is rare indeed, despite the closeness of its palette and its vocabulary to the Mamluk group. As a type, the design, including the eight-pointed star medallion and Mamluk wealth of small motifs, survives today in village rugs, among them the 17th-century example reproduced opposite.*

50. *A 'keyhole' or 'Bellini' carpet. Anatolia, 15th-16th century. Wool pile. Musée National de Valère, Sion, Switzerland. Closely akin to Mamluk prayer rugs and the para-Mamluk family in general, the 'keyhole' type appears in numerous pictures painted between the 15th and 17th centuries, two of them by Gentile and Giovanni Bellini. While some see the keyhole niche as the mythical Chinese mountain decorating the pillars of Buddhist temples, others identify the image as a schematic representation of the ritual ablution fountain.*

51. *Carpet with a star medallin. Anatolia, 17th century. Wool pile. Kirchheim collection, Stuttgart. The rug seen here is a descendant of the rare Bellini reproduced at left. It features an eight-pointed star medallion on a field with a regular, all-over, Turkoman-like pattern of repeating göl. This motif is both complex and unusual, composed of four octagons disposed about a square.*

'KEYHOLE' CARPETS

The 'keyhole' rugs were also made in several different regions of Anatolia. So named for the small niche at one end of the field (and sometimes two ends), the keyhole type appears in numerous pictures painted between the 15th and 17th centuries. One of the paintings was by Gentile Bellini and another by his son Giovanni. In both instances the rugs are related to the Mamluk prayer type as well as to the 'para-Mamluk' family. Several variations are also known. The niche has inspired diverse interpretations. While some see the mythical Chinese mountain decorating the pillars of Buddhist temples, others identify the image as a schematic representation of the ritual ablution fountain, since the keyhole motif shows up more often on prayer rugs. One example, and a very old one, is in the Château Valère at Sion in Switzerland, while three others are preserved in Turkey and several have been acquired by Heinrich Kirchheim. Western Anatolia and the Karaman region, among other places, have been suggested as a provenance for the group.

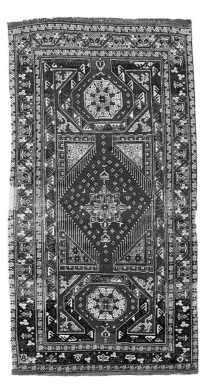

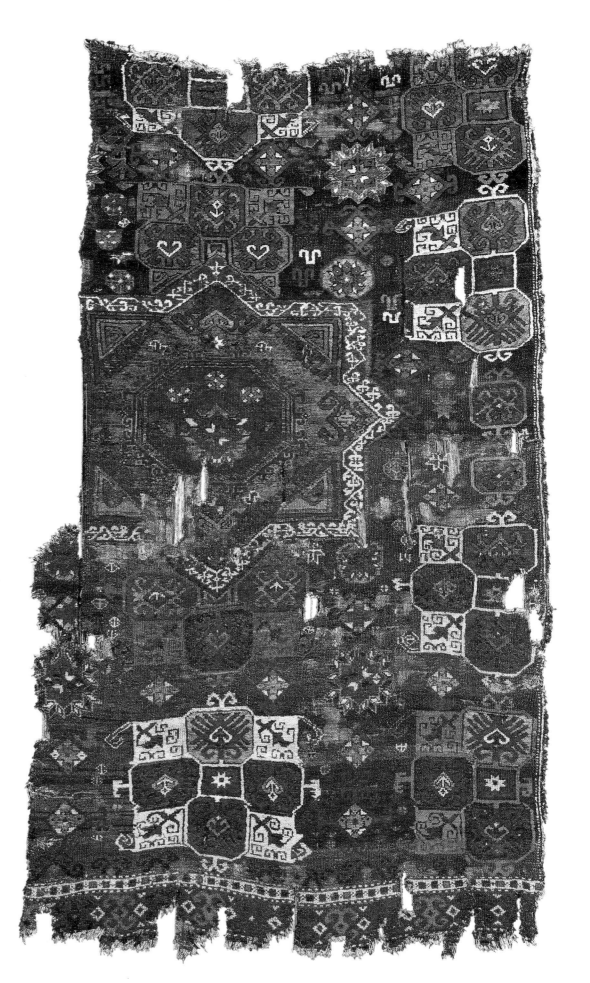

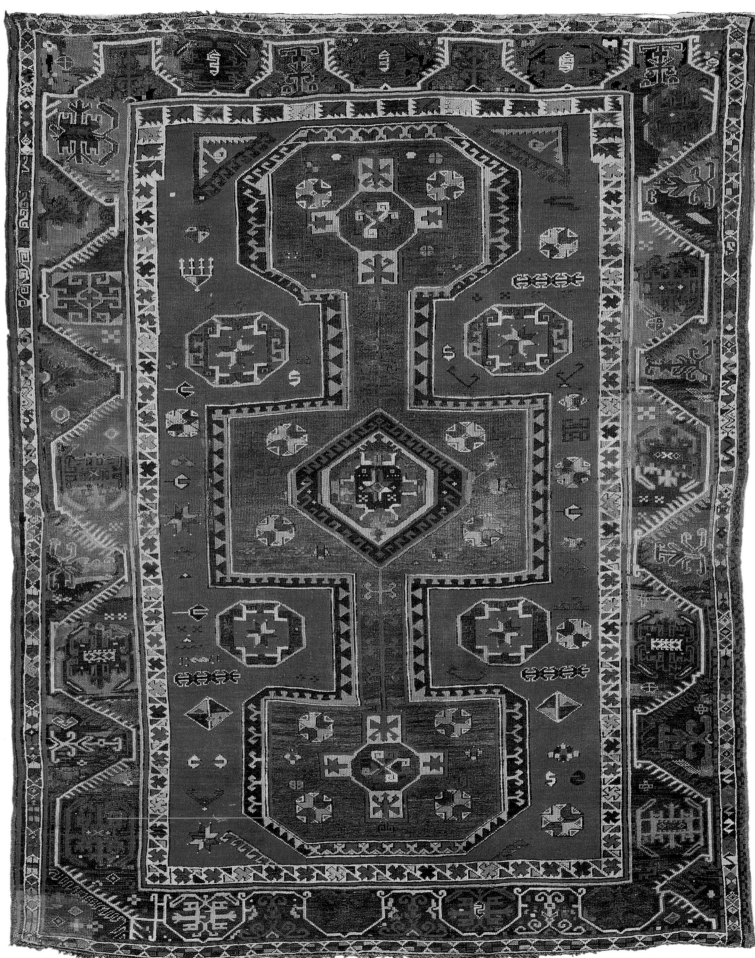

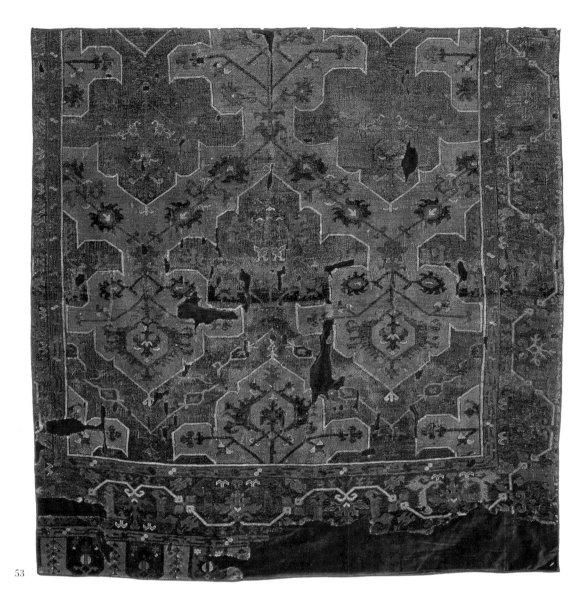

53

54. Francesco Bassano (Francesco de Ponte) the Elder. Virgin and Child Enthroned. *Venice, 1519. Museo Civico, Bassano del Grappa. Note the 'keyhole carpet' under the Madonna's feet.*

52. Carpet with a cruciform medallion and tamgha. Central Anatolia, 16th century. Wool pile. Musée des Arts Décoratifs, Paris. An authentic part of the Turkish repertoire, this pattern is closely allied with the Kazakh tribes of the Caucasus. It sports several tamgha, *the brand signs adopted as tribal emblems by the peoples of the steppes, who lived from animal husbandry.*

53. Carpet with imbricated fleurons. Central or eastern Anatolia, 16th-17th century. Wool pile. Musée des Arts Décoratifs, Paris. While the fleuron pattern could be considered archaic, the all-over network of angular arabesqus and palmettes anticipated new developments in Turkish rugs, beginning in the 16th century.

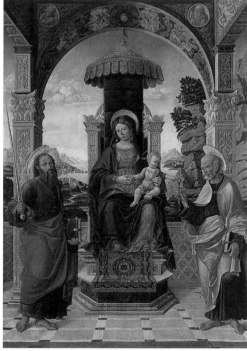

54

instances the rugs are related to the Mamluk prayer type as well as to the 'para-Mamluk' family. Several variants are also known. The niche has inspired several interpretations. While some see the mythical Chinese mountain decorating the pillars of Buddhist temples, others identify the image as a schematic representation of the ritual ablution fountain, since the keyhole motif shows up more often on prayer rugs. One example, and a very old one, is in the Château Valère at Sion in Switzerland, while three others are preserved in Turkey and several have been acquired by Heinrich Kirchheim. Western Anatolia and the Karaman region, among other places, have been suggested as a provenance for the group.

Other Archaic Designs

The Bellini pattern, moreover, is cousin to a pattern featuring a cruciform medallion with elongated arms terminating in polygons. Such a carpet, decorated with a considerable number of *tamgha*, can be found at the Musée des Arts Décoratifs in Paris. Four others are in the Vakiflar Museum.

Finally, there are several archaic-looking pieces which stand apart aesthetically from the rugs just cited. Among them are carpets patterned with interlocking fleurons, an example of which is in the Wher collection in Switzerland. Its colors are those normally associated with western Anatolia, whereas the muted palette of a similar piece in Paris's Musée des Arts Décoratifs suggests an origin of manufacture towards the center or the eastern part of the country. The same could

be said of the two pieces in the collections of Berlin's Islamisches Museum. The Paris example, with its all-over network of angular arabesques and palmettes, introduces something new, observable in Turkish carpets beginning in the 16th century.

A TIMID STEP TOWARDS THE FLORAL CARPET

Named for the Venetian painter Lorenzo Lotto (c. 1480-1556/57), the Lotto rug constitutes a transitional stage between the first Ottoman period and the floral art that would dominate the rugs of the 16th and 17th centuries. In the Lottos the field is activated by angular arabesques forming rows of generally octagonal or rectangular motifs resembling grillework. If the links between the Lotto rugs and the decorative program of the Green Mosque in Bursa are not immediately evident, just consider the system of arabesques which bifurcate and crisscross to form a rectangle. The pattern is the same in both rug and mosque. The arabesque, though created by an Islamic artist shortly after the 7th-century conquest, did not make an appearance in Turkish carpets until the beginning of the 16th century.

Sub-groups of Lotto Carpets

Today the Lotto family is divided into three groups. The oldest, called Anatolian, began to appear in European painting at the outset of the 16th century.[79] It is distinguished by the relatively supple drawing of the arabesque tracery. Some thirty years later came a stiffer version, known as *kilim* for the leaf imagery whose serrated edges so clearly resemble tapestry weaving. The ornate style, bristling with hooks and tendrils, which emerged in the early 17th century looks baroque by comparison with its antecedents. The oldest pieces normally have borders embellished with 'pseudo-Kufic' characters or with cloudbands. An example of each Lotto subgroup is preserved at the Musée des Arts Décoratifs in Paris. In the great majority of cases, the arabesque is traced in yellow

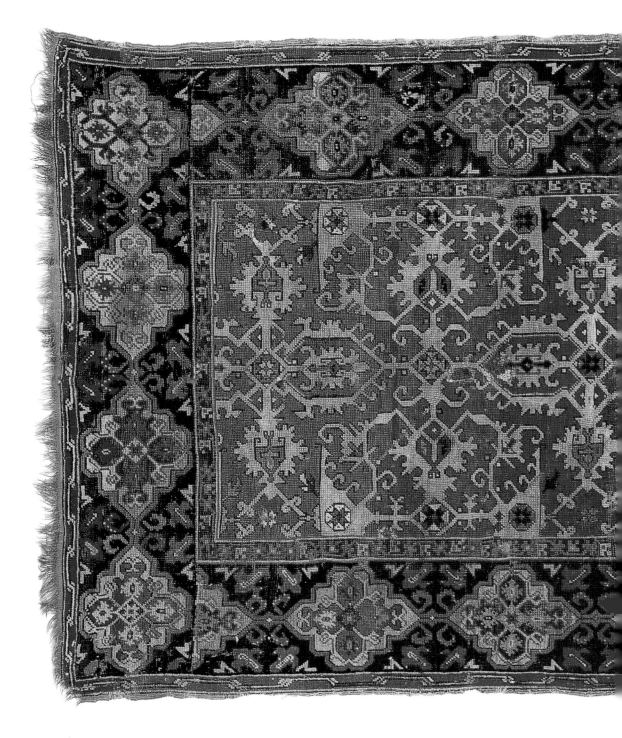

on a red ground. Other colors, however, may also be used, as in the specimen in the Alexander collection, where the arabesque has been worked in blue on a red ground. This carpet differs as well by the totemic motifs decorating the border.

The Lottos and the Holbeins resemble one another not only in color range but also in their borders, the décor of their secondary borders, and their formats. The organization of the field, in alternating rows of lozenges and octagons, is the same as the small-pattern Holbein. Just as in the case of the Holbeins,

the Lottos have been attributed to several different cities, from Bergama to Ushak and, more recently, to Konya. Could they all have come from the same workshop? The relatively high number of examples preserved in Western museums attests to the commercial success of the Lotto rugs. Moreover, the possibility of copies having been made elsewhere in Anatolia, or even in Europe, should not be excluded.[80]

With all due deference to historians, the history of the first Turkish rugs with floral patterns is certainly more complicated than

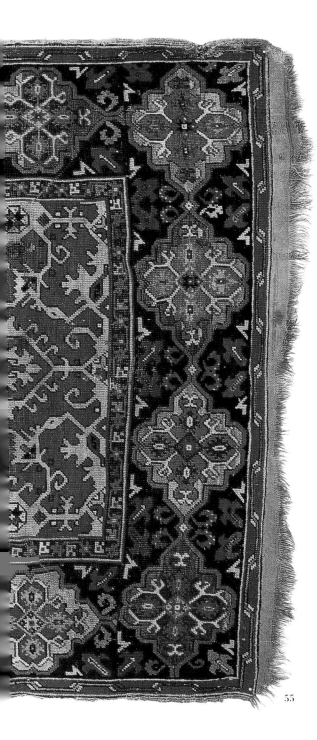

55

55. *'Lotto carpet'. Anatolia, early 17th century. Wool pile. Private collection. Named for the well-known 16th-century Venetian painter, the Lotto pattern is activated by angular arabesques forming rows of generally octagonal or rectangular motifs resembling grillework. The example seen here, which belongs to the ornamented subgroup within the Lotto family, looks almost baroque compared to the earliest Lottos.*

was once thought. The present theory, according to which arabesque carpets suddenly appeared in the 16th century, fails to take certain pieces into account, among them rugs in New York's Metropolitan Museum,[81] which are difficult to classify with the Lottos.

THE COURT STYLES

Beginning in 1453, after the conquest of Constantinople by Mehmet II (Mehmet Fatih, Sultan from 1451 to 1481), Ottoman power grew apace to reach its apogee in the 16th and 17th centuries. Once he had conquered Syria and Egypt, Selim I (r. 1512-1520) assumed the title of Caliph in addition to that of Sultan. He occupied Tabriz, the capital of the Safavid dynasty and forced a thousand artisans to leave for his own capital, Istanbul (Constantinople). Suleyman the Magnificent (r. 1520-1566) took Belgrade and Buda before laying siege to Vienna in 1529.

The Flowering of a Court Art

The Ottoman court, under the patronage of enlightened Sultans, entered a prolonged period of great artistic flowering inspired by the Timurid example. In the *nakkashane*, the royal painting atelier founded by Mehmet Fatih shortly after the fall of Constantinople, artists turned out illuminated manuscripts, superb book bindings, ceramic decorations, textiles, and carpet patterns. Two master rug weavers (*kaliçebâftân*), Hamza and Mustafa, are cited by name in the official register, compiled during the Conqueror's reign, of the *cemaat-i Kaliçebâftân*, the rug weavers' guild attached to the court.[82]

Research carried out by Walter Denny has revealed that while Persian painters did indeed work in the *nakkashane*, few weavers from Persia were ever enrolled in the guild of rug makers. For the most part, weavers were recruited through the *devsirme* system, the forced levies of Christian children who were Islamicized and Turkicized as Janissaries, the crack, ultraloyal corps responsible for guarding the palace and administering the Ottoman Empire. Thus, while many weavers came from

abroad, notably from the Balkans and Georgia, none from either Persia or Egypt is to be found in the guild register begun during the reign of Selim I and kept through the reign of Sultan Ahmet I (r. 1603-1617).[83] And even if the *cemaat-i Kaliçebâftân* register remains silent on the subject of location, the atelier whose activities it reflects must have been situated in Istanbul itself or in Bursa.[84]

New Art Forms

The *nakkashane* painters, who created cartoons or model patterns, brought vigorous new life and invention to the rug weaver's art. This flowering, moreover, stemmed in part from the striking stylistic relationship that existed between carpets designed for the court and those manufactured in the great producing centers, such as Ushak. It also attests to the capacity of Muslim artists to utilize and reinterpret an established repertoire in order to create new forms. Henceforth Turkish rugs would abound in circular or oval medallions, surrounded by scrolling, leafy arabesques, lotus and peony palmettes, cloudbands, and *tchintamani* motifs. The *tchintamani* or 'Buddha's lips' pattern, fashionable beginning with the reign of Mehmet the Conqueror, first appeared in textiles prior to its adoption for Ottoman court rugs as well as for Ushak carpets. Characterized by rows of motifs comprising small circles in groups of three, frequently accompanied by undulating lines, this design had its roots in Buddhist iconography, which accounts for the name.[85]

The link between Ottoman and Persian rugs during the 16th century has often been cited, and justifiably so in view of the many features their decorative repertoires share in common. Yet, even while acknowledging all such evidence, one must assert that Ottoman court rugs and Ushak carpets present qualities which differentiate them rather sharply from their Safavid counterparts. Rather than direct influence, the relationship could have been one of parallel development, the Ottoman weavers having found their sources, as seen earlier, in Timurid art of the 15th century. Furthermore, the composition of Ottoman rugs sets these works quite distinctly

*56. Ottoman court carpet with the 'Buddha's lips'
pattern. Cairo, 16th century. Wool pile. Musée
Jacquemart-André, Paris. Once the Ottoman
Turks had captured Constantinople and made it
their capital, Istanbul, the court established the
nakkashane, the royal painting atelier, which
began turning out illuminated manuscripts, superb
book bindings, ceramic decorations, textiles, and
carpet patterns. Among the last was the work seen
here, based on the tchintamani or 'Buddha's lips'
motif. Characterized by rows of small circles in
groups of three, accompanied by wavy lines, the
design had its roots in Buddhist iconography, as
the name implies. The weaving technique, however,
tells us that the cartoon was sent to Cairo for
execution. The border is in the hatayi style,
meaning 'from Cathay'.*

apart from the Safavid pattern. While the central medallion of the Persian carpet is a true focal point for the entire scheme, the Ottoman artist generally prepared rug cartoons as if they were for textiles, meaning that the medallion would be infinitely repeated and organized into rows cut off at random by the surrounding borders.

THE OTTOMAN COURT RUG

The Ottoman court rug differs from other Anatolian carpets by virtue of its vocabulary, its colors, and its technique. Even though a full analysis of the group has yet to be done, the patterns can be divided into two groups.

Two Main Groups

One is soberly elaborated with *hatayi* motifs. The other, richly ornamented with floral motifs, displays that *horror vacui* so native to Muslim designers. Among other examples of the first category, there are two pieces with a double niche, one of them belonging to the Metropolitan Museum of Art (McMullan gift) and the other in the Musée Jacquemart-André in Paris. In both instances, the field is embellished with an oval medallion surrounded by a border in the *hatayi* style. Walter Denny confirms that these rugs would have figured among the prototypes of the group.[86]

The second group is notable for its dense array of decorative motifs, creating a baroque effect, at least by comparison with the first group, and for its freshly invented motifs, such as the pennate leaf or *saz*, some-

56

57

THE CARPETS OF THE OTTOMAN COURT

The Ottoman Empire reached the summit of its power in the 16th and 17th centuries. Under the patronage of enlightened sultans, the Ottoman court entered into a prolonged period of great artistic flowering inspired by the Timurid and Safavid examples. In the *nakkashane*, or royal atelier, artists turned out illuminated manuscripts, superb book bindings, ceramic decorations, textiles, and carpet patterns. The *nakkashane* painters brought vigorous new life and invention to the rug weaver's art, which henceforth would burgeon with circular or oval medallions, surrounded by scrolling, leafy arabesques, lotus and peony palmettes, cloudbands, and *tchintamani* or 'Buddha's lips' motifs. The Ottoman court rug differs from other Anatolian carpets by virtue of its vocabulary, its colors, its technique, and the fineness of its execution.

57. Ottoman court carpet in the saz style. Egypt or Turkey, late 16th century. Wool pile on a silk foundation. Musée des Arts Décoratifs, Paris. This carpet, from a second group parallel to that represented by the work illustrated as fig. 82, is notable for its dense array of decorative motifs, creating, by comparison, a distinctly baroque effect. Among the freshly invented motifs are the saz or pennate leaf, accompanied by cloudbands and flowering prunus, and the 'four-flower' figures of the medallion and border, with their mixture of hyacinths, pinks, roses or peonies, and tulips, the last native to Anatolia. Whereas certain features of the weaving technique imply Egyptian manufacture, others, such as the silk foundation, red-dyed wefts, and knots in cotton could just as easily be interpreted as Turkish.

times accompanied by cloudbands and branches of flowering prunus. Usually the round or oval medallions occupy the center of the field, either alone or repeated as in a textile. The spandrel ornament formed like quarter sections of the central medallion, is a detail worth noting. The border and sometimes the medallion are decorated in the so-called 'four flower' style, which is a mixture of hyacinths, pinks, roses or peonies, and tulips, the last a flower native to Anatolia. Among the most delicate of these patterns are the round-medallion rugs at the Metropolitan Museum and the Musée des Arts Décoratifs. The latter, with its woollen pile on a silk foundation, is of a refinement to rival that of Persian carpets. The pennate leaf, treated in a light, feathery manner, is the distinguishing feature of the *saz* style, so named for the reed-pen drawings made in the mid-16th century by two émigré painters from Tabriz, Shah Quli and Wali Jan.[87] First used in the decorative arts – tiles, textiles, and rugs – about the same time, the saz style reached its apogee around 1570 and then declined in the course of the following century.

Ottoman Court Prayer Rugs

The court ateliers also produced superb prayer rugs. Together with burgeoning flora

and a horseshoe niche, the design of the piece owned by the Walters Art Gallery in Baltimore all but replicates the iconography of the *mihrab* in Bursa's Green Tomb. Other specimens make even more dramatic use of architectural imagery, including pairs of columns, numbering from one to three, complete with punctiliously drawn capitals, stylobates, and sometimes even domes. Among the most beautiful examples is one at the Metropolitan, a work notable for its tripartite niche. A prayer rug at the Textile Museum in Washington, D.C., is most unusual in that its design includes elements of Jewish iconography and an inscription in Hebrew. According to one theory, formulated by an Italian scholar, this piece could have served as a *Parikhet*, the curtain traditionally hung before the holy ark in European synagogues.[88] Whatever its actual purpose, the rug proves irrefutably that the atelier worked as well for a private clientele. The Ottoman prayer rug, which figures among the most beautiful of the Muslim types, served as a major source of inspiration for vast numbers of village weavers.

Despite its thoroughly Ottoman vocabulary, this group of carpets has long presented

problems of attribution, owing to a structure and a palette totally unrelated to the Turkish manner. Rather than two-strand symmetrical knots, the pile is made of asymmetrical knots composed of three or four yarns. The motifs are sometimes knotted with cotton. Moreover, the wool is spun in the opposite direction, S-spun, that is, instead of Z-spun. The palette, predominantly wine red, light blue, and intense yellow, is not often found in Anatolian carpets.

58. Ottoman prayer rug. Cairo, 16th century. Wool pile. Metropolitan Museum of Art (Ballard donation), New York. With its tripartite niche and its columns, this is one of the most beautiful of Ottoman prayer rugs, and the pattern served as a model for generations of village weavers.

59. Painting by an anonymous 19th-century Orientalist depicting a scene in the shop of a carpet merchant in Istanbul. The client is examining a Turkish prayer rug. Galerie Berko, Brussels.

59

Several 15th- and 16th-century sources mention the rugs of Bursa, a city situated in a region dedicated to sericulture. In this context, we should recall that carpet-weaving workshops had existed in Bursa, as well as in Istanbul, since the end of the 15th century. It is important as well not to forget that famous communiqué sent by Murad III to the governor of Cairo. In 1585 the Sultan requested that eleven master weavers be dispatched in all urgency to Istanbul, along with 100 kilograms of dyed wool.[92] Furthermore, a carpet presented to the Sultan Ahmet Mosque (1617) in the Ottoman capital still bears a contemporary label inscribed *Istanbul isi*, that is, 'made in Istanbul'.[93]

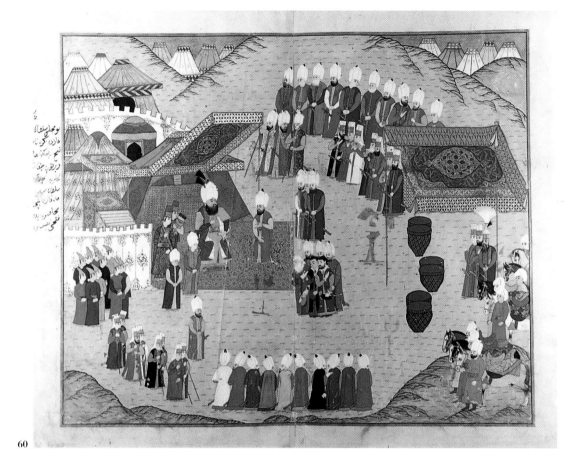

60

60. *Ottoman miniature. 1609. Topkapi Museum, Istanbul. Enthroned with a canopy overhead and a Ushak carpet under his feet, the Sultan Suleyman the Magnificent rather grandly accepts the surrender of Eger Castle in 1596.*

61. *Carpet with oval medallions. Ushak, 16th century. Wool pile, 16th century. Musée Historique des Tissus, Lyons. In addition to Holbeins and Lottos, Ushak produced rugs featuring oval or star medallions as well as prayer rugs. In the pattern seen here, oval medallions with fringed edges terminate in pendants filled with arabesques interlaced around four fleurons. On either side of the median line are staggered secondary polylobate medallions. The palette typical of Ushak is dominated by red and blue but extends as well to rose, pale blue, green, and the yellows.*

Cairo as a Place of Manufacture

At first attributed to all manner of disparate places, from North Africa to Damascus, the group was finally identified by Ernest Kühnel and Louisa Bellanger, who succeeded in demonstrating the technical affinity between these rugs and the geometrically patterned Mamluk carpets woven in the Cairo workshops discussed earlier.[89] Two pieces discovered in Florence's Palazzo Pitti appear to have resolved the enigma. One is decorated with Mamluk geometric motifs and the other with typically Ottoman floral imagery. Documents found in the palace archives prove that both carpets were made in Cairo.[90]

We should, nevertheless, note the colors of certain pieces, particularly one decorated with a cartouche medallion, owned by the Musée des Arts Décoratifs in Paris. The technique of the circular medallion rug already discussed, again in the Musée des Arts Décoratifs, exhibits several particularities, such as the silk foundation, red-dyed wefts, and knots in cotton, all of which would be more Turkish than Egyptian.[91]

CARPETS FROM THE USHAK REGION

Well established by the second half of the 16th century, the Ushak factory is one of the few whose evolution can be traced. Here, for more than four centuries, production has never ceased. Here too numerous dyers have long practiced their craft. At the heart of an easily accessible part of western Anatolia, Ushak is particularly well situated to serve the export trade. The products were shipped not only towards the capital, but also towards Europe and Asia, thanks to the port of Izmir (today Smyrna) on the west coast and the port of Anatalya to the south. In the 17th century, the production of the Ushak workshop surpassed that of all other centers, as we know from the quantity of rugs in the Yeni Djami mosque, inventoried in 1674 under the umbrella term 'Ushak'.[94] An imperial edict of 1726 required the city authorities to cease all deliveries in order to concentrate on those meant for the chamber housing the relics of the Prophet in Topkapi Palace, all of which proves that Ushak also worked for the court. For additional proof, we have only to consult Ottoman miniatures dating from the 16th century. Ushak retained its reputation right up to the 19th century, when it embraced production from weavers in neighboring villages, who worked by the piece from patterns furnished by merchants. This was the period when Europeans developed a taste for

THE USHAK WORKSHOP

In active production by the second half of the 16th century, the Ushak factory was particularly well situated to serve the export trade, what with the port of Izmir (Smyrna) to the west coast and the port of Anatalya to the south. In the 17th century, the production of this workshop surpassed that of all other centers. Ushak retained its reputation right up to the 19th century, when its carpets became known as 'Smyrna rugs' after the port through which they were exported. In addition to the Holbeins and Lottos attributable to it, Ushak wove carpets featuring oval or stellate medallions and prayer rugs. Although predominantly red and dark blue, the color range may include rose, pale blue, green, and the yellows.

'Smyrna rugs', so called for the port through which the 'Ushaks' were exported.

A Variety of Designs

In addition to the Holbeins and Lottos attributable to it, Ushak produced rugs featuring oval or star-shaped medallions as well as prayer rugs. Other forms of medallion are rarer, especially the polylobate and floral-lattice ones. Structure is typically Turkish, and colors are not numerous, on average no more than six to ten. Although predominantly red and dark blue, the color range does include rose, pale blue, green, and the yellows, as well as a blackish brown utilized, like ivory, for contours and occasionally as ground color. The beautiful colored fringes are obtained by soaking the warp ends in red, yellow, or, more rarely, green. This practice is common to the entire region.

Medallion Carpets

The large medallion rug, one of the handsomest designs ever to come from the Ushak looms, can reach vast dimensions, as in the example at the El Sabah collection in Kuwait, which is 7.23 meters long. Among the most

61

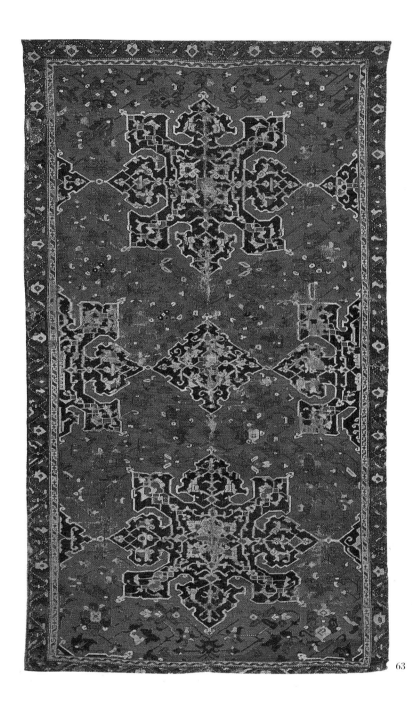

63

62. *Nicolas Tournier (1590-1639). The Concert. Early 17th century. Oil on canvas, 1.88 x 2.26 m. Louvre, Paris. A large-medallion Ushak is draped over the table.*

63. *A star Ushak carpet. Ushak, 16th century. Wool pile. Musée des Arts Décoratifs, Paris. In addition to the floral design and the colors typical of Ushak rugs, the star Ushak boasts eight-pointed medallions resembling snowflakes, linked together by lozenges and infinite knots, repeated across the field, through which a floral scroll threads its way. The origin of these motifs may lie in the Blue Mosque at Tabriz, erected in 1465, as well as in the book designs created during the reign of Mehmet Fatih.*

62

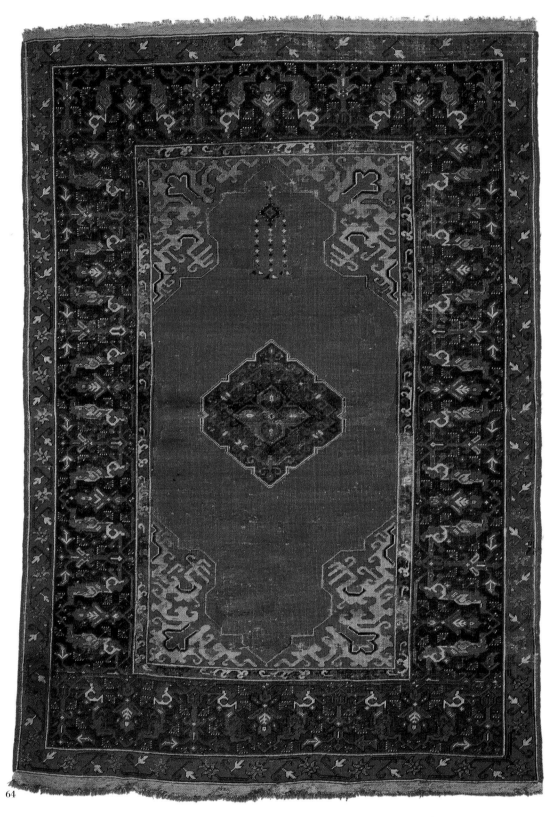

64

64. *'Tintoretto prayer rug' with a double niche. Ushak, 16th century. Former Emil Mirzakhanian collection. The double-niche prayer rugs woven in Ushak are sometimes called 'Tintorettos' for the 16th-century Venetian master who depicted the type in paintings. Characterisic of the double-niche group is the symmetry of the arches at either end of the field set off by a central lozenge and filigreed spandrels in the four corners.*

65. *Carpet 'with birds'. Selendi, 16th-17th century. Wool pile. Private collection, Paris. In this case, the all-over or continuous pattern comprises rows of rhomboids symmetrically organized about a rosette on a white ground. Whatever its inspiration, ornithological or floral, the bird carpet made its debut in European painting midway through the 16th century.*

remarkable pieces, it is worth citing those owned by the Thyssen Bornemisza collection in Lugano and by the Musée Historique des Tissus in Lyons. Here a pattern of oval medallions with fringed edges terminates in pendants filled with arabesques interlaced around four fleurons. On either side of the median line are staggered secondary medallions polylobed in shape. Their contours, overlapping like petals, are cut off by the border as in a textile repeat. A floral rinceau or scroll, embellished with splayed and veined oak leaves or more likely lotus leaves, flows across the whole field, encircling the large central medallion along the way. The field is occasionally stippled, and elements related to Kufic may appear in the border, as in the specimen at the Musée des Arts Décoratifs in Paris. Over the centuries, the format and the number of medallions decreased, no doubt in response to foreign demand. Simultaneously, the medallion lost its original form and became hexagonal or roughly rhomboidal in certain late pieces.

Despite the striking formal similarities between the large oval medallions and the décor of the famous Yeshil Türbe in Bursa, it was long assumed that the oldest cartoons went back no further than the second quarter of the 16th century. The reason for such an assumption was the absence of the Ushak carpet from European painting before that time. Now, research done by Julian Raby seems to confirm that, like the first cartoons for the Ottoman court rugs, those for the Ushak carpets were designed shortly after the opening of the first *nakkashane*, therefore by the same artists. There are, in fact, undeniable correspondences between the rugs with oval and star-shaped medallions and the architectural décor, bookbinding, and ceramics created during the second half of the 15th century.[95]

Star Ushaks

Because of its floral design and its colors, the carpet with star medallions is close to the pattern just discussed, even though, as a general rule, its format is smaller. Eight-pointed stars resembling snowflakes, linked together by

lozenges and infinite knots, repeat across the field, through which a floral scroll threads its way. Unlike the preceding group, the medallions along the lateral axes are identical to those on the median line. The star-medallion carpet is well represented in museums and private collections alike. The ultimate origin of these motifs may lie in the Blue Mosque at Tabriz, erected by the Turkoman Ak-Koyunlu dynasty in 1465, but also in the book designs created during the reign of Mehmet Fatih.[96]

Ushak Prayer Rugs

Ushak also produced magnificent prayer rugs. Their dominant color often a rich cerise, they divide into two groups, one composed of proper prayer rugs with a single niche, the other terminating in a double-niche. One of the features peculiar to prayer rugs is the continuous line around the field culminating at the top in a triangular niche often likened to a keyhole. Examples of this type, known as the 'Bellini' for Giovanni Bellini, the 15th-century Venetian painter who depicted such a rug in his portrait of Doge Loredan, can be found in Paris's Musée des Arts Décoratifs, among other collections. The second group is defined by its symmetrical niches decorated with cloud-bands or arabesques in a filigree pattern. The somewhat rococo contouring of the niches recalls the celebrated 'cloud collar' which originated in China. Double niches, sometimes called Tintorettos, again for a Venetian painter, have been preserved in several European and American museums, as well as in the Protestant church in the Romanian city of Brasov. Although some specialists believe these carpets were fabricated elsewhere in Anatolia, or even in Europe,[97] most authorities accept the attribution to the city of Ushak. The patterns were certainly created well before the rugs first appeared in European painting at the end of the 15th century.[98]

The Selendi Group

One group of rugs manufactured in the region, and at Selendi in particular, is singular by reason of its white ground and three types of design. While one model adheres to the *tchintamani* tradition, the two others are identified rather colloquially as 'with birds' and 'with crabs'. The overall or continuous pattern comprises rows of rhomboids symmetrically organized about a rosette. The best examples of the bird rugs, such as those in the Wher collection in Switzerland, and at the Metropolitan Museum (McMullan gift), include at least three rows of motifs. What-

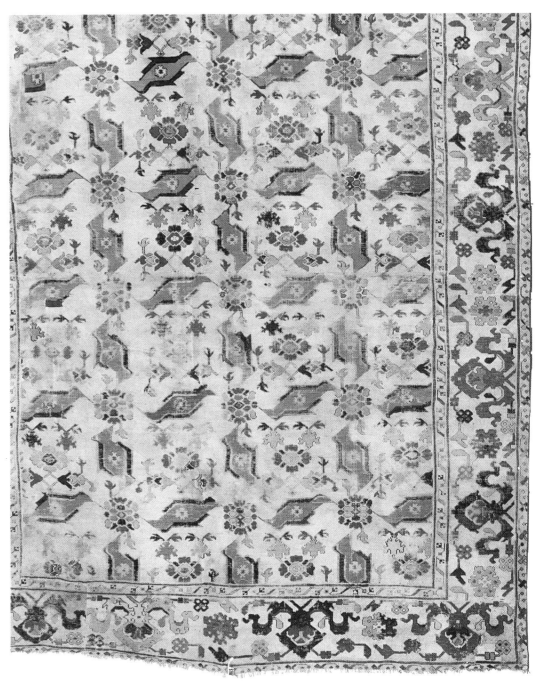

THE SELENDI CARPETS

These rugs are singular by virtue of a white ground and three types of design:
- *tchintamani*, a Chinese balls-and-stripe motif also known 'Buddha's lips'.
- 'with birds', which generally has at least three rows of motifs.
- 'with crabs', in which the stylized creature appears to be viewed from above.

The all-over or continuous pattern comprises rows of lozenges or rhomboids symmetrically organized about a medallion.

65

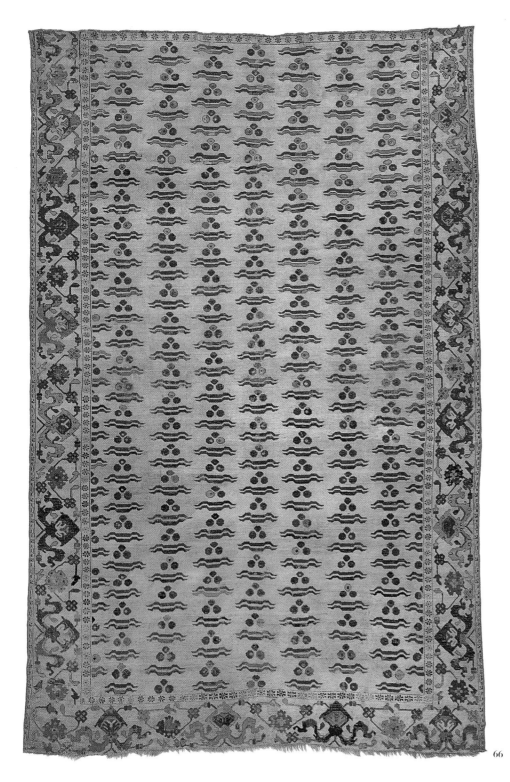

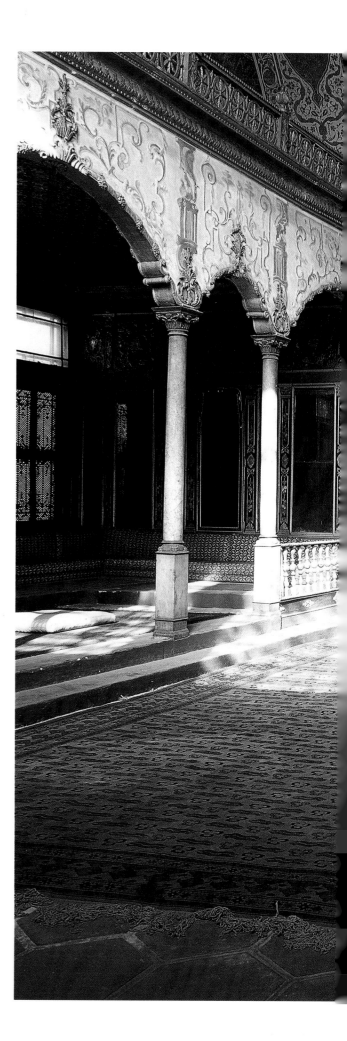

66

66. *Carpet with a tchintamani pattern. Selendi, 16th-17th century. Wool pile. Musée Jacquemart-André, Paris. This pattern represents one of three groups attributed to Selendi. Like the bird rug reproduced on page 91, the design is an all-over, continuous array of aligned motifs, in this instance the tchintamani figure, sometimes identified as the 'balls-and-stripe' or 'Buddha's lips' theme, usually set forth upon a white ground.*

67. *The audience hall at Topkapi Palace in Istanbul. On the floor lies a tchintamani rug woven in the modern era.*

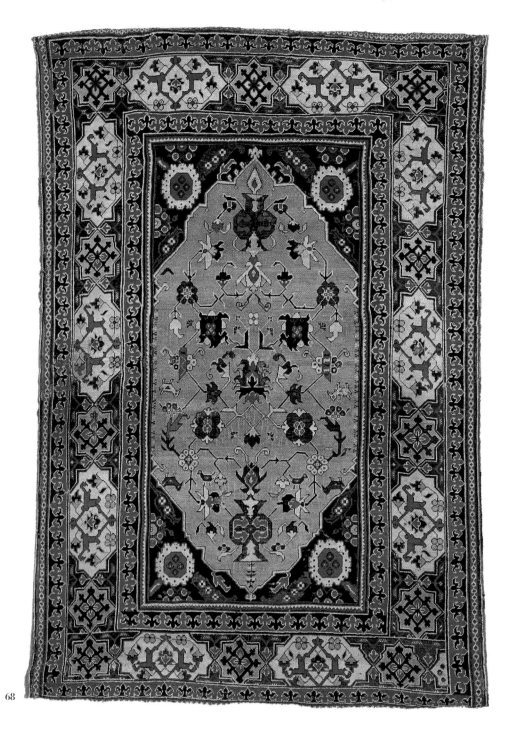

68

ever its inspiration, ornithological according to some, floral according to others, the bird carpet made its debut in European painting midway through the 16th century. The oldest of the *tchintamani* rugs have large formats, framed by a border of cloudbands, cartouches, or 'gothic' flowers. Beautiful examples can be found at the Textile Museum in Washington, D.C., and at the Museo Bardini in Florence. A price list from 1640, drawn up for rugs designed 'with crows on a white ground' and 'with a leopard skin', all woven in Selendi, makes it possible to attribute the group under present discussion to this city, located near Ushak.[99] Later pieces, which are copies made by countless village weavers, generally have smaller formats and often only one row of motifs. The origin of the rug 'with crabs' is more difficult to pin down. Its source may be a floral pattern. Certainly, it is the rarest of the three types. Two small-format examples, one in the Keir collection and the other at the Museum of Applied Arts in Budapest, are very likely the work of village artisans. Although white is the ground color for most of the rugs in this group, a few pieces within the family display other colors, as in the green-ground *tchintamini* carpet in the Musée Jacquemart-André in Paris.

Smyrna Rugs

Later patterns woven on the Ushak looms include a carpet with repeating rows of opulent palmettes disposed head to foot and framed by forked stems terminating in buds. European painters discovered it in the 17th century. Offshoots of the *hatayi* pattern, certain pieces bear a compositional relationship to other Ushak rugs, as in the example owned by the Musée Jacquemart-André. Woven in the back country and in such centers as Güre, this design would have a rather considerable progeny. Its nickname, 'Smyrna rug', arose from the many, rather crudely realized pieces exported to Europe through the port of Smyrna. The carpet also served as a model for the 'Turkey rug' woven as moquette, that is, fitted carpeting manufactured by European textile mills beginning in the 19th century.

68. *'Transylvanian carpet'. Western Anatolia, 17th century. Wool pile. Musée des Arts Décoratifs, Paris. Called 'Transylvanian' because of the great number of such carpets found in Romanian churches, this pattern adheres to the prayer-rug format, presenting a field with highly stylized double niches and vases sprouting angular arabesques and flowers, the whole framed by a wide cartouche border. The problem of provenance has not been resolved, specialists being divided between Anatolia and the Balkans.*

69. *The so-called 'Smyrna carpet'. Ushak, 17th-18th century. Wool pile. Musée Jacquemart-André, Paris. This pattern is marked by repeating rows of opulent palmettes disposed head to foot and framed by forked stems terminating in buds. The nickname Smyrna arose from the many, rather crudely made pieces exported to Europe through the port of Smyrna (today Izmir). The design served as a model for the 'Turkey rug' woven as moquette or strip carpeting by European textile mills in the 19th century.*

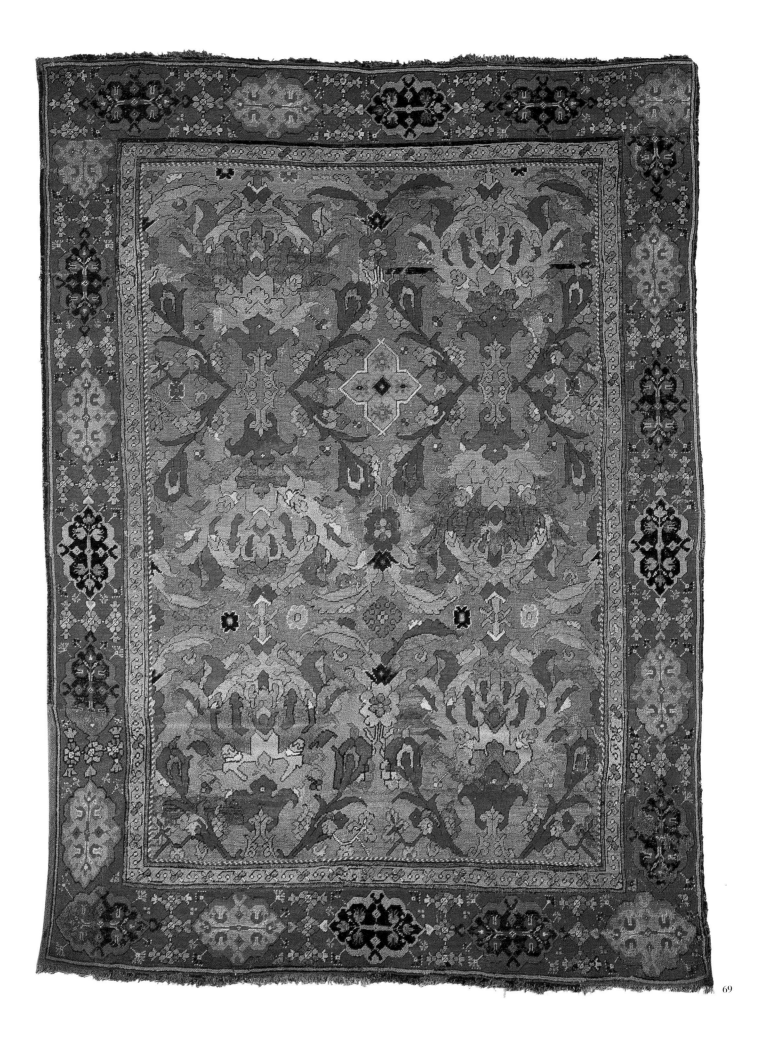

69

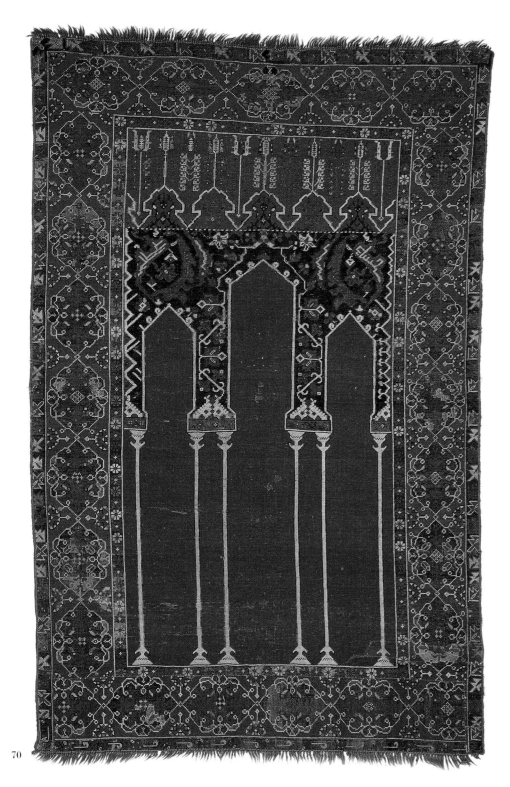

70

70. *'Transylvanian' prayer rug. Western Anatolia, c. 1700. Wool pile. Textile Museum (acquired by G.H. Myers in 1925), Washington, D.C. In addition to the double-niche pattern reproduced on page 94, the Transylvanian family includes a second principal design, this one featuring architectural motifs, mainly paired columns, capitals, and sometimes even stylobates. Archival evidence suggests that the prayer rugs with columns were woven at Kula and Bergama.*

71. *A Ghiordis 'Transylvanian' prayer rug. Ghiordis (western Anatolia), 18th century. Wool pile. Private collection, Paris. Ghiordis, which should not be confused with ancient Gordium, famous for the knot cut be Alexander the Great, wove this finely knotted piece, designed with columns supporting a central niche cut off at the corners. The border, inspired by Ottoman court models, is composed of palmettes and rosettes framed by curved saz leaves.*

The So-called 'Transylvanian Rugs'

Bergama, Ghiordis, Kula, Demirdji, and Kütahya are also important manufacturing centers in western Anatolia. Before examining their production, however, we should consider the so-called 'Transylvanians', rugs whose frequent presence in Romanian churches explains their name. For the most part prayer rugs, the Transylvanians found a place in many Dutch genre paintings executed in the 17th and 18th centuries.

They can be broken down into two principal groups, one of which comprises rugs framed in cartouche borders with fields displaying double niches and vases sprouting angular arabesques and flowers, while the other is made up of rugs featuring architectural motifs, mainly paired columns, capitals, and stylobates. There are several pieces, however, without columns. The group is well represented in museums and collections. There are some one hundred examples in the collection, the world's richest, owned by the Museum of the Decorative Arts in Budapest. Still, the problem of provenance has not been resolved, the specialists being divided between Anatolia and the Balkans, the latter a region which was under the Ottoman yoke for centuries. Based on the Ottoman prayer rug, these carpets, like so many others, were probably woven in several different places, as analyses of their structure bear out.

Kütahya, Bergama, and Kula

A few early documents confirm that prayer rugs were made in western Anatolian villages, mainly Kütahya, Bergama, and Kula. There is, for instance, the edict of 1610 addressed to the weavers of Kütahya, who were thereby enjoined from representing the *mihrab*, the *Kaaba*, or inscriptions on rugs meant for export and thus likely to be trod upon by infidel feet.[100] A list prepared in 1640 establishes prices for *direklü* carpets – carpets with 'columns' – made in Kula.[101] About the same time, a French traveler recorded having seen rugs 'with architectural columns and compartments like those of Bergama'.[102] The pieces referred to in these documents may

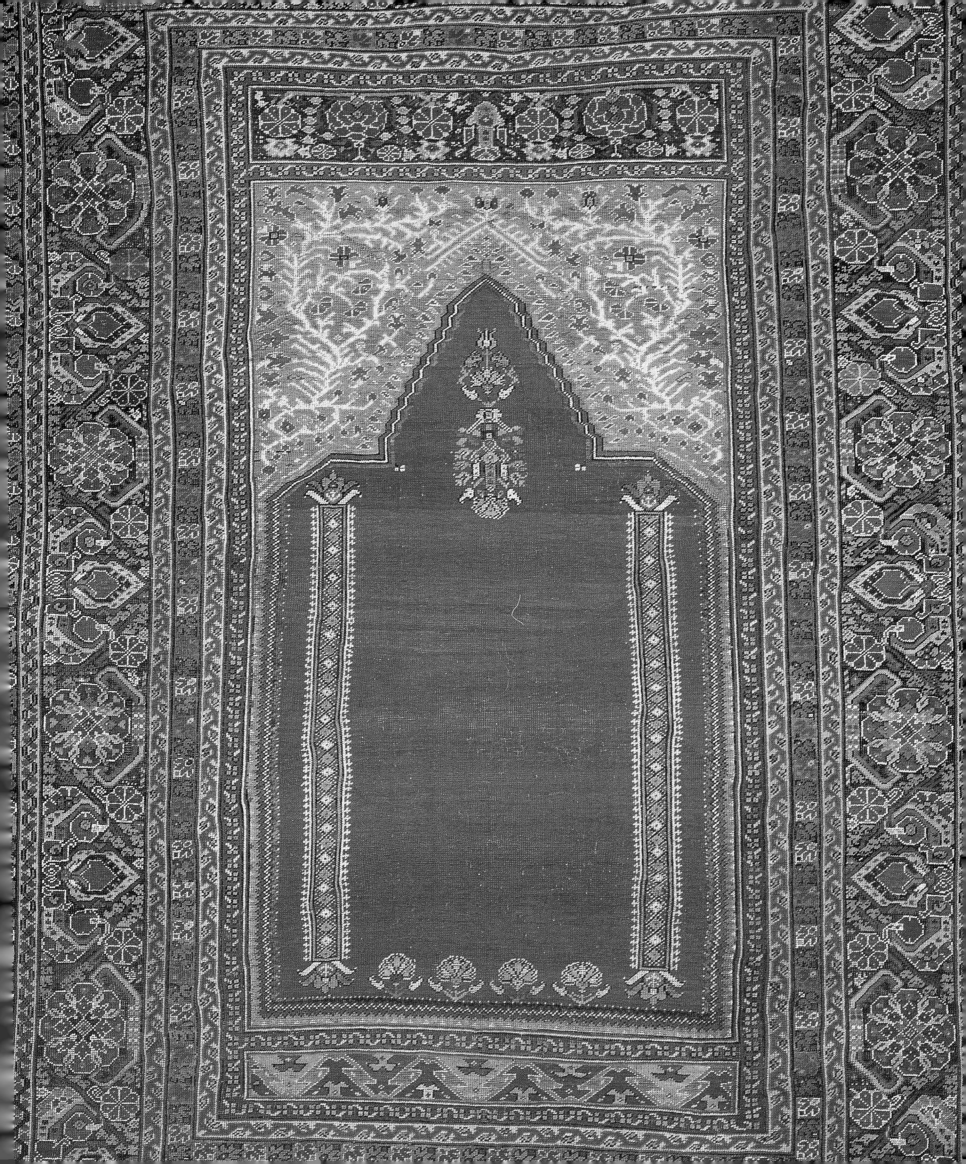

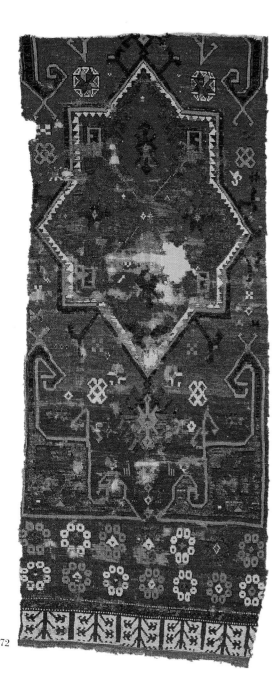

72

72. *Fragment of a village rug. Central Anatolia, 16th-17th century. Wool pile. Kirchheim collection, Stuttgart. This old village rug is interesting for its combination of stylized blossoms derived from Ottoman court designs and the archaic ornament in the spandrels, which link the piece to the animal patterns of early times.*

73. *Carpet with rectangles containing complex göl motifs. Konya, 17th-18th century. Wool pile; 1.84 x 1.31 m. Türk ve Islam Eserleri Müsezi, Istanbul. In this small village rug, the ancient Turko-Mongol repertoire is still alive. The carpets woven in or around Konya often present fields of golden yellow.*

very well have been Transylvanians. Indeed, the vocabulary used in the carpets, like the double-niche design and the vases sprouting arabesques, reappears regularly in rugs woven in the region at a later date.

Judging by the eye-witness account of the traveler Evliya Çelebi, who noted that merchants displayed Kula carpets during a parade of corporations before Murad IV in 1633, we can assume that Kula turned out a considerable number of rugs.[103] Yet, apart from the prayer rugs, greatly admired by 19th-century connoisseurs, we know nothing of the carpets produced in Kula, or Koloï as it was then called.

Ghiordis Rugs

A prayer rug decorated in the architectural style was also woven in the city of Ghiordis, a name known to history for the 'Ghordian' knot cut by Alexander. We should remember, however, that the ruins of Gordium, the capital of ancient Phrygia, are located near Ankara, far from rug-weaving Ghiordis. A finely knotted piece, the Ghiordis rug presents an image of columns supporting a central niche cut off at the corners. It is further characterized by a border composed of palmettes and rosettes framed by curved *saz* leaves. The white motifs are usually knotted in cotton.

THE KONYA REGION

Among the important rug-weaving centers in Anatolia were the city of Konya and neighboring towns, notably Aksaray, Karaman, Kayseri, Karapinar, and Ladik. As elsewhere, the old repertoire was perpetuated in new production, in carpets decorated with medallions of various forms sometimes framed by compartments, or by repeating *göl* and other small geometric motifs, echoes of the Turko-Mongol past. While golden yellow was often the preferred color for the field, shades of mauve and apricot also enjoyed great favor among the region's weavers.

A fragment of a star medallion rug in the Kirchheim collection engages our attention not only for its stylized flowers derived from the Ottoman court rug, but also for its archaic-looking spandrels, the latter a link with the animal carpets of old. Also worth noting, along the lower edge, is the supplementary frieze embellished with a row of pennant-like motifs, its counterpart at the opposite end having disappeared. This frieze is a frequent presence at the extremities of carpets woven throughout the region. Among other patterns common to central Anatolia, we should cite the niche or double-niche pieces, some of them reminiscent of the Transylvanian family, and the carpets enlivened with 'Ottoman flora': palmettes, hyacinths, and tulips.

Ladik

Despite their former renown, the carpets made in Aksaray and Karaman, other than the kilims and the 'keyhole' works already mentioned, remain undiscovered. The weavers of Ladik, near Konya, once made a type of prayer rug fully as prized as the Ghiordis. Ornamented with a crenellated frieze sprouting tulips placed above or below

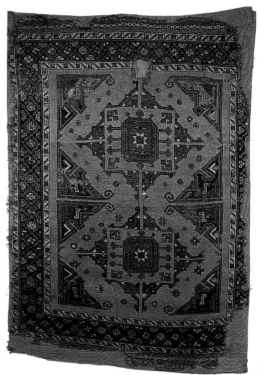

73

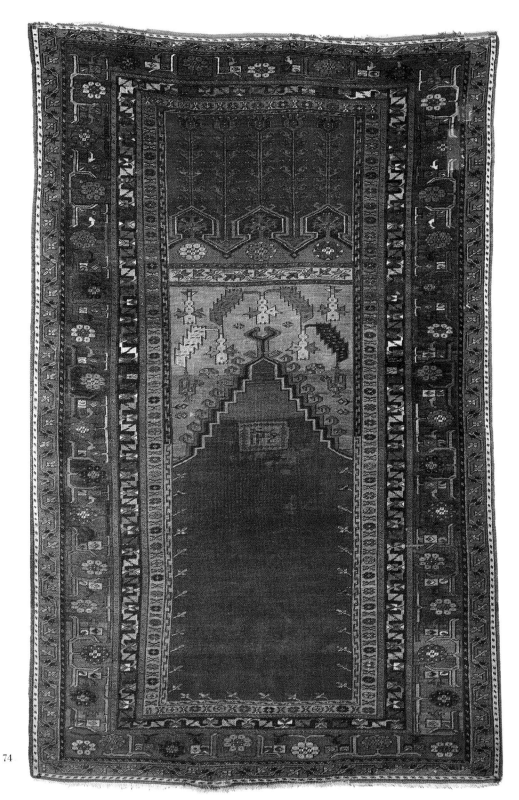

the *mihrab*, the carpet is sometimes surrounded by a border of stylized lilies. Today the rugs from this village are known to be mainly those which are without columns, featuring shades of mauve and apricot. During the 1960s, at the time of research conducted in Ladik, local weavers confirmed that they had used this pattern.[104] The date is sometimes woven into the design, particularly towards the end of the 18th century, as in the case of the carpet owned by the Fogg Museum in Cambridge, Mass., dated AH 1209 (AD 1794).

Karapinar

The carpets made at Karapinar, once confused with those from Ushak, have only recently become known. Now several designs are attributed to this center, located in the Karaman region, which had a taste for shades of pure red, brownish violet, and apricot as well as a white of unusual purity, utilized especially for contours. Based on an Ottoman court rug, the example in Amsterdam's Rijksmuseum displays a medallion supple-

74

74. *Niche prayer rug ornamented with a crenellated frieze. Ladik, 1794. Wool pile. Fogg Museum, Cambridge, Mass. On the Ladik prayer rugs, which were once as prized as those of Ghiordis, the date is sometimes woven into the design, as here: AH 1209 (AD 1794).*

75. *Carpet with a central medallion and pendants. Karapinar, 17th-18th century. Wool pile. Rijksmuseum, Amsterdam. Once confused with Ushaks, the rugs woven at Karapinar, in the Karaman region, reveal a taste for shades of pure red, brownish violet, and apricot, in addition to pure white used for contouring.*

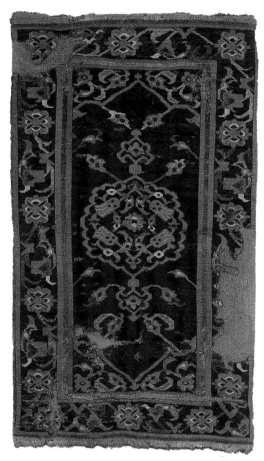

75

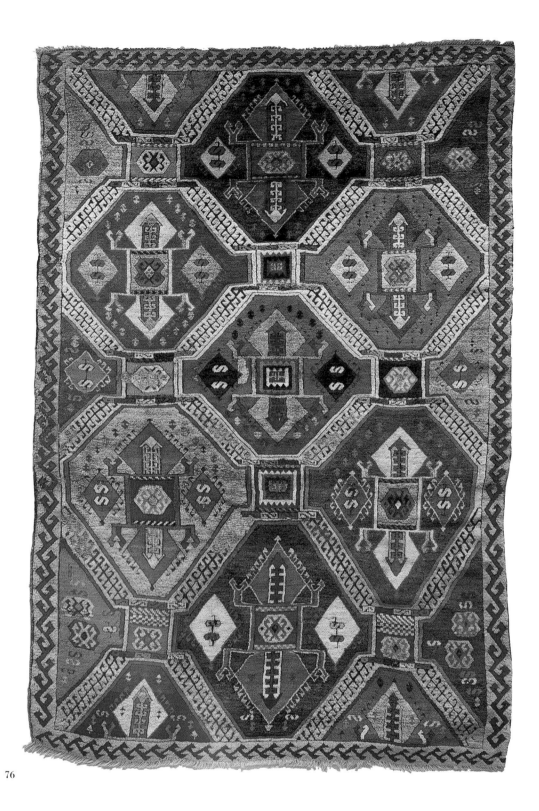

76

76. *Carpet woven by a Yürük tribe. Sarkisla (eastern Anatolia), late 18th century. Wool pile. Saint Louis Art Museum (Ballard gift). With their dark palette of purplish brown, brown, and brownish red, the rugs woven by the Yürük evoke the old Turkoman repertoire. Here it takes the form of hexagonal medallions filled with totemic motifs in staggered rows.*

77. *Village rug with a double niche. Eastern Anatolia, 16th-17th century. Wool pile. Private collection, Paris. The double niche reflects the influence of urban workshops on the village weavers, who, in this instance, revealed their own heritage in the wealth of enigmatic emblems and tamgha, as well as in a wide, richly elaborated border whose pattern changes midway.*

mented with pendants and spandrels. On the other hand, a carpet in the Türk ve Islam Eserleri Müzesi, decorated with repeating medallions and a cartouche border, seems closer to Ushak production. Research done on the spot during the 1970s made it possible to restore the links between the old pieces represented in 17th-century painting and those of recent production.[105] A prayer rug with multiple niches, fitted one into the other, figures among other patterns associated with this center.

EASTERN ANATOLIA

A region populated by nomadic tribes, primarily Kurds and Yürük, eastern Anatolia stretches from Sarkisla to Kars in the north and Mardin in the south. It embraces the cities of Sivas, Divrigi, Erzurum, and Dagizman. In the north, the territory around Erzurum and Lake Van is inhabited by Armenians who, in great numbers, took refuge in the Caucasus at the end of the 19th century, to escape Turkish persecution. The Yürük and especially the Kurds lead nomadic lives throughout the southern part.

A Little-explored Field

The woven products of eastern Anatolia, compared with those of the western and central regions, remain a relatively unexploited field of research. In recent times the weavers of Sivas have limited themselves to pastiches of old court models, mainly Persian, and little is known about the city's earlier production, even though it was famous. There must have been a factory in Erzurum, since the town was known to be a weaving center from the 13th century to the 15th. Moreover, two pieces, with central medallions accompanied by pendants and based on Persian work, have been discovered in mosques of the region.[106] This is a theory, however, without consensus among interested scholars. Rugs made by the Kurds, who nomadize across a territory extending from Turkey to Iraq and Iran, exhibit certain peculiarities of technique and palette that help identify them.

With their bent towards dark colors within a range of purplish brown, brown, and brownish red, the carpets woven by the Yürük and the Kurds evoke the old Turkoman repertoire. A piece in the Saint Louis Art Museum (Ballard gift), ornamented with hexagonal medallions filled with totemic motifs in staggered rows, is representative of a group attributed to Sarkisla. Occasionally these rugs betray a certain influence from urban ateliers, although the phenomenon is admittedly less common than in the western part of the country. Other models recall Caucasian rugs, notably those of the Kazakh tribes. Finally, it is worth noting that the Armenian identity of the weaver is often disclosed by an inscription in Armenian characters.

A CHANGE IN PRODUCTION METHODS

Beginning with the Age of Enlightenment, the Sublime Port gradually opened its doors to Europe. Thereafter, throughout the 19th century, the Ottoman Empire saw its power slowly but inexorably drain away. Europeans seized on the occasion to take charge of the country, flooding the bazaars with cheap textiles and aniline dyes, while establishing companies designed to control the production of village weavers.

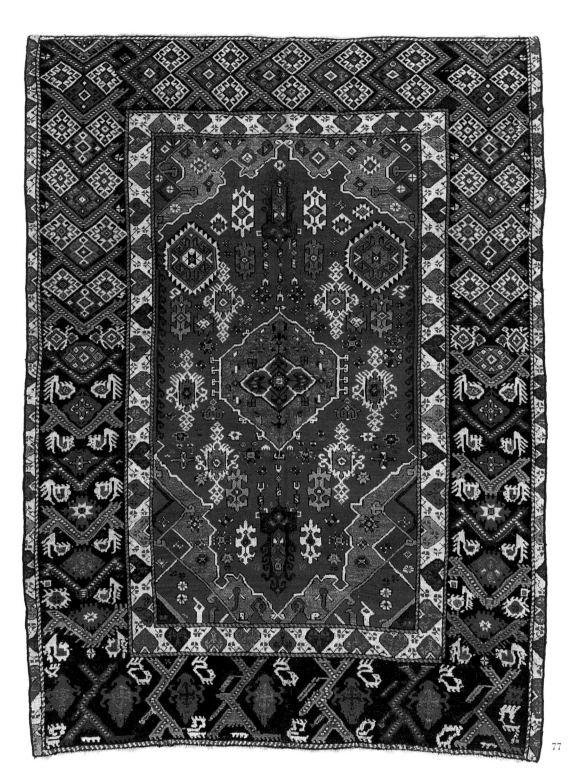

77

THE EUROPEAN INCURSION

Throughout the 19th century, the Ottoman Empire saw its power slowly but inexorably drain away. Europeans seized on the occasion to take charge of the country, flooding the bazaars with cheap textiles and aniline dyes. So great was this social and political upheaval that it even affected the court, where the taste for European styles gained a strong foothold. The new Turkish carpets, with their naturalistic foliage and flowers, reflected the influence of Aubusson.

The European Influence

So great was this social and political upheaval that it even affected the ways of the court, where the taste for European styles became prevalent. This was especially true during the reign of Abdül Mecit I (1839-1861), whence came the term *medjedieh*. The Sultan abandoned the ancient Topkapi Palace in Istanbul for Dolmabahçe, a palace in the Baroque manner he had erected on the very edge of the

Bosphorus. The carpets, with their more naturally drawn foliage and flowers, particularly full-blooming roses, reveal the influence of Aubusson. Sometimes even the border is omitted. Although clearly reflected in rugs woven at Ghiordis, Melas, and Hereke, the impact of the *medjedieh* style, which would last until the end of the century, was less felt on carpets than on other genres of Turkish art.

We have already noted that beginning with the mid-19th century, European companies

dominated the carpet trade, especially in western Anatolia. They afforded women of modest means the chance to put together enough money to purchase the necessary materials. A certain standard of quality was maintained but at the expense of innovation, since the company frequently supplied the pattern as well as the materials. Around 1850, following a journey to Ushak and Ghiordis with his compatriot rug manufacturers, the German Consul in Smyrna, Herr Spiegelthal, reported that the inhabitants of these cities all worked for the tradesmen of Smyrna. Eight or nine agents were in charge of supervising production, which used the wool of sheep or goats. Other than a repertoire of four or five simple patterns inherited from previous generations, woven after existing carpets, the Anatolian weavers worked with cartoons sent from Smyrna, sometimes directly from Europe.[107] Production leaned towards pieces of limited format, and knotting density tended to diminish.

The Hereke Workshop

During the reign of Sultan Abdül Mecit, the Imperial Silk Manufactory was created at Hereke, some forty kilometers from Istanbul. It counted among the most prestigious of the new textile workshops. According to a self-promoting brochure, the enterprise was set up in 1843 by Ohannes and Boghos Dadyan, two Armenian brothers in the service of the Sul-

tan, for the purpose of supplying velvet and silk textiles to the Ottoman court. Yet, according to a journalist writing for the London *Times*, who visited Hereke in 1848, the workshop was in fact founded by the Grand Vizier Riza Pasha some twenty years earlier. As for rug weaving, it appears to have been introduced after the silk textile function got under way. A booklet prepared by a former director states that the factory was 'the extension of the ateliers of Istanbul'.[108] Nevertheless, the style of the first rugs produced on the Hereke looms remains a mystery. Curiously, the Turkish government seems never to have shown any of the Hereke pieces at the great industrial and international expositions regularly held in Europe, even though it was proud to exhibit its silk textiles.

For the want of basic material, few rugs could have been woven from silk during the third quarter of the 19th century. The silk textile industry had been seriously undermined by pebrine, a silkworm disease, and it did not revive until after Louis Pasteur had advised on how to eliminate the scourge.[109] Thereafter, production increased ten fold over the next twenty years, from 1890 to 1910. The Hereke factory turned out many rugs made in silk as well as others made from wool, some of them carved in relief. Featuring floral motifs and scrolling arabesques ornamented with lotus mingled with cloudbands or hunting scenes, the patterns mimicked the art of the Safavid and Ottoman courts. To create

their models, designers utilized an album of photographs and, very likely, the first publications on Oriental rugs illustrated in color, among them a book by Julius Lessing, which appeared in 1887, and the catalogue of the Vienna exposition of 1892. Brocaded with metal thread, the rugs are woven mostly in brilliant colors though sometimes in pastels, the latter reflecting the influence of French Art Nouveau. The asymmetrical knot, probably introduced at this time by weavers from Kerman, was employed as well as the symmetrical knot.[110] The Hereke carpets often carry a signature, in the form of an octagonal or polylobate mark enclosing Arabic characters or Roman letters, these after 1928, when Atatürk ordered their use. One of the oldest known pieces attributed to the Hereke ateliers is fashioned of silk. In the *medjedieh* style, it is decorated with an image of the Mildiz pavilion erected for the visit of Kaiser Wilhelm II in 1898. The factory, which still exists, is capable of weaving rugs fine enough to rival those made in Iran.

The technical quality of the Hereke production was so perfect that it can fool even the experts. For quite a long time an ensemble of Safavid carpets was incorrectly attributed to this workshop. Erdmann was the first to state that several Safavid rugs, including the famous 'Salting' piece in the Victoria and Albert Museum, as well as a group of prayer rugs at Topkapi Palace, were in fact Turkish copies. Meanwhile, recent analysis of the dyes in a so-called 'Salting' prayer rug in the Topkapi collections revealed the presence of chemical compounds unknown to Turkish dyers, thereby disproving the hypothesis of the German scholar and re-establishing the work's Persian provenance.[111]

A New Style

Aesthetically, a remarkable number of rugs remain untouched by European influence. At Bergama, heir to Pergamon, the ancient Greek colony, and in the surrounding region, carpets continue to be woven in the medallion and architectural styles or in the Transylvanian double-niche manner. Outside Bergama, the villages of Ezine and Çanakkale produce

THE HEREKE WORKSHOP

It was at Hereke, about forty kilometers from Istanbul, that the Imperial Silk Manufactury was created in the early 19th century. Some confusion surrounds the exact origin of this prestigious enterprise and the precise date of its founding. In the beginning, the workshop supplied velvet and silk textiles to the court of Sultan Abdül Mecit. Only later did Hereke engage in rug weaving, although production increased rapidly, turning out rugs woven

from silk as well as wool and sometimes brocaded in metal thread.

For the most part, the patterns mimicked the art of the Safavid and Ottoman courts, complete with floral motifs and scrolling arabesques ornamented with lotus, cloudbands, or hunting scenes. The technical quality of the Hereke production was, and remains, fine enough to rival the best carpets woven in Iran.

THE KULA WORKSHOP

By the 19th century, Kula, had come to specialize in bedside and prayer rugs. Its weavers also made the *Kula mezarlik* or 'cemetery rug', so known for the small ediculae and cypress motifs which many thought made the pieces suitable for funerary services. Now the themes appear to have been inspired by a kind of European landscape painting that gained popularity among the Ottomans in the 18th century.

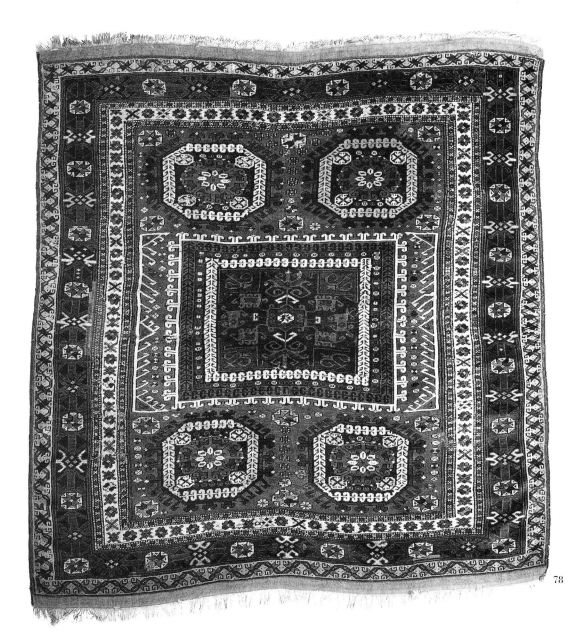

78

rugs with compartments enclosing octagonal, rectangular, or cruciform medallions, and even with quincunxial patterns or large fleurons. For the most part, their formats are relatively small, and their palettes dominated by reds and blues, together with a rather high proportion of motifs picked out in white. Ayvadjik, Demirdji, and Yagcibedir, worthy inheritors of the Transylvanian repertoire, are known for a variation of the double-niche carpet in dark hues.

Compared to the models of the previous century, the Ghiordis prayer rug evolved to become somewhat more geometric. The palette is predominantly cerise. The technique used to make it also underwent modification, with the increased use of cotton warps. The border either shows sprigs of flowers (erroneously called *elmali* meaning 'with apples') or red and white stripes embellished with flowers (termed *tchobokli* or 'with reeds'), a pattern borrowed from contemporary textiles. Ghiordis also produces *medjedieh* prayer rugs, the style asserting itself in the relative naturalism of the floral imagery and the absence of borders. As for the double niche 'Kis-Ghiordis' rug, said to be woven by young women for their dowry, there is little in the technique, it seems, to support an attribution to this city.[112] The Ghiordis prayer rug, however, which was already prized by the first connoisseurs, has been imitated all over the map, in Turkey but also in Tabriz, in Greece, elsewhere in the Balkans, and even in Italy.

The Kula Production

By this time, the Kula production was limited essentially to bedside and prayer rugs. Like the Ghiordis carpets, Kula pieces are well represented in public and private collections. The best-known pattern consists of a triangular niche and columns that have evolved into bands attached to the upper part of the niche but detached from the base. Kula's weavers also make a special type of prayer rug known as a *Kula mezarlik* or 'cemetery rug'. Its pattern of small ediculae and cypress trees was long thought to represent a cemetery, signifying a rug meant to accompany the dead to his or her resting place. Now these motifs seem closer to the kind of European mural painting, mostly landscapes, which became popular among the Ottomans beginning in the 18th

78. Medallion carpet. Bergama region, 19th century. Wool pile. Textile Museum (acquired by G.H. Myers), Washington, D.C. The villages of Ezine and Çanakkale near Bergama still produce rugs like the one here, with compartments enclosing octagonal, rectangular, or cruciform medallions. Formats are relatively small and the palette dominated by reds, blues, and white, the last used to highlight motifs.

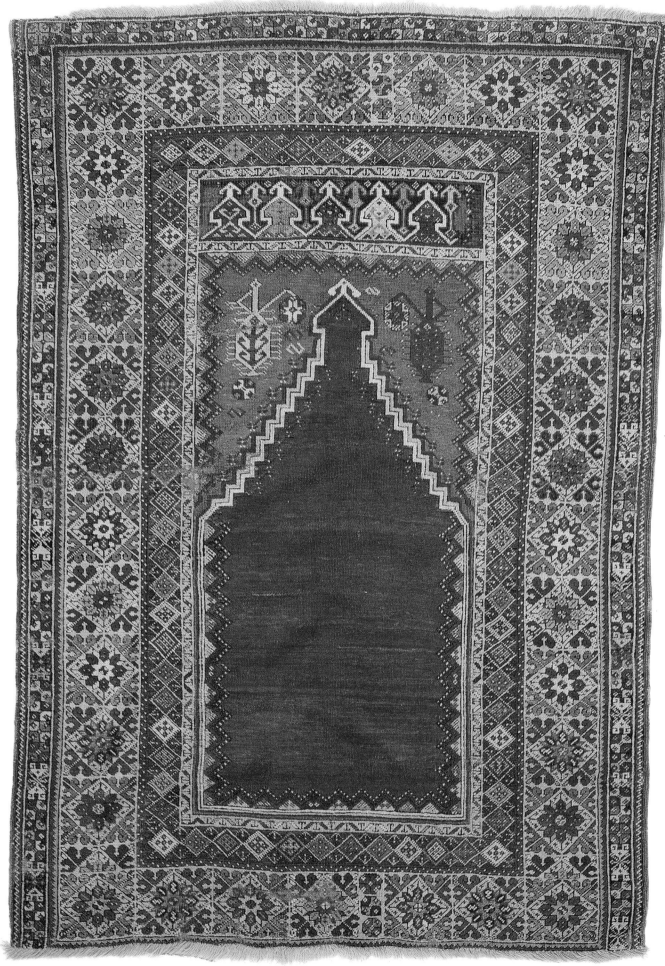

century. The style of these rugs has been called *medjedieh*, this hypothesis supported by the colors, predominantly yellow, blue, and beige in sober shades.[113]

Greeks, who in the 19th century constituted a third of the population of Kula, played an important role in developing the town's rug industry. Attesting to their activity in this domain is a carpet woven in 1868 for an Orthodox wedding and inscribed with what was probably the name of the family. Two other patterns recalling certain Caucasian rugs were no doubt imported in the 19th century during a wave of Armenian immigration. Similar pieces were woven in the neighboring city of Demirdji.

Melas and Magri

Moving farther down the Aegean coast, we arrive at Melas and Magri, cities that once produced beautiful prayer rugs. At Melas, the ancient Greek colony of Mylassa, the weavers specialize in a particular form of *mihrab*, a niche whose original curvilinear silhouette has been translated into a pair of confronted triangles on which rests the apex of the niche, it, too, geometric in form. Another pattern associated with Melas and Magri presents a field divided into stripes decorated with motifs reminiscent of certain borders. The colors range through red, deep yellow, and a special shade of mauve.

In addition to Ladik, the villages of Kirshehir and Mudjur are also renowned for their prayer rugs. A carpet made in Kirshehir

is recognizable by its border and its brilliant shades of pistachio green and magenta red, while its pendant made at Mudjur is surrounded by a border decorated with a succession of squares filled with rectangles framing leaf motifs.

Qum Qapur

From the late 19th century several new urban workshops established by Armenians sprang up in the Qum Qapur quarter of Istanbul. With their symmetrically knotted silk pile and metallic brocading, the products of these ateliers approach those of Hereke. The Qum Qapur artists also design patterns very much in the manner of the old Savafid and Ottoman models, or even that of Moghul India. As we saw in regard to the cartoon designers at Hereke, the repertoire of models available to designers expanded enormously after 1887, when the first books came out with illustrations of carpets in color. The Qum Qapur vocabulary includes medallions and animal combats on a floral ground, in the Persian or Ottoman tradition, as well as numerous prayer or 'horseshoe' rugs ornamented with cartouches and calligraphy, not to mention an original tripartite niche pattern, an example of which is owned by the Vakiflar Museum in Istanbul. The palette is high-keyed or even soft in muted or pastel shades. Finally, let us not forget that confusion reigns between the Qum Qapur carpets and the models which inspired them just as it does in the case of the Salting and Hereke groups.[114]

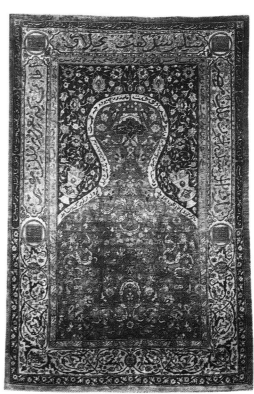

80

Designs Signed by Artists

Unlike the situation with regard to ancient pieces, we know the names of some master weavers and cartoon designers associated with Qum Qapur. Hagop Kapujkian, a native of Kayseri, appears to have been the first to mount an atelier in this quarter of Istanbul. It is still hazardous to make definitive attributions to him, given that he signed his works only occasionally. On the other hand, Zareh Penyamin (1890-1949), who also had his own workshop, signed his creations much more

freely. Zareh began his career at Hereke, since a piece exists with his signature as well as the mark of the atelier.[115] Penyamin, the author of many designs, created a series of prayer rugs known as 'Sultan's head', based on a collection of horseshoe-niche rugs at Topkapi Palace. He closed the last of his Turkish workshops, at Chepa, Takeja, and Pazzar Tekessa, in 1938, before moving to Paris. The activities of these artist-weavers gave rise to what it has become convenient to call the School of Istanbul. Among the worthy heirs of Hagop and Zareh, the school includes Garabed Apelian, Avedis Tamishjan, and Mehmet Ocevik, all names to be remembered.

Continuance of Craftsmanship

Although the craft of hand weaving has virtually disappeared in the West, it remains alive and well in Anatolia. One can only hope that this activity, once assured ongoing government support, will allow weavers to continue making carpets of genuine quality. One would also wish that their efforts be directed towards innovation, in order to avoid the trap of sterile repetition of older styles.

79. *Prayer rug with a border of square and leaf motifs. Mudjur (central Anatolia), 19th century. Wool pile. St. Louis Art Museum (Ballard gift). The color scheme and the wide border with a succession of squares containing leaf motifs are typical of this provenance.*

80. *Zareh Penyamin. Prayer rug with a 'Sultan's head' horseshoe niche. Qum Qapur, c. 1935. Private collection, London. Penyamin, a rug designer who signed his works 'Zareh', worked in the Armenian quarter of Istanbul known as Qum Qapur. Among his many original patterns is the 'Sultan's head' series, based on a collection of horseshoe-niche rugs at Topkapi Palace.*

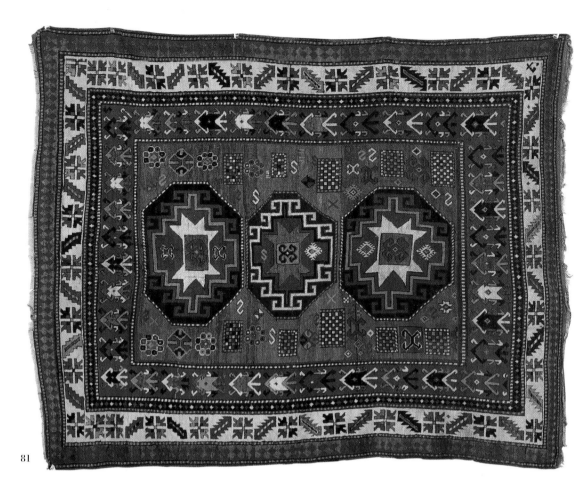

81

81.*Marriage carpet woven by the Salor tribe in western Turkestan. Early 19th century. Sotheby's sale, New York, 13 April 1995. Note the relationship between the tribal emblem or göl and the small-pattern Holbein carpet. Few such weavings made prior to the 14th century can be securely dated, yet the forms they share with old Anatolian carpets, such as medallions, presented singly or aligned in rows, or the range of colors, suggest parallel developments springing from a common source.*

82. *Detail of a Caucasian rug woven by the Kazakh tribe and dated AH 1319 (AD 1902). The Anatolian descendants of the large-pattern Holbein carpets which display this type of medallion were once attributed to the Bergama region. Today it is generally agreed that they were made throughout Anatolia and that their patterns date back to the origins of Turko-Mongol weaving.*

83. *Prayer rug. Bergama, 19th century. Nagel sale, Stuttgart, June 23 1993.*

HOW TO IDENTIFY
A TURKISH CARPET

It is important to bear in mind that in determining the origin of a carpet, the technique and colors used to make the piece are factors altogether as relevant as the motifs. A general rule frequently given to beginners holds that Turkish carpets present geometric motifs whereas Persian carpets feature floral motifs. A more precise formula, though still too broad, would distinguish floral models complicated enough to require the supervision of a master weaver in the royal or urban workshops from the tribal rugs with geometric motifs which entail less elaborate weaving procedures. But this second approach also leaves something to be desired. It contrasts two extremely different types of execution and ignores the production of sedentary villagers who weave most of the carpets.

What are they?
– the materials
– the way the warp and weft are structured
– the method used to finish the piece, its selvedges and fringes
– and, of course, the type of knot used
In Turkish carpets, the warp is usually made of two strands of wool or goat hair spun together. The number of shoots of weft per row of knots rarely exceeds two, and the weft yarn is wool frequently dyed red.

Cotton is seldom used for the foundation in old rugs. On the other hand, it is frequently the material chosen by 20th-century weavers.

Most Turkish weavers employ the symmetrical knot, also known as the Turkish knot or the Ghiordis knot.

In period pieces, the density of the knotting may be as great as 1,000 to 2,500 knots to the square decimeter for woollen rugs, and from 2,500 to 6,000 knots for carpets woven of silk for the Ottoman court. Contemporary rugs are much less densely woven, their knot count rarely exceeding 1,000 per square decimeter.

The selvedges are generally woven on the last three or four lateral warps as the piece progresses, the warps bunched together in groups of two or three. The result is called the 'selvedge cord'. Knotted-pile carpets woven in western Anatolia frequently have staggered wefts, known as 'lazy lines', and the warp ends may be dyed to form a beautiful colored fringe.

In Turkish prayer rugs, which figure large in Turkish production, the yarn used in the weft behind the niche area may be in a different color, coordinated with the pile.

Motifs

A shared tribal heritage means that many motifs which are common in Turkish rugs are also found in rugs from other areas, particularly those of Turkmenistan and the Caucasus, but also Iran. Often derived from the Central Asian tribal emblem, or *göl*, medal-

lions of all shapes and sizes, arranged as a central ornament or in rows, staggered or aligned, are virtually ubiquitous in Turkish tribal and village rugs.

Inspired by the example set by the Timurid and Safavid courts, Turkish artists introduced floral and Chinese motifs into ceramic tilework and textiles, beginning in the 15th century, and then adapted them to carpet patterns. The new designs included elegantly drawn prayer rugs, decorated with architectural motifs taken from the prayer niche in the mosque, which served as models for generations of village weavers all over Anatolia.

Borders may often be a better indication of origin than field designs, since weavers tend to remain faithful to a certain repertoire while trying out a new field pattern.

The symbolic interpretations given to a wide variety of motifs in much of the early carpet literature should be approached with caution. These motifs are often interpreted in the light of Eurocentric cultural tradition rather than the tribal and Islamic heritage to which Oriental weavers predominantly belong.

The Colors

Turkish weavers traditionally use a smaller range of colors than their Persian counterparts, achieving a range of remarkably harmonious designs with eight or nine colors. Primary colors tend to dominate, particularly blue and madder red. Roughly speaking, rugs made in western Anatolia are dominated by shades or red, yellow, and blue, with proportionately larger quantities

of white in those from nothwestern Anatolia. Weavers in central Anatolia are partial to yellow, orange, and purple, while those in the east tend to prefer a darker palette, with more brown and subdued shades of red and blue.

Dating

Dates are occasionally woven in, using the Islamic lunar calendar read from right to left. Before 1928, the year in which Kemal Atatürk, the 'father' of modern Turkey, imposed the solar calendar and the roman alphabet (including Arabic numerals written in the European style), Turkish weavers wove Arabic numerals in the traditional Turkish manner.

Finally, it is important to reiterate that copying and reinterpreting existing works of art is as ancient as the Romans and that design alone is an inadequate criterion for judging provenance. There are few hard and fast rules, and the foregoing should be regarded as no more than general guidelines.

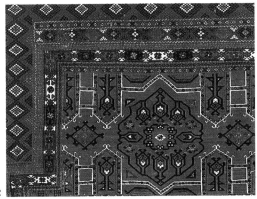

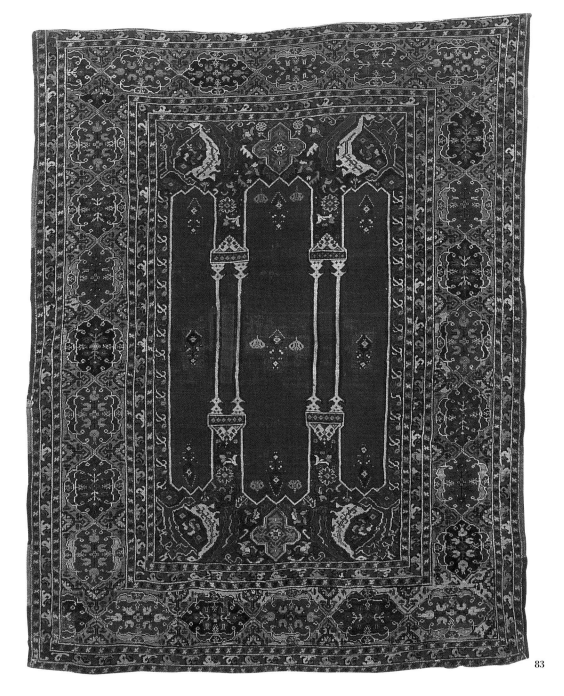

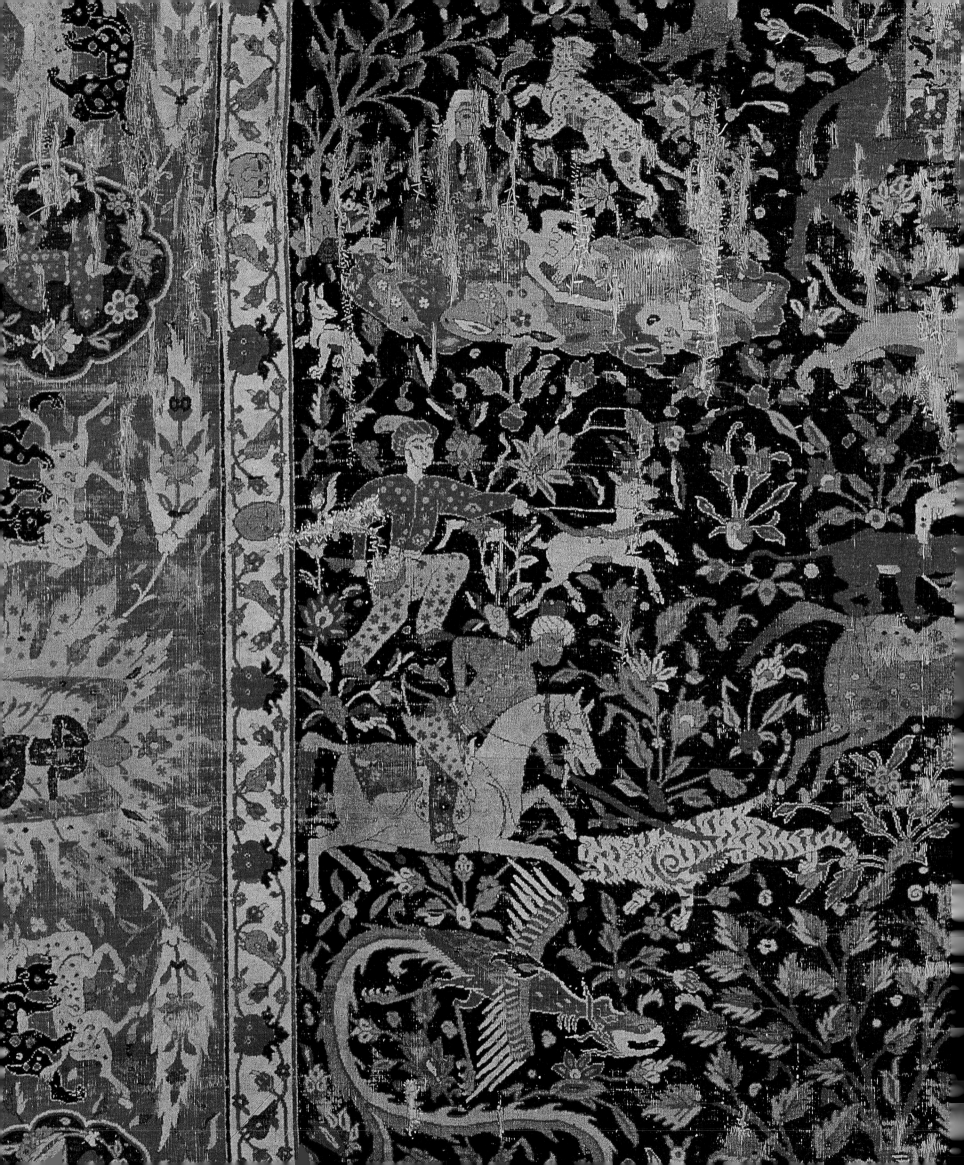

CHAPTER
IV

THE CARPETS
OF SAFAVID PERSIA:
GARDENS OF
EARTHLY DELIGHT

Susan Day

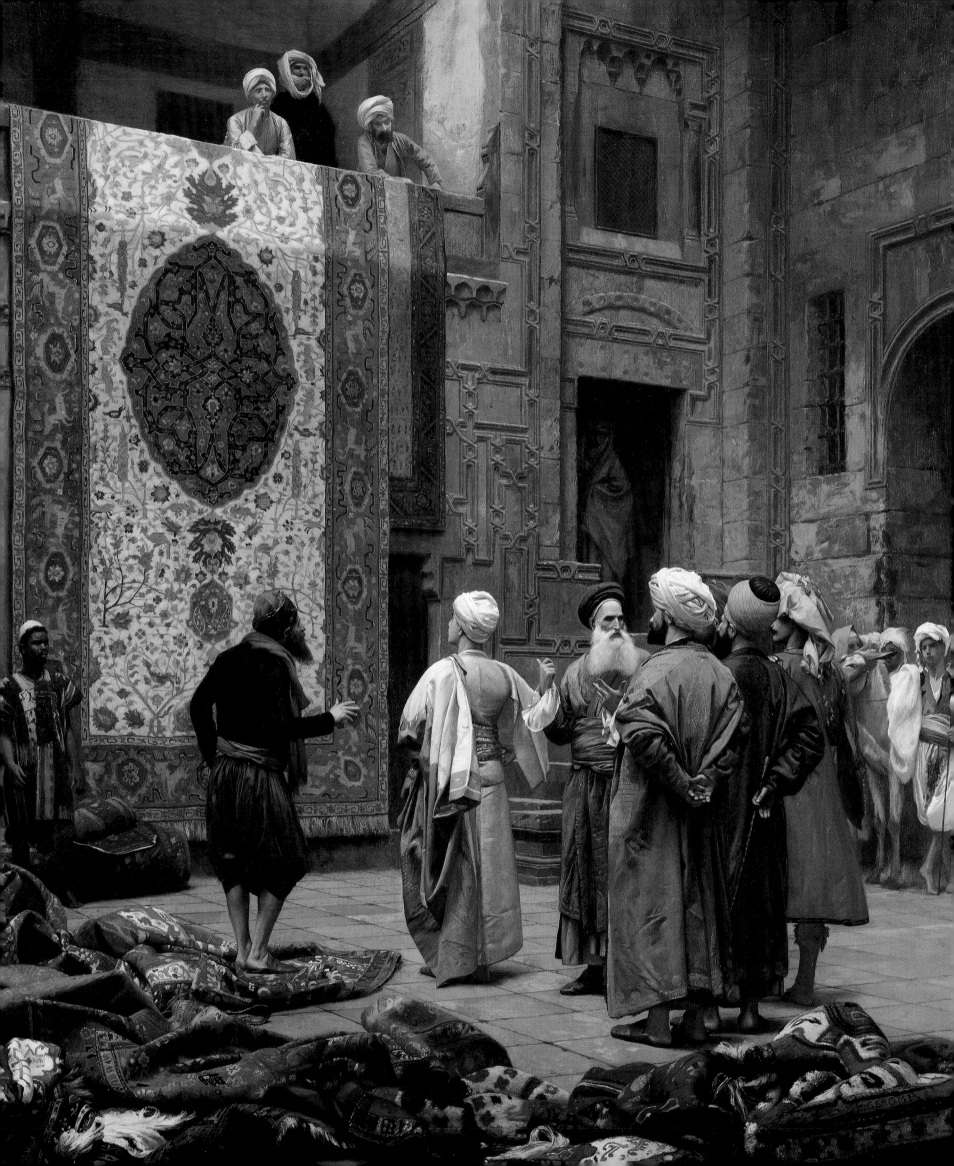

For most of us, it is the Persian carpet which springs to mind when the Oriental carpet is mentioned. Who has not dreamt of lounging on a silky Persian rug in a scented garden, one's senses caressed by the tinkling of fountains and the strumming of lutes, or even nursed the idea of a dramatic escape like Aladdin on a magic carpet? Yet the term 'Iranian carpet' is more correct, if less evocative.

Cultural and Religious Background

'Persian', an eponymous term for the country and the language, derives from the Fars, a region that reached its greatest heights of glory during the Achaemenid period, until Darius was defeated in battle by Alexander the Great. Situated in southwestern Iran, the Fars is just one of the many rug-producing areas of the country, which extends to Azerbaijan, Gilan, and Mazanderan in the north, Kurdistan to the northwest, the Khorassan in the east, and Sistan in the south.

Iran is a mosaic of peoples and religions, for in addition to the indigenous Iran stock, it is home to Armenians, Kurds, Baluch, and Turkomans. After the Sassanian dynasty fell to the Arabs in about AD 640, the country converted to Islam, which to this day is the religion professed by the majority. Minority faiths included Christianity, Judaism, and Zoroastrianism. Until the 16th century, when the Safavids came to power, Persia was ruled by dynasties of foreign origin, Arab and later Turco-Mongol.

The Ultimate in Carpet Weaving

The most beautiful Persian carpets date from the period of peace and stability ensured by

Shah Ismaël and his successors during the 16th and 17th centuries. Virtually unsurpassed from the technical point of view, these carpets, with their delicately rendered imagery, were recognized as works of art rather than mere floor coverings by discerning collectors from the mid-19th century onward.

Carpets in the form of felts, embroideries, flatweaves, and pile have been made in the Middle East since antiquity. An ancient text by Ptolemy Philadelphus dating from the 3rd century BC refers to 'short-haired Persian rugs with animal forms and other designs.'[116] A piled fabric can be made either by lifting the weft threads into loops, which is then cut or left uncut, as in velvets, or by tying or knotting short lengths of yarn individually to the warps, as in pile carpets.

Ancient Fragments

Fragments of flatweave and velvet were discovered during excavations of the Shahr-i-Kumis, a site in the Khorassan dating from the Sassanian period (AD 226-651),[117] while those unearthed at the Mesopotamian site of Dura-Europas (in present-day Syria), destroyed in AD 256, included velvet, as well as fragments tied with the symmetrical and asymmetrical knot. Both types of knot are

85

84. Jean-Léon Gérôme. Le Marchand de tapis au Caire. Oil on canvas. c. 1887. Minneapolis Institute of Arts. This almost photographically realistic painting of a carpet dealer in Cairo reflects the appetite that Europeans developed around the mid-19th century for Oriental carpets.

85. The 'Chelsea carpet'. Persia, 16th century. Wool pile. Victoria and Albert Museum, London. This magnificent variation on the Paradise Garden theme displays a bias pattern of repeating star and ogival medallions. On either side of a small central circular pond containing fish, ceremonial vases with affronted peacocks are mounted on a complex bracket, guarded by fierce creatures, some analogous to Buddhist temple dogs.

used by Iranian weavers, but the asymmetrical knot is far more widespread, and unless otherwise specified, the carpets discussed here are woven in this way. Although no complete carpets predating the early 16th century have come to light, we know from literary descriptions that some floor coverings were quite spectacular in appearance. An oft-repeated tale relates the fate of the booty taken by the Arabs in AD 638 when they sacked the palace of the Sassanian King Chosroes II at Ctesiphon. Dubbed the 'Spring of Chosroes', the silk and gold carpet studded with precious stones, probably an embroidery, was cut up and divided among the troops.[118] Another rug in use in the early days of Islamic rule, probably also an embroidery, had a compartment border containing human figures with inscriptions identifying them as portraits of Sassanian royalty and, curiously, one Umayyad prince.[119]

Arab geographers of the 9th and 10th centuries speak of carpet weaving in the regions of Fars, Mazanderan, Gilan, and the Qainat. These were in all likelihood tribal weavings made by the nomads for their own use, as the tribes still do. The paucity of ancient tribal rugs means that their history has remained and is likely to remain shrouded in mystery.[120]

THE TURCO-MONGOL PERIOD

At the beginning of the 11th century, the Seljuk Turks moved westwards from the steppes to take Bukhara, gradually extending their suzerainty over the whole of western Asia. In 1055, their chief, Tughrul Beg, had himself recognized Sultan by the Abbassid Caliph in Baghdad.

The Refinements of Persian Civilization

With the arrival of the Mongol hordes (or Tatars as they were known to the Arabs), led by their legendary chief Genghis Khan (1167-1227), the population was put to the sword. In 1257, Hülagu, grandson of Genghis, had the Caliph of Baghdad and his family massacred. Notwithstanding these inauspicious

beginnings, Hülagu succeeded in uniting Persia and Mesopotamia under the dynasty known as the Il-Khans, and a period of peace and prosperity ensued. Mongol social structure required Hülagu, a shaman, to pay fealty to his elder brother, Kublai Khan, Emperor of the Yiian dynasty which ruled over China. In 1270, Kublai Khan proclaimed Lamaist Buddhism the state religion, as a consequence of which the Il-Khan dynasty converted to this religion for about thirty years. Gradually, however, the Mongols, who employed Persian civil servants, succumbed to the refinements of Iranian civilization and gave up their nomadic existence.

Islam as State Religion

By the time Ghazan Khan (r. 1295-1304) came to power, Islam had been declared the state religion, an act which broke the oath of allegiance with the Yiian dynasty and may have contributed to the severing of diplomatic relations with China. Based in the Azerbaijan region, the Il-Khans embellished their cities and surrounded themselves with artists and scholars like Rashid ed-Din, Ghazan Khan's Prime Minister and author of the *Jami al-Tavarikh* (*Universal History*) written between 1307 and 1314. Under the rule of enlightened monarchs, the capitals of Tabriz, Sultaniyya, and its suburb, Rab i-Rashidi, where an academy was founded by the historian, became important centers of the arts and letters.

Timurid Art

The death without issue in 1335 of the last Il-Khan monarch heralded a new period of decline, sealed by the first invasion of Timur Lang (Timur the Lame, or Tamerlane). His acts of vandalism and savagery made both the East and the West tremble. A descendant of Genghis Khan on his mother's side, Timur was chief of the Barlas, one of the Jaghataï Turk tribes of Turkestan, of Muslim Sunni, or Sunnite, persuasion. From his base in Samarkand, he ravaged Persia, gradually extending his domination over a vast territory which stretched from Anatolia to India. Again, these

86

86. The Wedding of Humay and Humayun, *Timurid miniature from the* Diwan of Khwaju Kirmani. *Baghdad, 1396. British Library, London. Contemporary miniatures suggest that patterns similar to the one seen here – repeating geometric motifs across a field surrounded by a border embellished with Kufic script – may have been commonplace during the Timurid period.*

upheavals were followed by a period of peace and prosperity. A builder and patron of the arts, Timur spared the artists and craftsmen of the conquered cities, whom he deported to his capital. Timurid art, and particularly the arts of the book, perhaps the supreme achievement of Persian civilization, reached their peak during the reigns of his successors. Less predisposed to war, Timur's immediate descendants allowed the empire to disintegrate and shrink back to eastern Persia. Tabriz, as the capital of two successive Turkoman dynasties during the 15th century, remained an important cultural and artistic center.

Contemporary Descriptions

Few carpets can be assigned to Persia prior to the late 15th century. While the Seljuk Turks embellished Persia with remarkable monu-

TIMURID ART

Timur, or Tamerlane, who invaded Persia around 1380, may have gained power through fierce acts of barbarism, but he and his descendants reigned as enlightened patrons of finer things.

Not only did Timur spare the artists and craftsmen of the conquered cities, he deported them to his own capital at Samarkand, where they learned to work in a more refined style.

Under the Timurids, the arts of the book, perhaps the supreme achievement of Persian civilization, came into its fullest flowering.

ments, they left little trace of their floor coverings. Marco Polo, who traversed Persia during the reign of Hülagu, tells us in his memoirs that carpets were abundant, but he gives little precise information about them. Ibn Batuta, an Arab traveler of the 14th century who made a pilgrimage to the shrine of Imam Reza in Mashhad, describes the tomb as covered 'with many fine carpets',[121] while the Venetian diplomat Giuseppe Barbaro commented on the magnificent carpets in use at the Turkoman court in Tabriz in the late 15th century. To discover what type of floor coverings were in use at the time, we must resort to the illustrated manuscripts of the period, even if these tend to be somewhat schematically rendered. Unfortunately, the libraries created by the Il-Khans suffered from the depredations of Tamerlane's conquering hordes, with the result that surviving miniatures of the Mongol period are few relative to Timurid pictorial art.

The Mongols - Weavers?

Il-Khan painting was very much in debt to Chinese tradition, but the same could not be said of the rugs woven under the descendants of Hülagu. For several decades the art of Persian weaving remained relatively free of outside influence, as represented, at least, in miniatures painted from the 13th century through the 15th. By this account, the car-

pets were either geometric in design or embellished with animal motifs. The fact that Iranian tribes continue to weave to this day, while, curiously, their Mongol counterparts of the Russian steppes are versed only in the art of felt making, has incited certain historians to theorize that their ancestors never wove carpets and that those depicted in the Mongol *yurt* were imported from Turkey.[122] While it is certainly true, as proven by archaeological finds, that imported goods were transported over long distances to the

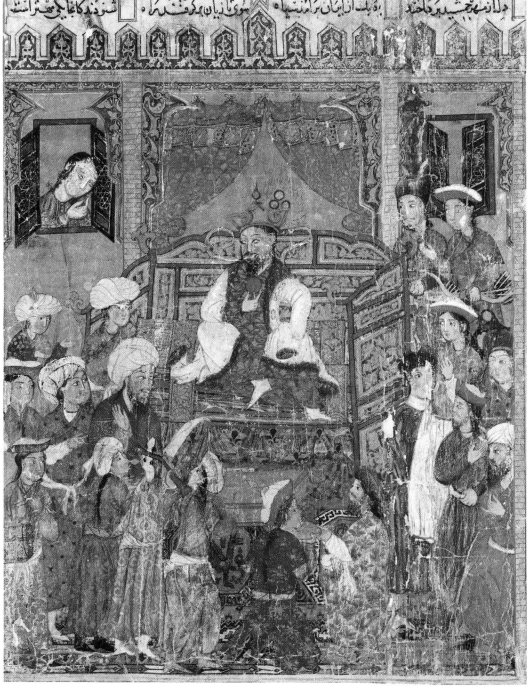

87. Zahhak Enthroned, *Mongol miniature from a Shah Nameh, The Book of Kings by the poet Ferdowsi. Tabriz, mid-14th century. Freer Gallery of Art, Smithsonian Institution, Washington, D.C. The Arab Prince Zahhak, who deposed the good King Jamshid, is enthroned on a partially visible carpet decorated with large octagons containing fabulous beasts, the paw raised in heraldic fashion. The border motifs would reappear much later in Turkish and Turkoman rugs.*

87

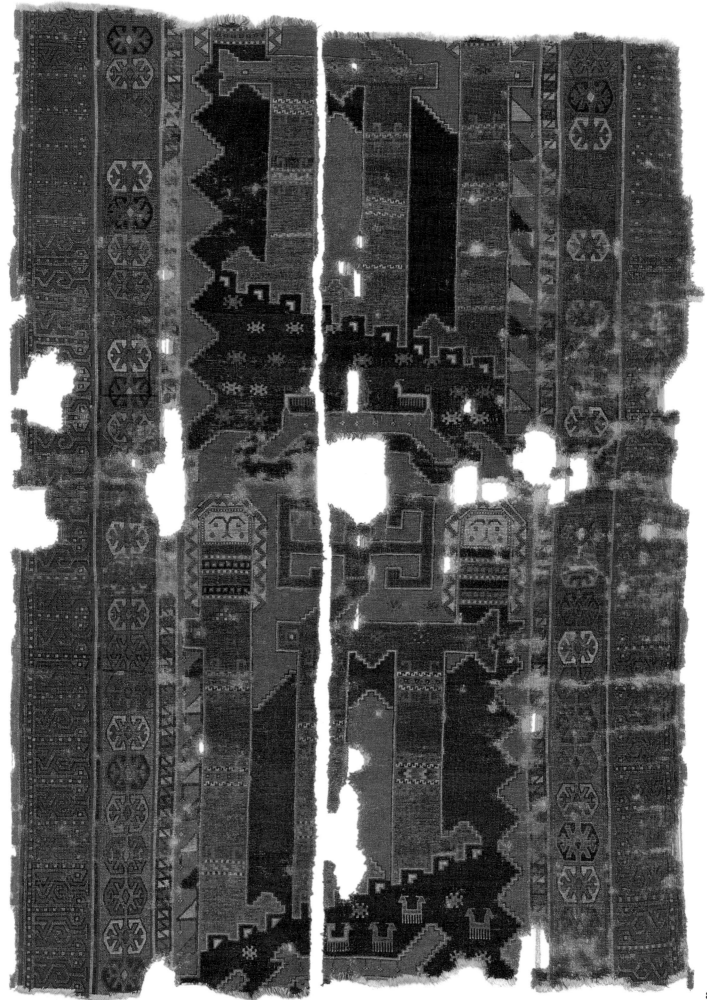

Altaï even prior to the Christian era, these were costly items of jewelry and metalwork or Chinese silks, which the nomadic tribes did not have the *savoir-faire* to make themselves. It is hard to imagine why the tribes would resort to the importation of bulky knotted woollen carpets, when they made their living from sheep husbandry and their womenfolk were skilled in the textile crafts. Moreover, it is virtually impossible, culturally speaking, to separate the Turkic tribes from the Mongols who have intermarried since time immemorial. Thus, while certain of the Mongols' descendants do not today weave knotted rugs, it seems risky to assume that none of the Mongols ever engaged in such craft.

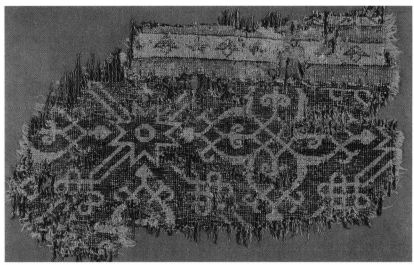

89

Carpets in Miniatures

Rugs depicted in paintings of the 13th, 14th, and 15th centuries may be divided into two groups, one with geometric patterning, the other with animal themes. Thirteenth-century Sung scrolls show that Mongol encampments were comfortably furnished with rugs in geometric designs of the type familiar from existing early Turkish and Mamluk carpets. One shows the so-called 'cloud-collar' device which was transmitted to Turkish and Persian carpet patterns. Several Mongol and Timurid miniatures of the 14th and 15th centuries depict rugs either with various types of small repeating Turkoman *göl* type ornaments, infinity knots, star and cross designs resembling tile patterns, or large octagonal medallions akin to the 'Holbein' carpets discussed in a previous chapter. Like their Anatolian counterparts, moreover, they are frequently surrounded by the border purportedly derived from the angular style of Kufic calligraphy known as 'kufesque'.[123] Here, it is worth pointing out the link between these weavings and certain contemporary works woven by the tribes of the Fars, the Baluch, and Iranian Turkomans.

A miniature in a manuscript attributed to Mamluk Egypt, painted in 1337,[124] shows two figures seated on a carpet decorated with a procession of two elephants and an ostrich. It may be an example of the type of handiwork which so impressed Marco Polo, who mar-

veled at the delicate embroidery of 'birds, beasts, trees and other images'[125] at which Oriental ladies excelled. Animal carpets also appear in Mongol miniatures. A *Miraj Nameh* (*Life of the Prophet*) in Topkapi Palace portrays Muhammed kneeling on a prayer rug decorated with affronted birds on either side of a tree, while a folio from a *Shah Nameh* (*Shahnameh Demotte*) in the Freer Gallery, depicts the villain Zahhak enthroned on a carpet decorated with large octagons containing fabulous beasts, the paw raised in heraldic fashion. The iconography of this carpet, which is related to early Anatolian animal carpets, may be a manifestation of the shamanist cult of totemism, which, as previously noted, was practiced until a relatively late date by the Turco-Mongol tribes.

Rare Fragments

Only a few fragments can be attributed with certainty to the Turco-Mongol period. One, in the Kirchheim collection, dated by the Carbon-14 method to between 1270 and 1470, has been attributed to the Azerbaijan region.[126] Somewhat difficult to decipher, its iconography has been variously interpreted as Mazdeist symbols,[127] as anthropomorphic masks, or as an animal combat of Chinese origin.[128] Apart from its decidedly ethnic air, the design recalls, albeit distantly, the Anatolian animal carpets in the Metropolitan Museum and Kirchheim collections. The repeating *göl* motifs on the inner border are

also similar to those on the New York carpet. Another fragment in the Benaki Museum in Athens is more easily assimilated with the carpets represented in Timurid miniatures. The design consists of a regular pattern of lozenge-like forms decorated with interlace and Rhodian crosses. Each quatrefoil is composed of forked arabesques which meet at the center and form fleurons at each end. Without being identical, the drawing of the field, and in particular the quatrefoil motif, recalls the ceramic revetment of the Blue Mosque in Tabriz, as well as a carpet depicted in a miniature in a *Shah Nameh* of 1494 at the Türk ve Islam Eserleri Müzesi in Istanbul. From the structural point of view, the use of the asymmetrical knot supports a Persian attribution.[129]

88. *Rug fragment from the Timurid period. Iran, 14th century. Wool pile. Benaki Museum, Athens. Only recently identified as Timurid, this pattern is close to those on carpets depicted in miniatures of the Timurid period. The asymmetrical knot with which the piece is woven confirms its Iranian origin.*

89. *Rug fragment from the Turco-Mongol period. Carbon-14 dated to 1270-1470. Wool pile. Collection Heinrich Kirchheim, Stuttgart. This fragment has been attributed to the Azerbaijan region.*

Nothing more than a few fragments can be attributed with certainty to the Turco-Mongol period. The iconography of one fragment, dated by Carbon-14 to the 1270-1470 period and attributed to the Azerbaijan, has been variously interpreted as Mazdeist symbols, as anthropomorphic masks, and as an animal combat of Chinese origin. Another fragment is made with the asymmetrical knot, which helps place the provenance in Persia, as does the design reminiscent of carpets depicted in Timurid miniatures.

THE GOLDEN AGE OF THE SAFAVID CARPET

Shah Ismaël Defeats the Reigning Turkoman Dynasty

The Safavid dynasty came to power in 1501, when Shah Ismaël I overcame the reigning Turkoman Ak-Koyonlu at the Battle of Sharur. Spiritual leader of the Shia, or Shiite, brotherhood of the Safaviyya of the Ardabil shrine, the new Shah claimed to be an 'Alide', that is, a descendant of Ali, cousin and son-in-law to Muhammed and first Shia Imam. In fact, Ismaël was also of Turkoman descent through his mother, and he came to power with the aid of the Qizil Bash Turkomans, who made up his army. Duodeciman Shiism was imposed as the state religion. In order to minimize possible dissidents, large numbers of potentially unruly Kurdish, Afghan, and Qadjar tribes were displaced.

Persia United

The Safavid empire reunited Persia as far as Herat, from Afghanistan to the Euphrates and eventually to the north of the Caucasus. Power was, in the first decades of the 16th century, concentrated in the Azerbaijan, a region divided today between Iran and Russia. Important cities within present-day Iran include Maragha, Ardabil, Sultanieh, and the capital, Tabriz. A number of important rug-weaving cities in the Caucasus, including Lenkoran, Shemakha, and Kuba, remained for most of this period under Persian control, until 1913 when, by terms of the Treaty of Golestan, the territory was ceded to Russia. Conventional wisdom tends to view Caucasian carpets as a separate entity, even though, theoretically, Caucasian rugs woven prior to 1800 should be treated as a branch of Safavid weaving, particularly so given that certain models show affinities with those made farther south.[130]

Development of Commerce and the Arts

A stable government allowed the development of commerce and the arts, which ushered in the golden age of Safavid weaving in the 16th and 17th centuries. At least two Safavid monarchs, Shah Tahmasp and Shah Abbas, are known to have taken a personal interest in carpet weaving. Important workshops were located in cities such as Tabriz, Herat, Kerman, Isfahan, Kashan, and Jawshaqan, whose carpet production will be reviewed in turn. Yet it must be admitted that the list is even longer when it comes to carpet-weaving centers about which we know little or nothing beyond the name, even though they are often cited as active sources of production. These cities include Hamadan in Kurdistan, Shiraz, and Darabjird in the Fars, Mashhad, Qain, and Sabzevar in the Khorassan, Suryan in the Sistan province, and the Tabaristan region. Khuzistan on the Persian Gulf was a major supplier of carpets to Moghul India, as was Sabzevar. Important cities located in the silk-producing regions of Gilan and Mazanderan and known to have woven rugs include Amul and Lahidjan. The production of Shah Abbas I's capital, Isfahan, has been examined in some detail, but to date relatively little is known about other contemporary centers in the Jibal region, like Qum and Yazd, the latter an important producer of silk fabrics and tapestry-weave carpets. Two 17th-century traveler-traders concurred that the carpets made in the Sistan province were superior to those of Kerman, one even venturing the opinion that the rugs of Suryan were 'the most beautiful in Persia'. Nor should the possibility be ruled out, in view of the volume of trade, that some of the major centers had more than one workshop. As a result, the absence of concrete facts with regard to the specific production of these cities imposes *de facto* a classification by design, rather than by place of manufacture.

Sophisticated Weaving Techniques

The second half of the 15th century witnessed a veritable revolution in the manufacture of carpets, which progressed from a domestic craft to a sophisticated court art. To comprehend the phenomenon, we must look to improvements in weaving techniques and to the art of the Turkoman and particularly Timurid courts. Until this time, carpet weaving had been an essentially tribal craft, made by women weaving from memory on the small, easily transportable looms used by the nomads. While it is perhaps foolhardy to place too much faith in the Muslim artist's sense of perspective, it is an undeniable fact that large-format carpets appear increasingly often in miniatures towards the end of the 15th century. As previously mentioned in the chapter devoted to the Ottoman court rug, the manufacture of a wide carpet necessitates a certain type of organization within the context of a workshop and connotates a division of labor. Mounted on a wide loom, the piece is worked by several weavers at once, to whom a foreman calls out the pattern, designed not by the workers themselves but by a master craftsman or a court artist. Nor should it be assumed that the cartoon was executed in the location where it was drawn. Court artists in Tabriz and Herat set standards of taste, and cartoons prepared by them were probably dispatched to manufactures all over Persia, resulting in a certain standardization. The new curvilinear patterns required sharply defined contours, and very likely it was for this reason that silk – a fiber which, because finer than wool or cotton, allows a much tighter, denser, and more compact weave – was used not only for the pile of the most sumptuous pieces but also for the foundation

TOWARDS A COURT ART

In the second half of the 15th century, Persian carpet weaving progressed from a domestic craft to a sophisticated court art. The scale of pieces increased, as did the quality of the designs, the latter often created by court artists in Tabriz and Herat. Once distributed to manufactures all over Persia, the new curvilinear patterns raised the standard of taste. The best 16th-century Persian carpets are marvels of technical perfection, their knot count sometimes in excess of 10,000 per square decimeter.

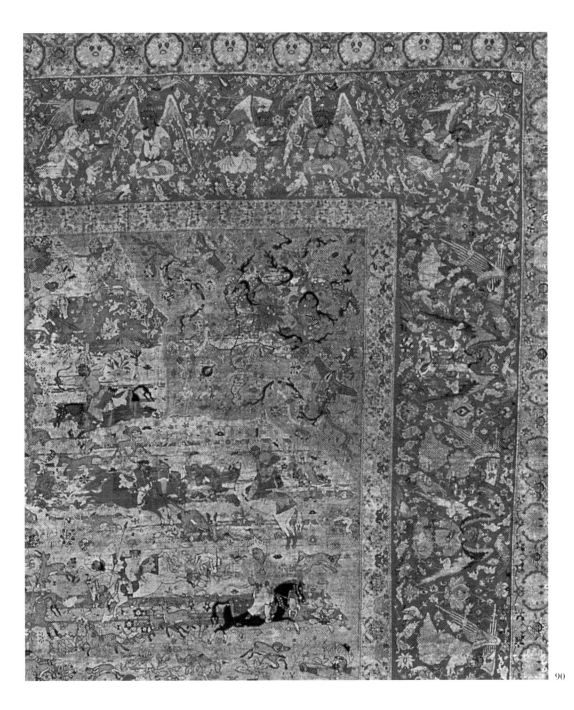

90

of carpets knotted in wool. The best 16th-century Persian carpets are masterpieces of technical perfection, their knot count sometimes in excess of 10,000 per square decimeter. The silk rugs were often woven in pairs, probably to satisfy the custom of laying matching carpets on either side of the main centerpiece in a room.

Gold and Silver Brocading

Another technical feature of the classical Persian carpet, at which more than one contemporary chronicler marveled, was the gold and silver brocading used to add richness to the weaving. The technique may very well be an ancient one, predating the Islamic period. Antique sources refer to the luxurious gold-embroidered carpets in use at the Achaemenid, Umayyad, and Abbassid courts, while Marco Polo describes the slippers specially made to protect the 'wonderful carpets in silk and gold' he saw at the Yiian court, without being specific about their technique or origin.[131] In the tale of Taj al-Mulk and Lady Dunya in the *Arabian Nights*, the *iwan*, a three-walled room open to the garden on one side, was furnished with silken carpets embroidered in gold and silver.[132]

The thread was made by wrapping fine strips of silver or silver gilt around a silk core, whose color varied according to the desired effect: white for silver, yellow for gold (in fact, silver gilt). It was brocaded in the

weft-float technique onto the upper level of the warps only. Slight differences occur in the way it is sewn. Most commonly, the thread is woven under two and over two upper level warps, or over three and under one. The number of picks of weft between the brocading is normally three, but may vary from one to six. Similarly, the number of threads corresponding to each row of knots may vary from one to six, although three is the most common.

During the Safavid period, this technique was used to embellish tapestry-weave carpets, described as 'tissues of the Arras kind' by

90. *The so-called 'Emperor's carpet'. Kashan, 16th century. Silk pile with silver-gilt brocading, 6.80 x 3.20 m. Österreiches Museum für angewandte Kunst, Vienna. This Paradise Garden carpet, which may have been a gift from Tsar Peter the Great to the Habsburg Emperor Leopold I, has a silk pile of great density, over 13,000 knots per square decimeter. It is further enriched with brocading in silver-gilt thread. The piece is thought to have been designed by Sultan Muhammed, court painter to Shah Tahmasp.*

91. Detail of brocading on a so-called 'Polish carpet'. Private collection, Paris.

91

contemporary observers, in addition to pile carpets made in silk and wool. An account written in 1567 describes the diplomatic gifts offered to Suleyman the Magnificent by Shah Tahmasp, so voluminous that forty-four camels were required to transport them to the Ottoman capital. They included 'silk carpets from Hamadan and Dargazin . . . the valuable gifts were twenty large silk carpets and many small on which birds, animals, and flowers were worked in gold. . . .'[133] Brocaded silk carpets from Kerman and Jawshaqan were offered to the Ottoman envoy during the reign of Shah Abbas. They were also made in Tabriz, Yazd, Kashan, and Isfahan.

Towards Industrial Production

During the reign of Shah Abbas I (1587-1629), the weaving workshops were reorganized along industrial lines. The legendary ruler invested his energies in reforming the country's economy through trade, rather than through conquest, with the result that Persia opened up to the West, leading to an ever greater exchange of embassies and merchandise. Among the crafts taken in hand were the metalwork, silversmith, painting, and textile trades, all reorganized as *kharkaneh*, or state manufactures supplying the court. They were also, in a fresh departure, allowed to accept private commissions.

Silk Production as a State Monopoly

The production and sale of silk became a state monopoly.[134] Great numbers of Armenians, who had formerly controlled the silk trade, were uprooted and displaced to the silk-producing areas in Gilan, Mazanderan, and Isfahan farther south. (Rugs of the period are sometimes inscribed in Armenian, proving that the Armenians were also weavers, although what their contribution to the art may have been is now almost impossible to determine solely on the basis of design.) Unlike the Iranian merchants, Armenian traders were allowed safe passage by the Ottomans over their territories, which explains why the Shah preferred to use them in his business dealings with Europe.[135] Carpets were also shipped to Europe by the East India companies, which set up a trading post at the southern port of Bandar Abbas.

State Manufacturers or Kharkaneh

Kharkaneh, which specialized in weaving textiles, were set up in Kashan, Mashhad, Astarabad, and Gilan, and in the regions of Karabakh and Shirvan in the north, as well as at the Shah's new capital in Isfahan. The Chevalier Chardin, a 17th-century French trader-traveler, who described the functioning of the *kharkaneh* in detail, relates that the workers received pensions and sick pay. In order to maintain standards, state officials were appointed as overseers, and the very best wools and silks were shipped to warehouses in Isfahan for storage and redistribution. The cartoons were undoubtedly the work of professional artists, a fact which again serves to underline the difficulty involved in assigning precise models to specific centers. Interestingly, in a decree covering the weaving establishments, Shah Abbas apparently specified that local traditions should not be discouraged,[136] suggesting potential sources of future research.

DESIGN PRINCIPLES

Basic Motifs

The classical Persian carpet is composed according to certain basic principles. Like Turkish carpets, most are rectangular, surrounded by a border, although other formats are not unknown. With the exception of the Ottoman court designers, the Persians were more adept than the Turks at finding successful solutions to the awkward problem posed by the angles or corners in the border.

Field patterns are occasionally directional, that is, viewed like a painting, from one end only. More frequently however, they are centralized or show endless repeats, as either cartouche or floral ornament. Medallion designs, popular since the Timurid period, are virtually ubiquitous in 16th-century Safavid art. Central medallions with pendant systems set off by corner quadrants or spandrels tend to prevail over the repeat patterns preferred by the Turks. Equally common are repeating floral compositions based on an underlying grid system, composed of spiral arabesques ornamented with floral and foliate motifs which develop from a medial axis. These may lie on a single plane, but more frequently they are superimposed one over the other, the nuances in shading giving the impression of depth. In the border, such motifs are undulating, and often show complex floral forms. Lattice patterns are also common, beginning in the 17th century.

A Passion for Gardens

With their abundance of floral motifs and hunting themes, most Persian carpets, down to the present day, express, directly or indirectly, the spirit of the garden. Fundamental to Iranian culture, the passion for the garden with its connotation of cooling shade and running water, as a place to entertain and listen to music, is hardly surprising in view of the arid climate of many of the regions in question. Verses taken from classical Persian poetry and quotations from the Koran appear regularly in borders, but also in the field, particularly in prayer rugs. To the devout Muslim, the garden is also a symbol of Paradise. The 15th *sura* of the Koran informs the faithful that in heaven they will 'delight themselves lying on green cushions and beautiful carpets.'

THE CARPET AND THE ARTS OF THE BOOK

The Timurid Renaissance

Iran enjoyed an extraordinary artistic renascence during the Timurid period, when the arts of the book came to their fullest flowering in court workshops founded in Isfahan, Shiraz, Tabriz, and Herat. The manuscripts created by artists attached to the court were illustrated with exquisite miniatures and illuminations contained within finely tooled bindings.

Chinese Influence

As the Timurids re-established diplomatic relations with Ming China, Chinese artists were invited to the Muslim court, and increased trade meant that quantities of luxury goods, such as silks, silver, jade, and porcelain, made their way westward along the Silk Route. Not unsurprisingly, Timurid art was strongly influenced by the Far East.

Herat, one of the great cities of Asia, became the undisputed capital of the arts of the book, thanks to the enlightened patronage of the Shahs who succeeded Timur. His son Shah Rokh, appointed governor of Herat in 1397, dispatched the painter Ghiyât ad-din Khalil as envoy to China. Upon his return in 1420, Timurid painting began to evince the naturalist style of landscape art then all the rage at the Ming court. Of course, certain motifs, such as flowering prunus and the lotus blossom (often incorrectly described as a palmette), real and mythical animals and birds, and the cloudband, or *tchi*, were known to the Mongol school. Open to his new wave of Chinese influence, Timurid art attained an unequaled peak of perfection during the 15th century. Buddhist iconography assimilated into Islamic art included the lotus blossom; the ribbon cloudband, appanage of the Bodhisattva; the Buddha's halo and lips; paired fish, a symbol of prosperity; and various mythical creatures such as the dragon, frequently represented in combat with the *feng-huang* (phoenix). A beneficent force and symbol of good fortune to the Chinese, the dragon was transformed by the Muslim artist into a fearsome creature, while the *khi'lin*, with its single horn and flaming shoulders, was metamorphosed into a menacing lion, and the animals peacefully browsing in Chinese landscape painting were depicted in flight, or in combat.[137] However, several decades would transpire before this vocabulary was adapted to carpet design.

COURT WORKSOPS OR *KARKHANEH*

During the reign of Shah Abbas I (1587-1629) the weaving workshops of Persia were reorganized as *kharkaneh*, or state manufacturers supplying the court. According to a contemporary French observer, the workers received pensions and sick pay, while state-appointed overseers made sure that standards would be maintained. The cartoons were undoubtedly the work of professional artists, which makes it difficult to assign individual models to specific centers.

THE DECORATIVE REPERTOIRE

Most often the field pattern is centralized or has endless repeats, as either cartouche or floral ornament. Medallion designs, popular since the Timurid period, are virtually ubiquitous in 16th-century Safavid art, with pendant systems set off by corner spandrels. Equally common are repeating floral compositions based on an underlying grid, composed of spiral arabesques ornamented with floral and foliate motifs developed from a medial axis.

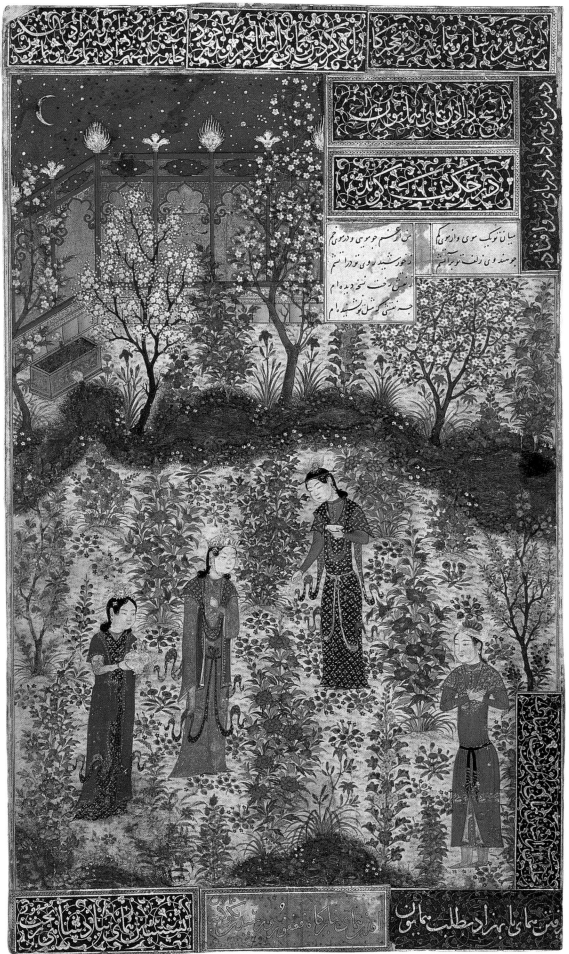

The Leonardo da Vinci
of the Muslim World

Beginning in the second half of the 15th century, the rugs represented in Turkoman and Timurid miniatures are increasingly related to contemporary bookbinding and illumination. Several new designs, including the scrolling arabesque grid pattern ornamented with lotus blossoms, central or repeating medallions, and repeating cartouche ornament appear in carpets represented in miniatures of the Herat school during this period.

Safavid artists relied heavily on the example set by their Timurid forebears. One of the great masters was Kamal al-din Bihzad (1450/60-1535/6), the Leonardo of the Muslim world, whose name is inseparable from the Herat school. Bihzad enjoyed the protection of no less than four successive Timurid and Safavid monarchs. He stayed on in the city following its sack by the Uzbeks in 1507, but moved to Tabriz after the usurper had been slain by Shah Ismaël. There he directed the royal library from 1522 until his death in 1535, in Tabriz or Herat, according to the source. While Bihzad's early style is quite distinctive, very little can be attributed with certainty to this artist during his Safavid period, since regional styles were by this time less discernable. Although it is not recorded whether the painter created rug patterns, his work would appear to have provided the impetus for many of the new designs.

Shah Tahmasp's role in the renascence of carpet design was also significant, if hard to define. Governor of Herat prior to ascending to the throne in 1524, Shah Tahmasp, having studied under the celebrated painter Sultan Muhammed, was an accomplished painter, calligrapher, and carpet designer in his own right.[138] A striking number of 16th-century carpets with pictorial designs show figures wearing the *kulah*, the stick turban fashionable in the early part of his reign, which indicates these masterpieces may have been commissioned by him. Yet, at the same time, the carpets display remarkable variety in the interpretation of motifs, leading us to speculate that, as a patron, the monarch may have commissioned the same theme from several different painters.

Were Carpets Woven in Herat?

Unlike Tabriz, no early references to Herat as a weaving center have yet come to light. The fact that the weavings of Afghan tribes who inhabit the region bear no relation, however distant, to Safavid weaving incited one authority to conclude that no workshop was ever located here.[140] Yet, it is said that Herat carpets figured among the booty brought back to the palace at Amber by the Maharaja Ma Singh (r. 1590-1615). Their renown was moreover later confirmed by the voyager Adam Olearius, who related in his *Reisebuch*, published in 1696, that the most beautiful Persian carpets were made at Herat. It is not unreasonable to assume that an atelier existed there long prior to these references in contemporary literature. Here it should be mentioned that Ellis has plausibly attributed the early compartment and Paradise Garden

THE CHINESE FACTOR

The influence of China on Persian art, already powerful during the reign of Timur, increased further after 1420, when the painter Ghiyât ad-din Khalil returned from the Ming court, bringing with him a naturalistic style of landscape painting. However, several decades would transpire before the new vocabulary of combined realistic and imaginary motifs was adapted to carpet design. Meanwhile, Timurid art, responding to the new wave of Chinese influence, reached an unequaled peak of perfection in the 15th century.

KAMAL AL-DIN BEHZAD
(1450/60-1535/36)

The name Kamal al-Din Behzad is indissolubly linked to the Herat school, where the artist painted under the protection of four successive Timurid and Safavid monarchs. Often characterized as the Leonardo da Vinci of the Muslim world, Behzad included several motifs in his work which sparked a significant renewal in the decorative repertoire of contemporary carpets.

93

92. The Meeting of Humay and Humayun, *Timurid miniature. Iran, c. 1430. Musée des Arts Décoratifs, Paris. Here the meeting of the 'Romeo and Juliet of Persian literature' takes place in a Paradise Garden. According to some historians, this miniature was painted by Giyât ad-din Khalil after his return to Iran from China, where he had been sent as the diplomatic envoy of Shah Rokh. The vernal landscape with its flowering prunus and shrubs, as well as the Buddhist iconography, reflected the influence of China, which in turn would also influence the weavers of the Safavid period in 16th-century Persia, especially those producing Paradise Garden carpets.*

93. Book cover. Herat, 15th century. Bodleian *Library, Oxford. The arts of the book, which came to their fullest flowering during the Timurid period, would have a great impact on the design of Persian carpets, beginning in the 15th century. The vogue of the oval medallion spread from Persia to Ottoman Turkey and Moghul India.*

designs to this center, while Martin and Edwards both noted the relationship between modern carpets made in the Qain region and the lotus and vine-scroll patterns.

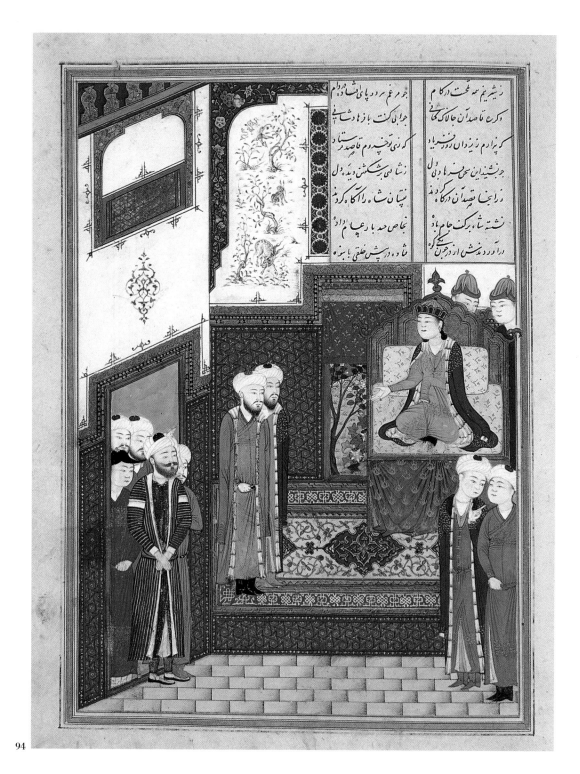

94

SAFAVID CARPETS OF NORTHWEST PERSIA

Tabriz, the Center of Power

For most of the 15th century, the city of Tabriz was controlled by the Kara-Koyunlu (Black Sheep), a federation of Turkoman tribes, which would be succeeded by the Ak-Koyunlu (White Sheep). Married to a Christian princess, Uzun Hasan, ruler of the Ak-Koyunlu, maintained a splendid court that did not fail to impress Venetian ambassadors. The arts of the book flourished here, as they did at the Timurid court. Initially, the Safavid dynasty was also based in the Azerbaijan with its seat in Tabriz. Under constant duress, the city was taken no less than four times in the first half of the 16th century by the Ottomans, who as Sunnites were sworn religious and political foes of the Shiite Safavids. This prompted Shah Tahmasp to move his capital farther south to Qazvin, very likely taking a number of the artists and craftsmen with him.

Tabriz, a City of Weavers

It is generally thought that a group of early Safavid medallion carpets were probably woven in the Azerbaijan. Workshops were located in Tabriz and Sultaniyeh and probably also in Ardabil, a city reputed for its silk textiles. Despite continuous political upheaval, the Tabriz carpet workshop, which had existed since at least the Il-Khan period,[141] continued to function, given that it is mentioned in a document dating from Shah Tahmasp's reign: 'In 1531, the Emir of Azerbaijan staged a revolt and imprisoned the governor of Tabriz, kidnapped the young girls we had entrusted to the Tabriz master-weavers to learn the art of gold embroidery, and shared them among his partisans. He also took a royal tent stored in the Tabriz carpet workshop.'[142] The document is also significant for its statement that the Tabrizi master weavers were versed in the art of metal brocading. And on a more human note, one cannot help but wonder about the fate of the young girls.

94. Chosroes Receives Farhad, *from a Khamseh (Quintet), a collection of popular romances written by Ilyas bin Yusuf Nizami in the 12th century. Herat, 1445-1446. Topkapi Palace, Istanbul. The carpet depicted in this manuscript is an older version of the quatrefoil medallion on a field of scrolling arabesques, a pattern which would come very much into its own during the 16th century, not only in Iran but also in Ottoman Turkey and Moghul India.*

95. Medallion carpet. Northwest Persia, 16th century. Wool pile. *Although considerably shortened and stripped of its main border, this remarkable piece presents a concentric stellate medallion containing other stars on a gold field enhanced with an elaborately drawn tracery of arabesque scrolls. Pairs of tiny birds are tucked into the foliage between the tips of the medallion and the border.*

Tabriz Carpets

Metal brocading, however, is absent from a group of surviving carpets normally considered to be Tabriz work. Most have a long, relatively narrow format, with a central polylobed, stellate, or fringed medallion, sometimes with offset corners, superimposed over a field ornamented with a repeating floral pattern, composed of either quatrefoil motifs or scrolling arabesques. A rug in the Boston Museum of Fine Arts has a circular polylobate medallion, on a field decorated with offset rows of quatrefoil medallions and interlaced stars resembling snowflakes. The ornamentation recalls the ceramic decoration of Seljukid and Turkoman monuments, particularly the Blue Mosque, erected in Tabriz by the Ak-Koyunlu Djahan Shah in 1467. A related piece, in the Calouste Gulbenkian Foundation in Lisbon, differs in having a sixteen-pointed stellate medallion containing smaller, eight-pointed stars set one within the

> ## TABRIZ
>
> During most of the 15th century, the city of Tabriz was controlled by first the Kara-Koyunlu (Black Sheep) and then the Ak-Koyunlu (White Sheep). The ruler of the Ak-Koyunlu maintained a splendid court at which the arts of the book flourished. Initially the Safavid dynasty also had its seat in Tabriz, but Shah Tahmasp, finding himself under constant threat of invasion, moved his capital farther south.

other and a small motif resembling a snowflake in the center. Rather than offset rows of motifs, it has cornerpieces and a ground of scrolling arabesques. A striking example at the Musée des Gobelins in Paris, albeit considerably shortened and deprived of its main border, has a similar concentric stellate medallion, which stands out on a gold field enhanced with an elaborately drawn tracery of arabesque scrolls entwined with cinctured cloudbands. Pairs of tiny birds are tucked into the foliage between the tips of the medallion and the border. While the bold drawing is Timurid in character, the escutcheon bar theoretically points to the Safavid period. A remarkably similar carpet, recently discovered, and now in the collection of Yves Mikaeloff, is probably a bit later than the Gobelins example. Did the 'beautiful carpets' seen by Barbaro at Uzun Hasan's court in 1474[143] resemble these?

A Link Between the Turkish Heritage and Court Art

As a group, the carpets just cited are of no small interest, in that they provide a link between the tribal heritage and the new court art. There is an undeniable link between them and the rugs represented in earlier Il-Khan and Timurid miniatures, as well as the

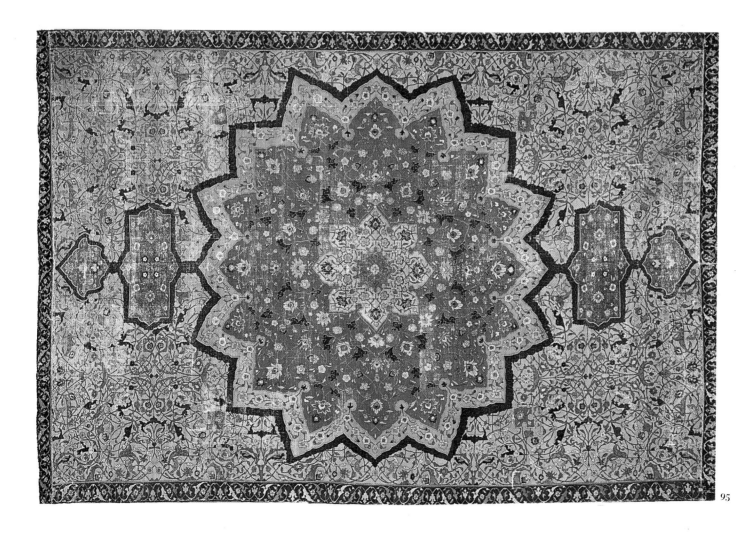

95

so-called 'small-pattern Holbein' carpets discussed in a previous chapter.[144] The medallion of the Gulbenkian, Gobelins, and Mikaeloff carpets recalls the tribal emblem of the Salor, one of the Turkoman tribes. Related pieces are conserved in Paris's Musée des Arts Décoratifs, the Textile Museum in Washington, D.C., the Bardini Museum in Florence, the Victoria and Albert Museum, and the Metropolitan Museum. Recent research has shown that some of the rugs may have been manufactured in the 17th century, which would indicate that the same patterns were woven with few modifications over an extended period of time.[145]

Another family of carpets frequently assigned to Tabriz does in fact feature the silver-gilt brocading mentioned in the document cited above. These rugs will be discussed below in connection with the so-called 'Salting group'.

MEDALLION AND COMPARTMENT DESIGNS

The Influence of Bookbinding and Illumination

We should recall that early Safavid carpets, particularly the medallion and compartment designs, are closely related to the arts of bookbinding and illumination. Two examples

of a handsome group of carpets with a field of repeating cartouche ornament, in the Musée Historique de Tissus in Lyons and the Metropolitan Museum, are reminiscent of the carpets depicted by Bihzad and his pupil Qasim Ali in their miniatures. Scalloped medallions surrounded by radiating cartouches containing dragon and phoenix combats and *khi'lins* are framed by the so-called *tabula ansata* border, which consists of repeating cartouches and octofoils highlighted by ribbon cloudbands. A variant in Topkapi Palace, one of a pair, shows a medallion superimposed over the cartouche field, surrounded by a strapwork or wide arabesque border. Gilan, Kashan, Tabriz, Qazvin, and Herat[146] have at various stages been advanced as the source of the original model.

Several variants on the design are known to exist. A carpet in Istanbul's Topkapi Palace and its pendant in the Österreichisches Museum für angewandte Kunst in Vienna have central medallions superimposed over the field. Others are enhanced by floral ornament, including the Clam Gallas carpet, also in Vienna, decorated with pomegranate trees, and the Havermeyer rug at the Metropolitan Museum, in which lotus flowers are framed within the cartouches. The differences in the patterns and color, as well as the fact that the design continues to appear in 17th-century painting, including one by Juan de Parejo in the Prado, tend to support the hypothesis that this model was made in more than a single place. Significantly, the Clam Gallas piece is woven in the technique now associated with the rugs of Kerman.

The Ardabil Carpet

Of a different order, yet a supreme achievement within the domain of medallion patterns, is the Ardabil carpet in the Victoria and Albert Museum. The circular polylobate medallion is set off by sixteen radiating ogival medallions prolonged at each end by a mosque lamp, and by quarter medallions placed in the spandrels on a field of finely traced spiral arabesque tendrils surrounded by a cartouche border. As behooves a carpet

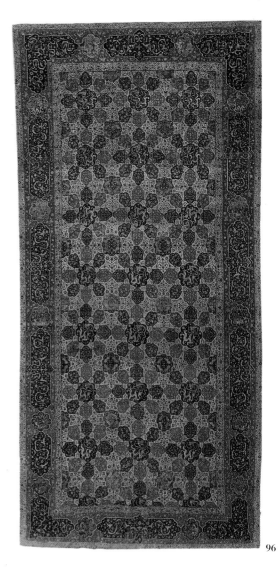

96

96. *Carpet with a pattern of repeating cartouche ornament. Persia, 16th century. Wool pile. Musée Historique des Tissus, Lyons. Note the closeness of the motifs in this carpet to those on rugs depicted in Timurid illuminations and miniatures. An example in a slightly smaller format is preserved at the Metropolitan Museum of Art in New York.*

97. *The 'Ardabil carpet'. Persia, 1539-1540. Wool pile. Victoria and Albert Museum, London. The so-called 'Ardabil rug' represents one of the supreme achievements in medallion design. As always on a piece meant for use in a Muslim place of worship, the pattern is devoid of animal motifs. Further evidence of the carpet's religious purpose are the mosque lamps at either end of the central radiating medallion, motifs reminiscent of ceiling designs in Islamic monuments. Its damaged pendant is now preserved at the Los Angeles County Museum of Art. Although this work bears the signature of Maqsud of Kashan (Maqsud Kashani), it has been attributed to more than one workshop, including Ardabil, Tabriz, Qazvin, and Kashan.*

intended for a Muslim sanctuary, the design is devoid of animal decoration. Its damaged pendant is in the Los Angeles County Museum (Getty gift).[147] Of particular interest is the inscription placed at one end, which contains the first two lines of a poem by Hafiz, the date 1535/40, and the signature of Maqsud of Kashan. The inscription reads:

> I have no refuge in the world other than thy threshold
> My head has no protection other than this porchway
> The work of a slave of the holy place, Maqsud of Kashan, in the year AH 942

On these points there is agreement; otherwise, scholars differ. Some believe that the name identifies the donor, while others infer that it is the name of the master weaver. Nor is there agreement on whether Kashan is simply a family name or the place of manufacture. Like most Persian carpets of the classical period, it has also been attributed to more than one workshop, including Ardabil, Tabriz, Qazvin, and Kashan.

The imposing carpet said to have been taken by the Duke of Anhalt as booty in 1683, after the rout of the Ottoman army laying siege to Vienna, is sometimes compared to the Gobelins carpet, with which it shares a similar pendant medallion scheme and escutcheon bar on a golden ground highlighted with scrolling arabesques intertwined with cloudbands and birds, in this case peacocks. Clearly the work of a master illuminator in a court workshop, this wonderful piece, now in the Metropolitan Museum, nevertheless contrasts stylistically with the former in the bolder handling of the arabesques and in the extremely sophisticated drawing of the motifs. Like the Ardabil carpet, it is frequently assigned to the Tabriz workshop, yet given the manifest differences between the two, such an attribution is somewhat hard to defend.

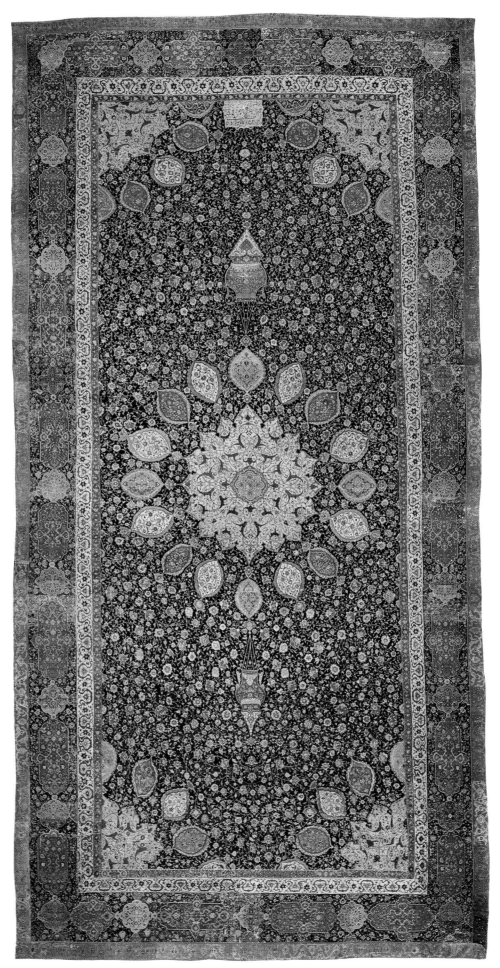

97

PARADISE GARDEN AND HUNTING CARPETS

Symbols of Paradise

The word 'paradise' (*paradaïza*) derives from the ancient Avestan language, meaning *pairi-daeza*, a walled-in park from which the Biblical concept of the Garden of Eden emerged. The Koran also conjures up visions of the eternal delight attendant upon the devout Muslim male, who upon departing this mortal coil will inhabit a garden and be served by winged *houris*, the celestial beings who administer to the blessed in Paradise. A Timurid miniature painted in 1430, and now in the Musée des Arts Décoratifs, shows the legendary lovers Humay and Humayun meeting in just such a garden. Paired cypresses are an even more ancient symbol of paradise. In pre-Islamic Iran, it was believed that the moon was the source of eternal life and that its elixir was contained in the sap of the moon tree, generally represented in the form of a cypress.[148] Paradise parks were vast game preserves in which the Persian kings indulged in their favorite sport, hunting. Inspired by miniature painting, the garden as a symbol of earthly and heavenly delight elicited a vast number of variants in carpet patterns.

Most Paradise Garden carpets have central pendant medallions on a floral ground evoking a spring landscape. Paired cypresses, flowering prunus, fruit trees, birds and wild animals, real and imaginary, some represented in combat, others shown singly, are frequently depicted with houris and occasionally musicians. The borders are ornamented with finely drawn floral tendrils and split arabesques bearing lotus blossoms, paired birds, and animals intertwined with cloud-bands or repeating cartouche ornament.[149] Several of them, including the Hatvany fragment, the so-called Paris-Cracow fragments, a carpet in the Los Angeles County Museum, and its pair in Berlin (virtually destroyed during the last war) have the same light-colored grounds as the miniature of Humay and Humayun.

A Choice of Interpretations

Despite a certain *air de famille*, the above pieces differ in their detailing. The Los Angeles/Berlin pair feature medallions decorated with flying cranes and spandrels containing houris on a ground with heavily laden fruit trees. On the other hand, the two halves of the carpet shared between the Musée des Arts Décoratifs in Paris and the Treasury of Cracow Cathedral (on loan to Wawel Castle)[150] and the fragment formerly owned by Baron Ferenc Hatvany, this piece too a casualty of the war, are more naturally rendered, from the leaves and bark on the trees to the attempts to represent running water and ponds with drinking animals. Whereas the Paris/Cracow carpet has no human figures, the Hatvany piece shows a garden party, with a pavilion and courtiers wearing the stick turban, a scene which allows the piece to be dated with relative accuracy to the period 1510-1540. A reputed scholar has advanced the theory that if the Paris/Cracow and Hatvany cartoons were not the work of Bihzad himself, they were designed by one of his most gifted pupils, in this instance Mirza 'Ali of Tabriz. Furthermore, according to the same scholar, the Getty crane carpet may be the work of Sultan Muhammed.[151] A caveat is necessary here. As previously noted, distinguishing the works of individual Safavid painters is a perilous undertaking, thanks in part to the model set by Bihzad himself, who trained Mirza 'Ali in his style but also numerous other young painters, namely Qasim Ali, Aqa Mirak, and Darvish Muhammad, to name just a few.

Later examples directly inspired by this design are in the Palais Schwartzenberg in Vienna and the Hermitage Museum in Saint Petersburg; another is the carpet formerly in a church in Mantes, now in the Louvre. In this last piece, the hunters are aiming guns, indicating a date no earlier than the late 16th century.

A Source of Inspiration for Artists

A leading authority has linked the Paris/Cracow and Hatvany fragments with several small fragments in the Textile Museum in

98

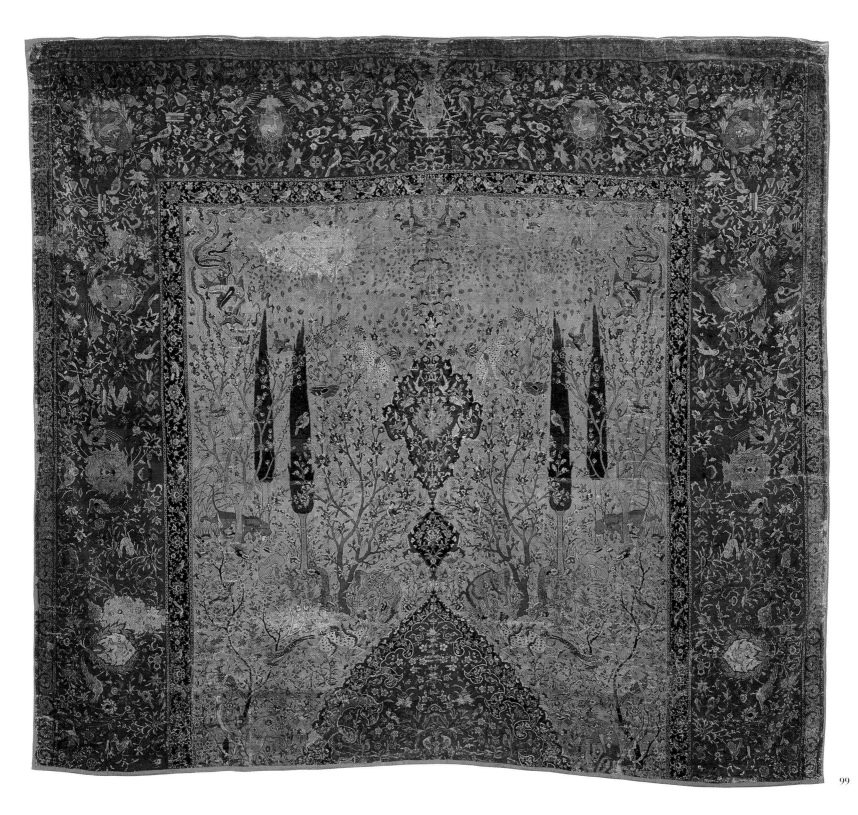

99

98. Carpet with figures. Persia, c. 1510-1540. Wool pile. Formerly collection Baron Hatvany, Budapest (destroyed during World War II ?). The medallion, only part of which survived, contains the scene of a garden party with pavilions and courtiers wearing the stick turban. This bit of clothing, fashionable during the reign of Shah Tahmasp, allows the rug to be dated to the period 1510-1540.

99. Fragment of a Paradise Garden carpet. Persia, 2nd half of the 16th century. Wool pile. Musée des Arts Décoratifs (gift of Jules Maciet), Paris. The other half of this piece, which belonged to the Treasury of Cracow Cathedral, is today preserved at Wawel Royal Castle in Cracow. Having captured the rug in the Battle of Parkany, King Jan Sobieski III donated it to the cathedral, where the altar steps proved too small for the great Oriental weaving, which was then cut in half and

one part sold. The beautiful design seems clearly to have been the work of a court painter. The iconography – naturalistically rendered plants in a brook with drinking animals – evokes the classic Paradise Park landscape as depicted in old Timurid miniatures. The provenance may be Herat or Tabriz.

Washington, D.C. The fact that they are woven on a yellow silk foundation, have a similar color scheme, and share an unusual minor detail – the narrow band of repeating cross motifs on either side of the guard stripes – suggest that these pieces, together with the repeating compartment patterns, are from the same production center, namely Herat.[152] The fact must not be forgotten, however, that artists and craftsmen in important centers like Herat, Tabriz, and Qazvin were frequently shunted back and forth between the cities at the whim of the monarch. Sometimes as well they fled elsewhere when the cities were put to sack. Again, this only serves to emphasize the difficulty inherent in assigning designs to specific places.

The theme of the Paradise Garden served as a source of inspiration for countless other carpet designers, as witnessed by the tree and shrub groups and a number of provincial variants. Among the magnificent variations on the theme are the so-called 'Chelsea carpet' in the Victoria and Albert Museum, two carpets in the Poldi Pezzoli Museum in Milan, the Emperor's carpet in Vienna, and the Sanguszko carpet. With one or two exceptions, the basic iconography of these carpets remains the same. Yet in each case, the ornaments are interpreted in an entirely different manner.

The Chelsea carpet is one of a small group which stands apart from most Paradise Garden carpets by virtue of its repeating medallion arrangement composed of rows of star medallions linked to smaller ogival medallions placed on the bias, rather than a single centerpiece in the field. Above and below the central row, on either side of a small central circular pond containing fish, ceremonial vases with affronted peacocks are mounted on a complex bracket, guarded by fierce creatures, some analogous to Buddhist temple dogs. The field is filled with flowering trees, birds, and animals surrounded by a reciprocal border of arabesques and cinctured cloudbands, the whole beautifully rendered. Among the related pieces, characterized by a similar arrangement of repeating medallions, are two fragments. One in the Victoria and Albert features houris,

while the other, in the Bardini Museum, has paired cypresses and a border with *naskhi* inscriptions (see chapter 5).

The 'Darius of the Universe' carpet in the Poldi Pezzoli Museum reveals a style of drawing which is decidedly looser than that in the preceding work. The piece takes its name, undoubtedly a dedication to the Shah, from the inscription brocaded in metal thread on the inner guard, which also contains an ode to the garden.[153] The pairs of dragons guard blossoming trees rather than cypresses, and, instead of pendants, houris watch over a vase sheltered by a canopy, endowing it with a Buddhist feeling. A date in the late 16th century has been suggested,[154] although a comparison of the elegant drawing in the sweeping arabesque and palmette border with that of the following carpet leaves one hard-pressed to believe that 'Darius' is posterior. A similar carpet, also embellished with metal thread, with a virtually identical border, is in the Musée Historique de Tissus in Lyons.

Hunting as a Court Pastime

A second remarkable carpet in the Poldi Pezzoli Museum, known as the carpet of Pope Pius IX, differs from the preceding patterns in that it is a true hunting carpet rather than a Paradise Garden. Hunting, a favorite pastime of Oriental kings for millennia, played a major role in court life. Summer and winter alike, the Persian khan raised camp in game preserves into which wild animals were herded and contained by reed palissades, a tradition inherited from the reign of the Mongols. The entire court was in attendance, since the khan's principal advisors and doctors accompanied him. Winter camps were so large they resembled towns, complete with streets, mosques, and bazaars, as well as a quarter reserved from the courtesans. There were even complaints about the cost of living, twice as high as in the city, owing to the expense of transportation. The accommodations consisted of felt tents and horsehair huts, which were burned once the camp moved on.[155]

Hunting Carpets

The discomforts fundamental to such an existence are not of course represented on the carpets, only the thrill of the chase. In the carpet of Pope Pius IX, mounted horsemen with bow and lance pursue terrified prey harried by falcons and beaters on a background of lattice-like stems. Woven in wool on a cotton foundation, small accents, such as the riders' stockings and boots, are picked out in white cotton, which relates it to a group of carpets assigned by Ellis to Herat. Qazvin and Kashan have also been advanced as possible places of manufacture. Linked to the 'Getty crane carpet' by the drawing of the ground and the style of the flying cranes within the central lobate medallion, the Pius IX carpet displays a cartouche with an inscription stating that 'this renowned work' was made under the supervision of Ghiyath ad-din Jami. One is tempted to assume that the piece was woven in Jam, a town in the Khorassan halfway between Herat and Mashhad, but this may be nothing more than the master weaver's family name, rather than an indication of origin. The date has been interpreted as either AH 929 (1522/23) or AH 949 (1542/43). Since the figures are wearing the same *kulah* stick turban as in the Hatvany fragment, in vogue between 1510 and 1540, the first date would seem to be more plausible. Yet the stylized border design and the style of the drawing of the figures are more consistent with the mid-16th-century date.

Realistic Hunting Scenes

Infinitely more luxurious than the preceding is the so-called 'Emperor's carpet' in the Österreichisches Museum für angewandte

100. *The 'Getty crane carpet'. Persia, early 16th century. Wool pile. Los Angeles County Museum of Art (formerly McKay collection, Getty gift). Although this design recalls that of the Paradise Garden rug on page 127, it differs in several important details, such as the flying cranes in the medallion and the houris on a ground with heavily laden fruit trees. Such variations suggest that the cartoon may have been prepared by a different artist.*

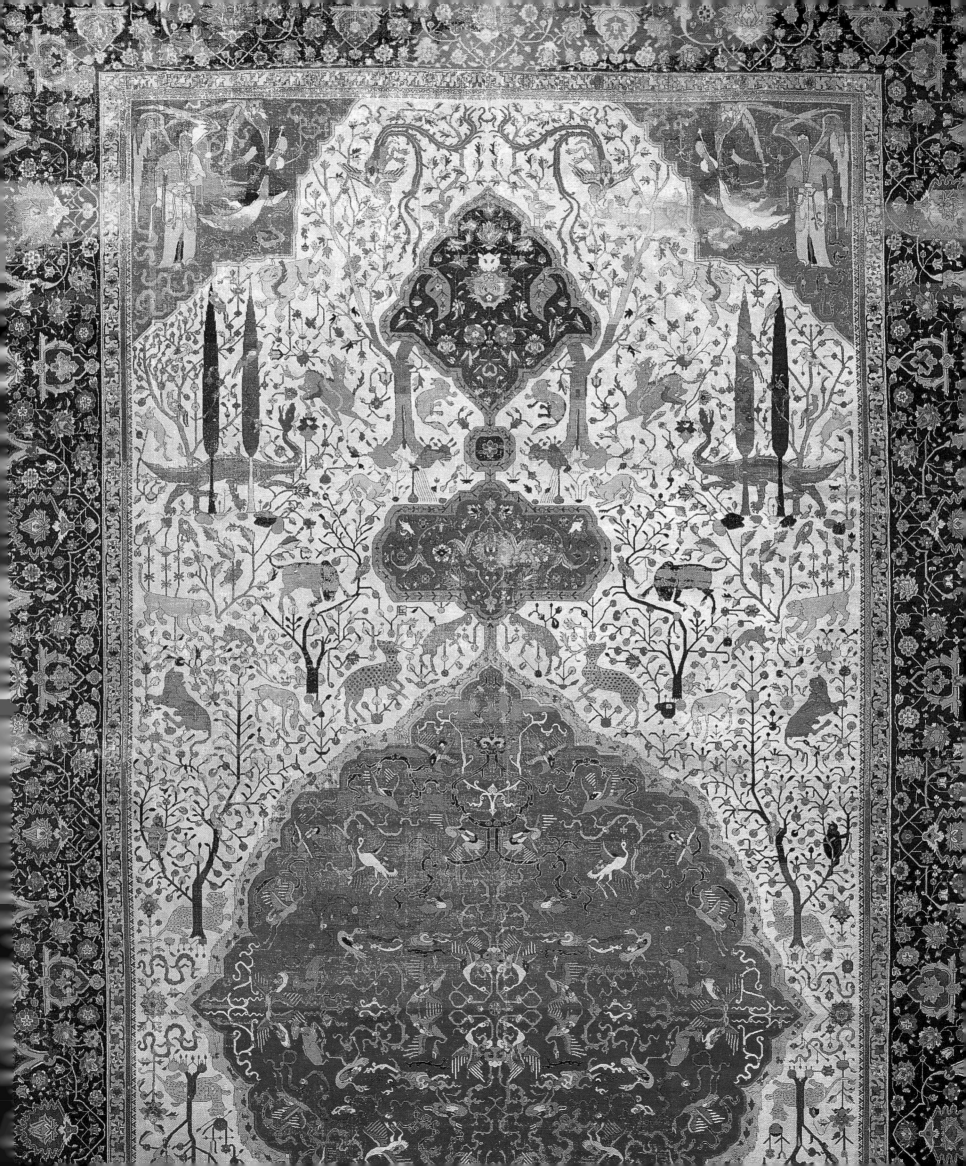

Kunst in Vienna, said to have been a gift from the Tsar Peter the Great to the Habsburg Emperor Leopold I. Perfectly rendered and executed, woven entirely in silk with over 13,000 knots per square decimeter, lavishly brocaded in silver-gilt thread, this carpet is a quite remarkable example of Safavid weaving. In the field, the hunters' features are drawn with such accuracy and individuality that they would appear to be portraits, while the rows of houris serving the blessed and playing music in the border remind us that this is yet again a variant on the Paradise Garden. Here, too, the figures sport the *kulah* stick turban, and it has been suggested that the cartoon was designed by Tahmasp's court painter, Sultan Muhammed. Yazd has been proposed as provenance, yet for once there is general agreement that this carpet, together with the Branicki hunting carpet,

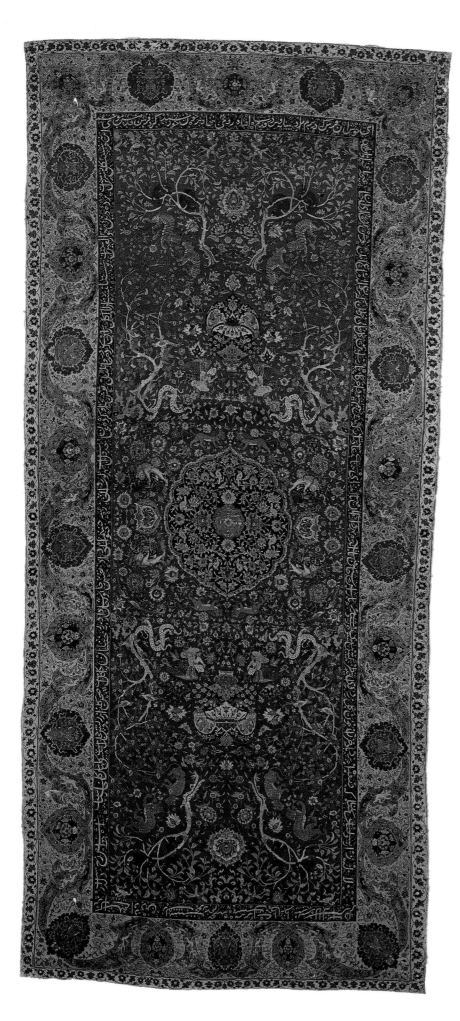

101. *The 'Darius of the Universe' carpet. Persia, 16th century. Wool pile. Museo Poldi Pezzoli, Milan. The piece takes its name, undoubtedly a dedication to the Shah, from the inscription brocaded in metal thread on the inner guard, which also contains an ode to the garden. This confirms the design as a variation on the Paradise Garden theme, handled somewhat more gracefully than in the Chelsea carpet. Dragons guard blossoming trees rather than cypresses, and, instead of pendants, houris watch over a vase sheltered by a canopy, endowing the rug with a Buddhist feeling. A much-disputed carpet, 'Darius of the Universe' was acquired in 1855 by Gian-Giacomo Poldi Pezzoli, a fact which undermines the suggestion that it may be a late copy.*

102. *The 'Pope Pius IX carpet'. Persia, 1522-1523 or 1542. Museo Poldi Pezzoli, Milan. Hunting, for millennia a favorite pastime of Oriental monarchs, played a major role in Safavid court life. Summer and winter alike, the Persian khan raised camp in game preserves into which wild animals were herded and contained by reed palissades, a tradition inherited from the Mongols. Here the designer conjoined the themes of hunting and the Paradise Garden, in a style similar to that of the Getty crane piece. The Pius IX carpet displays a cartouche with an inscription stating that 'this renowned work' was made under the supervision of Ghiyath ad-din Jami. The carpet has been attributed variously, to Kazvin, Kashan, and Herat.*

101

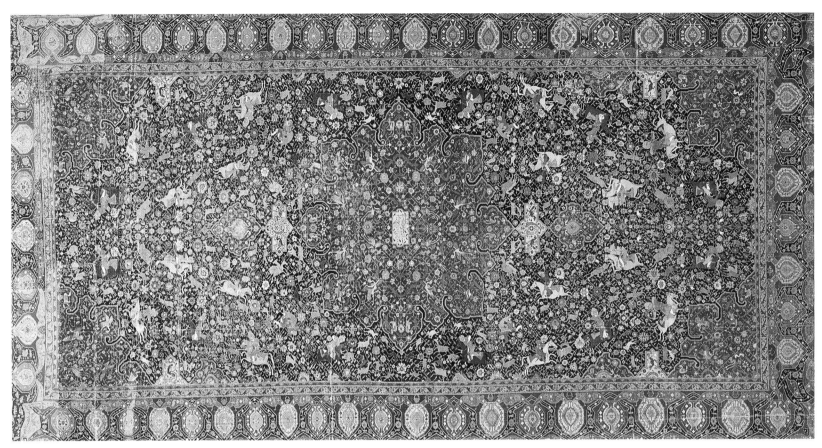

102

formerly in the possession of the Polish government (presumed to have been lost during the war), and the Rothschild carpet presently in the Boston Museum of Fine Arts, are from the same atelier, probably Kashan.

Another carpet, also woven entirely in silk and brocaded in metal thread, is the 'Swedish Royal Hunting Carpet', in the collections of King Gustav of Sweden. The central star medallion and cornerpieces are very similar to the Emperor's carpet, yet the treatment of the design is altogether more restrained, the motifs being more widely spaced and the huntsmen and their prey fewer in number. The field is highlighted by multiple cloudbands, while rows of trees and a procession of animals unfolds along the inner border. The same headgear makes it contemporary with the Emperor's carpet. If, as suggested, this carpet also originated in Kashan, the cartoon must be the work of another painter.

The carpet named after Poland's Prince Roman Sanguszko was for some years on loan to the Metropolitan Museum of Art.[156] This outstanding rug has a scalloped ogival medallion containing four smaller medallions orna-mented with pairs of winged houris, prolonged by pendants and escutcheon bars, on a blue field with animal combats and a color scheme of rich polychromy dominated by the abundant use of golden yellow. Hunters energetically pursue their prey in the spandrels. The border shows particular vigor. Ogival medallions containing affronted birds or winged houris, alternating with scalloped roundels in which tigers attack deer, are disposed on a red field filled with dragon and phoenix combats and thick lanceolate leaves. The minor guards feature humorous animal masks. The rug is said to have been captured from the Turks at the Battle of Chocim in 1621, which would imply that it was woven during the reign of Shah Abbas.[157] Similar pieces are in the Instituto de Valencia de Don Juan in Madrid, the Victoria and Albert Museum, and the Thyssen Bornemisza Collection (ex Countess de Béhague collection). Pope has suggested that the painter Master Muhammadi may have been the author of the cartoons.[158] Sanguszko carpets have been attributed to Kashan, Yazd, Qazvin, and Kerman. Beattie's research has shown that while certain Sanguszko carpets may be assigned to Kerman, on account of their technique, others formerly linked with the group on the basis of style must be excluded.[159]

PICTORIAL CARPETS

It is a popular misconception that the representation of living creatures is prohibited in Islamic art. While it is true that such subject matter is effectively banned on religious grounds from carpets intended for use in a mosque, it will by now be clear to the reader that human and animal figures abound in secular art. Scenes derived from Persian mythology or episodes drawn from the *Shah Nameh*, or *The Book of Kings*, the Iranian national epic written by Abu'l Qasim Mansur Ferdowsi in the 10th century, or yet from the *Khamseh (Quintet)*, a series of popular romances composed by Ilyas bin Yusuf Nizami in the 12th, may on occasion also be depicted in carpets.

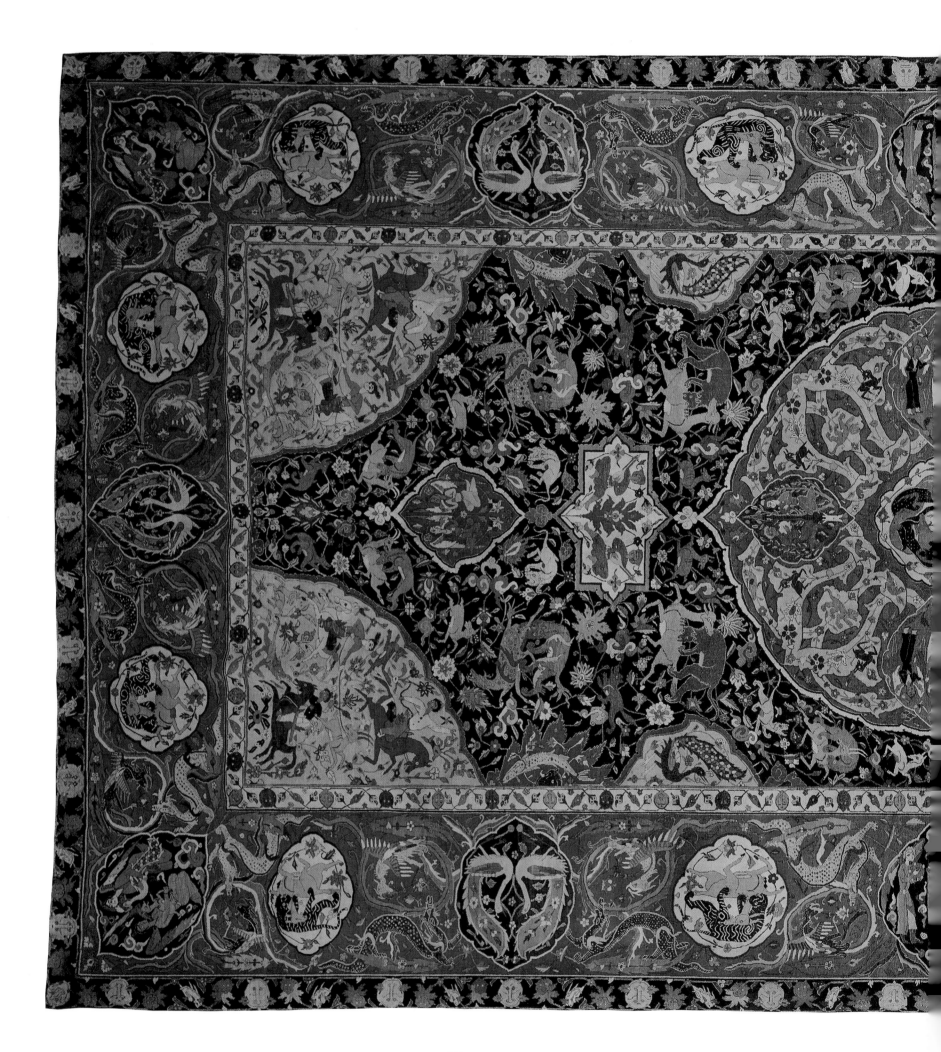

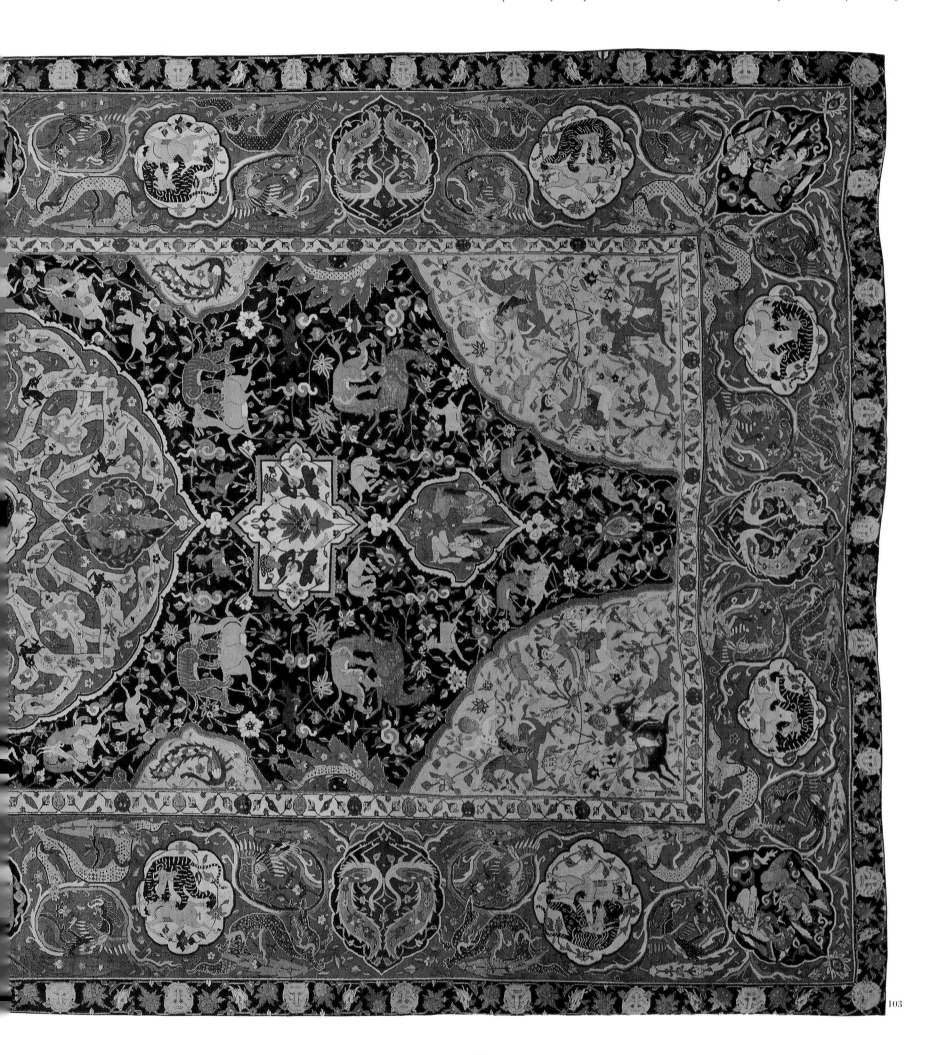

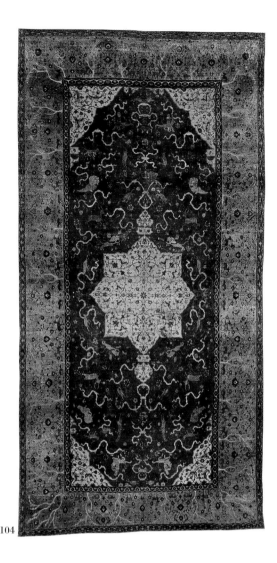

104

103. *The 'Sanguszko carpet'. Kerman, 16th century. Wool pile. Collection Shinjishumeikai, Shiga, Japan. Named after Poland's Prince Roman Sanguszko, and for many years on loan to the Metropolitan Museum in New York, this remarkable version of the Paradise Garden theme is the doyen of the Sanguszko group. The technique used to weave the carpet suggests Kerman as the place of origin. The rug is said to have been captured from the Turks at the Battle of Chocim in 1621, indicating that it may have been made during the reign of Shah Abbas.*

104. *'Swedish Royal Hunting Carpet'. Persia (probably Kashan), 16th century. Silk pile with metallic brocading. Collection His Majesty the King of Sweden, Stockholm. The theme is the same as that of the 'Emperor's carpet' reproduced on page 117, although treated in more restrained manner. If, as suggested, this carpet also originated in Kashan, the cartoon must be the work of another painter.*

The Talking Tree

According to a legend recounted in the *Shah Nameh*, Alexander the Great halted beneath a 'talking tree' that rebuked him for his lust of conquest and prophesied his early death. A late 15th-century copy of the manuscript in the Bodleian Library, Oxford, shows a pensive Alexander musing beneath the tree, its branches terminating in animal masks and a dragon. Similar iconography appears in Safavid miniatures as well as in the borders of several carpets, and it may very well be the source of inspiration for an unusual silk Kashan rug in the Gulbenkian Foundation. A long narrow field containing inscriptions is superimposed on a proportionately wide border decorated with scrolling arabesques adorned with human masks (light – and dark – skinned as well as Asiatic), animals, birds, fish, dragons, and horned demons. The theme of the 'talking tree', known additionally as the 'grotesque' design, figures on a number of fragmentary pieces, among them the same blue-ground carpet, in the Musée des Arts Décoratifs in Paris, presently attributed to Moghul India.

The Oriental Romeo and Juliet

A silk tapestry carpet woven in Kashan during the late 16th or early 17th century, given to the Louvre by Doistau, has a central pole medallion with a scene of Bahram Gur killing the dragon, it too from the *Shah Nameh*, while the corner quadrants feature the tale of Leila and Majnoun, the Romeo and Juliet of the Orient, from a tale in the *Khamseh*. A so-called 'Sanguszko carpet' in the Musée des Arts Décoratifs, woven in Kerman at about the same time, is decorated with rows of hunting scenes alternating with the scene of Leila arriving by elephant to visit the dying Majnoun in the desert and another equally famous scene from the *Khamseh*, this one of Chosroes espying Shirin bathing in a pond. The two rugs are unusual by virtue of their directional designs.

European Influence

As previously noted, Shah Abbas's reign marked the beginning of increased contacts between East and West. By the mid-17th century, European influence on Safavid painting had become marked, yet to date scholars have paid little attention to Western influence on carpet design, which makes it fertile ground for future research. Persian carpets are on occasion inspired by European iconography, or the patterns of French rugs. A noteworthy example is the Marcy Indjoudjian cope in the Victoria and Albert Museum. Woven in silk pile, brocaded in metal thread, the vestment was probably made locally for a church of the Armenian community established in New Julfa, a suburb of Isfahan.[160] In a fragmentary state, it depicts two scenes from the New Testament, the Crucifixion and the Annunciation, in which the figures are clothed and posed in the European manner, suggesting that the images were taken from a painting or engraving. A singular prayer carpet, formerly belonging to George Mounsey, is decorated with a French fleur-de-lis on a ground of repeating diamonds surrounded by a repeating geometric pattern. An inscription reveals it to have been made in Jawshaqan in 1757.[161]

So-called 'Portuguese Carpets'

The so-called 'Portuguese carpets' constitute an important group, its name inspired by the spandrel ornament, which depicts a European ship, sailors in European dress, and a man, menaced by sea monsters, drowning at sea. Fewer than ten examples are known. The earliest ones include a piece formerly owned by Horace Harding (now in a Swiss private collection), the Gulbenkian carpet in Lisbon, and the Potemkin carpet in the Musée Historique des Tissus in Lyons. The cornerpieces of all but the Harding rug have this type of ornament,[162] a scene which has elicited several different interpretations. According to one, the image signifies a Portuguese diplomatic mission arriving in the Persian Gulf, while another holds it to be the story of Jonah

PICTORIAL CARPETS

Islam prohibits the representation of living creatures in art destined for use in holy places, but not in secular art, including carpets, which abound in both animal and human figures. Among the images woven into rugs are garden and hunting scenes, or episodes from Persian literature, such as the *Shah Nameh* by the 10th-century poet Abdu'l Qasim Mansur Firdowsi. A popular subject from the *Shah Nameh* was the legend of the 'talking tree', which rebuked Alexander the Great for his lust of conquest. Another source was Ilyas bin Yusuf Nizami's 12th-century *Khamseh (Quintet)* with its romantic tale of Leila and Majnoun, the Romeo and Juliet of the Orient.

and the whale. A third, based on a Moghul commemorative miniature, sees the death of Bahadur Shah, ruler of Gujarat, who drowned, possibly murdered, while visiting the Portuguese fleet. A further possible source may have been a European painting or engraving. The carpets within the group are attributed to various centers in Persia, Portuguese Goa, and more recently Gujarat.[163] The widely differing techniques and the presence of *jufti* knotting in certain pieces, including the Lyons rug, tend to support the theory that some of the works originated in the Khorassan, while others were probably woven in the Caucasus and Moghul India, where the workshops were established with the aid of Persian weavers. Given that the unusual form of the concentric medallion, with its diamond shape and serrated edges, appears in a Safavid miniature of 1529 (Golestan Library in Teheran), it seems logical to conclude that the original model was the work of a Safavid artist.

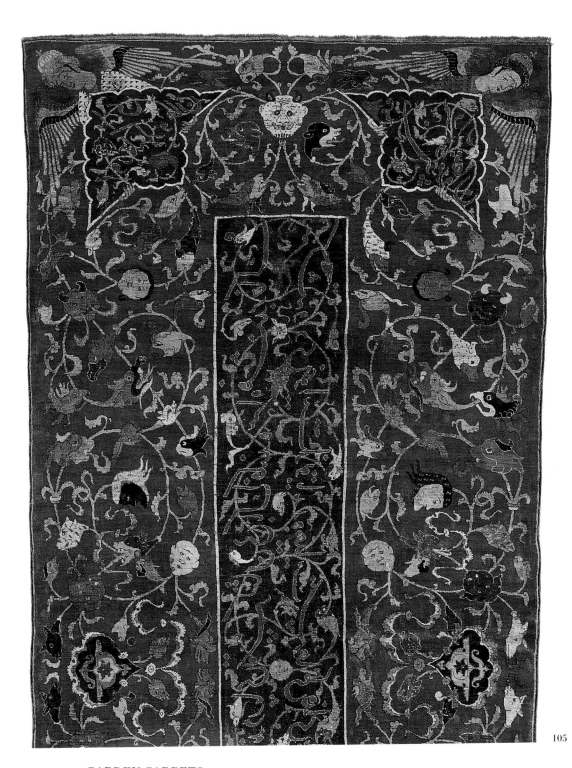

105

GARDEN CARPETS

The Chahar Bagh *Pattern*

Thanks to Xenophon's description, we know of the quadripartite layout of the garden designed for the Achaemenid monarchs Darius and Cyrus. This classic Persian garden provides the decorative scheme of the *Chahar Bagh* (Four Gardens) carpets. As noted earlier, a very precise description of the 'Spring of Chosroes' has also come down to

105. *Carpet with human masks and animals. Kashan, 16th century. Calouste Gulbenkian Foundation, Lisbon. The long narrow field containing inscriptions is superimposed on a proportionately wide border decorated with scrolling arabesques adorned with human masks, animals, birds, fish, dragons, and horned demons. The scene, which is comparable to iconography found in* Shah Nameh *miniatures, shows Alexander the Great at rest under a 'talking tree', which has rebuked him for his lust of conquest and prophesied his early demise.*

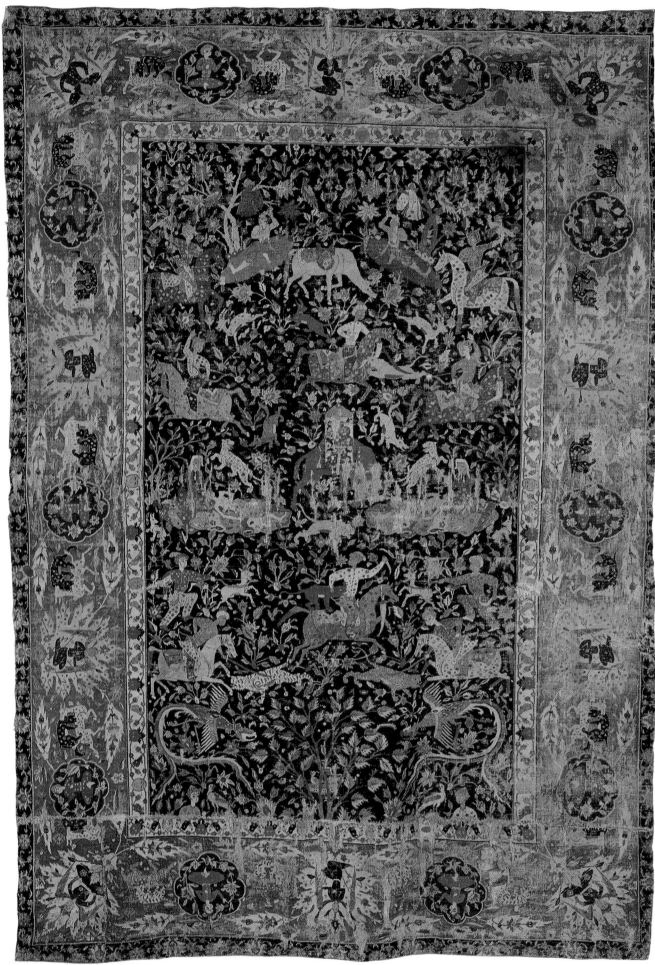

107

106. *'Sanguszko carpet'. Kerman, late 16th century. Wool pile. Musée des Arts Décoratifs, Paris. Composed in registers, the pattern includes hunting scenes which alternate with scenes taken from the Khamseh of Nizami. These feature Leila traveling by elephant across the desert to reach the dying Majnoun, was well as an equally famous episode involving Chosroes in the act of espying Shirin at her bath.*

107. *The 'Marcy Indjoudjian' cope. Isfahan, 17th century. Silk pile with metallic brocading. Victoria and Albert Museum, London. Beginning in the mid-17th century, European taste affected the look and design of Persian carpets, thanks primarily to Armenian dealers catering to the Western market. This fragment of a liturgical vestment is ornamented with scenes from the New Testament, in which the figures are posed and dressed in the European manner. It was probably woven for a church serving the Armenian community in New Julfa, a quarter in Isfahan.*

108. *A miniature depicting European ambassadors presenting the sons of the Ottoman Sultan Morad I to the Persian court, from the* Zafer Nameh (The Life of Timur) *by Sharaf ed-Din Ali Yazdi. Tabriz, 1529. Golestan Library, Teheran.*
In this miniature, the so-called 'Portuguese carpet' presents a concentric medallion whose unusual 'lozenge' or diamond form implies that the characteristic pattern of the Portuguese group originated in Safavid Persia.

us. This evidently exceptional floor covering was found in the Sassanian King's palace when the Arabs sacked it in AD 638. The ground of the carpet, treated in shades of red, blue, yellow, white, and green, was divided up into canals and connecting paths adorned with trees and spring flowers, while the borders were treated as flower beds. Thus described, the 'Spring of Chosroes' garden virtually matched the *Chahar Bagh* plan, which has remained almost unchanged since the Achaemenid period, and it survives today at the Moorish palace of the Alhambra in Granada. In the carpet, the soil as well as the trunks and branches of the trees were picked out in silver and gold, while stones the size of pearls represented the gravel paths, and transparent crystals the running water. No doubt an embroidery, this carpet, which is said to have covered the entire audience hall of the Ctesiphon palace, measuring over twenty-five meters long, was probably made in sections and sewn together. The victorious Arab troops forthwith divided it up for sale in sections to jewelers.[164] An account of the carpets laid in the palace's throne pavilion describes the 'Four Seasons' carpets, each of them representing a season of the year.[165]

Canals with Swimming Ducks

Dating from the 17th century, the oldest surviving examples of the Persian garden carpet are the Wagner rug in Glasgow's Burrell Collection, the Figdor piece in Vienna, and a carpet in the Central Museum in Jaipur. All conform to the *Chahar Bagh* grid plan. The field is divided into quadrants by water channels sporting ducks and fish and bordered by flowering trees atwitter with birds. The Vienna and Jaipur rugs have densely packed

108

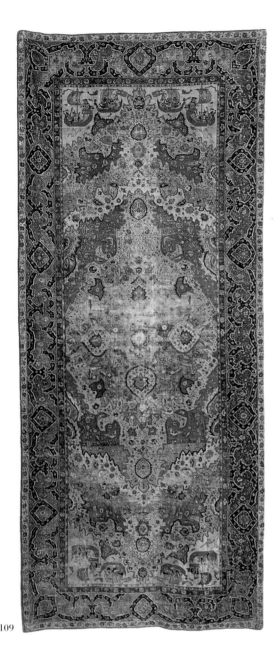

109

109. A so-called 'Portuguese carpet'. Persia or India, 16th-17th century. Wool pile. Musée Historique des Tissus, Lyons. The name of the important 'Portuguese group' derives from the figurative spandrel ornament, which depicts a European ship, sailors in European dress, and a man, menaced by sea monsters, drowning at sea. The scene has elicited various interpretations. According to one, it signifies a Portuguese diplomatic mission arriving in the Persian Gulf, while another holds it to be the Biblical story of Jonah and the whale. A third, based on a Moghul commemorative miniature, sees the death of Bahadur Shah, ruler of Gujarat, who drowned, possibly murdered, while visiting the Portuguese fleet.

foliage, cypress trees, and animals, while the Indian piece, measuring over eight meters long, has a garden pavilion at the center. Slightly different is the Glasgow rug, which boasts lobed cartouches within the flowerbeds sparked by bird combats. All three carpets were very likely woven in Kerman.[166] The Jaipur rug, discovered in the palace of the Maharajas of Jaipur at Amber, can be dated by inventory records to the reign of Shah Abbas in 1632.[167]

A Pictorial Perspective

In an original variant on the theme, woven during the same general period, the garden is perceived in pictorial rather than bird's-eye perspective. Here, miniature garden scenes featuring trees, flowers, and even grass are framed within a stellate lattice. The wildlife is absent, but stylized representations of streams and channels with rippling water can be detected at the base of the trees. Fragments of such a carpet, tentatively assigned to Kurdistan, were once in the von Hirsch collection and are now owned by several private collectors. A number of attractive pieces derived from the garden carpet were also made in northern Persia and the Caucasus, as well as by the Baksheish tribes.

PRAYER CARPETS

Recognizable by the niche symbolizing the *mihrab*, the prayer carpet has been in use for centuries. Carpets with rows of niches are also made for communal prayer in mosques. Owing to the widespread use of *zilus*, or cotton mats, knotted prayer carpets are less common in Iran than in Turkey.

An Attribute of the Wealthy

The more luxurious pile carpets, which form a distinctive class of their own, tend to be an appanage of the wealthy, who treat them as prized, intimate possessions. Many of these works display the horseshoe arch, a distinctive feature already known during the Il-Khan period, as a miniature portraying the

110. Chahar Bagh (Four Gardens) carpet. Kerman, 17th century. Wool pile. Burrell Collection, Glasgow. Known from an early description by Xenophon, the quadripartite layout of the Persian garden has remained essentially unchanged since the time of the Achaemenids, and it prevailed in splendid form as far away as the Alhambra in Granada. The field of the carpet is divided by canals full of aquatic creatures and linked by paths lined with trees and spring flowers. Garden carpets were also woven in India.

Prophet in prayer attests (Freer Gallery). Timurid miniatures depict several other horseshoe-niche rugs, although the oldest surviving specimens do not predate the Safavid period. Quality prayer rugs were made in the Khorassan, Kerman, Bahrain, and Kerbela (present-day Iraq). Felt carpets were a speciality of Jam. A feature of the Safavid prayer rug is the presence of inscriptions, generally quotations from the Koran or other devotional literature knotted in wool or brocaded in metal thread. The calligraphy is usually confined to the upper part of the field, to the spandrels and border as well as around the niche. In a number of rugs, the lateral borders are punctuated at mid-point by a small medallion reminiscent of Seljuk brickwork. An important collection of these carpets, once owned by the Sultans of Turkey, is now in the Topkapi Palace Museum. Their provenance is in dispute, since many of them show color schemes associated with the Salting group, which will be discussed in greater detail further along. It is worth noting that of the sixteen prayer rugs inventoried at the Ardabil shrine in 1759, the six Khorassan pieces are described as having inscriptions in the field or *mihrab*, while the five Kerman pieces had inscriptions in the border.[168]

The Saph Carpet

Surviving multiple-niche carpets of the Safavid period are extremely rare. Four portions of an important *saph* are presently distributed among several museums and private collections, namely the Türk ve Islam Eser-

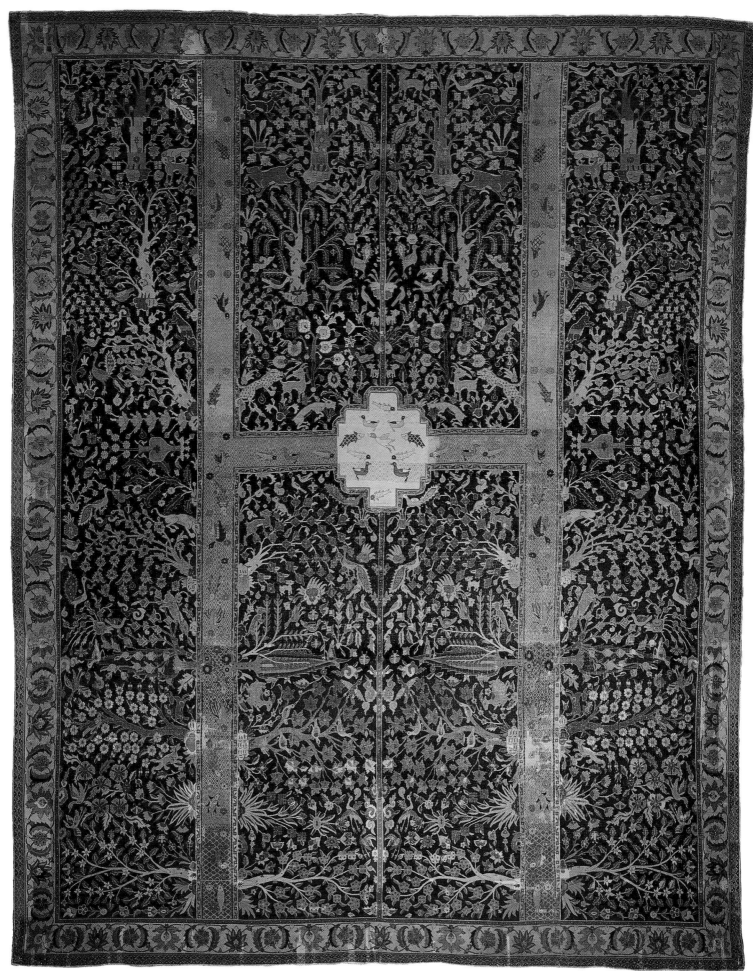

leri Müzesi in Istanbul, the Islamisches
Museum in Berlin, the Wher collection in
Switzerland, and the El Sabah collection, the
last on loan to the National Kuwait Museum.
Reconstituted, the carpet would have had at
least six rows of niches, each with a somewhat
angularly rendered horseshoe arch. An
unusual feature is the way in which the orna-
mentation of the field varies, a row of niches
with polylobate medallions alternating with a
row containing scrolling arabesques in the
lower half. The Istanbul fragment is the only
one to conserve part of the original border,
decorated with cinctured cloudbands. The
form of the niche is virtually identical to one
depicted in a Timurid manuscript in the
Jhaghataï Turkish script, painted in Herat in
1436 and owned by the Bibliothèque
Nationale in Paris. In the interim, however,
the geometric field on the Timurid rug has
evolved into the floral ornament of this piece.
The floral element, together with the cloud-
band border, has led a leading expert to date
the carpet to the mid-16th century, while pos-
tulating that it corresponds to one of the rugs
offered to the Ottoman Sultan's new mosque
in Istanbul, for which Shah Tahmasp
requested precise measurements and
required color schemes in a letter dated 1556.
According to the same expert, moreover, the
harsh quality of the wool would make the rug
a Tabriz work.[169]

The Metropolitan and the Victoria and
Albert also conserve fragments of multiple-
niche prayer carpets. These fragments, each
with two superimposed horseshoe arches,
share certain features in common, including
the border pattern, the form of the *mihrab*
defined by a spotted band, and the field deco-
ration of one of the niches. This has led cer-
tain scholars to suggest that the fragments are
in fact part of the same carpet. Furthermore,
an Indian provenance should not be
excluded.[170] It is worth noting that the princi-
ple of contrasted patterning in the field is the
same as that seen in the carpet discussed
above, to which it is posterior, probably dat-
ing from the 17th century.

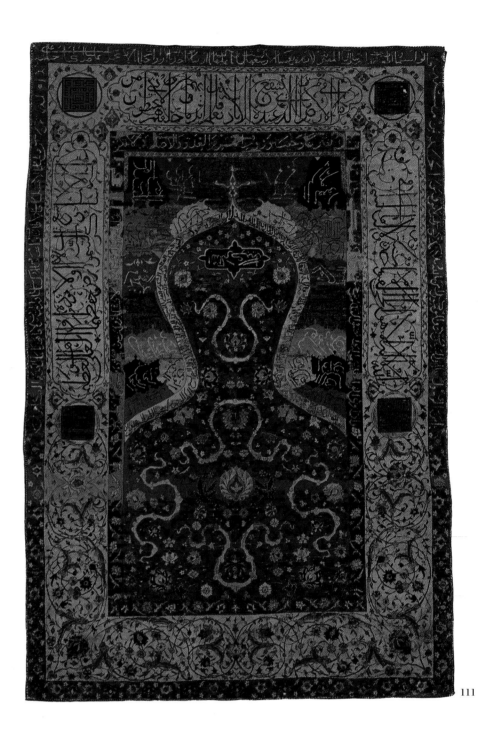

111

THE SANGUSZKO GROUP

Similarities in the flowing line, the border
pattern, and the palette have caused a certain
number of designs to be linked to the San-
guszko group, discussed earlier in relation to
Paradise Garden carpets. This class poses a
problem inasmuch as several pieces once clas-
sified as Sanguszko – including a repeating-
cartouche carpet owned by the Duke of
Buccleuch and Queensberry and, in Berlin,
the Cassirer medallion and animal carpet
with the paired-fish border – do not form a
homogeneous ensemble. Moreover, according

*111. Prayer rug. Persia, 16th century. Wool pile
with silver brocading. Metropolitan Museum of Art
(Fletcher gift), New York. Safavid prayer rugs
feature not only the horseshoe arch, known from
miniatures since the Mongol period, but also
inscriptions, generally taken from the Koran or
other devotional literature and knotted in wool or
brocaded in metal thread. The calligraphy is
usually confined to the upper part of the field, to
the spandrels and border as well as around the
niche. The provenance of the important prayer
rugs in the Topkapi Museum is the subject of
considerable debate, since many of them show
color schemes associated with the Salting group
(see figure 114, page 143).*

to May Beattie, the pieces show minor differences in weave, which may indicate they were woven elsewhere than in than Kerman.[171]

THE SALTING GROUP

Made of wool on a silk foundation, Salting carpets are very densely woven, with a knot count often in excess of 10,000 asymmetric knots to the square decimeter. They are normally embellished with brocaded inscriptions in metal thread. The designs found in the Salting group represent a range of ideas which flourished during the Safavid period, especially the central medallion enhanced by flora and fauna on a ground of arabesques, with the field surrounded by an inscribed cartouche border. The inscriptions intended for secular use are taken from Persian poetry, while those on prayer rugs are Koranic and often specifically Shiite.

Sir George Salting's Gift

A particularly fine example is the carpet from which the Salting group takes its name, a work donated by Sir George Salting to the Victoria and Albert Museum. Its scalloped central medallion, a finely rendered circular motif, appears on a field of spiral tendrils interspersed with lotus blossoms and ribbon cloudbands, paired birds, and animals in combat. The surrounding cartouche border is inscribed with a silver-brocaded ode from the *Diwan* of Hafiz on the pleasures of love, wine, and the garden.[172] Among other well-known specimens are rugs in the Thyssen Bornemisza Collection (ex collection von Pannwitz) in Lugano, the Musée des Arts Décoratifs in Paris, the Stieglitz Museum in Saint Petersburg, and the David Collection in Copenhagen. A less well-known piece, in the Musée Historique de Tissus in Lyons, represents the Paradise Garden, with houris placed symmetrically around a pool within the central medallion.

While most of the Salting rugs tend to be small, large ones are not unknown. They include the Marquand medallion carpet in the Philadelphia Museum of Art and the Baker

112

carpet in the Metropolitan Museum of Art. The New York piece, with its awkwardly drawn circular medallion containing a square with projecting lobes decorated with cloudbands, is close in conception to the rug at the Musée des Arts Décoratifs (ex collection Goupil), although the peacocks appear within the pendants rather than in the lobes of the medallion. Also associated with the Salting group are numerous horseshoe-arch prayer

113

112. *Fragment of a saph carpet. Persia, 16th century. Wool pile, 4.30 x 2.70 m. Türk ve Islam Eserleri Müzesi, Istanbul. The saph is a prayer rug with multiple niches meant for collective worship in a mosque. Other fragments of the same rug are preserved at the Islamisches Museum in Berlin and in the Wher collection in Switzerland.*

113. *Muhammed Seated on a Prayer Carpet, with Adam, Noah, and David, a miniature from the Mir'raj Nameh. Herat, 1436. Bibliothèque Nationale, Paris. Although the form of the niche in the Timurid carpet depicted here is generally comparable to the one cited above, the designer of the later work made the pattern floral rather than geometric.*

rugs, many of which are preserved at Topkapi Palace in Istanbul. Some, but not all, of these share the silk foundation of the Salting group.

An Unusual Palette

What sets these carpets apart from others of the classical period is their color scheme, dominated by maroon-red, blue-black, light green, and/or a harsh shade of orange-yellow. It is a palette which leaves something to be desired. Not remarkably satisfactory either is the *ton-sur-ton* shading common to many of the rugs, with the choice of pink on maroon

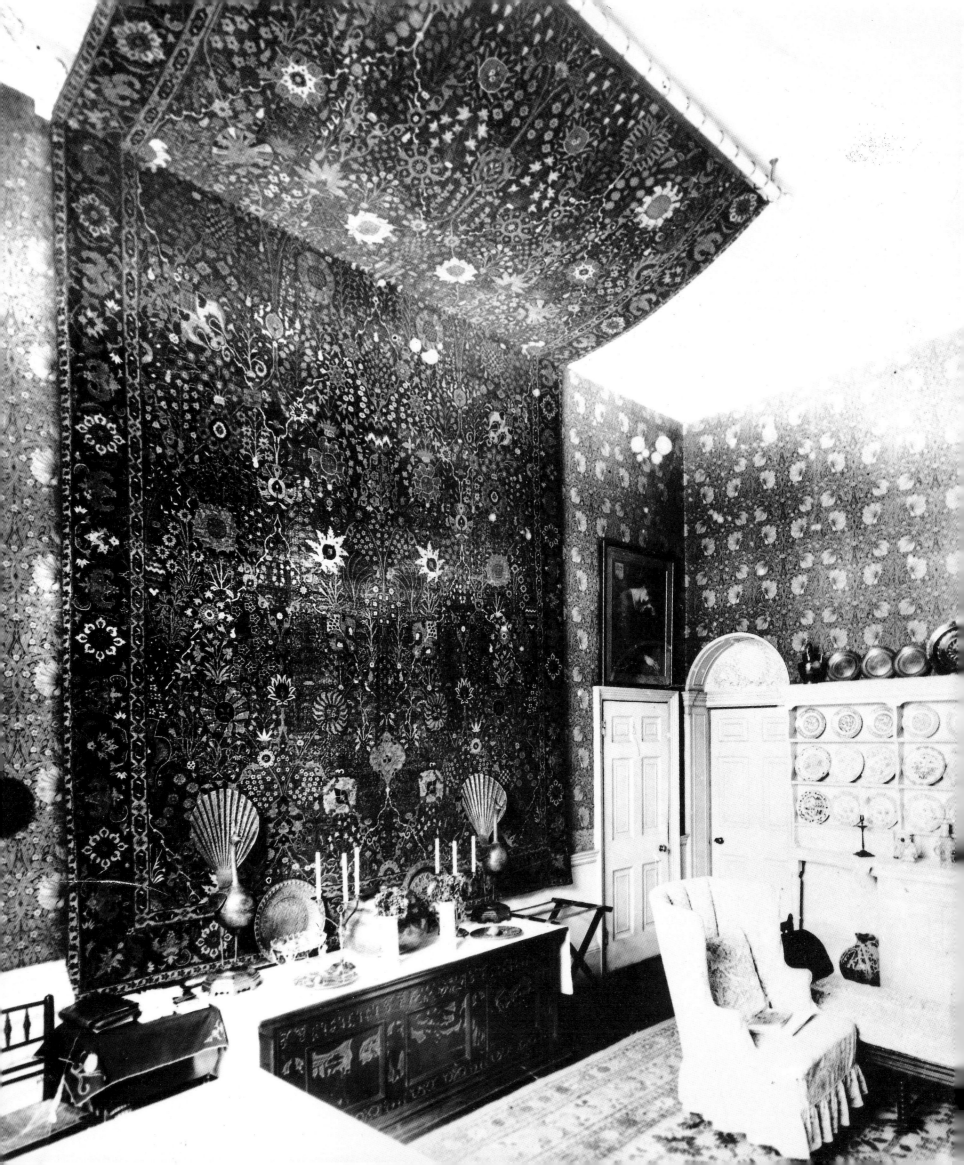

FLORAL CARPETS

Carpets with floral patterns make their first appearance in miniatures halfway through the 15th century. By the 17th century they tend to edge out hunting scenes and medallion patterns. Safavid floral carpets may be divided into several groups:

- arabesque or vine-scroll and lotus-blossom patterns
- tree and shrub themes
- 'Polish' or 'Polonaise' rugs
- vase or 'Shah Abbas' carpets
- strapwork (wide bands of imbricated arabesques)

and *café au lait* on ivory posing a particular challenge to taste.

A Source of Controversy

The Salting group has long provoked impassioned and controversial debate. The unusually fresh colors, the unattractive palette, and the great number of examples formerly in the collection of the Sultan, and now in Topkapi Palace, led certain scholars, beginning with Erdmann, to infer that the rugs were early 19th-century copies made in Hereke for the Turkish court.[173] Subsequent research, however, yielded few clues allowing these pieces to be attributed to the Hereke workshop, whose production prior to 1890 remains something of an enigma.[174] Moreover, dye analysis performed on several of the prayer rugs in the Topkapi collection disclosed the presence of a shade of beige obtained from walnut, yellow from larkspur (*delphinium semibarbatium*), and a red shade from lac, all of which points towards a Persian rather than a Turkish provenance.[175] Even today, the Salting group offers a lively forum for debate, although general agreement has now been reached on certain points, namely that some pieces are of Persian origin, that more than one weaving atelier was involved, and that the class predates the 19th century.[176]

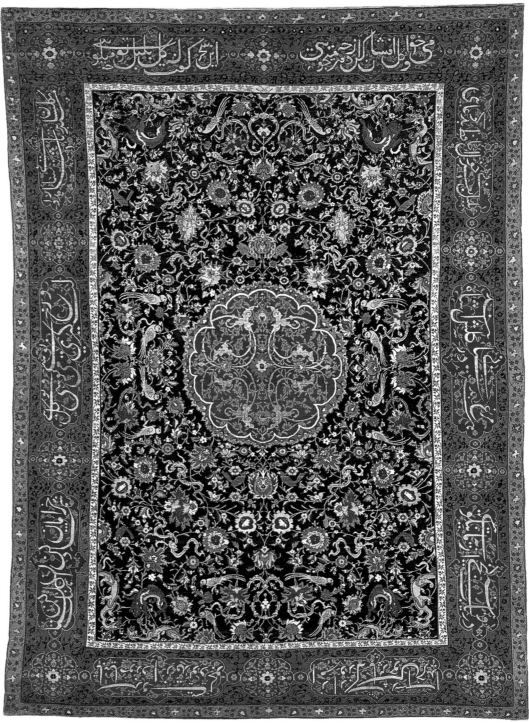

114b

114a. *Dining room at Kelmscott House, Hammersmith, London. 17th-century Persian carpet hanging from the ceiling. Residence of William Morris Gallery, Walthamstow, London.*

114b. *The 'Salting carpet'. Persia, 16th century. Wool pile with metal brocading. Victoria and Albert Museum, London. Named for Sir George Salting, who presented it to the Victoria and Albert Museum, this is the eponymous rug of the so-called 'Salting group', densely piled works with either a central medallion enhanced by flora and fauna on* a ground of arabesques or a prayer-rug pattern bordered in cartouches enclosing silver-brocaded inscriptions. They are also characterized by unusually fresh colors and a rather harsh palette, which, together with the great number of examples in Istanbul's Topkapi collection, have prompted certain scholars to infer that the Salting rugs were early 19th-century copies made in Hereke for the Ottoman court. However, the results of dye analysis performed on the Topkapi group point towards a Persian rather than a Turkish provenance.

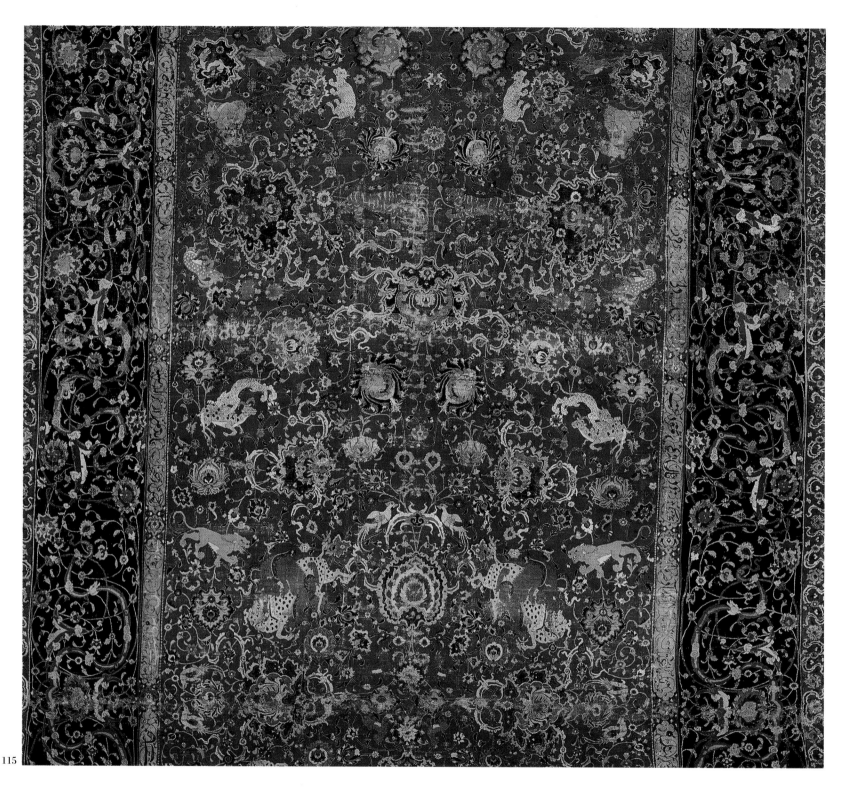

115

115. *Carpet with scrolling arabesques embellished with lotus blossoms, cloudbands, and animals. Persia, 16th century. Wool pile with metal brocading. Metropolitan Museum of Art, New York (formerly Rockefeller collection), New York.*
In this predominantly floral design, scrolling arabesques are disposed in an underlying grid arrangement, adorned with complex lotus blossoms, leaf palmettes, and foliage intertwined with ribbon cloudbands. Supplementing the system of delicate tracery are birds and prowling beasts shown either singly or in combat discreetly tucked

into the foliage. The arrangement of the lotus palmettes, an ancestor of the so-called herati *motif,* has caused this design to be dubbed the 'in-and-out-palmette' pattern. The rugs in the group to which the noble Metropolitan carpet belongs normally have a red field and a dark-blue or dark-green border.

116. *Carpet with a pattern of scrolling arabesques, lotus blossoms, and ribbon cloudbands. Isfahan, 17th century. Wool pile with metallic brocading. Musée des Arts Décoratifs, Paris.*

The underlying pattern of this rug is, for the most part, identical to the two preceding carpets. Although their origins are not known with absolute certainty, it would appear that pieces of this type – exported in great numbers to Europe beginning in the 17th century – were very likely woven in the workshops of Shah Abbas I in Isfahan. The many known variations of the pattern suggest that it may have been copied elsewhere, particularly in India.

FLORAL CARPETS

Miniature painting first takes account of floral carpets midway through the 15th century. In a miniature dated 1485 (Golestan Library, Teheran), Bihzad portrayed Sultan Husayn Mirza in a garden with a rug whose scrolling arabesque pattern is formed by spiral floriated stems laid out along the lines of a grid. The layering of the stems and the variations in their thickness create an illusion of depth. Interpreted in a multitude of different ways, the arabesque is fundamental to the Safavid carpet, either as a background for other ornament or as a decorative motif in its own right, the latter evident in the lotus and vine scroll, lanceolate leaf, strapwork, vase, and 'Polish' carpets. Other types of purely floral design – which during the 17th century tended to displace the medallion and hunting carpets in popularity – include tree, shrub, and lattice patterns. Small repeating flowering plants framed in a lattice are a feature of 16th-century Moghul art and thus may reflect Indian influence.

The evolution in style may be attributable to Shah Abbas, who undoubtedly imposed, or at least encouraged, the development of innovative designs in the newly established *kharkaneh*. At least one designer, Shafi' Abbassi, son of the painter Riza Abbassi, is known to have specialized in textile design, particularly floral designs and borders. He began his career under Abbas the Great but achieved his principal renown during the reign of Abbas II (1642-1667). It appears likely that after the death of the Shah, he emigrated to India, where he worked for the Moghul court.[177]

The Arabesque or Vine-Scroll and Lotus-Blossom Pattern

In this predominantly floral design, scrolling arabesques, also described as vine scrolls or spiral stems, are disposed in an underlying grid arrangement, adorned with complex lotus blossoms, leaf palmettes, and foliage intertwined with ribbon cloudbands. The lotus flowers and leaf palmettes are strategically placed in pairs, alternately affronted and addorsed, at the point where the spiral stems intersect in a lozenge-like configuration, leading May Beattie to dub it the 'in and out palmette design'. These rugs normally have a red field and a dark-blue or dark-green border.

A FUNDAMENTAL MOTIF: THE ARABESQUE

In an early version, which probably dates from the mid-16th century, the delicate tracery of a scrolling stem and palmette system is supplemented with birds and prowling beasts shown either singly or in combat, discreetly tucked into the foliage. The Metropolitan Museum owns a noble specimen, finely knotted on a silk foundation with a brocaded inscription on the inner guard stripe. Its companion piece can be found at the Österreiches Museum für angewandte Kunst in Vienna. Another fragment belongs to the Musée des Arts Décoratifs in Paris.

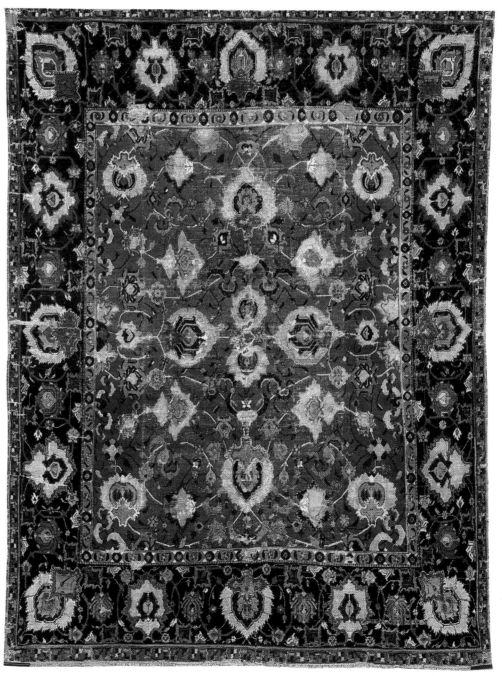

116

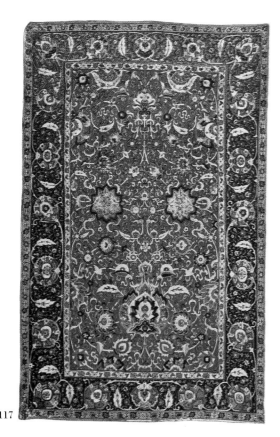

117

117. *Carpet with a pattern of scrolling arabesques, lotus blossoms, and ribbon cloudbands. Persia, c. 1600. Wool pile with metallic brocading. Shrine of Imam Reza, Mashhad, Iran. While the compositional elements are close to those in the preceding carpet, except for the animals, the variations in the treatment of the pattern allow it to be suggested that the two rugs came from different workshops. According to shrine officials, the piece seen here was a gift from Shah Abbas I himself.*

THE EARLIEST EXAMPLES

Two more stately carpets, these embellished with metal brocading, are in Berlin's Islamisches Museum (inherited from the Cassirer estate, destroyed during the last war) and at the Shrine of Imam Reza in Mashhad. The latter, according to shrine officials, was a gift from Shah Abbas,[178] which suggests that it and the Cassirer piece were probably made later than the New York and Vienna rugs. Since both the Berlin and Mashhad works lack animal motifs, they *a priori* lend credence to the theory that the lotus and vine-scroll patterns evolved from an earlier model with animals. However,

there is a marked contrast between the style of the Berlin and Mashhad carpets, characterized by large sickle leaves and complex lotus blossoms of Buddhist inspiration, and the style of the floral rugs with animals. It may eventually transpire that these carpets represent independent developments emanating from different workshops. Here we should mention that, in the view of A. Cecil Edwards, the rug commissioned by Shah Abbas for the Mashhad shrine was woven in the same city.[179]

TOWARDS A CERTAIN UNIFORMIZATION

By the mid-17th century the floral pattern had become standardized and was being exported to Europe in relatively large numbers, as proven by its regular appearance in paintings during the second half of the century. Although still handsome, these carpets do not bear comparison with their antecedents. Woven on a cotton foundation without brocading, the later examples are of a correspondingly lower quality. Also reduced are the dimensions, probably in response to demand, and the cloudbands are sometimes omitted. As the design coarsens, the lotus blossoms and leaf palmettes appear disproportionately large and often so awkwardly placed as to make it clear that the original design had been completely misunderstood.

Different Workshops?

When the floral rugs first appeared on the market midway through the 19th century, dealers attributed them to Isfahan. Martin was the first to debunk the theory, pointing out the relationship between the pattern and recent weavings from the Khorassan region. He was seconded by Pope, who unhesitatingly assigned the group to Herat. Ellis subsequently proposed that they had been copied in India, which led them to be dubbed 'Indo-Persian'. Recently the Isfahan provenance has been reconsidered,

given that the designs, although dissimilar in color, frequently resemble the 'Polish' rugs now thought to have been made in that production center. The fact that the so-called *herati* motif,[180] common in modern Persian rugs, must have originated at Herat, as implied by the name, lends credence to the Martin and Pope hypotheses. Each of these theories probably contains an element of truth. The popularity of the pattern among European and Indian clients undoubtedly incited other workshops to emulate it, which would explain the nuances in color as well as the variations in structure and design.

Tree and shrub carpets

The inspiration for an appreciable number of tree and shrub patterns may be traced to earlier prototypes, particularly the Paradise Garden carpets. A set of fitted silk rugs, made for the mausoleum of Shah Abbas II in Qum, was visibly made from cartoons drawn by a court artist. So finely woven they could be mistaken for velvet, the Qum pieces are decorated with small-scale, carefully rendered flowering plants and trees, mostly cypresses, each of them isolated and surrounded by a narrow cartouche border. On some of the rugs, but not all, tiny birds perch in the trees. The horn brackets cradling the cypresses (symbols of eternity), the bright greenish-turquoise ground (color of the heavens), and the tiny double-doored gate of heaven placed discreetly near the border on one rug reveal the Qum set to be a continuation of the Paradise Garden tradition. Despite their different designs and the absence of metal brocading, a leading scholar has linked these carpets to the 'Polish' group on the grounds of their similar color schemes. One piece is signed and dated by the master weaver Ni'mat Allah (or Bi' Matullah) of Jawshaqan in the year 1661.[181] While the floral sprigs of the Qum set are not without recalling Moghul carpet ornament, another type of tree carpet conveys the immobile quality of a Timurid miniature. A superb

17th-century example, in the Philadelphia Museum of Art, presents a field adorned with several species of trees, mostly prunus and cypress arranged in transverse rows. Similar designs survive in the later models ascribed to Kurdistan and Kerman. While tree and shrub carpets tend to be entirely floral, they may on occasion be enlivened with small paired birds perching in the trees or highlighted by small medallions.

The So-called 'Polish Rugs'

When a remarkable silk carpet richly brocaded in metal thread and emblazoned with the arms of a noble European family appeared in Paris at the Universal Exhibition of 1878, it was erroneously assumed that the five heraldic shields were those of its onetime owner, Prince Czartoryski. This justified the further assumption that the rug and pieces like it were of Polish origin. The original 'Polonaise' rug was later acquired by John D. Rockefeller, who gave it to the Metropolitan Museum. Inasmuch as the arms remain unidentified, while the group's Persian manufacture has been established, the term 'Polonaise' or 'Polish' becomes a misnomer even though it has proven ineradicable. By the 17th century, pile carpets were in fact being fabricated in Poland, but they differ from those of Persian provenance in design, color, and technique.

Large quantities of Polish carpets, products of the *kharkaneh* looms, made their way to the West during the 17th century. Approximately 230 examples are presently extant in Western collections, some of them the result of diplomatic gifts. One of five pieces preserved at the Treasury of San Marco in Venice was a gift to Doge Marino Grimani from Shah Abbas in 1603. Most of the pieces, however, were purchased by traders. The 'Coronation' carpet in Copenhagen's Rosenberg Castle, so-called because it was used when Frederick IV was crowned King of Denmark in 1701, is recorded as having been a gift from the Dutch East India Company to Queen Sofie Amalie in 1666.

Early specimens of Polonaise carpets date to the first part of the Shah Abbas period

and, for the most part, constitute variations on floral patterns, complete with fields of scrolling arabesques surrounded by borders composed of split arabesques or repeating palmettes and sickle leaves. Examples are in the Czartoryski collection at the National Museum in Cracow and the Liechtenstein

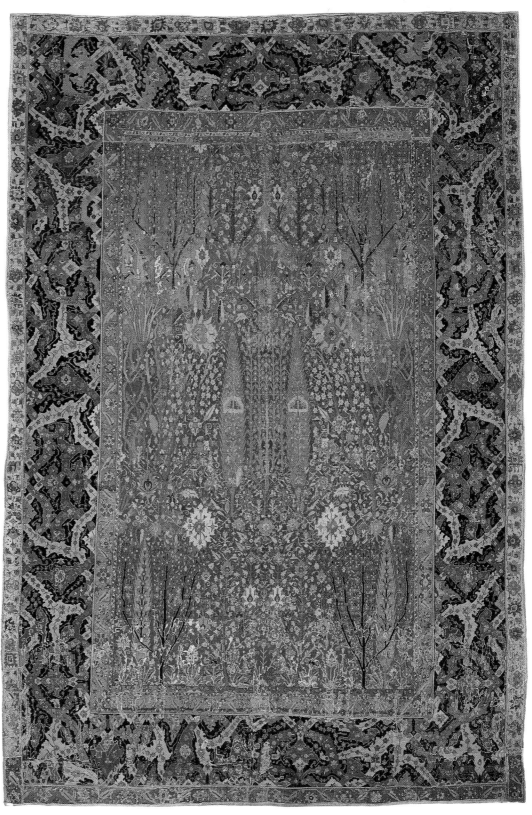

118

118. *Carpet with a tree pattern. Persia, 16th-17th century. Wool pile. Philadelphia Museum of Fine Arts (collection Joseph Lee Williams). Here, the field adorned with several species of trees, mostly prunus and cypress arranged in transverse rows, conveys the immobile quality of a Timurid miniature. The theme overall harks back to the ancient dream of the Paradise Garden.*

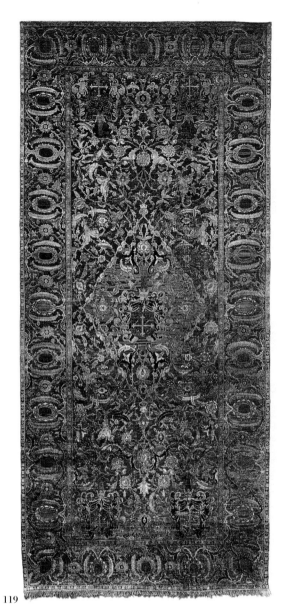

119

119. 'Polish carpet'. Persia (probably Isfahan),
early 17th century. Wool pile with metal
brocading. Metropolitan Museum of Art
(Rockefeller gift), New York. When this
remarkable silk carpet, richly brocaded in metal
thread and emblazoned with the arms of a noble
family, appeared in Paris at the Universal
Exhibition of 1878, it was assumed that the five
heraldic shields were those of its onetime owner,
Prince Czartoryski. This justified the further
assumption that the rug and pieces like it were of
Polish origin. The group's Persian manufacture
has now been established, although the arms
remain unidentified, but the term 'Polish' or
'Polonaise' remains in use, a misnomer which is
nonetheless ineradicable.

Gallery in Vienna. Another representative
piece is one of a pair formerly in the Ker-
vorkian and Mikaeloff collections. Polish
types may also be highlighted with cloud-
bands or endowed with one or more medal-
lions, quatrefoils, or compartment-like
schemes. Some are characterized by wide
bands of arabesque set off by a ground of
contrasting colors or by an allover pattern of
repeating palmettes or sickle leaves.

WOVEN FOR THE TRADE Generally piled in
silk, although sometimes in wool, Polish rugs
are less finely woven, on a cotton foundation,
than many classical Safavid carpets. Even the
finest examples rarely exceed 3,500 knots per
square decimeter, a low density relative to
that of some examples previously cited. Such
a knot count signifies trade pieces rather than
unique works made for court patrons. What
distinguishes them from their counterparts is
the unusual color scheme. Whereas Persian

carpets are, on the whole, richly chromatic,
most Polish rugs are woven in pastels, with
deeper reds and blues reserved for accents. A
combination of apricot and lime green is com-
mon, together with shades of yellow, pink,
orange, beige, mauve, and pale turquoise. It
has been suggested that the color scheme is a
concession to European taste. While the
ground of many Polish carpets is frequently
brightened by a shimmering abundance of
metal brocading, this feature is not systemati-
cally present throughout the group. Such
variations in technique tend to reinforce the
hypothesis that more than one workshop was
involved, with Kashan, Jawashaqan, and
particularly Isfahan most frequently cited.

Vase or 'Shah Abbas' Carpets

The vase, an ancient motif connoting the life-
giving water it contains, is associated with the

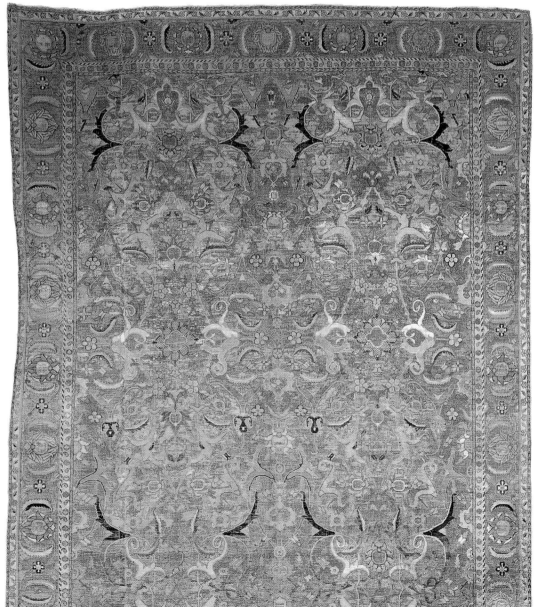

120

Assyrian fertility cult. A mural painting in the Mesopotamian palace of Mari, destroyed by Hammurabi in 1760 BC, depicts a goddess bearing an overflowing vase, symbol of the fertility of the twin Tigris and Eurphrates rivers. The vase filled with wine or fruits also played an important role in Turco-Mongol court etiquette, signifying a mark of high honor when held by a prince in front of a guest or, vice-versa, as a sign of respect and submission.

The reader will have noted that vases appear on a number of Safavid carpets, including the Chelsea, 'Darius of the Universe', and Baker carpets seen earlier. Somewhat confusingly, this motif is absent from the majority of rugs identified with the 'vase' group, which embraces several types of pattern. The primary feature is a tracery of slender undulating stems which intersect to form ogives or, in later pieces, a diamond lattice. Most commonly, vase carpets have complex layouts, with up to three stem systems, layered over one another in varying degrees of thickness to create the illusionistic effect of depth, on a ground of luxuriant foliage composed of large complex blossoms and lily-like flowers. Bouquets may erupt from one or two vases placed irregularly in the field. Quite a few variants are known. Among the three-plane systems of stem lattices are the carpets in Berlin, Lyons, and Vienna. The Baltimore Art Museum owns an example with a two-plane ogival lattice formed by arabesques or

120. *'Polish carpet'. Persia (probably Isfahan), early 17th century. Private collection. A great many Polish rugs, all essentially variants of the floral pattern, were exported to the West beginning very early in the 17th century. Whereas Persian rugs are generally characterized by sumptuous color, most of the Polish carpets are woven in pastel shades, with vivid tones used only for the accents.*

121. *Carpet fragment in the 'vase' pattern. Kerman, 17th century. Islamisches Museum, Berlin. Oddly enough, the main feature of the 'vase' group is not the eponymous vessel, which is absent from most vase carpets, but, rather, a tracery of slender undulating stems which intersect to form ogives or, in later pieces, a diamond lattice.*

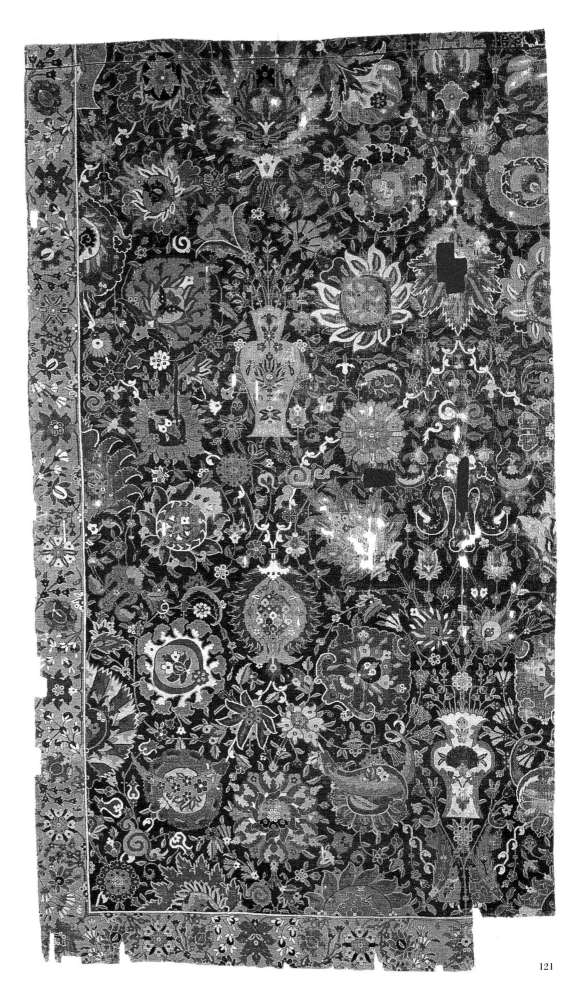

121

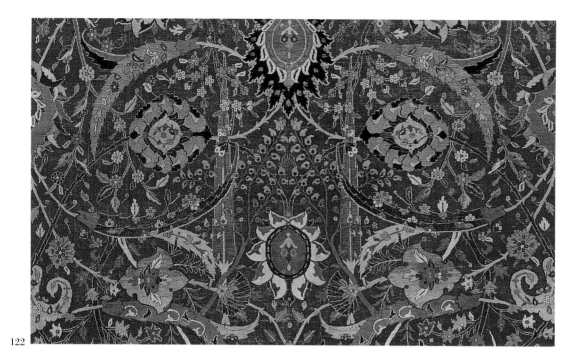

122

122. Detail of the 'Corcoran Throne' carpet. Kerman, late 16th century/early 17th century. Wool pile. Corcoran Art Gallery (on loan to the Textile Museum), Washington, D.C. (See also the full view on page 154.)

123. Detail of a carpet with the 'strapwork' pattern. Isfahan, mid-17th century. Wool pile, 2.65 x 1.93 m. Corcoran Art Gallery (Collection William A. Clark), Washington, D.C. The 'strapwork' pattern, which is yet another version of arabesque, comprises an endless repeat of broad bands of solid color overlaid with a delicate tracery of floral stems and lotus palmettes, generally on a red ground. Although this type of decoration figures in 16th-century Persian miniatures, particularly as dome, tent, and canopy ornament, it appears to have served primarily as a border motif until the 17th century.

leaves with serrated edges on a ground of contrasting colors. As for the single-plane lattice containing flowering shrubs and plants, a good example is the variant owned by the Kunstmuseum in Düsseldorf. Occasionally, the design is overlaid with repeating cartouche ornament, as on the piece in the Sarajevo Museum. Borders of the vase group, in keeping with the long formats, tend to be narrow, with a standardized repertoire of designs, featuring wide arabesques known as 'strapwork', reciprocal split arabesques, or vine tracery embell-

ished with alternating blossoms and sprigs of flowers.

The first vase rugs are known as the 'Shah Abbas' patterns, since they probably date from the eponymous monarch's reign. For many years these carpets were attributed to Jawshaqan, but recent research has revealed their technique to be characteristic of Kerman. Two dated pieces are known. One is the Sarajevo carpet, a section of a shaped carpet woven to fit the shrine of Ni'matallah in Mahan, a town southeast of Kerman. Curiously, it bears two dates, one signed in AH 1047 (AD 1637) by the master weaver Mu'min, son of Qutb al-Din of Mahan, a town near Kerman, and the other a chronogram interpreted as AH 1056 or 1066 (AD 1645 or 1656). A second dated piece, in the Iran Bastan Museum in Teheran, presents a single-plane lattice design enclosing leaves and flowers, as well as a signature and the date 1758 woven by the master craftsman Mohammad Sharif Kirmani.[182] The technique particular to the vase group will be described in connection with the rugs of the Kerman provenance.

Trapwork Carpets

The so-called 'strapwork' pattern, yet another version of arabesque, comprises an endless repeat of broad bands of solid color overlaid with a delicate tracery of floral stems and lotus palmettes, generally on a red ground. Controlled by an underlying grid system of floral scrolls with affronted and addorsed palmettes which meet and intersect, the design principle is identical to the lotus and vine-scroll system already discussed. Surviving examples in woollen pile are those at Hamburg's Museum für Kunst und Gewerbe (ex Tabbagh collection), the Corcoran Art Gallery in Washington, D.C., and the Cincinnati Art Museum, as well as in two collections in Bijapur. Silk specimens include the carpet at the shrine of Imam 'Ali in al-Najaf in present-day Iraq and a fragmentary piece in the Victoria and Albert Museum. While most of these patterns respect the grid's underlying symmetry, others do not, among them the carpet in Cincinnati. Another variant, and a particularly beautiful one, is depicted, thrown over a table, in a portrait of Don Francisco Lopez Suasso, painted, after Nicolas Maes, by an anonymous Dutch artist in 1688.

Although this type of decoration figures in 16th-century Persian miniatures, particularly as dome, tent, and canopy ornament, it appears not to have served primarily as a border motif until the 17th century. An early manifestation of its presence in the field can be seen in an embroidered silk cope signed by the court artist Djan Mohammed and now preserved at Vienna's Österreiches Museum für angewandte Kunst. Among the provenances advanced for the group are not only Herat and Isfahan but also India, where no less than three of the seven recorded woollen rugs have come to light. There is, however, some justification for believing that the earliest designs originated in Abbas the Great's capital, where they would have been created by a master working for the *kharkaneh*. Significant in this regard is the relationship between the design and the ceramic ornament on the dome of the Lutfallah Mosque

KASHAN

Famous as the center of the silk industry, Kashan also enjoyed a high reputation for its calligraphers and ceramists, as well as for its velvets and certain large-format court carpets. Also attributed to 16th-century Kashan are four groups of small-format rugs, identifiable by the following patterns:
- rows of animals arranged either singly or as groups,
- a central medallion with corner quadrants,
- medallions combined with animal combats,
- a quatrefoil medallion framed by a band.

In addition, Kashan produced remarkable silk kilims brocaded in metal thread. They were particularly admired by the French, who used them as models for fine tapestries woven at the Gobelins atelier. Even today, Kashan remains an important center of carpet production.

in Isfahan, completed in 1629. Also relevant is the fact that the monarch is known to have offered a vast two-part silk carpet in a strapwork pattern to the Imam Ali's shrine.[183] Moreover, the weave is similar to that of the Polish rugs, copiously produced in the city.

Among the other centers producing versions of the strapwork motif should be counted Kerman and the Kurdistan. An example from Kerman, this one enlivened with capering animals, and two versions of the angular type, these woven in the Kurdistan during the 18th century, are preserved at the Metropolitan Museum in New York.

Kashan

Kashan is famous as the center of the Iranian silk industry, but also as one of the great centers of the decorative arts, whose inhabitants enjoyed considerable renown for their calligraphers and ceramists. Yet Kashan was chiefly renowned for its production of velvets, and its carpets have the same velvety quality. Merchants who thronged the city heaped praise on the velours, but also on the silks and brocades, the flatweave and pile

carpets, brocaded in metal thread. John Cartwright, an Englishman who visited the city at the dawn of the 17th century, reported that 'the people are very industrious . . . especially in weaving Girdles and Shashes [sic] in making Velvets, Sattins, Damaskes, and very good Ormuzenes and Persian Carpets of a wonderfull finenesse . . . in a word, it is the very Magazeen and Warehouse of all the Persian Cities for these stuffes.'[184] To accommodate the many foreigners who flocked to the city to trade, a caravanserai was erected during the reign of Shah Abbas I. Immense wealth flowed in from commerce with India, whose merchants called crimson-ground silk carpets 'Kashanis'. In exchange, the Persians imported from India the shade of red insect dye known as 'lac' or 'laq' or even 'lake'.

Kashan probably had a carpet-weaving workshop well prior to the establishment of the *kharkaneh*, as suggested by the Emperor's hunting carpet. A noted scholar has recently dated this piece, as well as a group of small-format silk carpets commonly

believed to have been woven in Kashan, to the reign of Shah Tahmasp.[185]

Less than twenty small silk Kashans are presently inventoried. The designs are classified according to four main patterns. One has rows of animals arranged either singly or as groups in a directional pattern, like the Metropolitan Museum's Altman carpet and the Louvre's Peytel rug. A centralized medallion layout set off by corner quadrants is more usual however. Some of the medallion pieces, like the beautiful ones in the Musée des Gobelins and the Metropolitan Museum, are entirely floral, with quatrefoil medallions enlivened with either *tchi* or ribbon cloudbands. Another subgroup, which includes the Gulbenkian piece and a fragment in the Musée des Arts Décoratifs in Paris, features medallions combined with animal combats. A fourth subgroup, also entirely floral, displays a quatrefoil medallion framed by a band, as in the piece owned by the Metropolitan Museum. The shape of the quatrefoil medallion provides a link with the large-format rugs assigned to Kashan. Borders abound in

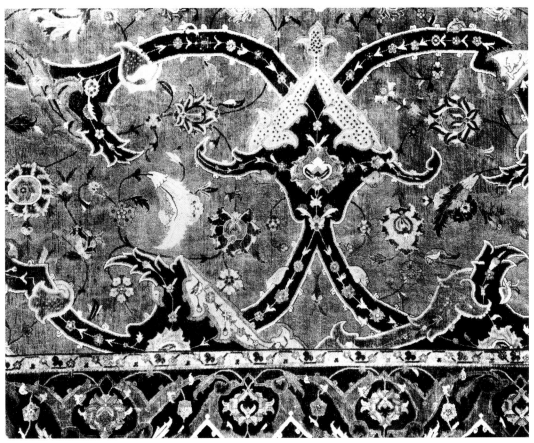

123

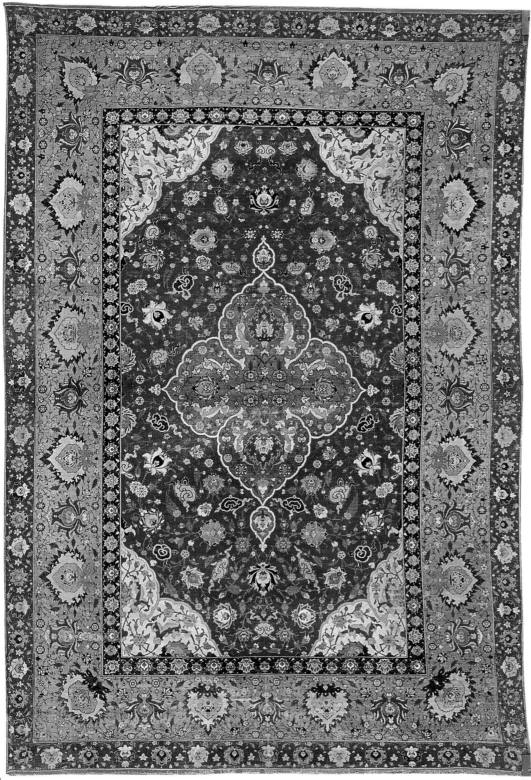

124

paired animals or birds, masks or houris. With the exception of the Louvre example, which has a blue ground, most carpets in this series boast a crimson field, frequently in combination with a particular shade of moss green. While virtually all the rugs have silk pile, the Paris rug proves an exception, being woven in wool on a foundation of bast fibers, probably jute, which would also have been imported from India.

Kashan was also famous for its production of silk kilims brocaded in metal thread. In 1601, Sigismund Vasa III, King of Poland, sent his court purveyor, an Armenian merchant named Sefer Muratowicz, to Kashan with instructions to order carpets and personally superintend their execution. An invoice in the Warsaw archives dated 12 September 1602 bills the monarch for six carpets worth from 39 to 80 crowns each, plus 5 extra crowns for the weaving of the royal arms. A rug in the Residenzmuseum in Munich, bearing the arms of the Vasa kings as well as a floral medallion and corner quadrants, is believed to be one of the surviving pieces. Kashan silk kilims were also highly prized,

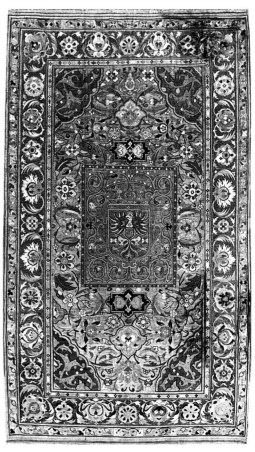

125

124. Carpet with a floral medallion. Kashan, mid-16th century. Silk pile. Mobilier National, Paris. This magnificent rug, with its centralized medallion layout set off by corner quadrants, its crimson field combined with shades of moss green, is typical of the small-format rugs made in Kashan, a city with a distinguished history of silk production.

125. Carpet with a floral medallion and the arms of the King of Poland. Kashan, 1601-1602. Flatwoven. Residenzmuseum, Munich. This kilim, or tapestry-woven rug, is believed to have been one of several pieces commissioned from Kashani weavers by the King of Poland, who sent his court supplier to supervise the work.

especially by the French, who used them as models for the fine tapestries made by the Gobelins weavers. A famous tapestry commemorates the visit made by Louis XIV in 1667 to the newly founded Gobelins workshop in Paris, one of the Sun King's most cherished projects. In the foreground, rumpled on the floor, is a brocaded silk kilim from Kashan virtually identical to the carpet in the Residenzmuseum.[186]

Kerman

Notwithstanding Marco Polo's admiring praise of the Kermanis' weaving skill, little is known of the Kerman carpet production prior to the 16th century. Until Abbas I pacified the warring Zulgadr and Afshar tribes who controlled southern Persia, anarchy prevailed in much of the region.

Rugs from Kerman were nonetheless highly prized during this period, for Shah Abbas I is reported as having offered Kerman rugs embroidered in silver and gold to the Ottoman envoy. Further, Akbar's biographer Abu'l Fazl mentions Kerman among the four centers that continued to export rugs to India after the Moghul workshops had been established. Nor did Kerman escape the eye of the Europeans. Thus, Engelbert Kaempfer, a contemporary, remarked upon the woollen carpets with animal designs from this provenance, which he saw during a reception in Isfahan in 1684. Two more 17th-century merchant-travelers – the Chevalier Chardin and Jean-Baptiste Tavernier – vouched for the fact that quality rugs were made here. Both, however, thought even more highly of the rugs woven in the neighboring province of Sistan, which prompted Tavernier to declare that the carpets of Suryan were 'the most beautiful in Persia.'[187]

Thanks to the pioneering research undertaken by May Beattie, carpets can now be assigned to Kerman on the basis of technique, which allows a number of unattributed designs into the Kerman fold. In terms of touch, the Kerman rug, with its double-warped structure, would seem to possess a particularly sturdy texture; however, the technique conceals an inherent weakness.

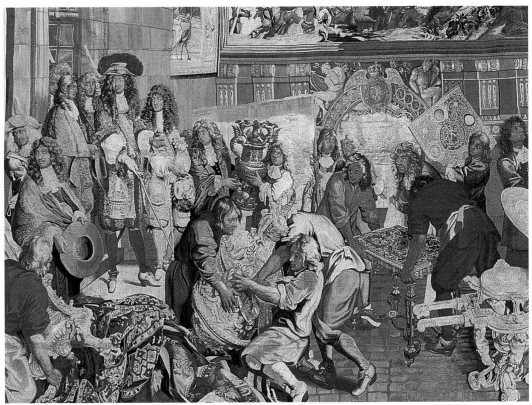

126

The cotton warps are held together by three picks of weft, the first and third in wool so tightly pulled that the warps are separated into two levels. The second sinuous weft is sometimes in silk but more commonly in cotton. Since the fabric is separated into two levels, it is the second wefts in contact with the ground which take the brunt of the wear, causing the fibers to break and expose rows of loose warps on the back of the rug.[188] The number of colors normally exceeds twenty, a rich palette that includes unusual shades, such as rust, rusty orange, and bright pink.

126. Charles Lebrun. The Visit of Louis XIV to the Gobelins. France, 1667. Tapestry. Musée des Gobelins, Paris. This superb tapestry was designed and woven to commemorate the Sun King's visit to the Gobelins manufacture in 1667. Crumpled up in the foreground is a metal-brocaded silk kilim from Kashan, a work virtually identical to the one in the Residenzmuseum in Munich.

Curiously, no structural analysis of a Kerman carpet has yet disclosed the presence of metal brocading.

Dr. Beattie's research also revealed a much wider range of patterns than hitherto thought possible from a single workshop, suggesting that a similar reality may hold true for other manufacturing centers, to which conventional wisdom assigns only one or two basic models. As the attentive reader will have noted, the designs made here include compartment, Paradise Garden, garden, shrub, strapwork, and prayer carpets, in addition to the vase rugs, which now lend their name to the Kerman process, known as the 'vase technique'. Among the more unusual models identified with this center are the Philadelphia Museum's carpet featuring a stepped-lozenge medallion and animal com-

KERMAN

The Kerman rug, with its double-warped structure, would seem to possess a particularly sturdy fabric. The double warping, however, leaves every second, sinuous weft, a weft of silk or cotton, unduly exposed to the floor, where it takes the brunt of the wear, causing the fibers to break and place the warps at risk. Kerman rugs have an unusually rich palette, often with more than twenty colors.

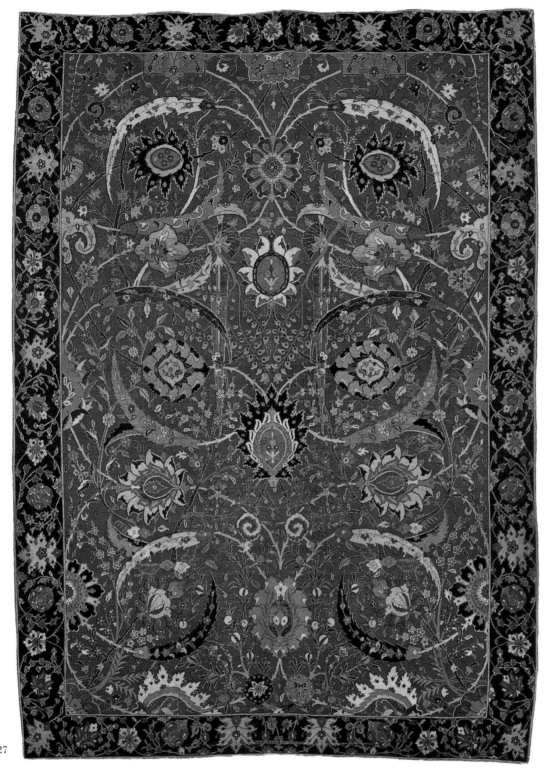

127

127. *The 'Corcoran Throne' carpet. Kerman, late 16th century. Wool pile, 2.65 x 1.95 m. Corcoran Art Gallery (Collection William A. Clark; on loan to the Textile Museum), Washington, D.C. This carpet, woven with the 'vase technique' (the Kerman double-warped structure), boasts a forceful design of sweeping arabesques and sickle leaves with a pair of cypress trees barely visible among the foliage.*

128. *Fragment of a rug with a floral lattice pattern. Jawshaqan, 18th century. Wool pile. Victoria and Albert Museum, London. This design, also known as the 'Jawshaqan tile pattern', is one of the few now attributed to Jawshaqan, once a great city and a major carpet-weaving center.*

bats, together with a reciprocal border, and the elegantly drawn rug known as the Corcoran Throne carpet, now on loan to the Textile Museum in Washington, D.C., from the eponymous gallery. In the Corcoran piece, a forceful design of sweeping arabesques and sickle leaves dominates a pair of cypress trees barely visible among the foliage. A related work, which lacks the cypress trees, belongs to the Gulbenkian Foundation in Lisbon.

Isfahan

In 1598 Shah Abbas I moved his capital from Qazvin farther south to Isfahan, a city embellished with a central *maidan*, or square, laid out as a polo track. With its surrounding buildings and gardens, including the Ali Qapu Palace, the Masjid-i-Shah mosque, and the Chihil Sutun pavilion (erected during the reign of Abbas II), the ensemble is one of the supreme achievements of Iranian art. For once we have a precise description of the *kharkaneh*, recorded by Jean-Baptiste Tavernier who, after visiting the manufacture in the mid-17th century, noted that it stood just south of the Ali Qapu and extended from the Maidan back towards the Chihil Sutun. Abbas the Great, a monarch known to have been skilled at weaving, must have enjoyed making impromptu visits, inasmuch as a secret door leading to the Treasury also gave access to the workshops, situated on one side of a large courtyard.[189] The warehouse full of the finest materials, gathered from all over the kingdom to await distribution to other centers, and the importance of Isfahan as a trade center, a center dominated by the Armenian community, have already been noted.

More than one chronicler has evoked the pomp and ceremony of the Isfahan court. Tavernier describes the Audience Hall of the palace, in which carpets constituted the principal furnishings: '. . . the floor on which one walks is covered with rich carpets of gold and silk made expressly for these premises. . . .' The King effected a majestic entrance followed by thirteen eunuchs and two venerable elderly gentlemen, whose sole task was to remove the royal slippers, as the party arrived in the chambers furnished with silk

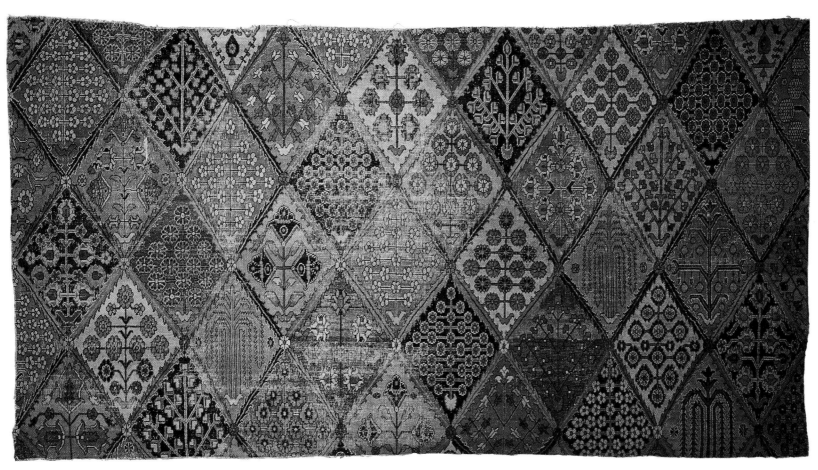

128

and gold rugs, and then return them to the sovereign's feet at the time of departure.

Jawshaqan

Summer watering place of the Safavid aristocracy, Jawshaqan is situated slightly to the northwest of Isfahan, at the point where the mountains reach the plain. Pope and Ackerman, in their monumental work of 1939, attributed a huge number of designs to Jawshaqan, including the vase group, shrub, tree, and lattice patterns, certain of the Polish rugs, a tree and animal carpet in the Residenzmuseum, and the series of silk carpets made for Shah Abbas II's tomb, one of which, it will be recalled, is signed by a Jawshaqani weaver. A few more patterns, including those of the sickle-leaf and palmette class, were tentatively attributed to the center. Pope's theory was later contested on the grounds that the present town is too insignificant.

Among the models that are conceded to Jawshaqan, which is still weaving a descendant of the pattern, is a single-plane lattice design, each lozenge containing a stylized

ISFAHAN: SPLENDORS OF A 17TH-CENTURY CAPITAL

Jean-Baptiste Tavernier, a European traveler in 17th-century Iran, describes the Audience Hall at the Isfahan court, where carpets constituted the principal furnishings: '. . . the floor on which one walks is covered with rich carpets of gold and silk made expressly for these premises. . . .' [190]

A MAJOR EXPORTER During the 17th century, Persian rag-weaving standards remained high and exports to Europe and India continued by the shipload. The production included pile carpets with lotus and vine-scroll patterns, as well as 'Polish' and strapwork designs, and silk tapestry-weave carpets. Tavernier observed another design in use in the palace, although it was not necessarily made locally. During an official reception, the Shah was seated on a podium in the Audience Hall, behind which was draped a carpet decorated simply with reli-

gious quotations. According to Raphael du Mans, father superior of the Capuchin mission in 1660, the pile carpets, though beautiful, brought in less revenue than the '*toiles d'or, d'argent faictes... par figures de soye comme à haute lice, en quoy l'on travaille icy en Hispan à merveille . . .*' [191]

After the capture of Isfahan by the Afghans in 1722, the weavers perished in the ensuing famine, and the art of silver and silver-gilt brocading died with them. The silk-weaving industry revived briefly during the reign of Fath Ali Shah (1798-1834), only to be overwhelmed by foreign competition. Yet in one domain the Iranians maintained their supremacy, and that was the hand-woven carpet. Carpet looms, which numbered very few in 1877, had increased to thirty thousand by the end of the century, becoming the most important aspect of the Iranian textile trade.

sprig or plant. Known as the 'Jawshaqan tile pattern', this design is reported to have been popular in India during the 17th century, although most surviving examples are probably no earlier than the late 18th century. The design was copied by tribal weavers within the area.

In fairness to Pope, it should be admitted that carpet scholars seem to have veered from one extreme to the other. Jawshaqan – or to give the town its full name, Jawshaqan Qali, i.e., 'Carpet Jawshaqan' – was according to Abu'l Fazl, one of the four great weaving centers that supplied the 16th-century Moghul court. Its importance during the reign of Shah Abbas as a supplier of silk and gold carpets has already been noted. Nor is the diminished size of the present town a valid argument, given that a 19th-century photographer en route to Isfahan from Kashan observed the ruins of the once great city. It is to be hoped that future research will redress the balance.

THE 18TH CENTURY

A Moment of Decline

The beginning of the 18th century brought a period of political upheaval during which decline set in, following the overthrow of the Safavid dynasty and the occupation of Persia by Afghan invaders. Order returned briefly under Nader Shah Afshar (r. 1736-1747), a Turkoman leader who established his capital to the north of Mashhad. Further years of anarchy came in the wake of his assassination, until the Kurd Karim Khan Zand (r. 1750-1779) declared himself regent in Shiraz in the name of the Safavid Shah Ismaël III. The Zand dynasty was brutally eliminated by Aqa Mohammed Qadjar, chief of one of the Turkoman tribes, who proclaimed himself Shah in 1786. Based in Teheran, the Qadjars remained in power until 1925, but their reign may be equated with general political decline.

Unabated internecine strife is hardly propitious to the development of the textile industry. Tribal weaving survived as a cottage industry, evidence of which is a report, made

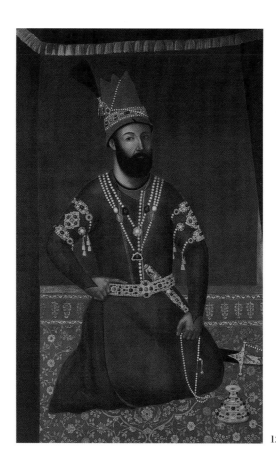

129

in 1847 by the British Consul in Teheran, stating that the Yomut Turkoman women and tribespeople around Shiraz, Ravar, and Kerman practiced this craft. But the production of the state manufactures was seriously affected by a drop in demand, which had economic as well as political causes. The slump was due to the Afghan occupation, of course, but also to foreign competition, particularly from the British and French whose Axminster, Wilton, Savonnerie, and Aubusson enterprises had moved in to fill the gap. Only two vouchers for Oriental carpets corresponding to the period 1719-1750 are preserved in the records of the British East India Company at the Bandar Abbas (Gombroon) trading post.[192]

The number of surviving carpets bearing an 18th-century date is sufficient to prove that some of the manufactures continued to function, despite the turmoil. Yet, with certain notable exceptions, the period has been neglected by most scholars, and it remains a fertile field for research. F.R. Martin informs us that Nader Shah Afshar displaced the best artisans, with the result that the Safavid tradition was perpetuated in the region circum-

scribed by Jawshaqan, Kermanshah, Hamadan, and Sultanabad, which wove designs normally associated with other workshops. In view of the fact that good design has the habit of migrating anyway, this hypothesis is not entirely satisfactory and requires further elucidation. A more plausible reason for the increased importance of Kurdish workshops during the 18th century may be that the Zand dynasty was of Kurdish stock. Karim Khan Zand, an enlightened monarch, reorganized the economy, but he also took an enthusiastic interest in the arts and letters, giving the crafts a new lease of life during his reign.[193]

Simplified Designs

Hunting carpets assigned to the 18th century tend to be characterized by their somewhat stylized drawing and primitive composition. Although still aesthetically pleasing, they cannot compare with the refinement of their forebears. Moreover, the small formats and naïve style lend credence to the notion that the supervision of a skilled master craftsman may no longer have been present. Patterns tend to be directional rather than organized around a centerpiece. The animal combats and trees are generally disposed in pairs on either side of the median axis, somewhat haphazardly, as in the carpets at the Metropolitan Museum in New York and in the Wher collection, or aligned in symmetrical rows, an

THE DECLINE OF THE PERSIAN EMPIRE

The early 18th century brought political upheaval and decline:

1722: The fall of the Safavid dynasty and the Afghan occupation of Iran.

1736-1747: Order temporarily restored under Nader Shah Afshar.

1747-1750: Three years of anarchy.

1750-1785: The Zand dynasty established by the Kurd Karim Khan Zand.

1786-1925: The Qadjar dynasty, under which Iran suffered gradual political decline.

example of which belongs to Heinrich Kirchheim. Since many of these rugs are woven with the symmetrical knot, they may have originated in Kurdistan, but also in the Azerbaijan or the Caucasus.[194]

An elegant series of garden carpets, also woven with the symmetrical knot, hails from Kurdistan. Less charged with floral motifs than their predecessors, the *Chahar Bagh* plan nevertheless remains unchanged. A vast piece measuring over nine meters long is in the National Museum in Kuwait, while another is in the Burrell Collection in Glas-

129. Portrait of Nader Shah. *Mid-18th century. Victoria and Albert Museum, London. The sovereign, who brought a brief period of stability to troubled 18th-century Persia, is shown kneeling on a medallion carpet with* herati *motifs.*

130. *Carpet with repeat floral pattern. Khorassan, 18th century. Wool pile. Victoria and Albert Museum. This work illustrates the transition from the old vine-scroll and lotus carpets to the so-called* herati *pattern with its small repeating floral motifs.*

131. *Carpet with a floral pattern. Northwest Persia, 18th century. 2.82 x 1.36 m. Musée Jacquemart-André, Paris. The design is a variation on the later* herati *and* minakhani *patterns.*

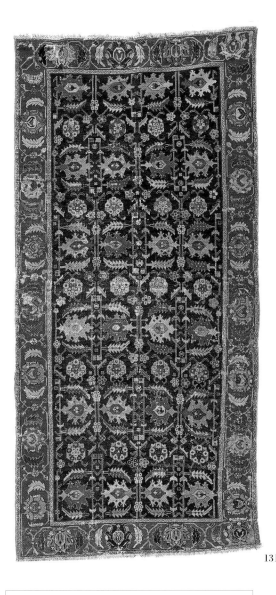

131

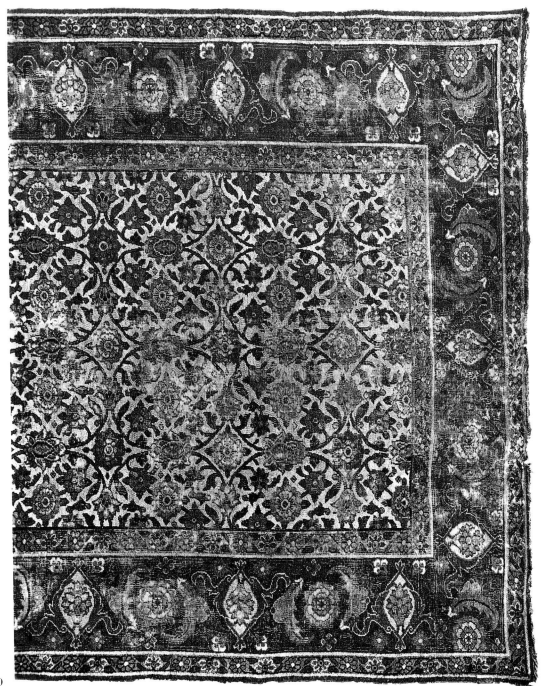

130

SIMPLIFICATION OF MOTIFS

Beginning in the 18th century, Persian carpet designs display stylized drawing and rather primitive composition. While aesthetically pleasing, they cannot compare with the refinement of their forebears. Moreover, the small formats and naïve manner lend credence to the idea that skilled master craftsmen may no longer have been present. Patterns, rather than organized around a centerpiece, tend to be directional, with pairs of motifs disposed, somewhat haphazardly, on either side of the median axis.

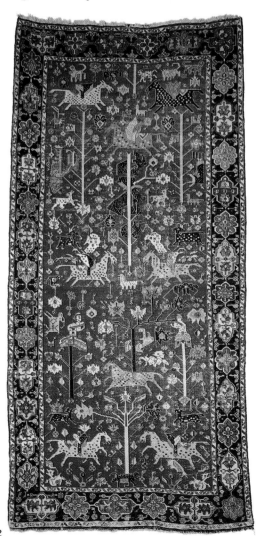

132. *Carpet with a hunting theme. Persia, 18th century. Wool pile. Metropolitan Museum of Art, New York. While not in the same league with their 16th-century forebears, the Persian rugs of this period do not lack for charm. The small formats and naïve style lend credence to the notion that the supervision of a skilled master craftsman may no longer have been present.*

gow. The fragments of a third piece are dispersed between the Wher collection and the Musée des Arts Décoratifs in Paris, while the Islamisches Museum in Berlin owns an example woven at a later date. A brightly colored, stylized version of the von Hirsch lattice garden carpet is in the Burrell Collection. According to Jenny Housego, vivid colors, replete with greens, yellows, and pinks, were in vogue during the Zand period.[195]

Attractive versions of tree and shrub patterns, rather stiffly drawn, were made in Kerman, Jawshaqan, and Kurdistan. Like the hunting carpets, these tend to be organized in repeating vertical or staggered rows, as in the carpets owned by the Metropolitan Museum and the L.A. Mayer Institute in Jerusalem. A colorful floral carpet, formerly in the Kevorkoff collection, reveals an interesting amalgam of motifs, derived from earlier tree, vase, vine-scroll and lotus, and sickle-leaf patterns, the whole surrounded by a cartouche border. Kerman and Kurdistan produced attractive variants on the strapwork pattern. Examples of strapwork carpets, one a Kerman rug with gamboling animals and two with angular stylizations originating in Kurdistan, are in the Metropolitan Museum.

The 'Herati' Motif

Several carpets are representative of the transition between the earlier vine-scroll and lotus carpets and the *herati* pattern. Khorassan rugs, renowned for their fast bright colors,[196] frequently display small repeating designs. One version is decorated with a regular composition of rosettes and leafy stems linked to the later *mina khani* patterns, while another has the affronted and addorsed palmettes framed by pairs of serrate-edged leaves from which the *herati* motif derives. The Victoria and Albert Museum owns a carpet woven in Khorassan, similar to one on which Nader Shah is portrayed in a contemporary painting. The monarch is shown kneeling on a medallion carpet superimposed on a herati field surrounded by a border depicting a row of shrubs. Another carpet, this one at the Musée Jacquemart André in

Paris, could also be attributed to the Khorassan on the basis of its herati design alone; yet the presence of the symmetrical knot shows it to have been woven in northern Persia.

Few carpets may presently be assigned to Shiraz. Because Nader Shah introduced Indian craftsmen, Persian art during the Zand dynasty was subject to influence from India. This, in addition to the fact that the Qashqai tribe weave a related design, has prompted Jenny Housego to make a tentative attribution of the Victoria and Albert Museum's prayer rug in the Moghul *mille-fleurs* pattern to Karim Khan's capital.

Kerman Put to the Sack

Fraught with unrest, Kerman suffered terrible depredations during the 18th century. The city was sacked, and the Qadjars are said to have sold twenty thousand Kermanis into slavery and blinded twenty thousand more in revenge for having sheltered the heir to the Zand throne. Even taking into account a certain amount of exaggeration, the advent of the Qadjars evidently had devastating effects on the textile industry. In response to Western demand, Kermani weavers competed with the Kashmiris in producing Paisley shawls. Once the market for shawls collapsed, the governor made an effort to mitigate unemployment by reviving the carpet industry, with remarkable success. In the interim, the production of carpets, although greatly diminished, had not entirely ceased. The double-warped fabric remained the norm, but the first and third wefts are of cotton, rather than the wool of earlier pieces. Weavers continued to make the vase pattern as well as a single-plane lattice design similar to that of Jawshaqan. Examples are in the Burrell Collection and the Iran Bastan Museum, the latter signed by a Kerman weaver and dated AH 1172 (AD 1758). Among the new patterns were rugs with the repeating *boteh*, or Paisley, motif taken from the shawls.

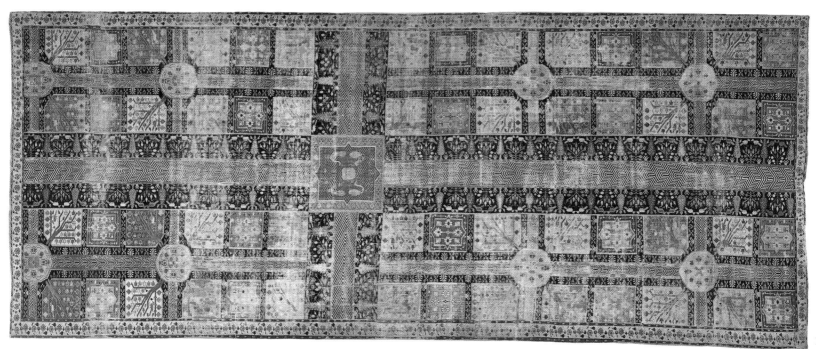

133

The Safavid Carpet as a Collector's Item

In the 19th century, the Iranian carpet industry took on a new lease of life, in response to demand emanating from the European bourgeoisie, newly enriched by the Industrial Revolution. Technical quality, which even today surpasses any hand-made carpet in the West, was at the outset controlled, to a great extent, by European firms, which often supplied the patterns. Traditional hunting, garden, and vase designs were revived, in the smaller formats made necessary by the interiors of city dwellers. Surviving Safavid carpets became collectors' items, with the result that, initially, historical studies were focused on these carpets, to the exclusion of less finely woven work from other regions. Today, the pendulum has swung in the other direction, to the point where research into the classical Persian carpet has now been somewhat neglected in favor of tribal rugs, more accessible to the purse of the contemporary collector. It is to be hoped that this brief overview will aid in reviving interest in one of the greatest achievements of Persian art.

133. *'Garden carpet' with the* Chahar Bagh *plan. Northwest Persia, 18th century. Wool pile. National Museum, Kuwait. Albeit less charged with floral motifs than in earlier works, the Chahar Bagh plan nevertheless remains intact even during a period of decline.*

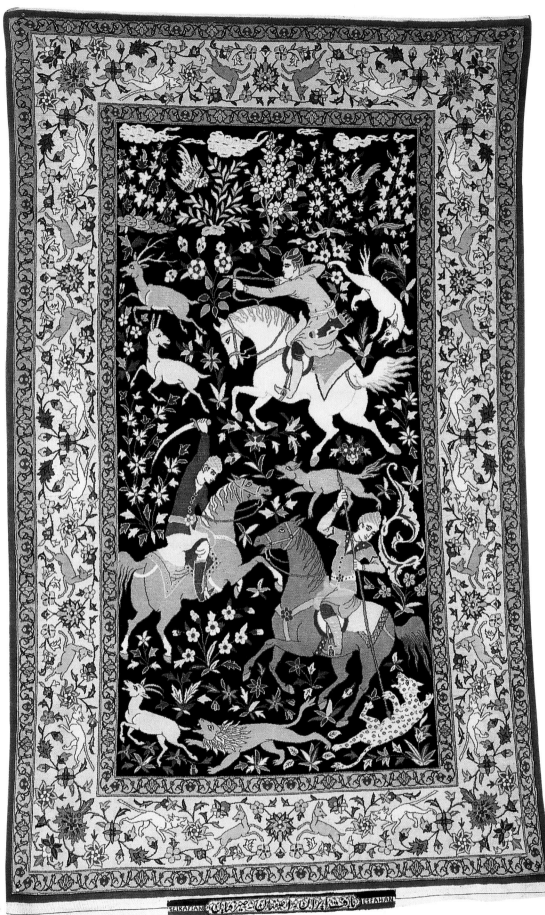

SE'RAFIANE ۱۵۱۰ اصفهان ۹۹۹۶ ۱ ISFAHAN

134

HOW TO IDENTIFY
A PERSIAN CARPET

Many Persian weavers, like their Tur-kish counterparts, are of nomadic des-cent, particularly Turkoman and Kurdish; as a result, some of the motifs which appear in modern rugs hark back to an earlier tribal tradition.

Technique

In the late 15th century, carpet weaving was transformed by the Timurids from a tribal craft into a high art, executed from cartoons supplied by court artists in urban workshops under the supervi-sion of master weavers. Sophisticated developments in technique, such as the use of silk for the foundation, meant that it was posssible to weave large-format carpets in remarkably intricate designs, either knotted in pile or flatwoven, fre-quently brocaded in silver or gold thread. Less luxurious pieces are woven in wool on a cotton foundation, which ensures a firmer weave. Two or three shots of cotton weft, or cotton alterna-ting with wool or occasionally with silk, is the norm. Selvedges are oversewn rather than woven.

Most Persian rugs are woven with the asymmetrical knot, although certain tri-bal and village weavers may use the Tur-kish, or symmetrical knot, as well as wool for the foundation. Some tribal rugs may also have details woven in silk pile.

The knot count of the classical Safavid carpet woven on a cotton or woollen foundation is rarely less than 2,000 knots per square decimeter, while those woven entirely in silk may reach 10,000 or more. A good quality modern woollen pile rug tends to have a knot count varying between 2,000 and 4,000 knots per square decimeter, but may have a good deal less. On average, ten to twenty colors are used, although the color scheme of tribal rugs may be less and court carpets may be more.

The Motifs

What sets the early Persian carpet apart from the Turkish is its figural decoration and garden themes taken from miniatures in ancient manuscripts. Needless to say, good design migrates, and so the Persian repertoire eventually ceased to be exclusive to Persian weavers.

The origin of many motifs can be traced to Chinese art of the Sung period, which Timurid artists sought to emulate: animals, birds, and mythical creatures, such as the dragon, the phoenix, and the *khi'lin* with flaming shoulders, the lotus blossom and cloudbands, the flaming halo. Interpretation of all such symbolic motifs should be approched with extreme caution.

Other designs inspired by nature or derived from earlier prototypes include symmetrical floral arrangements such as the *herati* and *mina khani* patterns, tree, shrub, and vase themes, repeating trellis and compartment compositions, as well as literal interpretations of the layout of the classical Persian garden.

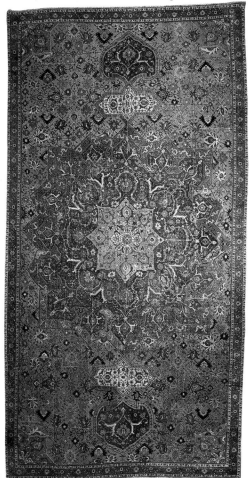

134. *Carpet with a hunting scene signed by Serafian. Isfahan, 1940. Sold at Sotheby's, London, on 12 January 1983. Modern Iranian carpets are both smaller and more realistically drawn than their predecessors, which no doubt reflects the influence of the Western market.*

135. *Carpet with medallions. Isfahan, 17th century. Private collection, Paris. Persians prefer designs with serial compartments or with central medallions set off by corner spandrels, more than the repeating patterns preferred by the Turks.*

The Problems of Identification

The luxurious weavings made in the urban workshops patronized by the monarchy, located in such towns as Tabriz, Herat, Kashan, Isfahan, and Kerman served to inspire local tribal and village weavers but also those farther afield, from Ottoman Turkey to Moghul India. The fact that carpet cartoons may have been dispatched from court workshops for execution elsewhere means that it is exceedingly difficult to assign Safavid carpets to specific places of manufacture.

Prior to the 1920s, when the Shah imposed the solar calendar, Persian weavers followed the Islamic lunar calendar when weaving dates into their rugs. Because of the slight difference in the way Persians write the figures, relative to Turkish practice, it is easy to modify the date by a hundred years merely by changing a few knots.

More Recent Carpets

Following the demise of the Safavid dynasty in the early 18th century, the quality of the drawing deteriorated, and dimensions tended to shrink, even though the designs retain a certain naïve charm. While recent products of Iran tend to be reduced in format compared with early pieces, their decorative repertoire, dominated by floral, medallion, and hunting scenes, remains essentially the same.

136. *Carpet with the bid majuun or 'weeping willow' motif. Bakhtiari (Fars), late 14th century. Sold at Christie's, Southwich House, Hampshire, on 18 October 1988. This design recalls the quartered Paradise Garden plan familiar in Persian civilization since time immemorial. Although still present in contemporary Persian carpets, the trees take their forms from 15th-century miniatures. The bid majnun motif is used by village weavers in northwestern Persia near Bijar, as well as by the Bakhtiari tribes living in the Fars region.*

In the 17th century European motifs began to infiltrate Persian art, becoming commonplace in the 19th century, when the Aubusson carpet frequently served as a source of inspiration.

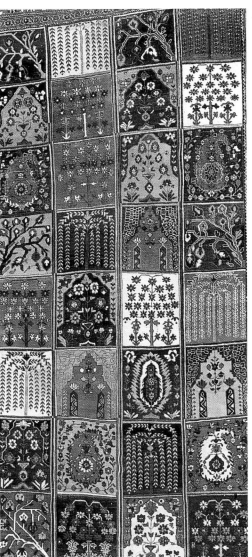

135

136

CHAPTER
V

POETRY AND
CARPETS:
THE CALLIGRAPHIC
ART IN THE
CARPETS OF IRAN

Aziyeh Ziai

Poetry in its various forms, oral as well as written, has always enjoyed an honored place in the lives and souls of the Iranians.

Calligraphy, an Islamic Art

Rooted in a long and rich tradition, deeply embedded in the collective memory, poetry has since ancient times overflowed into every aspect of Persian art and architecture. Not until the advent of Islam in Iran, however, did writing, and thus calligraphy, assume primacy over all other forms of artistic expression. Granted by the Koran, this pre-eminence of the pen (*qalam*), together with the absolute immutability of the Koranic text in all its details, made writing the first of all necessities and calligraphy the first of all the arts. The transmission of ideas and concepts in their different forms became one of the eternal and overriding preoccupations of those who lived on Iranian soil. Thus, despite its vast importance in pre-Islamic times, as witnessed by the magnificent Achaemenid inscriptions, the calligraphic art did not soar to quite such heights as it would later during the Islamic period.

Iran, Cradle of the Calligrapher's Art

It was in Iran above all that writing progressed, until the sheer vitality of its radiating influence permeated all manner of supports and objects. Writing very quickly found its way into the textile arts, including the art of rug design. The earliest known examples of woven calligraphy date from the 9th century, and they involve tapestries or carpets made in Persia. Unfortunately, only fragments survive with texts worked into them, usually Koranic verses. They are in Kufic, the oldest form of calligraphy, named after the city of Kufa, near Baghdad, where the script is thought to have originated. The Kufic used in the first specimens is decidedly austere and angular. Sometimes the calligra-

137

137. Dishes ornamented with birds. Nishapur, eastern Iran, 10th century. Painted ceramic. The color scheme of these bowls consists mainly of black and brick red on a cream ground. The profiles of the birds have been rendered as an affronted pair of linear scrolls. The inscriptions on Nishapur ware are often quite stylized, with the downward strokes of letters curled into exaggerated curves for the overriding purpose of creating aesthetic harmony.

pher, the date of the work, and the person who commissioned it are cited in the midst of a religious text or a verse from the Koran.

The First Carpets

Few carpets have come down to us from the pre-Seljuk era in Anatolia – the 13th century. Excavations carried out in a royal tomb (*kurgane*) at Pazyryk, in the Altaï mountains in southern Siberia, and others in Noin Ula and Lulan in Mongolia have brought to light samples of knotted-pile rugs.[197] Other fragments of pile rugs were discovered in 1967 at Shahr-i-Kumis in northeastern Iran, the site identified with Hecatompylus, one of the first capitals of the Parthians (3rd century BC-AD 3rd century).[198] Thus we know that knotted rugs existed at least as early as the Parthian age. Moreover, there are various historical accounts indicating that such artifacts were more numerous and their use more widespread than had been assumed.

The First Traces of Calligraphy

In the *Cyropaedia*, for instance, the Greek historian Xenophon (AD 430-359) cited the presence in Persia of carpets on which only the monarch was permitted to walk. Much later, after the Byzantine Emperor Heraklius had pillaged the city of Dastagird, in AD 628, he seized rugs made of a wool called *nakotapetes* in the booty lists drawn up at the time. At the very beginning of Islam, al-Mas'udi[199] described carpets with Persian inscriptions which decorated the palace of the Caliph al-Mustansir around AD 861. The Caspian province of Tabarestan alone supplied the caliphs with some six hundred rugs a year.[200]

Repeated Kufic inscriptions appear as well on other artistic supports, such as the pottery made between the 9th and 11th centuries at Nishapur or, farther east, in Transoxiana. Among such pieces are ceramic plates ornamented with majestic and stylized inscriptions, abstract forms expressing votive formulas and sometimes providing the name of the person who had ordered the ware.

The conventional, angular style of Kufic is occasionally found on the earliest Samanid (9th-10th centuries) and Buyid (11th century) textiles.[201] Here writing has become so abstract that the inscriptions are barely legible. The strokes of the letters (*alef*, *lâm*) lend themselves to the elaboration of elegant naturalistic forms, such as boughs, flower buds, curling foliage, or even the heads of animals and birds. These figures no doubt have their source in the artistic traditions of pre-Islamic Persia. Stylized animals were already present on pottery made at Susa (3500 BC), as well as on that of the Partho-Sassanians, a few examples of which can be seen at the Louvre in Paris.

This highly characteristic art of formal metamorphosis has been continuously practiced by Persian calligraphers, right into our own time. In their world a bird may reveal itself to be in reality a verse or a sacred word such as *bismillah*. The art involves a highly sophisticated kind of calligraphic play, which, while turning, curving, and pruning

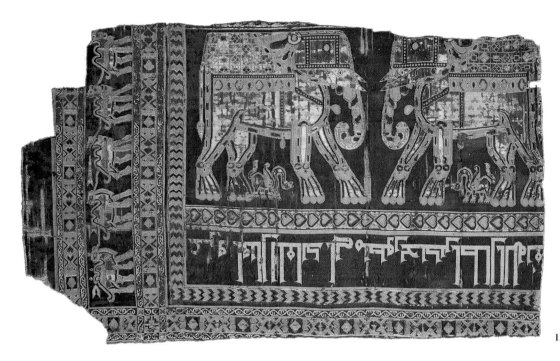

139

138

139. 'Shroud of Saint Josse'. Iran, 10th century. Silk and samite in three pieces; 0.52 x 0.94, 0.245 x 0.62 m. Louvre, Paris. This rare textile, from a reliquary once maintained at the ancient Saint Josse Abbey in northern France, is thought to have been brought back from the Orient by the brother of Godefroi de Bouillon, a leader of the First Crusade and the protector of the Saint Josse Abbey. The strict form of Kufic used for the epigraphic benediction allows it to be read without too much difficulty: 'Glory and happiness to Qa'id Abu Mansur Buhtegin, may God preserve him in prosperity.' The shroud thus offers a superb example of a blessing as it would have been calligraphed in eastern Iran.

138. Tile with animal motifs. Susa, 3500 BC. Painted terra-cotta. Louvre, Paris. On the pottery surviving from ancient Susa artists tended to seize upon a characteristic feature of an animal – the horns of the ibex, the necks of waders, the wings of birds – and elaborate it through calligraphic play until the image became so stylized as to pass from representation into virtual geometric abstraction. When repeated in a regular manner, the effect is extremely harmonious. This process of calligraphic metamorphosis continues to engage the Iranian aesthetic vision. A similar effect can be seen in the inscriptions on Nishapur plates, as well as on the textiles of the period, including the 'Shroud of Saint Josse'.

CALLIGRAPHY: AN ISLAMIC ART

Since ancient times, poetry has been deeply embedded in the Iranian soul, but only with the advent of Islam did writing and thus calligraphy assume primacy over all other forms of artistic expression. This pre-eminence of the pen was granted by the Koran itself.

the letters of a word or an entire verse, contrives to present them under the guise of a bird, followed by other animal forms, that of a lion, for instance. Realistic figuration, however, was avoided at all cost.

The Shroud of Saint Josse

One of the earliest examples of an ancient textile inscribed with Kufic writing is a rare silk fabric from the Khorassan; it has been dated to the 10th century and is now preserved at the Louvre as the 'Shroud of Saint Josse'. Unlike certain pieces of pottery and metal objects dating from the same period, this textile displays a stricter form of Kufic, which allows the epigraphic benediction to be read without much difficulty[202]: 'Glory and happiness to Qa'id Abu Mansur Buhtegin, may God keep him in prosperity.' The production of precious textiles – a very old tradition to which this piece belongs – is fully evident in the Sassanian era.

Another textile fragment, this one in the collection of the Metropolitan Museum of Art in New York, cites not only the name of its commissioner but also the date 879-880 and the place of manufacture, all in the angular Kufic script.[5]

The transformation of Kufic letters that occurred in 12th-century Khorassan, under the Seljuks, can be found on metal objects. Here, in certain instances, the writing not only succeeds in suggesting foliage; sometimes it also metamorphoses into the heads of a great variety of creatures: rabbits, snakes, lions, and even humans.[203]

The Great Seljuks, Patrons of the Arts

The 13th century brings us to the age of the Seljuks, the Turkish dynasty from Central Asia that conquered Iran at the beginning of the 11th century. It would endure a very long time, first in Persia and later in Anatolia. The Great Seljuks of Iran reigned over this territory as well as over Iraq from 1038 to 1194. It is important to note, however, that from 1150 to 1550 Persia and Anatolia constituted a single homogeneous culture. The official language of the court was Persian, and most of the Turkish tribes governing Iran were very conscious and appreciative of the artistic traditions already in place. The Seljuks, who must be counted among the greatest patrons of art and craft, encouraged the spread of new rug-weaving techniques. Quite particularly, however, it was the Seljuks of Central Asia who introduced new forms of weaving into Iran, only rare examples of which survive today.

Still, the few preserved fragments of Seljuk carpets reveal that Kufic script was regularly incorporated into borders. The strokes are extended into geometric hooks and branches which combine to generate a kind of rhythmic harmony. As a result, the letters lose a bit of their clarity and become somewhat hazardous to read. Within an overall geometric conception, the border contributes a design in the Kufic style, thus creating a harmonious effect with that of the main field.

From Kufic to the Naskhi Script

The basic composition of these Seljuk rugs comprises mainly rows of octagonal stars or rectangles at the center surrounded by two inside and outside bands with Kufic inscriptions serving as a border. The transformation of Kufic writing becomes clear once the more recent stylized broders are compared with the more ancient ones, such as the 'Shroud of Saint Josse'. The strokes of the Kufic letters are decorated with demi-palmettes or infinite knots either in a simple heart shape or in the more complicated Chinese version, which symbolizes fate. (To this

THE EARLIEST TRACES OF CALLIGRAPHY ON CARPETS

The earliest known carpets decorated with calligraphic elements date only from the 14th and 15th centuries, their presence confirmed by depictions in contemporary Persian miniatures. It has been established, however, that carpets inscribed in ancient Persian already existed in AD 861, at the dawn if Islam.

KUFIC SCRIPT

Kufic script, the oldest form of calligraphy, was used by the Arabs before the earliest date in the Muslim chronology. It is named after the city of Kufa, near Baghdad, where it is supposed to have originated. The Kufic used in the earliest woven specimens is decidedly austere and angular.

KUFIC, PSEUDO-KUFIC, AND NASKHI

Tenth-century Kufic is angular in form and highly legible. During the 12th century the script evolved, as calligraphers elaborated its terminals into vegetal motifs and the heads of animals. So-called 'pseudo-Kufic', derived from true Kufic, is an extremely stylized motif, meant to decorate rather than to convey a message. It would appear often in the arts of Persia, beginning in the 14th century. For texts conveying a message, Kufic was gradually replaced by the more cursive and readable *naskhi* script, a development that began as early as the 11th century. Then came *thuluth*, a grandly noble version of naskhi.

day the geometric Kufic border remains the one preferred in Transoxiana.) It was at the end of the 13th century that letters formed of animal and human heads disappeared. Kufic was then progressively replaced by a type of cursive writing known as *naskhi*, which is far more legible.[204]

Pseudo-Kufic

In 1380, Persia fell under the power of Tamerlane (also called Timur) and would subsequently be ruled by his successors. Thus began the Timurid dynasty, whose princes were munificent patrons of art and architecture. Unfortunately, only a few fragments of script survive from this period, but miniatures preserved in Timurid manuscripts depict a multitude of rugs. They show a border with Kufic script, which, although quite clear, remains illegible. The script is more the 'pseudo-Kufic' sort. The style of the overall composition derives from the Seljuk tradition, albeit with certain modifications.

Under Timurid patronage, the arts of writing, illumination, and bookbinding truly blossomed, to the point of becoming a very important factor in the designs and motifs adopted for carpets. The geometric pattern of the central field evolved into greater complexity, forming networks of crosses and rosettes, as can be seen in the miniature-filled *Shah-Nameh-e-Bâysonghori*, or *The Book of Kings for Prince Bâysonghor*. This masterpiece, dated 1430 (three years before the death of Bâysonghor), is preserved in the library at Golestan Palace in Teheran.

On the *Shah-Nameh-e-Bâysonghori* carpets, the Kufic border, reduced to a simple design, is composed of ornamental, stylized units, sometimes separate and free or else deftly tied together at the intersections of the rug's four corners. The pseudo-Kufic writing, needless to say, conveys no textual message, its purpose being entirely decorative. The absence of meaning in the Kufic borders of Timurid carpets poses several questions. Does it reflect an overriding interest in the purely visual, or could the inscriptions have been merely a simple extension of the old styl-

ized, affronted beasts, like those found on the oldest pile rugs, from Pazyryk, for instance, or from Fostat? Visual impact was undoubtedly the determining factor. As Edwin Binney III explained in 1973, 'Islamic calligraphers have continuously wrestled with the problem of bypassing the stark, "four-square" qualities of Kufic script. They evolved a flowery "variation" of it in which each stroke ended

140. *Page with a miniature painting from a Mongol manuscript. Il-Khan dynasty of Persia. Bibliothèque Nationale, Paris. Note the carpet and wall hanging with a medallion design and a palette of blue on a red ground in the upper part of the miniature, also, on the right, the phoenix illuminated in gold.*

140

141

in trefoils or other foliated decoration. The letters were thus used for their aesthetic value and illegible. One version was not even true writing but only "pseudo-Kufic".'[205]

The Art of Bookbinding

Around 1480, a new pattern, centered upon a medallion, made its debut in the Timurid miniatures. This composition, probably derived from bookbinding and the frontispieces of manuscripts, both of which featured a central medallion, the *shamsé*, emerged powerfully during the time of Behzâd, the celebrated miniature painter at the end of the Timurid era. That Western civilization would call the double frontispieces of manuscripts 'carpet pages' was not accidental.

141. *Frontispiece and binding,* Kalileh-o-Dimneh, *designed by Abul Ma'ali Nasrollah. Herat, AH 833 (AD 1429). Embossed and gilded leather, cardboard, parchment, paper, and colors. Bibliothèque Nationale, Paris. Calligraphed in* naskhi *script is a Persian distich composed by the binder to indicate that the book had been bound for the Sultan Jahangir.*

142. The Birth of Bahram, *from an album of Timurid miniatures. Herat, AH 833 (AD 1429). Watercolor and gold on paper, 18.2 x 10.6 cm. The carpet presents a central field patterned with latticed compartments.*

PRAYER RUGS AND RELIGIOUS QUOTATIONS ON CARPETS

Out of respect for the sacred, Islamic tradition forbade walking or sitting on rugs decorated with religious texts, except in the case of prayer rugs. Prayers and religious texts were woven into borders and frequently at the top of the rug around the *mihrab*. As for public prayer rugs used in mosques, they were

almost always simple and devoid of elaborated patterns. Meant quite specifically for daily worship, they invited the faithful to give themselves over entirely to religious meditation.

Rugs from the Timurid period display a cursive script, called *naskhi*, which represents a measure of progress in writing, from a complicated and barely legible style towards a style of greater clarity. Because of its readability, naskhi, which was already in use by the 11th century, increasingly became the script of choice.

Miniatures as a Visual Source

Kufic calligraphy finally gave way to naskhi, in manuscripts as much as in woven artifacts. One of the earliest known examples of a naskhi-inscribed prayer rug appears in a Timurid miniature of 1436.[206] A miniature from a version of Sa'adi's *Bustan* (*Garden of Pleasure*) offers a more recent specimen, datable to 1479. The scene shows Persia's great mystic poet – the Sufi of Fâryab – crossing the river on his prayer rug.[207]

Numerous instances of Koranic verses calligraphed on rugs and textiles attest to the fidelity of the Timurid sultans to Islam. One example, attributed to the painter Mansur,

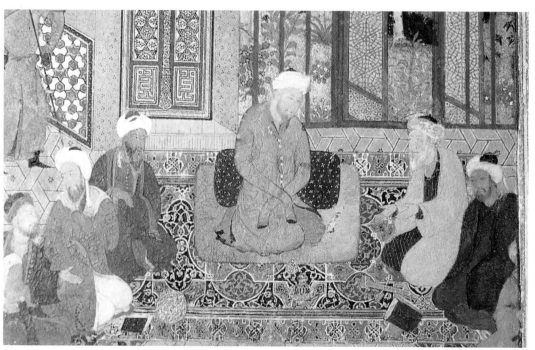

142

depicts the 'Coronation of the Sultan Hussein Bayqara' at Herat in 1469; here, on a green cushion at the center, appears an inscription in a bold *thuluth* style, the latter a more exalted version of naskhi, generally used on monuments and public places, or specially commissioned Korans. The inscription makes the declaration endlessly repeated by all the Muslim faithful: 'There is no other God than Allah, and Muhammed is His Prophet' (*Lâ illâh-i-ill'allâh, Mohammad rassoul i Allâh*).

In the course of the Timurid epoch, naskhi seems to have replaced Kufic, or pseudo-Kufic, at least on rugs, and the old sacred script abandoned altogether. The design of the pseudo-Kufic borders is thought to be based on Sassanian bas-reliefs.[208] Indeed, the stylistic and repetitive composition of pseudo-Kufic letters is actually rather close to the demi-rosettes of the Sassanian period. Ettinghausen has traced the origin of this motif to the 'long-short-long' strokes embodying the letters of the name Allah.[209] Nevertheless, there appears to have been a preference for iconographic details of a more precise kind.

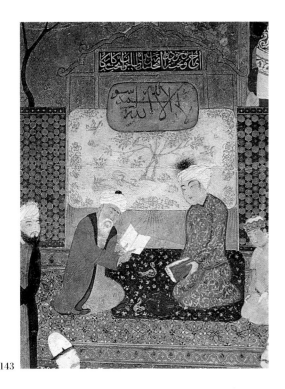

143

143. *Page from an album of Timurid miniatures. Persia, 1559. Bibliothèque Nationale, Paris. Scarcely any Persian carpets survive from the Timurid period, but contemporary miniature paintings show that the medallion design already existed by that time.*

144. *Mansur (attributed). Coronation of the Sultan Hussein Bayqara (Herat, 1469). Timurid Persia, 15th century. Art and History Trust Collection. Watercolor and gold on paper, 18.5 x 10 cm. On a* green cushion at the center appears an inscription in a bold thuluth *style, a more exalted version of naskhi. It repeats the declaration endlessly repeated by all the Muslim faitfhul: Lâ illâh-i-ill'allâh, Mohammad rassoul i Allâh (There is no other God than Allah, and Muhammed is His Prophet). Even the color of the cushion (green signifying the Prophet) asserts the devotion to Islam on the part of the Sultan, who thus exhorts his subjects to be similarly pious.*

144

Stylistic Evolution

Towards the end of the Timurid period, the composition of the central field became even more complex, showing 1) a grille- or lattice-like network dividing the ground into compartments, and 2) a design whose elements converge upon a central medallion. Both would recur later on Safavid carpets, the two innovations having no doubt originated in the influence flowing from iconographic elements used in frontispieces or on manuscript bindings. The composition with the convergent medallion had its antecedents in several examples of the frontispiece,[210] such as the one in the *Kalileh-o-Demneh* by Nizameddin Abul Ma'âli Nasrollah of Herat (AH 833/AD 1429).

Another example of a medallion carpet appears in a miniature entitled 'Audience granted by Timur in the city of Balkh on the occasion of his access to power in April 1370', by Ali Yazdi of Herat (AH 872/AD 1467-1468; Bibliothèque Nationale de France, folio 82v). It demonstrates the influence that various forms of art had on one another. A further case in point is an illustration in the *Negârestân*, a collection of Sufic prose and poetry, by Mohammad ibn Tchula'Guelan, al-Soghdi (11 Safar AH 1019/5 May 1610; Bibliothèque Nationale de France).

Poetry and Literary Symbolism

The importance placed upon rugs and the weaver's art during this period manifests itself in the poetic allusions and literary symbolism employed by the mystic poets, such as Sa'adi (1184-1291), one of the great bards of the late Mongol era (13th-15th centuries). Sa'adi begins his famous *Golestan* (*Garden of Roses*) with this allusion:

*Farrâch-é bâd-é sabâ râ gofteh tâ farche-é zomorrodine
begostarânade, va dâyehé-ye abré bahâri râ
farmoudeh tâ banâte
nabât râ dar mahd e zamin begostarânad.*

Thus did He order the servant wind blowing from the east

To spread a carpet of green,
and the spring clouds
To sow the earth with their soft
and sugared juice.

The reference is, of course, to God, who created the four seasons, and most particularly the spring, whence comes the rebirth of plant life, the flowering of trees, and the appearance of fruit.

145. Soltan Ali Mashadi (calligrapher) and Agha Mirak (miniature painter and illuminator). Page from the Golestan of Sa'adi. Persia, c. 1468. Watercolor, gold, and ink on paper. 18.5 x 10 cm. Art and History Trust Collection. Persian paintings and drawings like those seen here had a profound influence on carpet design. Chinese motifs, on the other hand, influenced both the pictorial arts and the art of carpet making in 15th-century Persia. China's phoenix appears in this miniature, beautifully rendered by the court painter Agha Mirak.

THE GOLDEN AGE OF THE PERSIAN CARPET

In 1502, Shah Ismaël Safavi (1487-1524) mounted the throne and established a dynasty which would endure more than 230 years, until 1732. He unified the whole of Persia, making it subject to a single set of laws and establishing the Shiite Islamic sect as the state religion.

From Mysticism to Politics

Shah Ismaël and the Safavids were descendants of Sheik Safi-ed-din, a famous 13th-century Sufi from Ardabil, which explains the name *safavi*, derived from *souf* meaning 'the garment of sackcloth of the sufis'. Under the Savafids, Persia recaptured the splendor it had lost following the overthrow of the Sassanians by the Arabs in the 7th century.

As a small Sufi sect, the Safavids lived at first according to fraternal principles based on Shiite beliefs. Later, they found it in their interest to forfeit Sufi mysticism in favor of

politics. As a result, the dynasty enjoyed a spiritually independent life even while governing at the very heart of Islam, thanks to its fervent embrace of Shiism in opposition to orthodox Arab Islam and Sunnism.[211] Shiism became an 'Iranian cultural phenomenon. Shah Ismaël considered himself the *tajalli*, that is, the mystic manifestation of God in human form. Most of all, he saw in himself the reincarnation of Ali, the imam, or infallible successor to Muhammed, venerated by the Shiites. Nevertheless, Sufism remained the leaven from which every political or artistic movement would draw its power. According to Dariush Shayegan, 'the Persian soul is evoked by countless images throughout its rich mystical poetry, which adds another dimension to the woven work.'[212]

The Safavid period was a time of great pride and glory for the Persians. The Safavids had learned much from their enlightened predecessors, the Timurids; they had even been profoundly inspired by them. True patrons of the arts, the Safavid kings sought out and encouraged every kind of talent: calligraphers, illuminators, miniaturists, designers, and weavers, all of whom worked side by side in the royal ateliers, an environment highly conducive to the exchange of ideas. The rug-weaving workshops became tremendously productive, sustaining a high level of creativity, in large part because of new patterns and better techniques. Royal patronage, which never flagged throughout the Safavid period, together with new prosperity, glory, stability, and political climate contributed to the flowering of talents in every artistic domain, especially in that of carpets. Furthermore, the most beautiful surviving examples of old Persian rugs date from this 'classical' period, frequently cited as the golden age of rug making.

Apogee of the Art of Carpet Weaving

The art of rug making reached its apogee during the reign of Shah Tahmasp Safavi (1524-1576) and, later, under Shah Abbas I (1587-1629), who was himself a skilled weaver.[213] These two monarchs created

THE COURT CARPET IN ITS GLORY

During the reigns of Shah Tahmasp and Shah Abbas I (1524-1629), Persian court artists carried the knotted-pile carpet to its ultimate glory. The two Safavid monarchs created numerous ateliers so as to encourage artists, weavers, and other artisans. Dedicated to fresh research and a new refinement, miniaturists, bookbinders, calligraphers, and weavers all worked together, sharing ideas and inspiration.

numerous ateliers so as to encourage artists, weavers, and other artisans. The surviving carpets attest to the high quality of the work produced in these workshops, which appear to have been dedicated to fresh research and a new refinement in both aesthetics and taste. Beginning with the reign of Shah Tahmasp, figurative art appeared on Persian rugs, adapted primarily from designs created by the great court miniaturists. Every motif is idealized, and every element becomes a visual symbol within an overall harmony. Quite justifiably, therefore, the rules of perspective have no relevance in Persian art, whether in miniatures or on carpets. Here it is the marvelous and the perfect that reign supreme.

In the royal workshops, the exchange of ideas and techniques among weavers, designers, calligraphers, illuminators, and bookbinders working side by side had a direct impact on the patterns for new carpets. Artists in different fields often used the same decorative elements. It was not unusual to find calligraphers or binders sharing the master weavers' animal motifs, such as those in the fantastic Chinese bestiary: the *lung ma* (wolf), the *khi'lin* (unicorn), the *simurgh* (phoenix, the mythological Persian bird derived from Chinese sources). They even exchanged the same motifs, such as arabesques and floral or plant imagery.

Early Scripts in Nastaliq

In miniatures, the *simurgh* became a decorative motif figuring in the margins of manu-

146

script pages as frequently as it does on the carpets. A beautiful example can be found on a page in a version of Sa'adi's *Golestan*, its leaves calligraphed by Soltan Ali Mashadi and illuminated by Agha Mirak. As for the calligraphy, it represented another of the period's innovations. A new style of script developed in the 15th century by the famous Timurid calligrapher Mir Ali Tabrizi was frequently employed on borders.[214] Under the Safavids,

146. *Faience tile panel from the mausoleum of Sheikh Nagami bearing the signature of the tile maker Haji Mahumud Vazin Shirazi. Torbat e Jam (Iran), AH 944 (AD 1537). Calligraphed in the noble, highly legible thuluth script, the existence of the signature proves the honor accorded this tile maker, who is distinguished by the world ostad meaning 'master'. Yet the art he practiced held a very modest place within the Persian hierarchy. The inscription reads: 'Work of the weak and humble ostad Haji Mahmund Vazin Shirazi.' The composition seen here, including the signature at the center of the medallion, is very similar to the pattern in the Poldi Pezzoli carpet (fig. 147). On the carpet the signature stands forth against a floral design, whereas on the tiles the background consists of a geometric pattern.*

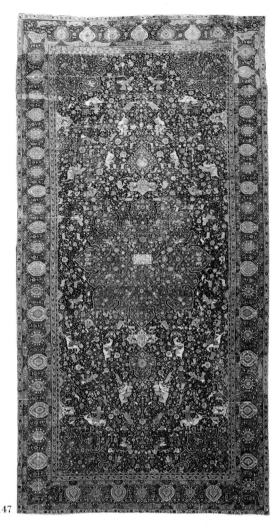

147

it would evolve further, thanks to such calligraphers as Soltan Ali Mashadi, Mir Ali Heravi, and Mir Emâd, who carried the style to its ultimate perfection. Nastaliq grew out of both cursive naskhi writing and one of its freer and even more elegant variations: *taliq*.

A PURELY PERSIAN CALLIGRAPHIC STYLE

As an essentially Persian form of writing, nastaliq was developed by calligraphers and used initially for great literary and poetic works. Only later did it become an ornamental feature in the design of carpets. Nastaliq, unlike Kufic and naskhi, would almost never be a vehicle for religious or Koranic texts. In fact, nastaliq, having been explored and cultivated by Safavid calligraphers, emerged as a form of art symbolizing an artistic movement committed to the expression of a national identity.

Until the advent of the Safavids, the calligraphic styles used on the few known exam-

147. Carpet with animal themes. Safavid Persia, AH 929 or 949 (AD 1522/1523 or 1543/1544). Wool pile, wool warp, silk weft; asymmetrical knot; 6.92 x 3.60 m. Museo Poldi Pezzoli, Milan. The art of weaving assumed such importance under the Safavid monarchs that for the first time weavers felt bold enough to sign their work. On the carpet seen here the master weaver not only signed his name, Ghiyath uddin Jami; he even took the liberty of singing his own praise, in a rhymed couplet placed at the center of the medallion: 'Achieved by the diligence of Ghiyath uddin Jami/This illustrious work attracts us by its beauty, in the year 929.' Surrounding the medallion is a menagerie of animal motifs, from the ever present simurgh, or phoenix, to mounted hunters galloping through a pattern of flowers and arabesques.

148. A Pair of Lovers in a Landscape, manuscript page. Early Safavid period. Bibliothèque Nationale, Paris. During the Safavid period, nastaliq script would replace Kufic and naskhi for all literary and poetic works. Here again, the art of the book had an impact on the art of rug weaving. The poetry is inscribed in polylobate cartouches around the main motif, just as on carpets.

149. Ardabil Shrine carpet. Signed 'Maqsud Kashani' (Maqsud of Kashan) and dated AH 946 (AD 1539-1540). Wool pile, silk warp and weft; asymmetrical knot; 11.28 x 5.34 m. Victoria and Albert Museum, London. The pair, unfortunately deprived of its main exterior border, is preserved at the Los Angeles County Museum of Art. The densely woven, and entire, piece at the Victoria and Albert comprises some 30 million knots. Both rugs carry the same inscription, which consists of the first hemistiches of a ghazal, or ode, by Hafiz, after which comes a modest signature by the Kashani master weaver Maqsud and the date. This most famous of carpets provides a supreme example of the excellence achieved by Persian weavers during the reign of Shah Tahmasp. The blue ground is ornamented with flowers, arabesques, and cloudbands around a predominantly yellow central medallion, encircled by sixteen projecting oval medallions and flanked by a pair of mosque lamps. Before its acquisition by the V & A in 1893, the Ardabil carpet had long been preserved at Iran's Ardabil Shrine dedicated to Sheik Safi-uddin Ardabili, a native of Ardabil and the founder of the Safavid dynasty. The polylobate central medallion mirrored the design of the dome under which the rug originally lay, just as the lamp motifs corresponded to the shrine's own lamps. This interplay between the 'vault of heaven' and its earthly reflection in the carpet medallion evinces the underlying mysticism of the Safavid era. It was during this period that nastaliq script was first used on Persian carpets, in keeping with the language of Persian mystical poets.

ples of Timurid rugs were first Kufic and then naskhi. The material they conveyed consisted of religious texts or epigraphic dedications. It was on Safavid carpets that nonreligious verses, and only verses, were transcribed for the first time in Persian and in nastaliq. On 'royal' carpets, the poems reproduced in nastaliq would always, during the Safavid

148

period, be embroidered in silver or gold thread and often on a light-toned ground. The effect produced by the contrast between the poems and the rest of the field was absolutely brilliant.

Among the few signed and dated rugs which survive from the Safavid era, four are considered benchmarks for dating other contemporary carpets.[215] Thanks to the new patronage initiated by the Safavid kings, a master weaver dared for the first time to sign his name, albeit still in the humblest manner possible, preceded by a modest poetic epigraph, according to Persian custom.

The Ardabil Carpets

The most famous pair of rugs is the one known under the name Ardabil. Dated and signed, the carpets go back to the beginning of the Safavid period. One of them is at the Victoria and Albert Museum in London and the other at the Los Angeles County Museum. The second piece lacks the main exterior border. Both carry the same inscription, which consists of the first hemistiches of a *ghazal*, or ode, by Hafiz, after which comes a modest signature by the Kashani master weaver Maqsud and the date AH 946 (AD 1539-1540), inserted between two spandrels near one of the vertical borders.

Joz âstane to am dar jahân panâhi nist,
saramra bejoz in dar havâlegâhi nist
Amal-é bandé-ye dargâh
Maqsoud Kachani, 946

There is no other refuge in the world
but the threshold of Your Gate,
Nowhere else can I rest my head.
The world of the servant of the court,
Maqsud Kachani, 946.

The epigraph contains a double allusion meant, on one hand, to show the gratitude of the master weaver towards his patron, who had ordered this magnificent piece and who very likely was Shah Tahmasp, while, on the other hand, expressing the weaver's devotion to Shah Tahmasp and God the Protector.[216]

The rug's composition, based on the plan of the mosque of Sheik Safi, ancestor and founder of the Safavids, at Ardabil, displays a profusion of stylized flowers and arabesques arranged about a six-lobed medallion.

The Poldi Pezzoli Carpets

Another famous weaver inscription can be found on a Safavid rug owned by the Museo Poldi Pezzoli in Milan. The form is a rhyming couplet containing not only the signature but also praise for the carpet and the weaver:

Chode az sa'a yeh Ghiyatheddin-e Jâmi,
bedine khoubi tamâm ine kar-é nâmi

Achieved by the diligence
of Ghiyath uddin Jami,
This work illustrates what
attracts us by its beauty.

The date has been read as AH 929 (AD 1522-1523) and 949 (1542-1543). Another rug at the Museo Poldi Pezzoli is known as the 'Darius's Carpet' because of two hemistiches woven into an interior border.[217]

Tarach az rechte'ye jân bâftehand,
bé dârâ yé jahân tâftehande

That this carpet be laid
at the feet of Darius,
Flower of his garden
and guarantee of his health.

It was therefore woven during the reign of Shah Tahmasp. The design is divided into four sections, each reproducing the same pattern in mirror image at the four corners of the field. In other words, each of them represents one quarter of the total scheme, including the central medallion. The rug from Ardabil, even though more severe and devoid of hunters and fantastic beasts, presents the same style of medallion composition, quartered upon a ground pattern of arabesques and foliage.

The Emperor's Carpet

Another rug with animal motifs, this one called the 'Emperor's Carpet' because of its association with Leopold I (1658-1705) of the Holy Roman Empire, has poems running along its interior borders.[218] It is also known as the 'Pannwitz', for a onetime owner. Today in the collection of Vienna's Österreiches Museum für angewandte Kunst, the rug, together with its pendant at the Metropolitan Museum in New York, was given to Leopold I by Tsar Peter the Great. The composition of these rugs contains an overall design with every kind of mythical and fabulous creature metamorphosing from vines and arabesques, albeit without the organizing principle of a central medallion. The whole is framed with verses or poetic inscriptions woven into the interior border. The script employed for the poems is nastaliq, and the final verses prove that the pieces belonged to a monarch, quite probably Shah Tahmasp. The verses do not follow one another in any logical order, and the calligraphic script appears not to have been correctly transcribed, a situation found in other rugs as well.

That they may pray for the king
of this world,
Wishing him eternal glory and success.

Other verses in the poem evoke a garden in full bloom, which in turn conjures up happiness.

Khoch barâyé rouz bâd o lab khandân tchon
gol châd, man ze
mast e bâgh khoch bâchi tchon salsabil

May you be as happy and smiling
as these flowers;
Just as I am intoxicated with this garden.

The 'Springtime Carpet'
at the Metropolitan

A superb poetic inscription embellishes another magnificent, but undated, carpet from the reign of Shah Tahmasp, a piece now

owned by the Metropolitan Museum in New York. Here the calligraphy used in the central medallion and around the cartouches in the main borders is of a different style.[219] The principal composition nonetheless displays the classical Safavid design, quartered and convergent upon the central medallion, with fantastic Chinese beasts, such as the *lung ma* (wolf) and the *khi'lin* (unicorn), as well as more realistic animals, among the arabesques and floral motifs. Inside the central medallion there is this *ruba'i* or quatrain:

Ey dar delé lâlé dâgh az daste ghamat, vey narguess o gol farche-é harimé haramat Az hasraté pâ boussé to sarveh ravân oftâdé gol-o-sabzé be zir'é ghadamate.

Oh! what a wound to the heart of the tulip,
a wound which flows from thy sorrow,
And, oh weeping willow, what a shame,
for the narcissus and the rose on the rug
in thy sanctuary,
That the fresh rose, being unable to kiss
thy feet, allows itself to fade beneath it.

Despite the generous scale of the letters, the calligraphy is not well done. Through its various analogies and symbols, this *ghazal*, or ode, compares the rug with a first love. Each hemistich ends with the word *sabz* (green), which calls attention to the color of the carpet simultaneously as it summons the youthful, the new, and the fresh. The final verse is an allusion to the poet's Sufi faith:

Soufi besouz kherghé ye azragh kenoun ké hast. May arghavâni o tarf é jouybâr é sabz.

The Sufi burns his green habit,
since thou canst enjoy
Purple wine on the banks of a green rivulet.

Kherghé yé azragh is an allusion to the modest *souf*, the 'sackcloth' of the Sufis. Thanks to its motifs and its verses, this piece is known as the 'Springtime Carpet'.

Gold Brocading

A mere half-century later, during the reign of Shah Abbas I, we find a sumptuous carpet brocaded in gold and silver among the six pieces given to the mausoleum of the Imam Ali, the most venerated of the Shiite imams, in the city of Nadjaf in Iraq.[220] It is dated, and its inscriptions are in the purest nastaliq. The composition embodies a field divided into

150. *Carpet with animal motifs. Tabriz, mid-16th century. Wool pile, warp, and weft; asymmetrical knot. Metropolitan Museum of Art, New York. At the center of this rug, woven during the reign of Shah Tahmasp, calligraphy runs almost completely around the inside rim of the flattened medallion, the latter filled with a quadrilobate medallion and flanked by a pair of affronted peacocks. Polylobate spandrels fill the four corners of the field, where combatant animals, stags, felines, and fish frolic against a red ground embellished with cloudbands, flowers, and palmettes. The composition may have provided the inspiration for the Salting series of rugs. Although commissioned by an aristocrat, the inscription seems rather overscaled and heavy, thus aesthetically at odds with the rest of the design. Like most Safavid verse, the poem is steeped in mysticism.*

150

151

151. *Medallion carpet from the 'Salting group'. Tabriz, late 16th century. Wool and silk with silver brocading; 2.51 x 1.70 m. Musée des Arts Décoratifs, Paris. The name of the so-called 'Salting group' arises from the gift of a particularly remarkable and now famous carpet made by the eponymous Sir George Salting to the Victoria and Albert Museum in 1910. The rug seen here and the 'Fletcher carpet' belong to the group and share its composition, palette, and weave. Like the piece seen in fig. 150, the calligraphy is somewhat overbearing and not very well executed. However, the general effect of the Paris carpet is more harmonius because the medallion is free of verses.*

152. *'Polish carpet'. Safavid Persia, 17th century. Wool pile, cotton warp, cotton and silk weft; silver and silver-gilt brocading; asymmetrical knot; 2.07 x 1.36 m. Formerly collection King Umberto II of Italy. Here, on an emerald field, cloudbands form a small central medallion flanked and surrounded by flower heads, arabesques, and foliage. Tiny spandrels fill the four corners of the field. The overall effect is quite sumptuous, deriving partly from the interplay of contrasting colors. Viewed as luxury items, Polish carpets were eagerly sought by the royal courts of Europe, particularly in Poland and Italy.*

three parts by three ogival niches. The ground of the two lateral niches is woven with gold brocading, whereas the middle ground and the three borders are brocaded in silver and gold respectively. The rest of the carpet has been worked entirely in wool. At the extreme right within the lower niche is an inscribed dedication composed of these words: 'Endowed by the dog of this sanctuary, Abbas' (*Vaqf nemoude kalb-é ine âstâne Abbas*). A mortification formula frequently used by Shah Abbas, it shows the importance of the monarch's devotion to Imam Ali, prompting him to take on the identity a dog within his own sanctuary! In this way, Shah Abbas proved he was capable of the greatest humility, a characteristic much admired by Muslims. Persian artists often demonstrated the same humility.

'Polish Carpets'

Silk carpets, brocaded in gold and silver, were always much sought after and extremely valuable. Offered by the Safavid court to Europe's crowned heads, and treasured as the most precious of gifts, such rugs were also made on commission in Iran for Western kings and nobility.[221] Many a Grand Tourist, such as the Chevalier Jean Chardin, had his breath taken away by the richness and beauty of these carpets. During his sojourns in Isfahan in 1673 and 1677, Chardin wrote: 'They had smoothed the path where the the king was to arrive, one side of which was covered with unfurled gold and silk brocades, and the other scattered with flowers. . . . Spread about the fountain were silk and gold carpets, and over the tiles a very rich brocade to sit upon.' The custom of laying out carpets on festive occasions endures even today. Called 'Polish carpets', after examples emblazoned with what were thought to be the arms of Prince Czartoryski, pieces like those just described were shown at Paris's Universal Exhibition of 1878 and errorneouly attributed to Polish weavers. Also mentioned were silk tapestries and kilims, several of which are inscribed with the armorial bearings of the Polish King Sigismund Vasa III (1587-

1632), who had ordered them from Kashan.[222] It is important to note that none of the so-called 'Polish' or 'Polonaise' rugs, woven in this very particular style and brocaded with gold and silver threads, displays poetic inscriptions, with the single possible exception of the one dedicated by Shah Abbas to the Nadjaf shrine.

There are two other specimens of signed and dated Safavid rugs, one of them with a vase pattern. It is inscribed 'work of Ostâd Mo'men b. Qotb al-din Mâhâni', followed by the date: AH 1065 (1656). The other, a silk rug woven a century later by Ne'mat-Allah Jawshaqan and now in the Sarajevo Museum, displays the date AH 1082 (1671), and it can be seen at the mausoleum of Shah Abbas II at Qum.

Nastaliq Script on the 'Salting' Carpets

A bold variation of nastaliq calligraphy appears on the rugs of the 'Salting' group, so named for a famous medallion carpet presented to the Victoria and Albert Museum in 1910 by Sir George Salting. The Salting group comprises a series of variously sized woollen carpets garnished with metallic threads and decorated with a central medallion surrounded by stylized animals and flowers. In his article 'The Art of Carpet Making' (1941), Kurt Erdmann became the first to note the similarities between the Salting carpets and prayer rugs displaying the same calligraphic style. From this he concluded that the two groups had been woven at Hereke towards the end of the 19th century.[223]

Actually, deep confusion and high controversy surround the origin and dating of the Salting carpets. Even though most of the pieces were thought to have been made in Persia at the end of the 16th century, some connoisseurs insisted upon attributing them to late 19th-century Turkish manufacture. This problem has now been exhaustively studied by Michael Franses and Ian Bennett,[224] who relied on Professor Mark Whiting's technical analysis of the red dye in similar rugs. The Kelekian/Bacri and Altmann examples contain lac, a pigment uti-

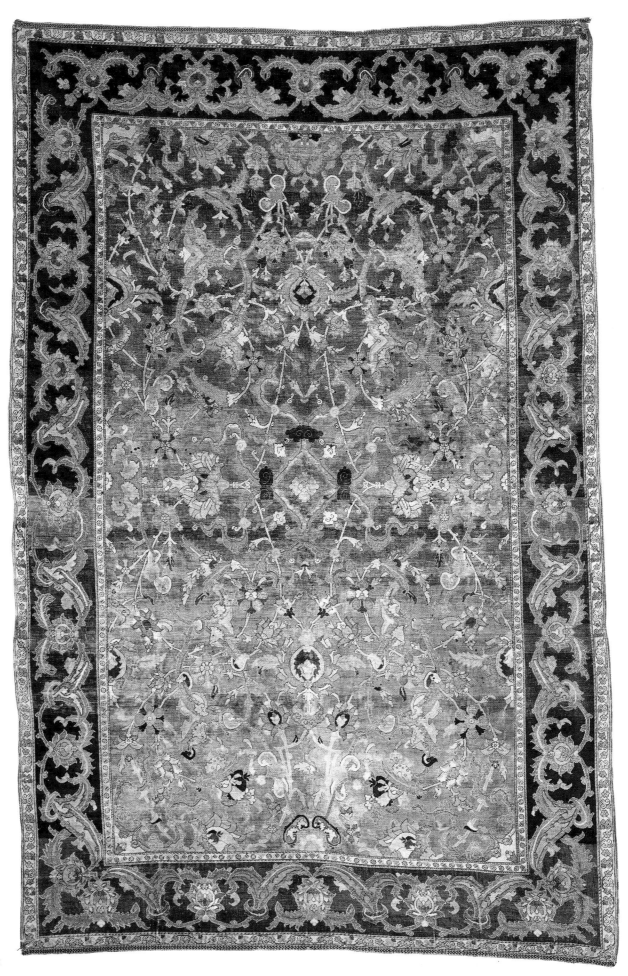

152

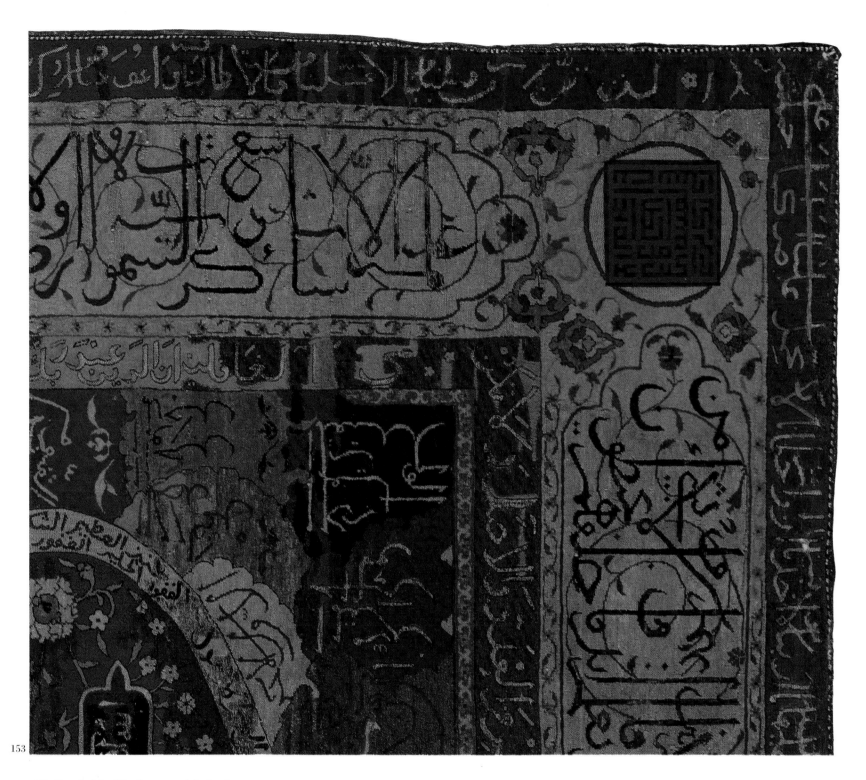

153

153. *Detail of the 'Fletcher carpet'. Safavid Persia, early 16th century. Silk pile, cotton warp and weft; silver and silver-gilt brocading; symmetrical knot; 1.60 x 1.83 m. Metropolitan Museum of Art, New York. The celebrated Fletcher prayer rug is one of the few known Safavid carpets with both Kufic and naskhi script woven into them. Under the Safavid monarchs, weavers used nastaliq exclusively for inscriptions on floral- and animal-patterned weavings. Naskhi script was considered more suitable for prayer rugs, religious manuscripts, and Korans. On the Fletcher piece, rectilinear Kufic makes it possible to inscribe an entire prayer within a single, tightly packed square. The design of this work has been a model for many latter carpets, including Turkey's Qum Qapi series in the 20th century.*

154. *Detail of an inlaid verse on a revetment of the Abdallah Ansari Mausoleum in Herat. 1428. Four-square Kufic was frequently the script preferred for verses or sacred names, such as Allah and Ali, inscribed upon architecture. Being radically stylized in an abstract, geometric manner, the letters are scarcely readable. Here they are formed of inlaid glazed but plain brick.*

lized mainly before 1800, which therefore suggested fabrication earlier than the 19th century. Of the six prayer rugs examined at Topkapi Palace, two contain madder and four cochineal, which means the pieces could not have been woven before the 18th century.

It is true that copies of the archetypal *mihrab* design present different styles of calligraphy. The conflict, however, can be easily resolved through technical analysis of not only the dyes but also the inscriptions. Several prayer rugs display Shiite inscriptions, which implies a Persian origin, given that Turkey has always been Sunnite. Moreover, Hereke and Istanbul were not known as centers of carpet manufacture before the end of the 19th century. The color combinations found on recent copies seem too harsh, which sets the pieces very much apart from the classical Safavids of the 16th and 17th centuries. In addition, silver brocading was usually employed on classical pieces woven of silk. A very good example of the late type of these rugs belongs to the Musée des Arts Décoratifs in Paris.

The Fletcher Carpet

The period brought forth another genre of prayer rug, this one with silver-brocaded naskhi and Kufic inscriptions, calligraphic styles most often reserved for religious textiles. A classic example of this type of Safavid prayer rug – probably the source par excellence of the Salting group – is the so-called 'Fletcher rug' at the Metropolitan Museum (gift of Isaac D. Fletcher).[225] Here the religious texts are verses from the Koran – the *sura al-Baqara, aya* 255 with the different attributes of Allah, or *asmâ 'ol hosna* – written in naskhi around the principal border and within the central field above the *mihrab*. Towards the bottom of the central field, the four *tchi*, or Chinese clouds, face one another as if to draw attention to the central medallion surrounding a large palmette. The inscriptions are flatwoven or brocaded, with the metal thread wrapped around a silk core. The knots are asymmetrical, which distinguishes the rugs from the Turkish carpets of the 19th and 20th centuries. This magnifi-

154

cent piece can be securely dated to the beginning of the 17th century. It abounds in such archetypal motifs as blossoms, palmettes, scrolling arabesques, and ramified vines. The religious inscriptions appear only in the upper part of the *mihrab*, while the names of Allah in the lower part surround the field.

The outside border also contains Koranic verses. They are from the *Ayat-ol Kursi*, a prayer for protection and the recovery of good health. Other verses from the Koran, these written in Kufic with geometric letters, grace the upper part of the *mihrab*, as in the four seals or square motifs, in the two upper corners and at the center, and in the two exterior margins. The square motifs twine about verses in one place and about a single religious word in another. The same motifs – 'squared' geometric letters – are often found on Safavid architecture, especially minarets. The excellent quality of the weaving and the harmonious colors tell us that the rugs were ordered by patrons of high social or even imperial status.

It would be useful to discover the reason why certain iconographic motifs were employed, to study the choice of poems and their significance.

Medallion Symbols

Although the medallion composition had already appeared in rugs at the outset of the Timurid period, it was during the Safavid era that it became a favorite design, as can be seen in the examples. The design shows up not only on carpets but also on the cover pages of Korans and other kinds of manuscript. The medallion, or *shamsé*, in the form of a small sun, comes from *shams*, which means 'sun' in both Arabic and Persian. On a rug or a manuscript, the *shamsé* may contain other medallions in the form of stars with six, eight, or sometimes even sixteen lobes, or rays, recurring in the four corners of a rectangular design by means of four medallions subdivided into four according to a strict geometric system.

While the interior of a *shamsé* often bears a dedicatory invocation citing the name of the patron (usually a Shah, a Sultan, or a Prince) and the dates of his reign, a religious verse, or yet a benediction, the name of the artist, the weaver, the calligrapher, or the illuminator is rarely mentioned. Moreover, the dedicatory or epigraphic invocation in the *shamsé* was rarely used prior to the Safavids. We have no signed example of a

> ### THE SYMBOLS OF THE MEDALLION
>
> The word *shamsé*, or 'medallion', comes from *shams*, which means 'sun' in both Arabic and Persian. Under the mystical Shiite Safavids, the medallion, with its concentric form, came to signify the centrifugal emanation of the central 'force', close in form and conception to the *mandhala*, the Buddhist symbol of the universe.

155

155. *Shamsé or medallion on a bookbinding, from
the* Diwan e Jami. *Safavid Persia. Embossed
leather embellished with gold and lapis lazuli.
Bibliothèque Nationale, Paris. The Safavid artists*

*involved with rug making found ideas and
inspiration in the work of contemporary
bookbinders, especially the designs with central
medallions and corner spandrels.*

Timurid carpet. There are only a few signed
examples from the Safavid period, which
attest to the important status enjoyed by the
age's master weavers, as can be seen in the
Poldi Pezzoli rug, where the signature also
praises its weaver.

The convergent composition of the *shamsé*
medallion developed under the Safavids was
in keeping with the dynasty's mysticism and
Sufi faith. The central medallion symbolizes
the esoteric nucleus or centrifugal emanation
of the central 'force'. It is the axis of the aes-
thetic and cosmic world, as wrote L.
Bakhtiar: 'Standing on the circumference of
Sufism, one relates in an outward direction
through the manifest world. The motion
inwards is through the spiritual methods
which lead to the centre, Secret or Spirit
which resides in a state of potentiality in all
things.'[226]

The medallion can also be seen as a cos-
mic-concentric design, closer in form and
conception to the *mandhala*, the Buddhist
symbol of the universe consisting of a circle
enclosing a square, with a divinity on either
side, but later reduced to its basic linear
design. This quite effectively evoked the mys-
tical thought of the Safavids. Sufism mani-
fested itself, with the exactitude of a
mathematical formula, in the precise layout
and the calculated structure of the Safavid
carpet, where the units serving as models or
patterns recur throughout various and very
exact numerical groups.[227]

Few Famous Poets

Virtually all the poems chosen for reproduc-
tion in Safavid rugs are Sufi in inspiration.
Welling up spontaneously from the Persian
spirit, sometimes composed by the designers
or the local weavers, the poems very often
are not the work of famous writers, as in
19th- and 20th-century rugs. The two 'Ard-
abil' rugs contain verses by the great mystic
poet Sheik Muhammed Shams-ud-Din Hafiz,
the venerated author, born in Shiraz and
buried in 1388, frequently cited by Persians
as 'the interpreter of mysteries' (*kâshef é
râz*). Some of the controversial Salting group

156

156. *Fragment of a royal textile. Safavid Persia, early 17th century. Silk with silver and silver-gilt brocading, 0.64 x 0.69 m. Art and History Trust. Under the Safavids, the Persian art of weaving attained the summit of richness and refinement. On textiles, moreover, calligraphic inscriptions were often more successful than on carpets, as can be seen in the fragment reproduced here. The script is in exquisite nastaliq, and it appears only within cartouches, just as in Safavid carpets. The metallic brocading springs from the period's love of luxury, a taste already seen in the Polish carpets. The inscriptions stress the importance of the weaver's patron, no doubt a king.*

carpets also have poems by Hafiz but rather crudely executed.

Verses on Textiles

The execution of the calligraphy on Safavid textiles was almost invariably more successful than on carpets, a reality borne out by the numerous surviving examples of different fabrics. In terms of calligraphic inscription, there are, as in the case of rugs, two sorts of textiles, those intended for mosques and other religious sites, with of course religious texts in Arabic, and others meant for secular use, such as the panels called *pardé* – literally 'curtains' in Persian – woven for kings or members of the court. The Safavid fabrics or brocades made to wrap the sarcophagi for placement in mausolea and mosques are covered with Shiite Koranic verses written in *sols* or in *thuluth*, one of the most exalted variations upon naskhi, while those designed for utilitarian purposes usually remain free of inscription. A fragment of Safavid brocade, in the Art and History Trust collection, is an example of a marvelous textile displaying extremely beautiful nastaliq. Here, the verses were composed for a king, as we know from the word *shah* which ends the passage:

Delâ bengar ine pardé yé zarnegâr,
vaz ou baz khan bazi é rouzegar
Bebine naqch é ine zarnechâne pardé tchiste
Beh dorâné ine dâvar-é nik-bakht
ké djâvid mânade bâ tâj o takht
sar é sarvarâne mir divân e 'chah'. . . .

Look therefore at this panel of brocade,
and ask it
the game of destiny. See the pattern
of this panel of brocade [cut part].
During the reign of this happy king,
may his reign be eternal,
may the palace of this king remain
for his dignitaries [missing part].

The allusions and the vocabulary proper to carpets and textiles were used by the mystical poets, as poetic symbols and metaphors, well before the Safavid era. The word *farche*, or 'carpet' in Persian, appears frequently in the poetry of Hafiz and Sa'adi, among others. Thus, Hafiz, speaking of the futility of all things material, wrote in a *ghazal*:

Khoche farche é bouriya o khâb
é amne kin eych nist
dar khoré orang é khosrovi

More than a carpet of straw
and a tranquil sleep,
Is this pleasure not worthy of a king?

There are moreover several examples of poems in which the carpet becomes a mystical symbol of the Garden of Paradise. The very idea of a Paradise Garden, as a mystical symbol, is materialized in various series of rugs which take the concept and render its order concretely. While some of these pieces display calligraphy or epigraphic inscriptions, they serve primarily to show that the garden theme returns endlessly, both as a mystical symbol and as a compositional scheme.

The Paradise Garden

The Paradise Garden is considered to be the cosmic prototype symbolizing paradise on earth. Its transposition onto the carpet must

157. *Bird's-eye view of the Royal Square in Isfahan. The plan is clearly that of the* Chahar Bagh, *the classic Paradise Garden. This consists of a main axis, usually a canal, crossed at right angles by other canals, all lined with cypress, box, and fruit trees. The* Chahar Bagh *provided the basic design for many Paradise Garden rugs.*

158. *View of the* Bag e Fin *garden in Kashan, Iran. 18th century. The garden and its pavilions have undergone restoration several times. Water being scarce in the region, the trickling of canals and fountains is music to Iranian ears.*

159. *View of the* Bagh e Shahzadeh, *a garden with a winter pavilion created in the early 19th century in Mahan, Iran.*

160. *View of the* Bagh e Golshan *garden at Tabas, Khorassan, Iran. 19th century. All these gardens follow the classic plan of the* Chahar Bagh, *with its rectilinear field divided into equal spaces by tree-lined canals crisscrossed in such a way that they lead to an elevated enclosure, often a pavilion, within a still lake conducive to contemplation. The plan reflects humanity's age-old desire to replicate paradise on earth. The Paradise Garden was meant to provide a fugitive vision of the Heavenly Paradise, a place where the imagination could soar, a place for the musings and daydreams of the poetic Iranian soul.*

therefore illustrate this idyllic passage in detail and in its most idealized form: trees green with foliage or laden with fruit, flowers in full bloom, birds of every sort singing in leafy trees, and streams aswim with ducks and fish. The conception is well represented in Persian miniatures, where landscapes always have the look of paradise. This type of order, so conducive to romantic encounters, also provided the allegorical setting in which the lover meets his beloved, symbolizing the Sufi adept attaining the love of God.

As mystical symbol, the garden on the carpet is materialized on two levels and in two forms: visually realist iconography and verbally rendered poetic conception. It is, in other words, a whole world of metaphorical experience translated through images derived from Persian poetic tradition. A poetico-mystical vocabulary consisting of such terms as 'wine' (*charâbe*), wine server (*sâghi*), 'tavern' (*meykhâné*), and 'the inebriated' (*mastân*) – all images prohibited by the Koran – is exploited to carry us into the world beyond.

The Chahar Bagh *Garden Plan*

The poet adopts the vocabulary and transposes it onto the metaphysical plane through spiritual hermeneutism. The word 'paradise' derives from the Persian word *paradeiza* or *pairi-daeza*, depending on the theory involved, which was probably introduced into the West by Xenophon's description of the gardens and palace of Cyrus at Sardis. According to the Avestan legend, the world was divided into parts by the crossing of two great rivers that intersected about an axis. The image reappears in the Old Testament as well as in the Koran (47:15), which speaks of the four rivers flowing, respectively, with water, wine, milk, and honey towards Moses's Promised Land. It inspired the very conception of the carpet and has perdured into our own time. Later, the plane would be divided horizontally by several axes: canals bordered by cypress, box, or fruit trees. The precursor of the Safavid garden rug was very likely the Sassanian carpet known as the 'Spring of Chosroes'. Discovered at Ctesiphon, this clas-

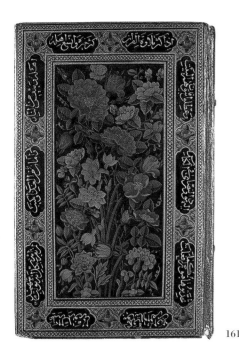

161. *Bookbinding for a Koran. Qadjar Iran, 19th century. Papier-mâché. The classic design, involving a central panel with calligraphy on the enframing border, continued into modern times.*

sic composition had the same design, divided at right angles into quarters.[228]

The layout of the Four Gardens or Safavid *Chahar Bagh* also represents a division of the garden space into equal parts, each of them advancing towards the central fountain, the spiritual home ground, along the four canals forming the axes of the composition. This paradise of four rivers converged at the center towards an elevated enclosure, often a pavilion, within a still lake conducive to contemplation. The same plan served for the installation of gardens as well as for the composition of Safavid rugs. Water being scarce in Iran, the Safavids took great care of their gardens, where the canals were built on different levels so as to amplify the sound of water, whose trickling was music to the ears of people living in a desert climate. The dynasty viewed the conception and execution of their gardens altogether as important as the architecture of their buildings.

The Paradise Gardens of Chehel Sotun and at Shah Abbas I's Ali Qâpu palace have the same composition as the *Chahar Bagh*, the great majestic way leading to Isfahan

whose plan originated in the four vineyards once located on the site. In 1670 Shah Suleyman I (r. 1666-1694) adopted the same layout for a very pretty pleasure pavilion. The design recurs on Safavid carpets, but conceived as an overview of the whole. Unfortunately, no Safavid garden has survived, leaving the carpets to become the sole witnesses to that long-lost beauty.

The Garden Carpet

The oldest as well as the most beautiful example of the garden carpet is at the palace of the Maharajahs of Jaipur at Amber. A label on the lining, discovered in 1937 at the same time the carpet was, bears the date 1632. It was undoubtedly woven before this date, that is, during the reign of Shah Abbas I. Two other examples of garden rugs from the same period – the Figdor carpet in Vienna and the Wagner piece in the Burrell Collection in Glasgow – present the same overall design.

The garden pattern would remain in favor right into the 20th century, even though the naturalist style of the Safavid pieces opened the door to more stylized or abbreviated variations devoid of animal forms. The style of the garden carpets has persisted, with naturalistic but completely different colors and

162

162-163. *Paradise Garden carpet. Heriz, 19th century. Silk pile, 3 x 5 m. Private collection, Paris. In later periods Iranian weavers have tended to interpret the Paradise Garden theme after their own fashion. As new approaches evolved, calligraphy appears to have assumed even greater importance. Verses spill over from the border into the central field, occupying a space previously reserved for the rippling canals with swimming fish. Poetry, inscribed in nastaliq, becomes the main feature within cartouches on a yellow and white ground shaped like a feline. The two hemistiches repeated four times along the interior axes of the canals are from a poem by Sa'adi: 'In the shade of the trees, the wind has spread a carpet or iridescent colors like the feathers of a turkey.' Others appear in red on the cartouches around the borders, harmoniously integrated with the foliage on a blue ground and alternated with the morbarak bâd – or good wishes. This last element suggests that the rug had been ordered for a wedding.*

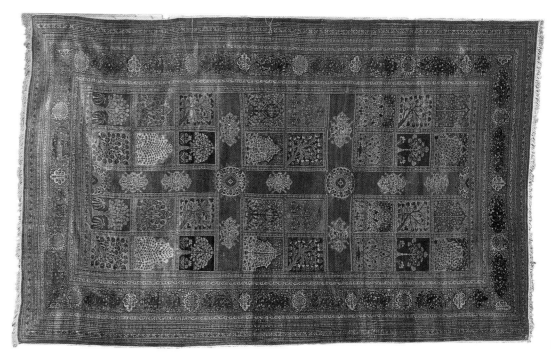

163

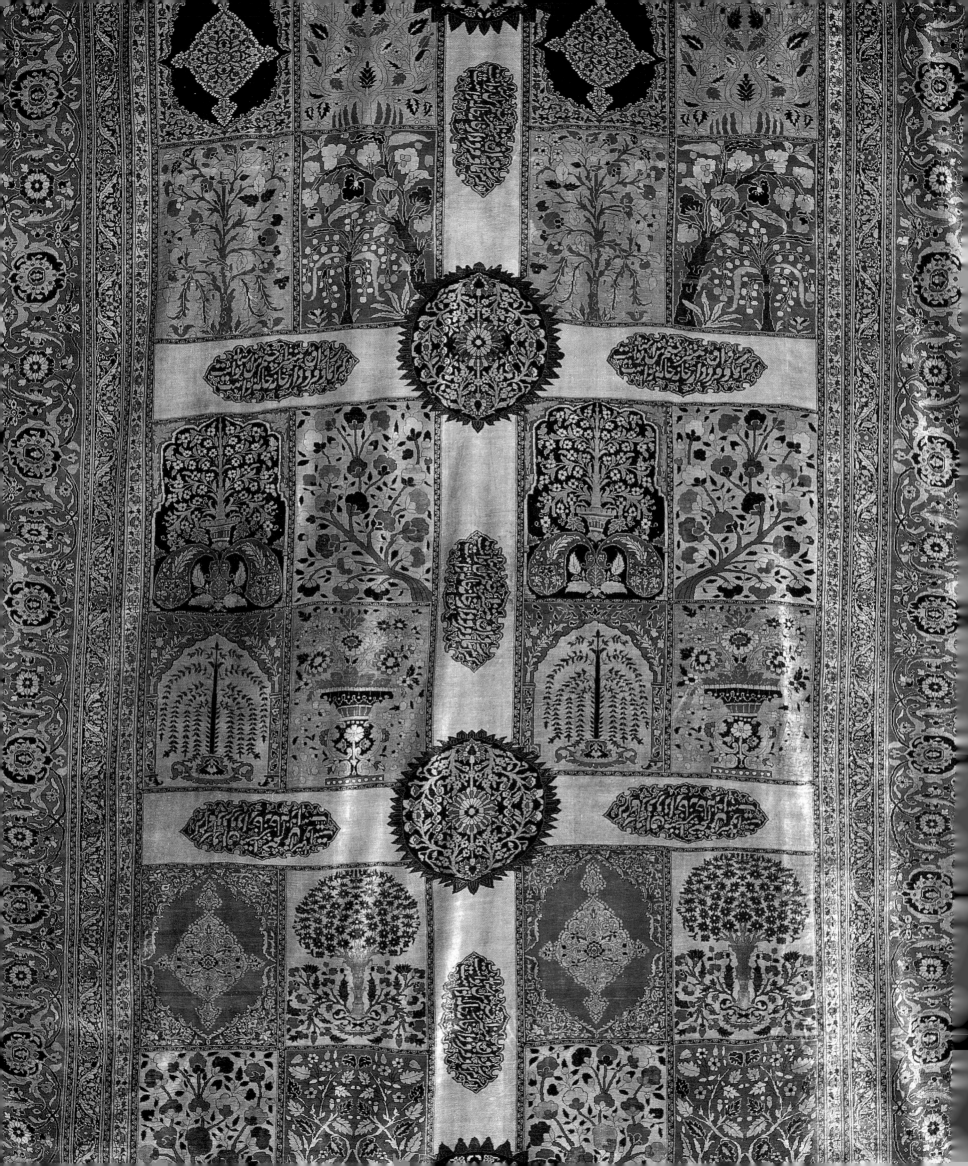

motifs. The rows of cypresses and flowering trees no longer reappear even occasionally.

The Term 'Carpet' as Metaphor

For a better grasp of the motivation behind these magnificent woven works, it is essential to understand the extent of their philosophical content, communicated above all through their poetry.

At the heart of this mystical context, Persian poets often used the word 'carpet' as a metaphor, within a literary play of words, to designate a mystical kind of poetry. Each poet therefore spoke of his subjective interpretation. The Persian verb *bâftane* ('to weave') and its derivative, the adjective *bâf*, describe a poet as well as a weaver, just as *she'r bâf* means 'he who weaves poetry' or 'the poet', while *ghalibâf* and *farchebâf* signify 'weaver of carpets'. Indeed, each profession and each form of artistic expression corresponded to a particular poetic genre.[229]

Thus, poems on metal objects sometimes contain the term *sukhtan*, which has a double meaning: 'burn' and 'cast' or 'found' as in 'metal casting' or 'foundry'.[230] This 'burn' therefore signifies metal quite literally at the same time that it alludes to the 'crucible' – the foundry – of the heart and thence to suffering. Thanks to such poetic allusions, mystical symbolism permeates the work, always within the context of an idyllic garden, where the poets speak of love divine, thus of intoxication, happiness, or yet the suffering which flows therefrom.

THE WORD 'CARPET' AS METAPHOR

Persian poets often used the word 'carpet' as a metaphor, within a literary play of words, to designate a mystical kind of poetry. The Persian verb *bâftane* ('to weave') and its derivative, the adjective *bâf*, describe a poet as well as a weaver. The poet therefore weaves words just as the weaver weaves the warp and the weft.

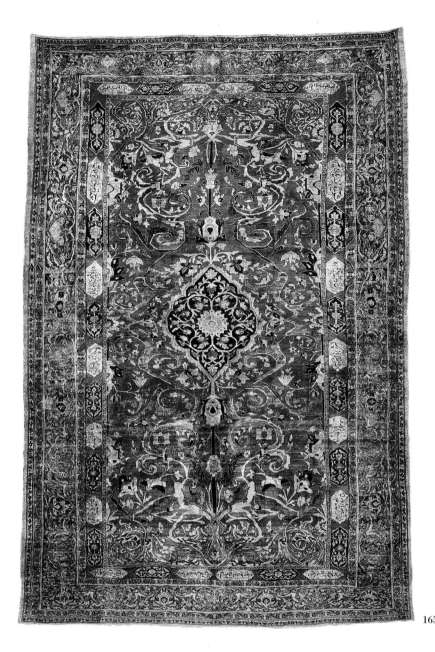

165

The Weaving of Words

In rug weaving, the weft and the warp (*târ o poud*) have frequently been compared to the body and the soul. Similarly, Persian poetry contains many more comparisons with the art of weaving than with any other form of craft. Classical Persian poetry is composed by combining modal units, the units consisting of verses, lines, and rhythmic stanzas. Similarly, in rugs the units consist of knots and well-ordered rows. Persian literature abounds in such exchanges involving the weaver's art.

Ferdowsi, Persia's great epic poet (d. 1020), made frequent use of this literary device, as in the preface to the history of Rostam and Shaghad, in his monumental work

164. *Garden carpet. Tabriz, 19th century. Silk pile, 3.40 x 2.50 m. Each little plan within the overall* Chahar Bagh *plan symbolizes a different Paradise Garden.*

165. *Medallion carpet with nastaliq inscription. Heriz, 19th century. 3.25 x 2.18 m. This design, with its blue medallion on a coral ground, comprises mainly arabesques, foliage, and a few flowers woven in indigo and ivory. The main frieze, which is accompanied by three internal and three external borders, boasts six horizontal cartouches within which poems have been inscribed in nastaliq calligraphy. The design and the poetry alike have been 'inverted', that is, arrayed so that each half of the pattern becomes a mirror image of the other, a device symptomatic of an underlying mystical inspiration. Still, the subjects of the poems are the universal ones of love and wine.*

entitled *Shah Nameh*, or *The Book of Kings*, which he begins as follows[231]:

> *Sokhanrâ yek andar*
> *degar bâftame.*

Thus, I have begun to speak
by weaving words.

Elsewhere in the *Shah Nameh*, Ferdowsi makes poetic use of *târ o poud*, as in the history of the battle of Rostam and Akhvân-é-div:

> *Hamé marzhâ kardami târ o poud,*
> *Hami rafté azin guné tâ Kâssérud*

It is from the weft and the warp
that I have woven the frontiers,
Thus will continue the ride
all the way to Kassehrud.

Or here:

> *Pey âmade bar in tchechmé*
> *âmade forud,*
> *Ké shode bâreh o mard*
> *bi târ o poud*

He came to the fountain, he landed there,
For the man and the fortress
Had lost their weft and warp
body and soul.

Or again:

> *Ze mâ bâd bar jân ankas dorud,*
> *Ké dâd o kherad bâshadache târ o poud*

I greet the spirit of him whose warp and weft
Are woven of nothing but justice and wisdom.

Mowlavi, or Mowlânâ Jalâleddin Rûmi (1207-1273), perhaps the greatest of all Persia's mystical poets, employs *târ o poud* in the true mystical sense in his poetic masterpiece *Masnavi*:

> *Nour-é hagh kas najuyad zâd o boud,*
> *khelghat-é hagh râ tcheh hâjat târ o poud*

The light of God shall not be revealed
to thee through thy birth and thy existence.
Divine creation has only to make
the weft and the warp.

In these verses, which are literally translated, *târ o poud* or 'warp and weft' mean, on every occasion, 'heart and soul'.

In other cases, the word *farche* or 'rug' may signify 'the path', thereby alluding to the mystic way which leads to the ultimate love divine. God the Ultimate is also written as 'the Divine Creator' or 'the Ultimate Craftsman' or 'Artisan'. The 15th-century mystical poet Bokharai, in ecstasy before the beauty of spring, praises his Creator:

> *Farchi fekand dacht' por as naqch âfarin,*
> *Tâji nahâde bâgh por az dorr é eftekhâr*

The plain has rolled out its carpet,
oh how colorful,
And the garden has put on its crown,
oh how bejeweled.

The use of the word *farche* as a mystical metaphor is a tradition that has persisted into our own time. The late 19th-century poet Monsef Qadjar once again evoked the idyllic garden:

> *Gosasté ast dasté falak éghdé marjân,*
> *fekandé ast bâdé' sabâ farche é dibâ*

The divine hand had broken
the necklace of coral,
The wind from the east [saba]
has spread its carpet of silk.

CALLIGRAPHY ON CARPETS

A Mediocre Style

It is rather surprising to find that, on many of the magnificent royal carpets from the Safavid period, the inscriptions are carelessly executed and in a clumsy style of calligraphy.

Is it possible they were written and then woven by inferior calligraphers, even though the calligraphers of this period surpassed one another in the art of writing and produced the very best examples of nastaliq? There are several ways to explain this quite astonishing phenomenon. First, it is very difficult to reproduce the elegant curves and delicate sinuosity of nastaliq script in a knotted carpet. Thus, the diacritical and graphic signs normally placed above and below Persian and Arabic letters, to differentiate and decipher them, are frequently omitted or misplaced. This makes the calligraphy confusing and illegible. The most telling explanation, however, springs from the fact that the weavers were for the most part illiterate and could not understand the poems. They had no knowledge of calligraphy, which meant that the transcription of poetry onto rugs lost its true significance. Where the poetry was poorly understood, it was of course badly woven.

The Oral Tradition of Weaving

The weavers were given patterns in the following manner. Once the design of a carpet had been established, the head weaver recited, almost in a chanting mode, the color and the type of knot to use, row by row. He followed the plan by heart, knot after knot, and often without any visual aid. For the other simple weavers, it was therefore impos-

> ### THE QUALAITY OF CALLIGRAPHY ON CARPETS
>
> Generally speaking, inscribed carpets display calligraphy that is surprisingly careless and even clumsy, even on rugs produced during the Safavid period, when court calligraphers surpassed one another in the refinement of their work. The explanation may lie in the illiteracy of the weavers, who could only work from models transmitted to them orally.

sible to have a sense of the work until several rows had been completed and the loose knots tightened, though not yet cut. This tradition has survived and continues to be practiced in several weaving centers.

THE DECLINE OF THE SAFAVIDS

Political Disintegration

Shah Sultan Hossein, the last Safavid monarch, was overthrown by Mahmud Afghan, who then reigned from 1722 to 1736.[232] For seven years, the Afghan invasions devastated the country. Iran was once again ravaged both politically and economically. The collapse of the Safavid dynasty brought an end to the whole infrastructure built up to serve the court, including the ateliers, which were suppressed, depriving the weavers of the supreme protection they had long enjoyed. Rug weaving went into considerable decline during the 18th century, owing to the absence of the kind of absolute control exercised during the classical period over the aesthetic and quality of pieces fabricated exclusively for the court, especially during the reigns of Shah Tahmasp and Shah Abbas. Nevertheless, the style and technique of the Safavid era had left their mark, which would serve as the basis for the designs of carpets produced later on.

The political disintegration of Iran, together with the terrible economic conditions, caused an abrupt decline in the production of textiles and carpets. Following the expulsion of the Afghans by Nader Shah Afshar, who reigned from 1736 to 1747, Persia recovered some small measure of political stability. Karim Khan Zand, the Kurd who succeeded Nader Shah Afshar, reigning from 1750 to 1779, also managed to improve the country's economic life. Yet it was only with the advent of the Qadjar dynasty (1779-1925) that Iran re-established its internal security, its stability, and a more flourishing economy.[233] The carpet industry expanded, owing to the patronage of the Qadjars, most notably under the long-reigning Fath Ali Shah (1797-1834) and Nasseredin Shah (1848-1896).

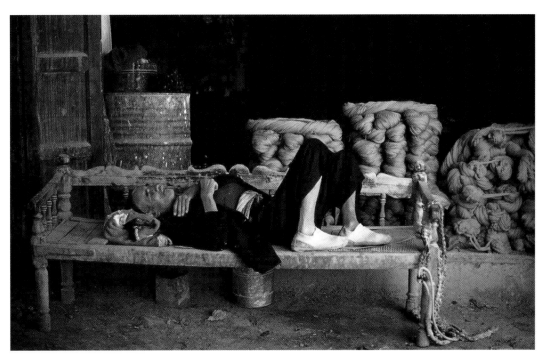

166

Still later, in the Pahlavi era and the years that followed, the carpet trade thrived under the stimulus of official interest. The production of silk rugs and rugs made of *kurk* (downy wool from the bellies of sheep reared in less arid regions) grew enormously.[234] Carpet making was fostered everywhere in Iran, so successfully that it brought a genuine revival of the industry, in town and country alike. The once exclusively royal ateliers of the Safavids, dedicated mainly to the fabrication of classic and exceptional carpets, gave way to more popular and democratic weaving centers.

In terms of aesthetics, the post-Safavid era has often been regarded as a period of decadence, with some even speaking of 'barbarization'.[235] True enough, the art of the carpet has never recovered the perfection of style, technique, and harmony known under the Safavids. Commercialization, more than anything else, has gradually undermined the mystical philosophy which had inspired the Iranian carpet. Once an emanation of Sufi radiance, the Persian rug has become no more than a piece of decorative merchandise, albeit still a luxury item.

It should be pointed out, however, that carpet production under the Safavids eventually became democratized. The patterns reserved for the court were supplanted by

166. An Isfahan dyer having a rest from his mordanting baths.

more individualized motifs. A certain candor can be detected, a nascent freedom of expression, a willingness to experiment. Moreover, new workshops created by private parties were directed by highly trained and experienced specialists.

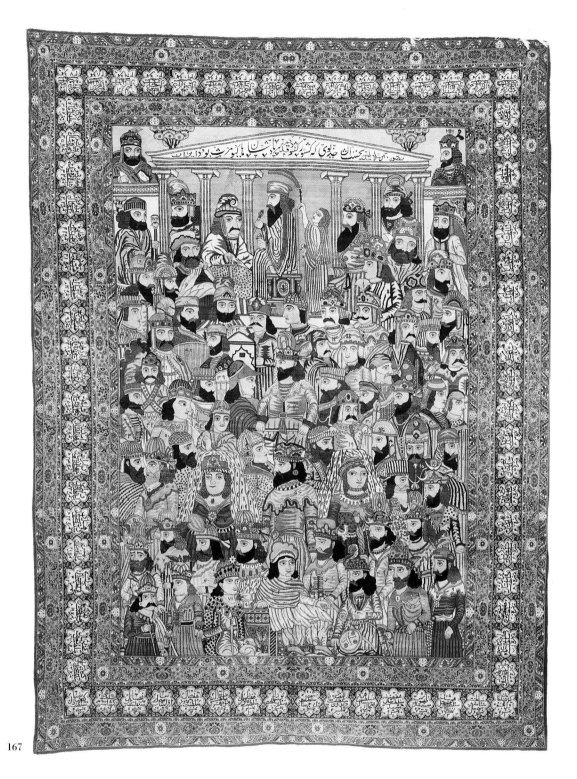

167

167. Carpet entitled 'Portrait of Persian Kings'.
Kerman, 20th century. Wool pile, 3.61 x 2.74 m.
Sotheby's sale, 17 October 1984. Composed as if on the
steps of a pedimented temple front are portraits of
Persian monarchs and certain historical figures. The
main border consists of a necklace-like series of small
medallions with the names of the subjects inscribed in
nastaliq. Each portrait is numbered and thus coded to
his 'name plate' in the medallion border.

EUROPEAN INFLUENCE
IN THE 19TH CENTURY

Trade with Europe

During the second half of the 19th century, trade with Europe and the influence of European businessmen gave the industry a new impetus. Indeed, it was the growing demand from the West that stimulated the commercial production of carpets. Some European firms even set up workshops in various Iranian cities and brought in new designs, techniques, and colorants. In the 1860s aniline and other chemical dyes were already being imported. Companies such as Ziegler, an Anglo-Swiss corporation, opened factories at Tabriz and Sultanabad (1874-1883), with agencies established in other towns. Nearco Castelli et Frère, an Italo-Ottoman financial house which had entered the rug business, opened offices at Tabriz, Kerman, Hamadan, Teheran, Heriz, and Kashan, as well as in the Khorassan. This increasingly important trade with Europe even managed to exercise a certain influence on Persian taste.

Figurative Carpets

The effects of the European presence on Persian carpets can be seen throughout a series of 'figurative' rugs woven mostly in the Kerman region.[237] Here the field is taken over by one or two figures, in the manner of European tapestries.[238] It reflects the influence of large-scale oil paintings, as opposed to the traditional influence from illuminated manuscripts. Still, the figures represented on these rugs are usually the old heroes and kings of Persian history and mythology. To help identify them, their names and titles are frequently inscribed near the images in naskhi or nastaliq. Examples are the wool Kerman entitled 'Portrait of Persian Kings' in a recent auction catalogue and a Kerman Lavar entitled 'Bahram Gur'. The female image rarely finds a place on Persian carpets. Only on nomad rugs, and these primarily Bakhtiari, do portraits of women appear with any regularity. But whatever the extent of European influence, this type of figurative

THE ERA OF
COMMERCIALIZATION

Commercialization gradually undermined the mystical philosophy that had inspired the Persian carpet. Still, the process could be viewed as democratic, a development that has simply led the Oriental carpet in other directions. Even under the Safavids, the willingness to experiment gave rise to a new freedom of expression.

rug appealed more to Persian taste than to European patrons, the historical or mythological legends having greater meaning for the native clientele.

Towards the end of the Qadjar era, Iranian weavers also made portraits of contemporary shahs, frequently on commission for presentation to visiting dignitaries from abroad. Another prized motif was the *göl o bolbol*, or 'flower and nightingale', with or without a vase and designed to decorate or fill the entire carpet surface. The image also showed up frequently on manuscript covers and pen boxes. It proved to be the rug pattern of choice in the years between 1896 and 1919. The instigator of the motif, Prince Zil-ol-Soltan, was famous for his Western taste. Around the turn of the 20th century, the European-inspired 'millefleurs' pattern came to the fore, first on carpets woven at Kerman and then copied by several other weaving centers. The pattern came to be known 'Zil-ol-Zoltani'.

Throughout the 19th century, and even into the our own era, poetry retained its privileged status in the aesthetic repertoire of Iranian rug weavers. Admittedly, carpets with poetry-inscribed borders appealed mainly to informed patrons. Appreciation of such works varies, depending on one's knowledge of Persian poetry, as well as on individual aesthetic sensibility. The 'poetic' or 'epigraphic' rug was therefore meant primarily for Persians, who were better able to understand and value it. In later examples, the verses are woven into the central field, which entailed the development of new compositions. There are magnificent pieces, from different regions, with poems woven along both exterior and interior borders, some of which attest to the exceptional quality of the weaving done at the end of the 19th century.

New Forms of Poetry and Gardens

In their handling of classical patterns, such as the Paradise Garden, the weavers of the late 19th century seem to have interpreted the compositions differently, even while achieving beautiful results. Indeed, the old Paradise Garden theme gave rise to some astonishing variations and new interpretations, to the point where the verses would occasionally spill over onto the central field, thus inhabiting a space once reserved for serpentine canals aswim with ducks and fish.

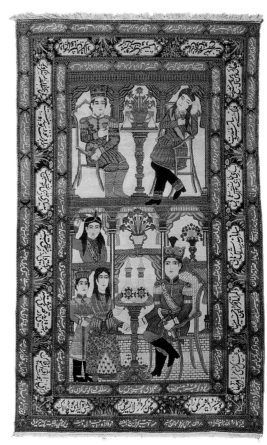

168

168. *The 'Royal Couple' carpet. Kashan, early 20th century. Wool pile, 2.54 x 1.47 m. Here the figures appear both upstairs and downstairs. They represent a seated prince holding the crown of the Qadjars and attended by his court, all gathered in the lower register. Above the prince is joined by his beloved princesss. Love poems fill the oblong cartouches running completely around all three enframing borders. The main frieze carries prose extracts from Nizami's Khamseh (Quintet). Such figurative rugs became very popular towards the end of the 19th century, possibly a reflection of European influence. A handsome carpet had come to be regarded as a painting or a tapestry hung on the wall. The result could appear rather naïve, but nonetheless charming, as in the 'Royal Couple'.*

169. *The Gebr school in Kerman. 1908. In the background hang several large Persian rugs. In Iran, photography developed apace during the reign of Nasseredin Shah, who was fascinated by the new art/technology, to the point of taking photographs of his subjects preparatory to sketching them. In most of the portraits the surrounding décor, whether in the background or on the floor, consists of rugs. Since furniture was never a part of Persian or Iranian tradition, the carpet played an important, ubiquitous, and greatly appreciated role in the everyday lives of Iranians, a fact which photography made clear for all the world to see.*

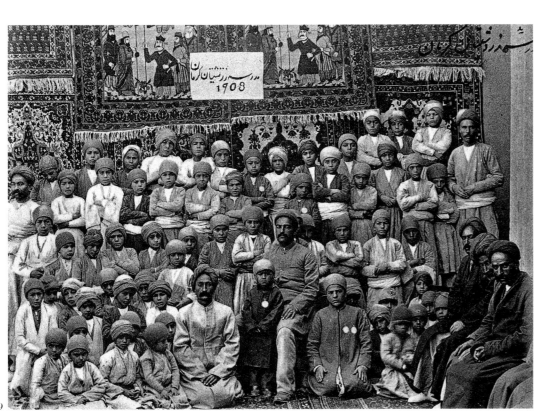

169

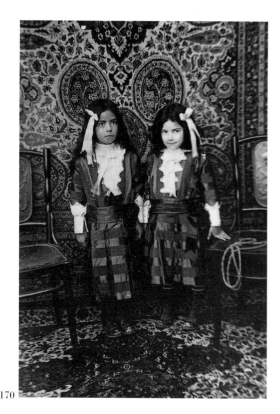

170

170. 'Les Demoiselles Malek', with a carpet at their feet and another on the wall behind.

The garden composition underwent considerable alteration, with the *Chahar Bagh*, or classic garden pattern, subdivided into several small niches, each sheltering a grove of different trees. The calligraphy appears to soar to new heights of importance, as seen in a marvelous silk Heriz from the turn of the 20th century (collection Yves Mikaeloff). Here the verses escape onto the inner field, once again taking over space formerly reserved for aquatic creatures. The gurgle of water is evoked through filigreed lines woven in blues and red-ochre. The poetry, framed in cartouches, appears against a feline-shaped yellow and white ground, which may signify a lion, the Iranian symbol of power and majesty. The two hemistiches, repeated four times along the interior axes of the canals, are from a poem by Sa'adi:

bâd dar sâyé yé derakhtanach gostarânidé
farsh boughalamoune

In the shade of trees,
the wind has rolled out a carpet of colors
iridescent like the feathers of a turkey.

Other hemistiches are woven in red on the cartouches, around borders harmoniously integrated with the red foliage on a ground of cobalt blue. They conclude with the *mobarak bâd*, wishing the viewer great happiness, while adding charm as well as value to the work. This piece was very likely commissioned and conceived on the occasion of a particular ceremony, such as a wedding. Although beautifully woven, the decorative program and the composition are less naturalist than those of classical Safavid carpets.

Other classical designs, such as the medallion, then very much in vogue, were freshly interpreted by later weavers employed at the newly created centers, such as Heriz and Farahan. The Heriz silk rugs are well known for the quality of their weaving, for their silk, and for their highly original design. This consists of gardens surrounded by poetic inscriptions running alongside isolated mythological figures placed in a landscape setting.[239]

Also from the Heriz workshop comes a superb example of a large-format garden carpet with a medallion composition and silk pile. Here it is interesting to note that the text is written backwards, like a mirror image, with words and images alike reflecting one another from either side of the divided field. The piece reveals anew the deep-seated mysticism of the Persian spirit, still present in every artistic endeavor.

The calligraphic style used in later pieces is primarily nastaliq, although naskhi may be the preferred script for the names, titles, and dates cited in figurative works. On other commissioned rugs – the *sefarechi* made to satisfy increasing demand – the names of the atelier, the patron, and the date of manufacture are set forth in a special cartouche in the middle of the border at one end of the carpet.

Modern Techniques and Standardization

Along with modern technology and chemical dyes, the fruits of industrialization, came a certain degradation, relative to Safavid prototypes, in the aesthetic quality of Iranian carpets. Moreover, important and outstanding centers such as Heriz disappeared altogether from the rug-making map, to be replaced by numerous other centers, among them Naïn and Qum, which adopted more standarized patterns. The Persian rug would now be aimed at a much larger market, where, aesthetically, it would have to satisfy a wider range of tastes. This meant developing a freer and more purely decorative style, a kind of synthesis in which the classical mode of the past could still be sensed. The traditional principles of the Safavid golden age continued, but their content – the profound meaning and mystical philosophy which once inspired the art – progressively evaporated.

Growing interest on every level of society contributed further to the commercial expansion of the artisan rug. It became an aesthetic symbol of opulence, an outward sign of wealth and power. By the end of the 19th century, rich families were having themselves photographed against a background of Oriental carpets. Couples posed with their children in front of or standing on carpets, thereby signaling their prosperity. For grand occasions or high ceremonies, photographers made sure to have Oriental rugs on full display.

Poetry remained precious to the Iranians, but the verse-inscribed rug would become increasingly rare. Nevertheless, a few such inscriptions continued to embellish handsome pieces right into the 20th century, with the quality of the calligraphic execution clearly improving along the way. A new, higher level of education and technical improvement in the art of weaving may explain this development, warming the heart of those who love Persian poetry and carpets. Be that as it may, the irresistible appeal of poetry and the deep love Iranians have for it will always make verse a major source of inspiration for Persian art in all its different manifestations.

171. *A Qadjar princess as a bride posed on steps covered with a splendid carpet. 1935.*

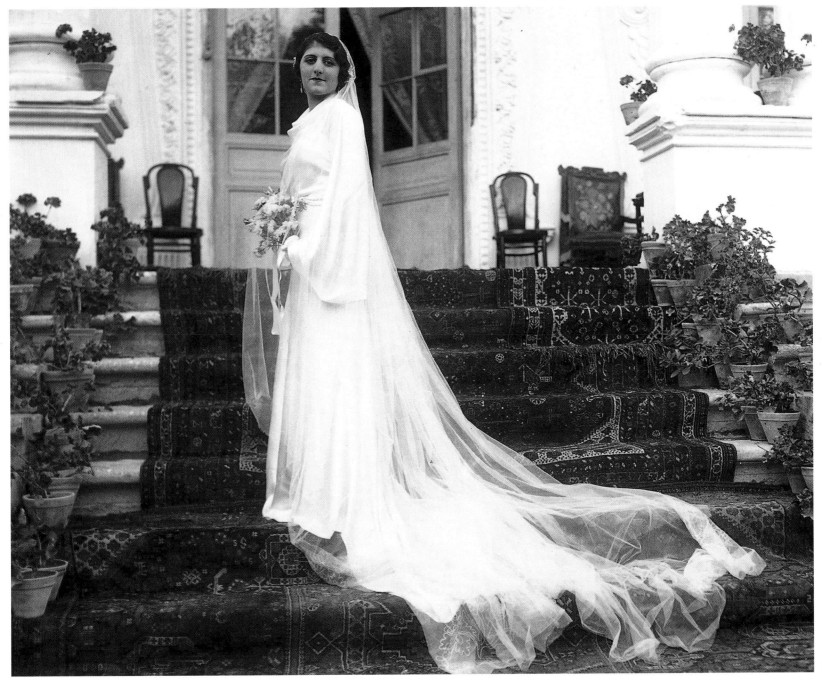

171

CHAPTER
VI

CARPETS
OF THE
GREAT MOGHUL:
16TH-19TH
CENTURIES

Valérie Bérinstain

India Subjugated by Europe

The riches of India have always captivated travelers making their way across the subcontinent. Among these fabulous treasures, woven goods invariably stood out and shared pride of place. The courtesans of ancient Rome draped themselves in diaphanous muslin from the region of the Ganges. In the 17th century, at the dawn of the Enlightenment, Europe fell under the spell of India. Indeed, the craze in France and elsewhere for painted and printed fabrics known as *indiennes* was so extreme that it caused an upheaval in the Western textile industry. Midway through the 18th century, however, the taste for cottons gave birth to *toile de Jouy*, a famous printed fabric manufactured in France.

Every year the ships of the various East India companies – Dutch, English, and French – returned to Europe laden with spices, precious stones, and textiles from India. Fine carpets woven of silk and wool also found their way into residences of Europe's crowned heads, who had long since succumbed to the beauty and luxury of Oriental rugs.

Unknown Origins

Yet, the origins and evolution of the carpet in India – unlike the development of Turkish or Persian rugs – remain poorly understood, for want of evidence earlier than the 16th century. While a few written documents confirm the presence of rugs in ancient India, none indicates what materials or techniques were used to make them. Could they have been fashioned of felt, like those used by nomads? Or were they embroidered, like the pieces mentioned by Marco Polo in his *Travels*? In his description of Gujarat,[240] the great 13th-century voyager noted that 'in this kingdom are made many beautiful mats of red and blue leather ornamented with birds and beasts and embroidered, very cleverly, with gold and silver threads. . . . the Saracens slept on them.' At about the same time, the historian Amir Kusrau used the Persian word *gilim* to designate rugs, but no description of

an Indian artifact by this name has ever surfaced.[241]

Despite the absence of written evidence, pile rugs were probably woven in pre-Moghul India, that is, before 1526, the year Babur invaded North India and launched the Moghul, or Mughal, Empire. From the beginning of the 13th century the country had been divided into small kingdoms, some of which, being Muslim, maintained solid ties with Persia and Baghdad. The Indian sultanates, being thoroughly immersed in things Persian, must have decorated the interiors of their palaces with knotted carpets.

THE WORKSHOPS OF THE EMPEROR AKBAR

In 1526, Babur, a descendant of Tamerlane, invaded India from Afghanistan and became the first Emperor of the long Moghul dynasty, which endured until 1857. Eager to legitimize his power, Babur wrote memoirs and filled them with broad descriptions of his environment. What fascinated him, however, was nature, and he never mentioned carpets. On the other hand, his grandson, Akbar, whose reign (1556-1605) proved especially brilliant, took an interest in all art forms and ordered his historian, Abul Fazl, to make

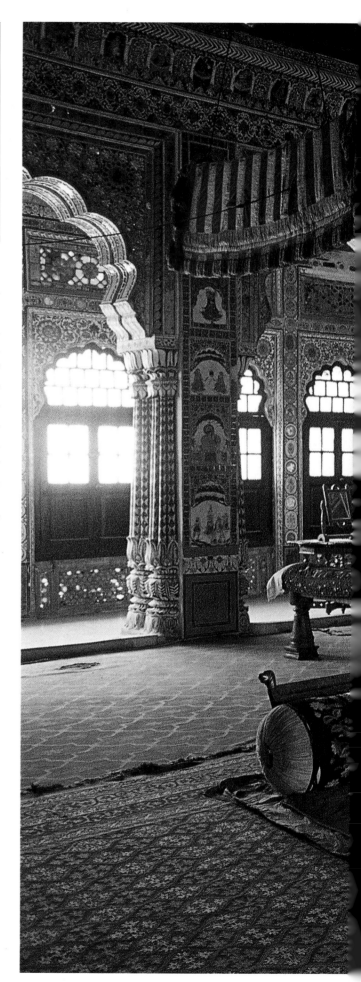

172. *Salon in the Red Fort of Delhi, Moghul India. Photograph from the Albert Kahn Collection, Boulogne-Billancourt. Moghul interiors were furnished solely with carpets and wall hangings.*

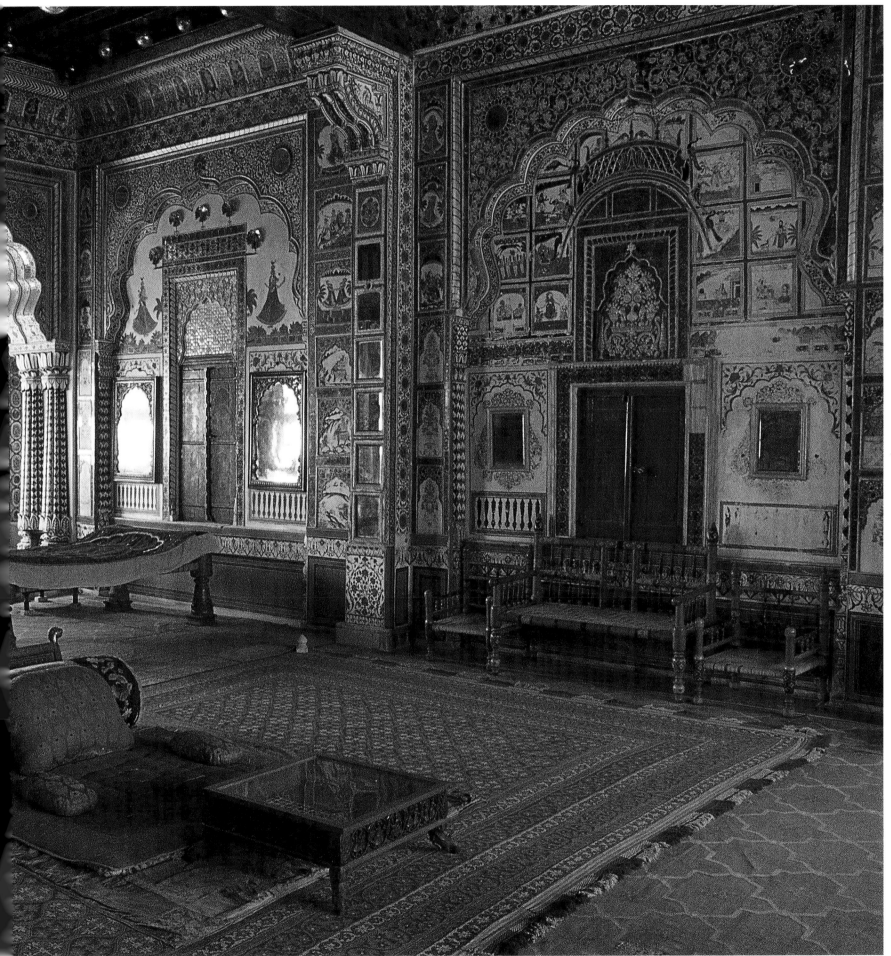

THE EMPIRE OF
THE GREAT MOGHULS

Founded by Babur, the Moghul Empire dom-
inated northern India and part of the south
from 1526 until 1857, when the British exiled
the last representative of the dynasty,
Muhammad Bahadur Shah. However, the era
of the Great Moghuls extended only through
the reigns of five Emperors: Babur (1526-
1530), Humayun (1530-1555), Akbar (1556-
1605), Jahangir (1605-1627), Shah Jahan
(1628-1658), and Aurangzeb (1658-1707).

THE EMPEROR AKBAR'S
WORKSHOPS

The Emperor Akbar (1556-1605), whose
reign proved especially brilliant, took a pas-
sionate interest in all art forms and ordered
his historian, Abul Fazl, to make detailed
descriptions of them in his biography. After
founding the city of Fatehpur Sikri, Akbar
had a large number of art and crafts work-
shops installed there, with carpet weaving
granted pride of place among the activities.

detailed descriptions of them in his biogra-
phy, the *Akbar Nameh*.[242] When the city of
Fatehpur Sikri was built, Akbar had numer-
ous ateliers set up for both the arts and the
crafts (*kharkaneh*), immediately next to the
imperial apartments. Among the various arts
practiced there, rug weaving occupied a priv-
ileged position of the first order. Persian mas-
ters directed the activities of the workshop,
where Indian weavers would receive their
training. Other imperial cities in North India,
such as Lahore, Agra, and Ahmedabad, also
had workshops dedicated to rug making.[243]

A Man in Touch with His God

In India, as in other Islamic countries, the
rug used for Muslim prayer is imbued with an
element of the sacred. It defines the privi-
leged space where the faithful can enter into
contact with God. At the same time, the
prayer rug served another, parallel purpose,

as decoration for royal buildings. Not only
did it cover floors paved with marble or red
sandstone; it also increased the comfort of the
tents run up as the sovereigns moved about
the countryside to hunt or to wage war. The
Moghul Emperors, descendants of Asiatic
nomads, rarely settled down, preferring
instead to live in large encampments, verita-
ble cities of canvas. Abul Fazl, describing one
of the encampments, noted that Akbar's
pavilion for private audiences (the *Diwan-i-
Khas*) 'is covered with rugs forming veritable
flower gardens.'[244]

173. *Carpet fragment with animals. Moghul India,
late 16th/early 17th century. Wool pile, cotton
warp and weft; 1.56 x 1.11 m. Louvre, Paris.
The rare carpets surviving from this period usually
display dark-red grounds with vegetal and animal
motifs.*

173

174

A Symbol of Wealth and Power

Carpets, like the silks and other precious fabrics, confirmed and celebrated the sovereign's wealth and power. It was also protocol to roll out carpets along the path where distinguished guests would tread. Another custom was to cover the tombs of dignitaries and princes with rugs and rare fabrics. The most precious textiles were kept in the imperial wardrobe, the *farrashkaneh*, and sometimes even in the Emperor's own private wardrobe, regarded as a genuine treasury. In 1579, after a fire completely ravaged this secure place at the heart of the palace, Akbar decreed that the disaster should be stricken from memory and absolutely never referred to.

The few carpets dating from this period, and preserved in various collections all over the world, testify to the great dexterity of the artisans working in the imperial weaving centers. With wool or silk pile and a foundation of cotton or, more rarely, silk, the rugs usually display a dark-red ground supporting a decorative scheme composed primarily of vegetal elements, sometimes embellished with animal figures.

The rugs made during the reign of Akbar present two types of ornamentation. One of these, found on pieces thought to be among the oldest, involves a rather particular design composed of scrolling arabesques bearing animal heads. The other, with its floral motifs scrolled around a central medallion, reflects the influence of Persian compositions.

174. Four rug fragments with 'grotesque' motifs. Moghul India, late 16th century. Wool pile, cotton warp and weft; 103 x 185 cm, 103 x 27.5 cm, 32.5 x 80 cm, 20 x 80 cm. Musée des Arts Décoratifs, Paris. The source of the 'grotesque' motifs remains an enigma, although some scholars have detected implications of the waq-waq legend, having to do with human- and animal-headed branches that cry when gathered. Most of the surviving fragments display red grounds overlaid with a variety of beasts and scrolling tendrils.

The 'Grotesque' Carpets

The first group is represented by no more than a few fragments, no complete carpet having been found thus far, and the vestiges are preserved in various collections and museums.[245] The origin of their 'grotesque' motifs remains an engima, although the roots undoubtedly lie in the iconography of the Middle East.[246] Some writers have detected implications of the *waq-waq* legend in the tree with branches terminating in human heads and animals, which cry *waq-waq* but perish once they have been gathered. Most of the fragments have a red ground overlaid with a variety of beasts – elephants, felines, stags, birds – all mingled with flowering stems, arabesques, and so sorth. Red being the most frequent field color, the blue ground of the piece in Paris's Musée des Arts Décoratifs constitutes an exception, as does the realism of the animals placed along a thin, scrolling tendril.

Along with the contemporary descriptions of Akbar's reign and the fragmentary artifacts, illuminated manuscripts or albums filled with miniature paintings also provide information – and this ample – about the ways and customs of the imperial court. Akbar, gifted with great charisma, was a passionate aesthete who encouraged all the artistic disciplines. As for the painting atelier founded by his father, Humayun (r. 1530-1555), Akbar urged it to scale the heights. The two Persian artists in charge, Mir Sayyid Ali and Abd us-Samad, had followed Humayun when he returned to India in 1554, after an exile of more than fifteen years at the court of Shah Tahmasp. What then developed was a very original kind of painting, a symbiosis of Persian and Indian elements, which little by little broke free of the Persian model. Although marked by a certain idealization, these new miniatures depicted, with great precision, the world of the Moghul court. The carpets, as it turns out, are practically always the same, featuring a blue field decorated with a central medallion composed of arabesques and palmettes. Not one corresponds to any of the fragments known today.[247] It therefore seems all the more sur-

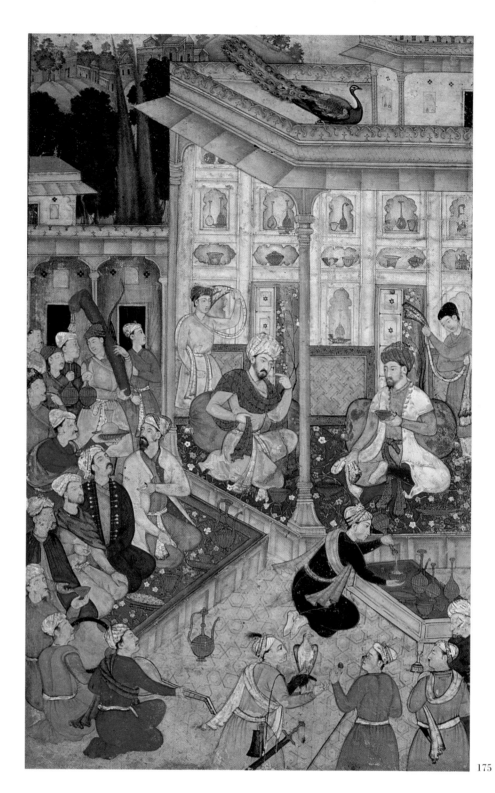

175

prising that several scholars have attributed the designs of certain rugs to painters active in Akbar's painting atelier.[248]

175. *The Emperor Babur Entertaining Bedi-Uzzalman Mirza, from the Babur Nameh. Moghul India, c. 1593. Gouche on paper, 24.5 x 23.4 cm. Musée Guimet, Paris. Painted during the reign of the Emperor Akbar, Babur's grandson, the Babur Nameh narrates the life of the first Moghul Emperor, a descendant of Tamerlane. No example of the blue-ground carpet with flowers and foliage is known to have survived.*

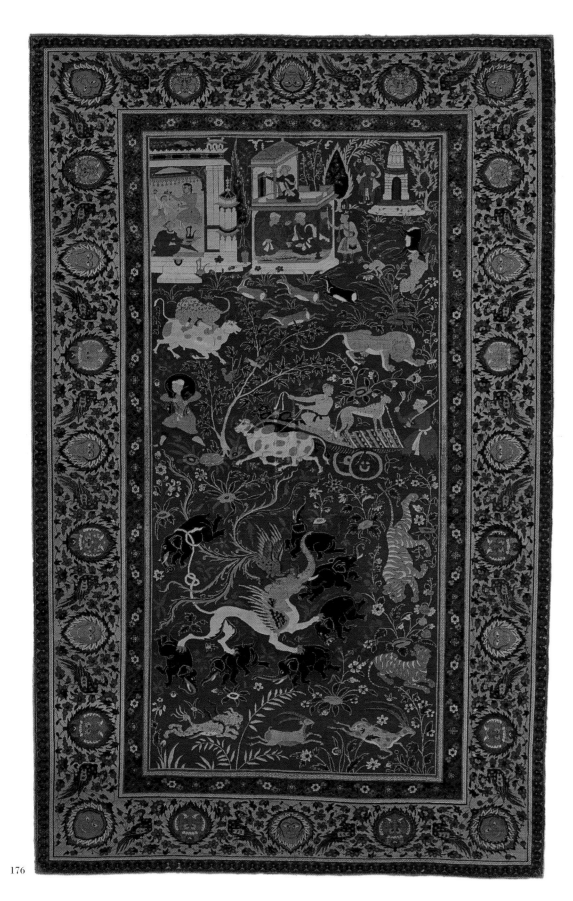

176

THE PERSIAN INSPIRATION

The Emperor Akbar's painting workshop was directed by two Persian artists, Mir Sayyid Ali and Abd us-Samad, who had accompanied Akbar's father when he returned to India in 1544, following an exile of fifteen years in Persia at the court of Shah Tahmasp. The resulting symbiosis of Persian and Indian elements yielded an original painting style, which gradually broke free of the Persian model. Still, Persia remained, in the second half of the 16th century, a primary reference for India, a fact evident in the iconography of real and imaginary animals intertwined with botanical forms, as well as in the colors, often borrowed from the Persian palette.

The Moghul / Persian Equation

There is no question that the rugs in the second group characteristic of the Akbar period relate to Persian pieces decorated with scenes in which real and fantastic animals are mingled together with vegetation.[249] Contrary to the Persian examples, however, Moghul carpets of the second half of the 16th century generally have airy patterns laced with realistic trees like those illustrated in the miniatures. Also present on occasion are men – mahouts or hunters – dressed in costumes typical of the style in vogue under Akbar.[250] The palette often adheres to the chromatic range used in Persian carpets. Foliage is rendered in several shades of green, while the reds display nuances running the gamut from carmine to salmon pink.

176. *Carpet with hunting scene. Moghul India, c. 1580-1590. Wool pile, cotton warp and weft; 2.43 x 1.54 m. Museum of Fine Arts (gift of F.L. Ames), Boston. The design of this carpet was very likely derived from hunting scenes illustrated in contemporary painting. The clothes worn by the mahouts or hunters represent fashion during the reign of Emperor Akbar.*

Finally, despite the development of its own court ateliers, Moghul India continued to import Persian rugs throughout the 16th century.[251]

THE COSMOPOLITAN TASTE OF JAHANGIR

A Court of Splendor and Luxury

At the death of Akbar, his son, Prince Salim, mounted the throne as the Emperor Jahangir (r. 1605-1627) and set about making the Moghul court a place of luxury and splendor. Once again, miniature paintings of the period constitute an important source of information. Indeed, the albums or manuscripts abound in celebratory portraits of the Emperor, and these in turn abound in clothing, tapestries, and carpets of particular magnificence. The patterns and motifs used in their embellishment, often floral in nature, confirm the extraordinary talent of the craftsmen working for the 'Great Moghul' as well as the taste of the sovereign for the arts of the entire world. While the influence of Persian carpets, notably those of Herat, remained predominant, decorative compositions more elaborate than anything seen during the Akbar era also came to the fore. Moreover, the examples in the miniatures display a style of pronounced realism, a characteristic of the painting developed under Jahangir. The manner is especially present in the case of a rug illustrated in a painting dating from about 1617,[252] where the scene, in the midst of a ballet of birds and 'Chinese clouds', allows the appearance of fabulous beasts, among them the phoenix and dragon. On a parallel piece, reproduced in a miniature showing Jahangir returning books to Sheik Hossein, the *waq-waq* theme is again evoked, this time strongly influenced by European 'grotesques'. Actually, the whole of this painting, which dates from 1615-1618, is permeated with numerous European elements.[253]

European Herbals

In the 1620s, Jahangir, a passionate lover of flowers, asked one of his artists, the painter

THE FLORAL MOTIF IN MOGHUL INDIA

During the 18th century, the flower became an archetype of the Indian iconographic repertoire. Architectural elements, objets d'art, and textiles were all ornamented with this motif, and always in a graceful, naturalistic manner.

It was while traveling through Kashmir in the 1620s that the Moghul Emperor Jahangir fell in love with the flowers of a region famous for its wealth of species. Almost a century earlier, Babur (r. 1526-1530), the founder of the Moghul dynasty, had caused several gardens to be laid out in India and Central Asia with the specific purpose of replicating on earth the Garden of Paradise described in the Koran. This passion for flowers was not unique to the Moghul emperors. Among the countries of the Middle East, Persia has always celebrated flowers and gardens in its visual arts as well as in its poetry.

During the reign of Akbar, the third of the Moghul emperors, the floral motif permeated the whole of the decorative arts, a development which occurred under Persian influence and only in the form of palmettes, scrolling foliage, and schematic and codified buds. Akbar's son, Jahangir, who had a passion for fauna as well as flora, brought a new dimension to the floral motif. Following a convalescence in Kashmir, the Emperor asked his court painter, Mansur, to execute a series of floral illustrations after the manner of the European *herbaria*. The resulting metamorphosis of the floral motif from the schematic to the extremely naturalistic came after printers in Europe, primarily Plantin in Holland, issued the first collections of botanical plates called *herbaria*. It was the Jesuits and the ambassadors of the various Western trading companies who introduced this style of drawing into the world reigned over by Jahangir. Thus, the Emperor's special interest and the arrival of the herbaria in the trunks of Western travelers combined to favor the transformation of a decorative element which, from a characteristic of Moghul art, grew into a pervasive archetype of Indian iconography.

177. The Garden of Fidelity (Kabul), from the Babur Nameh. Moghul India, late 16th century. India's Moghul Emperors had a veritable passion for flowers, which they cultivated by having opulent gardens laid out for their pleasure. Blossoms of every color also provided the decorative themes not only for carpets but also for the interiors of tents and palaces.

177

Mansur, to portray blooms in the manner of the *herbaria* – collections of botanical plates – printed in Europe. Although the floral motif remained discreet in the rugs of the early 17th century, a period during which taste ran to animal-populated landscapes, it would become a veritable archetype in the decorative arts of India throughout the second half of the 17th century and the whole of the 18th.

THE DEVELOPMENT OF
THE FLORAL MOTIF DURING
THE REIGN SHAH JAHAN

With the needs of the court growing apace, Shah Jahan, Jahangir's son and successor, lent firm support to the imperial weaving ateliers. During his reign (1628-1658), the Persian patterns of scrolling flowers were abandoned in favor of the floral motif, which soon became ubiquitous. Further, the composition of the field grew airier, with flowers and scrolls less abundant but more clearly defined in relation to the ground. It was this period which gave birth to the so-called 'Jaipur rugs', a group created primarily for the Amber palace[254] and then transferred to the Jaipur palace at the end of the 19th century. The originality of the group resides in the trapezoidal format of certain pieces.

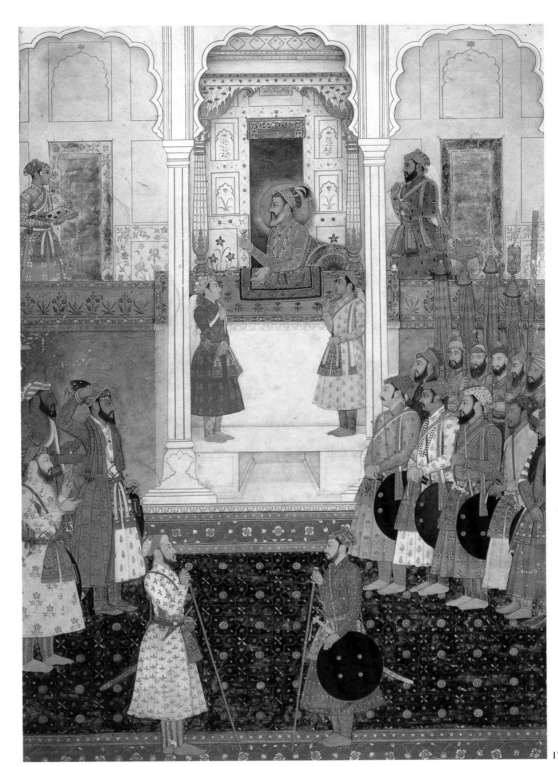

179

178

178. *Bas-relief from the Taj Mahal, Agra. Moghul India, c. 1640. Red sandstone. During the reign of Shah Jahan, dense Persian patterns of scrolling flowers gave way to floral motifs and airier compositions, which soon became ubiquitous, on everything from architecture to textiles.*

179. *An Audience Granted by Shah Jahan. Moghul India, mid-17th century. Gouache on paper, 30.5 x 21.5 cm. India Office Library, London. This miniature illustrates not only the prevalence of floral motifs during the reign of Shah Jahan but also the contemporary vogue of carpets with trellis and floral patterns.*

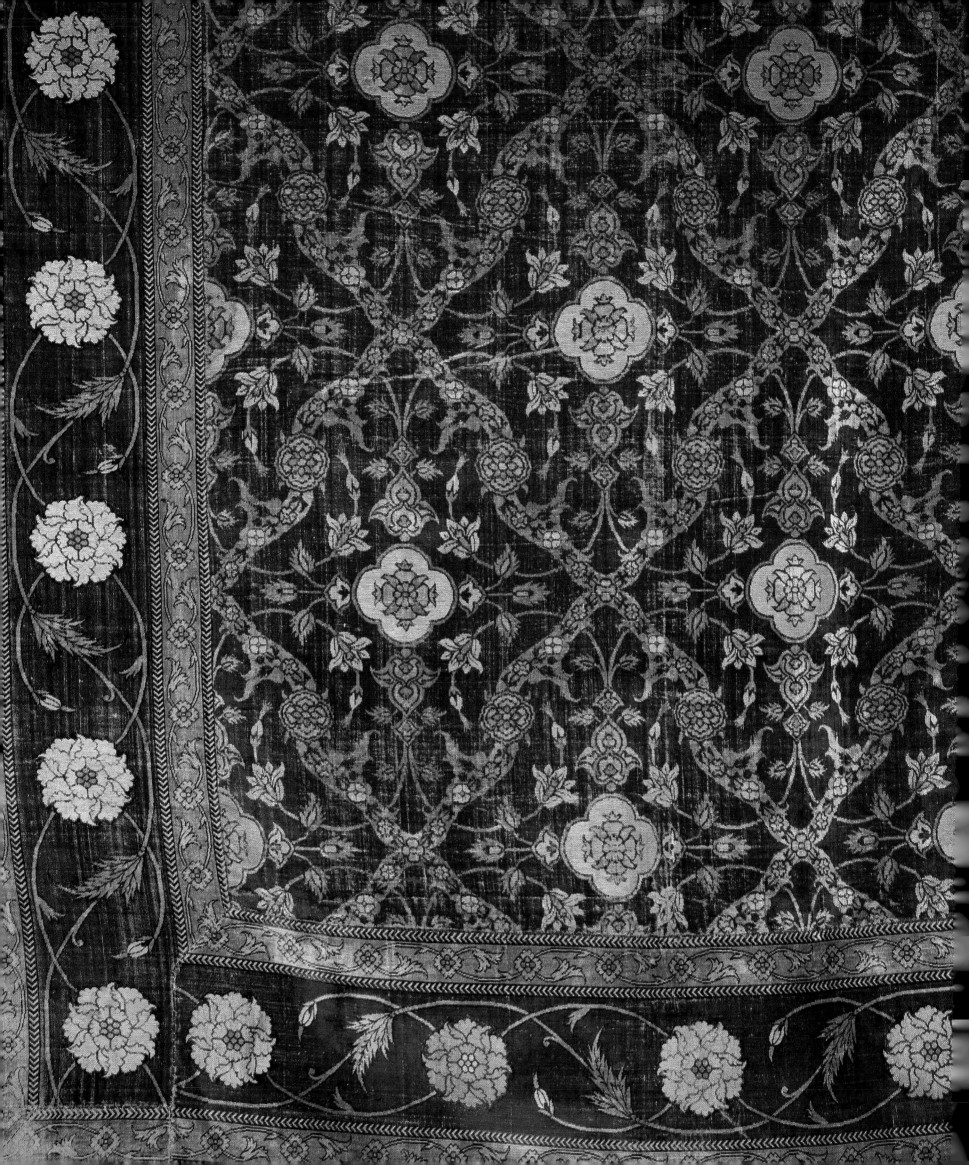

Their function has given rise to several hypotheses or questions. Were the carpets designed to fit around furniture or a floor plan – a throne or a fountain, for instance? Or perhaps to cover the floor of a room with rather particular dimensions at the Amber fort? Whatever the purpose, these rugs are all decorated with essentially the same pattern, featuring flowers rendered in a remarkably naturalistic manner and scattered over a cerise field. The deep-blue border is ornamented with scrolling foliage and palmettes. Certain pieces bear labels inscribed '*Lahore gilim*', which in no way proves that the place of manufacture was Lahore, even though this city at the time enjoyed a fine reputation for its carpet-weaving workshops. Indeed, the fame of Lahore production accounts for the great number of rugs attributed to the center. Dates ranging from 1650 to 1689 are also inscribed on several pieces. Very likely they correspond not to manufacture but rather to various inventories. Other rugs have been cut into several pieces, as we know from photographs taken in situ by A.J.D. Campbell during the inventory made at the Jaipur palace in 1929.

THE 'MILLEFLEURS' PATTERN

An Italian Origin

Side by side with the flower-sown pattern just considered, another style of ornamentation also enjoyed great favor under Shah Jahan, as well as under his heir and successor, the Emperor Aurangzeb (r. 1658-1707). This is the 'millefleurs' carpet whose ground is embellished with a lattice or trellis motif, each diamond of which contains a naturalistic flower or a palmette. Some specialists see Italy as the source of the pattern, which also shows up in India's architectural decoration during the 17th and 18th centuries,[255] as well as throughout the decorative arts, especially on jade pieces set with precious stones. There are several millefleurs carpets whose warp is made of multicolored silks, evidently a characteristic of woven products from Lahore.

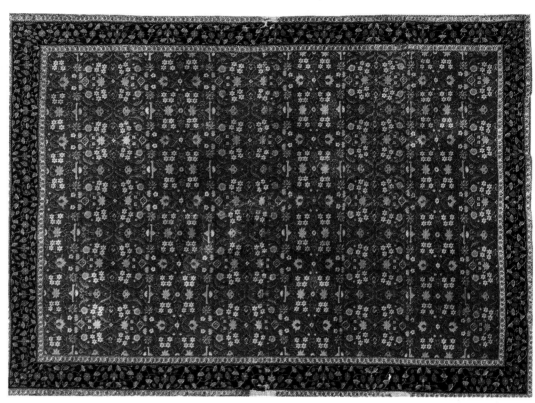

181

182

183

180. *Carpet or tapestry with trellis and floral design. Moghul India, late 16th/early 17th century. Silk pile, cotton warp and weft, metallic brocading; 3.80 x 2.80 m. Louvre, Paris. This carpet, a work of great refinement, typifies the decorative richness of the various trellis and floral patterns. The border recalls the carpet illustrated in the Shah Jahan miniature seen here.*

181-182-183. *Carpet with trellis and floral pattern. Moghul India (Lahore?), early 18th century. Wool pile, silk warp and weft; 1.90 x 1.25 m. Private collection, Paris. This carpet was purchased in Bengal by Colonel Sir John Murray McGregor. The design, unlike many during the period, is of great refinement, a quality reinforced by the vibrant palette.*

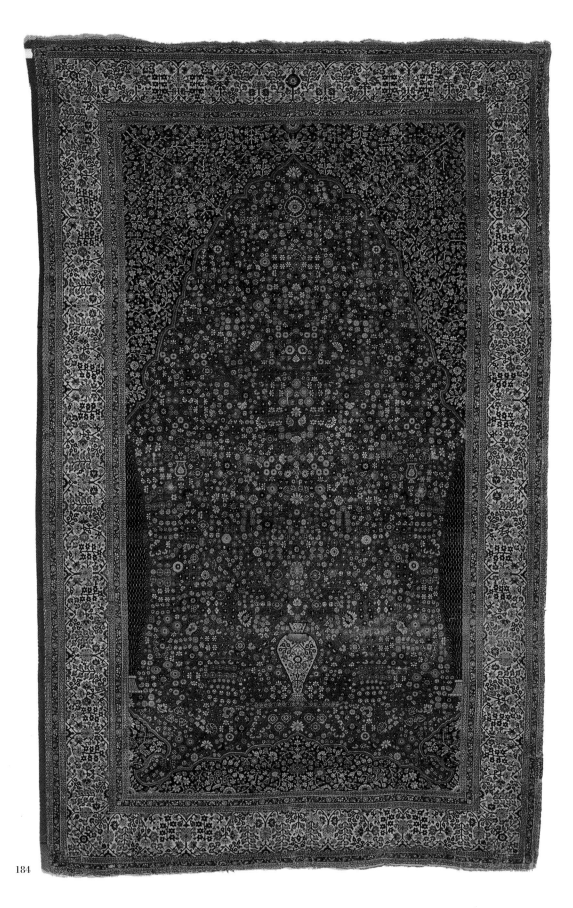

184

MILLEFLEURS CARPETS

Highly prized during the Shah Jahan's reign and until the early 18th century, *millefleurs*, presents an all-over trellis motif in which each diamond contains a naturalistic flower or palmette. Certain specialists believe Italy to have been the source of this pattern, which made a frequent appearance throughout the architecture and the decorative arts of 17th- and 18th-century Moghul India.

Changes in Design

In the early part of Shah Jahan's reign the millefleurs imagery was realized with great detail and precision. Later on, however, the pattern evolved towards greater stylization, especially during the second half of the 17th century and throughout the 18th. Somewhat set apart from these types of floral carpets is a group which bears the rather unsatisfactory name 'Indo-Herat' or 'Indo-Isfahan'. Although their origin, Indian or Persian, is subject to dispute,[256] the ornamentation is unquestionably related to the Persian aesthetic, which was moreover greatly appreciated at the Moghul court. And this was especially true because the wives of both Jahangir and Shah Jahan, as well as many courtiers and ministers, were from Persia.

184. *Carpet with the 'millefleurs' pattern. Moghul India, 18th century. Wool pile, cotton warp and weft; 1.87 x 1.17 m. Musée Historique des Tissus, Lyons. India has been an important producer of prayer rugs, a tradition intensified during the reign of the Emperor Aurangzeb, a fervent defender of Islam. Moghul prayer rugs are of two types, one of them with a flowering plant below the mihrab, and the other, like the example seen here, with the mihrab arching over a vase erupting with a bouquet of flowers.*

185

Prayer Carpets

During the second half of the 17th century, the millefleurs trellis pattern, often composed of foliage scrolled into volutes, lost its undulant form and became stiffer, more like a diaper pattern, endowing the cells with a geometric look. At the beginning of the 18th century, the diamonds sometimes assumed the form of stars with multiple points. The floral motifs, albeit of great richness, were now placed with greater concern for symmetry, a quality rarely seen in rugs dating back to the first half of the century. Finally, the border on these later pieces grew wider and more complex in its ornamentation, consisting mainly of flowering foliage sometimes framed within cartouches.[257]

Some of these rugs – frequently attributed to Lahore and often of considerable dimen-

sions – were woven with goat hair or even with cashemere wool, the latter used as well as in the famous cashemere shawls. The cashemere pieces, with their incredibly soft and supple texture, have an exquisite touch, as well as a brilliance rivaling that of silk.

The term 'millefleurs' is fully justified when it comes to the large prayer rugs. Here, the design presents a niche or *mihrab* arching over a vase erupting with a bouquet of flowers which, like a fireworks display, showers buds all over the field. After 1650 the compositions depart somewhat from their immediate antecedents, whose open or airy patterns would now become ever more dense. A kind of *horror vacui* invades these later pieces, notably in the 18th century.

India appears not to have produced a great number of prayer rugs. The best known of them is the so-called 'Parivicini carpet', made

around 1635-1640.[258] Unlike the millefleurs pieces, it is graced with a composition centered upon a flowering plant spread out below the *mihrab*. Most of the rugs ornamented with a *mihrab* date from the end of the 17th century or from the 18th century. The appearance in India of this genre of carpet may have been owing to the Moghul Emperor Aurangzeb, a fierce defender of Islam.

185. *The jubilee celebrating the 50th year (1927) of the reign of the Maharaja of Kapurtala. Photograph from the Albert Kahn collection, Boulogne-Billancourt. The carpet in the foreground confirms its continuing relevance for everyday life in India.*

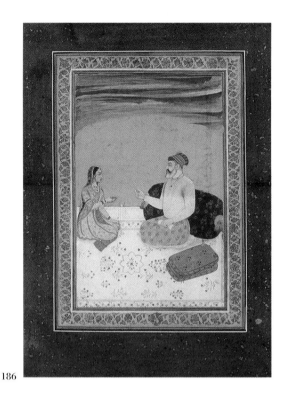

186

186. A Nobleman with a Courtesan, *from the* Shir
Djang *album. Moghul India, early 18th century.
Gouache on paper; 19.7 x 12.8 cm. Bibliothèque
Nationale, France. Here the figures are seated not
on a piled woollen carpet but, rather, on a cotton
'summer rug' embroidered in silk.*

187-188. Embroidered carpet. Moghul India, late
17th century. Layered cotton fabric embroidered in
silk; 2.11 x 11.15 m. AEDTA, Paris. This red-cotton
rug has a pattern of concentric motifs organized
around three central medallions, all embroidered
in yellow silk. The festooned border with its floral
motifs could have been inspired by plates in the
herbaria imported from Europe.*

EUROPE AND
THE INDIAN CARPET

It was during the reign of Aurangzeb, the
warrior Emperor, that quantities of Indian
carpets were exported to Europe, where the
first examples had already appeared at the
beginning of the 17th century.[259] Among the
high-quality exports was the 'Girdlers Car-
pet', a piece commissioned at Lahore by Sir
Robert Bell,[260] a member of the East India
Company from its beginning as well as Master
of the Worshipful Company of Girdlers in
London. Sir Robert had the carpet embla-
zoned with the Girdlers' arms and shipped to
England from Surat. Also worth noting is the
'Fremlin Carpet', so named for William
Fremlin, a member of the East India Com-
pany who served as president of the Surat
trading post from 1639 to 1644.

Merchandise Overlooked
by Europe

Actually, Indian carpets were not in very great
demand by the European trading companies,
their designs leaving something to be desired
from the perspective of Western taste. More-
over, the weaving centers worked primarily for
the Moghul court, as well as, later on, for the
other Indian courts. In addition, there was the
inordinate amount of time it took to weave the
carpets.[261] This worked against the quick
profit in the interest of which the trading com-
panies' agents would sometimes compromise
on the quality of the goods they dispatched to
the West. Taken together, these factors did not
provide much incentive to produce for
Europe, where Indian rugs arrived mainly as
diplomatic gifts. Great Britain's East India
Company preferred to place its orders for Ori-
ental carpets with the workshops of Persia,
which could supply high-quality pieces much
more rapidly.

The Decline of the Moghul Emperors

Following the sack of Delhi in 1739, by the
armies of Nadir Shah from Khorassan, the
rug-weaving enterprises of imperial India col-
lapsed, forcing many artisans and craftsmen

to abandon the Moghul capital for more hos-
pitable courts. The whole of Moghul art disin-
tegrated along with the monarchs of this great
dynasty, and it was not until the 19th century
that the Indian rug found its second wind. By
this time, indeed, European rug manufactur-
ers found themselves faced with a tremendous
demand for Oriental carpets. As a result, sev-
eral Indian cities, such as Agra, put prisoners

187

189

189. *Embroidered carpet. Moghul India (Gujarat?), late 18th century. Cotton embroidered in silk and gold thread; 2.95 x 2.38 m. Private collection, Paris. Gujarat enjoyed a high reputation for the quality of the embroidered pieces made in its workshops. This princely carpet would have been placed under a throne of polygonal shape, or under a pallet on which the prince could recline while resting on bolsters or cushions covered with precious fabric.*

to work weaving for the new market, turning out pieces under the Indo-Persian rubric 'Agra'.

EMBROIDERED CARPETS OR 'SUMMER RUGS'

Along with pile rugs, India also produced a great many small embroidered pieces. Made of several thicknesses of cotton fabric sewn together with a fine stitch forming a tight grid pattern, these beautifully decorative 'summer carpets' were fabricated in mass quantity for use as 'mats'.

Textiles as Furnishings

The relative absence of furniture in Indian dwellings encouraged the utilization of textiles, such as wall hangings, squares of cloth, or 'summer carpets', these last rolled out to create a place for reclining on cushions. Here again, the 17th- and 18th-century albums of miniatures clearly depict the rugs and their purpose. Many of the scenes are staged on terraces of white marble where the protagonists have settled themselves on cotton rugs embroidered with floral motifs. Rugs also cover the divans or *gadi* on which the princes sit.

The Quality Products of Gujarat

The oldest known rugs embroidered in India date from the 18th century. They are embellished with designs composed of naturalistic floral motifs, very similar to those found on pile carpets.

Although embroidery was practiced at all the great artistic centers of India, Gujarat enjoyed a high reputation for the quality of the pieces made in its workshops. Undeniably, it was from this region in the west of India that the finest examples came.

At the end of the 18th century the compositions tended to become more sophisticated, among them a relatively large-scale pattern of scrolling foliage around a central medallion filled with flowers in full bloom. Here gold thread would be generously employed, lending a precious look to rugs which were, in

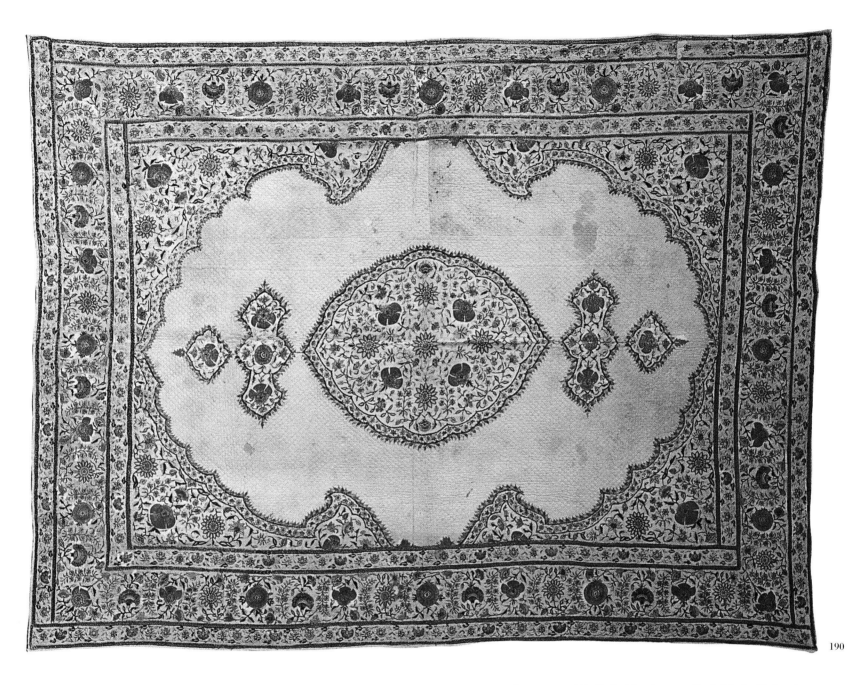

190

fact, quite fragile, and thus rarely meant to be trod upon.

Even though India could boast one of the world's richest textile economies, its production of pile carpets remained minor relative to the whole of the Middle East. The pieces that have come down to us are not very numerous, and their inconographic repertoire is limited. Compared to the rugs of other countries, the designs on Indian pieces continued to be quite figurative and oriented primarily towards the floral. The reference to paradise, as it is evoked in the Koran, can be detected, but, essentially, it was the aesthetic, rather than the religious, dimension of the concept that interested the Indian craftsmen,

whether they were Muslim or not. Unfortunately, 19th-century taste favored ornamentation in the Persian manner, at the expense of the decorative schemes characteristic of Indian carpets woven in earlier periods. This remains the case today, particularly in regard to the so-called 'Kashmir' rugs, whose patterns are densely floral and much closer to Persian models than to those of old India.

190. *Embroidered carpet. Moghul India (Gujarat), late 18th century. Piqué cotton and colored thread. This type of carpet could be easily rolled up and then rolled out again on a marble terrace.*

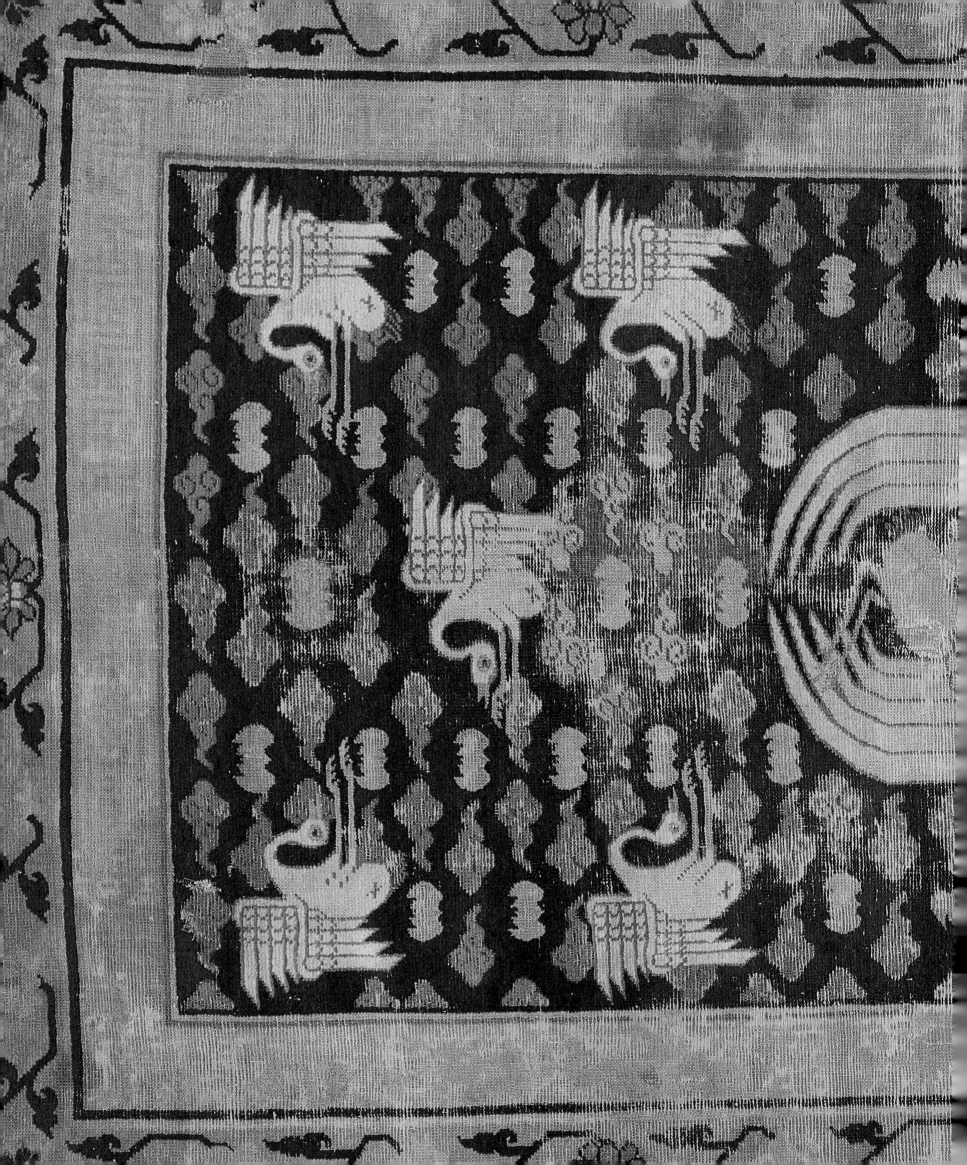

CHAPTER
VII

THE CARPETS
OF THE
MIDDLE KINGDOM:
CHINA

Valérie Bérinstain

In that Middle Kingdom otherwise known as China, carpets were important in ways quite different from those in the Middle East, where they played, and continue to play, a primary role in the religious and everyday lives of nomads and princes alike.

Carpets in the Chinese Interior

In China, for instance, houses are fitted out with real furniture, including tables and chairs. Moreover, despite the presence of numerous quasi-religious symbols throughout the décor in Chinese homes, rugs have little to do with the Oriental philosophy which would view them as objects somehow involved with the sacred as well as the profane. In the Middle Kingdom, the carpet is essentially one decorative element among others.

Chinese carpets have in fact been relatively little studied, despite the many historical references confirming their existence as far back as the Han dynasty (206 BC–AD 220). The problems are at least two-fold. On one hand, few old examples have survived – and most of these only from the 18th and 19th centuries – while, on the other hand, the carpets themselves provide little evidence allowing secure attributions of individual pieces to a given production center.

In 1960, however, a group of Chinese archaeologists discovered at a neolithic site in Normhong several fragments of a woollen fabric with heavy pile secured by knots, fragments which may date back to the 3rd millennium BC. From the Han dynasty there are now bits of material comparable to velvet, uncovered at sites in Minfeng and Luochan. Yet, consequential as these finds surely are, it would be premature to conclude that they actually represent what were knotted-pile carpets.[263]

The Golden Age of Chinese Art

The T'ang dynasty (618-907) constituted a golden age in the art of China, a nation that was opening its doors to foreign influences. These were both artistic and philosophical, brought in large part by travelers crisscrossing Central Asia along the Silk Route or Road. But equally significant for the

grandeur and flowering of the T'ang dynasty was Buddhism, which inspired numerous murals at major sites along the Silk Route. Some of the paintings, as at Dunhuang,[264] show that rugs were indeed a regular feature in the décor of temples, monasteries, and palaces. From this incredibly fertile period in Chinese civilization date several examples of the Chinese carpets offered in the 8th century to the family of the Japanese Emperor Shomu by monks from the Todara-ji Shrine in Nara. Today preserved at Nara's Shosho-in Shrine, the rugs – about thirty-one in all – are not pile-woven, but made of felt embellished with embroidery and fabric appliqués in an open, airy composition. Some of the pieces display scatter arrangements of birds, shrubs growing from hillocks, clouds, pilgrims, etc., while others have a large central medallion surrounded by flowers among scrolling arabesques of leaves and tendrils.

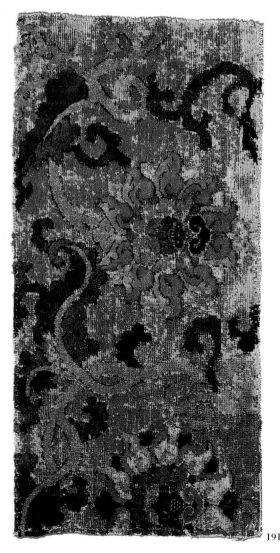

191

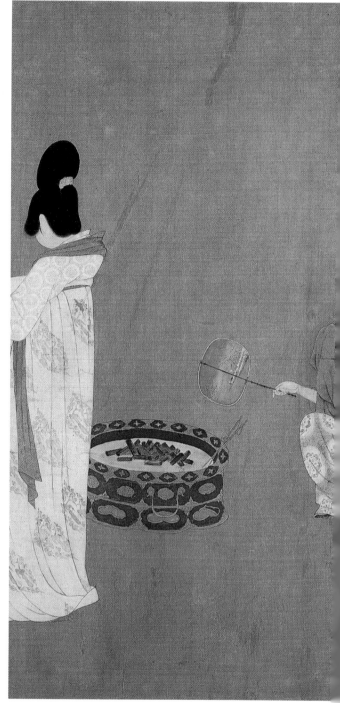

The Silk Route

The data just cited, although scant, suggest that knotted-pile carpets were little made in China itself. Very likely they arrived in the country by caravans traveling the Silk Route, that long meandering axis of trade between East and West. The pastoral tribes in northwestern China made rugs of pressed felt, sometimes ornamented with embroidery, or of knotted wool for use inside their yurts, to partition and brighten these rudimentary

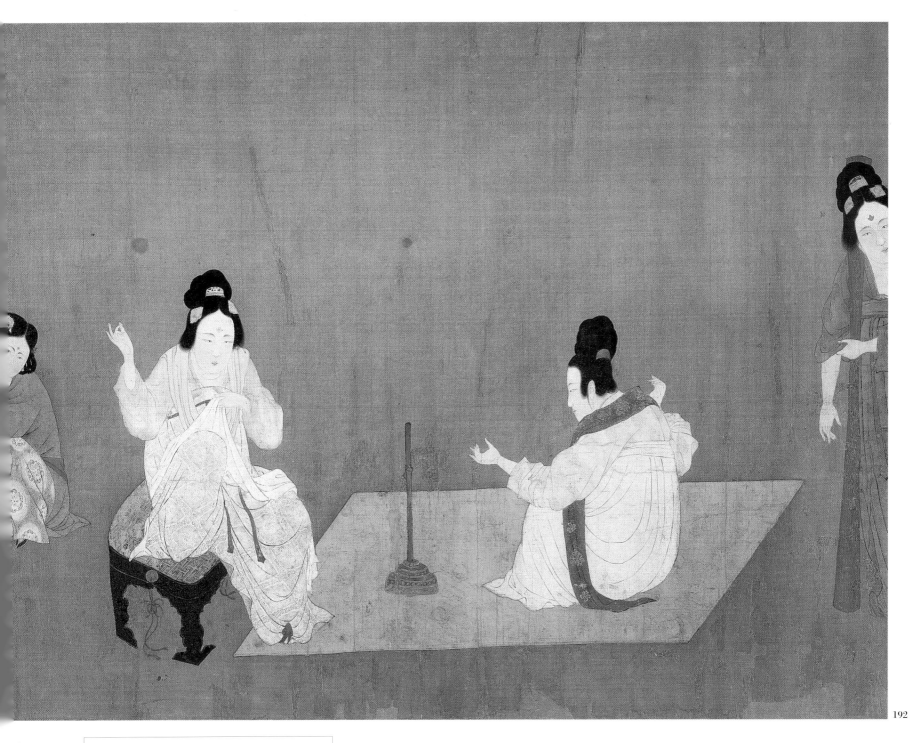

192

THE CHINESE DYNASTIES

Han: 206 BC–AD 220

'The Three Kingdoms': 220-589

Sui: 589-618

T'ang: 618-907

Five dynasties followed each other: 907-960

Sung: 960-1279

Yüan: 1279-1368: Mongol period

Ming: 1368-1644

Ch'ing (including Ch'en-lung's reign: 1736-
 1795): 1644-1911

192. Women Preparing Silk. *Attributed to the Emperor Hui Tsung (1082-1135), Sung dynasty. Painting on silk, 37 x 145 cm. Museum of Fine Arts (Chinese and Japanese Fund), Boston. In this detail, the figures are seated on a green-ground carpet with blue flowers. The image confirms the presence and use of carpets in 12th-century China.*

191. Carpet fragment with foliage and flowers. *China, 17th-18th century. Wool pile, cotton warp and weft; 0.60 x 1.20 m. Musée des Arts Décoratifs, Paris. The design of this carpet involves elaborately drawn foliage with flowering lotus against a brown field tinged with orange. The airy compostion and the absence of symbolic motifs suggest the age of the fragment.*

THE GOLDEN AGE OF CHINESE ART

Under the T'ang dynasty (618-907), China opened up to foreign influences, both artistic and philosophical, brought by travelers criss-crossing Central Asia along the Silk Route. Equally important to the blossoming of this golden age in Chinese art was Buddhism. In the 8th century, Chinese felt carpets, decorated with embroidery and appliqués, were offered by the monks from the Todara-ji Shrine in Nara to the Emperor Shomu's family. Today some thirty-one of them are preserved at Nara's Shosho-in Shrine.

TWO TRADITIONS IN CHINESE CARPETS

China held two completely opposite conceptions of the carpet: one, aristocratic, which saw the rug as an ornamental accessory; and the other, nomad, which treated it as an essential element of everyday life. The Mongol Yüan dynasty (1279-1368), with its nomadic tradition, proved especially effective in bringing new vigor to carpet production in China.

habitations or to serve as pallets. China therefore held two opposite conceptions of the carpet: one, aristocratic, which saw the rug as an ornamental accessory in palace décor; and the other, nomad, which treated it as an essential element of quotidian life, particularly among people of Mongol descent.

Nomadic Carpets

With the advent of the Yüan dynasty, which lasted from 1279 to 1368, the Mongols would dominate China for almost a century. The era also witnessed the spread of Islam into northern China, a cultural development which may have permitted the introduction or the rediscovery of such foreign techniques as rug knotting. The nomad origins of the Yüan monarchs no doubt stimulated the production of carpets, a genre of artifact they would have been accustomed to as part of their

unsettled way of life. Still, relevant hard evidence, written or pictorial, remains difficult to come by. Only a few paintings[265] depict rugs, and these are ornamented with compositions whose iconographic repertoire is remote from that of the indigenous Hans.

A native Chinese dynasty would return to power with the accession of the Mings, the 'Luminous', who reigned from 1368 until 1644. Eager to re-endow China with a civilization as prestigious as that of the T'angs, Ming sovereigns reunited the empire and reopened it to foreign trade.

The Brilliance of the Ming Dynasty

The Ming emperors also indulged their passion for surrounding themselves with beautiful objects, the effect of which was to propel the arts of China into a long period of extraordinary brilliance. During the 17th century, the size of the Chinese economy all but matched that of the West. Numerous workshops and factories were created, particularly for the weaving of silk and pile rugs. Most of these enterprises were located in the Ning-Hsia region, in northwestern China near Mongolia, a territory conquered by K'ang-Hsi, an emperor of the Ch'ing dynasty (1644-1911), who admired the rugs woven by the local workshops. This was the era in which the carpet started to become an integral part of Chinese culture, and it was also from this rich period that date the oldest known specimens, one of which is owned by the Musée des Arts Décoratifs in Paris. During the reign of Ch'en-Lung (1736-1795), the carpet industry of northern China grew and matured substantially, a development that would accelerate throughout the 19th century.

THE CARPET AS A DECORATIVE ELEMENT IN THE CHINESE HOME

In China, the floors of dwellings were far more likely to be covered with mats, rather than carpets, the latter normally used on furniture or hung on walls. This was even more the case in Buddhist temples, where long, narrow pairs of carpets were wrapped about

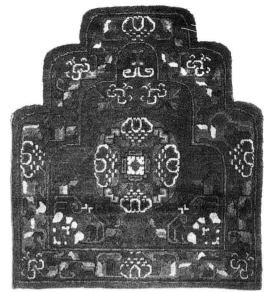

193

194

ACCOUNTS OF CARPET USE IN CHINA
(BEFORE THE 18TH CENTURY)

In 629, the Buddhist pilgrim Hsuan Tsang set out for India, to find the sources of the Buddha's teachings. He crossed Western China and Central Asia. Passing through the city of Khotan, he took note of the mulberry trees kept for the nourishment of silkworms, described the beauty of the taffeta fabrics, and added that 'woollen carpets and beautiful felt rugs are made in Khotan.' He tells the story of his long journey in *Memoires on the Lands of the Occident*.[266]

Later, in the 13th century, the great voyager Marco Polo recorded that, for a dinner given by Kublai Khan at Peking, 'the tables are arranged in such a manner that the great Lord can see everyone . . . and they are numerous! However, do not imagine that everyone might be seated at tables; quite the con-trary, most of the knights and barons eat in the hall on rugs, because they have no table at all.'

Du Halde, *Description de l'empire de la Chine et de la Tartarie chinoise*, Paris, 1785. Father Gerbillon, at the time of his journey to Tartary in 1697, wrote in regard to carpets: 'His majesty was presented with several foot rugs, rather similar to our Turkey carpets but coarser. They are made here, and the Emperor had the curiosity to have some fashioned according to his preference' (IV, p. 372). Father Du Halde also commented on the plays performed during a banquet: 'There are no sets for these plays which are performed during the feast; it is enough merely to cover the floor of the hall with a carpet' (II, p. 112).

193. *Seat and backrest covers. China, early 19th century. 141 x 0.67 cm. Victoria and Albert Museum, London.*

194. *A high military officer and his wife. Royal Ontario Museum, Toronto. This painting is particularly interesting for the carpet on which the two thrones are placed. The pattern, with its central medallion and two cranes on a field of foliage and flowers, resembles the piece illustrated at the top of page 21.*

195. *A pair of column rugs for a Buddhist temple. China, 19th century. 1.94 x 1.11 m. Victoria and Albert Museum, London. Chinese rugs were made to cover the furniture or the walls more than the floor. This was particularly true of the long, narrow pairs of carpets designed to wrap around and hang from pillars in Buddhist temples. In such pieces motifs were often conceived for vertical reading, with the dragons fragmented across the carpets so that they appear to coil about the pillar. In the example seen here, the image represents the Emperor reigning at the center of the universe. Below is the underworld, as well as the aquatic and terrestrial worlds. The celestial world, with its stylized clouds, is inhabited by the dragon and phoenix (symbols of the Emperor and Empress). The upper zone displays an inscription in Chinese.*

195

or hung from pillars and attached with thongs or straps. Even the designs, with their iconography of dragons or monks bearing symbolic objects, were conceived for vertical reading. Sometimes the dragons are fragmented across the carpets so that, once in place, they appear to coil about the pillar.

Carpets Draped over Furniture

Closely linked to architecture, Chinese carpets were also identified with the furniture designed to make domestic spaces pleasant and comfortable. Tables and chairs in particular were frequently covered with rugs. A good many 19th-century paintings show the dignitaries of the Empire seated upon thrones with carpets spread below and in front. Further, the thrones are furnished with two identically patterned rugs, one on the seat and the other on the backrest. Here, the pieces are, of necessity, small. In northern China, larger formats were used primarily to cover the *k'ang*, a plain-brick stove built like a platform housing several hearths designed to allow maximum diffusion of heat. A certain number of stacked rugs covered the whole, thereby creating a warm and comfortable stage on which the inhabitants could sleep, take their meals, or receive guests during the winter months. Only in the 19th century would very large pile rugs be woven in China.

TECHNIQUE, COLOR SCHEMES, AND DESIGN

With the exception of a few examples from around the turn of the 19th century, which have woollen foundations, Chinese carpets are woven upon a cotton foundation. The pile, however, is invariably made of wool from a species of broad-tailed sheep raised in Kansu or the Mongolian interior. In general, the asymmetrical knot prevails as in much of the Middle East, but the weft is shot every two rows of knots.

Unlike the Oriental rug with its multiple, richly colored patterns, Chinese carpets have palettes limited to black, several shades of blue and yellow, and dark red sometimes

verging on brown. The dye used for brown is so corrosive that rug makers prefer to employ wools that provide the color naturally. White and green rarely appear in Chinese carpets.

In China, where nothing is left to chance, every aspect of existence is believed to have its predetermined place in the universe. It follows therefore that the colors chosen to decorate carpets would correspond to the elements, the seasons, the cardinal points, etc., in a system of complex, symbolic correlations which date back to remote antiquity. Thus, black, the color of the first Chinese Emperor, Huang-ji, relates to water and the north. It connotes darkness, at the same time that it also signifies honor. Blue, the color of the sky and the sea, expresses serenity and purity. Yellow stands for the earth, central China, and the fifth cardinal point beyond. The color of the loess of northern China, yellow is also the color of wheat, but it may, in addition, represent glory and the emperor who reigns at the center of the universe. As for red, it is the giver of life. Red indicates the south, also wealth and bliss, and it was the color adopted by the Mings. White evokes the west, autumn, and metal. It was also the color of the Han dynasty, but, as a materialization of mourning, it can also be a symbol of bad omen. Green corresponds to the

east, to springtime, and to wood. The Ch'ings selected it as their emblematic color.

As in the carpets of the Muslim world, the patterns ornamenting Chinese rugs are not fortuitous. Like the colors, they relate to the principles of life, the earth, and the universe. The motifs, which also occur on countless objets d'art, especially bronzes and porcelains, come from various repertoires built up by traditional and religious China. The different symbols, whose interpretation requires an intimate knowledge of Chinese thought, can be divided into two broad categories: geometric elements and figurative elements, the latter including objects as well as flora and fauna.

The Geometric Motifs

Several motifs in this category survive from ancient Chinese civilization:
- The beaded band, no doubt influenced by Sassanian iconography, in which it often appears. The theme is also frequently encountered in Central Asia. On carpets, it serves primarily as a border ornament.
- The fret pattern, another regular feature on borders. The most sophisticated version is the *lei wen* – a 'lightning' or 'thunder' pattern. The motif appears on ancient bronzes, particularly those of the Shang and Chou dynasties (1766-1123 BC and 1122-221 BC respectively).
- The swastika, which also appears on borders, as well as on the central field. Derived from ancient shamanist cults, this element symbolizes the sun. In Buddhist iconography, the swastika evokes the continuity of life.

196. Carpet with quatrefoil motif. China, 19th century. Wool pile, cotton warp and weft; 8.05 x 7.19 m. Private collection, Paris.
With its huge dimensions, this carpet could have been made for the palace of a high Chinese dignitary. The quatrefoil motif, with its eight-pointed corner stars, symbolizes longevity. The wide border is composed of diagonal bands ornamented with small cruciform motifs. Equally original is the palette, comprised of golden yellow, beige, pale green, brown, blue, and rust. Adding to the richness of this scheme are the off-white bands embellished with blue and rust floral scrolls on either edge of the border.

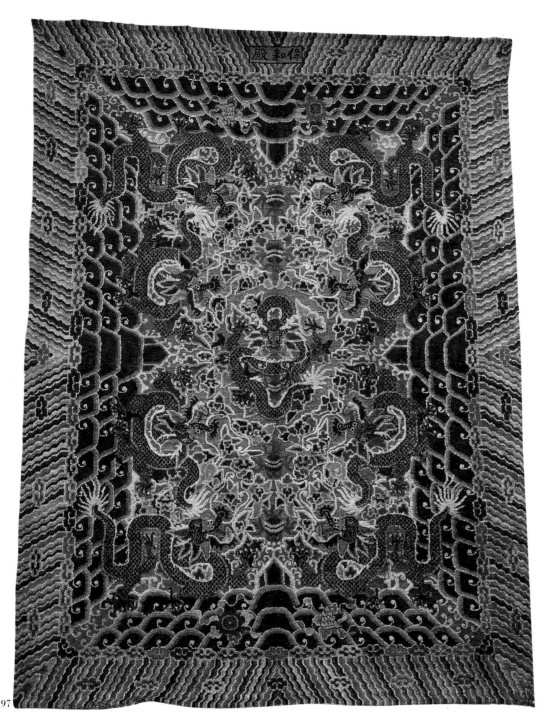

197

- The circle. The image of perfection par excellence, the circle signifies the sky and the earth and thus appears at the center of the field. Sometimes it is accompanied by the eight trigrams of divination, or the yin-yang sign of the feminine and masculine principles.

The Figurative Symbols

MYTHICAL BEASTS One of the most ubiquitous images in Chinese iconography is the dragon. Since the Chou era it has appeared on all the decorative arts. Although Western eyes see this fabulous creature as a symbol of evil power, Taoists view it quite otherwise, as an emblem of prosperity, strength, and perseverance. According to tradition, the dragon possesses the body of a snake, the paws of a tiger, the claws of a falcon, and the head of a camel with the horns of a stag. By the 2nd century of our era, dynastic China had made

198

197. *Carpet. China, 19th century. Silk and gold thread, 3.61 x 2.75 m. Private collection.*
This carpet design once again dramatizes the power of the Emperor, here symbolized by the dragon hovering at the center above three worlds: the underworld present in the striped border, the aquatic world embodied in the blue stylized waves, and the terrestrial world surging up in the rocky peaks. The imperial dragon is five-clawed and afloat in the midst of stylized flowers. Eight other dragons join in a dance around the ninth dragon. The inscription woven into the carpet means 'hall for the presentation of harmony', suggesting that the piece may have been laid in a main hall within the imperial palace.

198. *Imperial plate. Mark of the Emperor K'ang-Hsi (1662-1722), Ch'ing dynasty. Porcelain, 52 cm in diameter. Musée Guimet, Paris.*
This blue and white plate is vigorously animated by the traditional theme of combatant dragon and phoenix, here present among stylized clouds.

199. *Medallion carpet with a four-clawed dragon. Peking, 20th century. Silk pile, cotton warp and weft; 5.93 x 4.70 m. Private collection, Paris. Around the central medallion and its dragon, the field is ornamented with a scatter of flowers, butterflies, and bats. A bird of good omen occupies each of the four corners: the peacock signifying good fortune; the crane, longevity; the bird of paradise, the Mandarin and his great career; and the phoenix, happiness. The border comprises four parts each with its own theme: spots, floral motifs alternating with swastikas, and, in two friezes, arabesques, flowers, and butterflies.*

it the imperial symbol, and by the early 18th century, the five-clawed dragon would be reserved to the imperial family and the four-clawed beast to the aristocracy (a codification applicable mainly to clothing as a means of identifying persons clad in dragon robes). On Chinese rugs, the dragon occupies the center of the composition, on floor pieces as well as on pillar carpets. This is equally true even where the rug boasts a population of nine dragons, as on a piece formerly owned by Yves Mikaeloff. Eight of the beasts surround the ninth, which in turn symbolizes the emperor enthroned at the center of the world, beyond the reach of malefic powers. The nine-dragon composition is virtually commonplace in Chinese iconography.

While the Emperor is represented by the dragon, the Empress is identified with the phoenix, which has the head of a pheasant embellished with caruncles and the body of a peacock. Its five-colored plumage signifies the five elements: wood, earth, fire, metal, and water. The bird is freighted with numerous symbols. In peacetime, the phoenix is often the bearer of good tidings, such as the birth of a virtuous statesman, the beginning of a prosperous reign, and so forth. It means the south, the sacred direction in Han iconography. Moreover, it is supposed never to die and to evoke the sun and heat. Chinese poetry contains many references to a phoenix couple, the sign of the dualistic harmony of nature. From antique bronzes to late porcelains, the decorative arts of China accorded this fantastic bird a signal place of honor.

Also figuring among the mythical animals inhabiting Chinese rugs is the tiger, whose forehead stripes signify, for the Chinese, the word 'king'. Associated with autumn and western China, the tiger later evolved into an emblem of the military, because of its reputation for bravery. Its image is often applied to the structural frame of temples as a safeguard against danger.

The unicorn – *khi'lin* – also springs from Chinese mythology. The creature has the head of a dragon, surmounted by a single horn, and the body of a deer with a plumed tail.

Finally, the fo dog is the guardian of the home and domestic well-being. The ferocious

MYTHOLOGICAL ANIMALS

The dragon is without doubt the most ubiquitous animal in Chinese iconography. For the Toaists, it incarnates prosperity, strength, and perseverance. It also represents the Emperor.

The phoenix, the Empress's animal, symbolizes many things. The five colors of its plumage evoke the five elements: water, earth, fire, metal, and wood. Believed to be immortal, the phoenix evokes the sun and warmth. In peacetime, it is often the bearer of good tidings.

The stripes on the tiger's forehead meant 'king' for the Chinese. Admired for its bravery, the tiger evolved into an emblem of the military.

The unicorn, frequently associated with purity, has the head of a dragon, which is surmounted by a single horn, and the body of a deer, which is embellished with a plume-like tail.

The fo dog is the guardian of the home, of domestic well-being. It is associated with the Buddha.

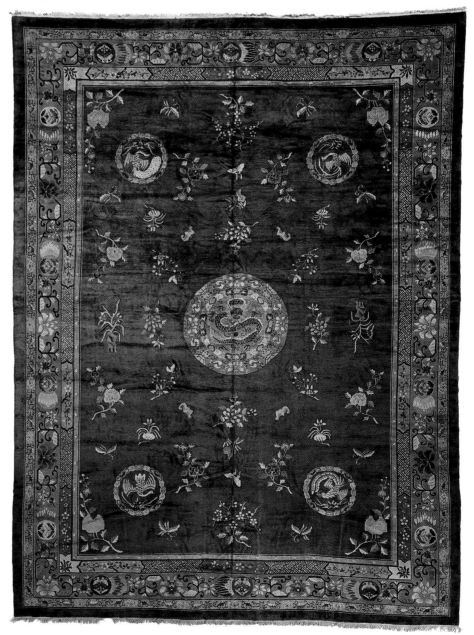

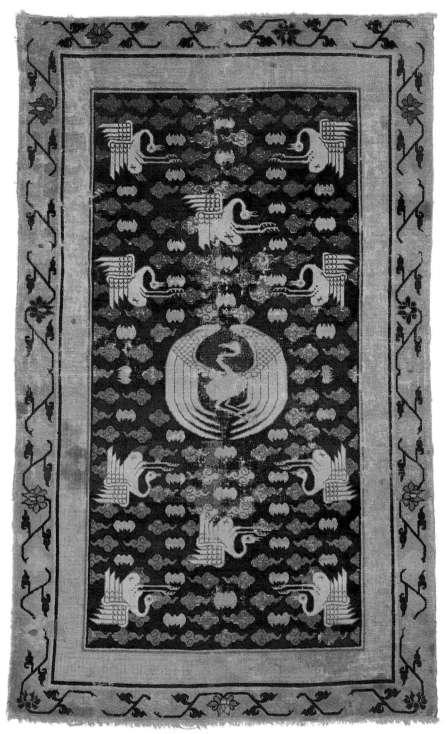

200

200. Carpet with the crane of longevity. China, 18th century. 2.72 x 1.65 m. Textile Museum (G.H. Myers acquisition 1920), Washington, D.C. This rug is dominated at the center by the crane of longevity, its wings spread and joined in mid-air to form a circle. On either side of the composition is a staggered arrangement of five other cranes, against a ground sown with stylized clouds and bats. The border, with its two rows of scrolling flowers, is particularly elegant.

look of the creature is accentuated by the snarling maw and shaggy mane of a lion.

THE OTHER ANIMALS The bat, an ill omen in the West, symbolizes wealth for the Chinese, and, even more, bliss, given that its name, *fu*, is pronounced like the word for happiness. Colored red, it indicates happiness on a grand scale. The bat often appears on rugs in conjunction with other motifs, but it remains a minor motif.

The crane, on the other hand, plays a major role throughout the arts of China. A companion of immortals and fairies, the crane signifies longevity. In some compositions, it appears with its wings spread and joined in mid-air to form a circle.

Another symbol of longevity is the butterfly, the emblem as well of conjugal success, like the two Mandarin ducks which, for the Chinese, represent marital bliss, because one duck is unable to live without its companion.

Carpets embellished with all the symbols of happiness, successful union, longevity, etc., constitute suitable presents for newlyweds.

FLOWERS Universally present in Chinese art, with their undulant forms and delicate colors, flowers are also the vehicles of a very precise symbolic language. Moreover, their placement within a composition is never left to mere chance.

Flowers function primarily to evoke the months and the seasons, even though their stylization, repeated down through the ages, makes them sometimes difficult to identify. Rather than take account of all the species, Chinese rug makers have preferred to represent those with the greatest symbolic import.

The lotus, one of the 'eight treasures' of Buddhism, holds a pre-eminent place in the heart of the Chinese. Symbol of purity and fertility (through its seeds), the lotus opens, spreading its petals, and thus foretells the plenitude of summer.

The peony, which Westerners regard as the Chinese flower par excellence, is indeed the queen of flowers after the lotus. It flourishes mainly in northern China and evokes the month of March or the spring. As this would suggest, the peony constitutes one of the four flowers symbolizing the seasons, the others being the lotus (summer), the chrysanthemum (autumn), and the plum blossom (winter). Called the 'evening flower' by the ancient Chinese poets, the peony conjures up the woman loved and feminine beauty, also distinction, prosperity, and successful marriage. On rugs, it is represented either in full bloom with green leaves, themselves emblems of good luck, or dried, petals and leaves alike, in which case the image connotes sorrow.

THE LANGUAGE OF FLOWERS

The lotus, closely allied with Buddhism, signifies purity and fertility. The beauty of its blossoming links it to the abundance of summer.

The peony, queen of the flowers after the lotus, symbolizes the beloved woman, prosperity, and distinction. It is the flower of the month of March.

The chrysanthemum, flower of longevity, connotes autumn.

The plum-tree flower, flower of winter, is synonymous with rectitude and indomitability.

201. *Fragment from a Mandarin's robe. China, late 18th century. Embroidered silk, 35.5 x 33 cm. AEDTA, Paris. One of the oldest textiles of its kind, this square fragment would have been sewn on the front of a high-ranking Mandarin's jacket, with a similar piece decorating the back. Here too, the crane and the stylized clouds recall the Textile Museum carpet.*

202. *Carpet with crane medallion, foliage, and peonies. China, early 17th century. 3.94 x 1.94 m. Musée Historique des Tissus, Lyons. Discovered only twenty years ago, this is one of the oldest of the known rugs made in China. Around the polylobate and rather Persian medallion, the pattern of foliage and peonies is still relatively realistic, by comparison with the more stylized works of later date. The two affronted cranes at the center recall the medallion in the Textile Museum carpet. In contrast to this work, however, the design of the four borders remains somewhat unsophisticated.*

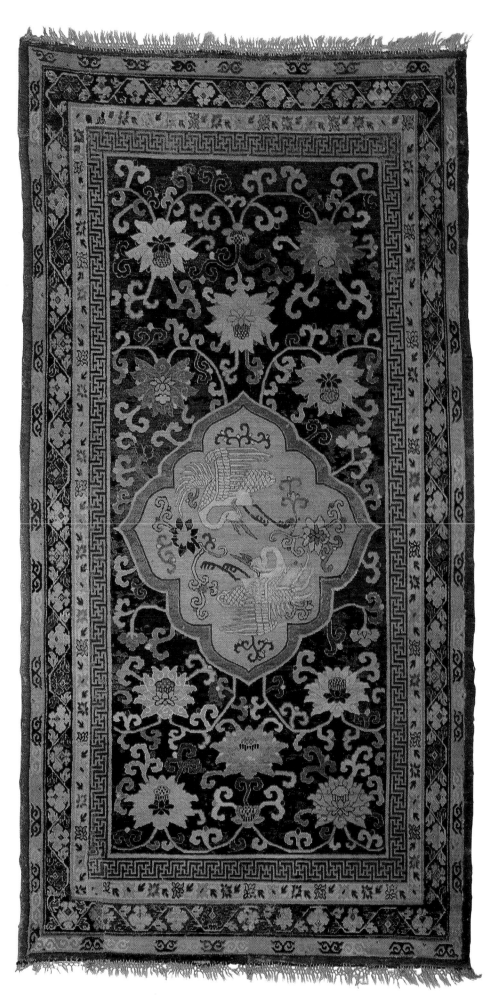

201

202

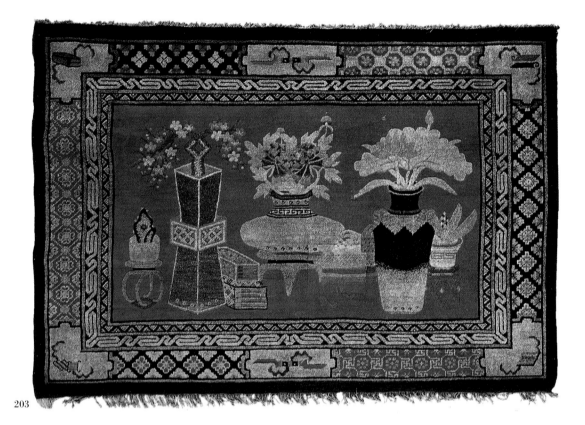

203

At last, the chrysanthemum, planted by the ancients in their gardens, finds its place in the ornamentation of carpets. Mostly, it signifies autumn and longevity

TREES Plum, native to China and cultivated there for the last three millennia, is the first tree to flower, coming into its own as early as January. Because of its resistance to inclement weather, the plum tree constitutes a symbol of uprightness and indomitability.

Bamboo, beloved by poets and painters, has always been the object of great veneration. Pliant but unbreakable even in gale-force winds, bamboo stands for resistance, particularly that of intellectuals subject to persecution. It too is an image of longevity, and the knotty joints along its stem signify in Chinese 'personal integrity'.

Still more popular are peach and the other fruit trees, which play a double symbolic role. The wood of a peach tree is thought to be capable of dispelling evil spirits, while fruit trees in general connote immortality. Taoist priests chose peach as the wood from which to carve the seals used to mark their talismans and amulets. Peach blossoms signify harmony in marriage, allowing rugs decorated with this motif to become the perfect gifts for newlyweds.

THE BUDDHIST, TAOIST, AND OTHER SYMBOLS Buddhist- and Taoist-like symbols – conventional signs or ritual instruments – also find a place in the ornamentation of Chinese rugs, without, however, endowing them with a strictly cultural function. Furthermore, symbols appropriated from Buddhism and Taoism very often appear together in the same pattern.

The term *pa pa'o* designates the eight Buddhist treasures or symbols of felicity:
- The wheel, the sign par excellence of Buddha, evokes *karma*, or the connection between causes and effects.
- The conch shell represents the gathering about Buddha, for when blown, it calls the faithful to prayer.
- The umbrella, the symbol of princes and dignitaries, implies good government.
- The canopy signifies in much the same way the umbrella does, although being wider, it protects more and thus promises security.
- The lotus flower is the inevitable symbol of purity, since it rises above the waters of the lake, which are sometimes muddy.
- The lidded vase, containing the elixir of immortality, is viewed as a cure for every ill. Through its name, *pao*, which denotes 'maintenance', and *p'ing*, which means 'peace', the vase stands for harmony and peace.

- The twin fish, or paired carp, derive from an ancient emblem for *yin* and *yang* (feminine and masculine) and have, over the centuries, evolved into a sign for good luck and plenty.
- The endless or infinite knot connotes the meaninglessness of life if one does not take the path opened by Buddha. Subsequently, the interlaced form came to symbolize abundance and longevity.

The eight Taoist attributes, regarded as talismans, also figure large in the decorative arts of China:
- The gourd and the pilgrim's staff. The steam rising from the gourd has the power to destroy pernicious influences. The staff, meanwhile, provides support for the resting pilgrim.
- The fan used by Chung-li Ch'uan to waken the souls. This is the attribute of the patriarch of the eight immortals.
- The flowering basket, which allows a wish to be expressed.
- The bamboo tambourine, originally used by blind fortune tellers.
- The lotus blossom, which, like Buddhism's 'eight treasures', represents purity.
- The sword with which Lu Tung-pin chased the demons. This made it suitable as an emblem of victory over evil spirits.
- The flute, the sign of the patron of musicians, who worked miracles by playing it.
- The castanets whose sound soothes and banishes evil influences.

Some carpets display a pattern composed of the 'hundred ancient objects', which serve to ritualize social behavior. Appropriated from the profane world as well as the sacred, they appear mainly in art works created since the beginning of the reign of K'ang-Hsi (1662-1722), an Emperor of the Ch'ing dynasty.

On carpets, therefore, as well as throughout the decorative arts, ornamental patterns do not spring from an artist's imagination; rather, they conform to a precise iconographic code, whose chief elements, programmatically composed, correspond to wishes for bliss, well-being, long life, and prosperity. For the Chinese, nature would therefore appear to be hostile, which means that humanity must subdue or overcome it by invoking beneficent powers.

THE CHINESE CARPET
AND THE WEST

Evidently unknown in Europe before 1900, since none is mentioned in old inventories, the Chinese carpet suddenly became fashionable among Western collectors at the beginning of the 20th century. The vogue emerged following the arrival of objets d'art and especially rugs sent from Peking in the wake of the European intervention against the nationalist 'Boxer Rebellion'. Although ornamented with colors and motifs intimately tied to philosophy and beliefs peculiar to the Chinese world, all barely accessible, if at all, to the profane mind, the Chinese carpet would gradually rival the Oriental rug among the furnishings of European and American houses.

In 1904, the St. Louis Fair (the Louisiana Purchase Exposition, held in St. Louis, Missouri) exhibited several Chinese rugs, imported products then mostly unknown to the public. Thereafter, a growing interest prompted American dealers to send buyers to what were then the two main centers of rug weaving in China: T'ien-Tsin and Peking.

During the Great War (World War I), trade between the Middle East and Europe came to a halt, or at least slowed to a trickle, as a consequence of which the French, for example, turned towards China, where rugs were then being made specially for export. These were large-format works generally woven with mixed wools, rather than with wool from the flocks of Kansu or Mongolia.

The field design consisted of mingled floral and symbolic motifs, the whole treated with a restraint aimed at Western taste. Medallion compositions came to the fore, and the borders, once relatively narrow and discreet, grew wider and richer in complex themes. To achieve a relief effect, Chinese craftsmen had revived, only recently, the technique of beveling, a process of shaving the contours of motifs with razor and scissors.

Unlike the Oriental carpets which had fascinated Renaissance Europe, the Chinese rug did not arrive in the West until very late, and its history is therefore poorly known. It also appeared relatively late in Chinese houses, no doubt because most of the population in

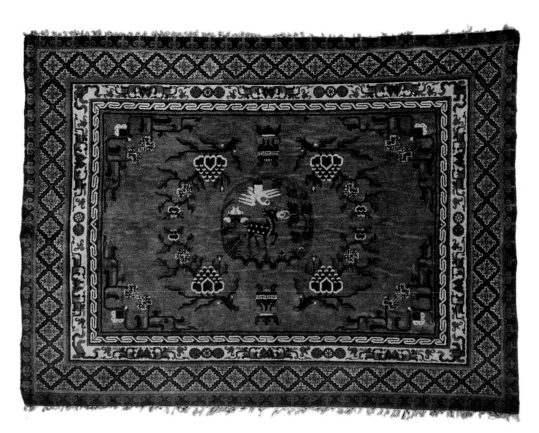

204

THE CHINESE CARPET
AND THE OCCIDENT

The Chinese carpet acquired its aristocratic status in Europe in the early 20th century. The vogue emerged following the arrival of objets d'art and especially rugs sent from Peking in the wake of the European intervention against the nationalist uprising. Americans discovered Chinese carpets in 1904 at the great fair in St. Louis marking the centenary of the Louisiana Purchase. During and after World War I, problems in diplomatic relations with the Orient led Europe to turn towards China for carpet production.

204. Medallion carpet with a stag surmounted by a crane. Peking, 1st half of the 20th century. Wool pile, cotton warp and weft; 1.72 x 2.38 m. Private collection, Paris. Around the central medallion of this blue and white rug are flowers so stylized they are difficult to identify. Spandrels composed of branches decorate the four corners. The large, richly ornamented border suggests a late date, well after the 18th century.

203. Carpet with vases and incense burners. Peking, 1st half of the 20th century. Wool pile, cotton warp and weft; 1.44 x 1.96 m. Private collection, Paris. The flowers contained in the vases and incense burners of this orange-ground rug are too stylized to be identified. The design comes close to the 'hundred old objects' pattern that emerged at the end of the 19th century. The wide, lavishly decorated border signals a late date.

China, an immense country, was sedentary, whereas the rug seems to have evolved in the temporary encampments of nomadic peoples. Like virtually everything produced in China, a civilization of vast originality, but one famously resistant to foreign influences, the Chinese carpet constitutes a separate chapter in the history of rug craft.

CHAPTER VIII

THE FRENCH CARPET
Élisabeth Floret

A TRADITION RENEWED
(1850-1995)
Martine Mathias
Chief Curator
Musée de la Tapisserie, Aubusson

The eye is defenseless against the allure of perfection. Like that of a snowy ridge, for instance, exquisitely sculpted under the rising sun – perfection bordering on the miraculous or the divine. But also the perfection sometimes attained in a human artifact, which seems all the more moving for being the work of human hands, inscribed in time, the fruit of patient labor.

Conceived as an integral and contributing part of a magnificent décor, the carpet, that utilitarian object, may even transcend itself to become a work of art. As this would suggest, the rug exists to be appreciated in several different ways, as a functional object but also as an *objet de luxe*, a cachet item, an aesthetic expression realized by a designer-architect, a virtuoso display of the weaver's technique – a piece in a puzzle, a witness to an era.

205

A Very Large Subject

Attempting to treat the French rug in so brief a space poses certain risks, given the sheer vastness of the subject, ranging from the *gloire* of Louis XIV's carpets to the 'elephant' pieces designed by Albert Cohen.[267] Thus, an overall synthesis would appear to be out of the question, especially since it might verge on a plagiarism of Pierre Verlet's authoritative book, *The Savonnerie*. We shall therefore aim more modestly, relying on the archives of the Garde-meuble (today the Mobilier National), and examine the output of the various workshops in the hope of offering examples representative of a period which extended from the 17th century to around 1860.

The term *tapis français* is often taken to mean the products of the Savonnerie factory, or manufactury, a former soap works at Chaillot, then just west of Paris, or perhaps those of the *manufacture* at Aubusson in south-central France (Haute Marche). In reality, however, the expression embraces a multitude of production centers, the most important of which is, of course, the Savonnerie. And this for the simple reason that, by reflecting royal or imperial taste, the Savonnerie set the tone for all the other rug-weaving enterprises. These, most notably Aubusson and Piat Lefebvre, were not content however merely to 'copy' or 'follow'; indeed, they brought forth works fully endowed with their own distinctive characteristics and their own charms.

The name 'Savonnerie' should be reserved for the carpets produced by the Manufacture de la Savonnerie. What the other factories make are rugs 'with the Savonnerie knot'. The market, meanwhile, has not hesitated to label as 'Savonnerie' all manner of products which actually are quite different in character. Similarly, the term *tapis d'Aubusson* is frequently, even abusively, applied to almost any kind of *tapis ras*, meaning pileless, flat- or tapestry-woven carpets.

206. Savonnerie carpet woven from a cartoon by Pierre Josse-Perrot for the Trinity Chapel at the Château de Fontainebleau. 1717. Wool pile, wool warp, hemp weft. On loan to the Résidence Marigny from the Mobilier National, Paris.

205. Detail, Savonnerie pile carpet commissioned by Louis XIV for the Grande Galerie at the Louvre.

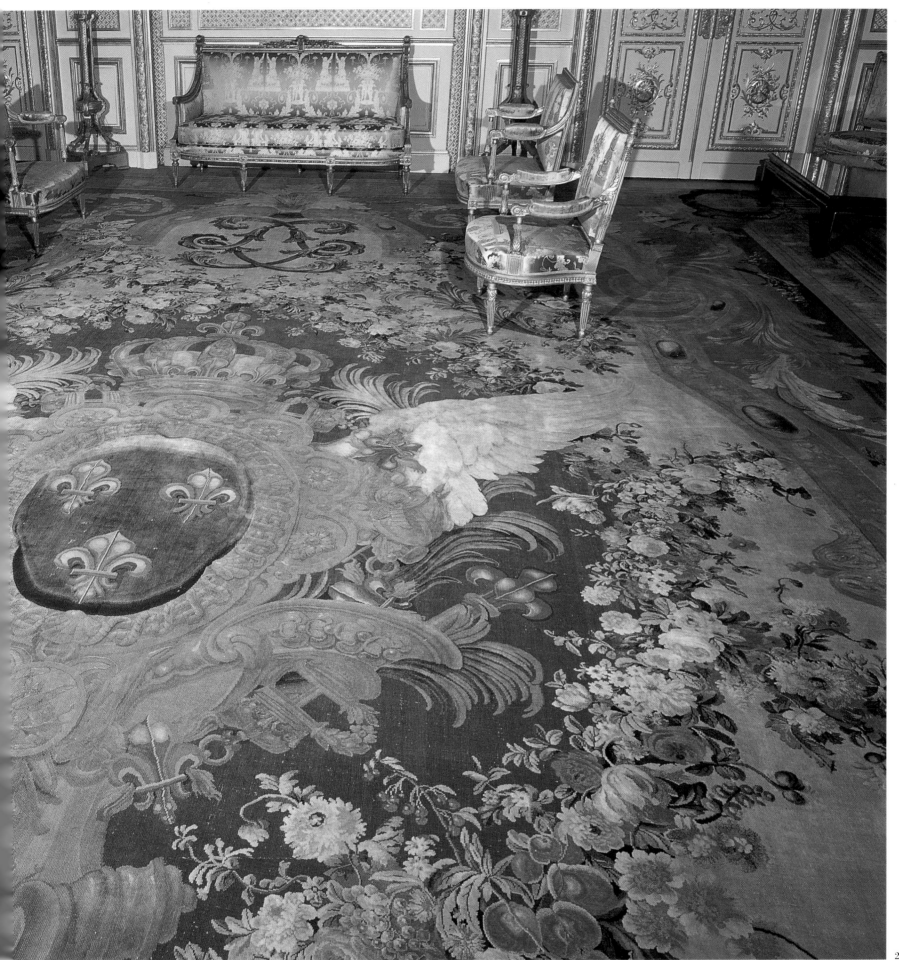

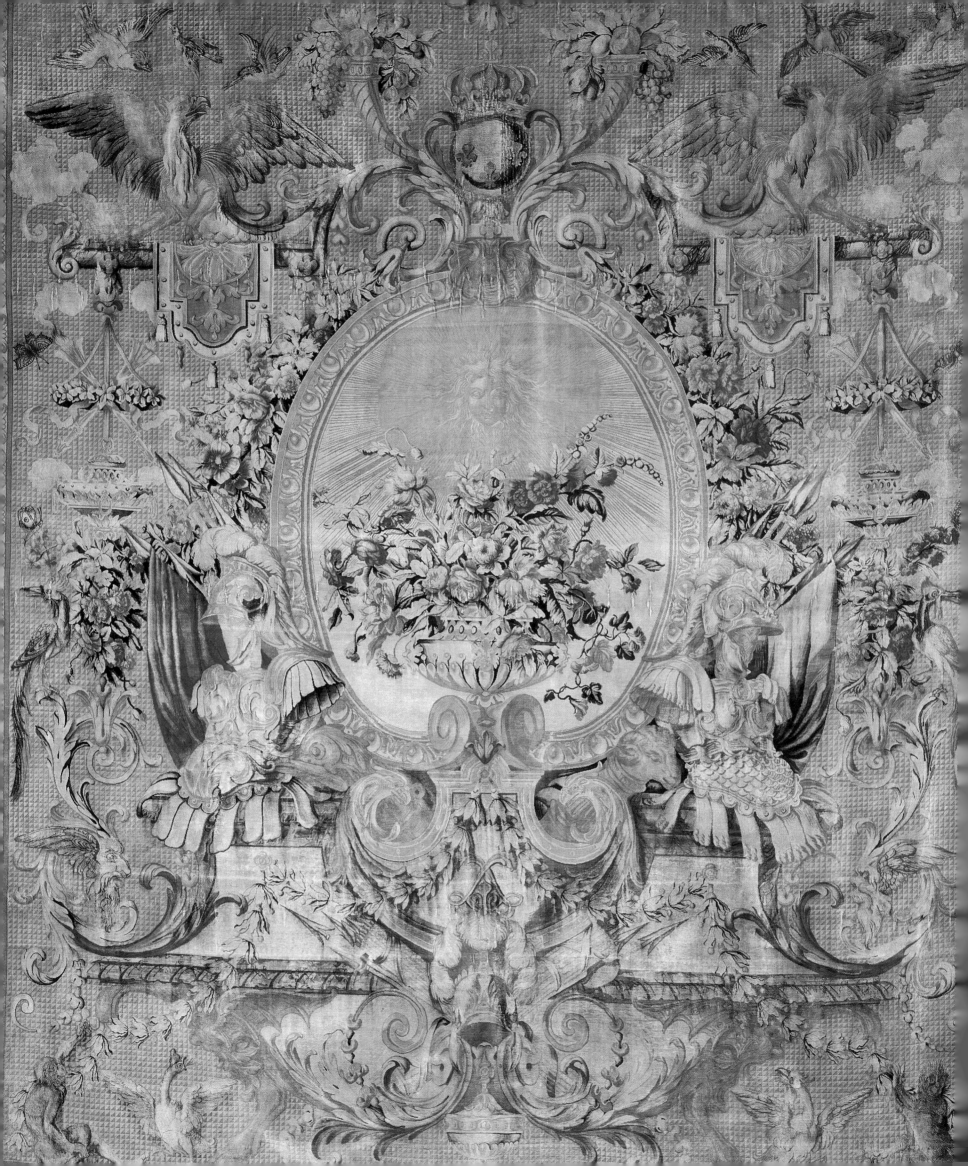

THE SAVONNERIE FACTORY:
LA MANUFACTURE ROYALE
DES TAPISSERIES DE TURQUIE
ET AUTRES OUVRAGES DU LEVANT

1660-1743

The Savonnerie factory, which was located on the site of the present Musée d'Art Moderne, inherited its name from the soap-making facility it took over after Louis XIII bought the property as an orphanage for foundlings. Beginning in the 1620s, the Savonnerie was therefore a *manufacture royale*, managed at first by two contractors, Pierre Dupont and Simon Lourdet, *directeurs-chef d'atelier*, who took on problems that were as much technical as human and economic. Provided with both designs and commissions, the directors had the rugs woven at first by orphans and apprentices but then by artisans, all male. The fruits of their labor, entirely handcrafted, were also intended for the court, as well as for certain high dignitaries, foreign diplomats, and heads of state.

A Counterbalance to Importations from the Orient

The Savonnerie was created, after many false starts, to counterbalance the importations from the Orient, whose weavings had long fascinated the Western world. At the outset, therefore, it was admiration for the *point noué* – knotted pile – which gave rise to imitation, a process clearly reflected in the title the atelier would soon adopt: Manufacture Royale des Tapisseries de Turquie et du Levant.

In 1632, Pierre Dupont characterized his project as *stromatourgie*,[268] a neologism he coined by combining two Greek words:

strôma (rug) and *ergon* (work). Pleased with himself, he went on to compose a bellicose sonnet addressed to the Orient.

Dupont, having reconstructed the carpet, revealed the dual aim of his enterprise: to end the costly importations, thus the outflow of gold and silver, and to provide employment for vagrants as well as for great numbers of abandoned children.

Apprenticeship at the Savonnerie was to be governed by obligations on the part of the factory, all duly recorded before a notary, to supply food and lodging and to ensure careful supervision. Dupont even specified that the apprentices would be trained as drafsmen, as illuminators, and as masters of tempera, a medium in which pigments are bound or 'tempered' with such water-soluble substances as glue or gum.

In 1604, thanks to Marie de' Medici, the wife of Henri IV, Dupont moved his workshop to a space in the Louvre, already a breeding ground for artisans and a privileged enclave where talents could develop under royal patronage. Here Dupont began by producing a set of furnishings in gold and silk for the Queen's private residence, the Hôtel de Luxembourg. By 1626, however, finances obliged him to collaborate with Simon Lourdet, a former apprentice, their affiliation duly recorded on 5 September by the notaries Dupuis and Paisant.

A Patent Royal

In 1627, Louis XIII granted the partners the privilege of fabricating all kinds of rugs and furnishings, 'Levantine' works, as much in gold, silver, and silk as in wool, for a period of eighteen years. Only on 23 January 1631 did they receive the patent royal allowing them to establish the factory for *tapis de Turquie*. Pierre Dupont had to abandon the Louvre galleries and join his associate Lourdet, leaving his sons to take full responsibility for the old workshop in the palace.

Numerous royal decisions mark the trail leading from the birth of the Savonnerie to the letters patent of 13 October 1644, which confirmed the royal privileges and status enjoyed by Dupont and Lourdet.

The So-called 'Louis XIII Carpets'

French carpets did not spring into being by spontaneous generation but rather through a slow process of maturation, the first fruits of which are known as *tapis Louis XIII*. The relationship between them and the Orient is not merely technical but also stylistic. Although the reign of Louis XIII lasted only from 1610 to 1643, the patterns it produced – the famous dark fields strewn with polychrome flowers – would remain fashionable throughout the 17th century. From this family, needleworked on a 'canvas' or plainwoven structure, only two examples are known to have survived. The 'petit-point' method by which they were made would give way during the second half of the century to knotted-pile weaving. The Louvre owns a rug typical of the Louis XIII production, with its multicolored flowers and black ground. Carpets such as the one at Waddesdon Manor in England were often used as coverings for tables rather than floors. The source of the patterns is not known with certainty, but two artists, Georges Baussonet and Androuet Du Cerceau, appear to have contributed to the series,[269] in which Oriental influence can still be detected in the treatment of the floral aspect of the design. Little by little, however, the field of flowers would be elaborated and organized.

Dupont and Lourdet: Rival Partners

From the start, the products of the Savonnerie found an enthusiastic reception among

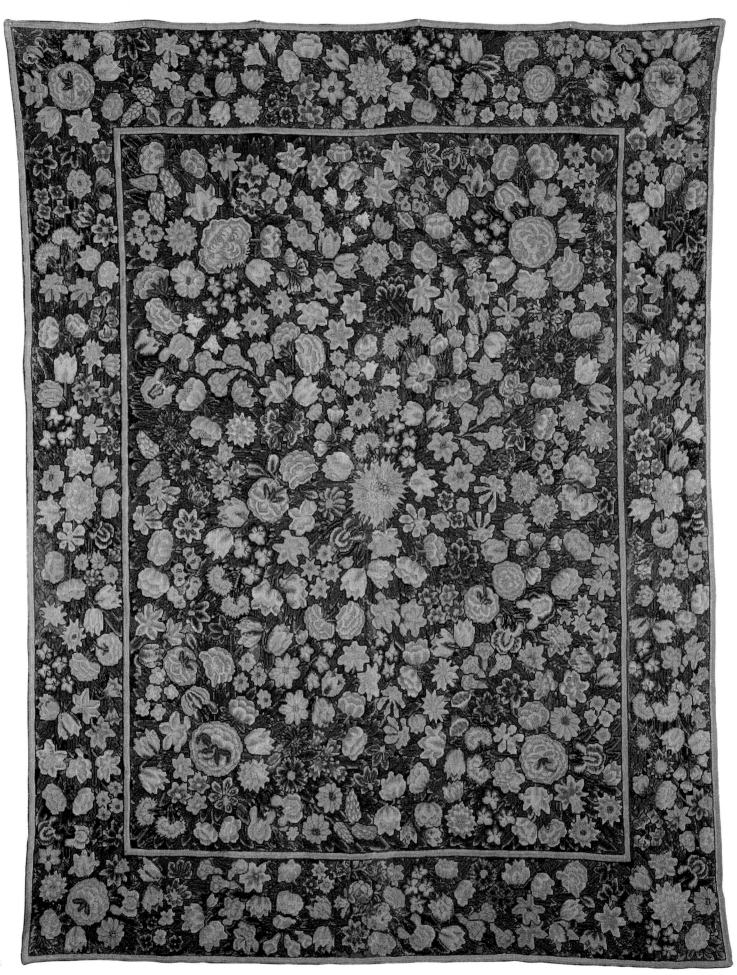

the great collectors. The few surviving rugs from the Louis XIII period come equally from the workshops of Pierre Dupont and Simon Lourdet. Although allied with Lourdet since 1626, Dupont, for various economic reasons, remained in the Louvre, as a consequence of which it was his associate who established the workshop 'in the house of the Savonnerie' and thus emerged as the dominant partner, triggering a series of long-lasting disputes between the rival managers.

Such, therefore, were the beginnings of the Savonnerie, a factory that would come very much into its own with two big decorative projects commissioned by Louis XIV: thirteen carpets for the Galerie d'Apollon in the Louvre, and ninety-three carpets for the Grande Galerie connecting the Louvre to the Tuileries Palace along the right bank of the Seine.

In 1666, the inventory taken after the death of Simon Lourdet constitutes a precious store of information giving access to the very heart of the Savonnerie.

DUPONT AND LOURDET, RIVAL PARTNERS AND FOUNDERS OF LA SAVONNERIE

In 1604, thanks to Marie de' Medici, the wife of Henri IV, Pierre Dupont established his tapestry workshop in the galleries of the Louvre. In 1626, financial constraints forced him to go into partnership with his former apprentice Simon Lourdet. For various economic reasons, Lourdet set up shop in the premises of the Savonnerie (a former soap factory purchased by Louis XIII), while Pierre Dupont remained at the Louvre. This separation, which gave Simon Lourdet a clear edge over his rival, would cause a series of long-lasting disputes between the rival yet brilliantly successful managers.

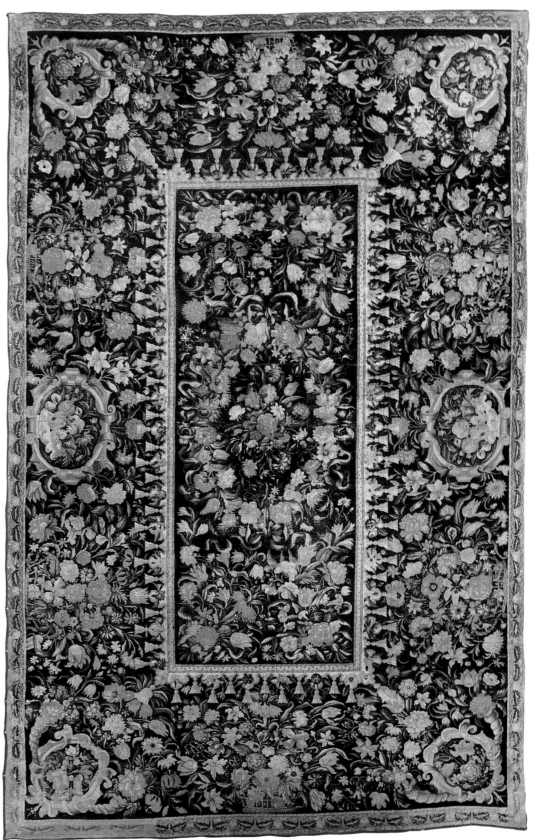

209

208. *Petit-point 'Louis XIII carpet' with flowers. Early 17th century. Wool and silk petit-point embroidery on canvas, 2.70 x 2.10 m. Private collection. The design of this needlework or 'embroidered' carpet, à semis de fleurs, proved enormously popular throughout the 17th century.*

209. *Savonnerie 'Louis XIII carpet' with polychrome flowers on a black ground. 1640-1660. Wool pile, wool warps, hemp weft. Louvre, Paris. Woven at either the Louvre or the Chaillot workshops of the recently established Savonnerie, the premier carpet manufacturer of France.*

A brief summary of the production
as revealed by the inventories[270]
taken after the death
of the Lourdet couple, contractors
for the Savonnerie.

It is on 8 April 1665 that the inventory is begun following the death of Françoise Quarré, wife of Simon Lourdet, weaver ordinary to the king and director of the Manufacture de Turquie et Ouvrages du Levant, dwelling at the house of the Savonnerie, Chaillot parish. The Lourdet couple, it is learned, had five children, one of whom, Philippe, is both the partner of and the successor to his father. In the course of these pages, we discover the life of the factory, the depth of its religious involvement, the tools of its work, mingled, in the inventory, with the personal effects of the Lourdet couple. While these may be of less interest, it is not beside the point to know that they owned many books, including the works of Plutarch, as well as large portraits of King Louis XIII and Queen Anne of Austria, Cardinal Richelieu, etc.

The inventory mentions numerous tapestries of the Rouen type, which appear to have been a fabric then very much in vogue. Most important of all, however, this precious document reveals the state of the production in 1665. (Prices were evaluated in terms of *livres* [pounds], *sous* or *sols*, and *deniers*. Twelve *deniers* were worth a *sou*, and 20 *sous* 1 *livre*. The *aune* is an old unit of measurement equivalent in today's terms to 1.19 meters. Carpet measurements, it should be remembered, are never exact.)

Following are the merchandise and works of the Turquie et du Levant and other kinds which have been appraised and estimated by the said Delamare who summoned, to be advised on the said appraisal, the said Sieurs Charles Lebrun and Henry Dubéas [?], merchant citizens of Paris living in the Rue Saint-Denis, the said merchandise being stored in a large cupboard in the hall.
(9) Item, nine chair seats in tapestry in the manner of the Turquie et Ouvrages du Levant appraised and estimated each seat at twenty

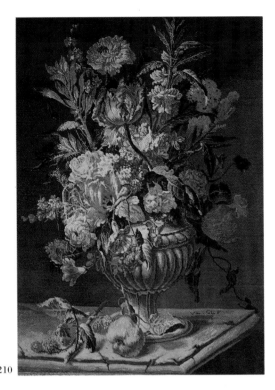

210

210. *Savonnerie 'vase with flowers'. 0.96 x 0.70 m. Louvre, Paris.*

livres, *the said price coming to a total of one hundred eighty* livres . . . *CIII XXX l.*
Item, eighteen chair backs in the same material in the Turquie manner appraised and estimated each back seven livres, *the said price coming to a total of one hundred twenty-six* livres . . . *CXXVI l.*
Item, eight chair seats with a yellow ground, works by the Marche [Aubusson] appraised and estimated each seat the sum of fifteen livres, *the said price coming to a total of one hundred twenty* livres . . . *VI XX l.*
Item, four chair backs in the same material appraised at the rate of one hundred sols the piece, the said price coming to a total of twenty livres . . . *XX l.*
(9) Item, six tapestry landscape pictures appraised and estimated at sixty livres *the piece, the said price coming to total of three hundred thirty-six* livres . . . *III C XXXVI l.*
Item, a picture of flowers in a basket also tapestry appraised thirty livres . . . *XXX l.*
Item, another tapestry picture representing a piping crow appraised one hundred livres . . .
Item, a square filled with feathers in the same tapestry appraised ten livres . . . *X l.*
Item, two other chair backs in the same tapestry [canceled in the text].

Item, six pillows with two round ones appraised together at the sum of one hundred livres . . . *C l.*
Item, seven pieces of the same material serving to cover caskets and boxes appraised together at the sum of ten livres . . . *X ll.*
Item, nine small gilt-wood frames appraised together eighteen livres . . . *XVIII l.*
Item, two tapestry extensions in the same flowered material, one measuring two and a half aunes and the other three aunes by one half aune one-eighth high appraised together one hundred fifty livres . . . *CL l.*

After having inventoried the above-said merchandise mentioned in twelve articles, the said Philippe Lourdet has declared that they were of the company that was between the said deceased gentleman his father and him with the exception of the chair seats and backs fabricated by the Marche, . . . signed P. Lourdet.
In the wool storehouse:
Item, three tapestry chair seats and four backs made Turkey style appraised [in the margin] one hundred livres . . . *CI.*
Item, a tapestry altar carpet of the same manufacture measuring five and three-quarters aunes by three aunes less a half tiers appraised and estimated at a sum of fifteen hundred livres . . . *XVCL.*
Item, another carpet of the same material and the same manufacture measuring six and a half aunes by three and a quarter aunes wide appraised at the sum of sixteen hundred fifty livres . . . *XVICL l.*
These last two carpets inventoried are those which were begun of which one of the designated to be two-thirds and the other a third mentioned in article fifty-six of the said inventory not being entirely the same thing.
Item, two thousand three hundred ninety livres *of wool of different colors appraised and estimated the* livre *at forty sols, the said price the said quantity coming to the sum of four thousand six hundred eighty* livres . . . *IIIIMVI-ICIIIIXXl.*
(12) Item, ten large foot carpets Turkey style measuring altogether two hundred ninety-two aunes square, or approximately, and three other carpets of the same fabrication mounted on looms measuring one hundred twenty-seven aunes, or approximately, of which there may

be nine or so aunes finished and in which ten large perfect carpets are included in the one hundred fifty squares aunes of goods mentioned in the fifty-seventh article of the said inventory and which were then mounted on the looms of which thirteen carpets not herein appraised for the said inventory, given that they had been made for the service of the King pursuant to the agreement made for this reason with His Majesty.

Following the inventory from which three carpets the said Sieur Philippe Lourdet has declared that they were the property of the company which was owned by the said late Sieur Lourdet his father and himself on which has been received several sums of deniers on various occasions against signed receipts and has promised and promises to have the said works finished immediately, for which task he will use wools inventoried herein and has signed P. Lourdet.

Item, there are found on the looms sixteen partially finished tapestry chair seats in the Turkey style, and seven chair backs of the same fabrication appraised altogether at the sum of three hundred ninety livres . . .

Item, a carpet of two and a half aunes wide by four aunes long, or approximately, appraised per square aune at the sum of six hundred livres . . . VIC I.

Item, another carpet of two and three-quarter aunes wide of which there are three aunes of finished length, or approximately, appraised per square aune as above at the sum of sixty livres tournois [Flemish pounds] coming at the said price to the sum of eight hundred eighty livres . . . VIIICIIIIXX I.

This impressive list, unfortunately drawn up with few descriptions of the items appraised, discloses a far more diversified production than had been supposed. One year after his spouse died, Simon Lourdet himself expired, which entailed a new inventory, this one requested by the five children of the deceased, particularly his son and successor, Philippe, and carried out by the notaries Rollin and Adam Sadot. It would be checked by Françoise Quarré, and several errors concerning the landscape and fruit tapestries (five rather than fifty) corrected.

THE EVOLUTION OF TERMS

Diderot and d'Alembert's *Encyclopédie* (1757-1780) distinguished three categories of carpets, defining them as follows:

The **mosquets**, very likely the ancestor of the word *moquette*, were sold by the piece, according to size and quality; they are the most beautiful and the finest.

The **tapis de pié**, so termed because they were bought by the '*pié carré*' [square foot, or 32.4 cm in the 18th century]; they are the largest. Remember that by analogy, '*tapis de pié*' signifies as well carpets which cover the floor – as in the Grande Galerie '93 *tapis de pié* made in the Turkish manner', which were paid for by the square *aune*.

The carpets of the lowest quality are called '**cadènes**' or '**mocades**'.

In the course of decades, the same technique could be identified by various terms.

During the reign of Louis XV, *le point noué* (pile)knotting), a process originated in the Orient, was called *tapisserie de Turquie et du Levant* (tapestry of Turkey and the Levant) at the Manufacture de la Savonnerie.

Little by little, the name 'Savonnerie' would designate, in a general way, knotted-pile carpets, which the inventories of the royal and imperial Garde-meuble differentiated according to origin. For example: a *tapis de velours* or *velouté* (pile carpet) from Aubusson or Tournai, or yet *façon de Savonnerie* (Savonnerie manner), or *point de savonnerie*, or even *tapis de moquette*.

The last term would not necessarily refer to the industrially produced moquettes, that is, strip or fitted carpeting sewn together end to end or side by side, the use of which became widespread in the 19th century.

211. *Savonnerie chest cover. Late 17th century. Louvre, Paris. In addition to floor carpets, the Lourdet inventories cite woven works of this kind, decorative pieces made primarily to cover furniture.*

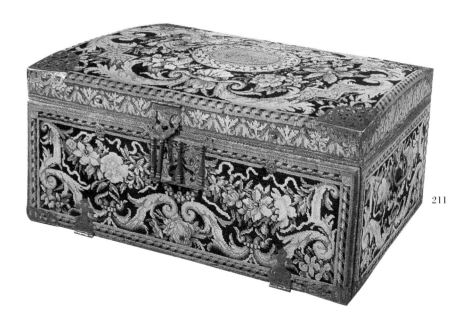

211

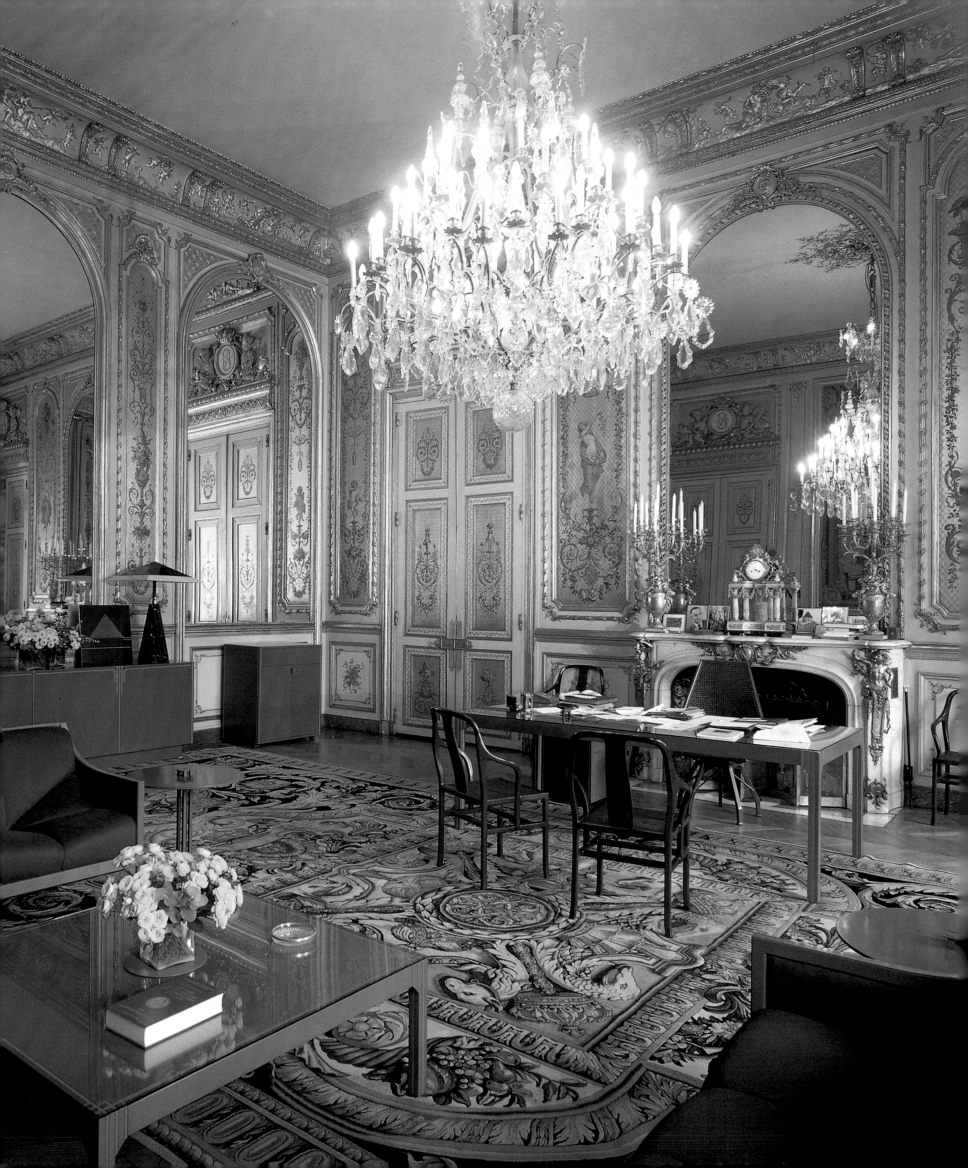

THE STATE OF THE CARPETS FOR THE GALERIE D'APOLLON This new document interests us primarily for the information it contains regarding the state in 1666 of the thirteen rugs commissioned for the Galerie d'Apollon, six of which had been finished, while three others remained on the looms.

[9] *Next the tapestry works in the Turkey style which were found as much in the large cupboard in the hall as in two large cases in the large storehouse.*

Item, a large foot carpet measuring seven and one-eighth aunes by three and three-quarter aunes.

Another carpet of five and a quarter aunes by three and a third aunes, another carpet of five aunes by three and two quarter aunes, and another of five and a third aunes by three and one-eighth aunes.

Another carpet of four and a third aunes by three and one-eighth aunes, another carpet of four and a quarter aunes by two and a half aunes, another carpet of two aunes by one aune.

Another carpet of two and a half aunes by one aune.

Another carpet of two aunes by one aune, another square carpet of two aunes by two and one-eighth aunes, another carpet of two and a half aunes by one aune, five small daybeds.

A small prie-dieu of one aunes by three-quarters and a half, bringing all said works together to one hundred thirty-seven square aunes appraised by the aune at a rate of sixty livres coming at the said price to the sum of two thousand two hundred forty livres tournois.

Item, thirty-nine chair seats, as many brown grounds as white and yellow ones, and twenty backs, the cover of two small night boxes appraised together four hundred livres.

Item, two [series of] tapestry wall hangings, one of eight pieces from the story of the Holy Scriptures, one measuring three aunes high by twenty-six aunes around, the other of six pieces of nineteen aunes by two aunes, flat-woven with figures and landscapes appraised together at six thousand livres.

[10] *Item, a large portrait of the late King and the Queen Mother of Louis XIV and of Mon-*

sieur appraised at a thousand livres tournois.

Item, a picture of the Nativity, a picture of [illegible], a picture of the dying Christ, a picture of music, two pictures of [illegible], two pictures of a [illegible], a picture of the Queen of Sweden, a large landscape after Blin, a landscape with the child Saint John, fifty landscapes, fifty still lifes of fruits and oranges, two other pictures of radishes and bread, five pictures of flowers, one hundred seventy-nine small pictures of ten to twelve square pouces, or approximately, the whole fabricated in the Turkish manner, appraised together at the same of three thousand livres.

Furniture of the company of the said Sieurs Lourdet and Philippe Lourdet his son who declared them in proceeding to the said inventory.

Item, three foot carpets to wit one of four and one-eighth aunes long by two and a half aunes, one seize [1/16 ounce] wide making nine square aunes, or approximately, another of four and three quarters and a half aunes long by two and a third aunes wide, and the other of four aunes less a seize by two and a quarter aunes making eight square aunes, or approximately, making the whole twenty-seven square aunes fabricated in the Turkish style appraised at the rate of sixty livres per aune coming altogether at the said price to the sum of sixteen hundred twenty livres tournois.

Item, eight brown-ground chair seats and four chair backs appraised together at the sum of one hundred fifty livres tournois.

Item, two other foot carpets in the Turkish style one of which measures two-thirds and the other (white) a third appraised together at the sum of one thousand fifty livres . . . MLI.

[11] *Item, one hundred fifty square aunes of works in several parts and foot carpets which are on the looms and which are being worked for the King, as the said Sieur Simon Lourdet senior and Philippe Lourdet, his son, have declared and that it was their company on whose works they have received the sum of nineteen thousand livres on being less than all the said works done and to be done appraised the said works at the sum of*

Here then is the exact title of the carpets made for the Galerie d'Apollon, the first large project completed by the Savonnerie workshops under Louis XIV. A whole array of criteria, emerging from a desire to make the rugs harmonize with the ceiling, dictated the characteristics: brown ground, which today would be called black, scrolling foliage, acanthus leaves, symmetrical ornamentation, Classical motifs, very large format (about eight meters long). These, in fact, were the first carpets to embody what truly could be termed *le goût français* or, even more, *le goût royal*. The so-called 'Louis XIII carpet' had clearly evolved, and with the second set of rugs – the ninety-three pieces made for the Grande Galerie – a very precise style would be born.

The activity of the Savonnerie was not limited to the thirteen pieces for the Galerie d'Apollon, since the inventories of the Garde-meuble enumerate other works undertaken during the same period, as well as numerous Persian rugs.[271] The verification made by Françoise Quarré, the wife of Philippe Lourdet, also confirms the existence of a book bound in vellum entitled *Au nom de Dieu*, the factory's log book, wherein we learn that the Queen, the Maréchal de Senectere (Saint-Nectaire), the Princesse de Beauvaut (Beauvau), and Monsieur de Boiffrand were clients with Lourdet accounts.

DIPLOMATIC GIFTS In addition to serving its high-borne clientele, the Savonnerie was also involved in producing goods for use as diplomatic gifts. This was the case of a black-ground carpet ornamented with scrolling foliage, garlands, acanthus leaves, and a central medallion awrithe with a quartet of

212. *The office of President François Mitterrand at the Élysées Palace, Paris. As here arranged, the presidential interior offers the paradox of contemporary furniture combined with rug no. 70 from the series of 93 knotted-pile carpets woven by the Savonnerie for the Grande Galerie at the Louvre. The title of the piece is 'Virtue', and it was delivered to Louis XIV in 1680. Mobilier National, Paris.*

213

213. *Savonnerie carpets woven for the Salon*
d'Apollon at the Louvre. Wool pile, wool warp,
hemp weft; 890 x 390 cm. Louvre, Paris.
These magnificent carpets were nos. 6 and 7 in a
series of 13 commissioned by Louis XIV for the
Salon d'Apollon and delivered on 7 October 1667.

214

214. *Savonnerie carpet in the style of the rugs woven for the Galerie d'Apollon at the Louvre. Late 17th century. Wool pile, wool warp, hemp weft. Palazzo Pitti, Florence. The Savonnerie often wove rugs to be offered by Louis XIV as diplomatic gifts, an example of which is this piece, made for Cosimo III, Grand Duke of Tuscany, on the occasion of his state visit to Paris and Versailles in 1669. The coiling snakes in the central medallion signify the armorial bearings of Jean-Baptiste Colbert, France's leading statesman during the reign of Louis XIV. An identical carpet is at the Rijksmuseum, Amsterdam.*

215-216. *'Peace' and 'Abundance', two pendants to 'Felicity', no. 84 in the series of 93 carpets woven by the Savonnerie for the Grande Galerie at the Louvre. 1682. Wool pile, wool warp, hemp weft; 2.29 x 1.41 m each. Private collection.*

snakes, all in the Galerie d'Apollon style. It was part of an ensemble of three rugs and a suite of four wall hangings presented by Louis XIV to Cosimo III (1639-1723), Grand Duke of Tuscany,[272] on the occasion of his visit to

Paris in 1669. Luckily, these pieces, stored away by the Florentine court, have remained intact. The second piece (no. 5280) has a black ground, a fleur-de-lis medallion framing two lyres, and an ornamental pattern composed of scrolling foliage, garlands, and acanthus leaves, the whole surrounded by an egg-and-dart border. The set includes as well a pair of trompe-l'oeil bas-reliefs representing Neptune and Galatea in camaïeu.

The Ninety-three Carpets for the Grande Galerie

On 20 November 1668,[273] Simon Lourdet delivered to the Garde-meuble a commission consisting of a carpet woven for Louis XIV's bedchamber in the Tuileries (little used, this work, now preserved at the Louvre, has retained its freshness and beauty, to such a degree that for a while it was even catalogued as a 19th-century work[274]); a carpet for the throne; and finally 'another carpet for the beginning of the Grande Galerie'. The last piece, in other words, was the first in a series of ninety-three meant for the Grande Galerie connecting the Louvre to the Tuileries, which would prove to be one of the most important decorative arts projects achieved in 17th-century France.

As early as 1565, Catherine de' Medici,[275] queen consort of Henri II and Regent of France during the minority of his male heirs, had wanted to link the Louvre to the Tuileries, for reasons both political and aesthetic. The architects Louis Métezeau and Jacques II Androuet Du Cerceau designed what came to be known as the Grande Galerie, a project completed only under Henri IV. The decoration of the immensely long vault was assigned to Nicolas Poussin, but it would not be executed until 1668, by Boullogne, together with his sons, working from Poussin's drawings. However, the ceiling had to be considered in relation to the whole, including the walls and the marquetry parquet, the latter to be covered by ninety-three carpets, laid one after the other the full length of the 442-meter gallery. The overall scheme is now attributed to Charles Lebrun and Louis Le Vau, even though the accounts kept by the Bâtiments du

Roi[276] cite François Francart, Baudouin Yvart, and Jean Lemoyne called Le Lorrain. In reality, these artists merely carried out the vast decorative program, aided by the painters at the Gobelins: Jean-Baptiste Monnoyer, a specialist in flowers, Boel, an animal painter, and Goevel, a landscapist and the collaborator of Van der Meulen.

HYMN TO THE GLORY OF LOUIS XIV The harmony of the whole – that unity without uniformity – was a hymn to the *gloire* of Louis XIV, celebrated in thirteen episodes each with its own allegory, such as Peace and Abundance, Vigilance, Victory, and Strength, all emblematic imagery borrowed from the Cartari repertoire and the 16th-century *Iconologia* of Cesare Ripa.[277] The deliveries made by Pierre Dupont, Philippe Lourdet, and then Veuve Lourdet, Jeanne Haffrey, would arrive in installments over a period of twenty years, from 1668 to 1688. The unity and rhythm of the long series of carpets emerged from basic characteristics common to all the pieces: large format (around 9 meters long), egg-and-dart border, brown ground, acanthus leaves, landscape medallions alternating with illusionistic bas-reliefs woven in camaïeu.

AN INTACT CHEF-D'OEUVRE Before long, however, Louis XIV lost interest in the Louvre and turned towards Versailles, leaving the Grande Galerie to be transformed into a museum of maps and plans, completed in 1697. One outcome, among others, was the preservation of the carpets by the Gardemeuble and then brought out only on special occasions, which makes it possible to retrace their journey through the decades. This process continued as described and without hitch throughout the 18th century, at least until the Revolution, when the vicissitudes of the times engulfed the carpets as they did everything else royal or aristocratic. Their size and their quality combined to work against them, with the result that many were cut down.[278] Such was the fate of number ninety-four, 'Felicity',[279] whose central section is preserved in the Salon des Jeux at the Château de Versailles, and whose two ends are known from photographs.

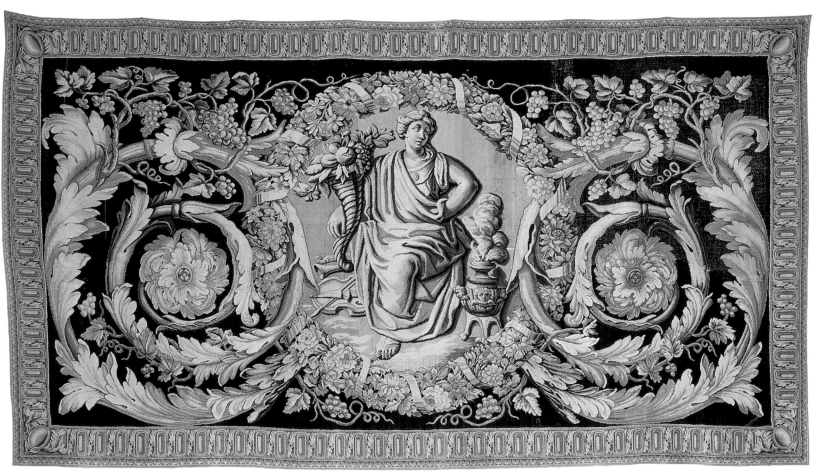

215

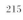

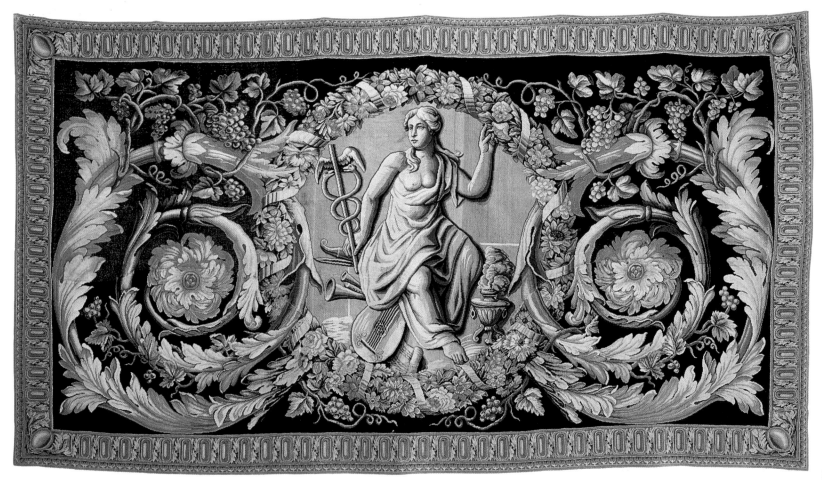

216

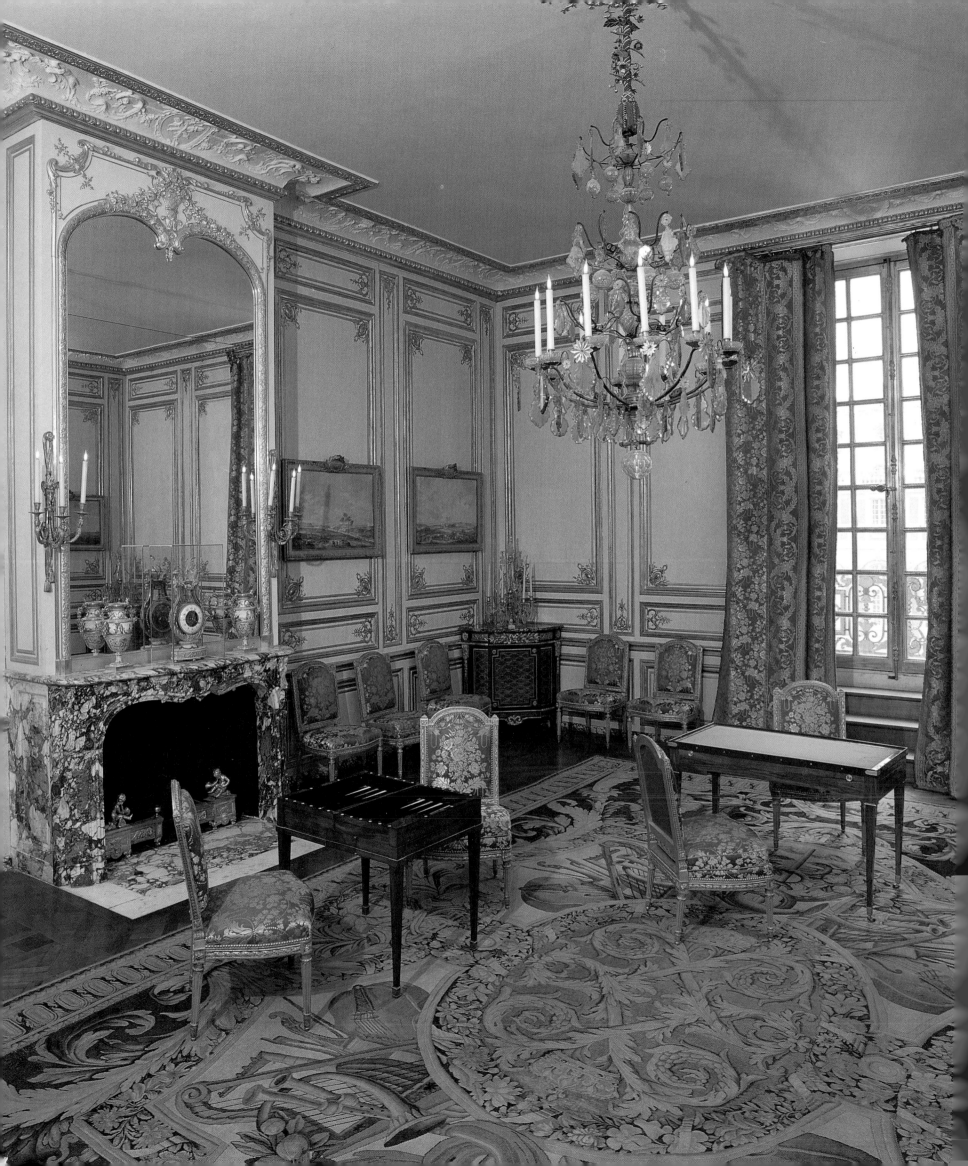

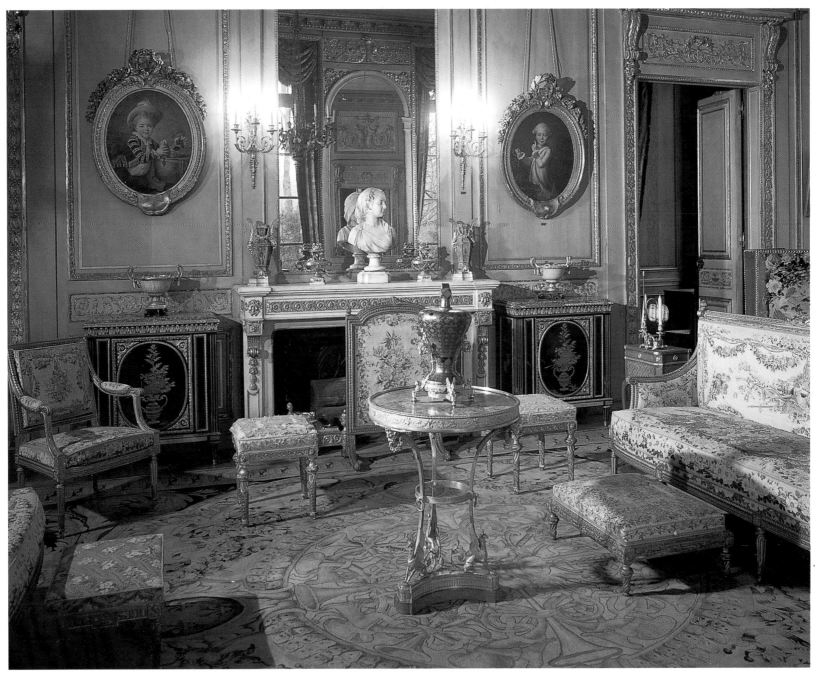

'Air' would have a similar fate, its central section eventually winding up at the Musée Nissim-de-Camondo. This was rug number five, 'a brown-ground carpet representing Air, on which there is a white-ground compartment filled with the arms of France in four cartouches crowned and held aloft by the wings of Fame, set off by festoons and flowers, and in the middle, a blue-ground circle with butterflies surrounding personifications of the four winds. At the ends, two bas-reliefs in blue representing Aeolis and Juno.' Now brought together, the last two fragments belong to a private collector in France.

The Savonnerie's huge Grande Galerie project would also serve a political purpose, most notably when several patterns were reproduced for use as diplomatic gifts. During the revolutionary period, the ruling Directoire deigned to employ the originals but not before effacing the emblems of the old Bourbon monarchy. 'This has been masked with great adroitness,'[280] at a cost ranging from five to twenty francs per fleur-de-lis.

PAYMENT IN KIND Finally, the Grande Galerie carpets became a fungible asset once the law of 2 Nivôse II, in the revolutionary calendar,

218. 'Air', Savonnerie pile carpet no. 45 made for the Grande Galerie at the Louvre. Late 17th century. Musée Nissim-de-Camondo, Paris.

217. Detail of carpet no. 84 made for the Grande Galerie at the Louvre. Delivered on 6 June 1682 by the widow of Simon Lourdet. Now in the Salon des Jeux at the Château de Versailles.

allowed the Directoire to raise money by disposing of state-owned properties and negotiable instruments. By such means, at least, the suppliers could be paid. Among the beneficiaries were Bourdillon and Chapeaurouge, with the consequence, however, of leaving the

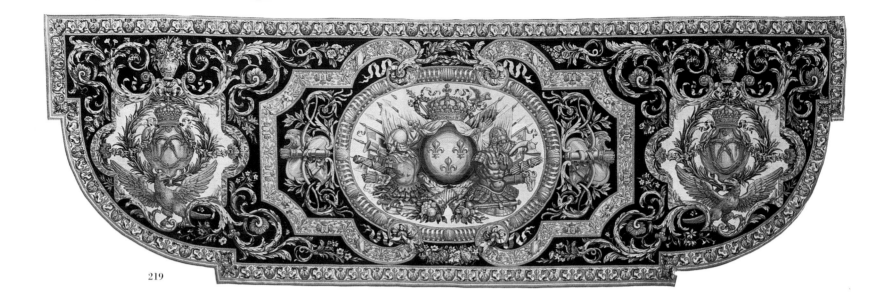

219

carpets open to a very uncertain future. Among the many known examples of what happened, the latest is the sale of 'Strength', formerly in the Garcia collection, at Sotheby's in New York in November 1991.

Continuity and Renewal in the 18th Century

Louis XIV's move to Versailles brought the Savonnerie a new commission, this one for carpets to cover the marble mosaic floor of the chapel,[281] a project conceived by the royal architects Jules Hardouin-Mansart and Robert de Cotte.

The project would prove critical, for, coming as it did in the wake of the Grande Galerie undertaking, the new carpets represented a continuation but also a renewal of the Savonnerie, as witnessed by the carpet now preserved at Versailles, woven, from a model prepared by Blain de Fontenay, under the direction of Robert de Cotte. While the royal attributes and the fleur-de-lis borders form a link with the Grande Galerie ensemble, the overall field design constitutes the beginning of a break with the past.

The evolution can be traced through two pieces with a common theme: the arms of France. Lourdet delivered the first rug in 1668 for placement in the alcove of Louis XIV's bedchamber at the Tuileries. It simply radiates magnificence, all of it dedicated to the glory of the monarch. The second rug,

meanwhile, blends glory with exuberance, thanks to the first budding of the Rococo under the influence of Pierre Josse-Perrot. This design, found in a carpet formerly in the Riahi collection and now privately owned in France, became a bestseller, its pattern reproduced twenty-three times. The royal prototype, a work dating from 1735, would end up in Louis XV's dining room at the Château de la Muette. The Garde-meuble inventoried the carpet as follows when, on 18 February 1740, it received delivery from the Château de Choisy of 'a carpet woven at the Savonnerie of wool, black ground, design by Perrot, representing at the center an escutcheon with the arms of France, borne aloft by eagle's wings spread between four

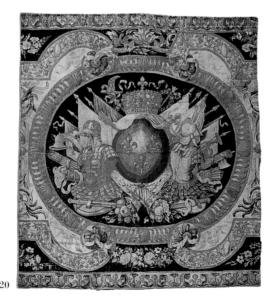

220

sets of trophies formed of crisscrossed quivers and torches tied with blue ribbons. Around the field is a double border, one of the friezes laden with imposts and, at the center, spiderweb-like cartouches, and the other, a blue-ground affair, ornamented with scrolling foliage, horns of plenty, and garlands of natural flowers, five and a sixteenth by five *aunes* wide.'

Two other examples of this pattern survive, one at the Cleveland Museum of Art and the other at the Musée Nissim-de-Camondo in Paris, the latter affected by the usual revolutionary tampering with the royal emblems. Very likely the version in the Riahi collection was given as compensation to one of the state's foreign creditors, which would explain its extraordinary freshness.

These pieces are also interesting for the differences in their texture, providing a prime opportunity to investigate matters of technique.

TOWARDS A LOUIS XVI STYLE At the dawn of the 18th century, therefore, it is clear that a break was under way in the treatment of the ground, which would no longer be systematically brown, but often yellow, lime, jonquil, fawn, and, most of all, check- or mosaic-patterned. This could be seen in the first carpet created for the royal tribune, and then twice copied. One example, discovered at Saint-Eustache in Paris, is now preserved at the Château de Compiègne.

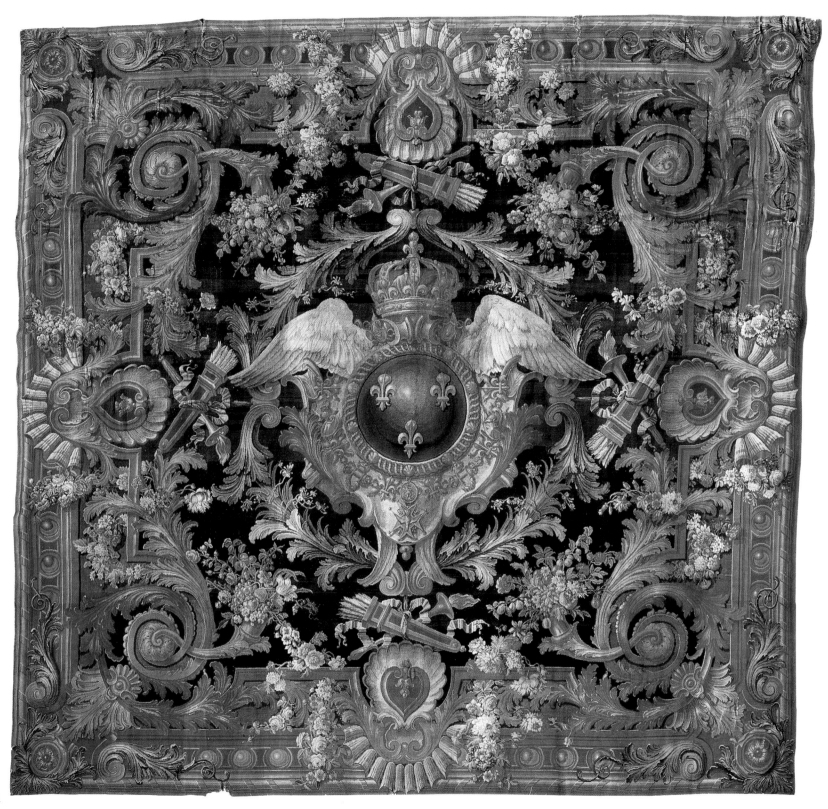

221

219. *Savonnerie alcove rug with the arms of France woven for Louis XIV's bedchamber at the Tuileries Palace. Delivered by Simon Lourdet on 20 November 1688. Wool pile, wool warp, hemp weft. Louvre, Paris.*

220. *Savonnerie carpet identical to one made for Louis XIV at the Tuileries Palace, albeit with a few variations in the field pattern. c. 1688-1690. Wool pile, 2.70 x 2.43 m. Private collection, Paris.*

221. *Savonnerie carpet designed by Pierre Josse-Perrot, who ushered in the style Louis XV by blending Louis XIV's gloire with a touch of exuberance. Wool pile, wool warp, hemp weft, 5.67 x 6.03 m. Reproduced in a 1994 sale catalogue. Private collection*

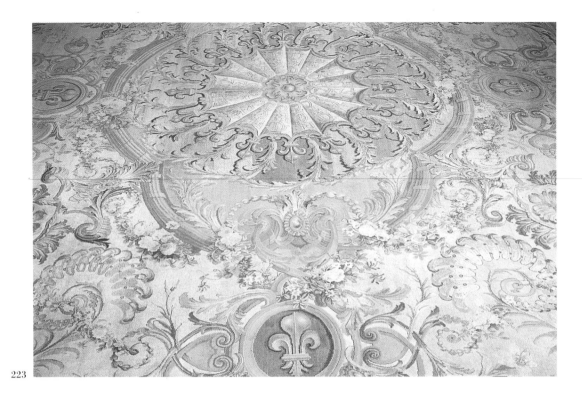

223

223. Pattern designed by Pierre Josse-Perrot for the Queen's bedchamber at Versailles. c. 1728. Ink and chalk on paper. Mobilier National, Paris.

224. Savonnerie carpet delivered to 'Mesdames, à la chapelle de la Vierge' at Versailles. 1745. Wool pile, wool warp, hemp weft; 4.78 x 3.37 m. Musée Nissim-de-Camondo, Paris.

225. Savonnerie carpet similar to one designed by Pierre Josse-Perrot for Louis XV's dining room at Fontainebleau. Delivered c. 1740. Private collection.

This was the fruit of team work, involving such specialized painters as Bacqueville,[282] Monnoyer, Le Lorrain, and Blain de Fontenay, who launched the stylistic revolution. It would then evolve slowly through the work of the painters Gravelot, Chevillon, and Jacques, the authors of the 'Louis XV style', the roots of which lay in the innovations of Perrot.

Pierre Josse-Perrot worked at the Savonnerie from 1725 to 1750. His style is characterized by a symphony of brilliantly colored royal emblems, shells, fruits, acanthus leaves, horns of plenty, garlands, and bouquets of flowers *au naturel*, meaning treated with minutely detailed realism. A good example is the bedchamber rug delivered to the Queen in 1730.

The center of these carpets is sometimes given over to a monogram, but more often to a *rose moresque ou arabesque*, which was the innovation of the period, or to a spiderweb motif,[283] or yet to a bat, with the image occasionally repeated in the four corners of the rectangular field. The central motif may also comprise a rosette, as in an ink and chalk drawing by Perrot,[284] representing a rug meant for the King's dining room at Fontainebleau, a very close version of which was shown in the recent exhibition entitled *Les Fastes de Versailles*.[285] The Musée Nissim-de-Camondo[286] owns a rug with a similar pattern, woven in 1745 and delivered to *'Mesdames* [the pious, unmarried daughters of Louis XV], *à la chapelle de la Vierge'* at Versailles. The patterns would remain in vogue throughout the 18th century, and even today they serve as the basis of modern works, such as the rug

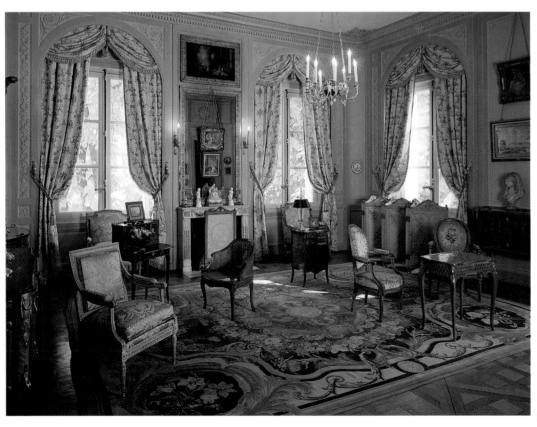

224

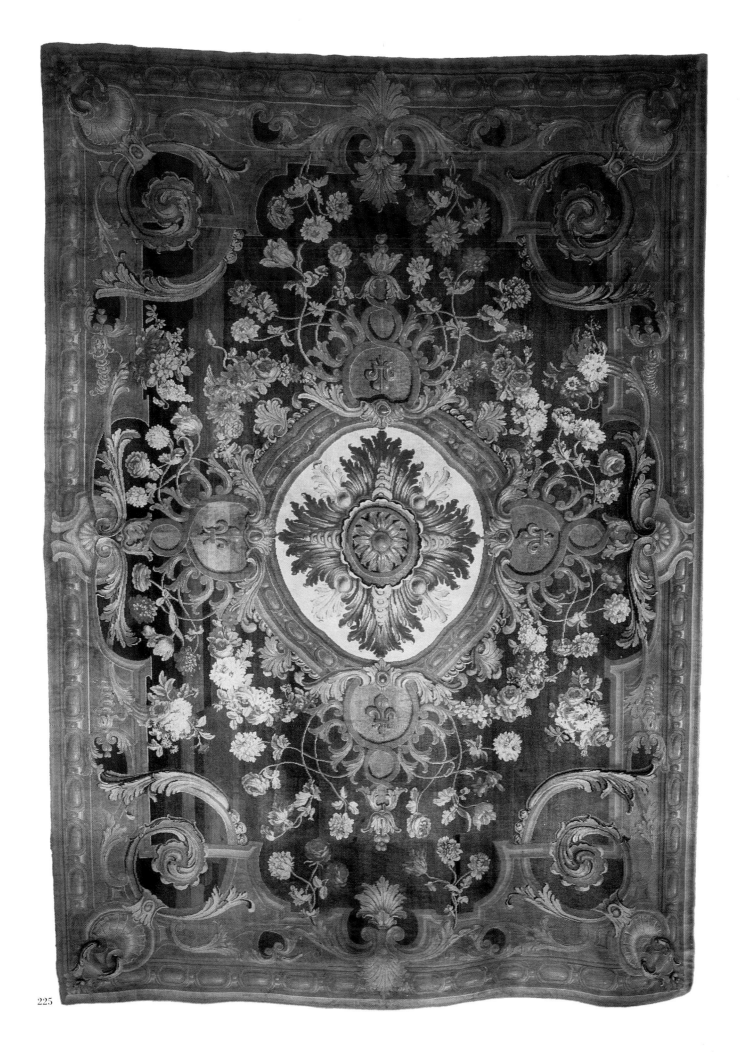

225

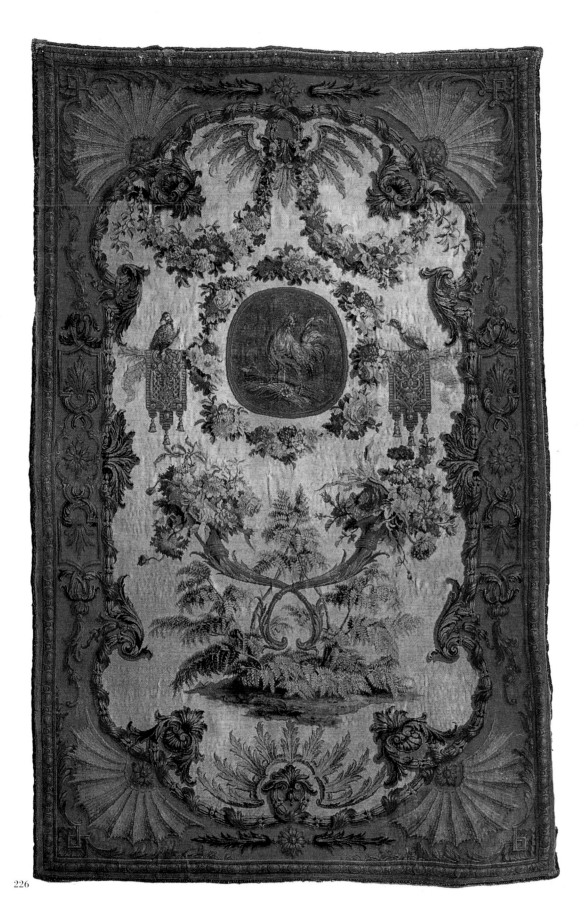

226

sold at Stockholm,[287] a piece with the monograph of Gustav V, woven by the Braquenié firm from a pattern attributed to Perrot preserved in the Swedish royal collections.

A DEVELOPING MARKET From the very beginning, the Savonnerie produced not just carpets but also chair and bench seats, as well as a variety of panels, exploiting all the resources of a staff composed of apprentices, young workers, and qualified artisans The contractor sought to diversify his repertoire, which probably accounts for the portière, or door hanging,[288] entitled *Le Coq et la Perle*. Poaching on the Gobelins's preserves, the Savonnerie wove two portières as mentioned in the archives:

State of different pieces which are finished and ready to sell [brown order book].
No. 2. A large portière with animals, flowers, fruits, and ornaments, measuring 2 to 20 seizes . . . by 1 to 14 seizes.
- at 220 livres per aune: 1082 livres
- at 250 livres per aune: 1230 livres
No. 3. Another [portière] representing 'Le Coq et la Perle' measuring 2 to 4 seizes 1/4 by 1 to 5 seizes 3/4 (about 2.70 x 1.65 m).
- at 220 livres per aune: 678 livres
- at 250 livres per aune: 770 livres
Le Coq et la Perle is a theme borrowed from Aesop, the Greek fabulist of the 7th and 6th centuries BC, who, long before La Fontaine, featured animals in his satiric morality fables. The portière in question presents a rich cartouche whose cream ground is embellished with two birds perched upon lambrequins and

226. *The Savonnerie wove two portieres, only one of which is known today, a piece entitled, courtesy of Aesop,* Le Coq et la Perle. *The richly elaborated cartoon on which it was based is attributed to Jean-Baptiste Oudry and Pierre Josse-Perrot. c. 1730-1740. Private collection.*

227. *Savonnerie pile carpet of c. 1736 based on a square piece woven around 1730 for the Council Chamber at Fontainebleau. The design enjoyed a great vogue, right through the 19th century, when it was copied many times in various grades for the general market. Royal Swedish collection, Stockholm.*

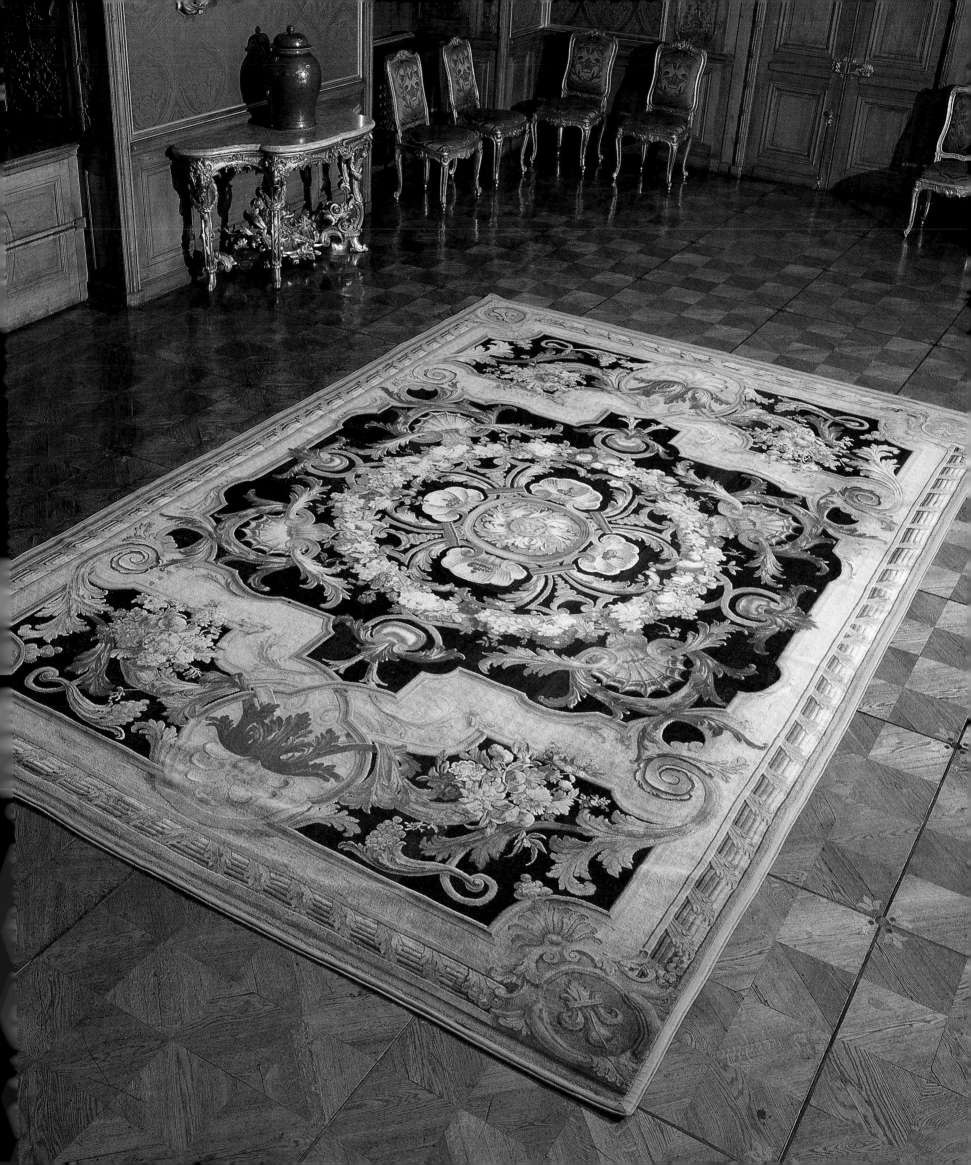

a décor of polychrome garlands and flowering horns of plenty on a ground of ferns. Bat-wing motifs with dark outlines fill the corners and dramatize the gadrooned border.

The current attribution of the design to Jean-Baptiste Oudry and Pierre Josse-Perrot dates this very atypical piece to around 1740. Yet, technical analysis reveals the rug, which has woollen warps and linen wefts, to be very finely woven, its symmetrical knots numbering 32 per horizontal decimeter and 25 per vertical decimeter. These characteristics, as well as a note in the Savonnerie archives, allows the suggestion of an earlier date. Actually, the texture of the Savonnerie rugs evolved in the course of the 18th century. In 1720 it is not rare to find an average of 38 knots per 10 centimeters, whereas at the end of the century we discover only 16 knots. These fluctuations can be explained by the system of worker compensation, which was paid by the *aune*, prompting the weavers to use larger knots so as to earn more for the time invested in the task. This phenomenon would increase right up to the Revolution.

The hypothesis of an earlier date should, however, be treated with care. The portière under discussion is the kind of masterpiece that precludes comparative analysis; thus, by definition it has nothing in common with the many screen panels which exploited a fashionable pattern during the years 1715-1740.

By the mid-18th century, the magnificence of the Savonnerie carpets, their value as decoration, and the quality of the comfort they offered generated such a demand that production had to expand. Aubusson recognized an opportunity and seized it.

FROM THE TURNING POINT OF 1743-1745 TO THE REVOLUTION

The Emergence of Aubusson

Beginning in the 1740s, the Savonnerie ceased to be the only factory producing carpets in *le goût français*. Aubusson had now become the second to undertake a comparable production. Already renowned for its tapestries, the town of Aubusson would little by little win an honorable share of commissions from the Garde-meuble Royal. A proof in point is this extract from a statement by the inspector Chateau-favier,[289] prepared in 1781 for Diderot's *Encyclopédie*: 'There are two factories (Aubusson and Felletin) which fabricate Turkey-style pile rugs, as already mentioned; but the era in which this genre of production was begun is as modern as that of tapestries is old, since it was only in 1740 that this new branch of industry was introduced . . . its growth has been very rapid, and it has subsequently extended to Felletin.' The inspector confirmed that, technically, the looms did not in any way depart 'from those of the Savonnerie at Chaillot', that the methods were the same,[290] and that only the handwork was different.

Aubusson: The Mark of Diversity

A label of quality, Aubusson constituted a diverse production that broke down into a number of units. Unlike the Savonnerie, the Manufacture Royale d'Aubusson was not a single workshop but, rather, a network of independent ateliers described in a report of 1794[291]: 'The Aubusson factory is spread throughout the city, the employees work at home, some for their own account, others do piece work for the manufacturers, who gather under their own direction a certain number of workers.' Aubusson, in other words, functioned as a collective of private enterprises grouped together under royal control and protection. The letters patent for the production of tapestries date from 1730 and 1732; they were then supplemented, in 1743 and again in 1746, by articles[292] specifically regulating the manufacture of *tapis de pied* – foot rugs or floor carpets – as well as other works in the manner 'of

Turkey and Persia', since the production would include screens and chair covers.

The decision to produce knotted-pile floor rugs was made originally by Orry de Fulvy, France's Comptroller-General of Finances, and Charles de Trudaine, State Counsellor, who in 1743 assigned to Sieur de Bonneval, Inspector-General of Commerce, the task of getting the project started. On 8 March 1744 a plan or set of rules, numbering thirty articles, was submitted to the Conseil, which, in a decree of 21 May 1746, granted two contractors, Mage and Dessarteaux, the exclusive privilege of making rugs.[293] The two manufacturers commenced production with eight looms, tools, and utensils, all provided by the King along with a secured loan[294] for ten years and the responsibility for developing the described speciality. Without further delay, Mage and Dessarteaux recruited subcontractors, at the same that, once installed at Aubusson, they also set up as rug merchants in Paris.

GEOGRAPHICAL HANDICAP AS A STIMULANT TO ENTERPRISE The town of Aubusson, despite its enclavement at the heart of the Haute Marche (Creuse), did not live in self-sufficient isolation. Auvergne supplied it with wool for ordinary rugs, Picardy the wool for fine rugs, and England the material for superfine carpets.[295] Production was quickly organized according to a hierarchy of materials and quality. Indeed, the geographical handicap of the town appears to have stimulated its manufacturers, who proved to be extraordinarily dynamic, producing goods not only for Paris and the French provinces but also for Germany, Switzerland, Holland, Prussia, and England.

None of this, however, occurred right away, at least not in the company's first major projects. Of these, the carpet made for Cardinal de Rohan,[296] still preserved at the Palais Rohan in Strasbourg, is an example both precious and prestigious. In 1779, an inventory of the palace mentions the presence in the chapel of 'a foot rug, Aubusson manufacture, 19 *pieds* [*pied* being a unit of measurement equivalent to 32.4 cm or 12'11/16"] long by 15 wide with the Rohan arms.'[297] Delivered in 1745, it was made – very likely from a Dumons pattern – by

Picon, a subcontractor working for Dessarteaux. The great interest of the piece is that it shows the degree to which Aubusson had truly found itself and crystallized.

STILL A TASTE FOR THE ORIENTAL Even so, the work was not yet in the 'French taste'; rather, its design and its colors, both strongly influenced by the Orient, earned the label 'Smyrna', meaning *goût turc*, as products from the Levant were called. Technically, of course, it was woven in the 'Turkish manner', meaning also the 'Savonnerie manner' – that is, knotted.

Regular meetings took place between the Inspector-General Bonneval, qualified as a traveling inspector of the kingdom's factories,

Chateaufavier, and the jury-guards. Summoned 'at the sound of a bell', they made sure that regulations were being respected (the weight of the wool, the supply of dyestuffs, etc.) and took pains to correct whatever required it. The problem at the start was design, or the lack thereof, and to resolve it the group virtually laid siege to Sieur Dumons, painter to the King. We know very little about what contribution this artist made to Aubusson, apart from his obligation to provide three designs per year, beginning on 17 September 1743.

The privileges granted to Mage and Dessarteaux were not renewed, which gave rise to a period of bracing competition among the various ateliers. For some ten years, Aubusson's production adhered to *le goût oriental*, a style that would gradually die out. The organization of the work, the dynamism of the manufacturers, and the taste of the clientele were to be the key factors in the success of Aubusson.

THE TASTE OF AUBUSSON'S CLIENTELE The aristocracy placed their orders, sometimes with precise descriptions of what they wanted, as in the commissions sent in 1755 by

La Reynière, Boullogne, Hainault, and Breteuil. The patterns woven for Madame de La Reynière and Monsieur de Boullogne were created by Le Lorrain and interpreted by the Veuve Picon. A description on the annotated pattern[298] called for 'a carpet with mosaic and flowers' for the boudoir and, for the bedroom, 'a carpet whose heart or center will be composed of our Persian design; this center shall be enclosed with strong interlacing; the

228. *Aubusson pile carpet displaying the arms of Cardinal de Rohan. c. 1745. 'Savonnerie knot', 5.65 x 4.65 m. Chapel, Palais Rohan, Strasbourg.*

229. *Anonymous carpet design created for Aubusson at the end of the 18th century.*

230. *A rare Aubusson rug designed in the 'Smyrna manner' (Oriental or Turkish style) and woven in the 'Savonnerie manner' (with a symmetrical knot). c. 1745. Wool pile, 3.17 x 2.62 m. Private collection, Paris. This fragment offers a perfect illustration of the first knotted-pile carpets, with their reference to Oriental prototypes, made by the entrepreneurs of Aubusson. The piece belongs to the same group as the Rohan carpet in Strasbourg. It is valuable not only for its rarity but also for the link it provides between East and West.*

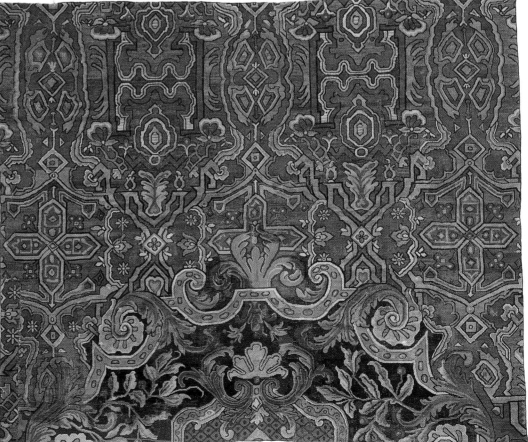

tone shall be maintained by a border in the Persian taste. . . .'

Beginning in 1743, Aubusson's rug designs were prepared by Jean-Joseph Dumons (1687-1779), painter and designer to the King, who continued supplying them until 1750, when the torch passed to Roby the Elder, albeit relayed by Julliard and then by Le Lorrain and Jacques. Still, the creation of suitable designs remained a problem for Aubusson, as a result of which the inspector packed Finet off to Paris for special training. When Le Lorrain sent three drawings and won considerable praise for them, Roby was advised to work in the same manner. It is assumed moreover that Aubusson merely 'executed on a large scale the designs supplied by the King',[299] or else the *manufacture* worked in the style of the painters in service to the crown. Occasionally, Aubusson dealt directly with a painter, as shown by a bill addressed to Dessarteaux[300] for a carpet design submitted by Huet, who described the work as 'a vase of flowers with a border of ornaments.'

In 1755 Dumons acquired a portfolio[301] of drawings that included several patterns for floor carpets, stools, and benches, all from the Oudry estate, which makes the artists difficult to identify.

TOWARDS A FRENCH STYLE Aubusson enjoyed the patronage of several prominent clients, including Madame de Pompadour, who around 1749 ordered a rug, covers for benches and stools, plus another carpet for the Château de Choisy. The enterprise, supervised by overseers appointed by the crown, evolved gradually towards an output in the French style, stamped with an undeniably naïve charm. This is fully evident in carpets[302] like the one at the Musée Nissim-de-Camondo,[303] with its central rosace on a cream ground and its pattern of branches forming a mosaic, as well as the one in a private collection, it too with a central rose medallion, this time encircled with a garland of flowers on a mosaic ground. The texture of these carpets[304] is unquestionably less fine and less dense than that of the Savonnerie works, the fruit of long experience. Yet, this

judgment too should be tempered, inasmuch as the Savonnerie contractors also found reason to complain of an uneven quality in the work done for them, particularly towards the end of the 18th century,[305] a problem which would generate confusion about the origin of certain pieces.

Gradually, the influence of Perrot worked its charm, bringing Rococo flourishes and scrolling foliage into the patterns of Aubusson

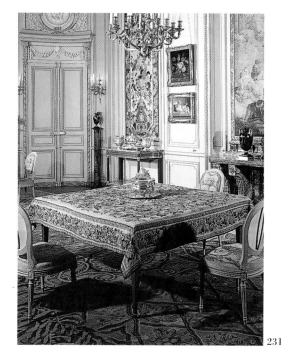

231

232

carpets. In earlier examples, such as the one in the Musée Nissim-de-Camondo,[306] the treatment is uncertain. Over time the touch becomes more deft and then improves to full mastery, as demonstrated in the rug with a decentered design woven from a cartoon owned by the Hamot factory. This piece is quite Perrotesque, with its black ground and white overlay and its *rose moresque* garlanded with flowers. Four flower baskets, shells, scrolling foliage, and interlace complete the decorative scheme set forth upon a mosaic field. The border, a garland of beribboned flowers, effects a transition towards carpets in the Louis XVI style.

The Advent of the Tapis Ras

Both Aubusson and Felletin, a neighboring village, saw their production increase throughout the decade of the 1770s. Because of the pauperized state of the region, the manufacturers had been granted royal decrees,[307] after which 'it was decided in 1771[308] that to create employment for the tapestry workers of Aubusson, fifteen floor rugs would be fabricated.' The idea was to utilize the technique of tapestry weaving to make rugs inventoried by the Garde-meuble as *ras* or, later, as *à point plat*, both meaning flatwoven, tapestry-woven, or pileless.

A good example of the *tapis ras*, one with a central rosace haloed by flower garlands, lau-

231. *Aubusson carpet woven in the 'Savonnerie manner', meaning knotted. c. 1760-1770. Wool pile, 4.17 x 3.33 m. Musée Nissim-de-Camondo (formerly Ephrussi de Rothschild collection), Paris.*

232. *Aubusson carpet with a central rosette on a cream ground woven in the 'Savonnerie manner'. c. 1760. Wool pile, 5.47 x 5.11 m. Musée Nissim-de-Camondo, Paris. Little by little, the Aubusson manufacture comes into its own.*

233. *Aubusson carpet woven in the 'Savonnerie manner'. 2nd half of the 18th century. Wool pile, 3.58 x 3.35 m. Private collection.*
This carpet reveals Aubusson in the process of evolving; yet, the rather stiff arabesques and the variable shading, in lieu of contrasting colors, convey a naïve and captivating charm.

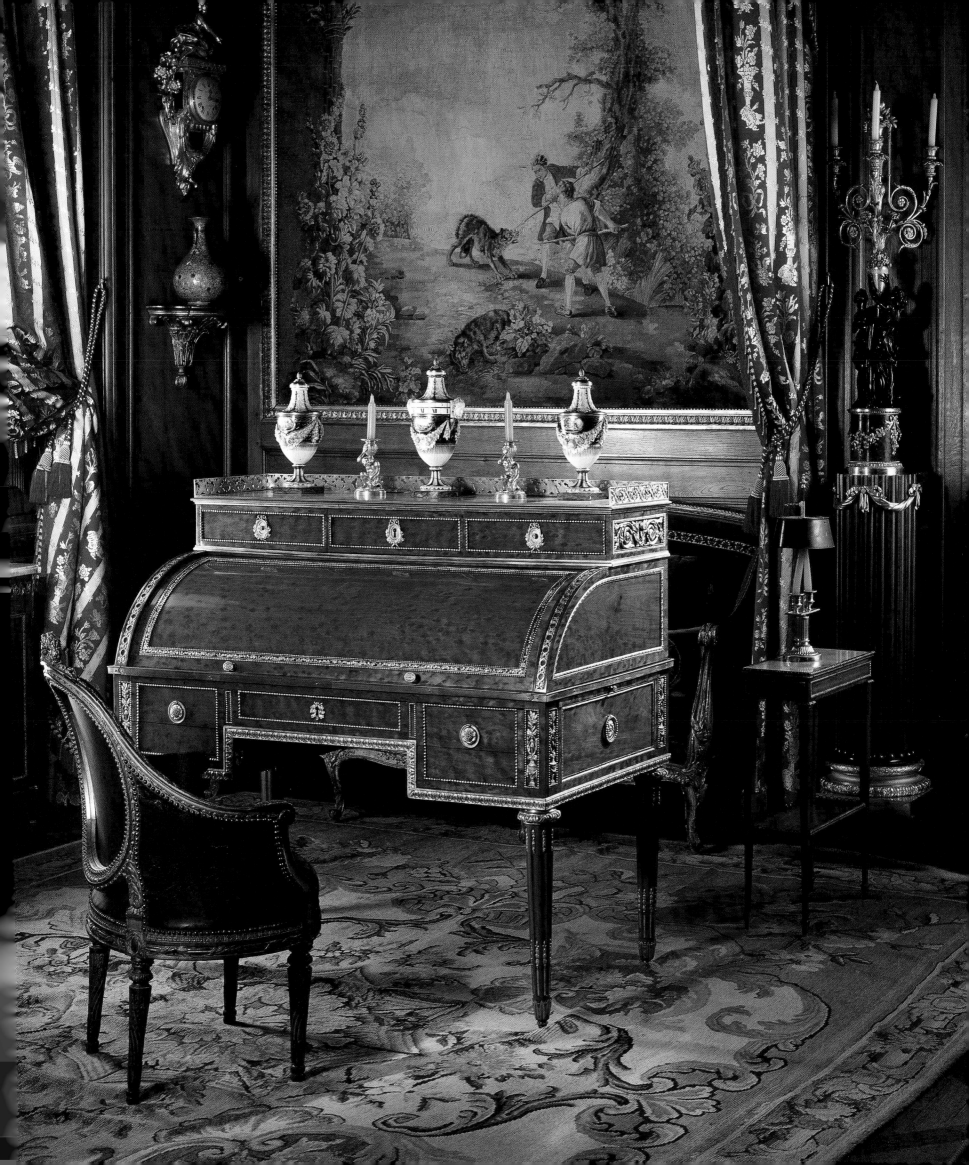

rel, and ribbons, can be found in a private collection in Paris. This genre of rug would achieve great favor in the 19th century, and it contributed to the democratization of Aubusson's clientele. Indeed, tapestry-weave carpets saved Aubusson from economic stagnation by providing a means of redirecting its production after tapestries were abandoned in favor of wall paper.

Aubusson, however, did not wait for assistance from the state. The directors experimented with cotton rugs, the first of which were delivered to the King on 2 June 1773. This initiative, however, did not go any further, owing to the punitive tax on imported cotton. In addition, the dyes took badly, and, as the Savonnerie also discovered, there was little demand for square pieces. An attempt was made to establish rules governing how a carpet should be labeled. Many manufacturers, spurred by Sallandrouze de Lamornaix and Rogier, made a great effort to improve their production, so that, gradually, forms

grew more refined, as can be seen in the accompanying illustration, where the central rosace is surrounded not only by beribboned flower garlands but also by fluting, beads, medallions, and laurel leaves.

The Arrival of the Flatwoven Carpet

In the library at the Musée Camondo is a carpet typical of the period,[309] its rosace contained within an octagonal compartment and garlands of polychrome flowers. Another piece, this one in the study,[310] is also very representative, displaying a beige ground, baskets of flowers within an oval surrounded by garlands, and reserves of blue mosaic patterning intermittently embellished with bouquets. Clearly, remarkable progress had been made within three decades.

French carpet production during the last quarter of the 18th century could be fairly described as variations on common decorative themes. The same patterns would some-

times be used at all three workshops – Savonnerie,[311] Aubusson, and Beauvais – as witnessed by a rug in the Louvre,[312] on which the interlaced flower garlands appear against a brown field whose border simulates a frame made of beads and palmettes. The pattern was rewoven many times, with variations in the border design. The one seen here evokes the motifs of Classical antiquity, all the rage once again following the excavation of Herculaneum and Pompeii in 1748 and the famous Grand Tour of the Comte de Caylus.[313] The same orchestration of motifs can be seen on a carpet owned by the Mobilier National, probably from Aubusson, a piece with a brown field and a center composed of a fleur-de-lis and eight compartments housing medallions of birds and swans, the whole within a rectangle bordered with a laurel leaves, flowers, beads, and palmettes.

234. *Aubusson flatwoven carpet. c. 1770-1780. Tapestry weave (tapis ras), 5.30 x 4.55 m. Private collection. This type of production remains popular even today.*

235. *Aubusson or Savonnerie carpet with a floral wreath pattern on a brown ground. c. 1800. Wool pile, 3.20 x 2.40 m. Louvre, Paris. In 1808 the Savonnerie still had in stock 'a rug with rose garlands on a brown ground and a border of blue baguettes'.*

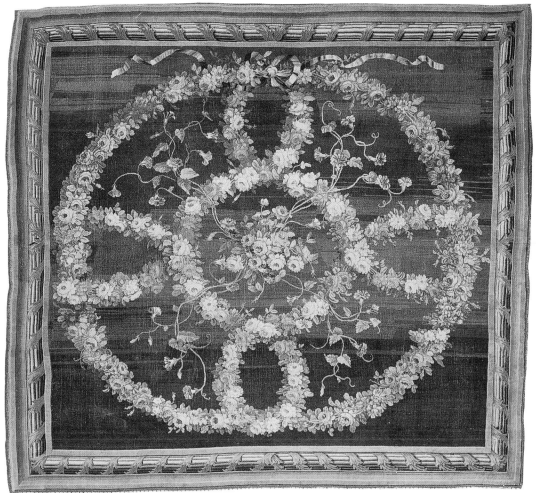

234

235

A Growing Taste for the Exotic

In 1775, however, the Savonnerie assumed a new tone – arabesques in the exotic Turkish and Chinese manner on delicate, light-colored grounds – which may be traceable to Michel-Bruno Bellengé (d. 1793), painter to the King.[314] It was Bellengé who, among others, designed the carpet for Marie-Antoinette at Fontainebleau, finished in 1778 and copied in 1810 for the Empress Marie-Louise at Compiègne. The rustic attributes, the Neoclassical elements, and the *turqueries et chinoiseries* proved to be a crucible of inspiration for the entire period. Also contributing to the Classical revival were the painter Lagrenée (1739-1821), followed by the architects Jean-Démosthène Dugourc (1749-1831) and Louis de La Hamayde de Saint-Ange (1780-1831).

A Luxury Item Banned by the Revolution

Soon, however, all the rug makers found themselves in the maelstrom of the French Revolution. The Savonnerie suffered through a difficult period, and for a while it even had to shut down. At Aubusson the merchant-weavers found themselves so mired in economic recession and general pessimism that they joined together and requested a new state decree allowing them to begin fabricating material for curtains.[315] They assumed that carpets, being luxury items, would be banned by the Republic. Moreover, the warehouses in Bordeaux, Lyons, Lille, and Paris were closed, and the exports to Germany, Spain, Holland, England, Russia, and America were halted, with dire economic and social consequences.

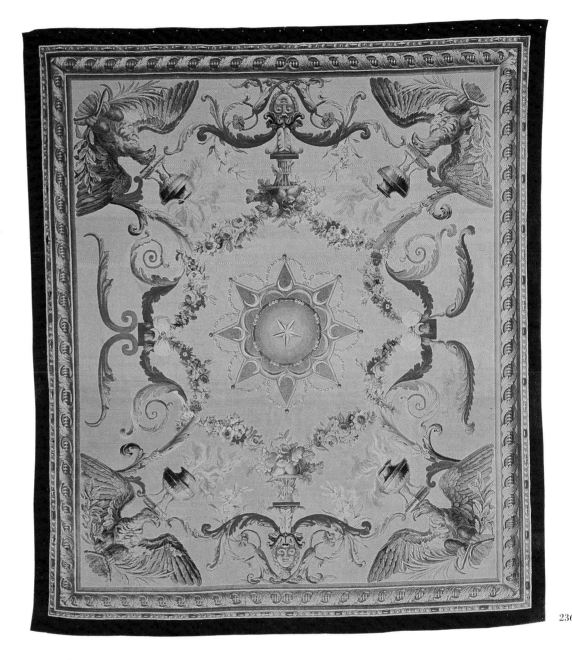

236

order to reimburse the state's creditors, army suppliers and others. The director of the Savonnerie, Duvivier, declared that the factory had no more than three carpets in reserve.[316]

236. *Savonnerie carpet made for Marie-Antoinette's Turkish boudoir at the Château de Fontainebleau. Wool pile, 1778. Louvre, Paris. The Romantic taste for things exotic – for the imaginary paradise – had already begun in the late 18th century.*

THE 19TH CENTURY

The Revolution left the Garde-meuble in a critical state. Some of the carpets in its inventory, such as the Grande Galerie suite, were utilized by the Directory; others were altered, cut down, and their emblems effaced. Some pieces, in keeping with the law of 2 Nivôse IV (1792), served as collateral or payment in kind, or even sold at auction in

NAPOLEON, SAVIOR OF THE RUG MAKERS
Eventually, however, things did improve once the Garde-meuble was reorganized in 1792, and, even more so, following the decree of 28 Floréal XII (1803), which allowed Napoleon, soon to be Emperor (1804), to utilize the royal palaces.[317] In 1807, while at Tilsit in East Prussia, the Emperor took the decision

to aid the manufacturers, not only for economic and social reasons but also from a desire, even the need, to refurnish the imperial residences. This would sow the seeds for a remarkable blossoming of French rug making in the 19th century.

STYLISTICAL RENEWAL DURING THE EMPIRE
The imperial government enabled the Savon-

nerie to benefit from the stylistic renewal ignited by the architects Percier and Fontaine. In a similar fashion, the administration would affect the other workshops, sustaining them as it played the role of quasi-maecenas. This also produced, under the leadership of the Savonnerie, a kind of unity, detectable in the maintenance contracts. One of these, concerning the Château de Saint-Cloud[318] and dated 1811, states that out of eighty-three rugs, twelve came from the Savonnerie, eighteen were termed *genre Savonnerie*, and fifty-three others were an assortment of rugs woven *double broche* (brocaded), moquettes (strip or fitted carpeting), and flatweaves. The connecting element, which ran like a red line from one production to another, consisted of the designs furnished
b y

238. Detail of the Empire style carpet with 'the fasces of the 16 members of the Légion d'Honneur' woven by Piat Lefebvre for Napoleon's large study at the Château de Saint-Cloud. Tournai, c. 1808. Wool pile, 9.42 x 7.45 m. Mobilier National), Paris.

237. Carpet design by Louis de La Hamayde de Saint-Ange for the Emperor's large study at the Tuileries Palace. Savonnerie, 1808. Château de Compiègne. Each medallion represents the emblem of a member of the Légion d'Honneur. The piece was somewhat altered during the Restoration (1815-1830).

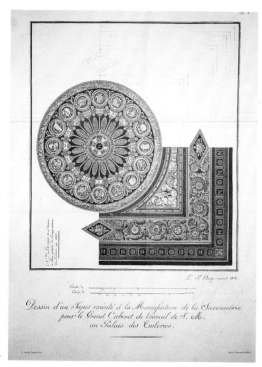

237

the painters and architects working for the Savonnerie: Percier and Fontaine, Berthault, Lagrenée, J.D. Dugourc, Brongniart, and Louis de La Hamayde de Saint-Ange.

Les Tapis d'Apparat

Ceremonial carpets, or *tapis d'apparat*, were made for the state or reception rooms in various palaces, such as the Tuileries, Saint-Cloud, Compiègne, Narrac, Laeken, and Strasbourg, even Monte Cavallo in Rome.

THE POLITICS OF PRESTIGE The politics of prestige, meant to endow a parvenu regime with a royal air, translated into carpet designs composed of imperial emblems intermingled with military trophies, symbols of the arts and sciences, and motifs appropriated from Classical antiquity. The resulting 'Empire style' is perfectly exemplified in the carpet made for the membership of the Légion d'Honneur.[319] The insignia of this order, created in 1804, provided the rug makers with a theme which lent itself to numerous variations. Thus, on 27 August 1812,[320] the Savonnerie – now La Manufacture Impériale de la Savonnerie – delivered, for the large study of His Majesty at the Tuileries, 'a two-part carpet representing the attributes of the sixteen members of the Légion d'Honneur', for a sum of 54,393 francs and 53 centimes. Louis de La Hamayde de Saint-Ange (1780-1891) created the pattern,[321] while Bellanger, *retrayeur* or official 'mender' for the Mobilier Impérial, took charge of assembling the two parts.[322]

CARPETS FOR THE LÉGION D'HONNEUR During the same year, 1812, Bellanger,[323] this time in his capacity as representative of the manufacturer Piat Lefebvre in Tournai, delivered a rug of 'Savonnerie type, fine quality with the attributes of the Légion d'Honneur, the middle figuring the fasces of the 16 members of the Légion d'Honneur, and at the center the cross of this order, for the large study of His Majesty the Emperor at the Palace of Saint-Cloud.' A more precise description, dated 1806,[324] indicates that 'Imperial escutcheons are held by Fames, terminating in scrolls',

moreover that a second identical example was still on the loom.[325] Patterns and completed works 'for the members' not only reflected the taste of the Empire; they also reveal the way in which the market was organized and orchestrated by the Savonnerie.

MILITARY TROPHIES AS MOTIFS Another specimen of the ceremonial production is the carpet made for the Emperor's bedchamber at the Tuileries.[326] Designed by Saint-Ange and now preserved at the Louvre, this piece was modified during the Bourbon Restoration (1815-1830) in order to add fleurs-de-lis. The military trophies, contained within an octagonal medallion, constituted motifs then very much in fashion. On 10 December 1809, Sallandrouze de Lamornaix[329] sent a bill for a carpet described as having a 'round middle with antique shields', the piece meant for the Emperor's bedroom at Fontainebleau. Another bill, this one from 1810 and sent to the Palais de Meudon,[328] concerned 'an ordinary pile rug . . . designed with military trophies on an amaranth ground, linen gray and white, a central rosace medallion and a wreath of oak leaves, border of laurel leaves.' The description could be compared with the one at the Mobilier National.[329]

The 19th-Century Market

Apart from the Savonnerie, indisputably supreme, and the Beauvais factory, orders from the Garde-meuble and from private individuals were divided between two rivals, Sallandrouze de Lamornaix and Bellanger, who fought one another tooth and nail.

Bellanger,[330] already under state contract for maintenance, was the Parisian agent for the rug manufacturer Piat Lefebvre of Tournai. This Flemish city, at the heart of oft-contested ground, was for the moment French and would remain so until 1815, with the result that its enterprise was not affected by the ban on imported carpets.[331]

Tournai, as a consequence, flourished in the early 19th century, receiving a good part of the commissions let by the Garde-meuble. The designs for some of these orders are attributed to Saint-Ange, while many others

23

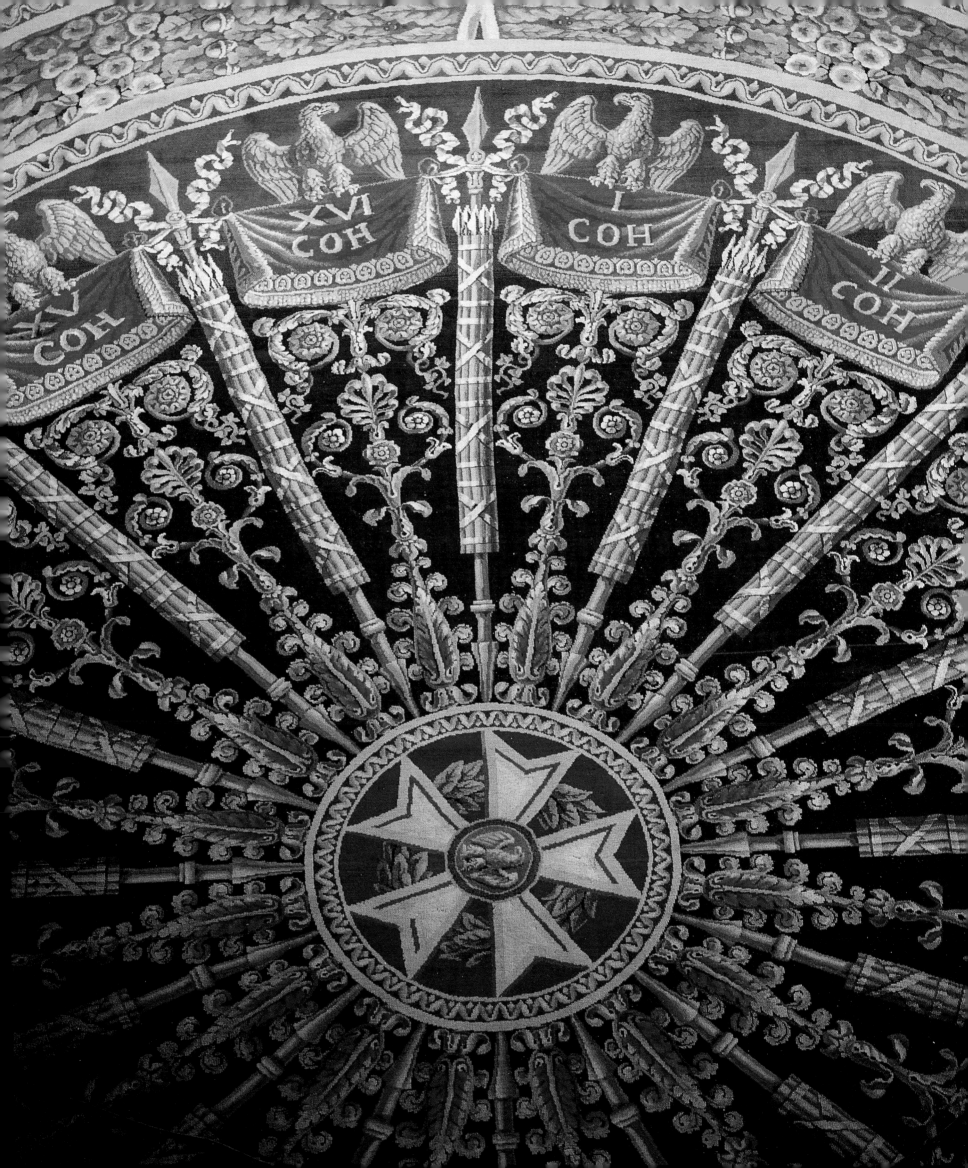

are the work of the architect Renard, the author of the plans for the factory. Founded in the 18th century,[332] the Tournai workshop was the economic engine of the region, exporting to Germany, Italy, and Russia.

In competition with Piat Lefebvre was Sallandrouze,[333] dignified by the title 'Manufacture Royale d'Aubusson', even though the concern subcontracted much of its work to various workshops in or around the town.[334] In year XIII of the revolutionary calendar (1804), Jean Sallandrouze formed a partnership with Guillaume Rogier.[335] Renewed in 1816, the agreement stipulated that only the corporate name 'Sallandrouze' should appear, at the same time that it also established the division of work. Sallandrouze would devote itself to the Paris factory for *tapis fins première qualité* (fine carpets premier quality), and Rogier to fabrication and subcontracting at Aubusson and Felletin. The partnership was a dynamic one, which responded to the taste of the times by ordering patterns from Saint-Ange, the designer at the Garde-meuble.

Rugs for Living Quarters

Although not conceived in the interest of imperial glory, the French rugs made for private suites were none the less beautiful. Here, military imagery gave way to swans, horns of plenty, baskets of flowers, poppies, and arabesques, as in a splendid example designed by Saint-Ange in 1814 for the bed-

chamber of the Empress Marie-Louise at Saint-Cloud. The Piat Lefebvre factory also competed for this market, offering its own swan carpet, with enough success that four known specimens survive.[336] The same is true of a 'civil' version of the Légion d'Honneur rug, on which the military emblems have been replaced with motifs from Classical antiquity.[337]

On 29 June 1808, for reasons of care and maintenance, the *valet tapissier* in service to Prince Murat sent an inventory of twenty-six rugs then among the furnishings at the Élysée Palace.[338] The inventory, complete with detailed descriptions of the rugs, their grades, and even fitted carpeting or moquette made for doorways and window openings, is not merely a windfall for the specialist; it is also, for everyone interested in the styles and modes of living, a reflection of the period's taste, or rather the taste of one of the Empire's highest dignitaries.

239. *Sallandrouze de Lamornaix carpet based on the Saint-Ange design seen below. Aubusson, c. 1810. Wool pile, 5.30 x 5.10 m. Mobilier National, Paris. The pattern was woven by other manufacturers as well, and one example came up for sale at Drouot (Millon Jutheau, lot 144) in Paris on 9 December 1987.*

240. *Savonnerie carpet designed by Saint-Ange for the bedchamber of Napoleon I at the Tuileries Palace. 1810. Wool pile. Louvre, Paris. Under Louis XVIII the Imperial bees were replaced by Bourbon fleurs-de-lis.*

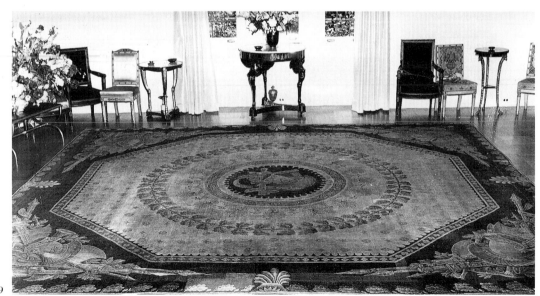

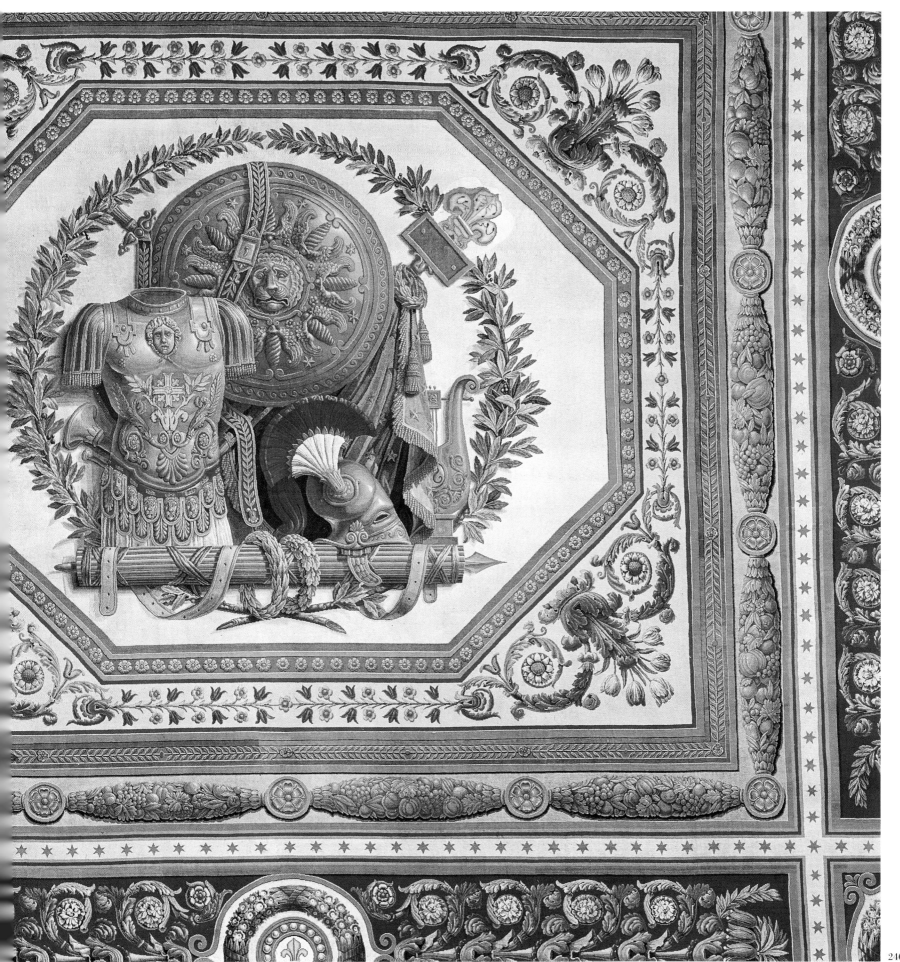

240

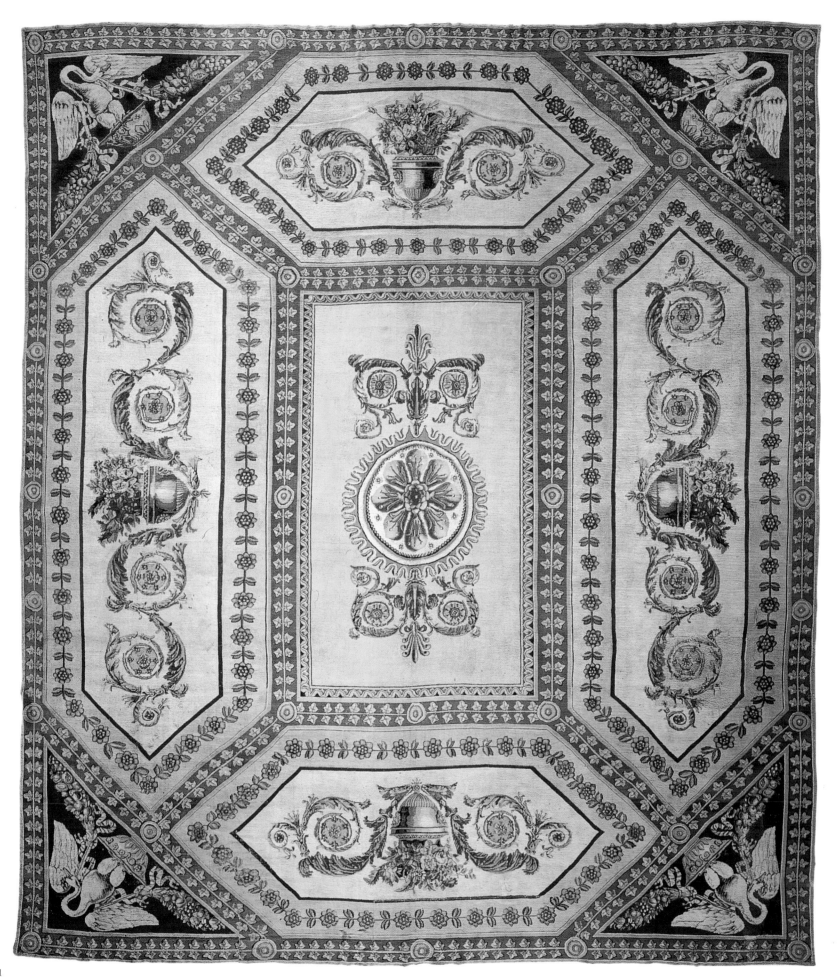

241

In the inventory we should note a 'pile carpet medium fine, pattern with griffons'. While it cannot be proven that the rug so described is the same as the one *aux griffons* from the Murat estate sale,[339] the design of the latter is particularly characteristic of the Empire style. A similar carpet is preserved at the Musée National de la Malmaison,[340] where it lies in the Emperor's library. Originally at the Tuileries Palace, it still bears the label 'Tuileries no. 63'.

The Élysée Palace inventory also lists the rugs in secondary rooms and passageways, thereby providing a good sample of favorite motifs. Lilac, leopard, and tiger-paw themes, in vogue since 1778, flowerbeds (lawn and scattered-rose patterns), gravel, and green jaspé all form part of the décor of certain rooms, becoming fitted or wall-to-wall carpeting wherever the lengths were stitched together. Other fashionable motifs are compartment or caisson patterns, grid designs originally created by Leclerc, Dugourc, and Saint-Ange for the Savonnerie,[341] which yet again underscores the influence of this production on that of the private carpet makers. All the factories wove compartment rugs,[342] reviving the pattern over the years, with more complicated and enriched imagery, or heavier, as the case may be. Knotted or flat-woven, the pattern would play a major role in the democratization of carpets.

The years 1815-1820 brought the abdication of Napoleon and the Bourbon Restoration, without having any impact on the Napoleonic designers, who went on producing carpets in the Empire style, albeit with a certain enrichment of the motifs. Indeed, it was in this very period that the Savonnerie created one of its most beautiful carpets, the piece for the throne room at the Tuileries.[343] The first rug, based on a Percier and Fontaine design, had been ordered by Napoleon and then woven in 1806-1809. Come the Restoration, Louis XVIII, followed by Charles X, had all 'unseemly emblems' expunged, which, together with other modifications, made the carpet unusable. J.D. Dugourc was then commissioned to design a new carpet for the throne room, whose overall decoration he would supervise. This was rug making on a grand scale – 155 meters square in

three parts – all in brilliant colors: 'At the center the arms of France and Navarre on a white ground encircled by the chain of the Order of the Holy Ghost and wreathed in lilies; on either side, the attributes of Justice and Royalty. The lateral parts comprising, on the one hand, a large military trophy, cuirasses, banners, helmets, and shields and, on the other hand, emblems of the navy, the arts, and the sciences; at the two ends, the King's monogram framing the head of Phoebus.'

A carpet in a private collection also exemplifies the period to perfection, what with its central rosace cinctured by garlands of flowers and laurel on an amaranth ground, the

241. *Piat Lefebvre carpet 'with swans', a design after the manner of Saint-Ange. Tournai, 1809. Wool pile, 6.85 x 6 m. Private collection. Three other examples of this pattern are known, one of them at Pavlovsk in Russia, another in the second salon (private apartments) of the Empress Marie-Louise at Fontainebleau, and a third in the Mobilier National, Paris.*

242. *Drawing attributed to Saint-Ange for a 'civilian' version of the Empire-style Légion d'Honneur carpet woven by Piat Lefebvre, Tournai. A variation of this pattern is now preserved at the Mobilier National, Paris.*

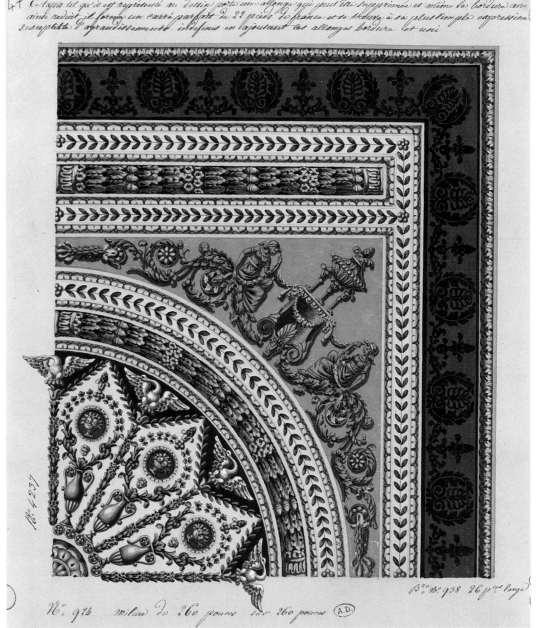

242

243

243. *The Emperor's Library at the Château de Malmaison. The pile carpet 'with griffons' came from the Tuileries Palace, and it stills bears the label 'Tuileries no. 63'. Wool pile, 3.55 x 3.70 m. Empire period and style.*

décor of the latter composed of flower baskets, horns of plenty, and scrolling foliage. There are in addition several examples with very similar patterns, pieces known thanks to the Seligmann[344] and Dutasta[345] sales. Also related is the carpet placed in the Serres-Barriol salon at the Musée des Arts Décoratifs. Here again, this design 'in the taste' of Saint-Ange is quite explicitly borrowed from the Savonnerie repertoire. Sorting out the prove-

nance of these rugs is not an easy task, given the continuous evolution of the market.

The Dynamism of the Factories and Its Link with Democratization

The arrival of the flatweave carpet with its simplified patterns constituted a first step towards what could be called the *tapis bourgeois*, the rug of the middleclasses. The time had come to diversify production, to which the manufacturers responded by offering a wider range of grades, even as they continued to serve their elite clientele. In 1816, Sallandrouze and Rogier enlarged their workshop at Aubusson,[346] in order to produce rugs within the economic reach of a broader market.

THE BOURGEOIS CARPET Producing for a broader market was a smart move, with ramifications noted in the account given of the Exposition of Products and Industry held in 1844: 'It exhibited, as a sample of its grades and prices, a repetition in a flatwoven rug of a most remarkable design, several samples of marbled and plaid rugs, deep-pile carpets and moquettes. This house is particularly seeking to enlarge the taste for and the use of rugs by multiplying its productions in all genres suitable for the middleclasses.'

The Chenavard factory,[347] which enjoyed the patronage of Madame la Dauphine (Duchesse de Berry), figured among the dynamic enterprises that produced 'economical rugs' right along with its high-quality pieces, such as the one with a pattern 'imitating marquetry'.[348] At its workshop in Biancourt, near Sèvres, Chenavard fabricated rugs of *velours feutres*, or 'felt pile', as well as 'canvas rugs varnished in the English manner'. Moreover, at a shop known as the Maison du Page, on the Rue Vivienne in Paris, it sold rugs with new designs as well as small Turkey and cashmere rugs in a wide range of qualities.

A DYNAMIC INDUSTRY IN FULL MUTATION A letter dated 29 May 1816[349] gives us a good idea of how the private sector was organized, of the alliances formed and the strategies employed. Sallandrouze in Paris, Aubusson, and Felletin continued their allied war against Bellanger, whose partner was Vayzon. In the context of

THE SUCCESS OF THE FLATWEAVES

In the 1770s Aubusson converted its tapestry looms in order to begin making flatwoven – tapestry-woven – carpets. Production of both knotted-pile and flatweaves accelerated, but the latter type – the classic *tapis ras* of Aubusson – proved such a success that the name Aubusson remains virtually synonymous with the pileless carpet. Flatweave production allowed the Aubusson entrepreneurs to weather many economic storms.

THE VARIOUS GRADES AND FORMATS

In 1806 Duvivier, the manager of the Savonnerie, suggested to Daru,[1] the chief steward of the Emperor's household, that he consider three prices based on the difficulty of reproducing the design: 1) figures, armorial bearings, and complicated ornaments, 2) contemporary floral designs, 3) *ouvrages faciles* (easy works). Yet, we know that the factory made only one grade of carpet (even if this fluctuated[2]). The other manufacturers, whether Aubusson or Piat Lefebvre at Tournai, did produce different grades of rugs.[3] The same pattern could be woven *façon Savonnerie, premiere qualité* (Savonnerie manner, top quality) or as a fine or an ordinary flatweave carpet, with the price ranging from standard to double. Such willingness to adapt to the needs of the market allowed carpets to become democratized.

Nineteenth-century fashion dictated that the floor surface of the room be entirely covered. As a result, it was often necessary to add extra pieces known as *embrasures* (rugs made to fit recesses in front of windows or doorways), *entreportes* (bridge rugs through doorways between rooms), and *bordures* (borders). These supplementary pieces, woven to measure, were made by Aubusson and Tournai, for their own carpets and for those of the Savonnerie as well.

1. O²909 (1806 dossier).
2. P. Verlet, *Bulletin du* CIETA, art. cited.
3. O²622 (Creuse dossier).

244

244. *Flatwoven carpet with compartments. c. 1815. The simplified design represented a first step towards the 'democratization' of carpets. Tapestry weave (tapis ras), 2.94 x 2.73 m. Private collection, Paris.*

245. *Carpet woven 'in the Savonnerie manner' (piled with a symmetrical knot). c. 1820. Wool pile, 5.49 x 4.72 m. Private collection, Paris. Here again the source of inspiration was the great Empire-style designer Louis de la Hamayde de Saint-Ange. Similar rugs are to be found in the famous Seligman and Dutasta collections, as well as in the Serres-Barriol salon preserved at the Musée des Arts Décoratifs, Paris.*

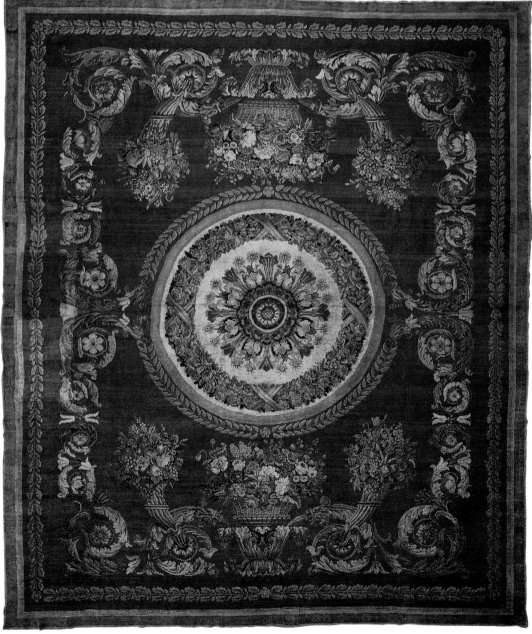

245

246

246-247-248. *Manufacturers' motifs for strip carpeting meant to be laid in corridors or secondary rooms. Here the manufacturer was Piat Lefebvre at Tournai. Musée des Arts Décoratifs, Paris.*

249. *Carpet embellished with silver yarn. 1840. 2.96 x 1.61 m. Private collection, Paris.*

The Turkish Manner at the Alhambra, from an album of watercolors assembled by the manufacturer Piat Lefebvre in Tournai. Musée des Arts Décoratifs, Paris.
The mid-19th-century revival of interest in things Islamic assumed a variety of forms and names.

247

the ban against foreign rugs, the incorporation of Tournai into the Netherlands, following the collapse of the Empire in 1815, caused a major reshuffling of the cards. Indeed, Bellanger, who now found it impossible to obtain products from the Piat Lefebvre factory, 'one of Europe's best in this genre' but, alas, located in Tournai, was compelled to work with the Aubusson subcontractors Roby, Desfarges, and Maingonnat. This gave rise to a veritable campaign of slander, accusing Bellanger and his suppliers of illegal importations from Tournai, probably in the hope of undermining their relationship with the Garde-meuble. What such fierce competition reveals is just how high the stakes were, for what the letter portrays is a dynamic industry in full mutation, an industry totally committed to innovation and diver-

248

249

THE INDUSTRIALIZATION OF PRODUCTION

Early in the 19th century, manufacturers began diversifying their production to include moquettes, hearth rugs, and linings, all of which contributed to the democratization of carpets. The result was intense competition within the industry, a sure sign of the importance and challenge of an expanding market.

sification. Thus, the *haut de game* (top of the line), namely the *tapis velouté* (pile carpet), which came primarily from Aubusson and Beauvais, should not make us overlook the *parents pauvres*, those 'poor relations' which took the form of moquettes, hearth rugs, jaspé carpets, linings, and carpet felt, all of which fueled the democratization of carpets. The list of French carpet manufacturers filing applications for patents during the first half of the 19th century attests to the inventiveness and vigor of the industry. Some of the entrepreneurs even proved worthy of the awards passed out at the various 'Exhibitions of French Industry'.

Industrial Exhibitions: A Mirror of Trends

Eleven industrial exhibitions or fairs[350] were held between 1798, with 110 exhibitors present, and 1849, which had 4,532 registered participants. The press covered the events, and official reports appeared, providing full evidence of the stylistic profusion now seen as the hallmark of the 19th century.

Thanks to the fairs and the detailed accounts of them, we can identify certain of the exhibited carpets. Now recovered from obscurity and indifference, they attest to the richness of the period, not only through the dexterity of the weavers but also through the diversity of

250. *A design from an album of engravings issued by the Chenavard factory. It represents a foot carpet woven for Comte A.I. Musée des Arts Décoratifs, Paris.*

251. *A design from an album of engravings issued by the Chenavard factory. This time, the piece was woven for the Dauphine of France (the Duchesse de Berry). Musée des Arts Décoratifs, Paris.*

250

251

THE MOQUETTE

From the beginning of the 19th century, the mechanical processes for weaving moquette were promoted: 'There is a kind of fabric called moquette[1]: it is a textile knotted on warps of linen or hemp, whose pile is in more or less mediocre wool. This material, with a unified ground whose small, uniformly distributed designs are woven on a drawloom, is used most often as a frame around floor rugs. . . .' An industrial offshoot of carpets, linked to the economic expansion of the 19th century, moquette nonetheless had its place, notably at Abbéville.[2]

1. BN, V 2733, III, p. 444, 'Description des Expositions des produits de l'industrie française (1824)', Bibliothèque de J.Viaux.
2. Louis Greux.

production made possible by the availability of designs from a great variety of sources.

The exhibition of 1839[351] displayed a remarkable 'extra-fine carpet, embellished with gold, silver, and silk, the middle with a peacock on a gold ground displaying birds, monkeys, flowers, and fruits, a double border on one of them with mauresque ornamentation on a white ground, the colors rich and extremely vivid.' We know nothing of what happened to the original piece, but several variants have survived, one of them in the collection of the Mobilier National (GMT 2111). The closest example seems to be the one sold at Sotheby's in New York on 21 May 1988. Wolves' heads appear among its decorative themes.

The Sallandrouze factory demonstrated its brilliance in a sumptuous carpet entitled 'Asia',[352] a work of around 1840-1843 (a gift of the Cino del Duca Foundation to the Louvre). 'Virgin Forest', a truly magisterial piece, emerged from the Sallandrouze looms for exhibition during the fair of 1844. At the same time, works more typical of the period also received places of honor, as in the case of the 'pile carpet with flowers and fruits, a rich border with coffers and gold ornaments'[353] acquired by King Louis-Philippe for the Mobilier National.

'The Virgin Forest'

This carpet, the jewel of the 1844 show, was presented *hors concours*, which made it ineligible for a prize, because the manufacturer, Charles Jean Sallandrouze de Lamornaix, was a member of the jury. Actually Sallandrouze exhibited two rugs, one of them destined for the Hôtel de Ville and the other, *Forêt Vierge*, which would eventually be purchased by the King of Prussia, Friedrich Wilhelm IV.[354]

On 4 May 1844, Louis-Philippe inaugurated the exhibition in the Grand Carré des Jeux on the Champs-Élysées. The great theme of the time was the application of art to industry 'as a means of social improvement', a movement whose principal theoretician was the architect-decorator Amédée Couder (1797-1864). Turning theory into practice, Couder virtually orchestrated the exhibition, for which he designed tapestries with titles such as 'Joan of Arc' and 'The Vision of Saint Hubert', as well as a bookcase, a dresser or sideboard, and patterns for European cashmeres and two carpets, these bought by Sallandrouze, one of which was 'Virgin Forest'.

Commenting on his drawing, Amédée Couder wrote: 'In preparing the design for "Virgin Forest", so marvelously executed by M. Ch. Sallandrouze Lamornaix [sic], the author thought that by placing a combat of terrible beasts at the center of luxuriant vegetation he would thereby add a powerful interest. The tiger, vanquished by the mortally torn lion, is about to fall; he tries to remain standing, while the claws of his clenched paw sink deep into the body of an immense boa constrictor; the latter rises up, emits a cry of acute pain, which, mingled with the dreadful roars of the two combatants, spreads terror. The birds and the peaceable creatures flee in every direction. A lynx, like all those who know how to profit from disaster, takes off in hot pursuit of a frightened gazelle. Only the owl and the vulture, like two witnesses to this duel, have remained impassive; but already the latter has begun to flap his wings joyously; he senses that he is about to devour a prey.' The project Couder actually had in mind would have been even more elaborate, but time was lacking, no doubt to the great

relief of Sallandrouze, for obvious reasons of cost and deadline. Moreover, the design lost nothing of its bounding enthusiasm once realized on the loom.[355] Note especially the skill with which the weavers translated the variety of botanical life, achieving the kind of quasi-encyclopedic perfection found on certain wallpapers, such as the 'Isola Bella' made by the Zuber factory (Rixheim). The period, with its obsessive eclecticism, was dominated by Amédée Couder, Louis de La Hamayde de Saint-Ange, and Aimé Chenavard, all three of whom worked for the Garde-meuble as well as for the Sallandrouze factory, as the exhibition of 1839 demonstrated.[356] Sallandrouze cultivated this variety, promoted the taste for exoticism and the hothouse, which would enjoy a long life, as witnessed by the Goncourts' description, twenty-eight years later, of the salon furnished by Princess Mathilde, the niece of Napoleon I: 'Brand new, the luxury of these salons, which date back only twenty years . . . which even then astonished Paris. With her somewhat barbarian taste, the Princess has seeded this hothouse, which encircles her mansion surrounded by the most beautiful exotic plants, with all sorts of furniture from every country, from every period, of every color, and every form. The place has the strange air of a display of bric-à-brac in a virgin forest.'

A TASTE FOR ECLECTICISM The exhibition of 1849[357] was also a celebration of eclecticism. 'Two carpets,' according to the report, 'are going to enhance the old and new reputation of their maker, Aubusson. One is a flatweave, which features a happy combination of designs borrowed from widely diverse schools: Arab fantasies, inspired by the Alhambra; artfully selected ornaments, like those in the loggia of Raphael; and a formal pattern, which takes us back to the age of Louis XIV. Mixed into all this is a profusion of gold, with an art which overcame all the inherent difficulties of handling this metal in weaving, and the colors of the wool have not suffered in the least from the proximity of gold, so vivid are their colors and so great is the illusionism of the pictures. The other carpet is pile-woven. Here the ornamentation, most of which dates back to the time of

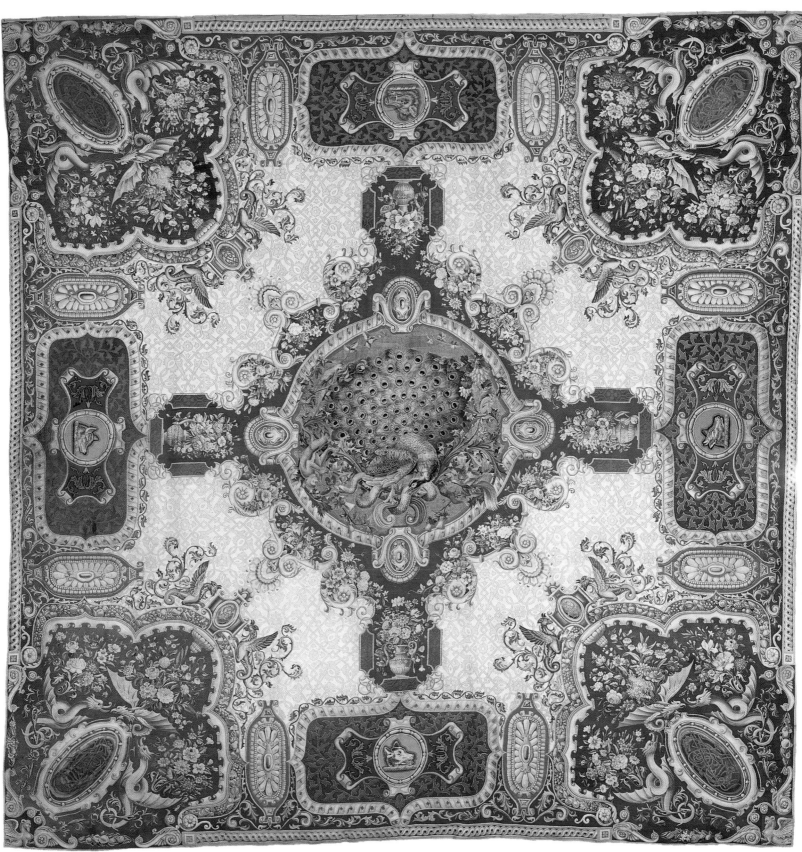

252

252. *Carpet with peacocks, one of several versions offered by the Aubusson firm of Sallandrouze de Lamornaix in 1839. Sold at Sotheby's in New York on 21 May 1988.*

Louis XIV, is enhanced by several details which recall the Renaissance.'

The report provides a good resumé of the tendencies within contemporary rug making, among which one may note the survival of Islamic influence, however watered down and degraded. The taste of the day, around 1866, can be seen to full effect in the apartments of the Duc de Morny at the Louvre, where the carpets have been copied from the originals.

SALLANDROUZE DE LAMORNAIX By the years 1742-1743, the Aubusson directors understood that quality of workmanship was nothing without good designs. Moreover, it was important that exports to Europe and America transit through the Paris market. Thus, Jean Sallandrouze installed his ateliers in the Hôtel de Trudaine, Rue des Vieilles-Audriettes, and in 1804 he formed a partnership with the rug maker Guillaume Rogier,[358] at 6 Rue de la Huchette. Rogier managed the ateliers at Aubusson and Felletin, while Sallandrouze ran the factory in Paris, where he made 'fine pile carpets' and handled the merchandise produced at Aubusson and Felletin. Given that Sallandrouze was responsible for the partnership's 'communication', it was decided that 'Sallandrouze' would be the only trade mark used in dealing with the Garde-meuble.

This arrangement must have proved satisfactory, since it was renewed in 1810,[359] when the Garde-meuble had become the company's principal client. Still, Sallandrouze continued to export a great deal and worked for prominent individuals, among them the Duchesse de Rohan, the Salaun brothers, the Duc de Bourbon, and the Duc de Valmy, as we know from the inventory taken after the death of Jean Sallandrouze.[360] Sensitive to the importance of an excellent architect-designer, Sallandrouze had also established a working relationship with the architect Louis de La Hamayde de Saint-Ange. Next, the company sought to diversify and began producing so-called 'economical' rugs aimed at a less exclusive clientele.

NEW ALLIANCES WITH OLD COMPETITORS In the same enterprising spirit, Charles Sallandrouze de Lamornaix took account of his competitors north of the English Channel (whose production was 90 percent greater than that of France) and quickly formed new alliances, particularly with the English. On 3 May 1856,[361] the 'Compagnie Anglo-Française des Manufactures d'Aubusson et Felletin' came into being, with headquarters at the Hôtel Montholon on the Boulevard Poissonnière.

From 1743 until 1865, Sallandrouze ran a faultless race, which unfortunately, and rather oddly, came to a halt after reverses forced the company to offer its various factories at auction, only for no sale to take place.

At the end of the century, stylistic diversity faded into pale copies of neo-Louis XIV and XV patterns. Designers like Dieterle, Jules Chebeaux, etc., gave birth to overloaded compositions intended to flatter the 'Saccards' and the 'César Birotteaux' of this world, a bourgeois world vividly portrayed in the novels Balzac and Zola.

A TRADITION RENEWED
Martine Mathias

The history of French carpets since 1850 offers a wealth of material for the curious and the serious alike. A few milestones and examples will perhaps help us comprehend how attitudes and life-styles have influenced the look and character of carpets. Depending on the civilization being considered, the rug has continued to function as a principal or an accessory element of the human habitation, but either way, it serves today, as always before, to make life a softer, warmer, and more sumptuous experience.

The carpet is a territory, one that can be traversed and moved about within. It has its frontiers, its laws, and its constraints, just as a country does. Once inside, we can read it rather like an open book filled with the aspirations and dreams of a society, and, in the 20th century, with those of the individual artist/creator.

253. *'The Virgin Forest', woven in the 'Savonnerie manner' by the Manufacture Sallandrouze de Lamornaix from a design by Amédée Coulder. Wool pile, 7.85 x 5.70 m. Exposition Française des Produits de l'Industrie, 1844.*

Breaking with the Past

The second half of the 19th century was a time of breaking free of the past. It ushered in the age of industrial manufacture on a large scale, much to the benefit of the public at large. Within the world of carpets, a major industry emerged, proud of itself, intoxicated with its technical innovations and its triumphs over difficulties well beyond the ability of previous generations to solve. At the same time, moreover, the period also brought even greater perfection in the handcrafted work of artisan weavers.

The Great Exhibition of 1851 in London inaugurated a long series of Universal Exhibitions or Worlds Fairs, sites of global encounter among the arts and technologies of the industrialized nations. The finest and most beautiful examples of manufactured goods were shown side by side with innovative productions.

The Rapid Ascent of Moquettes and Strip Carpeting

Five-frame moquette was the proud display of Flaissier, a rug manufacturer based in Nîmes. This achievement, eagerly adopted by the British, would soon be surpassed by strip carpeting fabricated on nine and even ten frames, which allowed mechanically woven rugs to be embellished with a great wealth of colors and patterns. The astonishing quality of the moquettes in the collections offered by Braquenié et Compagnie bears witness to this breakthrough. In 1851 the British even introduced a process whereby wool could be cut into segments and passed through holes in two plates for deposit on a bed of hot latex reinforced with canvas. The result was a cheap, mass-produced pile carpet whose support would become the foundation for most of today's industrially produced carpeting.

The Second Empire, which was a privileged time for textile manufacturing, saw a vast increase in the production of rugs, both piled and flatwoven. Many of these carpets, often of huge dimensions, have survived into our own time.

254

255

THE SUCCESS OF FLATWOVEN CARPETS The *tapis ras*, produced in great volume by Aubusson, has proved so successful that the name Aubusson is virtually synonymous with 'flatwoven carpet', even in the United States. This type of production actually required a reconversion of the loom – the traditional low-warp, or horizontal, loom, which until then had been used primarily to weave wall tapestries. It had to be adapted for warps and wefts heavy and strong enough to endure the wear and tear of service on the floor. This change, made in response to demand, allowed the Aubusson workshops – which had always remained private despite their collective honorific, Manufacture Royale and then Impéri-

256

The patterns of the former Bournaret atelier at Felletin or of Braquenié et Compagnie were the work of painters most often employed by the large manufacturers or of design studios in Paris. Enlarged, point by point, right in the factory, they became the cartoons which, placed directly behind the structural warps, allowed the carpets to be woven.

How could one not be struck with wonder before the superb garden patterns offered by Braquenié? Here was a theme drawn from deep within the tradition of Oriental carpets but completely reinvented within the context of a traditional *jardin à la française*.

THE CRISIS OF THE FRANCO-PRUSSIAN WAR
After 1870, a year that brought the Franco-Prussian War, the collapse of the Second Empire, and the deadly Commune, France's rug industry entered a period of crisis, remaining on the sidelines even as aesthetic renewal energized the whole of the decorative arts. What caused such inertia? Is it possible the French carpet fell victim to its own long success?

The attempts at stylistic renovation made by Antoine Jorrand at Croq et Jorrand, one of Aubusson's family manufactures, met with general indifference. Only on the eve of the

256. Garden carpet from the Second Empire period (1852-1870), issued by Braquenié et Compagnie. Here the old Persian Garden of Paradise theme is revived within the context of Western tradition. It reflects the period's bourgeois love of opulence and comfort with a touch of Anglophilia mixed in.

257. Detail of a Braquenié flatwoven carpet with intertwining grape leaves. Aubusson, c. 1867. Musée Départemental de la Tapisserie, Aubusson. Photo R. Godrant. The border of medallions ornamented with naturalistic fruit is beautifully conceived and executed.

254-255. Carpet maquette from the Bournaret factory. Felletin, late 19th century. Musée Départemental de la Tapisserie, Aubusson. The workshops of Aubusson and Felletin catered to the design studios of Paris, which in turn provided fresh patterns. Since the design was to be symmetrical, only the central part was worked out in full.

ale – to survive the economic crises that hit them from time to time.

In 1862, the weaving industry at Aubusson and neighboring Felletin employed some three thousand people, many of them engaged in the production of rugs. The Franco-Prussian War of 1870 brought this prosperity to an abrupt halt. The firm of Sallandrouze de Lamornaix, which had performed brilliantly throughout the century, went bankrupt.

THE TASTE FOR OPULENCE Now, after more than a century, it is possible to sort through the evidence – the mass of influences – and detect a true *zeitgeist*, a 'spirit of the time'. Prominent characteristics were a love of opulent décor and a taste for comfort with a touch of Anglophilia mixed in. Also symptomatic was great skill at reviving, revising, and recombining the decorative repertoire of past centuries and even those of ancient civilizations in a veritable maelstrom of stylistic eclecticism.

257

258

1914-1918 war did a new attitude towards carpet design finally begin to emerge.

The 20th century, with its wealth of sometimes contradictory tendencies, finally brought a fresh and successful concept – the 'artist rug'. What the artist now contributed, more than anything, was the stamp of his own personality, which the carpet would share with other areas of his creative activity, especially painting, and draw its legitimacy from this association. Here, at last, we find an early manifestation of the modern Western consciousness, in full rebellion against notions traditionally dominant in carpet design.

The great movements in 20th-century art would have a direct impact on carpets, thanks to designs prepared by painters and architects. Irish-born Eileen Gray (1878-1976), for example, brought her advanced modernist instincts to bear on the rugs she had woven in her own studio in the 1920s, thereby launching a style that remains astonishingly vital today. Louis Marcoussis, Fernand Léger, Pablo Picasso, Hans Arp, Henri Laurens, and Joan

Miró, were all solicited by Marie Cuttoli (1879-1973), the founder of Galerie Myrbor, the first Parisian gallery devoted primarily to the sale of artist-designed rugs. A major star of the gallery was Jean Lurçat, who, together with his collaborator Pierre Chareau, won fame as an artist specializing in tapestry and rug design. Sonia Delaunay (1885-1979) carried over into rugs the unique and distinctly modernist form language she had devised for her painting or indeed for her textiles.

Meanwhile, another approach continued along a parallel path, that of the decorator rug, which now became the designer rug. Here, the carpet was more clearly viewed as one element within a total ensemble created for a particular place and for a specific client, public or private. While this practice may seem relatively traditional, the results could also be quite innovative, as in the case of Maurice Dufrène (1876-1955), for twenty-five years artistic director of La Maîtrise at the Galeries Lafayettes. Equally creative was his rival, Paul Follot, who designed for Pomone at the Bon Marché department store.

Other ways of working could be found at the Atelier Martine, established in 1910 and named for the new-born daughter of Paul

Poiret, the celebrated couturier. As early as 1912 Atelier Martine organized a collective of young women who, under the workshop's leadership, proved enormously spontaneous in their cartoons for rugs.

In 1920, the famous and long-lived Compagnie des Arts Français brought together the talents of Louis Süe (1875-1968) and André Mare (1887-1932), a partnership subsequently joined by many other artists. Anonymity, however, cloaks the creations of DIM (Décoration Intérieure Moderne), behind which initials were several designers specializing in rugs.

In the work of Dufrène, Follot, Martine, Süe, Mare, the DIM group, et al., the carpet functioned as an integral part of a décor in which it was only one element among others, a conception generally embraced by decorators, whatever their aesthetic orientation. Needless to say, anonymity does not facilitate the task of historians or the few pioneers in this field of research.

The workshops of Aubusson went on issuing their well-crafted products, but, in reality, a large part of the new rugs came from a multitude of ateliers, some of them short-lived, which utilized the knotting technique but at locations now difficult to establish. However admirable the formal quality of their work, the execution frequently leaves something to be desired, which makes conservation difficult and compromises the rugs' durability.

Decorators had access to many different kinds of weaving service. Thus, Ruhlmann,

THE DECORATOR RUG

During the first decades of the 20th century, the art of the carpet flourished anew, thanks to the emergence of the 'decorator rug'. Here the great innovators were Maurice Dufrène of the Galeries Lafayettes and his rival Paul Follot at the Bon Marché, both of whom designed carpets to become one element within a total ensemble created for a particular place and for a specific client. The trend flourished until the outbreak of World War II.

259. A carpet design created by Leleu in 1939. Musée d'Art Moderne de la Ville de Paris. Photo Leleu archives. The house of Leleu, founded by Jules Leleu and staffed by his entire family, was an exemplary enterprise specializing in 'designer rugs'. Beginning in 1924, at the height of the Art Deco age, Leleu worked closely with the Brazilian painter Ivan da Silva Bruhns, an artist who was not only prolific but also versatile and dedicated to quality.

260. Pile carpet from the Atelier Martine. Musée des Arts Décoratifs, Paris. Named for the newborn daughter of the celebrated couturier Paul Poiret, Atelier Martine, as early 1912, organized a collective of young women who, under the workshop's aegis, produced numerous 'designer rug' cartoons marked by spontaneity and imagination.

259

260

Printz, Dominique, Chareau, the Adnets, and Follot responded to the needs of their clientele directly or by placing orders with outside suppliers. In this respect the house of Leleu, created by Jules Leleu and staffed by the whole of his family, is exemplary. Beginning in 1924, Leleu worked intimately with the Brazilian painter Ivan da Silva Bruhns (1881-1980), an artist who, not only for his fecundity but also for the quality and diversity of his production, must be counted among the most important figures in the whole of 20th-century French carpets.

The 'decorator' tendency prevailed until the period immediately after World War II, carrying with it the wall tapestry, which came in for a full-fledged revival. The Leleu firm and the Compagnie des Arts Français, taken over by the Adnet brothers, made tapestries a regular component of their ensembles.

Now, however, the renewal that bore the art of French tapestry to new heights, thanks in large part to the personality of Jean Lurçat, did not have a comparable effect on carpet making.

THE EIGHTIES REVIVAL Subsequently, and particularly in the 1980s, rugs would once again become a subject of interest, a development that appears to be gaining momentum, to the point where one might well ask just who has not created his own carpet, since those trying their hand at it include plastic surgeons, architects, and couturiers, as well as designers.

261

This craze has resulted in a number of reissues and many original designs. Unfortunately, traditional techniques have for the most part been replaced by *tufté*, an industrial process which yields the look of a knotted-pile carpet, at less cost, of course, but with nothing like the quality of fine Savonnerie. Herein lies the source of the numerous reissues, among them rugs purveyed by the Musée des Arts Décoratifs in Paris, as well as those of the Galerie Lucie Weill-Seligman, the latter based on carpets commissioned by Marie Cuttoli beginning in the late 1920s. In 1975, the Galerie Artcurial adopted a more imaginative policy, alternating reissues with original editions designed by Rougemont, Meurice, and François-Xavier Lalanne. Another program is that of Andrée Putnam who, in an outstanding series undertaken with Ecart International, has reissued rug designs created by Eileen Gray, works that remain aesthetically vital even today. Within this profusion of activity, we should also cite the Galerie Yves Gastou, which, in 1991, brought out an impressive collection of tufted carpets designed, most notably, by André Dubreuil, Olivier Gagnère, and Ettore Sottsas.

THE SAVONNERIE TODAY Even in this environment, a few initiatives have made it possible to sustain the Savonnerie, with all its sumptuousness and warmth. Many of the orders come from public agencies, enough anyway to keep the Savonnerie production at

262

263

261. *Flatwoven rug designed by the Swiss artist John Armleder. 1980s. Mobilier National, Paris. This rug, with its very particular palette, represents a homage to René Perrot (1912-1979), a painter-designer who contributed significantly to the revival of tapestry in the 20th century.*

262. *Tufté rug designed by Sonia Delaunay and issued by Artcurial. In 1975 the Galerie Artcurial adopted the imaginative policy of alternating reissues of old models with original editions based on designs by living artists.*

263. *Tufté rug designed by Olivier Gagnère. 1991. Manufactured by Tisca. Galerie Yves Gastou, Paris.*

264. *Pile carpet designed by Pierrette Bloch. 1979-1980. Woven by the Manufacture de Lodève. Mobilier National, Paris.*

the Manufactures Nationales busy working from cartoons by Geneviève Asse, François Bouillon, Pierre Buraglio, Pierrette Bloch, and Zao Wou-Ki. For its knotted-pile rugs, the Lodève ateliers have utilized designs by Étienne Hajdu and François-Xavier Lalanne. Aubusson, by virtue of its collaboration with contemporary art galleries, has issued a monochrome pattern by Oliver Mosset and a circular rug by Sarkis entitled *Les mains qui se chauffent* in which two hands come together, one warm and the other cold.

THE GRAPHIC PRECISION OF FLATWEAVES The *tapis ras*, whose flatwoven surface undoubtedly invites a more abstract and less sensual approach, has provided a new field of exploration. Favored by a few decorators in the 1930s (Arbus, Quinet, Leleu, etc.), the pileless rug has emerged quite spectacularly into its own since 1945, right along with the tapestry revival, even though the weaving technology remains the same. Because of the graphic precision it allows, this kind of floor covering provides contemporary designers with a totally different set of opportunities. Handwork, a basic necessity since the dawn of time, has become an activity of choice – a

shared labor in which the weaver plays an all-important role. No longer is he or she merely a pair of skilled though anonymous hands dedicated to a tradition but, rather, an interpreter who, at every step, serves and makes manifest the particular world of a creator. The relationship thus established is founded as much on reciprocal interrogation as much as it is on mutual trust.

Among the most recent creations is one from Aubusson, a rug designed by Sylvain Dubuisson, who has made subtle use of the braiding motif, with all its possibilities for a modulated intensity of color. From the Swiss artist John Armleder come two flatweaves, the first in a series of twelve meant for the Château d'Oiron. One of them is based rather freely on a 17th-century brown-ground Savonnerie and the other on the peculiar chromaticism of René Perrot (Pierre-Josse? dates?).

A new chapter in the history of the carpet now opens before us, but it will lead nowhere unless the savoir-faire so patiently acquired and still so alive can continue to engage and serve the interest of contemporary design. Should this occur, the rug, that territory of the nomad, will become the fertile field of our dreams.

264

AN EXPERT EYE CAST UPON FRENCH CARPETS

Buyer Beware

Elements of design help the expert evaluate a French carpet, but they alone can never be considered decisive. Ornament does not necessarily reflect the period in which the carpet was actually made. The rugs created for the Louvre Grande Galerie have been copied many times over the years, and similar patterns are being manufactured even today. Nor can pattern provide reliable proof that a rug was even made in France. The rug manufacturers of 17th-century Spain, of 18th-century England, and of present-day China have adopted and copied French designs and then gone on to inspire new ones. To distinguish between a collector's carpet from a purely decorative rug, one needs an educated eye and an appetite for research. Colors as well as do not necessarily constitute an index to what a carpet really is. The idea that a faded weaving is older than a piece with bright, sparkling colors flies in the face of experience. Such an argu-

ment must be sedulously resisted. Some carpets which have been rolled up and carefully stored for a long while have retained their original hues and emerged looking vivid and fresh. Others, of more recent date but exposed to both sun and moon, may look worn and relatively monochrome. Also to be considered are the chemical colorants and the artificial aging techniques used since the 19th century, all of which were designed to fool the eye.

Textures

Rugs are woven in three different qualities: the needlework or petit-point rug; the flat – or tapestry woven carpet (tapis ras) erroneously called 'Aubusson', and the knotted-pile carpet. The details of the techniques employed in making these types of rug are explored in Chapter 2. Two identical patterns may be woven by the same manfacturer using two different techniques, even at the Savonnerie. Further, most manufacturers offer pile carpets in three different qualities: superfine, fine, and 'current'. As a result, it is even difficult to identify one manufacturer with a given type of pile or a single quality of production.

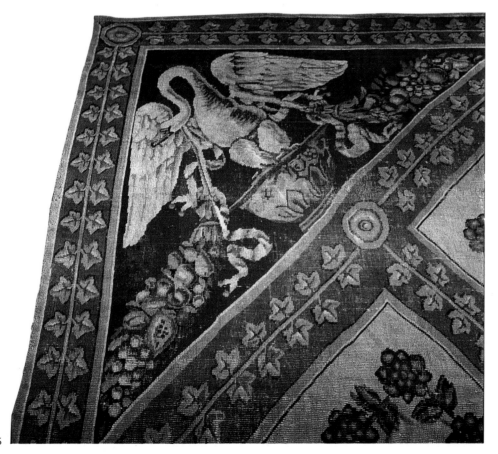

265

A Brief Repertoire of Ornament Period by Period

Le Style Louis XIII

The Louis XIII style is readily identifiable by its flowers, scattered in dense array or gathered in bouquets, sometimes embellished with ribbons or pompons, and its cartouches and arms on a black ground. The rare examples that survive are greatly prized by serious collectors.

Le Style Louis XIV

The carpets woven for the Louvre – for the Galerie d'Apollon and the Grande Galerie – constitute the supreme examples of the Louis XIV style and the decorative repertoire of the period: egg-and-dart border, large volutes or scrolling stems and acanthus leaves on a brown (black) ground, a central ornament, and a trompe-l'oeil motif at either end.

Le Style XV

The style evolved by Pierre Josse-Perrot contains everything associated with the Rococo manner in vogue during the reign of Louis XV. The decorative elements of the style are frequently those of the immediately preceding periods, but the colors are more vivid and the compositions more vivacious.

Le Style Louis XVI

A brown ground, wreaths of foliage and flowers, and the elegant charm of ribbons are among the main constants of the Louis XVI style, all of which were worked through many variations. The forms are generally purified and marked by a return to the antique.

The Early 19th Century

The return to the antique evolved into a major stylistic renovation. The carpet illustrated on the left is attributed to Louis de La Hamayde de Saint-Ange, the official designer of the Mobilier Impérial in 1810.

The Mid-19th Century

Eclecticism reigned at mid-century in the design of French carpets, with constant references to Louis XIV and Louis XV models, as well as to Persian models and even more exotic ones.

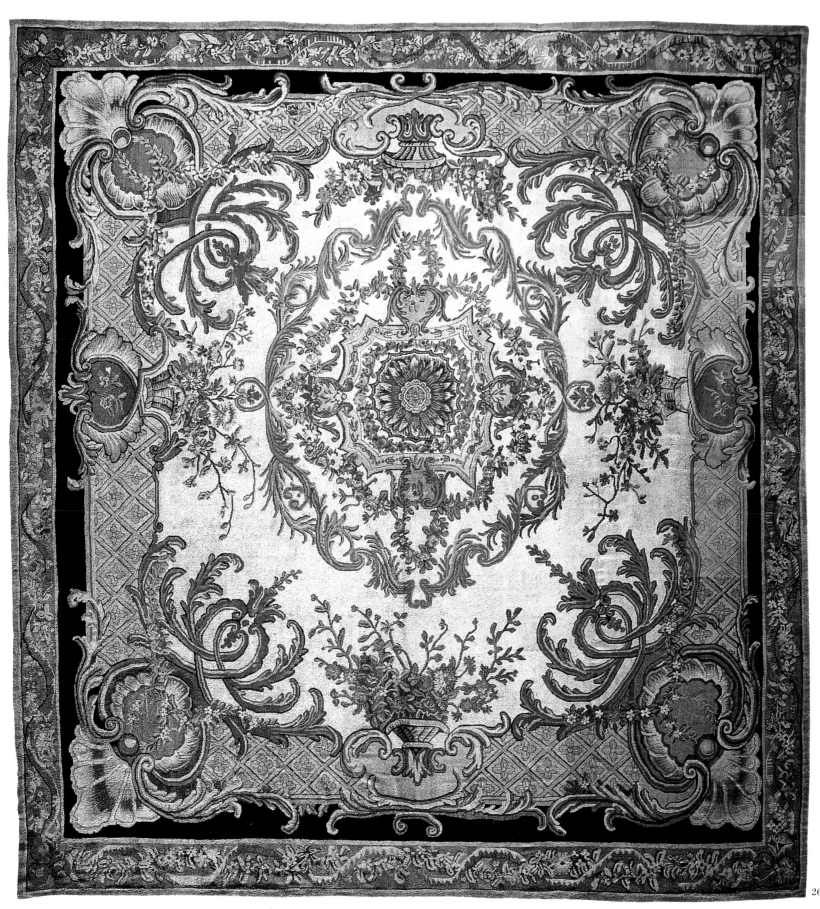

265. *Carpet with a swan design. Tournai, 1810. This magnificent carpet was woven by Piat Lefebvre from a cartoon attributed to Louis de La Hamayde de Saint-Ange.*

266. *Aubusson carpet woven with the Savonnerie knot. c. 1750. Private collection, Paris.*

266

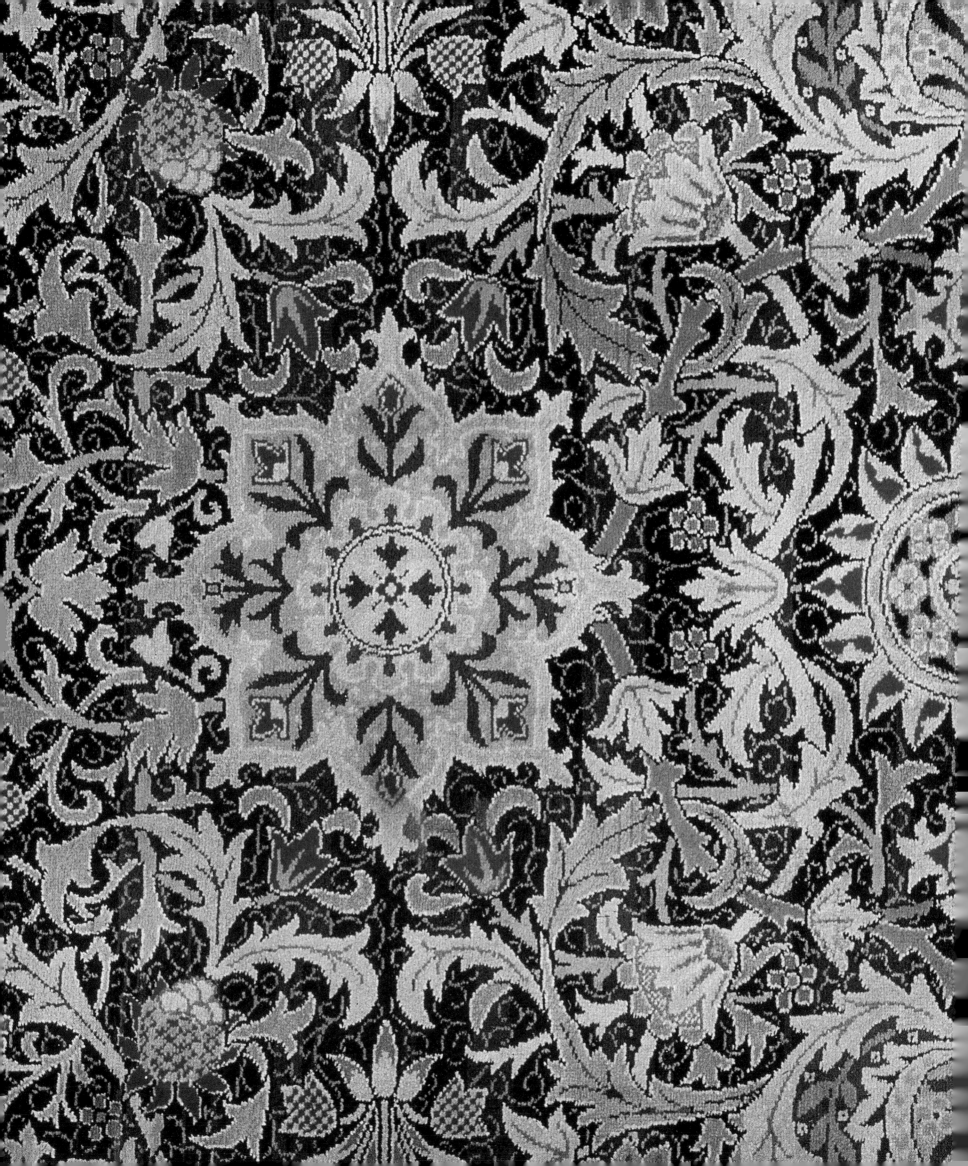

CHAPTER
IX

THE CARPET IN
GREAT BRITAIN

Clothilde Galea-Blanc

267. *Richard Sackville, third Earl of Dorset. Miniature by Isaac Oliver. 1616. For thousands of years, natural fibers such as rush, sisal, and coconut, have been used to make floor coverings. The ancient Egyptians, for example, wove bulrushes gathered along the banks of the Nile. From a site near the Sea of Tiberias in Palestine, there are mats whose wealth of Kufic inscriptions worked in gold and silver thread attest to the thriving nature of the mat-making craft in the 10th century. Examples are preserved at the Benaki Museum in Athens and the Metropolitan Museum in New York. In England and France especially, the custom of covering the entire floor of a room with carpets or mats made of rush would have a very long life. In this stunning little portrait of the Earl of Dorset, a grandee noted for his love of finery, the Ottoman carpet, in all its sparkling colors, lies directly on a wide mat of simple rush.*

Rug making in Great Britain is closely linked to the 'discovery' of Oriental carpets, to the spell they cast and the consequent desire to reproduce them.

Straw and Rush Matting

Unlike embroidery, pile knotting did not spring from native English traditions and folkways. Moreover, the carpet as a floor covering was unknown in medieval Britain, except in the rare church, where a rug might be laid before the altar on feast days. A document drawn up shortly before 922 acknowledges the gift, made by Egelric II, abbot of Croyland, of two woven 'rugs' ornamented with lions and meant for placement in front of the altar on holy days. Also cited are two smaller, floral-pattern rugs designed for use on the Feast of the Apostles. Until the mid-17th century, the floors in royal, aristocratic, or burgher houses – whether made of stone, tile, wooden planks, or beaten earth – were covered with layers of straw, rush, or various grasses and aromatic plants, which were renewed from time to time. In 1598 the German traveler Paul Hentzner wrote in *Travels in England* that the audience hall in the palace at Greenwich was littered with straw. Meanwhile, a contemporary engraving[362] depicts a pair of servants spreading armloads of straw over the floor in one of Queen Elizabeth's reception halls, a room otherwise sumptuously decorated with tapestries and wood paneling.

The braided mats common in France at the beginning of the 15th century[363] appear to have been unknown in England before the reign of Henry VIII (1509-1547), and only under James I (1603-1625) did they finally come into general use. Several English painters active during the late 16th and early 17th century portray members of distinguished families standing on mats made of small braided bands forming sophisticated geometric motifs. In these official portraits, it is interesting to note how precisely this bit of furnishing has been rendered.

Arrival of the First Carpets

The English, however, had come to know Oriental carpets during the Crusades, between 1096 and 1270. According to the chronicler Matthew Paris,[364] they admired but also mocked the rugs used at the wedding, in 1255, of the future Edward I and Eleanor of Castile. The Spanish ambassadors, in London to negotiate this alliance, had decorated their apartments with tapestries, silk wall hangings, and carpets. For the marriage ceremony carpets had also been spread over the streets and throughout the royal bride's lodgings at Westminster.

Exchanges with Turkey

Between 1511 and 1534, according to Richard Hakluyt, the English geographer and historian, ships out of London, trading with Sicily, Crete, Chios, Cyprus, Tripoli, and Syria, returned with cargoes of silk, wine, olive oil, cotton, and Turkish carpets.

In 1518, after long parleys with Venetian merchants, Cardinal Thomas Wolsey, Lord Chancellor under Henry VIII, received a shipment of eight 'Damascus' rugs and another shipment of some sixty pieces in 1520. These were undoubtedly Anatolian carpets similar to those depicted by Holbein in portraits of Henry VIII and his family. Yet, the inventory of the Cardinal's rich collections at Hampton Court mentions only four Oriental rugs and eleven pieces made locally, none of which has survived.

The peace and prosperity that came with the reign of Elizabeth I (1558-1603) were conducive to foreign trade, the consumption of luxury goods, and the establishment of manufactures. With some regularity, the Muscovy Company and the English Turkey Company (chartered in 1555) imported carpets from both Turkey and Persia. During the second half of the 17th century, the East India Company, chartered by Queen Elizabeth in 1601, brought in a great many rugs from Turkey, Persia, and Moghul India. These importations caused a major slump in Britain's own weaving industry, which, in response, dispatched a dyer named Morgan Hubblethorn to Persia in

QUEEN ELIZABETH

Queen Elizabeth, English school, around 1592. Hardwick Hall, Derbyshire.

In this official portrait, Elizabeth I is shown in all her magnificence. By surrounding herself with fine and precious textiles, the English Queen affirmed the economic and political power of her kingdom as well as her taste for pomp and luxury.

The diversity and splendor of the materials reveal the technical mastery of the English and Continental artisans of this period, as well as the sovereign's immoderate passion for finery. The inventory of her wardrobe, taken after her death, cites more than a thousand embroidered dresses.

Practiced by artisans since the Middle Ages, embroidery became, under the Tudors, a female occupation at every level of society. The Queen herself and Mary Stuart as well were dedicated embroiderers. The court dress worn by Elizabeth in the portrait seen here is ornamented with naturalistic motifs, the repertoire favoring roses and bulb flowers, in addition to monsters and animals from the fabulous bestiaries.

The lace collar and cuffs could have been made in French, Flemish, or English workshops.

An abundance of velvet woven in England or on the Continent is used for both clothes and furnishings. Dark velour serves for the Queen's mantle, embellished with precious stones and pearls like those Elizabeth lavished on her person from head to foot. The tapestry, the cushions, and the upholstery on the throne are of crimson velvet, a color signifying strength or power, and embroidered with gold and silver thread.

No carpet decorated with acanthus leaves and medallions in a manner similar to the one in the portrait appears to have survived.

1579 for the purpose of learning the art of rug making and to bring back a qualified worker. The mission seems to have been without consequence, since the Persian asymmetrical knot was never adopted in Britain.

Until the 17th century, Oriental carpets remained luxury items of almost incredible magnificence. Rare and precious, they were reserved for the King and persons in very high places. An imported knotted-pile rug could be found underfoot but also on a table, on a chest, or in Queen Elizabeth's audience hall, there spread over three beds of straw! According to historians, the passion for Oriental carpets developed in the wake of Cardinal Wolsey's grandiose example. From then on, the English could not rest until they had reproduced such marvels.

In England, carpets were made in two ways, by knotting and by needlework on canvas. Flatwoven rugs appear to have been produced in a manner unlike any other. As for table rugs, knotted or needleworked, their patterns differ from those of floor pieces. Organized laterally, the ornamentation most often consisted of scenes from the Bible and Ovid's *Metamorphoses*. A remarkable example is the Bedford carpet at the Victoria and Albert Museum, a work from around 1600. Deciding whether a piece was made for use underfoot or on a table can be tricky, since floor carpets frequently did service as table decoration. The needlepoint carpet seen here has sometimes been called a 'table rug' because of its design of roses and thistles. The table rug, as well as piled upholstery and cushion covers, will not be considered in this chapter.[365]

THE KNOTTED-PILE CARPET IN ENGLAND

The Oldest of the Preserved Rugs: 16th and 17th Centuries

A TECHNIQUE MASTERED BY 1570 From the outset, the English took the Anatolian carpet as their model, which meant symmetrical knots and geometric motifs. Throughout the development of English rug making, the symmetrical knot was used exclusively; the motifs, on the other hand, evolved quite rapidly, in step with

stylistic trends. The materials involved were hemp and linen for the foundation and wool for the pile. Woollen warps became more frequent beginning in the 18th century. Tradition holds that the workshops were located around London, at Ramsey, Barcheston, and, especially, Norwich, where Flemish weavers had settled as refugees from religious persecution. The inventory drawn up for the estate of Robert Dudley, Earl of Leicester, who died in 1588, cites a 'Turquoy carpett of Norwiche work', which allows us to suppose there had been one or more carpet looms in a city already known for its woollen textiles and its mats. No available source indicates the size of the English workshops or tells us about the artisans employed there. Could there have been factories as early as the mid-16th century, or was it simply a matter of domestic looms, or, more likely, small ateliers financed by members of the nobility? The artisans were probably weavers, three of whom wove or embroidered their initials on three carpets dating from 1585, all in the collection of the Duke of Buccleuch. Whatever the situation, technical mastery had been achieved by around 1570, as witnessed by the oldest known example of a knotted-pile carpet made in England.

Until the Industrial Revolution spearheaded by Great Britain, textiles played a major role in the art of living. During the reign of Elizabeth I they symbolized wealth, luxury, and refinement, serving as a primary element of decoration in the great London houses built along the Thames embankment, as well as on the gilded barges used for the river promenades which so delighted the Queen and her court. Fine materials figured prominently in the lavish celebrations or even in the everyday life evoked by Shakespeare's plays. Like Henry VIII, Elizabeth desired a setting capable of glorifying her sovereignty and power. Paradoxically, this monarch was not much given to playing the maecenus, which left the role to the aristocracy. Thus was born the tradition of the great lord as collector and protector of the arts, and it thrives to this day.

STYLISTIC TENDENCIES The earliest preserved carpets range in date from about 1570

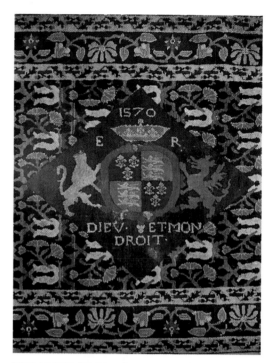
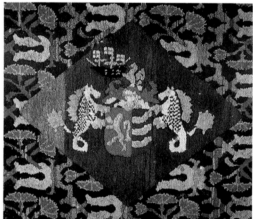
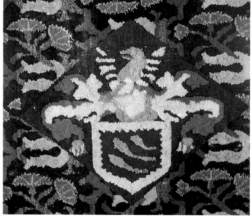

268

to 1603, meaning the reign of Elizabeth I, and divide along two stylistic lines. One conforms to the Ushak, Lotto, or Holbein type of Anatolian rug dominated by geometric forms; the other emulates Islamic iconography, especially Persian, while also drawing from the

Elizabethan floral repertoire. Armorial bearings, inscriptions, and dates reveal the great favor they enjoyed, as does the commemoration of such signal events as the dubbing of a knight, a wedding, or a royal visit. The colors are remarkable for their quality, the dyes still fresh and bright. In this period, green and blue-green appear to have been favorite ground hues. Although seldom used in Oriental carpets, these two colors do show up in certain Anatolian Ushaks and in Spanish rugs, among them the 16th-century pieces ornamented with foliage wreaths.

The oldest of the preserved rugs, dated to 1570, features a Persian-style arabesque pattern, pinks and tulips derived from Ottoman art, and Islamic palmettes, as well as oak leaves and woodbine, motifs more purely English and destined to remain in vogue until the end of the 19th century. The mixture of motifs from the decorative repertoires of both Islam and England endows this piece

with its originality, its specifically Elizabethan character. The colors are vivid and plentiful, with a tendency towards yellow and green for details, against a deep-blue ground.

DIVERSE SOURCES OF INSPIRATION Four rugs from the late 16th century, today owned by the Duke of Buccleuch, display patterns which clearly place them within the ornamental tradition of Anatolian carpets. Three of the pieces, two of them dated 1584 and 1585

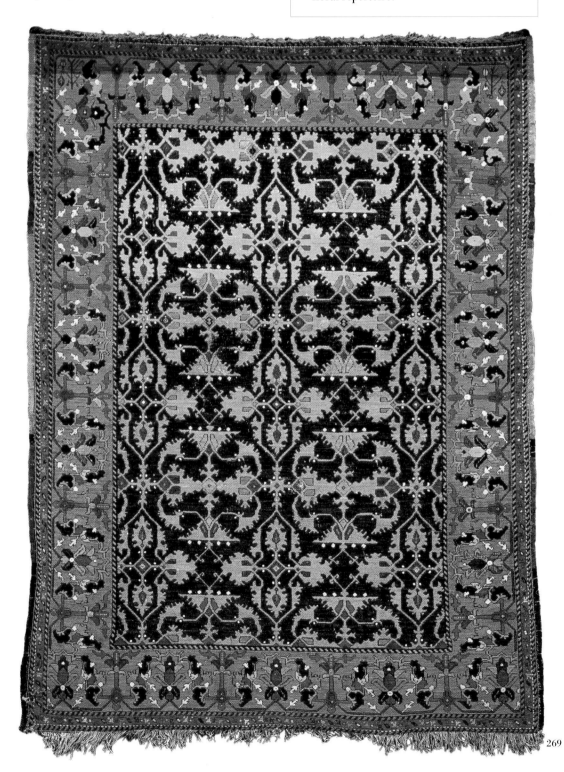

269

268. Armorial carpet. Great Britain, 1570. Wool pile, hemp warp and weft; 5.88 x 1.52 m. Collection the Earl of Verulam, Gorhambury, Hertfordshire. The central field is emblazoned with the royal arms, accompanied by the initials ER (Elizabeth Regina) and the date 1570 atop the motto 'Dieu et mon Droit'. On the right appear the arms of the Harbottle family and on the left those of the city of Ipswich. The oak leaf and honeysuckle motifs decorating the border were very much in vogue among the English throughout the centuries, showing up on everything from porcelain and wallpaper to textiles, such as the carpets designed by William Morris in the mid-19th century.

269. Ushak-type carpet. Great Britain, 1585. Wool pile, hemp warp, green silk weft; 2.82 x 1.78 m. Collection the Duke of Buccleuch, Boughton House, Northamptonshire. The Anatolian 'star-pattern Ushak' reappears on three carpets woven in England at the end of the 16th century for the Montagu family, ancestors of the present Duke of Buccleuch and Queensberry. The freshness and brilliance of the colors, as well as the fine state of preservation, are owing to the care with which the carpets have been maintained by an old family whose collections of paintings, furniture, silver, and rugs can only be termed fabulous. The work seen here is most remarkable for the fineness of its execution and the density of the pile (about 2,140 asymmetrical knots per square decimeter).

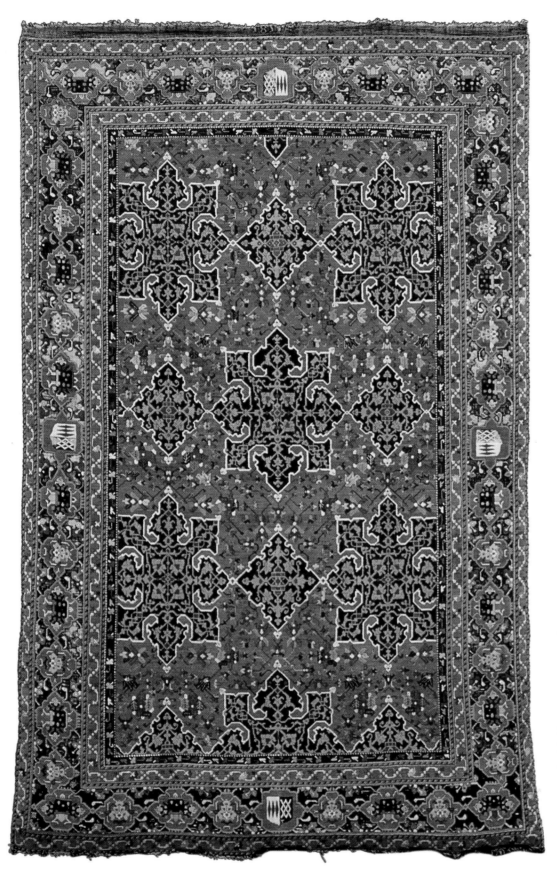

270

and emblazoned with the arms of Sir Edward Montagu, replicate the star-pattern Ushaks exactly, while the fourth adheres to the Lotto scheme. Their materials, according to C.E.C. Tattersall,[366] consist of hemp or linen for the warp, silk dyed blue or green for the weft, and wool for the pile. In their knotted carpets, English weavers used silk in an entirely exceptional manner.

These four examples were for many years thought to have been made in Anatolia, an attribution which is no longer tenable, given the presence in the rugs of hemp and linen, both typical of English craft, and the treatment of certain details, such as the elongated star motifs and the small oblique lines in the delicately patterned border. The place of manufacture remains a mystery, although some writers have suggested Antwerp, a city known in the 16th century for its Turkish-style pile carpets.[367]

English weavers also found inspiration in small-pattern Holbeins and in borders with pseudo-Kufic inscriptions. For the purposes of knotted and embroidered carpets, this iconography proved quite as successful in England as it did across the Channel. On a green-ground rug woven in 1603 the lateral frieze, with its inscription commemorating the dubbing of Sir Edward Apsley, and the geometric ornamentation of the field recall Spanish rugs of the 15th and 16th centuries. Here then is one more manifestation confirming the variety of sources exploited by English rug makers.

THE PURITAN REVOLUTION Following the Elizabethan era of initiative, rug weaving went into serious decline brought on by the cost of handcrafted goods, the difficulties of setting up workshops, and the increasingly abundant and regular imports from the Orient. Also unfavorable to domestic rug making were the political upheavals that rocked Great Britain throughout the 17th century. After the death of Queen Elizabeth in 1603 came the troubled reigns of the Stuarts from Scotland, James I (1603-1625) and Charles I (1625-1649), the civil war between the crown and Parliament, the Puritan Revolution, the execution of King Charles, and the Commonwealth and Protectorate under Oliver and Richard Cromwell.

RESTORATION AND RECONSTRUCTION The Restoration of 1660 returned the Stuarts to the throne, beginning with Charles II (1660-1685), but trouble erupted anew only three years after the accession of James II (1685-1688), banished by the Glorious Revolution in favor of William and Mary of Orange. Religious intolerance among Protestants, Catholics, Calvinists, and Puritans, the persecution of political adversaries, and the repressive policies against both the Scots and the Irish decimated the population and triggered substantial emigration to New England. Meanwhile, however, the wars between Holland and Spain over maritime and commercial supremacy ended in favor of Britain. Too, the devastation of London by plague in 1665 and then by fire in 1666 brought a need to reinvent and revive, creating an opportunity for both the fine and the decorative arts.

To reconstruct the capital, builders chose stone over wood and used it massively, for the great town houses which would replace the fortified redoubts of old. Architecture and design, flourishing early in the century, especially in the work of Inigo Jones, a disciple of Palladio, but then suppressed by the puritanical Cromwell, could once again come into their own and flourish. It was in the reconstruction period after the Great Fire of London that Christopher Wren (1632-1723) built Saint Paul's. In this talent-rich period, Sir Christopher could count among his contemporaries Henry Purcell (1659-1695), who developed English opera, John Dryden (1631-1700), the father of modern English prose, and Peter Lely (1618-1680) and Godfrey Kneller (1646-1723), worthy heirs to the tradition of courtly portraiture begun by Anthony Van Dyke during the reign of Charles I.

A CENTURY OF FEW CARPETS Seventeenth-century English carpets appear therefore to have been relatively rare, but nonetheless distinguished by a still nascent floral aesthetic, evincing a taste for naturalism, and by Elizabethan embroidery. Geometric motifs were no longer favored, and heraldry too was giving way. The new patterns consisted of volutes and arabesques along with a multitude of blooms, among them the pansy, the

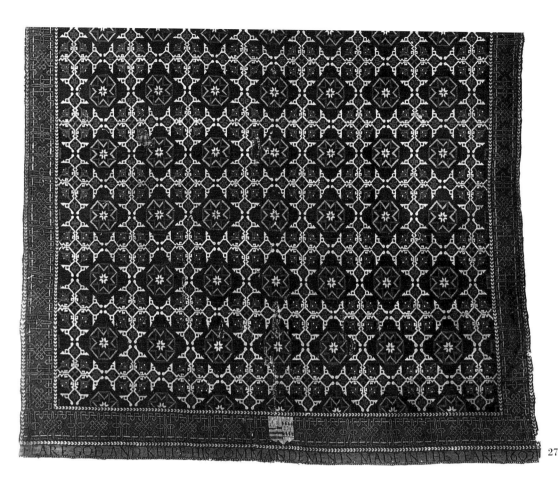

271

favorite flower of Queen Elizabeth, fruits, and sometimes even insects, as in the 'Huls carpet' and a piece displaying the arms of Mary Curzon. While the Orient continued to influence, as demonstrated by the 'Strathmore rug', with its rare Moghul ornament, at the Royal Museum of Scotland in Edinburgh, the 18th century was being announced in the organization of motifs and the black color used for the field in the floral carpet owned by the Sackvilles at Knole.

The 18th Century

CENTURY OF POWER AND PROSPERITY During the 18th century, England saw its power and prosperity grow at an extraordinary rate, especially in the military, naval, industrial, and commercial spheres. At the death of Queen Anne in 1714 the crown passed to the Hanoverian dynasty, beginning with the German-speaking George I (r. 1714-1727) and continuing with George II, whose long reign ended only in 1760. Under George III (r. 1760-1820) Great Britain wrested Canada from France in 1763 but lost the American

270. *Small-pattern Holbein type carpet. Great Britain, 1603. Wool pile, hemp warp, hemp or linen weft; 5.08 x 2.31 m. Victoria and Albert Museum, London This carpet was woven to commemorate the dubbing of Edward Apsley on 11 May 1603. Thus, in addition to the inscription 'Fear God and keepe his commandements made in the yeare 1603', the field sports the arms of Sir Edward Apsley of Thakeham, Sussex, and his wife Elizabeth Elmes of Lilford, Northamptonshire. These elements enhance the Anatolian ornament whose honeycombed, all-over geometry recalls Spanish rugs of the 15th and 16th centuries.*

271. *Lotto type carpet. Great Britain, late 16th century. Wool pile, hemp warp and weft; 1.55 x 1.34 m. Collection the Duke of Buccleuch, Boughton House, Northamptonshire. So accurately does this rug reflect the ornamental traditions of Anatolia that for many years it was thought to have been made in Turkey. This attribution is no longer tenable, however, given the hemp and linen used for the foundation and the treatment of certain details, such as the elongated star motifs and the small oblique lines in the delicately patterned border. Moreover, the stylized arabesque tracery in yellow, with its little 'eyes', appears on a bluish-green ground rather than on the red characteristic of Anatolian Lottos. The lotus flowers worked into the borders would have come from Persia by way of Turkey.*

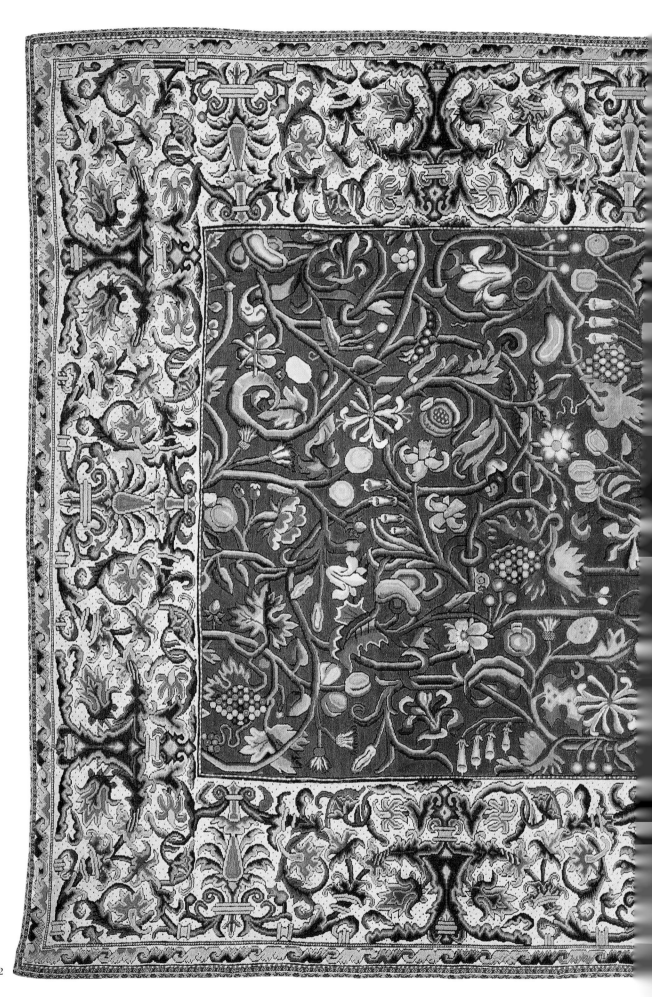

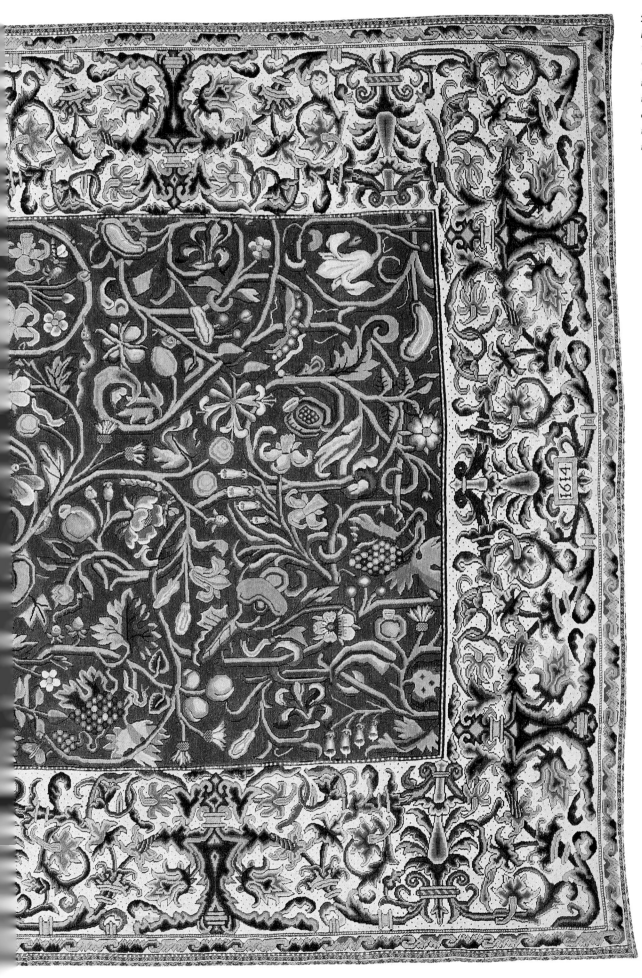

272. The 'Hulse carpet'. 1614. Wool pile, linen or hemp warp and weft; 3.49 x 2.52 m. Collection Sir Westrow Hulse, Breamore House, Hampshire. The luxuriance and variety of the floral ornament, the wealth of Renaissance motifs scrolling through the border, the brilliance and number (21) of the colors, the lustre of the wood, and the fineness of the execution combine to make this a unique and masterful piece of British weaving.

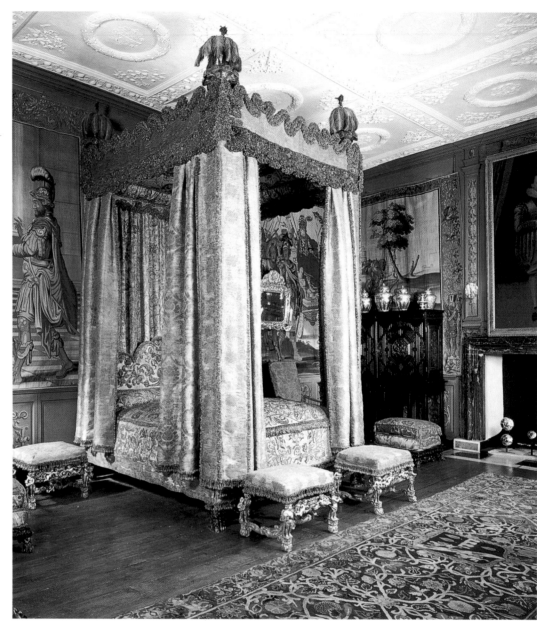

273. *Royal bedchamber, Knole Park, Kent. National Trust.*

274. *Carpet with the arms of Mary Curzon. Great Britain, early 17th century. Wool pile, hemp warp and weft; 5.15 x 3.05 m. Collection Lord Sackville, Knole Park, Kent. Mary Curzon married the fourth Earl of Dorset in 1612, and this carpet may have been woven at the time of her wedding.*

273

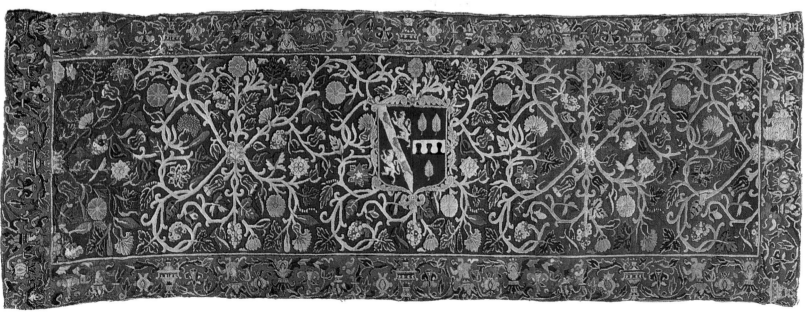

274

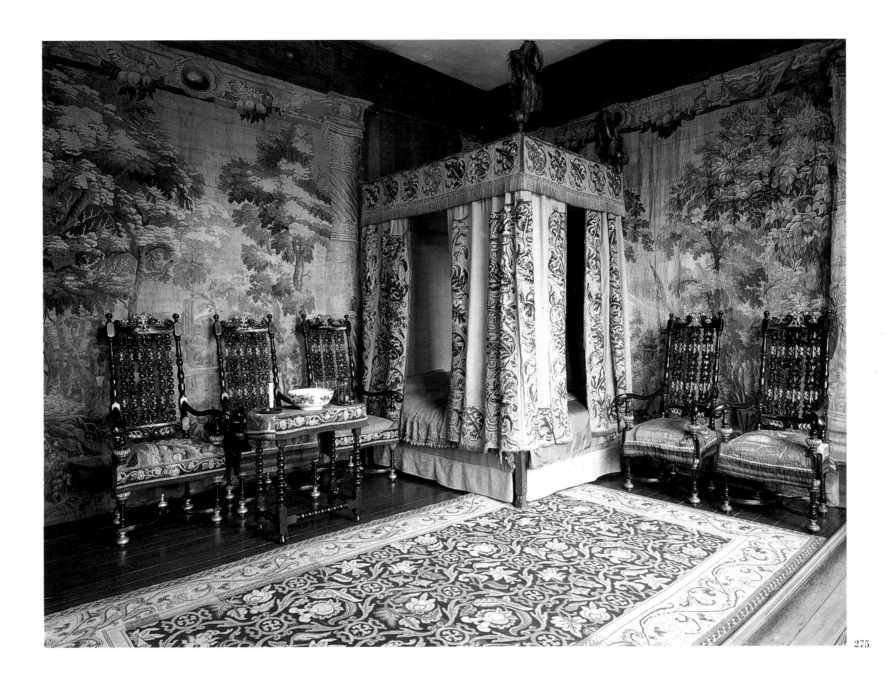

275

276

275. *Bedchamber of Lady Betty Germain at Knole Park, Kent. National Trust.*

276. *Carpet with a dark ground. Early 17th century. Wool pile, hemp warp and weft; 3.65 x 2.19 m. Collection Lord Sackville, Knole Park, Kent. During the 17th century, black was much favored as a background color in carpet design, a tendency equally prevalent in France.*

colonies in the Revolutionary War of 1775-1783. This was the era of the great composer George Frederick Handel, the writers Samuel Johnson, Alexander Pope, Horace Walpole, Henry Fielding, and James Macpherson (*The Works of Ossian*), the architects John Wood the Elder, John Wood the Younger, William Kent, James Paine, James Wyatt, and Robert Adam, the painters William Hogarth, Joshua Reynolds, and Thomas Gainsborough, and the cabinetmakers Thomas Chippendale, Matthias Lock, J. Linnell, George Heppelwhite, and Thomas Sheraton.

ACTIVE PATRONAGE OF THE ARTS The aristocracy and the wealthy middleclass alike cultivated the arts, especially portraiture, in which they delighted to see an affirmation of their breeding and refinement. Country houses were often built with galleries for displaying spectacular collections of fine paintings and precious objects. These mansions, often Palladian, stood surrounded by a great park designed in the 'picturesque' manner, as if nature followed the landscape art of Claude Lorrain and Nicolas Poussin, an impeccably 'wild', romantic scene studded

with sham Gothic or Classical ruins and exotic 'follies' such as pagodas. Overall, the style of 18th-century England has long been called 'Georgian', despite the general indifference to culture of the first two Georges, the second of whom declared in his German-accented English: 'I hate bainting and boetry, neither one nor the other did any good.'

In matters of dress and stylistic trends, the English overcame their rivalries with France to follow the latter as it evolved from the Rococo to Neoclassicism. Moreover, it was during the 18th century that the design of carpets took a definitive turn, this time in keeping with developments in furniture design and interior decoration.

THE HUGUENOT FACTOR English carpet manufacture, following the slump in the 17th century, benefitted enormously from the arrival of Huguenot artisans from Aubusson and the Savonnerie, fleeing France after Louis XIV revoked the Edict of Nantes in 1685. In this very year some of the refugees gathered at Wilton and began operating under royal protection. Around 1735 a workshop was set up at Kidderminster near Birmingham, but its

carpets are rare and little known. The first real successes came from the looms of the Lorraine-born Peter (Pierre) Parisot,[368] who, in association with two former workers from the Savonnerie and with the aid of the Duke of Cumberland, established a rug-making atelier at Paddington in 1751. The first pieces, finished during the same year, won immediate admiration from the British nobility, among them not only the maecenus Duke of Cumberland but also the Princess of Wales. Orders poured in, and by 1753 the manufacture had a hundred workers on its payroll. Two years later, however, the operation came to a halt, owing to the financial disarray of Parisot, who fled England to escape his creditors.

The venture, albeit brief, stimulated interest in the craft, as did the competitions announced by the Society for the Encouragement of the Arts, Manufactures, and Commerce, which, in 1756, began offering 'premiums' to the best weavers of knotted-pile carpets. It was in this context, therefore, that England's most reputable carpet makers came to the fore, despite manifold difficulties, some failures, changes of ownership, and, finally, the mechanizations of the 19th century.

THREE LEADING CARPET WEAVERS The story of important rug making in 18th. century. England is best told through the careers of three remarkable entrepeneurs, who produced most of the scotted-pile carpet:

278. *Carpet with a mosaic pattern. Exeter, c. 1760. Wool pile, wool warp, linen weft; 4.70 x 4.15 m. Henry Francis du Pont Winthertur Museum, Delaware. Mosaic patterns were very popular during the second half of the 18th century.*

279. *Carpet with a floral pattern. Exeter, c. 1760. Wool pile, wool warp, linen weft; 6.52 x 4.60 m. Henry Francis du Pont Winthertur Museum, Delaware. Exuberant displays of peacocks and flowers were very much to the taste of Victorian England.*

277. *Carpet with a small dog. Exeter, 1757. Wool pile, warp, and weft; 4.54 x 3.66 m. Victoria and Albert Museum, London. The charm of this pattern, woven by Passavant, springs from its mixture of the picturesque and the classical, as in the puppy dozing on a cushion at the center of a conventional setting.*

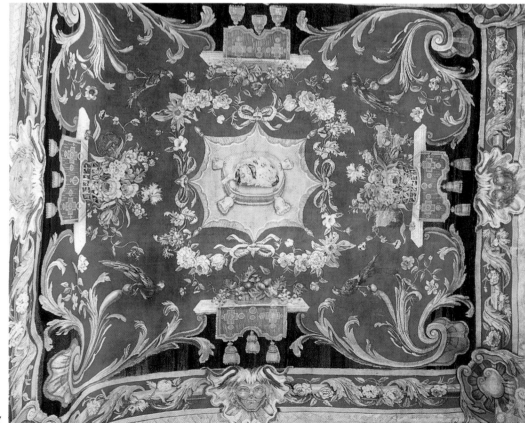

277

THREE MANUFACTURERS

In 18th-century England most of the knotted-pile carpets came from three manufacturers:
- Claude Passavant, a Swiss, who set up shop in Fulham near London but also in Exeter (Devon), where he remained until 1761.
- Thomas Witty, in 1755, founded Axminster, now a legendary label.
- Thomas Moore, who established his workshop at Moorfields before 1757.

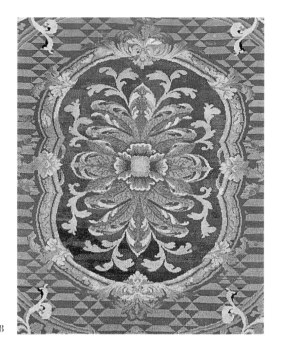

278

- In 1756, Claude Passavant (d. 1776), a Swiss weaver, bought the remains of Parisot's enterprise in Fulham, a village just south of London, as well as in Exeter (Devon), where, beginning in 1755, he continued the carpet operation until it went bankrupt in May 1761. Some of the carpets are marked EXON and dated along the edge. Passavant enjoyed a high reputation for his mastery of the dyeing process.
- In 1755 Thomas Whitty, thrice awarded by the Society for the Encouragement of the Arts, Manufactures, and Commerce, founded Axminster, one of the most legendary names associated with British carpets. This prestigious firm wove rugs in various styles, Savonnerie and Aubusson, Neoclassical, Egyptian and Chinese, Oriental, none of them identified as Axminster. The atelier closed in 1835, at which time its looms were bought by the Wilton factory, known until then for machine-made 'strip' carpeting.
- Last in chronological order was Thomas Moore (c. 1700-1788), who established a workshop before 1757 at Moorfields on the eastern edge of London. Moore produced mainly for Robert Adam (1728-1792) and his two brothers John and James, architects and designers noted for the Neoclassical style which bears their name. The Moore establishment ceased to operate in 1795, shortly after the death of Robert Adam.

THE PREDOMINANCE OF FRENCH TASTE During the 18th century, French taste predominated in England just as it did throughout Europe, and it remained a powerful influence in the 19th century, albeit in combination with

local stylistic trends and copies of Oriental rugs. The cartoons created after the middle of the century revived or continued many decorative elements found in the Savonnerie carpets made for Louis XIV, such as acanthus leaves and volutes, solar masks, combinations of purely decorative motifs and flowers, beasts, or naturalistic scenes, all set against dark-brown or black grounds. Also favored was the Rococo fashionable under Louis XV, complete with its suavely vivacious curves and countercurves, its ribbons and bows, and its softer colors, a style that embraced such arts of living as dress, furniture, and silverware.

The materials used in English carpets varied. From around 1750 to approximately

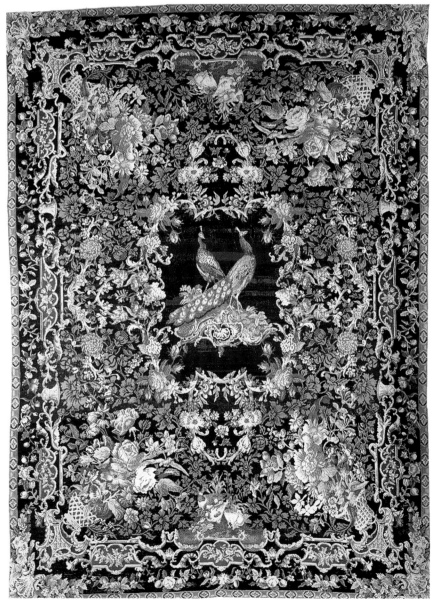

279

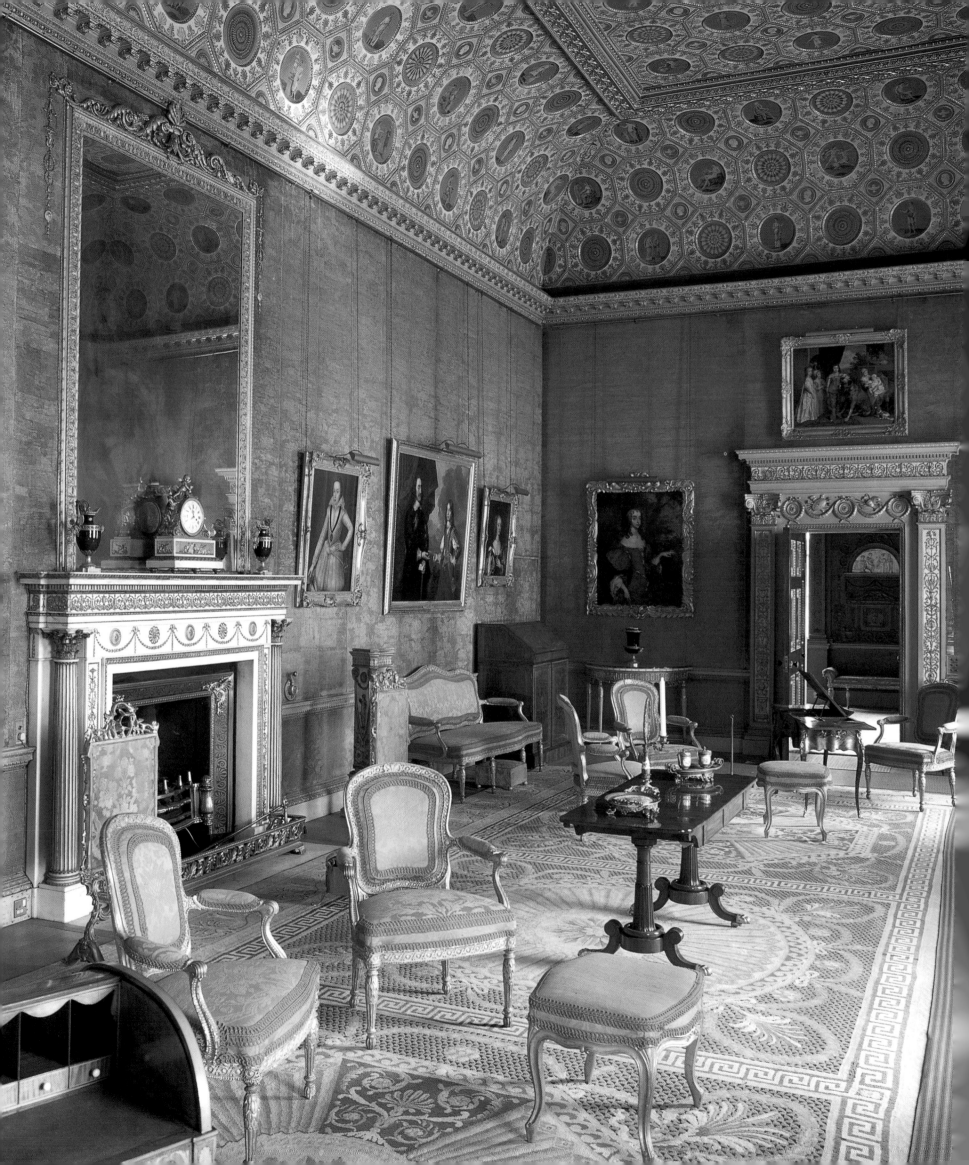

THE POWER OF FRENCH TASTE

In 18th-century England, French taste prevailed just as it did elsewhere in Europe, reflected in such decorative schemes as:
- acanthus leaves and volutes, solar masks, and combinations of purely ornamental motifs and flowers, beasts, etc., against dark grounds, all in the Louis XIV manner.
- the playful curves, and countercurves, the ribbons and bows, and the softer colors characteristic of the Louis XV style.

1770, rugs appear to have been made exclusively of wool. Later, wool was reserved mainly for the pile, the warp and weft being fashioned of linen or hemp or a mixture of both. Cotton would make its appearance very soon thereafter.

The carpet woven by Passavant in 1757 reveals its indebtedness to French precedent, the source of the masks, the decorative corner motifs, the acorn-embellished fabrics, the large acanthus leaves, the bows, and the garlands of flowers. The presence of a puppy offers the charm of a remarkably English feature within a formal French setting. This trait would re-emerge in the hybrid ornamentation of a carpet woven around 1790 for the throne room at Carlton House,[369] the residence of the Prince of Wales (the future Prince Regent before he received the crown as George IV), in which the Classical pattern of the field and the Pompeian theme of the border are interrupted by medal-

280. Robert Adam (1728-1792). Red Drawing Room, Syon House, Middlesex. A true and original form-fixer, Robert Adam could be said to have invented interior decoration in Great Britain, given that he designed for the complete ensemble, achitecture and furnishings alike. His taste was Neoclassical and refined in the extreme, running to harmonious combinations of pale, almost tone-on-tone colors, delicate relief work, discreet elaborations in the antique manner, and vast expanses of flat color, punctuated by stuccoes and statuary. To assure the perfection of the whole, he designed carpet cartoons and had them executed by Thomas Moore.

281. Carpet from the drawing room at Bridwell House, Devonshire. Wilton, 1780-1792. Wool pile, wool warp, hemp weft; 6.10 x 4.42. Private collection. This carpet was made for Richard Hall Clarke and his wife Mary Were, whose country house at Bridwell, Devon, was built between 1776 and 1780. Mary Were was celebrated both for her beauty and her fortune. The carpet, in form,

theme, and color, was woven precisely to order. Thus, the pale yellow of the border sets off the cerise of the field, while also echoing the light color of the surrounding parquet. Moreover, the pattern as a whole is carefully coordinated with the décor of the room itself, especially the large floral arabesques on the ceiling, elements very typical of the Neoclassical style invented by Robert Adam.

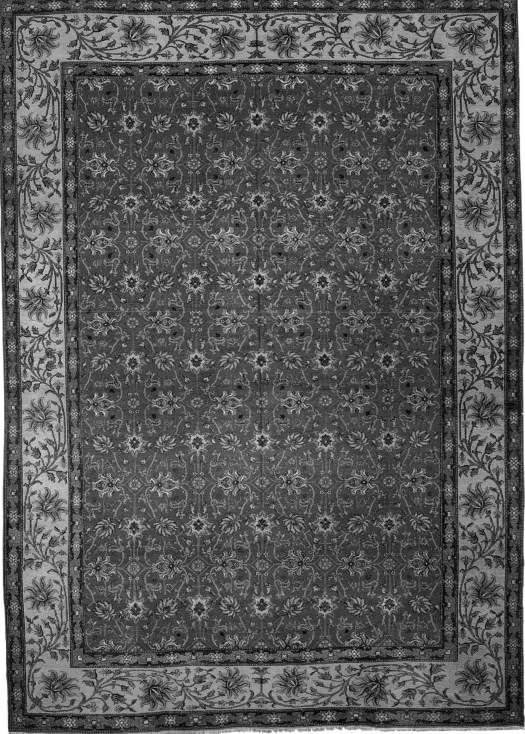

lions and cartouches framing naturalistic and animal scenes and decorative architectural elements. An Exeter carpet, woven by Passavant from a French pattern and preserved at Clandon Park (Surrey), evinces the period taste for birds. Cocks and pheasants, caught up in flowering garlands, surround a central medallion radiant with a stylized sun.

Classical compositions and motifs characterize more than one carpet made in this period. Two examples from the Exeter works, one dated 1758 and now in the collection of Lord Leconfield,[370] and the other from around 1760 and preserved at the Winterthur Museum in Delaware, make the case in point. However, something quite different is found in a piece from the 1760-1780 period, probably woven by Axminster, using a pattern of floral profusion encircling a pair of peacocks. The colors, numerous and vibrant, contribute to the overall exuberance of the design, while the peacock motif seems a preview of the Victorian taste to come. The 19th century appears announced as well in the stylistic eclecticism of certain works. A carpet in a private collection has its ancestry in Oriental rugs, which is now mixed, however, with themes from various other sources: 17th-century Indo-Persian rugs for the field and 18th-century Chinese enamels for the attenuated flower stem gracefully meandering through the border. The piece was woven by Wilton, which in 1835 had acquired the looms at Axminster after this firm went broke.

The Neoclassical style attained the height of fashion during the years 1760-1780, thanks largely to Robert Adam and his brothers. The carpets are distinguished by simplicity, geometric figures, floral imagery, Greek-key friezes, antique ornaments, and finely wrought, pastel-colored motifs silhouetted against large expanses of pale color.

NEOCLASSICISM The Neoclassical style, introduced in Great Britain by the architect James Stuart (Spencer House, London), attained the height of fashion during the years 1760-1780, especially in the realm of furniture and furnishings as well as in the interiors and architecture created by Robert Adam and his

282. Carpet in the Neoclassical manner of Robert Adam. Axminster or Moorfields, 1780-1790. Wool pile, warp, and weft; 4.78 x 4.50 m. Private collection. Four similar rugs have survived, two with a beige ground (Victoria and Albert Museum, and the 'Stradbroke' carpet formerly in a collection by the same name) and two with a blue ground (Metropolitan Museum and the Philadelphia Museum, the latter originally at Lansdowne House). The version seen here has lost its border, a fate suffered by many fine English and French carpets whose owners had them cut down to fit into smaller rooms. The delicacy of the design, especially the floral basket motif, is enhanced by the vast field of solid background color, in this case a matchless blue.

283. Drawing room from Lansdowne House, reassembled at the Philadelphia Museum of Art (gift of the Lorimer family in memory of George Horace Lorimer). Lansdowne House was built in London in the early 1760s by Robert Adam (1728-1792), initially for the Earl of Bute and then for William Fitzmaurice, the Earl of Shelburne and Marquis of Lansdowne. When the mansion was pulled down in 1929, the Philadelphia Museum and the Metropolitan Museum in New York acquired, respectively, the drawing room and the dining room. Originally, a carpet designed by Adam in 1769 figured among the furnishings of the drawing room, but it has now been replaced with a work conceived in the Adamesque manner.

282

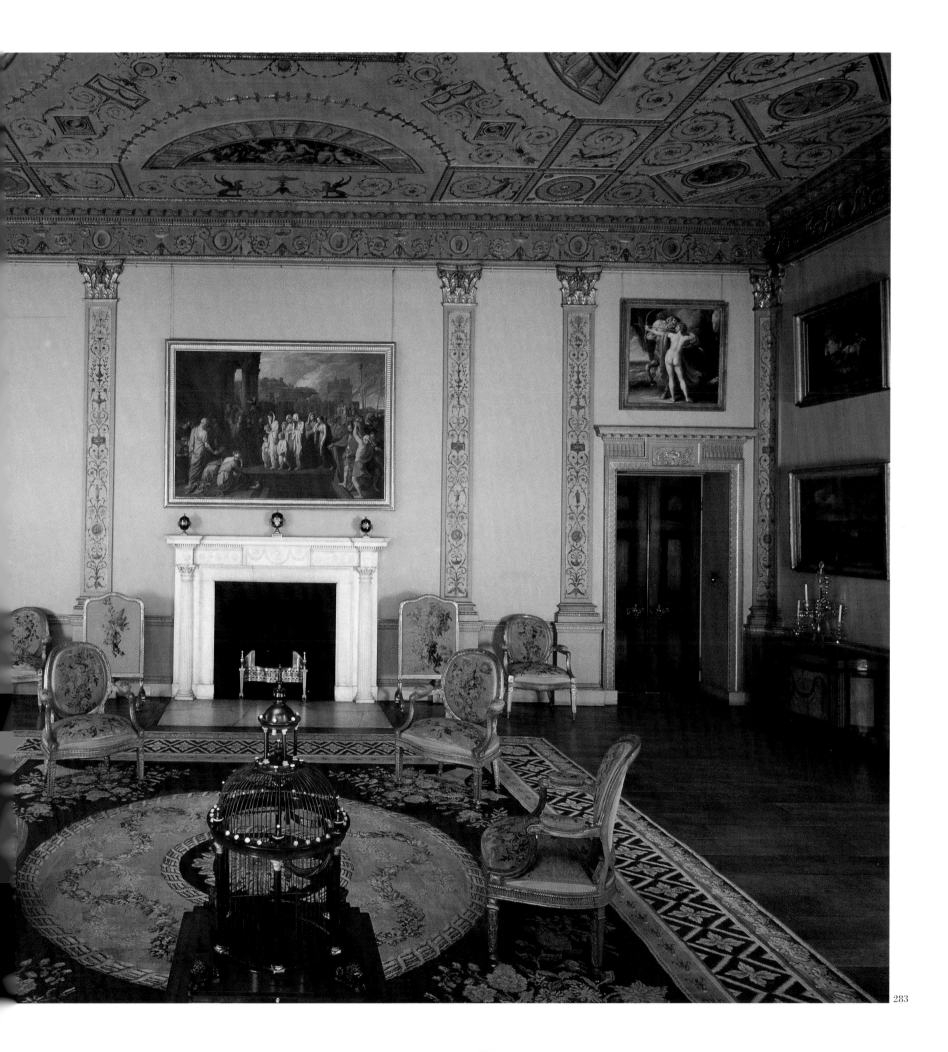

284

284. Axminster carpet. c. 1825. Wool pile, linen warp and weft; 8.55 x 4.52 m. Private collection. Even though French taste prevailed in the early 19th century, it did not altogether supplant the English appetite for things Oriental, particularly when it came to private commissions for carpets. Witness the rug seen here, with its rosettes, acanthus leaves, and cross motifs, all borrowed from the Persian repertoire. The originality of such carpets lies in the Western interpretation of the imagery and the choice of colors, the orangey-red background being typical of Axminster production at the end of the Regency period and the reign of George IV (1820-1830).

285-286. Detail and overall view of a British-made carpet. Mid-19th century. Wool pile, linen warp, linen and hemp weft; 3.22 x 2.19 m. Private collection, Paris.

brothers. Like the Rococo, Neoclassicism emerged in France, in 1757-1760, before it appeared in England and then spread throughout Europe. The source of inspiration was Italy, where the villas of Herculaneum and Pompeii had been discovered in 1738 and 1748, revealing the domestic side of Greco-Roman Classicism for the first time in archaeology. Bedazzled lovers and connois-

seurs of art saw the villas and their frescoed interiors as models for a whole new direction in all the visual arts.

The carpets are distinguished by the simplicity of their composition, formed of geometric figures, floral imagery, and Etruscan or Pompeian ornaments, Greek-key friezes and motifs taken from coffered ceilings and mural paintings. The finely wrought, pastel-colored ornaments are silhouetted against large expanses of solid, often pale color. Conceived as part of the overall architectural décor of vast country houses built for rich aristocrats passionate about art, these carpets echoed the ornamental program carried throughout the ceilings, the stuccoes, the exquisitely detailed wall paintings, and the furniture. England was an eager and sophisticated participant in the Neoclassical movement, as demonstrated in the two photographs seen opposite.

19th and 20th Centuries

AN ERA OF WEALTH AND STABILITY The 19th century, which opened with the Napoleonic wars and the defeat of Napoleon by Great

Britain at the Battle of Waterloo (1815), was nonetheless shaped mainly by the political stability and economic power of the long reign of Queen Victoria (1837-1901), who was also Empress of India, beginning in 1876. The Industrial Revolution had given birth to new social classes, the proletariat and the commercial bourgeoisie. It also ushered in trade unionism and mounting demands for political and social justice, for, among others, overworked women and children, whose wretched condition was described to such dramatic effect by Charles Dickens. Romanticism triumphed in literature, especially in the poetry of Wordsworth, Coleridge, Byron, Shelley, and Keats and in the novels of Walter Scott and both Emily and Charlotte Brontë. Later came the Pre-Raphaelitism of Dante Gabriel Rossetti and William Morris, the social idealism of George Eliot, and the rationalism of William Makepeace Thackeray. At the high tide of the Victorian era, eclecticism took possession of all the decorative arts, with a new style introduced and promoted every fifteen years.

During the first half of the 19th century, hand-knotted rugs were made primarily by

285

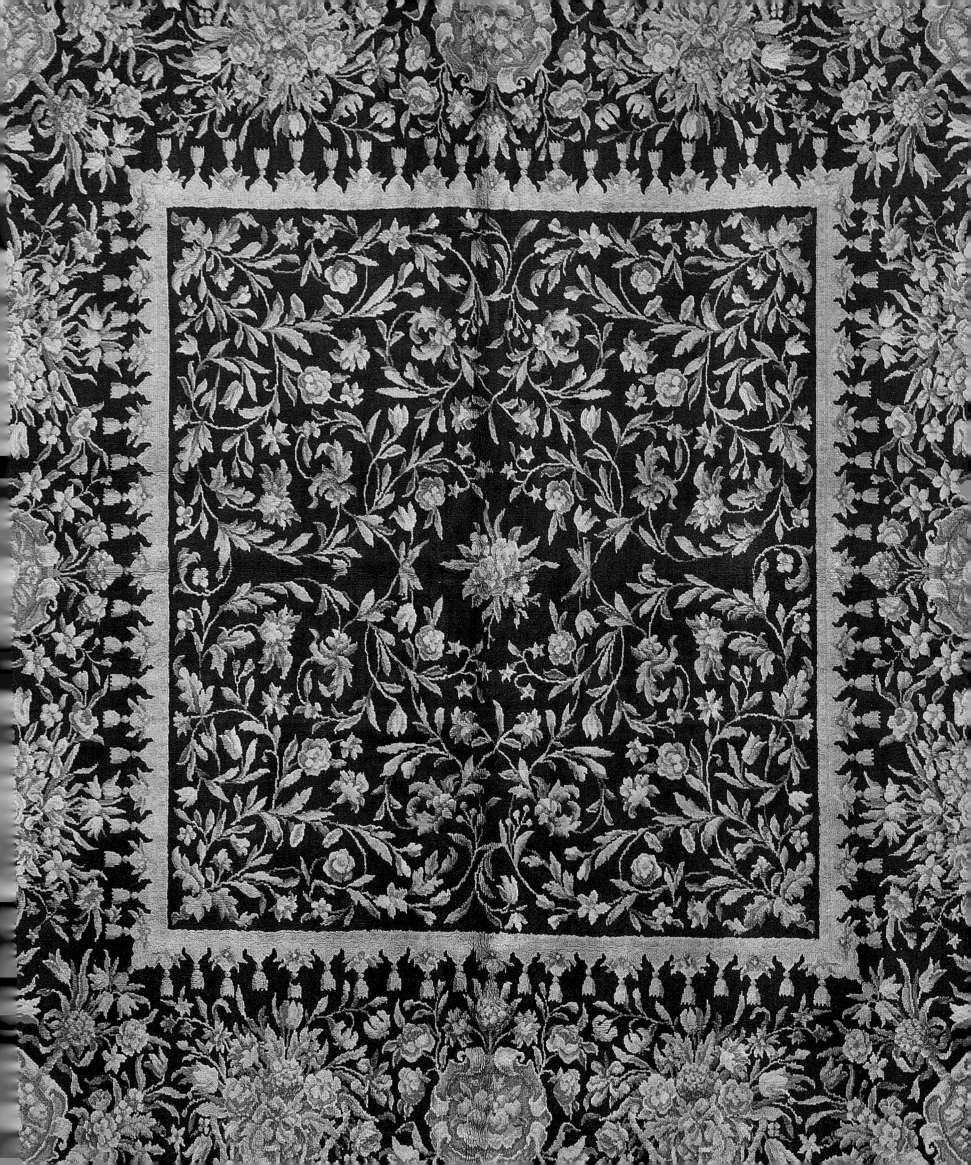

287

the Axminster and Wilton factories. The latter used mechanical technology for most of its production, although, after acquiring the looms of bankrupt Axminster in 1835, it also produced hand-woven carpets. Handcraftsmanship was already at risk from technological innovation, beginning in the late 18th century. The greatest threats were the Jacquard loom, first used for rugs around 1820, and the steam-powered loom. New methods, such as Brussels low-pile strip carpeting (moquette), Axminster chenille (1839), and the Axminster Spool and Gripper looms (around 1870), expanded the possibilities for velvet upholstery and fitted carpeting, giving

287-288. Modern Lotto type carpet. Great Britain, c. 1840-1850. Wool pile, linen warp and weft; 7.10 x 5.33 m. Private collection, Paris. The red field evokes the dense patterns of the old Anatolian carpets, especially the cruciform motifs of the Lottos. Also recalled are the first knotted-pile carpets woven in England, such as the Gifford rug, from the mid-16th century, and the Apsley carpet of 1603. The field, with its all-over pattern, which stems from Islamic art, and its various shades of red, stands in marked contrast to the luxuriance of the border. This is ornamented with a lavish floral garland meandering across a cream ground, an arrangement similar to that on a carpet woven c. 1845 by Wilton for Trafalgar House.

rise to more and more industrial factories dedicated to making rugs and moquettes. Machine-made rugs and strip carpeting, generally meant for clients of modest means, participated in the Victorian taste for composite styles and clashing colors. In 1820, jute, a cheap material imported from India, was adopted for both warp and weft.

Finer carpets continued to reflect the iconographic and stylistic traditions of the 18th century, with the same French influences still at work, simply copied or, more often, freely interpreted. The scatters of pastel flowers across a deep maroon field and the baskets filled with roses and tulips in full bloom had their source in the rugs of Aubusson and the Savonnerie, among them a piece displayed at the Musée Nissim-de-Camondo in Paris.[371]

THE REGENCY The Romantic taste for Asian and Islamic exoticism – motifs, colors, and settings – would also be reflected in carpet design at the beginning of the 19th century. For his Brighton pavilion, a picturesque fusion of Indian, Chinese, and Gothic forms, including onion domes, the Prince Regent commissioned Axminster to weave three large chinoiserie carpets, all made and delivered between 1817 and

ASIAN AND ISLAMIC EXOTICISM

The Romantic movement generated a taste for the exotic in motifs, colors, and settings, as at the Brighton Pavilion. For this picturesque fusion of Indian, Chinese, and Gothic elements, including onion domes, the Prince Regent (future George IV) commissioned three large carpets decorated with such chinoiserie as dragons, serpents, bats, and huge flowers.

1820. On the eve of his coronation as George IV, the Prince spent vast sums to decorate and furnish what was a sumptuous and exotic folly. The Music Room, the circular Saloon, and the Banqueting Room each boasted a tremendous carpet designed by Robert Jones and decorated with dragons, serpents, and huge flowers. The rug on the floor of the Music Room measured 18.60 by 12.20 meters, which made it the largest and heaviest (762 kilos) in the kingdom. Its decorative program included combatant dragons, attenuated foliage, geometric figures, stars, butterflies, bats, and an array of Chinese and Taoist ornament. The red

288

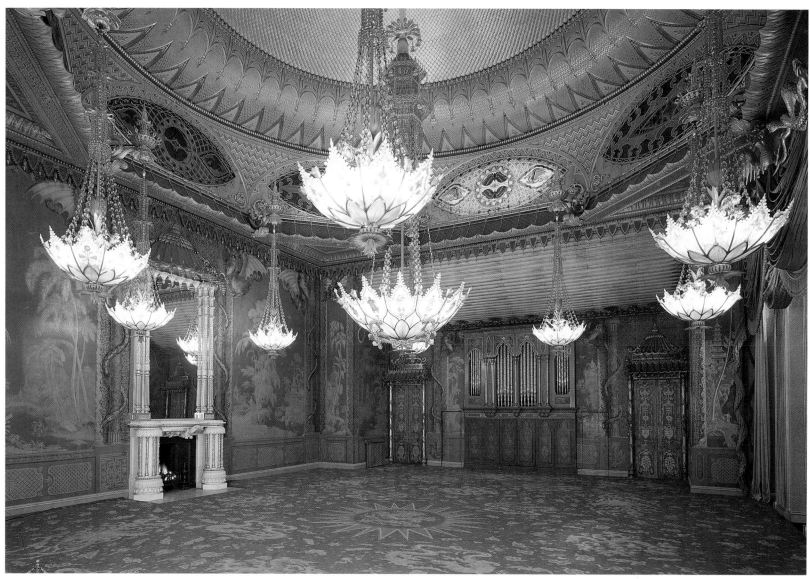

289

289. *John Nash. The Music Room in the Royal Pavilion at Brighton. 1815-1823. 'Chinese' on the inside, 'Indian' on the outside, and Neo-Gothic in between, the Royal Pavilion built by the architect John Nash for the Prince Regent surpassed, in splendor, fantasy, and dazzling, inventive color, all the other exotic follies built across Europe in the 18th and early 19th centuries. The architecture historian Marvin Trachtenberg has called Nash the pre-eminent master of the High Picturesque.*

290. *John Nash. Banqueting Room, Royal Pavilion, Brighton. 1815-1823. Reproduced in* Views of the Royal Pavilion, *published in 1826 by the Brighton Pavilion and Art Gallery, Brighton, Sussex. The eclecticism of the Regency style found its ultimate expression in the Brighton Pavilion built by the architect John Nash in the years 1815-1823. Each of the three main interiors—the Music Room, the circular Saloon, and the Banqueting Room—boasted an immense carpet designed by Robert Jones and embellished with dragons, serpents, and huge exotic flowers.*

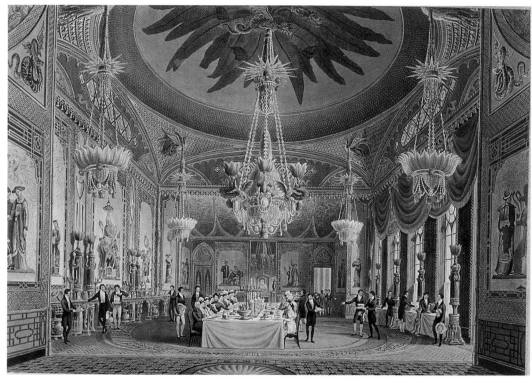

290

and golden-yellow motifs appeared against a robin's-egg-blue ground, which, together with the resolutely Chinese iconography and the exuberance of the ornamentation, matched the overall décor of the rooms.

THE VICTORIAN ERA In 1845-1847, following the accession of Queen Victoria, the Brighton pavilion was partially dismantled and its cut-up carpets either lost or used to decorate Buckingham Palace. The Victorians, with their love of eclectic and often garish ornamentation, tended to produce incoherent combinations of Gothic, Renaissance, Classical, Islamic, and Chinese elements or styles. The industrial weavers, then at the summit of their power in the mighty British Empire, believed that copying historical styles would guarantee sales. This aesthetic retrenchment provoked a vigorous reaction on the part of a group of artists led by a member of the government, Henry Cole. Preparing for the Great Exhibition of 1851, the architects A.W.N. Pugin, Owen Jones, and Digby Wyatt designed or described designs for carpets. Joining them in the resistance to 'shoddy' were painters and designers, including Richard Redgrave and Christopher Dresser. All strove to liberate the iconography of the applied arts from degraded alien influences. The renewal that followed was owing in large part to William Morris.

THE ARTS AND CRAFTS MOVEMENT Poet, politician, and designer, William Morris (1834-1896) played a truly capital role in the creative life and the decorative arts of Great Britain, opening the way to such pandemic modern styles as Art Nouveau (1890-1905). At the height of the Victorian era, Morris preached socialism, beauty within the reach of all, the superiority of work well done, and the dangers of machine production. He extolled the value of craftsmanship and restored respect for materials, the function of objects, and manual labor. He also improved ornamental design, notably the stylizations eventually associated with Art Nouveau, and it was thanks to him that practitioners of 'high' art took an interest in the applied arts, until then regarded as minor. Through his voluminous lectures and political writings, Morris sought to build a kind of medieval society in which socialism and art would bring human happiness. Among his friends, two were particularly close to Morris, the painters Edward Burne-Jones (1833-1898), whom he met at Oxford and who, too, was intended for the church, and Dante Gabriel Rossetti (1828-1882). A leading Pre-

Raphaelite, Rossetti influenced the art of both Morris and Burne-Jones. An all-important influence on Rossetti was William Morris's wife, Jane Burden, the feminine ideal and Pre-Raphaelite beauty par excellence whom Rossetti portrayed again and again, with almost obsessive devotion.

William Morris launched the so-called 'Arts and Crafts' movement, which from

291. *Carpet designed by Edward Welby Pugin for the Blue Drawing Room at Scarisbrick Hall. c. 1860. 7.04 x 3.76 m. Private collection, Paris. Edward Welby, son of the architect A.W.N. Pugin (1812-1852), followed in the Neo-Gothic footsteps of his distinguished father, who, with Sir Charles Barry, designed the new Houses of Parliament. One of Edward Pugin's clients was Lady Anne of Scarisbrick Hall. The carpet is representative of the Pugin aesthetic, with its Gothicism, its evocations of medieval floor tiles, its crisp, carefully worked-out composition, and the minute detailing of the ornament overall. The piece even recalls the tiled revetments in the Church of St. Giles, at Cheadle in Staffordshire, built by A.W.N. Pugin around 1846.*

292. *Altar carpet, from a cartoon by William Morris. c. 1880. 2.62 x 1 m. Private collection, Paris.*

WILLIAM MORRIS
(1834-1896)

Poet, politician, and designer, William Morris played a cardinal role in the creative life and the decorative arts of Great Britain. He purified the cluttered opulence of the Victorian era and cleared the way for modern developments, beginning with the Arts and Crafts movement. His own distinctive style can be recognized by its dense yet simplified compositions, flat patterns, spring-fresh palette, and gracefully stylized imagery based on English field and garden flowers. He executed hand-knotted carpets whose Persian influence is quite obvious, including a central medallion, large arabesques, and fleurons.

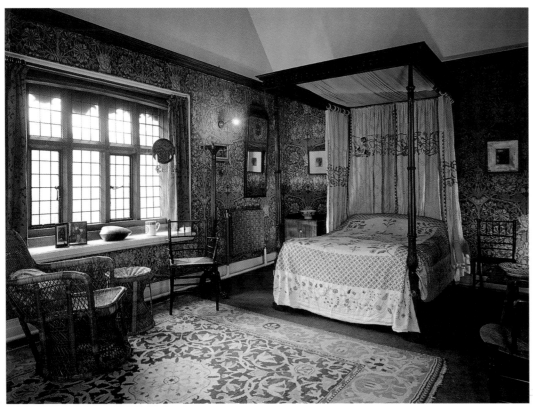

293. The 'Honeysuckle Bedroom' at Wightwick Manor, West Midlands, with an embroidery by May Morris and the rug 'Small Bar' by William Morris.

294. William Morris. Small rug with flowers and vase. 1880. Wool pile, cotton warp, wool weft; 105 x 68 cm. Private collection, Paris. The small-format carpets designed and woven by William Morris were generally meant to be hung like tapestries. Realizing that such treatment caused the rug to lose its shape, Morris switched from wool warps to cotton ones, beginning in 1880, the same year in which he ended the series seen here. The great Victorian artist was a perfectionist when it came to the technical quality of his pieces, for the benefit of which he conducted extensive research in the realm of dyestuffs. The brilliance of his colors and their fastness over time are remarkable, as can be seen here in the rich blue of the principal border.

295. John Henry Dearle. The 'McCullough carpet'. 1900-1902. Wool pile, cotton warp, jute weft; 4.52 x 3.51. Private collection, Paris. Henry Dearle, beginning in 1890, was in charge of carpet design for William Morris and Company, a position he held until the death of William Morris in 1896. Dearle created the piece seen here for the home of the wealthy Australian businessman George McCullough, where it would lie in a room hung with the Holy Grail tapestry series designed by Burne-Jones, Morris, and Dearle.

1880 to 1920 interacted with a number of British stylistic trends. Its influence could be felt all over Europe, particularly in the Netherlands, Germany, and France, but also in the United States. Morris's own works sold throughout the world, even as far away as Russia and Australia.

In his workshops at Hammersmith and Merton Abbey, and in collaboration with artists such as Burne-Jones and Rossetti, Morris designed and fabricated tapestries,

embroideries, textiles, printed cottons, laces, book illustrations, tiles, and carpets, all marketed by his own Morris and Company. Beginning in 1873, this polymath created cartoons for machine-made rugs, produced in factories like those of Heckmondwike, Whitwell, and Yates, some of which proved so successful that they were pirated by other manufacturers.

In 1878-1879, Morris created his first hand-knotted rugs, their designs based on classical Persian carpets. Around 1859 he had begun collecting Persian pieces and possessed a vast knowledge of Persian, Turkish, and Chinese rugs. Thanks to his advice, the Victoria and Albert Museum acquired the famous 'Ardabil' and 'Chelsea' carpets, both 16th-century Persian works.

The rugs woven at Hammersmith in the years 1878-1881 are small in format and sometimes trade-marked with a hammer, an M, and/or sinuous lines evoking the River Thames nearby. The influence of Persian carpets is usually quite obvious. Still, the art of William Morris is inescapably distinctive, characterized by dense yet simplified compositions, utterly flat patterns, a rich but spring-fresh palette, and gracefully stylized imagery based on English field and garden flowers and trees: 'the rose, the lily, the tulip,

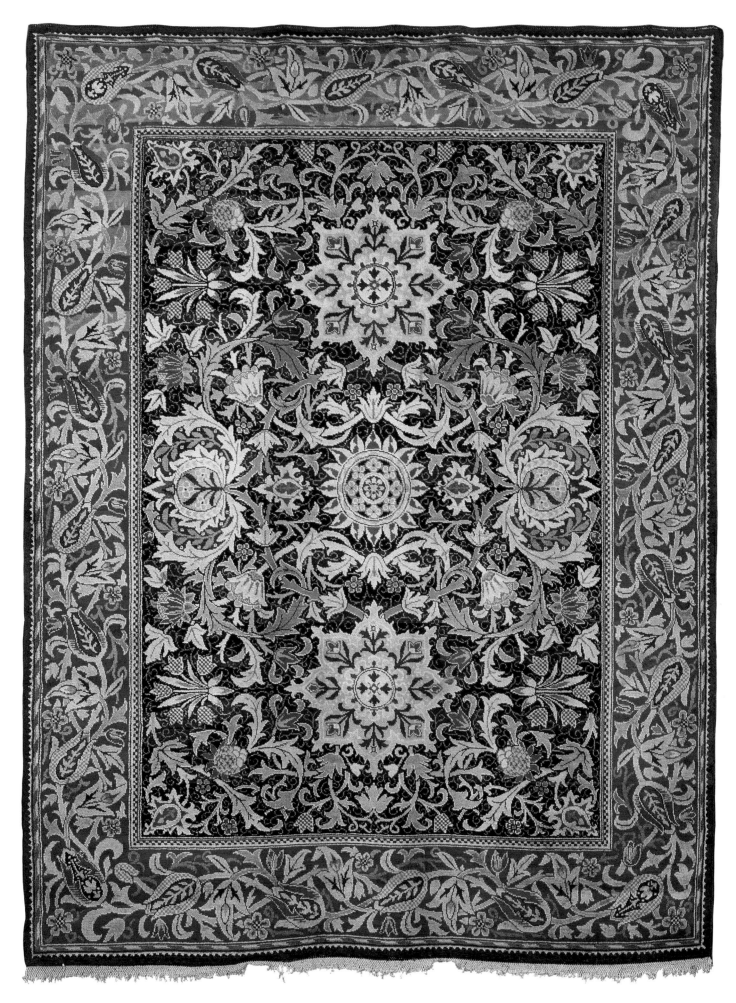

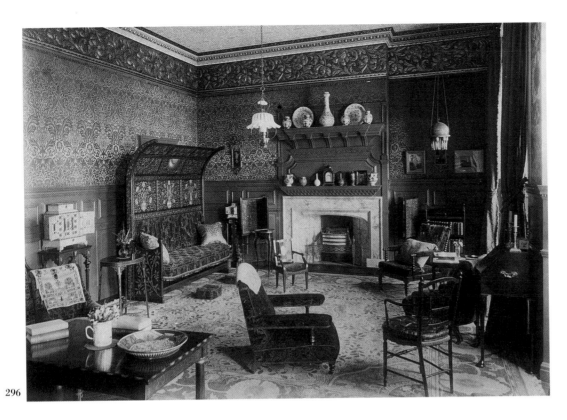

296

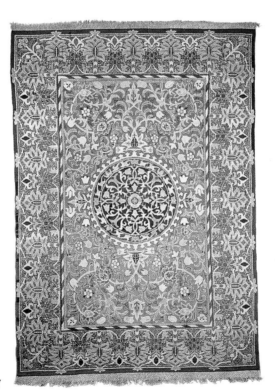

297

296. The drawing room at Old Swan House, London, in which the carpet known as 'Large Swan House' once laid, here photographed around 1890. Courtesy the British Architectural Library, London. In 1881 William Morris designed for M. Wickam Flowers a pair of rugs which were thoroughly Persian in style, complete with a central medallion but modified by a border more typical of Ottoman carpets. This kind of frieze, which was very popular, would be revived in several later rugs, such as 'Little Flower'. The Chicago Art Institute owns an example of the 'Swan House' pattern.

297. William Morris. 'Little Flower'. c. 1883. Wool pile, cotton warp; 4.40 x 3.30. Private collection, Paris. The cartoons created by William Morris and Henry Dearle would be used for several series of rugs, albeit varied along the way. The rug reproduced here derives from 'Little Flower', for which a drawing is preserved at the Victoria and Albert Museum. In both color and pattern, it is similar to a piece that once lay in Gessner House in Chicago and is now in the collection of the Chicago Art Institute.

298. C.F.A. Voysey. 'The Rose'. 1899. Wool pile, warp, and weft; 4.68 x 3.77 m. Voysey's distinctly modern carpet designs are marked by stylizations giving effect to a sense of nature reinterpreted by human artistry. The pieces are notable for their serene air and the freshness of the colors.

the oak, the vine, and all the herbs and trees that even we cockneys know about.'

In 1881 Morris moved to Merton Abbey near London, where he could mount large looms. From then on, until his death in 1896, he wove carpets in a variety of sizes, working from his own cartoons and with the help of his assistant John Henry Dearle. The ulti-

mate models for these pieces were Persian carpets of the 16th and 17th centuries, and they sometimes featured a central medallion, large arabesques, small flowers, and a palette of contrasting red and blue. Examples are 'Holland Park' at the Chicago Art Institute, created in 1883 for the Holland Park residence of the enormously rich Greek merchant Alexander Ionides; the field in the rug entitled 'Little Flower', made around 1883; and 'Clouds', a work of 1887 and now at the Fitzwilliam Museum, Cambridge. Other sources of inspiration were Ottoman velvets of the 16th and 17th centuries, whose palmette motif has been incorporated into the border of the Swan House carpet as well as into that of the 'Little Flower'. Medievalized motifs and themes, so cultivated by the artist in the domains of embroidery, tapestry, and illustrated books, are scarcely present in his carpets. Chinese rugs had little impact on Morris's carpet making, apart from one or two pieces, such as the example dated around 1880 and presented to Margaret Burne-Jones on the occasion of her wedding.

It is interesting to note that Morris, despite his admiration for Persian carpets, utilized the Turkish symmetrical knot. The materials he preferred are rather varied, reflecting his love of research and experiment. Wool and then, after 1880, cotton were the stuff of his warps, with the wefts made of wool or jute. The knot yarn is wool, although sometimes silk, as in the small piece at Merton Abbey, or a mixture of mohair and wool, as in 'Redcar'. Passionate about vegetable dyes, Morris brought them back into favor for British-made carpets.

A DECORATIVE ARTS REVIVAL

The new life that William Morris brought to the decorative arts affected not only carpets but also ceramic tiles, book illustration, furniture design, wallpaper, and upholstery textiles. It also launched Art Nouveau, distinguished by purified serpentine curves or straight lines, attenuated botanical motifs, and deeply resonant, unmodulated colors.

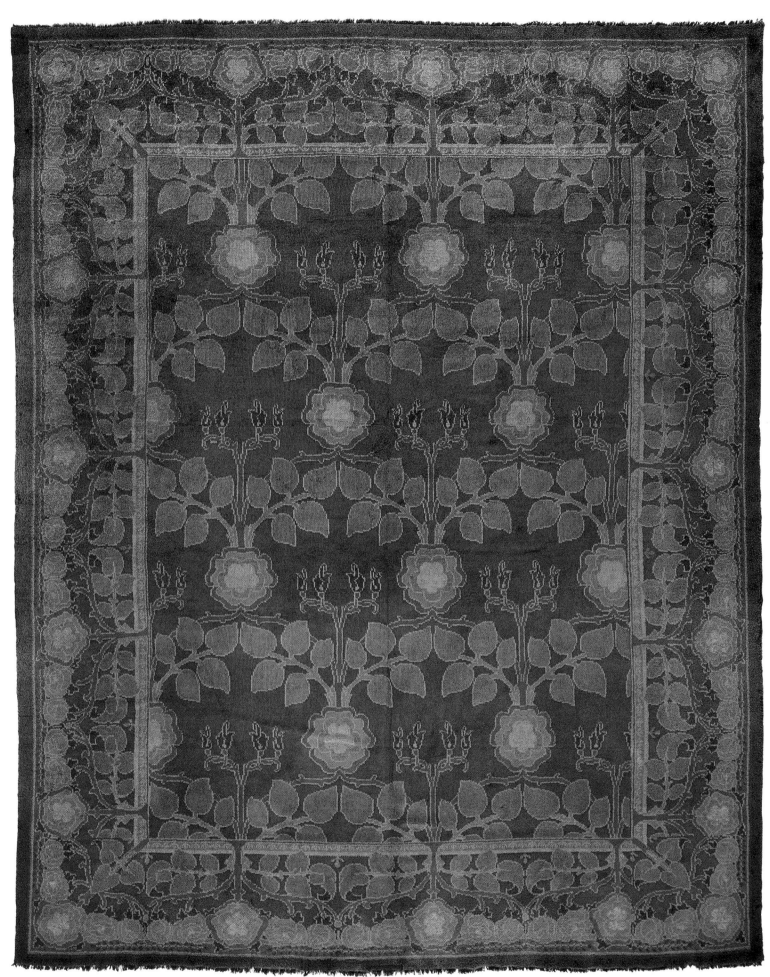

VOYSEY AND ART NOUVEAU

C.F.A. Voysey (1857-1941), painter, designer, and architect, followed the lead of William Morris and emerged as a key leader of the Art Nouveau movement in English textiles. Full blooms, twining foliage, and occasionally animals make up favorite Voysey themes, all ripe with a sense of nature reinterpreted by human artistry.

ALEXANDER MORTON AND COMPANY

Rug knotting did not evolve as a tradition in Ireland, despite the estate workshop established in the early 16th century by the Earl and Countess of Ormonde, or the premiums offered in the 1740s by the Royal Society of Dublin. In 1895, however, Alexander Morton and Company set up several factories in County Donegal, where impoverished villages began hand knotting the designs of C.F.A. Voysey. Some of the patterns created by the Morton designers made stunning use of the Irish Celtic heritage. The Morton rugs were sold in the United States by Gustav Stickley, the great American exponent of the Arts and Crafts aesthetic.

A REVITALIZATION OF THE DECORATIVE ARTS The vigorous new life that William Morris brought to the decorative arts, ranging from ceramic tiles and book illustration through furniture design and upholstery textiles to interior decoration, is a major factor in the history of 19th- and 20th-century art. Beginning around 1893, a trio of artists, C.F.A. Voysey (1857-1941), Lindsay P. Butterfield (1869-1948), and George Charles Haité (1855-1924), carried Art Nouveau textiles to the summit of their glory. Naturalism returned, to brilliant effect and distinguished by purified lines, repetition of large vegetal motifs, and deeply resonant, unmodulated colors. The taste for gardens, botanical life, and flowers in the Elizabethan tradition (hyacinths, jonquils, iris, woodbine) returned, as did the love of embroidery, a craft revived and energetically fostered by Morris.

Charles Francis Annesley Voysey (1857-1941), designer, painter, and architect, led the way towards a new spirit, a modern, idealizing simplicity. The rug entitled 'The Rose' illustrates this stylistic trend, with its flowers in full bloom, its leaves, and twining stems, all ripe with a sense of nature reinterpreted by human artistry. Flowers and foliage, as in the rugs called 'Donnemara', 'Fintona', and 'Lisburn', trees, and occasionally animals ('Duleek') make up the themes favored by Voysey for the composition of halcyon, idyllic but rarely picturesque scenes ('River May'). Duplicated in different colors ('Donnemara' reinterpreted in four tonalities), the carpets radiate naturalism. Later, in the 1920s and 1930s, they also reveal a touch of naïveté, woven as they were for children's rooms.

Creativity in the domain of carpets continued with the Celtic movement and the rugs of Mary Watts, among them 'The Pelican' and 'Ardmore', the latter adapted from medieval Ireland's Book of Kells. Also related are certain pieces by Archibald Knox. Other emerging trends included unified fields framed by a simple, monotone border, the pastel geometric figures of Charles Rennie Mackintosh and Serge Chermayyeff, and the rugs of Marion Dorn.

The Knotted-Pile Carpets of Ireland

In Ireland, woollen fabrics, such as ratiné,[372] were well known around the 12th century and even exported to the Continent. Rug knotting, however, did not evolve in the country, despite many exchanges with Norway and Sweden, where rya, a Scandinavian pile weave, was made.[373] In the 14th century, moreover, a trading relationship developed between Galway and Spain,[374] the latter famous since the 11th and 12th centuries for its knotted-pile carpets.

From the 16th century through the 18th, crochet rugs with a heavy, loose structure were made in the coastal regions of Ireland, although no old piece with native motifs has survived.

The first mention of pile carpets in Ireland dates from 1525, when the Earl and Countess of Ormonde established an estate workshop with Flemish weavers at Kilkenny near Abbeyleix, County Kildare, for the purpose of fabricating 'tapestry, diaper, Turkey carpets, cushions &'.

In 1740-1742 the Royal Society of Dublin offered premiums for rugs woven in the Turkish or Scottish (reversible or 'ingrain') manner, but even this inducement failed initially for the want of contestants and did not succeed until 1752. The workshops, set up mainly in Dublin, garnered a certain fame, but the patterns followed established styles, and the absence of ornamentation peculiar to Ireland caused the enterprises to fade away.

In 1895, James Morton (1867-1943) and his brother Gavin took over Alexander Morton and Company, begun in 1867 by their father, Alexander Morton, in Darvel, Scotland, and later expanded to Carlisle in the north of England. With a contract for designs by C.F.A. Voysey, the Mortons set up several factories in County Donegal, Ireland, where impoverished villagers would do skilled hand knotting at a competitive rate. The beautiful rugs woven at Killybegs, Kilcar, Crolly, and Annagry were sold in the United States by Gustav Stickley, the great American proselytizer of the Arts and Crafts movement. The Mortons sought patterns not only from Voysey and Butterfield but also from such reform-minded designers as J.S. Rigby and Mackay Hugh Baillie Scott, some of whom created large-scale, broadly rendered patterns derived from the Irish Celtic heritage. The rugs made by hand, as well as by machine, around 1900 are notable for their colors—all chemical, pastel, acidulous, and brilliant, with a bias towards pinks, salmon red, and soft green—and for their locally grown wool, its quality excellent, soft and silky.

EMBROIDERED AND NEEDLEPOINT RUGS

Needlework rugs did not come into general use in England until the beginning of the 18th century, even though the oldest example of such work – the so-called 'Gifford carpet' – dates from the first half of the 16th century.
A Great English Tradition

299

Opera nuoua ʒ̃ inʃegna alle Donne a cuʃire, a racam
mare & a diʃegnar a ciaʃcuno, Et la ditta opera ʃara di
molta utilita ad ogni artiʃta, per eʃʃer il diʃegno ad ogni
no neceʃʃario, ʃaqual e intitolata eʃʃempio di recammi.

M D XXVii.

Con gratia ʒ̃ Priuilegio.

300

300. *An embroidery workshop, from Giovan
Antonio Tagliente's* Opera nuova che insegna alle
donne a cusire a racammare, e a disegnar a
ciasaeuno (*A New Work with Advice to Ladies on
How to Sew and Embroider and Make Their Own
Clothes*). . . . *Venice, MDXXVII. Bibliothèque
Nationale, Paris.*

299. *Flower patterns for embroidery, from Giovan
Antonio Tagliente's* Opera nuova. . . . *Venice,
MDXXVII. Bibliothèque Nationale, Paris.*

EMBROIDERY:
AN ENGLISH TRADITION

As early as the 12th century, English embroidery was celebrated throughout Europe for its quality and beauty. The Elizabethan nobility practiced the craft with passionate enthusiasm. The motifs, both flora and fauna, were taken from botanical books as well as from scientific and fabulous bestiaries. Only in the 18th century, however, did carpets worked on a canvas.

The English truly excelled at needlework; indeed, their embroidered church vestments were renowned in the West as *opus anglicanum*. The subjects of Elizabeth I practiced the craft with passionate enthusiasm. Master embroiderers in the service of the nobility contributed their expertise and their advice. When Mary Stuart returned to Scotland in 1561, following the death of her first husband, François II of France, the French suite attending her included a *brodeur* named Pierre Oudry. Patterns, in booklets of engravings, and transfers could also be purchased in Britain. The motifs, both flora and fauna, were taken from botanical books, scientific and fabulous bestiaries, and travelogues, replacing the old religious iconography, swept away by the Protestant Reformation. Embroidery covered every type of garment as well as the textiles used for household furnishings.

In the 17th century, the upheavals in life style and hygiene, triggered by the Great Plague (1665) and the Fire of London (1666), joined with the reaction against the austerities imposed by Oliver Cromwell to generate a taste for rugs made of embroidered velvet. This craze, however, proved short-lived, and by the outset of the 18th century it had given way to carpets worked on canvas in a variety of stitches: chain stitch, cross stitch, stem stitch, tent stitch, gros point, and petit point. Yet, despite their success and their perfection, attained over the course of the century, needlework rugs succumbed to overwhelming competition from Oriental carpets as well as from English pile carpets made by hand or by machine.

Needlework carpets require the use of a canvas or plainweave foundation to provide strength and resistance to pressure. This canvas is a fairly heavy fabric made of linen, jute, or hemp, and, after the 1830s, of cotton. It consists of a single, continuous piece or of joined strips (18th century) or squares ('tile design', 19th century). Among the 18th-century canvases sold in mercery shops, some had already been prepared with a transfer pattern, a technique which would become a fad after the arrival, in 1830, of German kits made up of prepared canvas squares and the required wools ('Berlin woolwork').[375] By the 1850s canvases were being printed industrially for use

301. *The 'Gifford carpet'. c. 1550. Wool petit-point,
linen canvas; 5.60 x 1.40 m. Victoria and Albert
Museum, London. Three wide wreaths composed of
acorns and oak leaves styled in the Renaissance
manner are set forth against a geometrically
patterned ground. Roger Gifford, a physician in
the service of Elizabeth I, very likely had this
carpet woven on the occasion of his ennoblement,
given that the central wreath encircles the Gifford
arms. Among the other motifs, the stags under an
oak tree signify speed and power according to the
symbolic system then in vogue.*

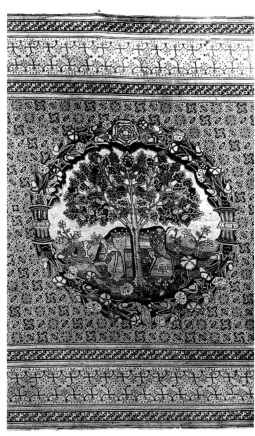

301

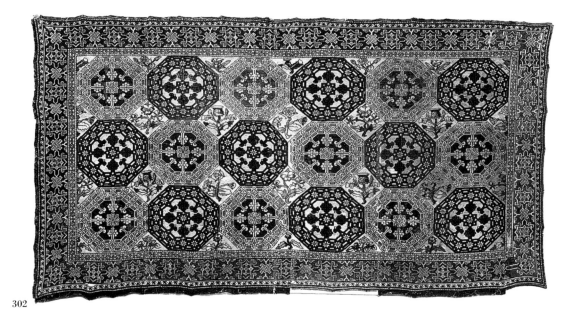

302

traditional English literature abounds in scenes of ladies busily manipulating their needles while sitting quietly by the fire. Merely avoiding idleness or commemorating a notable event (marriage, a royal visit) constituted sufficient occasion to create, indeed elaborate, veritable works of art. Although little written information about this practice has come down to us, there is no ignoring the vast amount of embroidery supplied by village and urban workshops, particularly those of London, as well as by orphanages. The ateliers of embroiderers, whether or not under the patronage of some grandee of the realm, existed in England from the beginning of the Middle Ages. It was these professionals who, working for an ecclesiastical, royal, or aristocratic clientele, created the celebrated *opus anglicanum*. Subsequently, rug making became a profitable enterprise for needleworkers already organized into a guild or, as of the 16th century, into brotherhoods, the beneficiaries of a charter signed in 1561.

The oldest embroidered rugs survive mainly from the 18th and 19th centuries. Earlier known examples, dating back to the 16th and 17th centuries, suggest that this kind of rug

302. Embroidered carpet with roses and thistles. c. 1550. Wool mat and cross stitch, linen canvas; 4.24 x 2.10 m. Victoria and Albert Museum, London. The rose symbolizes England and the thistle Scotland.

303. The 'Saint John of Bletso carpet'. c. 1602. Petitpoint and cross stitch embroidered in wool, silk, and gold and silver thread on linen canvas, 4.24 x 2.10 m. Victoria and Albert Museum, London. This carpet was woven to mark the wedding of Oliver Saint John, Earl of Bolingbroke, and Elizabeth Paulet, which was celebrated in 1602. In the center of the field appear the arms of Saint John together with the initials O.S. and E.S. for Oliver Saint John, first Baron of Saint John of Bletso, who died in May 1582, and his second wife. The border sports the blasons of families related to the Saint Johns.

304. The Palmer-Harpur wedding carpet. c. 1742. Gros demi-point stitch in wool and silk on linen canvas, 3.12 x 2.49 m. Private collection. In addition to the heraldry of the wedding couple, the rug bears the motto Par sit fortuna labori, proclaiming the importance of hard work in the wealth amassed by the British industrial and trading classes.

305. The Prince Regent's Room, Clandon Park, Surrey, furnished with a petit-point carpet. Early 18th century. Carpet, wool petit-point on canvas, 330 x 275 cm. The Rococo became all the rage in England during the 1750s, particularly in the domain of needlework carpets. Consistent with the new fashion are the accolades and cursive lines permeating the pattern seen here and giving it style. The flowers, with their vivid colors, their plenitude and fullness, and the naturalness of their treatment, are a tribute to the extraordinary skill and sure sense of form characteristic of 18th-century England.

with domestic wool or, beginning in the early 19th century, wool imported from Germany. Silk also played a role in such work, but usually in combination with wool, while gold and silver thread made only the rare appearance. The dyes, as in the case of pile rugs, were natural until around 1856, the date the first aniline was discovered. Needlework is traditionally a craft practiced by women, and

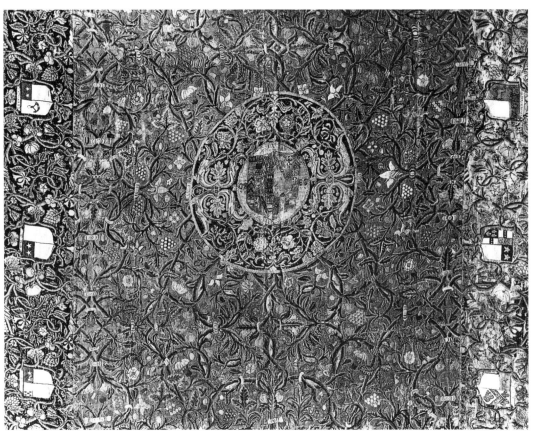

303

making evolved in a manner similar to that of knotted carpets. At first, the objective was to copy Anatolian specimens, after which the craft moved towards Renaissance and Elizabethan ornamentation. The 'Gifford rug' of 1520-1550, with its geometrically patterned borders and field and its wide wreaths of oak leaves and acorns, demonstrates the interpenetration of styles. The wreath motif can be found as well in 16th-century Spanish carpets. A rug dated around 1550 presents a design of octagons and pseudo-calligraphy imitating the ornamentation on Holbein rugs, in combination with flowers, roses, and thistles drawn from England's own repertoire of imagery.

Meanwhile, the rug emblazoned with the arms of Saint John of Bletso boasts a decorative program which is resolutely floral and Elizabethan, a pattern similar to that of the knotted 'Hulse carpet', with its supple green arabesques invaded by blossoms, clusters of grapes, and acorns.

At the beginning of the century, during the reign of Queen Anne (1702-1714), chinoiserie and the Baroque style came into vogue. Large flowers in full bloom reflected the impact of Moghul art, while also announcing the true emergence of the embroidered carpet.

ENGLISH EMBROIDERED CARPETS OF THE 16TH AND 17TH CENTURIES

At first, needlework rugs evolved in a manner similar to that of knotted carpets, mimicking Anatolian models. Then the craft moved towards Renaissance and Elizabethan ornamentation, featuring roses, thistles, leaves, acorns, and clusters of grapes.

18TH-CENTURY EMBROIDERED CARPETS

Now the designs are floral, composed of various brightly colored blossoms and spreading leaves, rendered with great naturalism. Sometimes the pattern is an all-over arrangement of bouquets in baskets or vases, possibly contained within a central medallion.

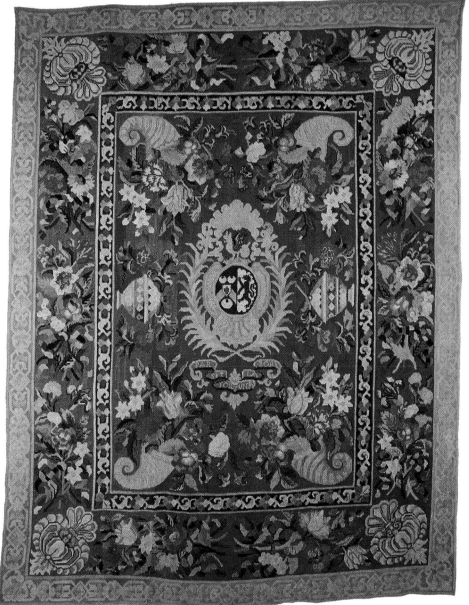

304

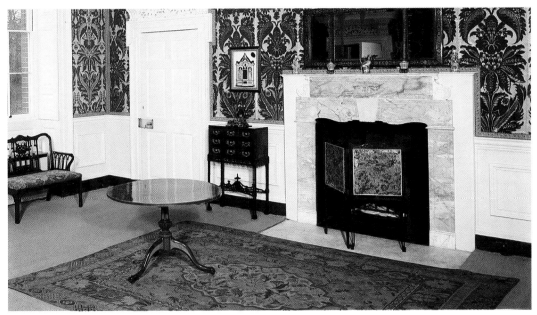

305

306. *State Bedroom, Clandon Park, Surrey, furnished with a petit-point carpet. The rug, c. 1765.*
The exuberant treatment of the flowers, especially the carnations, sunflowers, and roses, the gracefully curvilinear foliage, the sparkling colors, the dark ground, and the Persian-style composition, with its central medallion and spandrel corners – all combine to make this work a true paradigm of the genre.

307. *Embroidered chinoiserie carpet. Great Britain, c. 1760. Wool cross stitch on linen canvas, 2.13 x 1.71 m. Colonial Williamsburg, Virginia.*
Chinoiserie seized the imagination of English designers during the second half of the 18th century. It invaded the drawing rooms and bedchambers of elegant society, filling them with chinoiserie porcelain, furniture, and textiles. The flowers – peonies and roses – and the colors – blue, red, and golden yellow – all have their source in Chinese art.

Given the quality of the ornamentation, the wool, and the natural dyes, it could be said that the culminating moment for this genre arrived during the reign of George II (1727-1760). Surviving specimens attest to the vigor and maturity of the new style, as well as to the diverse influences which brought it into being.

Eighteenth-century designs are essentially floral, composed of various brightly colored blossoms and spreading leaves, all rendered with great naturalism. Ornament is distributed over the field in keeping with a pair of fairly precise schemes. One of these has the flowers arranged as bouquets in baskets or vases, sometimes contained within a central medallion, its shape continuous or polylobate and inherited from Oriental carpets. The other allows the floral imagery to expand in a generalized way over the entire field, sometimes accompanied by armorial bearings.

The essential characteristics of these works have been integrated in a rug made to commemorate the marriage, in 1735, of Thomas Palmer of Carlton and Jemina Harpur. Here the field is embellished with horns of plenty overflowing with tulips, roses, jonquils, and hyacinths, in addition to a pair of hyacinth-decorated pots. Two secondary borders, one with an interlace of blue rosettes and the other with yellow geometric motifs, frame the principal frieze filled with bouquets and four corner rosettes. This carpet, even though typical in the exuberance of its ornament, the variety and form of its flowers, and the quality of its colors, displays several distinctive features. The ground, for instance, is not the usual deep blue, brown, or coral but red, and horns of plenty seldom appear on pieces made during the second quarter of the 18th century.[376] As a rule, borders are simpler, single rather than multiple or flanked by two fine, discrete floral, geometric, or monochrome bands. In the present case, the three borders are remarkable both for their size and their ornamentation. Flowers tied with ribbons constituted an iconographic innovation, dating, according to Mayorcas, from the 1730s.[377] The piece seen here would have to be considered one of the first manifestations of this new fashion. Finally, the two lidded jars and the corner rosettes announce the advent of English Neoclassicism. A close cousin to the Palmer rug is the 'Holte carpet', now in the Birmingham Museum and Art Gallery,[378] a work decorated with armorial bearings at the center, Neoclassical rosettes in the corners, sharply differentiated secondary borders, and a luxuriant, allover floral pattern.

Ornamentation, while retaining its plenitude, gradually acquired a Rococo suppleness, especially in the treatment of the burgeoning foliage, as this new style reached its apogee in England during the 1750s.

The English decorative arts opened wide to Chinese influences during the second half of the 18th century, after the publication in 1754 of Thomas Chippendale's *Gentleman and Cabinet-Maker's Director*, followed in 1757 by the appearance of Sir William Chambers's account of travels in China, the latter filled with detailed descriptions of Chinese furniture. Those given to this fashion sipped tea from tiny

306

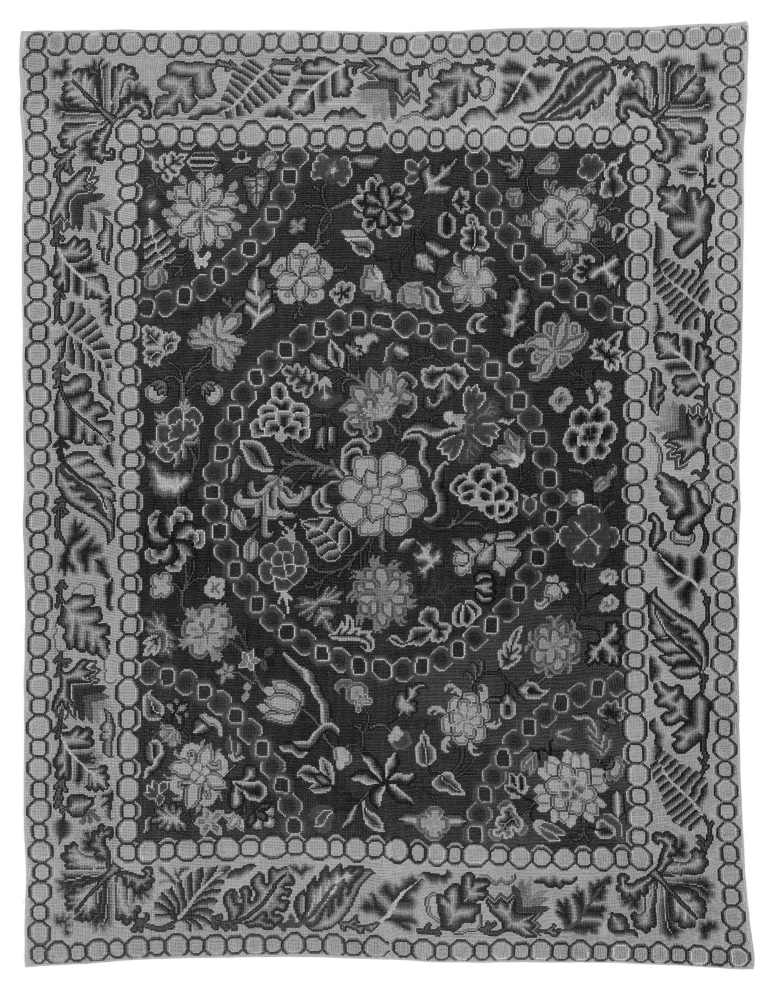

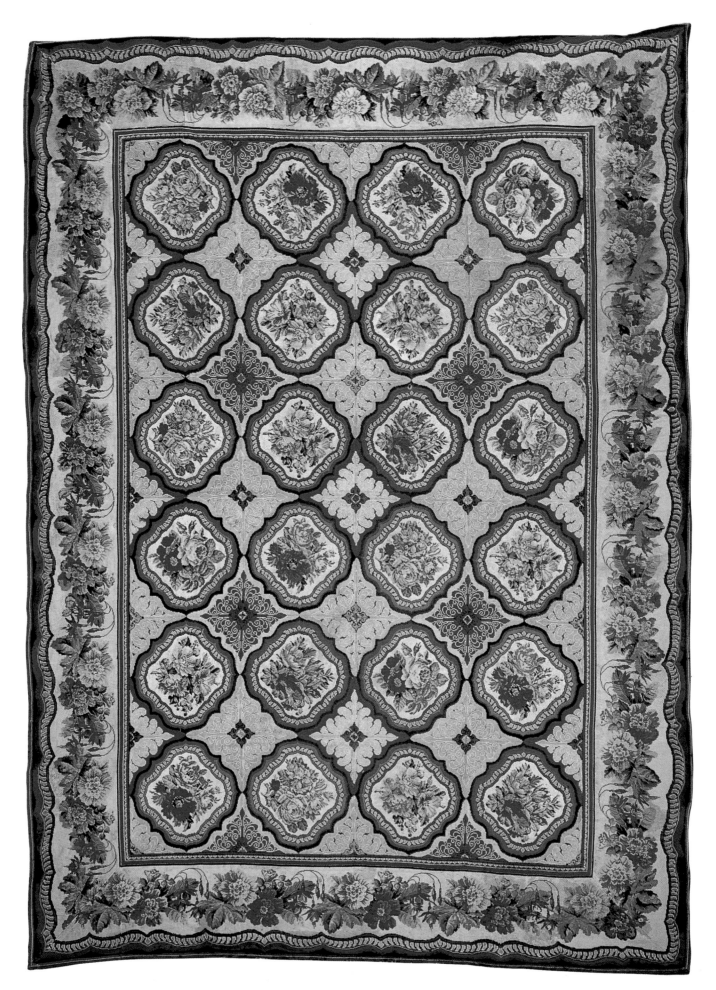

cups and surrounded themselves with lacquers, porcelains, and Chinese silks in salons and bedrooms furnished and decorated in the same taste. This passion for chinoiserie, although damped by Neoclassicism, would live anew when it captivated the Prince of Wales, the future George IV, around the turn of the 19th century and again, later, in the needlepoint carpets of the Victorian era.

During the 19th century, when it became extremely popular, the embroidered rug evolved through the whole succession of revivalist styles which emerged during the long reign of Queen Victoria: Louis XV and XVI, 'neo-Gothic', chinoiserie, mock-Caucasian, and so sorth. At the start of the century, opulent flowers and foliage came into vogue, to remain a constant throughout the Victorian age. Their large size, their colors, which often clashed, and the choice of exotic specimens, orchids, ferns, and bindweed, finally added up to aesthetic mediocrity, against which the Arts and Crafts movement reacted. Yet, by 1880, the style had grown even heavier, with peacock feathers, sunflowers, and the 'Queen Anne revival' added to its repertoire of excesses.

When, around 1830, the squares of canvas and colored wools began arriving from Germany, rugs made from assembled panels enjoyed a quick and lively success. By 1850 landscapes, contemporary scenes, and animals as well as flowers had invaded this territory, against a ground of cream and then black.

The 'Gothic revival' – initiated halfway through the 18th century by Horace Walpole when he built Strawberry Hill, his country house – enjoyed a long and very successful run, virtually to the end of the 19th century, affecting the decorative arts of every kind. Neo-Gothic or medievalized themes could be found on great houses and public buildings, in painting and on furniture, and certainly on carpets, such as the one in the Kingston-upon-Hull Museum.

In the 20th century, needlework rugs have rarely been made. From about 1905 to approximately 1940, the Pontremoli family, of Italian origin, attempted to revive the tradition and technique. In their London atelier they fabricated works ornamented with arabesques of flowers and fruits in the spirit of rugs dating back to the 17th and 18th centuries.

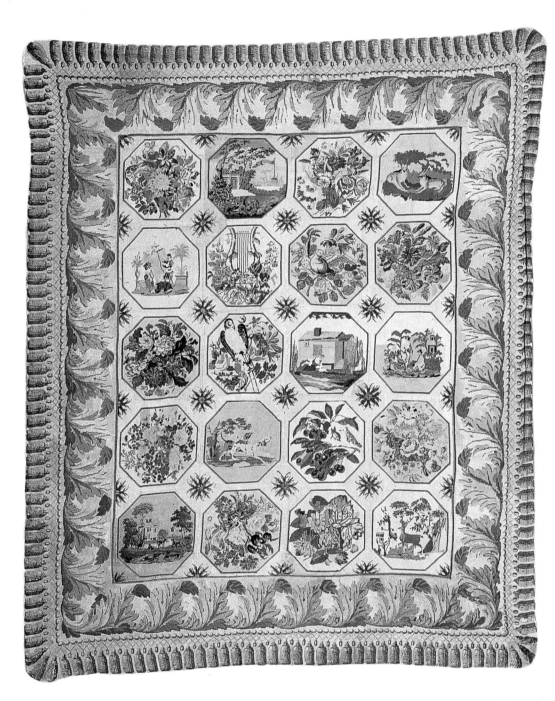

309

309. *Needlework rug assembled from 'squares', 1845. 3.73 x 3.15 m. Sold at Sotheby's on 16 December 1993. This piece is a perfect example of the needlework rugs made during the 19th century. All the elements then fashionable are present: the field divided into 'squares', the picturesqueness and variety of the themes, the luxuriance of the botanical motifs, etc.*

310. *Needlework rug with Gothic motifs. Great Britain, c. 1840. Wool cross stitch on canvas, 4.33 x 4 m. City and County of Kingston-upon-Hull Museum. This pattern, with its roses and Gothic windows, would be taken up even in France.*

308. *Needlework rug. Great Britain, late 19th century. 4.06 x 2.97 m. Sold at Sotheby's on 28 October 1995.*

310

CHAPTER
X

THE CARPET
IN SPAIN
AND PORTUGAL

Clothilde Galea-Blanc

The First European Rug Maker

Spain was undoubtedly the first country in medieval Europe to make knotted-pile rugs, an activity that began around the 11th century during the Islamic occupation. Carpets were in fact one of the many facets of the glittering Hispano-Islamic civilization which flourished in Spain from the 8th century through most of the 15th century. The technique of carpet weaving, perhaps introduced in the 10th century by Coptic artisans, appears to have quickly taken root, according to both literary sources and archaeological fragments.

A Fabulous Cultural Diversity

Apart from an example dated to the second half of the 14th century, the earliest preserved carpets are works fabricated in the 15th century. They reflect the cultural diversity of Spain, a country in which the arts, traditions, and know-how of markedly diverse populations – Christian, Jewish, Muslim Arab, and Berber – cohabited and intermingled for eight extraordinary centuries. Also mixed into this fabulous heterogeneity were influences from Anatolia and Persia as well as from Italy and France. Further, the 15th- and 16th-century pieces are Mudejar work, Mudejar meaning Muslims living on lands reconquered by Spain. As such, they embody not only Islamic elements but also Gothic and Renaissance features, all in response to the taste of the Spaniards of the Christian Reconquest.

Carpet Weaving at Its Zenith in the 16th Century

By the 11th century Spanish rugs were being exported to the Orient, as we know from the Fostat excavations in Cairo, but also to England and France, a phenomenon attesting to the expertise and prosperity of Muslim and Mudejar weavers. Admired, collected, and commissioned by the Muslim and Christian princes and their courts, the carpets of Spain, like the textiles, were integral to the art of living and refinement during the medieval and Renaissance periods. Along with tapestries, cushions, bed sets, chests, and a few chairs and tables,

rugs constituted objects indispensable to the nomadic life of 15th-century Spain's court and nobility. The court, we should recall, did not truly settle in Madrid until the reign of Philip II in the second half of the 16th century (1556-1598). The Renaissance centuries marked the apogee of the Spanish carpet, for by the 17th century it seemed irretrievably condemned to become one of the minor arts, a mere complement to interior décor. Spain's economic depression and the loss of qualified artisans, brought on by the expulsion of Jews and Muslims, left the rug industry seriously weakened. However, with the support of the monarchy and other rich patrons, renewal did occur, along lines already established in France. Thereafter Spanish carpet making would adhere to the norms of European art, following trends in France and England, as these pace-setting cultures evolved into Neoclassicism or succumbed to the allure of chinoiserie, or yet resorted to mimicking Anatolian and even Hispano-Moresque styles. The verve and fantasy – the brilliant originality – of native Spanish iconography gave way to the merely decorative and pleasing.

SPANISH WEAVING TECHNIQUES

Hispano-Moresque weavers had a distinctive way of making pile carpets; that is, they employed the so-called 'Spanish knot' or single-warp knot, which was looped about one warp yarn only, rather than the two warps needed to make either the symmetrical or the asymmetrical knot familiar from Oriental carpets.

The Spanish Knot

Despite its remote Asiatic origins, this technique never achieved wide currency other than in Spain. The exact place of its invention remains elusive, although Dimand and Mailey[379] have argued for Chinese Turkestan or eastern Persia. Two fragments, one dated to the 2nd or 3rd century and found at Lulan, during the Stein excavations, and the other, a 5th- or 6th-century piece, discovered at Kyzyl, by von Le Coq (see Chapter 1), were woven with the Spanish type knot. Could they have been made

In the Islamic world there is no heraldry in the proper sense. Tribal signs existed from a very early date, in the Near East and Far East alike, and they were in use in Syria and Egypt under the Ayyubids (1171-1250) and the Mamluks (1250-1517). In Spain, armorial bearings appear on a variety of Islamic objects: ceramic tiles at the Alhambra in Granada inscribed with the shield and device of the Nasrid emirs (1232-1492), dated to the 14th century; and a late 14th-century *albarello* jar displaying the Nasrid arms.[399] Heraldry is peculiar to Christian Europe, where, by their emblems and their colors, medieval Europeans declared 'this is my liege lord' and 'this is who I am.'[400] During and after the Reconquest, Spaniards felt compelled to assert their identification with Christianity and the West, and to do so proudly, while also treasuring the refined civilization inherited from the Islamic past. Blazons and inscriptions decorated everything from façades and ceramics to carpets.

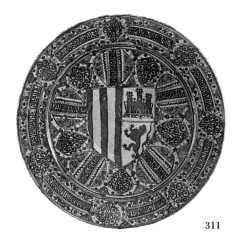

311

311. *Dish with the arms of Maria of Castile, the wife of Alfonso V of Aragon. Spain (Manises?), early 15th century. Musée National de la Céramique de Sèvres, Paris.*

in Chinese Turkestan, or imported from eastern Persia, from Sogdiana, for example?

This peculiar knot may have been introduced into Spain during the 10th century by Copts, as several fragments seem to indicate, such as the one in the Bouvier collection deco-

rated with a praying figure (again, see Chapter 1). From time to time, the technique cropped up elsewhere in Europe, evidence of which is the Quedlinburg 'tapestry' executed in Germany in the 12th century.

Spanish weavers worked primarily with lamb's and sheep's wool, produced locally or imported from North Africa. Lamb's wool appears to have been used earlier than the wool of sheep, but then, in the 18th century, it disappeared from Spanish pile rugs. Linen, utilized for weft but more rarely for warp, came into play during the second half of the 16th century before being widely adopted during the 19th and 20th centuries. Jute would have a similar history in the 18th and 19th centuries. Cotton warps became common around the turn of the 18th century, while silk found almost no place in Spanish rugs, although one specimen is known, now preserved at the Dallas Museum of Art.

Dyes, locally produced or imported from Morocco, Algeria, or Tunisia, were of excellent quality until the 15th and 16th centuries, when the expulsion of Muslim artisans and Jewish dyers resulted in a gradual loss of savoir-faire. Another consequence was the time it took for Spanish workers to become expert in the use of new dyestuffs, such as cochineal from Mexico.

A Concentration of Workshops in Murcia

According to Arab and Christian sources, most of the ateliers were concentrated in Murcia, a region permanently reconquered in 1270, in the towns of Chinchilla, Albanilla, Hellin, Alcaraz, Letur, Lietor, and Cuenca. After the Reconquest of 1492, royal patronage gave rise to other workshops, at Villamalea, Valencia, and Salamanca. By the 18th century, however, many provincial looms had disappeared, while the factories in Madrid, notably the Real Fabrica de Tapices, became the most reputed in Spain. The artisans, possibly trained by Copts, were all most likely Muslim, working at first for a Muslim clientele and then for Christians. Once expelled, they would be replaced by Christian workers, many of them women if one may judge by the number of domestic and convent looms.

Since no rug earlier than the 14th century has been preserved, we have no choice but to rely on Arab and Christian texts and archaeological fragments in order to reconstruct the beginnings of the Hispanic carpet.

THE OLDEST SPANISH CARPETS

The Arab and Christian Texts

The earliest references to rugs in Spain date from the 10th century. La Cronica del Moro Rasis, an anonymous work, mentions such items briefly, while an Arab text speaks of the wonder expressed by Greek ambassadors upon encountering the carpets in the courtyards of the Córdova palace during their mission to Caliph 'Abd er-Rahmann II in 949. From the 11th century to the 14th, Arab writers recorded a great deal of information about textiles in Spain, including the important fact that rugs were exported to the Near East and to other parts of Europe. In 1154, the geographer al-Idrisi wrote in his Description of Africa and Spain: 'At Chinchilla woolen rugs were fabricated that could not be imitated anywhere . . . because of the qualities of the air and the water.'[380]

Moreover, Makkari reports that the city of Murcia is particularly famous for the rugs of Tantali [Chinchilla], which are sent into Oriental countries, and for the mats with which the walls are covered and which are pleasing to look at. . . .'[381]

In the Christian West, travel accounts, chronicles, and inventories of religious, royal, and princely houses indicate the degree to which the early Spanish carpets were appreciated. An especially picturesque witness is one from 1255, when carpets were laid out in the Westminster lodgings assigned to Eleanor of Castile, who had arrived in London as the bride of the future Edward I.[382] In France, Pope John XXII (r. 1315-1334) acquired geometrically patterned heraldic carpets for the Papal Palace in Avignon. Matteo di Giovanetto depicted one of them in a fresco he painted in the Saint Martial Chapel in 1344-1346. The inventory of the estate of the Duc de Berry, drawn up in 1416, lists at least five rugs 'of Spanish work'. Numerous Spanish inventories enable us to pinpoint the apogee of the rug-

312. Matteo di Giovanetto. Fresco, Saint Martial Chapel, Palace of the Popes, Avignon. 1344-1346. A rare witness, on an unusual support, to the vogue of Spanish carpets in 14th-century France.

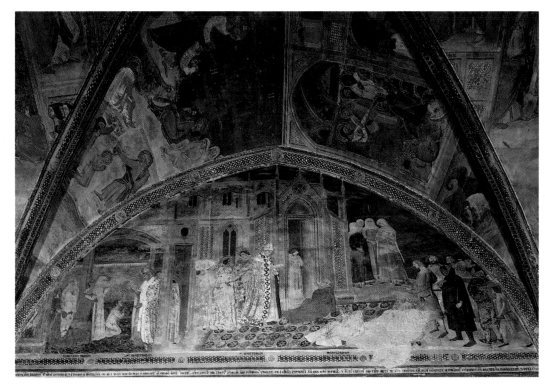

312

Since no Spanish rug woven earlier than the 14th century has been found, scholars must rely on Arab and Christian texts and a few archaeological fragments in order to reconstruct the history of carpets in pre-Renaissance Spain. A 10th-century document, for example, speaks of the wonder expressed by Greek ambassadors when they encountered the carpets in the Córdoba palace. The English had a similar reaction upon seeing the carpets laid out in the Westminster lodgings of Eleanor of Castile.

making ateliers, such as those in Alcaraz in the 15th and 16th centuries and in Cuenca in the 16th and 17th centuries. Indeed, they provide a contemporary witness to the booms and busts of the trade right up to the 19th century. The inventory of assets belonging to Alfonso V, King of Aragon and Sicily (r. 1414-1424), for example, cites heraldic carpets, among others, including 'those of the Infante'. Further, the sovereign is depicted in his Book of Hours[383] kneeling on a rug ornamented with five sets of Aragon arms. At his court in Naples, Alfonso also maintained one Francisco de Perrera, a 'master of carpet making'.

The Earliest Fragments

Several fragments of Spanish carpets[384] have been found at Fostat, the famous archaeological site in a Cairo suburb, confirming that trade existed between Egypt and Islamic Spain. The oldest of these vestiges date from the 11th century,[385] while the others would range from the 12th century to the 14th. With their pattern of imbricated geometric figures, their Kufic inscriptions praying for health and prosperity, and their identical colors, the pieces bear a marked resemblance to the armorial rugs of 15th-century Spain. The artisans who wove them had clearly found their models in Anatolian carpets, which makes the fragments interesting for the history of Oriental rugs as well as for the history of Iberian ones. They also shed light on lost Timurid and Seljuk rugs. Indeed, the remnants constitute the oldest available evidence of Anatolian and Central Asian designs, given that, apart from 13th-century Seljuk rugs, no work earlier than the 14th century has been preserved.

The So-called 'Synagogue Carpet'

The oldest known Spanish rug dates from the second half of the 14th century, and it is an enigmatic piece, distinguished by a composite

313. *The 'Synagogue carpet'. Spain, late 14th century. Wool pile, wool warp, goat-hair weft; single-warp knot; 303 x 94 cm. Islamisches Museum, Berlin. This enigmatic rug earned its title by virtue of an image of the Jewish Ark of the Covenant thought to be woven into the pattern. Yet, the same image could easily be construed as the Sassanian Tree of Life, since the 'buds' in the border recall Sassanian metalwork. The piece belonged to a small Tyrolean church before it entered the collections of the Berlin museum.*

pattern involving Sassanian-like elements (small beads or 'buds' in the border), an Arabic inscription repeating the name of Allah, and the Jewish Ark of the Covenant, unless this image could be construed as the Sassanian Tree of Life.[386] An isolated work, comparable to no other, this carpet actually poses more questions than it answers.

THE GOLDEN AGE OF
SPANISH WEAVING:
15TH AND 16TH CENTURIES

The 15th century was a decisive moment in the history of Spain, because the political divisions of old disappeared with the marriage of Isabella of Castile (1451-1504) and Ferdinand II of Aragon (1452-1514), who thereby unified the Christian Hispanic kingdoms both geographically and spiritually.

Geographic and Spiritual Unity

In 1492, Ferdinand and Isabella eliminated the Moorish kingdom of Granada, the last Islamic foothold on the Iberian peninsula, thereby making the whole of Spain subject to a single crown for the first time since the disappearance of the Visigothic monarchy in 711. They also set about establishing a single faith, Catholicism, aided in their task by the Inquisition, created in 1478 by Pope Sixtus IV.

For Spain, this cruel and intolerant century was also a period of intense trading activity with countries north of the Pyrenees as well as with those of the Mediterranean basin and the

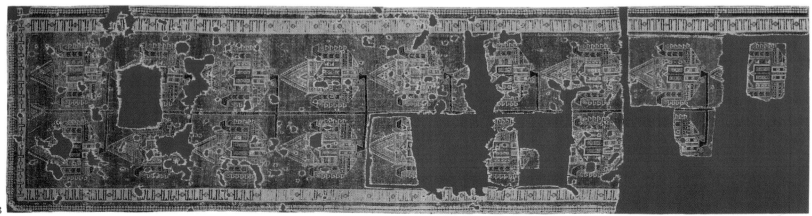

313

Middle East. The trade involved every kind of merchandise: wool and saffron from Spain especially, but also iron, lead, leather, agricultural products, and wine; salt and gold from Africa; cloth and fish from the North; cochineal from Mexico and indigo from Turkey; textiles, colorants, spices, perfumes, precious stones, etc., from the Orient. All these raw materials and luxury goods created wealth not only for the crown but also for the traders and other middlemen who handled the commerce. Agriculture, burgeoning with cereals, vegetables, and wines, and the large-scale transhumant breeding of sheep – a practice controlled by the all-powerful Mesta – contributed to the economic prosperity shared, in one degree or another, by every segment of the population. The nobility and the clergy, lavishly rewarded with vast domains for their contribution to the territorial and spiritual Reconquest, still dominated Spanish society. Finally, the discovery of America by Christopher Columbus helped lay the foundations of a great colonial empire, which for a time would make Spain the most powerful country in Europe.

Foreign Influences

The Gothic style of 15th-century Spain evolved, assimilating influences from Italy, which combined with Mudejar ornamentation to produce the exultant manner known as 'plateresque', seen to brilliant effect in the façade of Salamanca University. Painting, long a dynamic tradition at the various Christian courts, achieved distinction and great fame through the Hispano-Flemish school, whose leading exemplar was Fernando Gallego (active between 1466 and 1506). By the end of the 15th century, painting too succumbed to the Italian model, imported into Spain by Pedro Berruguete (c. 1450-1503). The new technology of movable type and the conquest of Naples by Aragon made the works of Dante, Petrarch, and Boccaccio widely available in Spain. Chivalric romances (*Amadis de Gaule*) and the lyric poems of the *Romancero*, a uniquely original work of Spanish literature, would enjoy wide and long-lasting favor. Clothing, which in the 13th and 14th centuries had borrowed from Muslim attire, cast aside this influence and

THE 15TH AND 16TH CENTURIES IN SPAIN

With the marriage in 1469 of Ferdinand of Aragon and Isabella of Castile, Spain would soon acquire political and spiritual unity. In 1492, the Catholic monarchs eliminated the Moorish kingdom of Granada, the last Islamic foothold on the Iberian peninsula. During the same year, Columbus 'discovered' the Americas and claimed them for the Spanish crown. During the reigns of Charles V (1516-1556) and Philip II (1556-1598), the country reached the zenith of its political and financial power, as well as the pinnacle of its artistic and religious prestige.

moved towards the 'Franco-Burgundian' mode for men, complete with pleated and sometimes fur-lined tunic and puckered sleeves puffed out at the shoulder. Women's fashion was hispanicized, a trend marked by farthingales (hooped skirts), which would be adopted throughout Europe in the 16th century.

The Empire's Prestige and Political Power

Spanish carpets of this period, by their iconographic variety and their technical quality, reflect the multiple facets of Hispano-Islamic civilization, a heritage which in the 16th century would be further enriched by the new Renaissance aesthetic flowing in from Italy.

During the reigns of Charles V (1516-1559) and Philip II (1559-1598), when the Spanish Empire reached the zenith of its political and financial power, as well as its artistic and religious glory, italianization dominated rug design just as it did sculpture (as in the works of Alonso Berruguete, a disciple of Michelangelo) and architecture (examples being the Toledo alcazar, the imperial palace at the Alhambra, and the Cathedral of Granada). The Counter-Reformation launched by Pope Paul III gave birth to a new style, the Baroque, which in Spain assumed the austere though majestic look of the Escorial. However, it had little effect on carpet design. The Spanish monarchy made itself the leading champion of the Catholic faith,

and thanks to the masses of gold and silver imported from the New World, it could play a leading role in the wars not only against Protestants but also against the Turks, climaxing in 1571 at the Battle of Lepanto. The ecstatic painting of El Greco (1541 1614), the new religious orders, such as the Jesuits, and the mystical poetry of John of the Cross and Theresa of Avila exalted the union of the soul with God, doing so with both lyricism and great passion. The art of Spain would be overwhelmingly religious in both form and content.

The Spanish rug of the Late Middle Ages and the Renaissance was iconographically diverse and superb in its technical quality. The 15th-century experience of imitating imported Anatolian rugs gave rise to a series of remarkable and original works – heraldic rugs, Holbeins, 'pomegranate' patterns, and foliage wreaths.

Armorial Carpets

The emblazoned carpets which are known, as well as similar pieces – that is, geometrically patterned rugs without heraldry[387] – were all woven during the 15th century in urban workshops in Lietor, Letur, and Alcaraz. However, fragments dating from the 11th, 12th, 13th, and early 14th centuries, as well as Matteo di Giovanetto's fresco of 1344-1346 in the Papal Palace at Avignon, reveal that heraldic carpets had been woven before the 15th century.

FOUR GROUPS OF CARPETS Within the armorial series four groups can be distinguished:
- Rugs commissioned, between 1416 and 1458, by Alfonso V, King of Aragon and Sicily, and his wife, Maria of Castile, three examples of which survive (Textile Museum, Washington, D.C.; Hispanic Society of America, New York; and the Detroit Institute of Arts). Their palettes are rather somber, typically composed of brick red, dark brown, soft yellow, deep blue, and white.
- Rugs of the Enriquez family, fabricated between 1425 and 1475 and generally known as the 'Admiral carpets'. In 1405, Alfonso Enriquez (1354-1429), uncle of Alfonso V, was invested, as his son Fadrique would be several years later, with the prestigious title of Admiral of Castile. Three rugs survive from this series: that of Maria, the daughter of Alfonso

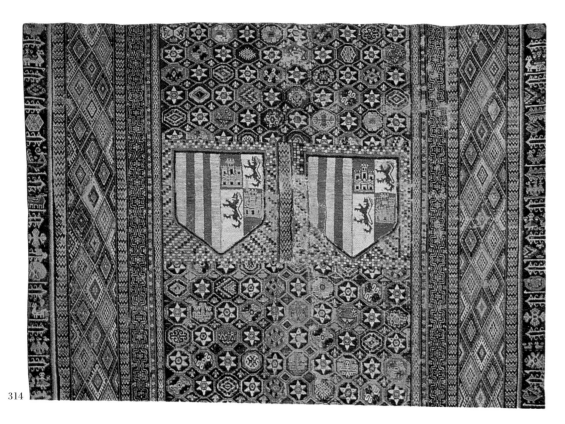

314

314. *Fragment of an armorial carpet. Spain (Letur?), early 16th century. Goat-hair pile, warp, and weft; single-warp knot; 3.96 x 2.23 cm. Textile Museum, Washington, D.C. The heraldry is that of Maria of Castile (1401-1458), the wife of Alfonso V of Aragon and Sicily, who reigned alone while her husband tended to his Italian possessions. The rug was for long preserved at Santa Isabella de los Reyes, a Toledo convent built on property belonging to a friend of the Queen's, Inès de Ayala, prior to its entering the famous Paris collection of the Comtesse de Béhague.*

315. *An 'Admiral carpet' with the arms of Fadrique Enriques. Spain (Alcaraz?), mid-15th century. Wool pile, warp, and weft; single-warp knot; 5.81 x 2.67 m. Philadelphia Museum of Art (Collection Joseph Lees Williams). Fadrique Enriques (d. 1473), Lord of Medina de Rioseco and 26th Admiral of Castile, was the first cousin of King Alfonso of Aragon and Sicily, as well as the grandfather of Ferdinand II of Aragon, King of Spain. The carpet comes from the Santa Clara de Palencia convent, where Fadrique and his first wife, Marina de Ayala y Toledo, were buried. The work seen here represents the 'Admiral' series at its technical and stylistic best. Particularly remarkable are the lateral scenes with the women dressed in farthingales.*

Enriquez, and her husband (Textile Museum); the one made for Fadrique and his first wife (Dade County Art Museum, Miami-Viszcaya); and the third one inscribed only with the arms of Fadrique. They exhibit a growing mastery of ornamentation.

- The rugs inscribed with unidentifiable heraldry (Instituto Valencia de Don Juan, Madrid; Metropolitan Museum of Art, New York; Islamisches Museum, Berlin).
- Finally, rugs with simplified geometric patterns and no escutcheons, two examples of which are owned by the Chicago Art Institute.

The long, narrow field typical of these rugs is articulated by a rigorously all-over honeycomb pattern of tiny cell-like figures, the latter filled with geometric motifs, some of them Anatolian in origin (stars, polygons, *göl*), human figures (*orans*, hunters, riders, women in wide dresses), and beasts (birds and various quadrupeds). The blasons are set forth against this field, like separate islands positioned at regular, repeating intervals.

The borders, numerous and narrow, present a great variety of motifs. The main frieze may be decorated with lozenges reminiscent of certain Moroccan rugs or with pseudo-epigraphy whose strokes are embellished with decorative motifs and picturesque scenes. These last

ARMORIAL CARPETS

Proof exists that armorial carpets were made in Spain before the 15th century in the workshops of the cities of Lietor, Letur, and Alcaraz. The long, narrow field typical of these rugs is articulated by a rigorously all-over honeycomb pattern of tiny cell-like configurations, the latter filled with beasts, human figures, and geometric motifs, some of them Anatolian in origin. The blasons are set forth against this ground like separate islands positioned at regular and repeating intervals. The borders, numerous and narrow, present a great variety of motifs.

became increasingly larger, as shown in the exemplary piece at the Philadelphia Museum of Art. The border, or 'apron', along the two short ends of the rug is a Spanish innovation, its field divided into boxes containing zoomorphic figures, usually bears, wild boars, and sometimes hunters, all set forth under apple trees. The rather brilliant, skillfully managed colors enhance the honeycomb effect and the variety of motifs, while accentuating the play of diagonal lines.

INFLUENCES AND TRADITIONS The poetic verve of this ornamentation, abundant and varied, is the fruit of many influences and traditions inherited from medieval Spain. Anatolia supplied the swastika and *göl* motifs, while the stylized beasts with angular contours originated in such Oriental animal patterns as the one identified with the 'Marby rug', a decorative scheme known in Spain.[388] The honeycomb ground pattern is related to 13th-century Anatolian rugs, like those discovered in the Konya and Beyshehir mosques or even the ones painted by Hans Memling. Kufic inscription was a feature peculiar to Turco-Mongol carpets, which in turn influenced the Mudejar artisans. From Hispano-Moresque art came the Fatima hand and the lozenges decorating the borders. Yet, the picturesque element and the emphasis on animals, bear- and boar-hunting, praying figures, and strong colors sprang from local Iberian tra-

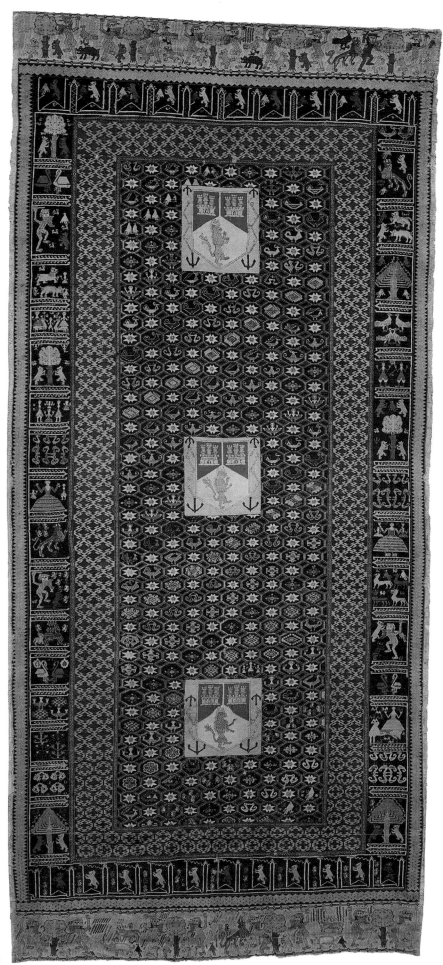

315

ditions, both Visigothic and Christian. The heraldry inherited from the Crusades and the world of chivalry, like the fantastic animals borrowed from bestiaries, carved even in the stone capitals of small Romanesque country churches, partook of the visual language common to the whole of medieval Christian Europe. As for the 'aprons' or lateral borders, with their apple trees, bears, and occasional human figures, they were special to Spanish rugs of this period.

Carpets of the Holbein Type

Often cited in the inventories under the rubric 'wheel rug', the Holbein type carpets are attributed to the workshops of Alcaraz, where they were knotted during the 15th century by Mudejar artisans working from small- or large-pattern prototypes of Anatolian origin.

SMALL-PATTERN HOLBEINS Few small-pattern examples have survived. The one in the Museum of Fine Arts in Boston adheres to the Anatolian tradition with its rows of octagons and stars, its epigraphic strokes in the border enlivened with infinite knots and floriated ornament. As for the Persian influences conveyed by way of Turkey, they can be detected in a piece at the Textile Museum in Washington, D.C. Rows of octagons highlighted with infinite knots were fundamental to the ornamentation of Timurid carpets depicted in 14th- and 15th-century Persian miniatures.

LARGE-PATTERN HOLBEINS The large-pattern Holbeins of Spain present a field divided into one, two, or three vertical rows of octagons within frames against a variously checkered ground. The geometric or floral ornamentation of the borders, which are few in number, remains uniform. The Spanish 'scorpion' motif, which is actually a floral abstraction, would be repeated again and again, whereas the pseudo-Kufic border would make only the rare appearance, except where transformed into a play of ribbons. Also surviving is an 'apron' featuring dogs (Textile Museum). The dominant colors are blue, red, green, yellow, and white.

The design of the central octagon serves as a means of distinguishing three groups of rugs,

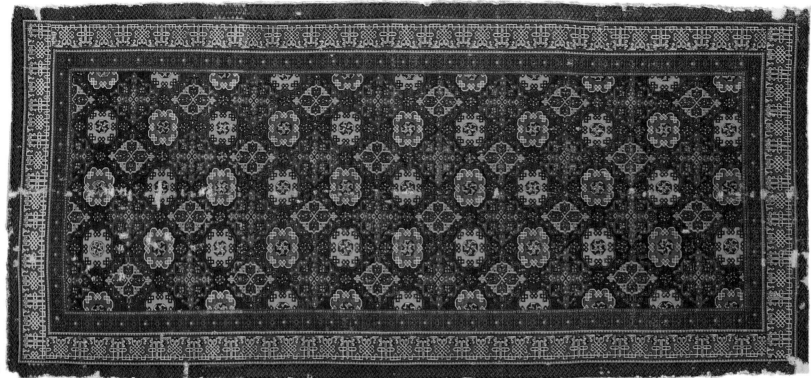

316

316. *Small-pattern Holein carpet. Spain (Alcaraz?), 15th century. Wool pile, warp, and weft; single-warp knot; 4.63 x 2.06 m. Museum of Fine Arts, Boston.* Only a few Spanish carpets of this type have survived. The one seen here adheres to the Anatolian tradition with its rows of octagons and stars, its epigraphic strokes in the border enlivened with infinite knots and floriated ornament. Persian influence, conveyed by way of Turkey, can be detected in the octagons highlighted with infinite knots, elements fundamental to the ornamentaion of Timurid carpets depicted in 14th- and 15th-century Persian miniatures.

317. *Large-pattern Holbein carpet. Alcaraz, mid-15th century. Single-warp knot. Victoria and Albert Museum, London. Goat-hair pile, warp, and weft; single-warp knot; 181 x 96 cm. Textile Museum (Elizabeth H. Flint Foundation, in memory of Sarah Gore Flint Townsend; acquired by G.H. Myers in 1931), Washington, D.C.* This pattern, with its eight-pointed star embellished with infinite knots and interlace, recalls carpets depicted in 15th-century Persian miniatures, the Kufic epigraphy of borders on Anatolian Holbeins, and Hispano-Moresque ornamentation. The pattern characterizes one particular subgroup of Spanish Holbeins.

318. *Large-pattern Holbein carpet. Alcaraz, 15th century. Single-warp knot; 2.74 x 1.55. St. Louis Art Museum.* The surviving examples of the Holbein subgroup represented by this rug are relatively numerous, all more or less marked by octagons with a small central star formed as a wheel encircled by eight palmettes. The all-over ornament of the field betrays a tendency towards schematization.

319. *Large-pattern Holbein. Alcaraz, 15th century. Single-warp knot. Victoria and Albert Museum, London.* In the borders of Spanish Holbeins the 'scorpion' motif, which is actually a floral abstraction, would be repeated again and again. The richly decorated sixteen-pointed star with an octagon is a defining feature of yet another subgroup of Spansh Holbeins. Although originally Anatolian, the pattern has come down to us only in Spanish rugs.

the first of which boasts a richly decorated sixteen-pointed star within its octagon. An archetype of this motif graces two Anatolian rugs depicted by Carlo Crivelli, one in the *Annunciation* of 1486 at the National Gallery in London, and the other also an *Annunciation*, this one owned by the Städelsches Kunstinstitut in Frankfurt. In the second group, the eight points of the star are embellished with the infinite knot and interlace recalling the patterns of rugs portrayed in 15th-century Persian miniatures,[389] the Kufic epigraphy of borders on Anatolian Holbeins, and Hispano-Moresque ornamentation, as in the stuccowork at the Alhambra. Similar Anatolian carpets were depicted at the end of the 15th century by Crivelli, Huguet, and Carpaccio,[390] none of which has come down to us. The more numerous rugs of the third group, some of whose Anatolian antecedents do survive, sport octagons with a small central star formed as a wheel encircled by eight palmettes. The borders retain the same pattern found in the two other groups, although marked by a tentative simplification of the geometric motifs.

Pomegranate or Lattice Patterns

By the second half of the 15th century, Spanish art was taking a new turn, gradually moving away from the geometric style inherited from Islam, and prolonged through the Gothic

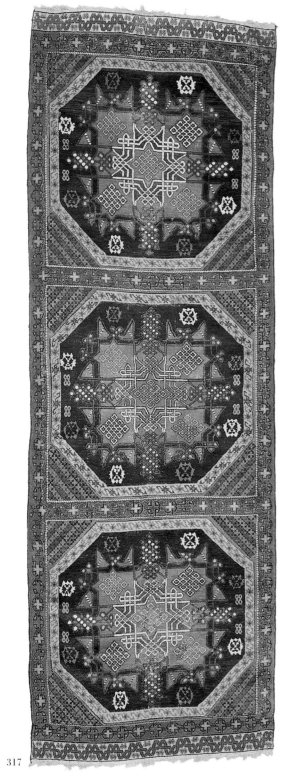

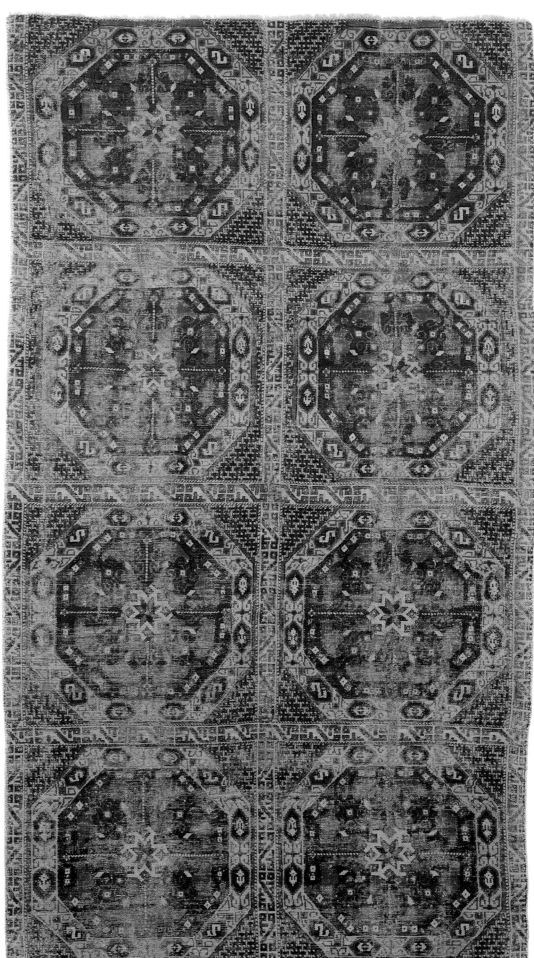

317

318

319

period, towards a Renaissance aesthetic. The stylistic evolution is particularly evident in ceramics, fabrics, and rugs, where the novelty consisted of imitating the motifs and colors of Italian silks, brocades, and velvets. This was not an isolated phenomenon but rather a pan-European or Mediterranean development, since the pomegranate figure, flanked by a pair of palmettes and subsumed in an ogival or lattice pattern,[391] can be found in Italian, Ottoman, and Flemish as well as Spanish textiles. In Spain, the production came from Alcaraz and perhaps Letur, its iconography inspired by textile motifs and then interpreted in various ways. The central design, for instance, could be a sheaf of leafy stems, sometimes supporting a bird, a pair of affronted lions (Victoria and Albert Museum), or a blossom (Victoria and Albert Museum). The colors are brilliant and sumptuous with a predilection for red, as in the remarkable specimen at the Metropolitan Museum in New York, but also for white and yellow, in combination with green for the ogival

320. Fragment of a carpet with Gothic forms and thistle motifs. Chinchilla or Alcaraz. 48.2 x 55.8 cm. Victoria and Albert Museum, London.

321. Tapestry with a scene of King David receiving Bathsheba at his palace. Brussels, c. 1515. Wool with silk and gold thread. Royal Palace, Madrid. The figures stand on a carpet strikingly reminiscent of Spain's 'pomegranate' pattern, as in the carpet preserved at the Metropolitan Museum in New York, which displays the same bright red ground. Given that Spain and Flanders were long united under the same crown, its seems strange that Spanish textiles and rugs have had so little influence in northern Europe.

322. Carpet with pomegranate motifs. Letur or Alcaraz, late 15th century. Single-warp knot, 2.54 x 1.52 m. Musée Historique des Tissus, Lyons. Repaired, albeit with its own pieces, this rug, with its 'apron' and its border desgn, harks back to the armorial carpets, at the same time that the field ornament of pomegranates and palmettes subsumed into a lattice reflects the Renaissance. Spain's pomegranate pieces display the remains of a once powerful chromaticism, here evident in green and blue on a pale yellow ground. The best known works in the group are dominated by deep, brilliant red.

321

trellis or lattice, blue for the palmettes, and green and ivory for the pomegranates. During the second half of the 16th century, the pomegranate theme would evolve and give birth, in the Alcaraz workshops, to a dozen purely Renaissance works, displaying, along with the pomegranate, crosses, bouquets in vases, and candelabra-like motifs. The lattice is woven in luminous blue on a yellow or orange ground, or sometimes yellow on a red ground (Hispanic Society of America), or yet salmon or coral (Philadelphia Museum of Art) or even cream on a blue ground. The shades of red obtained from Mexican cochineal, and sometimes misused, have faded into orangy and tan tones. The powerful chromaticism of Spanish carpets woven in the 15th century and the early 16th has disappeared, the number of colors reduced to the point of bitonality and even monochromy, perceptible in this series and quite symptomatic of the wreath rugs.

Wreath Designs

The wreath pattern emerged from the Holbein octagons, while also echoing the Renaissance wreaths and garlands in the enameled terracottas of the Della Robbias in Italy. Knotted at

THE RENAISSANCE AESTHETIC

Midway through the 15th century, the geometric style inherited from Islam slowly disappeared from Spanish carpets and gave way to the kind Renaissance aesthetic then spreading throughout Europe. The central design could now be a sheaf of leafy stems, sometimes supporting a bird, a pair of affronted lions, a blossom, or a pomegranate. Unfortunately, few of the flaming colors have stood the test of time, owing to an incorrect use of new dyes, such as Mexican cochineal, as well as to the loss of expertise which came following the expulsion of Muslim weavers and Jewish dyers.

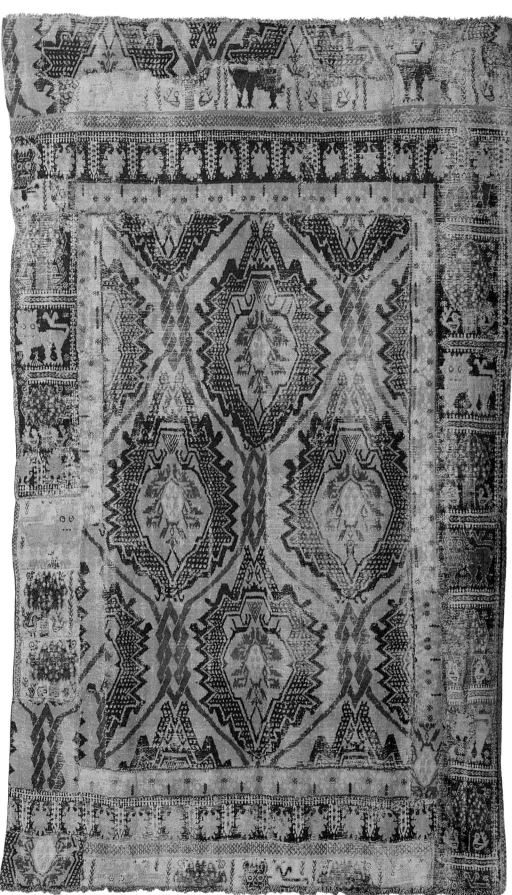

322

Alcaraz and Cuenca in the 16th century, they proved enormously successful.

These rugs are ornamented with double wreaths whose leaves, punctuated by four rosettes, form a wide circle around arabesques radiating from a central 'Anatolian' octagon. In the second half of the century, some of the wreath carpets became totally Renaissance in character, with essentially floral wreaths, large flowers in full bloom, and a beautiful arabesque of affronted dragons. The wreaths, in several late examples, surround a human-faced lion or vases decorated with flowers and birds. Atypically, there may also be two wreaths embellished with flowers and funerary urns.

The quality of the execution and the dyes varies considerably in this series, depending on the place of manufacture, of course, but even

more on the loss of expertise which came following the expulsion of the Muslim weavers and Jewish dyers. The color of the warps – red, no doubt a characteristic of Alcaraz, and yellow, the mark of Cuenca – has prompted some specialists, among them Bellinger, to assign several wreath carpets to the Cuenca looms.

THE 17TH CENTURY

A Period of Decline

By the 17th century Spanish carpet making had run out of steam, which led to a drying up of demand and the failure of numerous ateliers. The origin of this decline can be traced to the

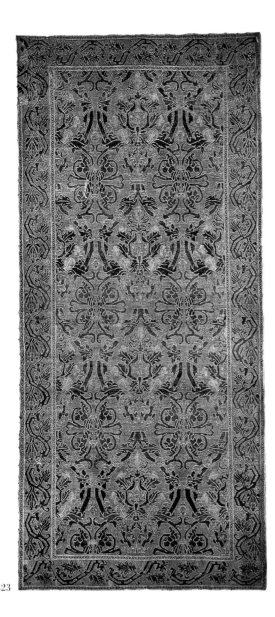

323

323. Carpet with pomegranate motifs. Late 15th century(?). Victoria and Albert Museum, London. The lattice field design with its rows of pomegranates and the border embellished with crosses and arabesques constitute the essential features of the pomegranate group.

324. Carpet fragment with wreath pattern. Alcaraz, early 16th century. Goat-hair pile, warp, and weft; single-warp knot; 2.33 x 1.14 m. Textile Museum (acquired by G.H. Myers in 1918), Washington, D.C. This piece and another in the Victoria and Albert Museum figure among the oldest known works from the group of Spanish carpets patterned with foliage wreaths, punctuated by rosettes, forming a wide circle around arabesques radiating from a central 'Anatolian' octagon.

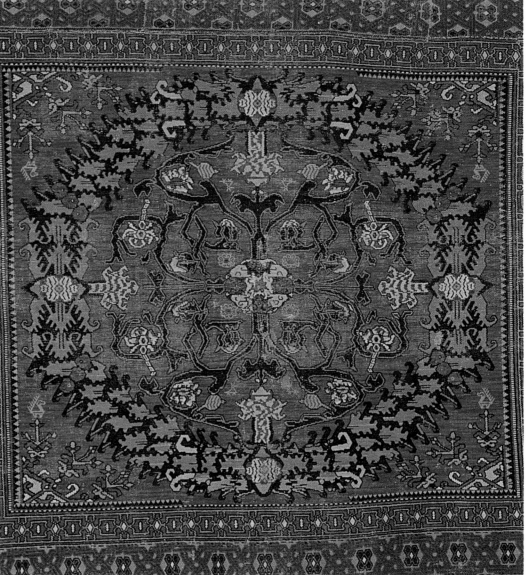

324

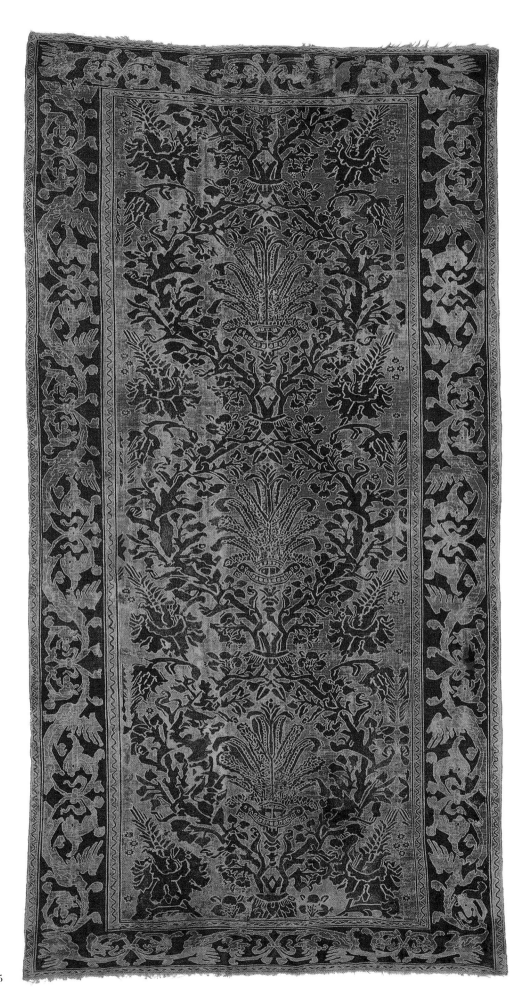

326

325. *Carpet with wreath pattern. Alcaraz or Cuenca, late 16th century. Wool pile, warp, and weft; single-warp knot; 3.05 x 1.63 m. Private collection. In the second half of the 16th century some of the wreath carpets became totally Renaissance in style, with essentially floral crowns, large, full blooms, and beautiful arabesques of affronted dragons.*

326. *Rug fragment with wreath pattern. Alcaraz or Cuenca, mid- or late 16th century. Goat-hair pile, warp, and weft; single-warp knot; 2.33 x 1.14 m. Musée Historique des Tissus, Lyons. The 'Franciscan cord' motif, so beloved by Queen Isabella I, a devout Catholic, appeared frequently in 15th- and 16th-century Spanish art, including carpets like this one. Here it divides the field from the border, the latter ornamented with candelabras, motifs typical of the Renaissance. The palette of contrasting colors – red and blue-green, but in other works, dark green on light green, green on a yellow ground – is a distinguishing characteristic of the wreath series.*

325

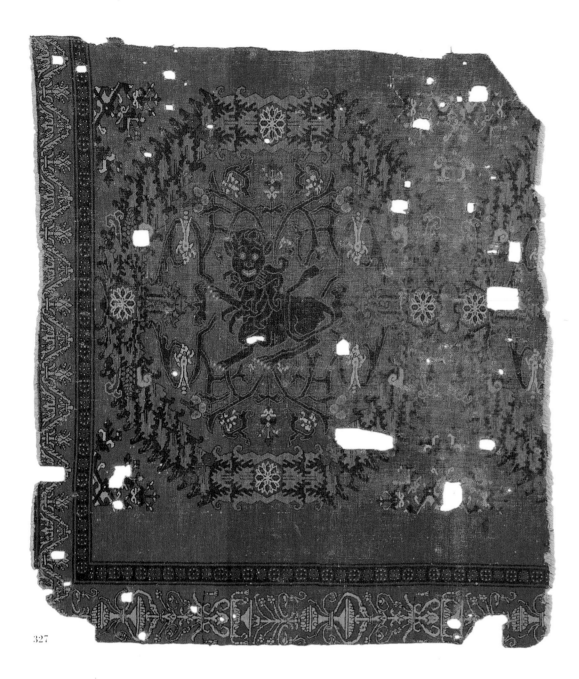

327

327. *Carpet fragment with wreath pattern. Alcaraz(?), 16th century. Wool pile, warp, and weft; single-warp knot; 1.31 x 1.16 m. Islamisches Museum, Berlin. The wreaths in several late examples surround a human-faced lion, a motif surprisingly more related to the Gothic period than to the Renaissance.*

328. *Carpet with a Lotto pattern. Cuenca, 17th century. Symmetrical knot, 4.20 x 2.40 m. Private collection. Based on the iconography of the Anatolian Lottos, the field pattern consists of stylized arabesques in a grid-like arrangement and, near the interior border, an array of birds, quadrupeds, and female orans clad in wide skirts. Overall, the pattern echoes the famous armorial carpets of 15th-century Spain. In the main border, however, the Renaissance asserts itself in a repertoire of arabesques punctuated with candelabras and serrated leaves. As this would suggest, the Spanish carpet derives from and reflects several different sources, always, however, interpreted in an idiomatic manner. That such reliance on established prototypes should continue into the 18th century proves that carpet design in Spain had stagnated, for the want of creative energy and imagination.*

loss of skilled weavers and dyers as well as to an ossification of the design process. Motifs had become standardized, without variety, and notable primarily for an aesthetic trapped in retrograde Anatolian and Renaissance imitations, leaving little room for real innovation. The Spanish knot was abandoned during the second half of the century in favor of the more rapidly executed symmetrical knot. This grave crisis marked a definite turning point in the history of the Spanish rug, which, in the following century, was to become resolutely European. None of it would happen, however, without the patronage of both the state and private individuals.

Yet, while the nation's rug industry was collapsing, Spain entered a golden age of painting, a period in which El Greco continued to achieve mystical wonders, even as Zurbarán, Ribera, and Murillo triumphed by combining faith with realism. Also in his glory days was their great contemporary, Diego Velázquez, very likely the most accomplished court painter of all time. Despite political decay, owing to the weakness and sometimes even the debility of the Habsburg monarchs, despite the financial ruin of the state, brought on by past wars, and the population drain, induced by the expulsions, of course, but also by emigration to the Americas and by plague, 17th-century Spain could also display extraordinary brilliance in the world of letters, dignified by the works of Lope de Vega, Calderón, and the population drain, iSpain displayed no less genius in the major visual arts, marked by that unity of a dramatically chiaroscuro style known as 'tenebrism' or 'realist mysticism'. The opportunity for artists to excel sprang in large part from the determination of the three last Habsburg Kings – Philip III (r. 1598-1621), Philip IV (r. 1621-1665), and Charles II (r. 1665-1700) – to complete the Escorial Palace, the Retiro Gardens, and the various religious foundations. Also important was Rome's proclamation of the dogma of the Immaculate Conception, which would inspire not only the painting of Murillo but also much popular imagery.

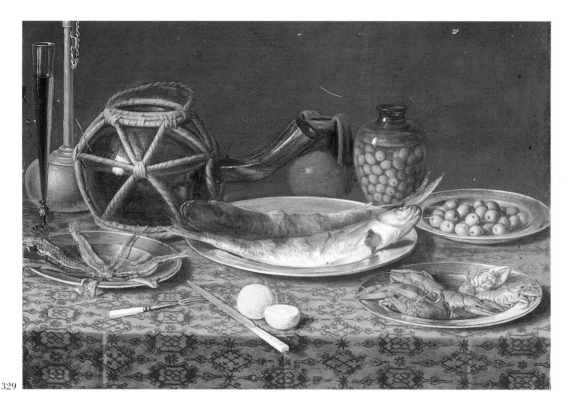

329

330

331

Failure of Imagination

When it came to pile carpets, however, 17th-century Spain displayed little imagination or sparkle. Other than faithful copies of Anatolian Ushaks (Museo Diocesano, Cuenca), court pieces (Victoria and Albert Museum), and prayer rugs of the 16th and 17th centuries (Glasgow Art Gallery Museum), Spanish rug makers wove, on the whole, no more than three types of pattern.

The stylized arabesque pattern of the Anatolian Lotto was widely and repeatedly undertaken during the 16th and 17th centuries by the artisans of Cuenca, and no doubt by those of Alcaraz as well. The designs, so rich in novelty at the beginning of the period, went through a process of simplification, becoming a series of lacy, indented crosses or double lozenges which tend to evoke ceramic tiles of the first half of the 16th century.

The 'pomegranate' or lattice rug, attributed to Cuenca, also evolved, now into a dense composition with a palette oriented towards mustard yellow and turquoise.

In Spain, rugs were also created for specific purposes. For example, the Cuenca workshops provided covers for the coffins of Jesuits during funeral services. These works conformed to a precise iconography, consisting of hour glasses, skulls and bones, phoenixes (symbols of immortality), and Latin texts: *Ex menet renascor* and *Victoria doctis* ('I shall rise from my ashes'; 'Victory to the scholar'). All reminded the living of life's brevity and the importance of reflection and knowledge, while also evoking the promise of resurrection.

329. *Still Life. Spanish school, 18th century. Oil on canvas. Christie's sale, London, 31 March 1989. Here a carpet in the Anatolian Lotto style covers a table set with a typical Spanish still life, a bodegon or cluster of 'edibles', treated with the spare, unadorned, factual realism that has always been the glory of Spanish still-life painting. Nothing could be further from the French and Dutch schools of still-life art, with their lavish displays of fruit, venison, and fine plate.*

330. *Ceramic revetments, Casa de Pilata, Seville. 15th or early 16th century. Photo: B.Marrot. As the name demonstrates, Lotto carpets were often depicted by European painters during the Renaissance. Their motifs turned up as well in other media, such as the sumptuously eclectic tile revetments at the Casa de Pilata built in Seville for the Duke of Medinacelli around the turn of the 16th century.*

331. *Spanish Lotto carpet. Cuenca or Alcaraz(?), 17th century. Wool pile, warp, and weft; single-warp knot; 2.31 x 2.09 m. Textile Museum (acquired by G.H. Myers in 1940), Washington, D.C. The Spanish Lotto pattern, so rich in novelty at the beginning of the period, went through a process of simplification, to the point, finally, of ossification.*

333. Funerary carpet. Spain, 19th century. Symmetrical knot, 3.51 x 1.91 m. Private collection, Paris. Hour glasses, skulls and bones, phoenixes (symbols of immortality), and Latin texts figure prominently in the repertoire of emblems used in Spanish carpets designed to cover coffins. Two rugs similar to the one seen here are preserved at, respectively, the Victoria and Albert Museum in London and the Textile Museum in Washington, D.C. The brilliance of the colors, such as strong blue against brown and yellow with white contouring or highlights, reflects the Spanish taste for splendid religious ceremonies, even funereal ones.

332

332. Carpet with a pomegranate pattern. Cuenca, 17th century. Symmetrical knot. Museo Diocesano, Cuenca. Like the Spanish Lotto, the pomegranate or lattice rug also evolved, this time into a dense composition with a palette oriented towards mustard yellow and turquoise. A remarkable collection of Spanish carpets, liturgical objects, and paintings is owned by the Diocesan Museum in Cuenca, Murcia province.

333

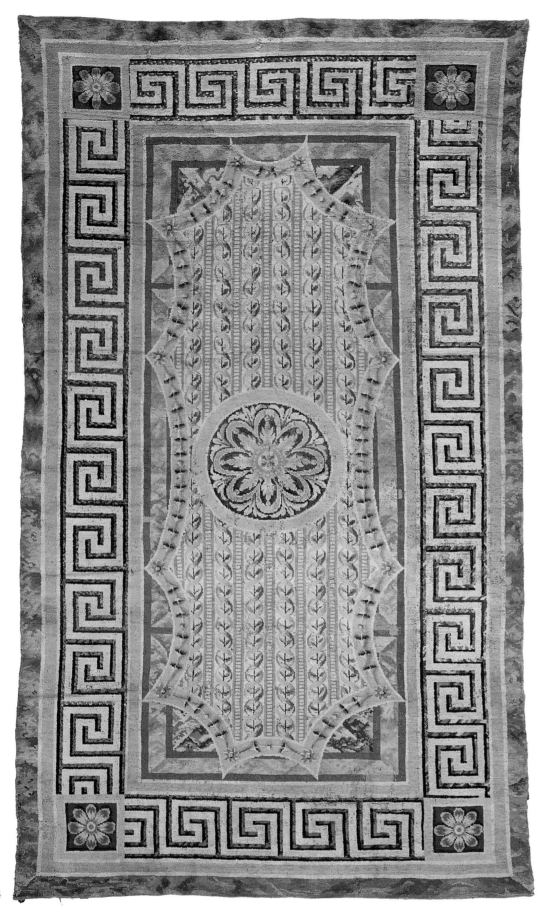

THE 18TH CENTURY

Cultural and Economic Resurgence

The death of the childless and invalid Charles II in 1770 caused a major dynastic shift in Spain, from the Spanish Habsburgs to the Bourbons of France. The Duc d'Anjou, crowned Philip V of Spain (r. 1700-1746), was a grandson of the Infanta Maria Teresa and Louis XIV, which meant that he had been reared at Versailles, for which he would always retain a deep nostalgia. Dedicated to the concepts of enlightened despotism as well as to the artistic tastes and politics of the Sun King, Philip, once arrived in Spain, launched an era of stability and a remarkable cultural and economic resurgence, all of which would be extended by his two successors to the throne. The French and Italian artists summoned to Madrid, the former by the King and the latter by his second wife, Elisabeth Farnese, developed a court art with cosmopolitan sophistication. The academies created after the French model and the construction of palaces, such as the Palacio Real in Madrid and the Granja Castle, monopolized the talents of architects (Sachetti, Juvara), painters (Van Loo), sculptors, cabinetmakers, and carpet weavers. After Ferdinand VI (r. 1746-1759) founded the Academia de San Fernando, Neoclassicism became the style of the day, especially in architecture (Prado, Madrid) and interior design, including carpets. Under Charles III (r. 1759-1788), an absolutist monarch given to traditional values, religious painting loomed large in all the big projects, except in the Madrid palace. Even so, a new tendency pushed to the fore, representing an interest in scenes of everyday life and behavior of the Spanish – all subject matter dear to the great Francisco Goya. This master designed many tapestry cartoons which were then woven by the Madrid ateliers, among them La Real Fabrica de Tapices situated at the Santa Barbara gate, but he seems never to have designed a rug.

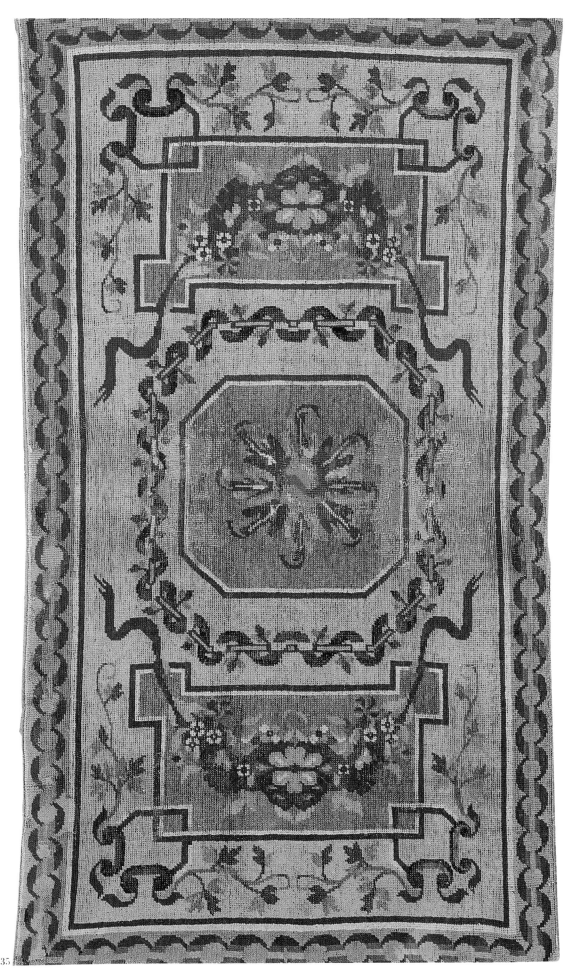

336

334. Carpet in the Neoclassical style. Spain, late 18th century. Wool pile, cotton warp, wool weft; symmetrical knot; 5.35 x 3.12 m. Christie's sale, London, 8 December 1994 (formerly Houghton Hall collection). The Neoclassical vogue sweeping across Europe in the late 18th century did not halt at the Pyrenees, which Jean Démosthène Dugourc and François Grognard, two of France's leading carpet designers, crossed in order to fulfill a commission for the flamboyant Duchess of Alba. The rug reproduced opposite reflects their decorative innovations, especially the delicate parchment of the field and the faux-marbre theme.

335. Carpet with a classic European pattern. Cuenca, 18th century. Wool pile, hemp warp, wool weft; symmetrical knot; 2.67 x 1.47 m. Private collection. The urban workshops of 18th-century Spain wove mainly classic designs, among which central medallions, ribbons in billowing bows and streams, and flower garlands proved enormously successful. An important atelier for these patterns was that of Gaspar Carrion in Cuenca, where today the Museo Diocesano owns a representative piece.

336. Carpet with clerical attributes. Cuenca, 18th century. Symmetrical knot. Museo Diocesano, Cuenca. In this important weaving center, the clergy traditionally ordered rugs featuring their attributes and arms.

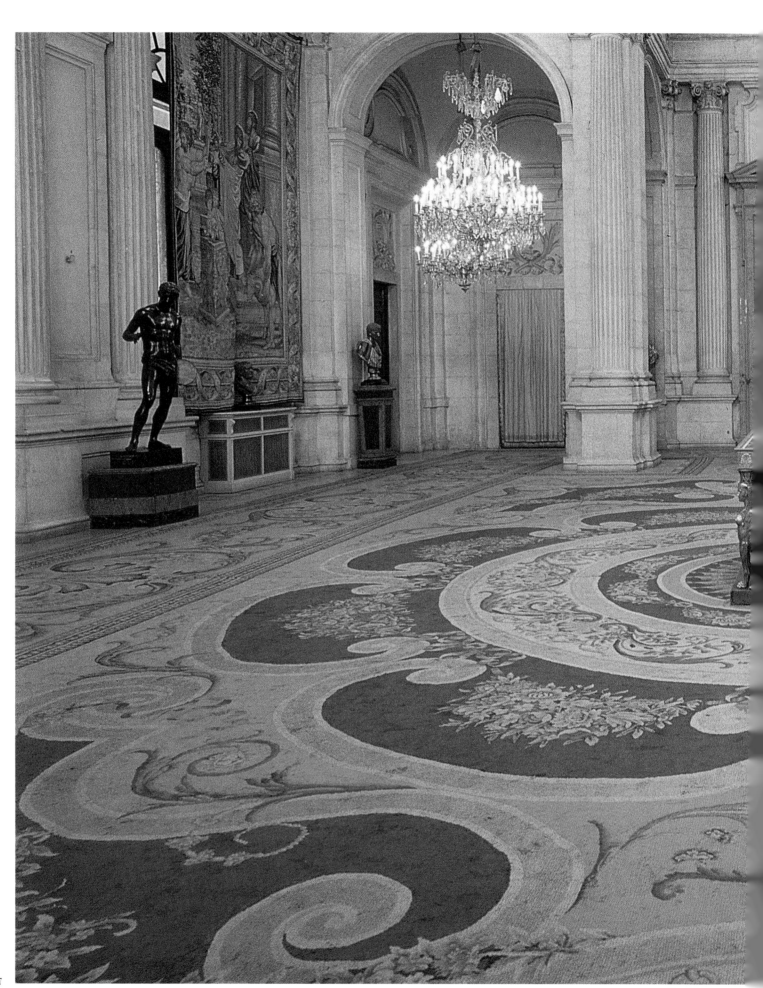

*337. Hall of Columns,
Royal Palace, Madrid.*

337

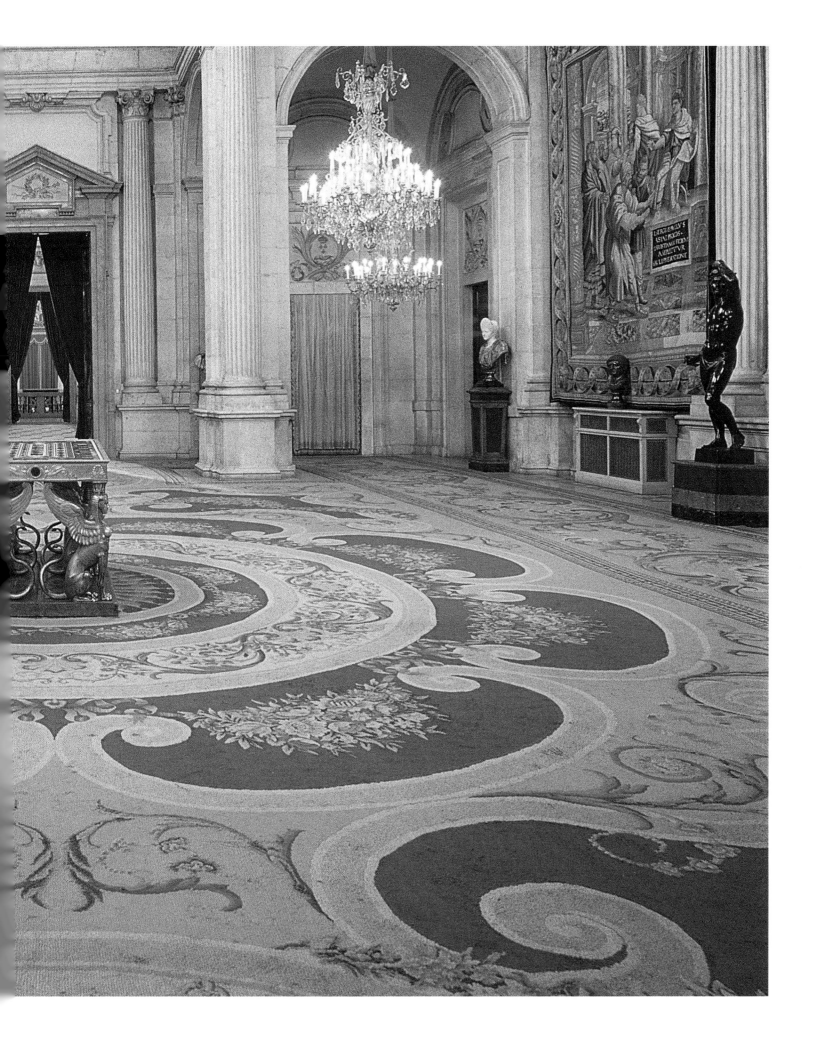

A Royal Workshop

338. *Carpet with a dove pattern. Early 20th century. Wool pile, cotton warp, fiber weft; symmetrical knot; 3.50 x 3.10 m. Private collection. The Savonnnerie carpets for the Louvre Grande Galerie were the model for the large acanthus leaves and egg-and-dart frieze in this late work. Symbols, such as the dove bearing initials, found an appreciative public in Spain.*

339. *Drawing room, March Palace, Palma de Mallorca. The series represented by the carpet seen here remained popular throughout the reign of Charles IV (1788-1808), which kept the urban workshops of Spain busy, especially those of Cuenca, where this rug was woven.*

In the 18th century the urban workshops in the big Spanish cities turned their backs on the Islamic and Mudejar past and, at the initiative of Charles III and Charles IV (r. 1788-1808), worked for the royal palaces in Madrid and at the Escorial. The Real Fabrica de Tapices, founded in Madrid in 1712, won renown with the designs of Livinio Stuyck, and the many rugs knotted at the Real Fabrica from then on until the 20th century may very well be inscribed with the maker's name and the date of manufacture. Among the old workshops, those of Cuenca, which were still active, contin-

A ROYAL PRODUCTION

In 1712, Charles III, a Bourbon reared at Versailles, founded the Real Fabrica de Tapices in Madrid. Thereafter the urban workshops of Spain turned away from the Islamic and Mudejar past and worked for the royal palaces in Madrid and the Escorial. Patterns were drawn mainly from the pool of European iconography, and such classic designs as the central medallion, ribbons in billowing bows, and flower garlands proved enormously successful.

ued to produce thanks to Charles III, the Archdeacon Alfonso Palafox, and the artisan Gaspar Carrion. The workshops of Valencia too enjoyed a fine reputation.

The symmetrical knot was now the only one used. Patterns were, on the whole, drawn from the pool of European iconography, while the rugs of the Savonnerie were actually imitated. The classic designs, with a medallion at the center, ribbons in billowing bows and streams, and flower garlands proved enormously successful. These models were fabricated in great numbers at Cuenca, particularly in the ateliers and the craft school founded by Gaspar Carrion.

The floral designs were ordered for the most part by the court, the nobility, the bourgeoisie, and the religious institutions. The clergy appear to have been particularly fond of rugs, for there are many surviving examples inscribed with ecclesiastical heraldry, attributes, and symbols (vases, lilies, etc.).

Colors are again varied and bright, with a tendency towards red – rasberry red especially – mustard yellow, aqua, blue verging on turquoise, and blue combined with golden yellow.

After the 18th century, the sources of inspiration ran dry, and the patterns woven in the 19th and 20th centuries merely reproduced those of earlier periods. Once again, the large acanthus leaves in the Savonnerie's ninety-three rugs for the Grande Galerie at the Louvre served as a model, and continued to do so right into the 20th century.

338

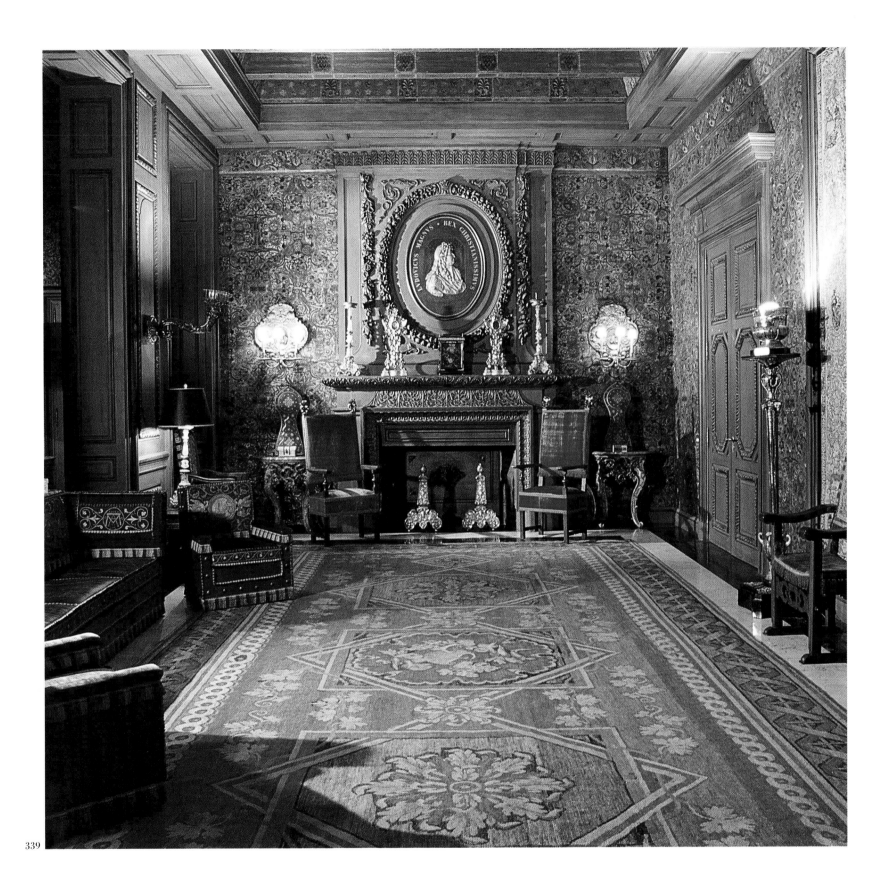

339

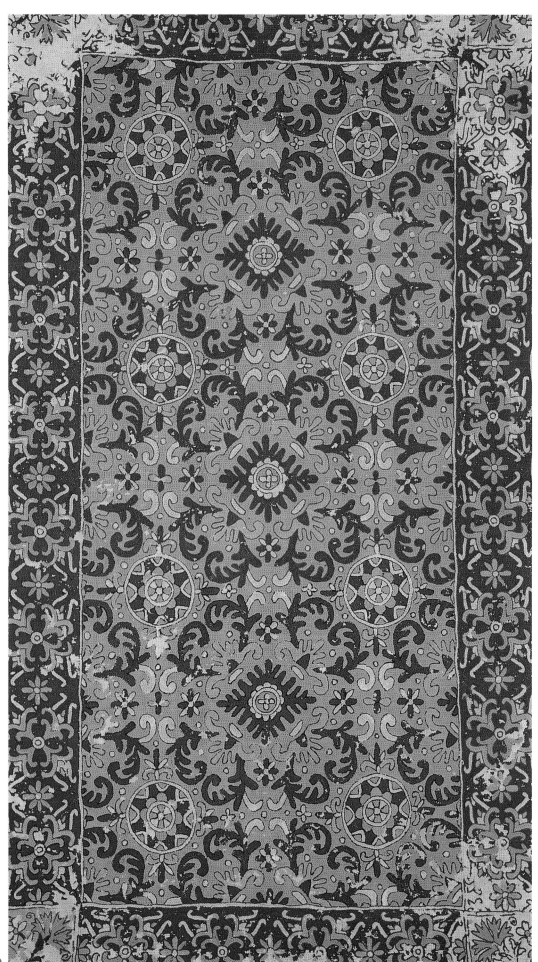

340

THE PORTUGUESE CARPET

Art of the Picturesque

In Portugal the Islamic overlords departed earlier, in the 12th century, and had less impact than in Spain, and while it was certainly the Arabs who introduced knotted-pile carpets into the region, the art of making them quickly evolved, producing refined and picturesque works with a specifically Portuguese character. The iconography of Portuguese rugs has scarcely altered over the centuries. Further, the more ornamental styles did not really take hold in this culture, and to the degree they did, the design of motifs and the number of colors underwent notable simplification.

A Window on the World

The maritime explorations of the 15th century,[392] the colonization of Brazil, and, beginning in the 16th century, the trading relationships with the Indies, China, and Japan opened the world to the Portuguese. The fleets returned to Lisbon laden with spices, Indian cottons, Gujarat rugs, and both lacquers and porcelains from China and Japan. Such prosperity proved favorable to the arts, evident in the Manueline ornamentation which, during the 16th century, spread its abundance and originality over the façades of palaces and religious buildings of Belem and Tomar. In the 17th century the Italianism of the Counter-Reformation and the advent of the Baroque opened the way to the Rococo, which would come in the following century. Meanwhile, rugs were embellished with a few animal figures, occasionally Moghul flowers, or themes from Persian carpets.

The origins of rug making in Portugal remain obscure, mainly because of the late dates of the surviving works. Indeed, the oldest known Portuguese carpets are attributed to the 16th and 17th centuries, and not until 1704 is there an inventory with an entry using the precise term 'Arraiolos rug'. However, there are no clues by which to establish with certainty when such work began, the origin of the first artisans, or the reasons for choosing the embroidery technique. Portuguese carpets are

for the most part needleworked rather than knotted, and flatwoven rugs are also rare.[393]

Knotted-pile carpets, however, were known in 12th-century Portugal, as indicated by a document of 1124[394] noting a purchase of Spanish carpets. Had the Muslims, who were finally driven out in 1139 by Alfonso I Henriques (1110-1185), set up rug-weaving workshops? Did the ateliers traditionally associated with the Portuguese court actually exist? Or were the rugs made by Muslims expelled from Lisbon in 1496 by Manuel I? And is it possible that while taking refuge for a while in Arraiolos, a small village east of the capital, these same Muslims introduced the art of embroidered carpets and a repertoire of Persian motifs? It has also been suggested, without, it would seem, much scientific basis, that the rugs originated in nunneries.

Arraiolos Carpets

The so-called 'Arraiolos' rugs were produced by the ateliers in Arraiolos and neighboring villages, as well as in convents and sometimes even in prisons located in Lisbon and the surrounding area. An additional source of production, and not a negligible one, were the domestic looms, worked by women or by men. This production reached its peak in the 17th century, but it continues today. Other ateliers grew up in the region of Oporto, their actual beginnings as unknown as the others, but the products are immediately recognizable by the fineness of their execution.

<div style="border:1px solid">

THE ARRAIOLOS CARPETS OF PORTUGAL

The earliest known inventory reference to a so-called 'Arraiolos' carpet dates from 1704. Made in the eponymous village near Lisbon, Arraiolos rugs are pileless, needlework pieces with colorful designs featuring zoomorphic and botanical motifs. The technique involves wool and silk cross- and stem-stitched on a canvas foundation made of heavy linen, hemp, or jute.

</div>

341

342

340. *Needlework carpet. Arraiolos, Portugal, 17th century. Cross stitch on canvas, 2.50 x 1.40 m. Museu Nacional de Arte Antiga, Lisbon. The motifs in this Portuguese work relate not only to Hispano-Moresque tile revetments and traditional Portuguese tile designs but also to the geometric patterns of Anatolian carpets.*

341-342. *Loggia de la Casa do Fresco, Quinta da Bacalhoa, Azeitao, Portugal. The Quinta da Bacalhoa – built for Bras de Albuquerque, son of the Viceroy of the Indies – boasts a towered Renaissance pavilion in the Moroccan manner and a portico like those of Indian palaces. The azulejos illustrated here figure among the very oldest in Portugal, which explains their Islamic quality, a element of Portuguese life that perished midway through the 16th century.*

The rugs are worked in cross stitch in both wool and silk thread on a canvas foundation made of fairly heavy linen, hemp, or jute from India. The cross stitch was a popular technique, quick and simple to execute, and employed, for example, in the Balkans and in Morocco. On the Iberian peninsula it was used as early as the 12th century, as we know from a tapestry preserved at the Astorga convent in Spain, a work embroidered in red silk on linen,[395] and decorated with sheep and lions. Portuguese fragments from the 14th and 15th centuries[396] display the same technique, along with polylobate and stellate motifs characteristic of rugs made at the end of the 16th century and the beginning of the 17th. The Portuguese used an elaborate form of cross stitch, emphasizing certain features such as the borders and the contour lines around motifs. In the 17th century, the cross stitch became smaller and

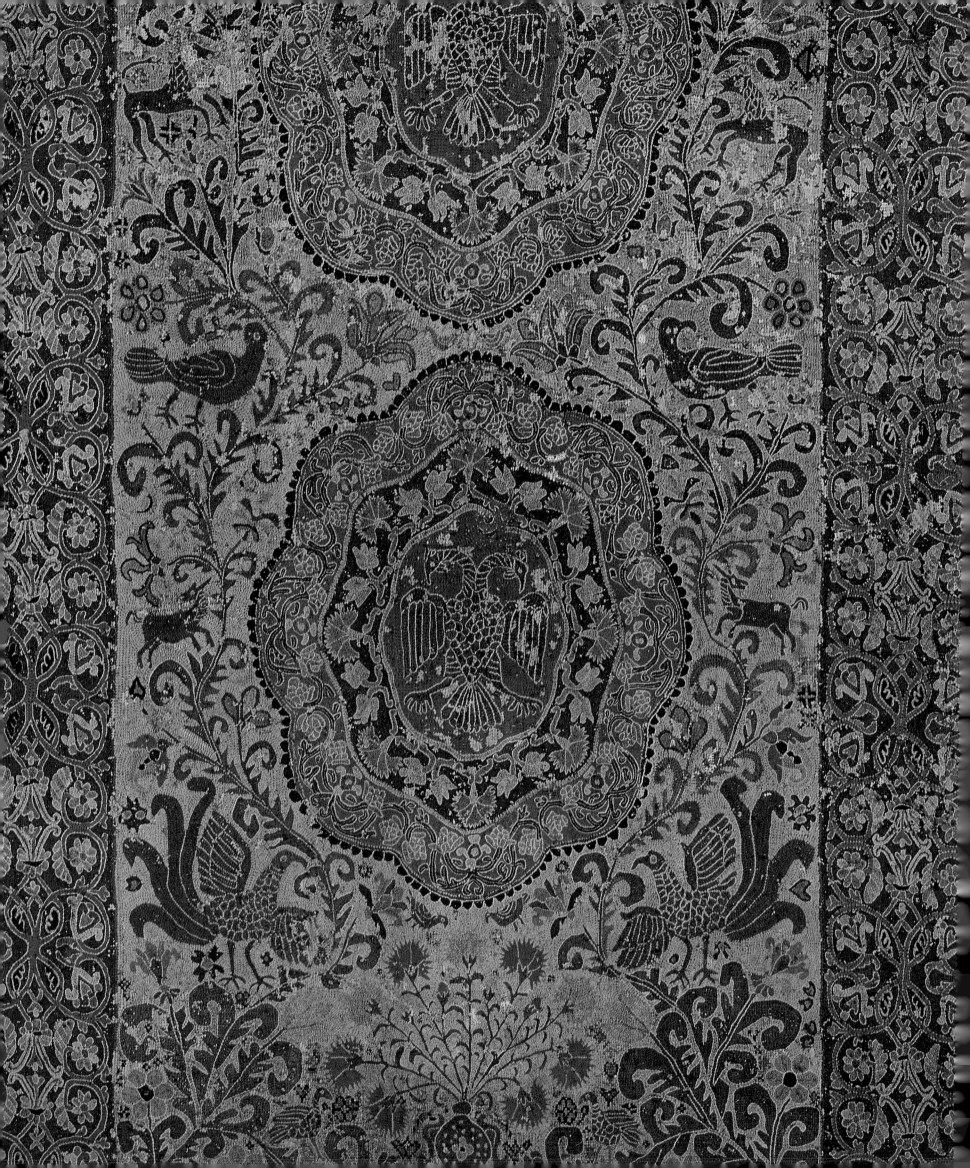

enriched with the stem stitch. A century later this element would disappear and the stitch become heavier. Fringes, along two sides but also sometimes on four, are short and made separately on a small loom or by crochet.

The patterning of Portuguese carpets tends towards homogeneity, the decorative schemes beautiful but little varied and repeated endlessly throughout centuries. Still, the zoomorphic and botanical motifs allow a certain inventiveness, thanks to their number and their picturesque qualities. The bird images, particularly the peacocks, came from the Moghul repertoire, known by the Portuguese from all the objects, fabrics, Gujarat rugs, ceramics, and metalwork imported by their trading companies.

Influence from Abroad

The oldest preserved rugs present a field and a single border decorated with rosaces and both polylobate and stellate motifs, the latter separated by foliage and small fleurons. These motifs are close to those figuring on Hispano-Moresque ceramic tiles and echo from afar the geometric vocabulary of the Anatolian carpet.

The floral style, with its obvious influence from India,[397] came next, yielding works ornamented with flowering arabesques adorned with beasts or birds, images which still remained rare at the outset of the 17th century. The principal colors are deep blue-green, light blue, brick red, and various shades of yellow.

Beginning in the second half of the 17th century, Portuguese weavers made numerous copies of 16th- and 17th-century Persian but relatively few of Anatolian and Caucasian rugs. The interpretation of the Persian medallion carpet, for example, gave rise to works ornamented with medallions as well as with Safavid and Moghul birds and flowers, to which the Portuguese artisans added flowers and beasts from their own popular art. The fantasy and charm of these figures[398] and the delicacy and elegance of the whole give the rugs their special character.

During the period of Portugal's annexation by Spain, from 1580 to 1640, it was Spanish rugs which served as the model for Portuguese carpet making.

In the 18th century, the same cartoons were revived, albeit with the motifs simplified and the number of colors reduced. Popular imagery, such as hearts and figures in regional costume, enjoyed a certain vogue, and new colors appeared, among them maroon, utilized to stress the contours of motifs. The rugs of Porto and Arraiolos still surpassed all others, constituting prized pieces, as witnessed by a special commission from a member of the Scottish nobility named Dempster.

In the following century, animal imagery disappeared in favor of greater emphasis on simplified forms and a reduced number of colors. French pieces from the Savonnerie and Aubusson were sometimes imitated; certainly, the repertoire of flowers, baskets, and garlands *à la française* enjoyed considerable success.

The decline, which began in the 18th century, accelerated after the Napoleonic forces invaded, triggering political and economic upheaval. Thanks to serious patronage, handmade rugs enjoyed a rebound at the beginning of the 20th century, and it continues today. After World War II, Countess de Mafra organized an atelier at Casa San Vicente in Lisbon, where the embroidered rugs proved that the Persian spirit lives anew in Portugal.

343. *Needlework carpet. Arraiolos, Portugal, 17th century. Cross stitch on canvas, 3.40 x 1.53 m. Musée des Arts Décoratifs, Paris. The medallions of this Persian-inspired rug are ornamented with a two-headed eagle, a dove, or flowers.*

344. *Needlework carpet. Arraiolos, Portugal, 17th century. Cross stitch on canvas, 3.55 x 2.41 m. Private collection. Unlike Spain, which continued, after its own fashion, the pile-weaving tradition inherited from Islam, Portugal took a more independent approach to carpet making, in both technique and design. Portuguese artisans revealed genuine originality and great vivacity in their choice of motifs and patterns, even while incorporating elements from various sources, among them Persia (for the polylobate central medallion and the floral ground), Moghul India, and occasionally Anatolia (for the stellated geometric patterns). The birds were of local inspiration. Two large 17th-century carpets, one at the Textile Museum in Washington, D.C., and the other at the Victoria and Albert Museum in London, display, albeit less ambitiously, designs similar to the one seen here, with its medallions inhabited and surrounded by flora and fauna, all rendered in a lively and picturesque manner.*

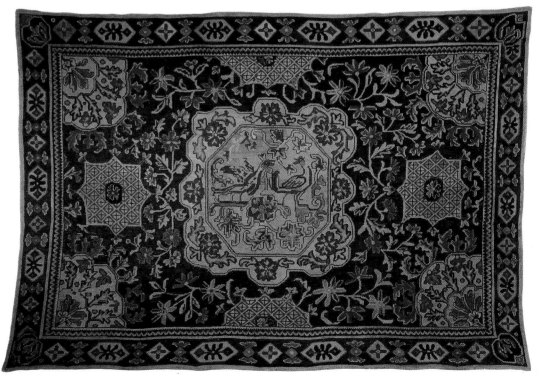

344

345. *Armorial carpet. Porto region, Portugal, 17th century. Cross stitch on canvas, 4.57 x 3.42 m. Private collection, Paris. This rug was commissiond by the Dempster famly of Mures, Scotland, whose arms appear to be those displayed at the center of the field and set off by an enframing pattern of flowers and foliage. The heraldry consists of two silver swords and a pair of lions rampant crowned by the Latin motto* Fortiter et Strenue.

346. *Needlework carpet with a central medallion, flowers, and peacocks. Arraiolos, 18th century. Cross stitch on canvas, 1.92 x 1 m. Private collection, Paris. The essential characteristics of the Arraiolos needelwork rug are fully evident here, especially in the composition and choice of such motifs as the central medallion, flowers, vases, and peacocks. Arraiolos carpets enjoyed great popularity throughout the 18th century, among the aristocracy and the bourgeoisie alike. The decorative repertoire remained fairly constant, including such elements as the animals (peacocks, for example) inherited from Indian work and the rosettes and vases furnished with one or more flower stems, the latter taken from the local repertoire. Portuguese taste also dictated the palette of blue in various shades presented on a gold ground. Similar pieces can be found at the Metropolitan Museum in New York, the Museu Nacional de Arte Antiga in Lisbon, and the Museu Nacional de Machado de Castro in Coimbra.*

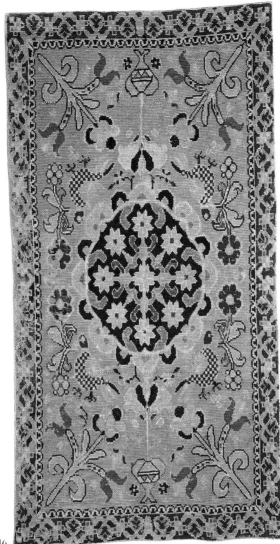

346

348. *Needlework carpet with popular imagery. Arraiolos, 17th century. Cross stitch on canvas, 3.64 x 2.04 m. Museu Nacional de Arte Antiga, Lisbon. In the 18th century, the Arraiolos rug makers, with considerable success, began incorporating into their decorative repertoire such popular imagery as hearts, fleurs-de-lis, flower vases, and figures in regional costume.*

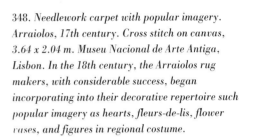

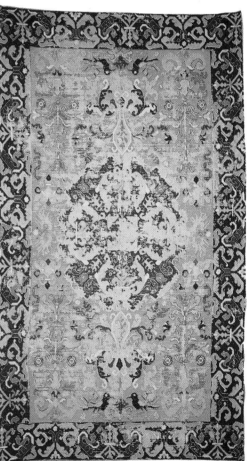

348

347. *The 'Blue Room', Trent Park, Hartfordshire.*

347

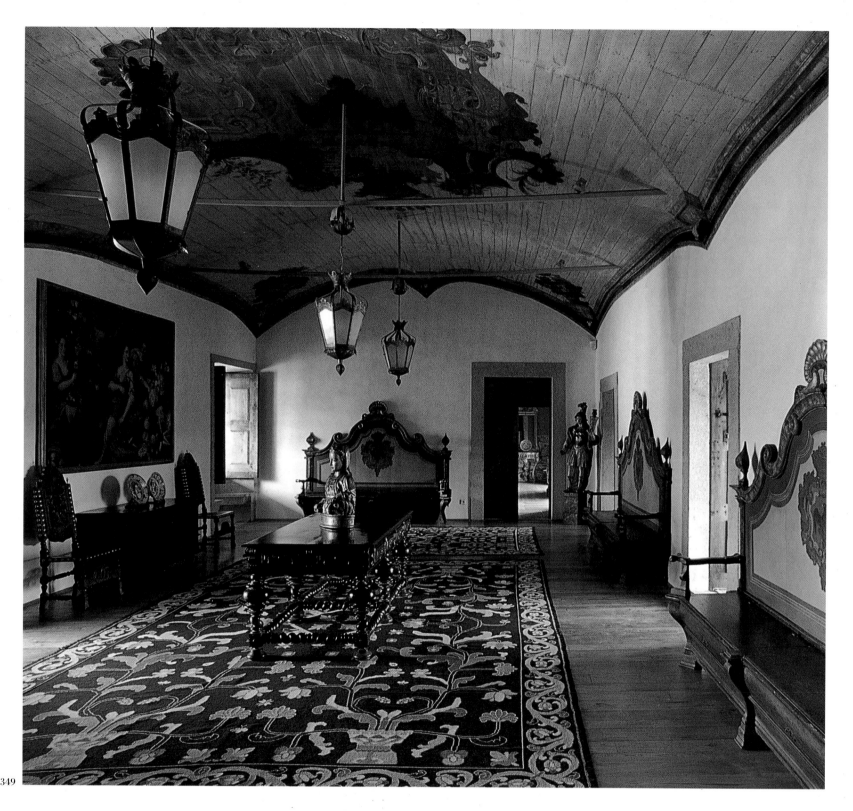

349

349. Entrance hall, Honra de Azevedo, Minho, Portugal. The needlework carpet seen here, a piece decorated with basins sprouting large arabesques, was made to order for the space it occupies.

350. Needlework carpet in the Persian manner. Arraiolos, c. 1950. Cross stitch on canvas, 7.16 x 6.46. Private collection. The grace and elegance of Arraiolos ornamentation remains undiminished even in the most recent production. This includes the Persian element, evident in the composition as well as in the selection and form of the flowers.

CHAPTER
XI

OTHER CARPETS

Jean-Philippe Follet

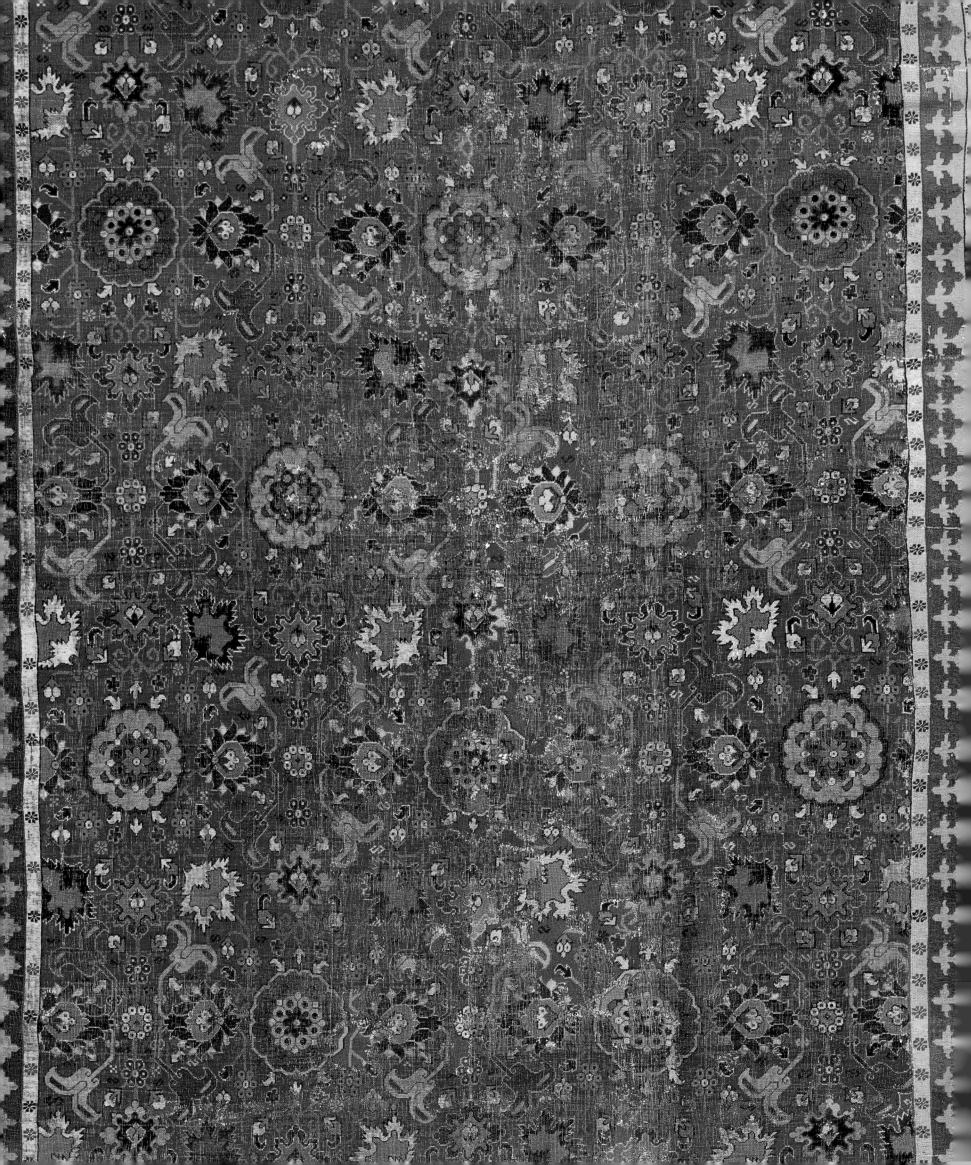

CARPETS OF THE CAUCASUS

It was in the 11th century that the Caucasian peoples of Central Asia learned how to make knotted-pile carpets from the Seljuk invaders. For the next eight centuries, as the Caucasus grew into a veritable melting pot of religion and culture, those populations had ample time in which to absorb decorative ideas and motifs from many different repertoires – Arab, Turk, Mongol, Persian, Russian. In the domain of rugs, however, they appear to have learned the most enduring lessons from the Anatolian tradition.

Any attempt, therefore, to sketch a history of the Caucasian rug in a few lines verges on the rash, for the subject is altogether as complex and multifaceted as the mosaic of ethnic groups dwelling along the shores of the Caspian Sea. In the southern and central Caucasus, a Russian expert, S. Zerimov, counted almost 123 villages each of which was producing carpets of distinctive design. Thus, the long-pile rugs characteristic of the grazing regions, such as Kazakh, Gendje, and Karabakh, differ in every respect from the Cherkess (Circassian) carpets. Moreover, they have sometimes been made by Armenians.

For the most part, however, Caucasian rugs are double-wefted and woven with a symmetrical (Turkish) knot. They are also marked by rigorously geometric designs and a pronounced tendency towards abstraction, even in animal forms, which are radically stylized. The most widely favored patterns consist of 'aligned medallions, with an endless repetition, over the entire field, of a small, unique geometric motif.' Frequently encountered as well are simplified polygonal forms between which appear highly stylized vegetal, animal, and human figures. The most common motifs are 'rosaces' or medallions, flowers, combs, and crosses. As for the enframement, it is composed – again generally speaking – of three borders, ornamented with an alternating series of sawtooth-edged leaves and tulips, confronted or interlaced hooks, 'running-dog' motifs, squares, or rectangles bristling with four projecting hooks. Colors, although not numerous, are vivid and strongly contrasted: yellow, red, and orange often side by side with blue, green, ivory, white, and black.

CAUCASIAN CARPETS

The patterns most frequently found in Caucasian rugs include:
- aligned medallions with a small geometric motif endlessly repeated throughout the field,
- simplified polygonal forms alternating with stylized vegetal, animal, and human figures.

The most common motifs are 'rosaces' or medallions, flowers, combs, and crosses. Borders are three deep and the colors, although not numerous, are vivid and strongly contrasted.

351. *Rug with the* afshan *pattern. South Caucasus, late 18th century. Wool pile, 5.40 x 2.30. Private collection. This afshan design, which means a field without a main, central medallion, consists of longitudinal rows of motifs, an arrangment characteristic of this Caucasian type. Relatively rare, however, is the color red used for the ground, which is normally blue. The small tripartite motif in the border betrays an influence from Armenia, suggesting that the piece may have been woven by Armenians in the Caucasus.*

352. *Rug with a dragon motif. Shirvan, Caucasus, late 17th century. Today the group to which this rug belongs is identified with Shemakha in the Shirvan region.*

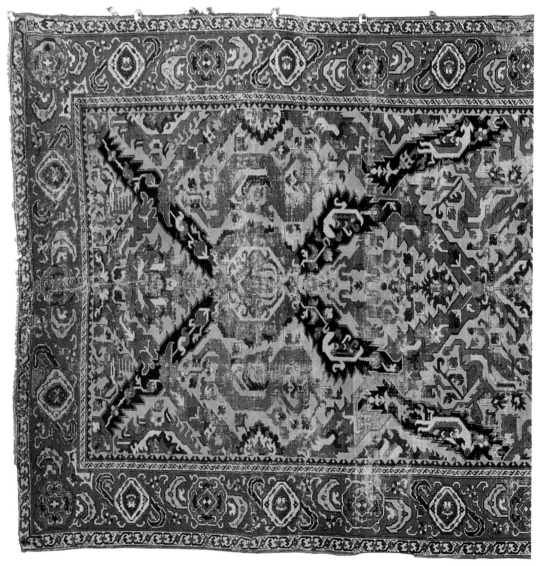

352

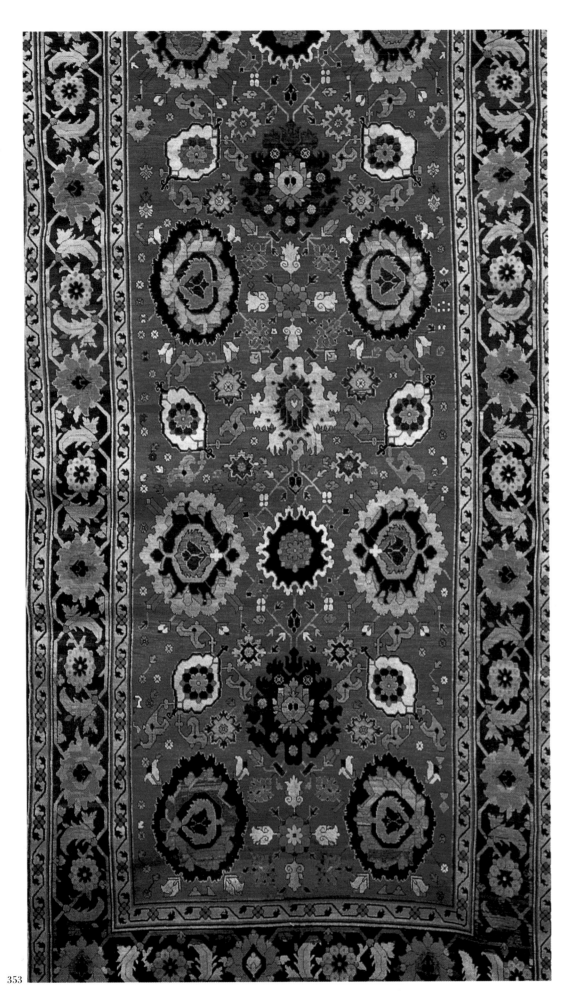

353

Flowers or Dragons

In the opinion of Ernst Kühnel, Kurt Erdmann, and Ulrich Schürmann, the oldest Caucasian rugs date to the 16th and 17th centuries. An example is a fragment preserved at the Textile Museum in Washington, D.C., thought to have been woven in 1689. Until the 19th century, Caucasian production appears to have been centered exclusively around two very distinct types: the 'dragon rug' and the 'floral rug'.

The earliest pieces come from the Karabakh region in the southern Caucasus. Their dragon motif recurs either as a drop repeat or as a figure nestled between rows of lozenges, the latter scheme found in the celebrated 'Graf', or 'Count', rug at the Islamisches Museum in Berlin. On this late-19th-century example, the animal, which is spotted, resembles a sea horse or a giraffe more than a real dragon. Most often, however, the dragon design is constituted of 'a transversal trellis of large rectangles formed by two-colored, stylized foliage with serrated edges, inside which are S-shaped, stylized dragons as well as other mythical beasts, among them the phoenix and the *khi'lin*,' the latter, according to Enza Milanesi, 'half-dragon and half-stag.' It is framed by three borders embellished with palmettes, geometric flowers, scrolls, and rosaces. The dragons and the other motifs, which may be ivory, yellow, or green, stand forth against a ground traditionally dominated by red, black, or blue.

The florals come from Kuba, a region also in the southern Caucasus. They sport stylized palmettes and small cruciform medallions (17th century), or large, highly stylized floral elements arranged like overlapping medallions (18th century), or yet tiny geometric floral forms linked together by stems or tendrils and arabesques. Some pieces display pretty ivory-colored, multifoiled rosettes in the so-called *afshan* design (devoid of a central medallion), while others present lilies, tulips, grape-leaf palmettes, and zoomorphic pal-

353. Rug with a floral pattern. Kuba, Caucasus. Wool pile, 5.26 x 1.98 m. Private collection, Paris. The Caucasian floral patterns come mainly from Kuba, a region in the southern Caucasus.

mettes rather like the complex blossoms (*kharsiang*) whose forms suggest those of a crab. Historians, eager to sort out this plethora of botanical ornament, have followed Shürmann and distinguished three types of floral carpet: the tree rug, the palmette rug, and the large pieces with motifs taken from the *herati* and 'vase' designs of Safavid Persia. A very beautiful specimen of the last type is the 'Nigdé rug' at the Metropolitan Museum, a work from the early 17th century and measuring 752 cm long.

A Return to Geometric Designs

In the 19th century, the Russian occupation put a brake on the region's traditional production, as a consequence of which large manufacturers closed their doors one after the other. Artisans, confined to the little villages of the Karabakh and the eastern Caucasus, abandoned the floral patterns and the large formats, once so prized by the local nobility, and returned to their ancestral repertoires. Motifs grew increasingly rarefied, larger, and more geometric.

Two experts, Lyatif Kerimov and Ulrich Shürmann, have succeeded in establishing a precise system of classification for Caucasian rugs according to their geographical provenance. As a result, it is now possible to distinguish a Talish weaving (long and narrow and sometimes sown with small polychrome stars resembling corollas) from a Shirvan (its dark-blue ground ornamented with stepped hexagons) as well as from the Baku rug (notable for its light palette, such as ivory and shades of blue).

The most renowned of all the Caucasian rugs is, by far, the Kazakh. Knotted in thick wool, it is decorated with hooked lozenges, hourglasses, scorpions, and tarantulas. Gendje carpets offer a silkier wool, from the Kirovabad region, and small ornaments generally organized in wide diagonal bands or in meanders. Some Gendjes also display, inserted head to foot in the meanders, sawtooth-edged leaves stylized rather like the *boteh* or 'Paisley' motif associated with Persian weavings.

The rugs of the Kuba region, on the northern side of the Caucasus, frequently have bright colors on dark grounds. Characteristically, they feature pseudo-Kufic borders with alternating rosaces and paired hooks and fields in which stylized botanical motifs predominate: rosettes, palmettes, bouquets, carnations, corner leaves, and trees contained within an all-over lattice pattern. The details are as dense as the knotting, and the Kuba knot can be very tight indeed, the count running as high as 290,000 knots to the square meter. The most original Kubas are the rugs from the village of Perepedil with their large 'handlebar' and ram's head (*wurma*) motifs, the Seishours with their St. Andrew's cross medallions, and the Chichis. These last are woven by the Chechen peoples of the eastern Caucasus. Their principal border is often decorated with a small stepped polygon contoured in white on a blue or brownish-black ground.

The Eagles and Roses of Karabakh

The Karabakh region, situated between Lake Van and the Caspian Sea, has also produced a multitude of very different carpets. Yet despite their fabrication by villagers or by semi-nomadic tribes, they have two characteristics in common: an echo of the Persian tradition and a shade of rose tinged with violet, the color obtained from cochineal. In the Karabakh, the most frequent formats are the *sedjadeh* or prayer rug (160 x 220 cm) and the *kellegi*, a Oriental rug measuring approximately 3.5 x 1.5 meters.

Clearly, the most original Karabakhs are the rose-patterned ones, created in response to Western taste. These superb carpets boast geometric pink or red flowers arranged in garlands on a ground of dark blue or black. At the same time, Karabakh offers other designs that are just as marvelous, particularly the Chelaberds, known in the trade as 'Kazakh Adlers' or 'eagle Kazakhs', and the Chondzoresks. The former, which are much favored among collectors, display motifs resembling an eagle with spread wings. The Chondzoresks, meanwhile, have two or three large blue octagons aligned in a row down the center and ornamented with somewhat vermicular, albeit angular, white cloudbands.

Within this harvest of Karabakh carpets (the quality of their style always excellent), specialists have been able to detect another inter-ethnic constant: a principal border that is often composed of 'rows of eight-pointed stars, alternately red and blue, on a white ground, linked by stylized tendrils which define the octagonal spaces, each of them inhabited by two small square leaves.'

The Sumakh Carpet

Shemakha, a city some fifty kilometers from the port of Baku (Azerbaijan), is known for its production of Caucasian Soumaks, rugs characterized by a total absence of pile. Indeed, these Soumaks are woven exclusively on the warps. The oldest known examples date to the early 19th century. Their intricately worked-out patterns spread over a field whose color is traditionally rust or reddish brown. Erwin Gans-Ruedin, however, in his anthology of Soumaks, has published a superb example, a Seishour of 1926, which features four dragons on a midnight blue field, where 'the one at the top of the row is upside down, in order to balance the design. Red and blue or red and green, with orange tips, they are contoured with a white thread picked up from the red *medahils*. Antennae sprout from the heads of the two [beasts] at the center, while the other two have fanged mouths and a piercing look in their eyes. The spandrels, like the rest of the field, swarm with so many different elements, often reduced to a mere line or two, that one could despair of counting them all. At the least, there are dragons, crabs, dogs, fowl, trees of life, combs, hooks, S and X shapes, and tiny figures. . . .'

THE CARPETS OF CENTRAL ASIA

'Central Asia' is the name given to that vast territory, extending from the Caspian Sea to Chinese Turkestan, the Aral Sea, and the northern part of Afghanistan, across which for centuries the old trader caravans meandered back and forth along the Silk Route. Conquered by Russia in the 19th century, this much contested region found itself renamed 'Russian Turkestan' and divided into five republics: Uzbekistan, Kirgizstan, Kazakhstan, Turkmenistan, and Tajikistan. In these lands, with their arid steppes, deserts, and mountainous massifs, live nomadic and semi-nomadic tribal peoples, loyal to their ancestral traditions, who weave on horizontal looms and produce relatively simple rugs designed to cover the floors of their yurts.

The most archaic of the surviving rugs are the Baluchis. Thanks to the research of the Russian scholar Valentina G. Moshkova, we know that these long-pile weavings represent 'one of the most primitive forms in the whole of carpet art.' Woven by Uzbek, Kazakh, and Kirgiz women right into the 1950s and 1960s, the Baluchis, whose name means 'bear skins', served mainly a domestic purpose, as, for example, protection against both humidity and winter cold. The rugs could also be hung on the 'sides' of the tent, placed at the entrance (*ensi*), and stacked for use as sleeping or resting pallets. These were rugged weavings, irregular pieces made of sheep's wool, sometimes of goat hair, and no doubt of yak hair as well. Once knotted, the long pile was trimmed with a knife. Most of the Baluchis displayed geometric, abstract, and magical motifs, among them moons, eagle feathers, squares, ram's horns, medallions embellished with amulets, and the so-called 'shaman tree', 'birth', and 'axis of the world' motifs. The beige, ecru, or brown wool was dyed in shades of crimson, amber, and purple. Until the 1920s, these Central Asian weavers colored their yarns only with vegetable dyes (weld and reseda) and indigo, a vat colorant mordanted with yoghurt and gum arabic.

George W. O'Bannon has established a system of classification for Turkoman rugs based on the ethnic criteria of the various rug-weaving tribes. Such a typology, how-

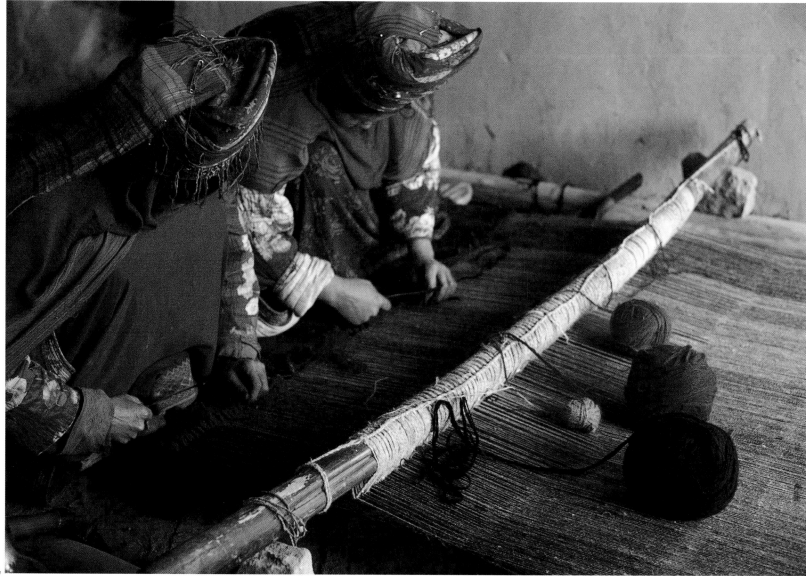

THE BALUCHIS

These may be the most archaic of the surviving Caucasian rugs. Knotted by women right into the 1950s and 1960s, they served mainly a domestic purpose, as protection against both humidity and winter cold. They are rugged, irregular weavings made of sheep's wool, sometimes of goat and even yak hair. Among the featured motifs are geometric, abstract, 'magical' representations of moons, eagle feathers, squares, ram's horns, and medallions embellished with amulets.

ever, has its limits, given that over the centuries the peoples of Central Asia have been profoundly interactive, until it is difficult to isolate the specific characteristics of Salor, Saryk, Tekke, Yomut, Ersari, or Baluchi carpets. In general, though, we can say that the four principal tribes of Turkmenistan knot rugs – or 'Bokharas' as they are known in the trade – which are marked by silky wool, short pile, and geometric patterns, the last invariably featuring parallel or staggered rows of *gül*. The *gül* is a medallion, usually octagonal and ornamented at the center with simplified motifs, which in some way constitutes the tribe's distinctive emblem or totem.

355

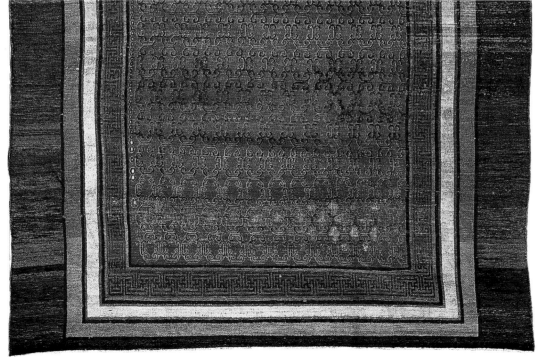

356

354. *Turkoman women at their loom weaving a carpet.*

355. *Rare carpet with a cloud-lattice pattern and swastika borders. Yarkand, eastern Turkestan, c. 1750-1850. Wool pile, 3.68 x 2.6 m. Private collection, Paris. The cerise ground of this rare piece signifies joy, while the clouds making up the lattice symbolize not only long life but also happiness and peace. The lotus in the border originated in China and the swastika in India, both transformed here by the creative imagination of the Turkestan nomads. The swastika connotes infinity. Woven at the crossroads of several civilizations, this carpet is a testimony to their powers of invention, even within the contest of age-old conventions.*

356. *Rug from eastern Turkestan. 18th century. Wool pile, 2.92 x 2.82 m. Photograph courtesy Sotheby's.*

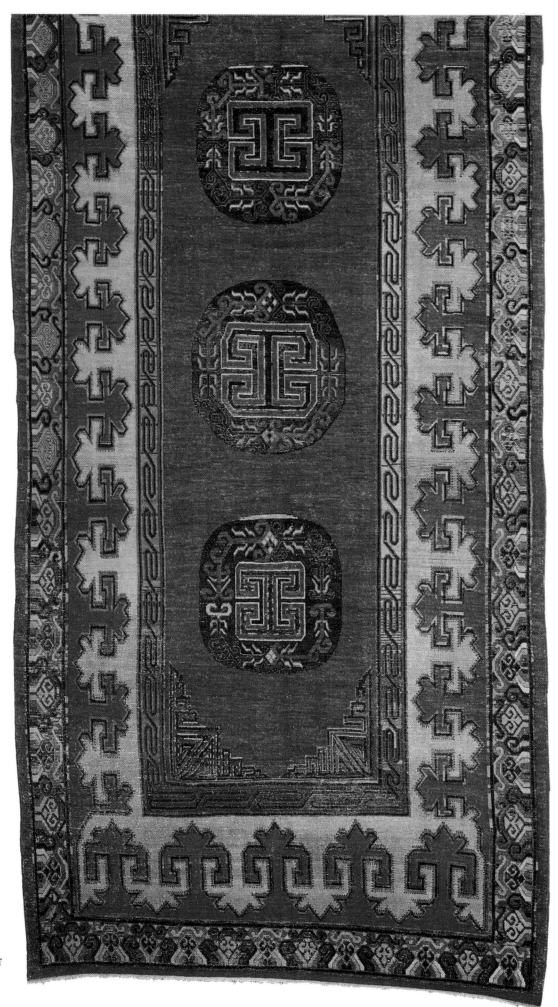

The border, equally consistent with the ancestral model, is for the most part decorated with polygonal designs and geminated or paired rams' horns (*aina-kotshak*, meaning 'mirror-ram').

The Tekkes, who live in the region around Merv, favor an almost brick or scarlet red, whereas the Salors sow the fields of their rugs with *gülli gül* (floral *gül* with a small trefoil motif at the center) or with the *gül salor*, its contours formed of projecting tiny black triangles. Also worth noting is the Salor knot, which is tighter than that of the Tekkes. Jacques Anquetil has pointed out another constant of these Turkoman rugs: 'depending on the viewing angle and the light, the colors alter; moreover, the rug absorbs light according to the height of the pile. When the pile is seen against the light, the colors appear more intense, so that light madder red becomes a burgundy, whereas, viewed from the same direction as the light, the red looks softer, almost rose, and the colors more harmonious overall.'

The tribes of eastern Turkestan (the Autonomous Region of Sinkiang), dwelling around the three oases of Kashgar, Yarkand, and Khotan, produce long, narrow weavings (1 x 2 m) called, erroneously, 'Samarkands' and invariably dyed with aniline and other artificial colorants. While the Kashgars betray a debt to Persian and Chinese tradition, the Yarkands evince a degree of originality, particularly in the central field decorated with an all-over pomegranate pattern, symbol of prosperity.

359

357. Rug from Yarkand, eastern Turkestan. 18th century. Wool pile, 4.29 x 1.93 m. Photograph courtesy Sotheby's. Each medallion is filled with a gül motif, that distinctive emblem or totem by which the Turkoman tribes chose to distinguished themselves from one another.

358. 'Bokhara' rug. Yomut Okbash tribe, western Turkestan. 1800. Wool pile, 0.58 x 0.45 m. This small rug, with its characteristic silky wool, short pile, and geometric pattern, would have served as part of an external ornament hung from the pegs of nomadic tents.

359. Carpet with a pattern derived from Persia, India, and China. Kashgar or Khotan, eastern Turkestan (Sinkiang), 18th century or earlier. Silk pile with metallic brocading, 1.16 x 1.18 m. Private collection, Paris.

KILIMS

In its narrowest sense, the Turkish word 'kilim', according to Yanni Petsopoulos, signifies a woollen weft-faced carpet woven on a low-warp loom. Called *gilim* in Persian and *palas* in the Caucasus, the kilim is fabricated in certain Balkan countries (Albania, Bulgaria, and Bessarabia) as well as in the Middle East. The principal centers of production are Anatolia, Iran, and the Caucasus. Because a kilim always formed part of a bride's dowry, it was never meant to be sold. The rug is relatively fragile, owing to its structure, which, like the weaving technique, is very simple. The horizontal wefts are alternately passed over and under the warps harp-strung completely across the width of the carpet. Moving in the opposite direction, the wefts pass over and under an alternate set of warps. Since the weft must stop and relay or turn back where a color change is required, a tiny, characteristic slit develops along the vertical line between two different color zones.

The decorative composition, on the other hand, may be extremely complex. The motifs, which are essentially geometric and floral, are by turns juxtaposed, imbricated, and upside down along a zigzag or meandering line, as in the borders decorated with vines, foliage, and trefoils. The carnation and the tulip, both flowers beloved by the Ottomans,

alternate with such motifs as bracketed lozenges, running dogs, ram's horns, and the two-headed eagle, all common to the kilims of the Middle East. However, the most important motif of all is the *gül*, in this instance a geometric design inscribed within a hexagon.

The Lost Language
of Anatolian Kilims

According to Belkis Balpinar and Garry Muse, Anatolian weavers appear to be ignorant of what all these motifs, images, and compositions mean. They weave the designs they have inherited, knowing only that the pattern itself is absolute and immutable.

Among the 'absolute and immutable' designs is the arch motif, also known as the 'prayer rug niche', which recall the arcades of the first mosques; the *parmakli*, a serrated motif representing a very schematically rendered goddess; a vulture motif; and the *elibelinde*, a beast with leopard-like spots. The kilims of Anatolia, where they once served as screens or partitions inside the nomad tents, were ornamented with colors and forms subject to an endless number of combinations and most certainly derived from ideograms.

The archaeologist James Mellaart, writing in 1983, was the first to suggest that a great majority of the Anatolian kilim motifs were

360

360. Geçek near Sivrihisar in western Anatolia. Women of the village explain the motifs woven into a Turkish kilim.

361. Kilim woven in one continuous piece, from the Ulu Mosque in Divrigi (Sivas). Flatwoven wool, 3.95 x 2.35 m. 17th century. Vakiflar Museum, Istanbul. Virtually every motif seen here can be found as well on Ottoman blankets and textiles. The border designs, the palmettes, and the hexagons divided lengthwise by color resemble elements found on Ottoman tents.

361

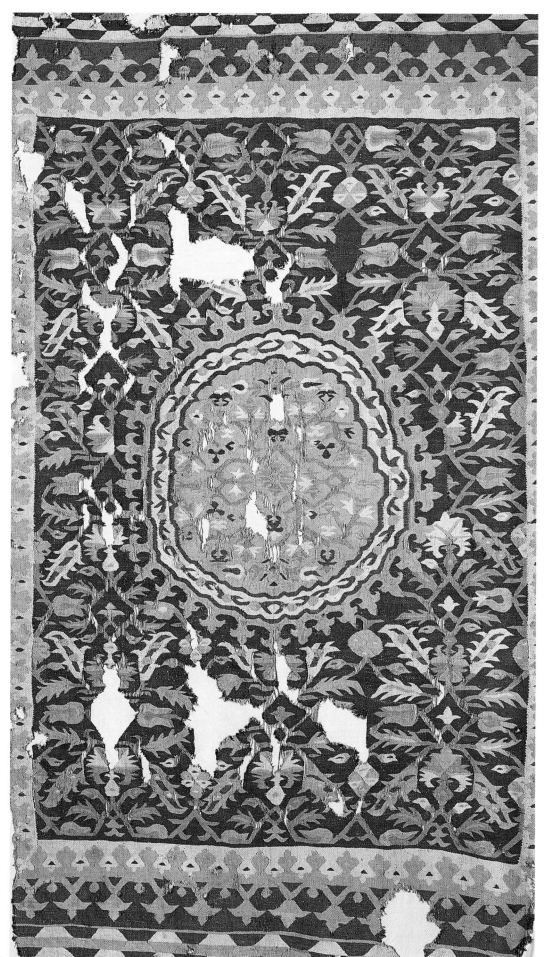

362

363

362. *Kilim from Ermidag. Flatwoven wool, 44.5 x 1.50 m. Vakiflar Museum, Istanbul.*

363. *Kilim woven in a continuous piece, from the Ulu Mosque in Divrigi (Sivas). 17th century. Flatwoven wool, 4.33 x 1.42 m. Vakiflar Museum, Istanbul. This rug belongs to a group of flatweaves made by Egyptian artisans either in Egypt or in Anatolia, working from designs prepared for the Ottoman court, which means they were most likely commissioned by the court or by a member of the ruling class. They were used in tents during battle campaigns, journeys, or feasts. In both design and technique, the rugs differ quite radically from every other variety of kilim.*

THE LOST LANGUAGE OF ANATOLIAN KILIMS

Anatolian weavers weave the designs they have inherited, evidently unaware of what the motifs, images, and compositions once meant. Among the 'absolute and immutable' designs and motifs are the prayer niche, a serrated goddess, the vulture, and a beast with leopard-like spots. Some scholars have hypothesized that the Anatolian motifs may be neolithic in origin.

361

of neolithic origin. Cathryn M. Cootner, who has made a close study of the kilims in the Jones collection at the Fine Arts Museum of San Francisco, even sees a correlation between the motifs in nomad and village kilims and the motifs of traditional basketweaving and even those of Bronze Age earthenware jars. Thanks to these scholars, we now understand that the imagery in the wall paintings at Çatal Höyük (7000 BC) and

neolithic pottery from Hacilar survived in Anatolian kilims right up to the 19th century. Understandably, the oldest known kilims have now come in for intense scrutiny, including that of Carbon-14 analysis, which dates the rugs in Istanbul's Vakiflar Museum to the 9th-15th centuries and those in the Jones collection to the 15th-18th centuries. Another marked characteristic of Anatolian kilims is abrash, that tonal variation in color

zones caused by successive dye baths – indigo and madder – for different batches of wool.

Caucasian and Persian Kilims

The composition of Caucasian kilims is also based on the repetition of rectilinear and strictly geometric ornaments. Moreover, the weaving technique is analogous to that of the Anatolian slit-tapestry process, but the warps are of natural brown wool or sometimes of white and brown wool plied together. The colors, however, are stronger than those found in Anatolian kilims. Another distinctive trait is the way the warp ends are finished. Rather than a fringe, the ends are knotted together in groups, which are then divided in two and each half tied with its neighbor. This process is repeated until four rows of knotted warps create a decorative lozenge-like effect.

The two most important weaving centers are Kuba and Shirvan. At Kuba the kilims have decorative borders and large geometric medallions with serrated edges or angular cartouches. At Shirvan the kilim lacks both borders and crenellated lines. The patterns are more abstract and arranged in horizontal bands.

Despite the difficulties of classifying the kilims of Persia, Petsopoulos has succeeded

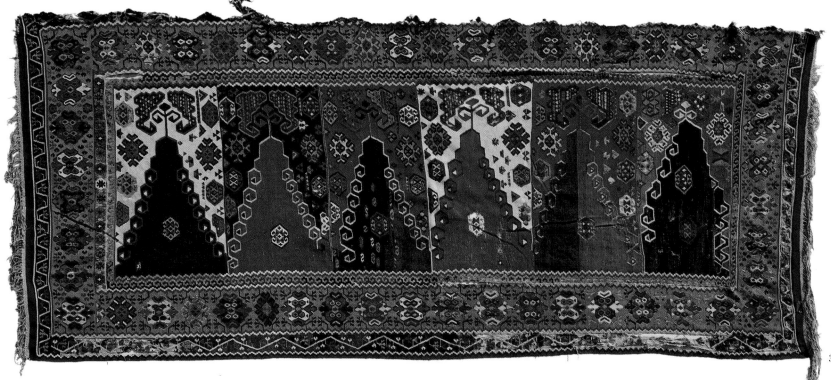

365

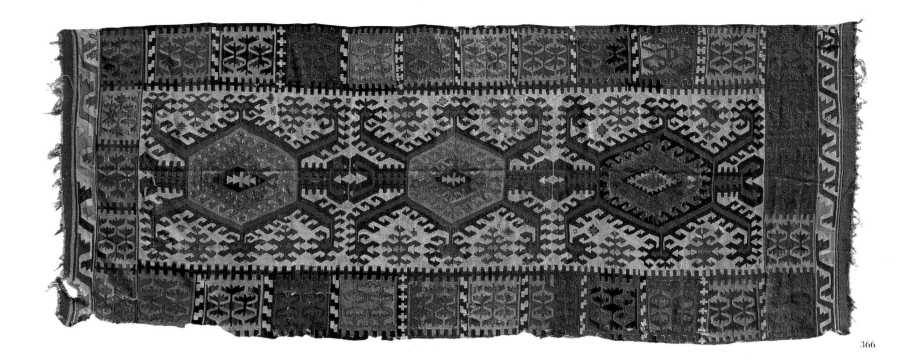

366

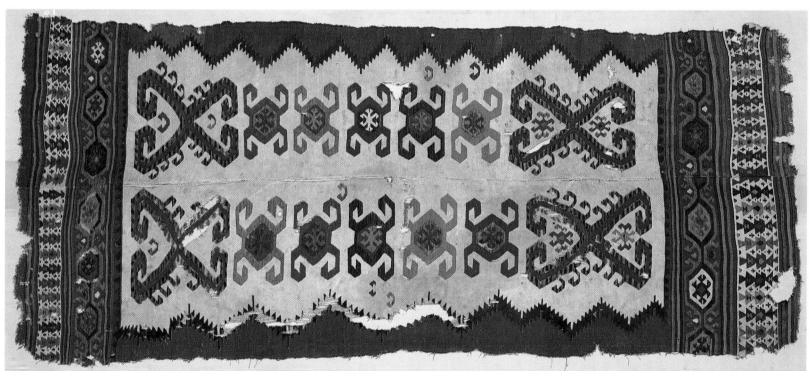

367

364. *Gokçekuyu near Eskisehir, western Anatolia. All the riches of the house spread out under the sun.*

365. *A saph prayer rug woven in a continuous piece. Flatwoven wool, 4 x 1.64 m. Vakiflar Museum, Istanbul. This kilim was made in Susehir or Sebinkarahisar by a Caucasian artisan, which may explain the 'dragon' motif in the pattern. The rug represents the Bayburt or Erzunum type of prayer kilim. The prayer niche woven into the design, to indicate, like the mihrab, the direction of*

Mecca, is essential to Muslim prayer rugs. It is thought by some to echo the arcades built into early mosques.

366. *Kilim woven in one continuous piece, from the Ala-ed-Din Mosque in Ankara. 14th century. Flatwoven wool, 1.70 x 1.30 m. Vaklifar Museum, Istanbul. This kilim was made in the Turkoman village belonging to the Hotamis tribe. The motif in triple repetition is the very schematic image of a tortoise.*

367. *A two-piece kilim from the Eshicioglu Mosque in Ankara. Flatwoven wool, 3.85 x 1.60 m. Vakiflar Museum, Istanbul. Families in the region around Anakara used tghis type of kilim for burial services.*

or almost all, tribal in origin, such as the heavy woollen kilims made by the western nomads, the *talish* kilims with their narrow red and green friezes, and the floral kilims of the Senneh Kurds.

In the area around the city of Shushtar, the Bakhtiari weave kilims in which the wefts are wool, natural camel hair, and cotton, the last, sometimes dyed pale blue, being the distinctive feature of the Shushtar flatweaves. The kilims of Sarand are made of heavy, thick wool with an irregular texture. Those of Veramin differ from their Persian cousins by the presence of narrow weft-float bands with conjoined S forms and by their pattern, composed of imbricated motifs rather similar to the optical effects later achieved by Victor Vasarely and characterized as 'eye-dazzling' by some specialists.

Albanian Kilims

In the country of the eagles, women of the mountain and pastoral regions, such as Lume and the Has plateau, turn to their looms during the winter, producing *qilima*, rugs and blankets woven with sheep's wool. The Department of Ethnography at the Tirana Museum owns numerous examples of kilims from Malesia i Labërit and from the districts of Kukës and Korçë. The Albanian *qilima* and the *sixhade* (prayer rugs) are notable for the extreme vivacity of their colors and the variety of their patterns.

As a general rule, the field is decorated with relatively complex motifs, geometric or figurative and highly stylized, as in the two-headed eagle or the so-called 'wheel' and 'little mosque' images typical of the Korçë region. The borders present a continuous series of octagonal or rhomboidal figures, double lozenges aligned diagonally or in horizontal bands, triangles, and broken lines. *Qilima* weaving, which continues today, constitutes an important part of Albania's folk production.

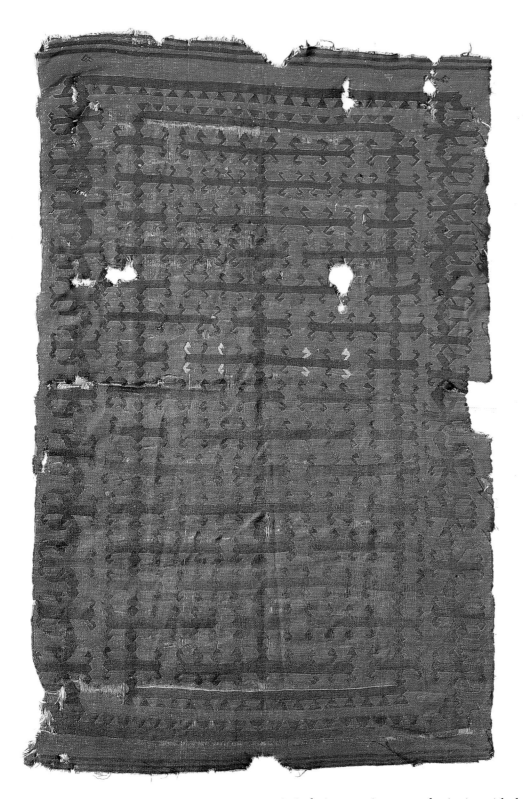

368

368. Kilim woven in one continuous piece, from the Ahi Elvan Mosque in Ankara. 14th century. Flatwoven wool, 1.96 x 1.45 m. Vakiflar Museum, Istanbul. Made by members of the Yüncü tribe in the Balikesir region, the kilim reproduced here displays at the center motifs often interpreted as 'centipedes'. The lateral extensions are called 'ram's horns'.

in isolating certain groups, beginning with the family of Safavid kilims, woven in the 16th and 17th centuries in the workshops of Isfahan and perhaps Kashan from cartoons designed by the court miniaturists. The Safavid kilims, brocaded with silk and gold thread, have decorative programs featuring arabesques, floral motifs, figures, and hunting scenes, all in the manner of the Safavid pile carpets. The other Persian kilims are all,

369

CARPETS OF NORTH AFRICA

Historians generally group Moroccan rugs according to five producing centers or regions: the Middle Atlas (very 'ethnic'), the High Atlas (often yellow and luminous, knotted with lamb's wool), Rabat, eastern Morocco, and the Atlantic plains. This last category, in which figure the carpets of Haouz, a village near Marrakesh, and those of the coastal Chiadma tribe, is easily the most unusual, given the rugs' total lack of structure, irregular motifs, deliberately confused layouts, and rough yarns. Yet, perhaps by virtue of these very qualities, the weavings radiate mystery, which seems to well up from some deep primitive source.

In Tunisia, the best-known rugs are the *zerboya* or knotted carpets from Kairouan and the Bedouins' somewhat rare long-pile pieces (*ktifa*). These works can also be subdivided, into the rugs of the Drid, those of the Ouled bou Ghanem, and finally those of the Hamama, Mahadba, and Zlass.

The Fleecy Carpets of the Middle Atlas

In this mountainous, pastoral region, sheep's wool is the material used for knotting carpets, but also for weaving blankets, the bands of fabric with which tents are made, burnouses, shawls, and those long, loose hooded garments known as *djellabas*. The rugs of the Middle Atlas are long-pile weavings designed to function like mattresses and thus protect sleepers from the cold. Also for this reason, the piled side (*bilo*) is always placed against the ground, which means that the right side of the rug is actually the flat side (*taghessa*).

369. *A caravan leaving for a trek across the North African desert.*

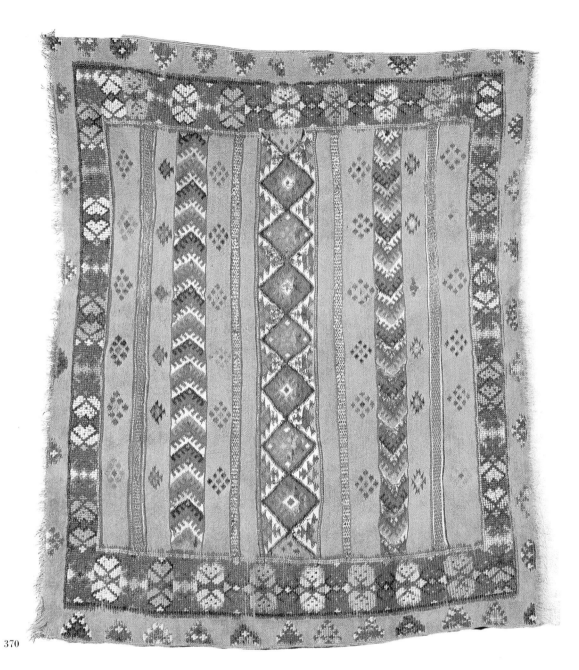

370

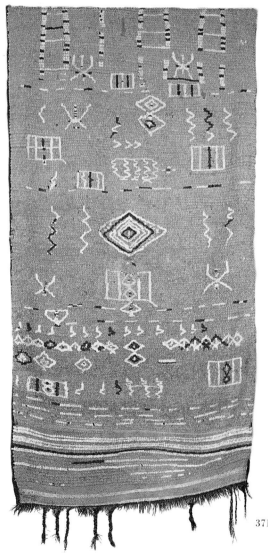

371

taroubia [madder] or, in its absence, the roots of *tazra* [sumac] well dried; crush them together with *asemmoum* [wild green grapes] or, lacking that, with *tisemmoumine* [wild sorrel] in a ratio of two-thirds *taroubia* to one-third *asemmoum*. Place this mixture in a water container with the yarns to be dyed and leave them overnight. The next morning, boil the lot for two or three hours; remove the yarns and lay them out to dry. Dissolve the oak ashes in water, immerse the warp yarns in this bath and leave them for a good hour; retrieve and rinse thoroughly in running water.'

The motifs are, on the whole, geometric and angular. No circles or curves here, nor a central motif. Berber rugs are decorated mostly with grid patterns or horizontal bands filled with lozenges, triangles, and chevrons.

The most productive tribes are the Zaïane, the Beni Ouaraïn, and the Beni Mguild, who weave three types of rug: the *ichdif* (white-ground pieces embellished with colored lozenges), the *tazerbit* (rugs with three-color grounds), and the *aberachno* (white rugs devoid of decorative motifs). Some Berber rugs are made with two different techniques – knotting and flatweaving – and two types of wool: sheep's wool for the body of the rug and goat or camel hair for the fringes. They are woven, generally by women, on low-warp looms. The weavers of the Aït Ighezrane tribe employ the *jufti* knot, which is looped around four warps.

Today, red is the predominant color on the rugs woven in the Middle Atlas, although each tribe once had its own favorite hue: black in the case of the Aït Yacoub and snow white for the field in the rugs woven by the Beni Ouaraïn. The field in the Marmousha pieces may be brown, cream, or blue. The Beni Mtir and the Beni Mguild prefer to work their patterns in yellow. As for the Mrirt, they are bold enough to combine such strongly contrasted colors as orange and green. The sources of the hues are numerous: madder root for garnet red, dried and crushed apricots, pits and all, for scarlet, lamp black and iron sulfate for black, the skin of pomegranates for yellow.

Around 1920 Prosper Ricard, while in the region of the Beni Mguild, obtained the recipe for reddish brown: 'take the roots of

The piled side of very large Beni Alahams, some of which measure 7 x 2 meters, displays a succession of small white lozenges separated by a network of black knots. The multiple rectangles could symbolize the tents of a douar. The other figurative motifs are traditionally interpreted as fleshy lips, amulets, babouches, tent stakes, storks, lion's claws, and jackal feet.

The Ceremonial Carpets of Rabat

Finer and more ornamental than the rugs of the Middle Atlas, the carpets known as 'Rabats' are all, or nearly all, derived from Oriental carpets, in motif and composition alike. The most prestigious of the Rabats is, according to Francis Ramirez and Christian Rolot, the 'large modern Rabat, with a rose or red ground, a star-shaped or rosace cen-

370. *Berber carpet woven by the Aït Ouaouzguit. High Atlas, Morocco, 19th century. Piled and flatwoven wool, 1.31 x 1.13 m. Musée des Arts d'Afrique et d'Océanie, Paris. The Aït Ouaouzguit tribe specialized in rugs with strips alternately flatwoven and piled, organized in a well-ordered and 'closed' composition. The sense of stability this conveys would appear to arise from a nomadic people who have 'sedentarized'– who are 'no longer on the move'.*

371. *Berber carpet woven by the Ouled bou Sba. Haouz near Marrakesh, Morocco, late 19th century. Goat-hair pile; symmetrical knot; 2.95 x 1.54 m. Musée des Arts d'Afrique et d'Océanie, Paris. The white and brown motifs are arranged on the faded-madder field in a highly imaginative fashion, with the whole somewhat reminiscent of hieroglyphics. Concentric lozenges make up the medallion at the center. Having come from the Sudan, the Ouled bou Sba employ certain motifs derived from Coptic and African textiles.*

372. *Berber carpet woven by the Beni Ouaraïn. Middle Atlas, Morocco, late 19th century/early 20th century. Wool pile; three-warp Berber knot; 4 x 1.82 m. Musée des Arts d'Afrique et d'Océanie, Paris. The black and white palette of this rug, as well as the softness and density of its wool, evoke the speckled fleece or fur of an animal. The design consists of horizontal registers of diamond-shaped motifs and zigzag lines.*

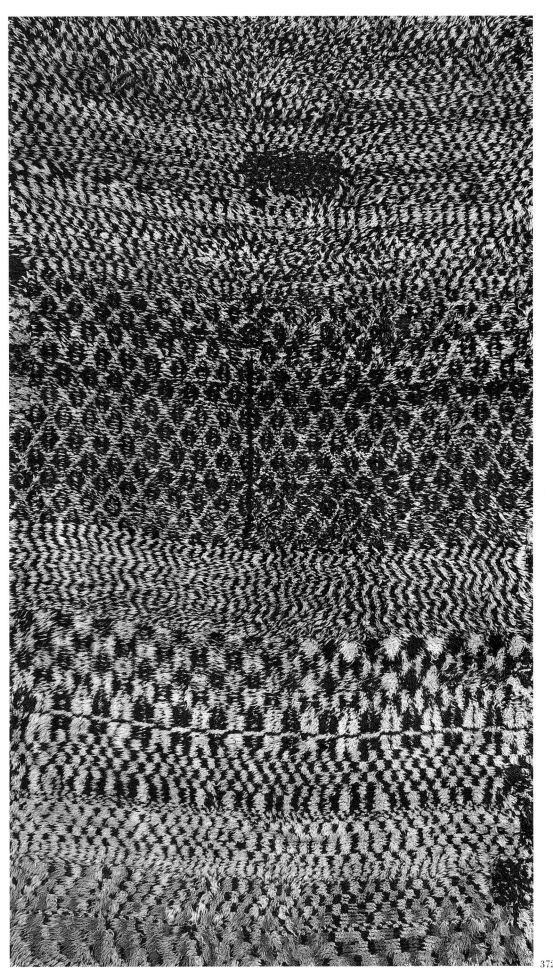

372

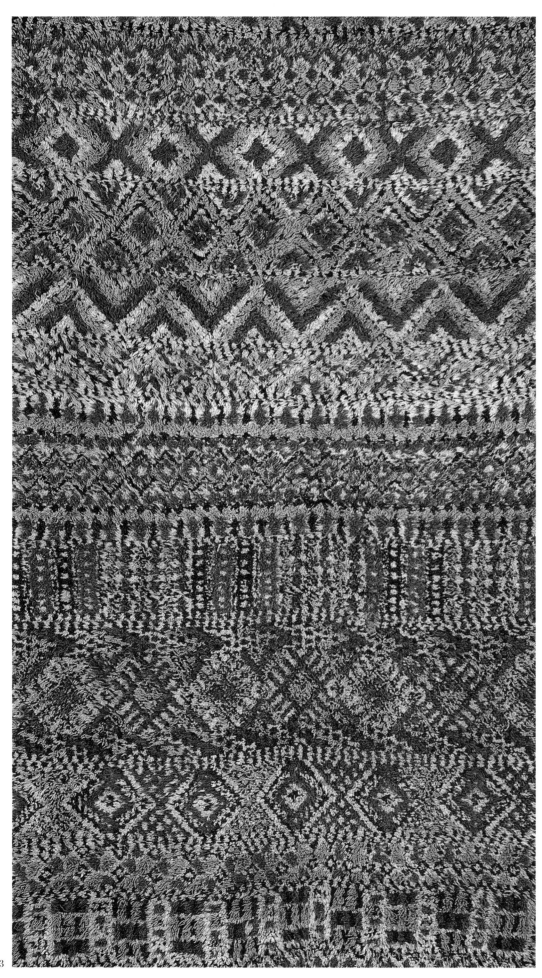

373

373. Berber carpet woven by the Aït Youssi of Guigou. Northeastern Middle Atlas, 19th century. Wool pile, three-warp Berber knot, 4.40 x 1.87 m. Musée des Arts d'Afrique et d'Océanie, Paris. The geometric pattern of successive horizontal registers woven in brick red, golden yellow, white, and black produces an effect verging on pointilism. Free of both a border and a central motif, the pattern seems to continue ad infinitum, reflecting the space in which the nomadic or semi-nomadic populations live. The pile of Berber rugs is usually quite thick, the knots running as long as 5 or even 12 centimeters, the better to serve the owner as both mattress and blanket. While providing protection from the cold, it also cheers up the tent through its warm colors. Some Berber rugs are called 'reversible' because they are indeed used on both sides. In the winter, for example, the long, thick tufts become a good defense against the harsh weather, and in summer the flat side, with its striking pattern, serves as insulation against the North African heat.

374. Berber carpet woven by the Beni Mguild. Central Middle Atlas, Morocco, late 19th century/early 20th century. Wool pile; four-warp Rabat or akrous knot; 4.96 x 1.68 m. Musée des Arts d'Afrique et d'Océanie, Paris. The geometric design, consisting of lozenges (smooth, jagged, indented, or fringed), crosses, checks, and X's, is construed in diagonal zones, all worked in a rich array of colors: white, indigo, orange, reddish mauve, light brown, and black. At one end, 'ladder' motifs (perhaps symbolizing a carding comb) provide rectilinear foils to the diagonal ornamentation elsewhere on the field. The overall effect is one of power and abundance.

tral motif, and a tight weave. A symbol of wealth and success, it is the obligatory ornament of the vast salons of the [Moroccan] bourgeoisie.'

Rabat carpets, the oldest of which date to the 18th century, were knotted by local women. The motifs, each of them with a very specific name, are dense and highly fanciful. In addition to the usual fleurettes, rosaces, and birds, they include stylized insects, tile patterns (*zellij*), small eight-pointed stars, date palms, jujubes, snakes, and daggers. Prosper Ricard has carefully catalogued the various motifs, among them the *khamsa*, a stylized hand, whose presence can be detected here and there in Rabats, serving, some say, to ward off evil.

The Garnet-Red Rugs of Kairouan

The so-called 'Kairouan' is a resolutely urban carpet once used exclusively in houses of worship and the homes of Tunisian notables. The rug made its debut in Kairouan midway through the 19th century, after which numerous and popular imitations soon appeared in other cities of the region, among them Bizerte, Gabès, Sousse, and Sfax.

The motifs typical of the Kairouan rug, and even the composition, were borrowed not only from the carpets but also from the ceramic tiles of Anatolia. The colors, however, are less varied and more contrasted than those on Anatolian weavings. A strong shade of garnet is almost always chosen for the central field or *mihrab*, with combinations of dark red and almond green or dark red and sky blue predominating elsewhere. The dyes come from cochineal, kermes, indigo, knapweed centaurea (which flourishes in central Tunisia), curcuma, and henna.

The texture of a Kairouan is comparable to that of a Rabat, meaning that the surface is piled, 'knotted on two warp threads, with the rows of knots separated by two or three shoots of weft.' Kairouans can be classified in three groups according to format and function: the *zerboya* properly speaking, the prayer rug (1.25 x 1 m), and the saddle carpet (0.90 x 0.90 m). The botanical motifs

374

376

– roses, pomegranates, bouquets – are sometimes combined with ewers, frogs, and small medallions.

L. Poinssot and Jacques Revault, who in the 1950s studied the different types of Tunisian rug, have written about the rites that accompanied the fabrication of Kairouans: 'Monday is considered a day on which it would be bad luck to begin such a task, and, in some families, the same is true of Tuesday and Friday. After the various amulets have been placed on the warp, the workers say: "Oh facilitating one, facilitate, and, Satan, be away with you!" Then, just as the first knot is to be tied, the weaver [a woman] intones: "In the name of God, may the execution of the rug be rapid and proper!" Finally, when the piece has been completed, a real celebration is organized.'

Berber Rugs

A salient feature of the Berber carpet of Algeria – woven in villages throughout the region lying south of Oran towards Djelfa in the Djebel Amour range of the Atlas Mountains – is its mixed technique, which combines flatweave and pile. The rug-making craft, once a flourishing activity among the Berbers, benefitted from the availability of an excellent quality of wool (wool from sheep

known as *trafis*, their fleece much cleaner than that of Saharan sheep) as well as from the skill of the women weavers and the *reggam*. The *reggam* was the male designer, a specialist who used strands of white wool knotted on the warps to limn the compartments or shapes the artisans would then fill to create fields of colored knots.

The palette of classic Djebel Amours consists of red, deep indigo (*nil*), green, and saffron, with white used to contour the the motifs. The rugs are decorated with essentially geometric figures or with objects familiar to nomad life: bands of affronted triangles, large scissors (*megueçç*), etc., combined with claws (*mekhleb*), douar tents, and pomegranate seeds.

Djebel Amours were made to serve as beds, which meant a width corresponding to the size of a man – 1.80-1.90 meters – and a length equal to that of a tent. R.P. Giacobetti, who in 1929 established the Djebel Amour corpus, noted that the most precious, the rarest, and the most carefully made of these rugs was the *tag*, the piece used to partition the Berber tent between the areas reserved for men and those for women.

375. Berber carpet 'with multiple fields'. Rabat, 19th century. Wool pile; symmetrical knot; 4.04 x 1.65 m. Musée des Arts d'Afrique et d'Océanie, Paris. Unlike the Moroccan designs seen earlier, this rug has both a central motif and a border. The palette is subtle, its range extending to light blue, dark blue, white, yellow, and brown on a pinkish-beige ground. The Andalusian-type medallion is also found, albeit rarely, on Turkish weavings. Meanwhile, the Berber element is clearly evident in the cross, lozenge, herringbone, and star motifs employed in the field and its enframing border.

376. Djebel Amour carpet. Algeria, 19th century. Wool pile; symmetrical knot; 3.83 x 1.60 m. As in all Berbers woven by nomads, the pattern here is all-over. The dominant blue and ochre are underlined or contoured in white and accented in green and yellow. The crenellated motifs are thought to serve as 'traps' to protect the tent or house from evil spirits intruding through the floor.

BIBLIOGRAPHY

CHAPTER I.
THE ORIGINS OF THE KNOTTED CARPET

Barrelet, M.T. 'Un inventaire de Kar-Tukulti-Ninurta: Textiles décorés assyriens et autres', *Revue d'assyriologie et d'archéologie orientale*, 1977, no. 71, pp. 56-62.

Dimand, M.S., and J. Mailey, *Oriental Rugs in the Metropolitan Museum of Art*, N.Y., 1973, Chap. 2.

Ehand, L. Murray, 'Evidence for Pile Carpets in Cuneiform Sources and a Note on the Pazyryk Carpet', *Oriental Carpet and Textile Studies*, vol. IV, 1993, pp. 9-18.

Folsach, K. von, and A.-M. Keblow Bernsted, *Woven Treasures: Textiles from the World of Islam: The David Collection*, Copenhagen, 1993.

Fuji, H., and K. Sakamoto, 'The Marked Characteristics of the Textiles Unearthed from the At-Tar Caves, Iraq', *Oriental Carpet and Textile Studies*, vol. IV, 1993, pp. 35-46.

Gantzhorn, V., *Le Tapis chrétien oriental*, Taschen, 1991.

Hirsch, U., 'The Fabric of Deities and Kings', *Hali*, 1991, no. 58, pp. 104-111.

Lamm, C.J., *Carpet Fragments: The Marby Rug and Some Fragments of Carpets Found in Egypt*, Stockholm, 1937.

Lombard, M., *Les Textiles dans le monde musulman, VIIᵉ-XIIᵉ siècle*, Paris, 1978.

Mackie, L., 'Covered with Flowers: Medieval Floor Coverings Excavated at Fustat in 1980', *Oriental Carpet and Textile Studies*, vol. I, 1985, pp. 23-35.

Rogers, C., *Early Islamic Textiles*, Brighton, 1983.

Ryder, M.L., 'A Note on the Wool Type in Carpet Yarns from Pazyryk', *Oriental Carpet and Textile Studies*, vol. III, pt. I, 1987, pp. 20-21.

Sakamoto, K., 'Ancient Pile Textiles from the At-Tar caves in Iraq', *Oriental Carpet and Textile Studies*, vol. I, 1985, pp. 9-17.

Schürmann, U., 'The Pazyryk, a 2,500 Years Old Knotted Rug Found in an Icegrave in the Altaï. Its Use and Origin: A Paper Read During the Symposium of the Armenian Rugs Society', N.Y., 1982.

Stronach, D., 'Patterns of Prestige in the Pazyryk Carpet: Notes on the Representational Role of Textiles in the First Millenium BC', *Oriental Carpet and Textile Studies*, vol. IV, 1993, pp. 19-34.

Sümer, F., 'Early Historical References to Turkmen Carpet Weaving in Anatolia', *Oriental Carpet and Textile Studies*, vol. I, 1985, pp. 36-40.

Unger, E. de, 'An Ancestor of the Mamluk Carpets',

Hali, vol. V, no. 1, 1982, pp. 45-46.

Whiting, M.C., 'A Report on the Dyes of the Pazyryk Carpet', *Oriental Carpet and Textile Studies*, vol. I, 1985, pp. 18-22.

Tissus d'Egypte: Témoins du monde arabe VIIIe-XVe siècle: Collection Bouvier, exh. cat., Institut du Monde Arabe, Paris, 1993.

CHAPTER II. THE MANUFACTURE,
RESTORATION, AND CONSERVATION
OF CARPETS

Devalier, L, 'Techniques de fabrication', *Tapis, présent de l'Orient*, exh. cat., Paris, 1989, pp. 192-194.

Dillmont, T. de, *Encyclopédie des ouvrages de dames*, Paris, pp. 201-203.

Dobry, M., *Tapis au point: Techniques et réalisations*, Fribourg, 1979, pp. 45-51.

Ghadimi, B., *Les Tapis persans: Techniques et décorations*, Belgium, 1979, pp. 68-73.

Rieger, A., 'Rouge d'Andrinople et bleu Turquin', *Tapis, présent de l'Orient à l'Occident*, Paris, 1989, pp. 189-191.

Sabahi, T., *Splendeurs des tapis d'Orient*, Paris, 1987, pp. 28-44 and 68-73.

Tattersall, C.E.C., *Notes on Carpet-knotting and Weaving*, Victoria and Albert Museum, Her Majesty's Stationery Office, London, 1969, pp. 7-42.

Merritt, J., *Tapis: Présent de l'Orient à l'Occident*, Paris, 1989, pp. 183-184.

Sabahi, T., *Splendeurs des tapis d'Orient*, Paris, 1987.

Viallet, N., F. Salet, and G. Souchal, *Principes d'anayse scientifique: Tapisserie*, Ministère des Affaires Culturelles, Imprimerie Nationale, Paris, 1971, pp. 9-53.

CHAPTER V. POETRY AND CARPETS:
CALLIGRAPHIC ART IN THE CARPETS
OF IRAN

Achdjian, A., *Le Tapis*, Éditions Self, Paris, 1949.

Aga-Oglu, M., *Safavid Rugs and Textiles: The Collection of the Shrine of Imam Ali at al-Najaf*, N.Y., 1941.

Allgrove, J., *The Qashqa'i of Iran*, exh. cat., Manchester, 1976.

Archer, M., 'Gardens of Delight', *Apollo*, Sept. 1968.

Aschenbrenner, *Oriental Rugs: Persian*, vol. II, Suffolk, 1990.

Bailey, J., 'The Other Ardabil', *Hali*, no. 56, April 1991.

Bakhtiar, L., *Sufi: Expressions of the Mystic Quest*, London, 1976.

Bakhtiar, L., and N. Ardalan, *The Sense of Unity*, Chicago, 1975.

Bartels, H., 'Kufic or Pseudo-Kufic as Anatolian Border Design', *Oriental Carpet and Textile Studies*, vol. III, no. 2, 1987.

Bennett, I., *Rugs and Carpets of the World*, N.Y., 1977.

Bennett, I., 'Splendours in the City of Silk', *Hali*, no. 9, July-Sept. 1987.

Bennett, I., and M. Franses, 'The Topkapi Prayer Rugs', *Hali*, no. 39, May-June 1988.

Bennett, I., 'Isfahan Strapwork Carpets', *Hali*, no. 41, Sept.-Oct. 1988.

Bernus-Taylor, M., *Arabesques et jardins de paradis*, exh. cat., Louvre, Paris, 1989-1990.

Binney, E., III, *The Nasli M. Heermaneck Collection*, exh. cat., ed. P. Pal, Los Angeles, 1973.

Briggs, A., 'Timurid Carpets', *Ars Islamica*, no. 7, 1940.

Bode, W. von, and E. Kühnel, *Vorderasiatische Knüpfteppiche aus älterer Zeit*, Leipzig, Seeman, 1922.

Bode, W. von, and K. Kühnel, *Antique Rugs from the Near East*, trans. C.G. Ellis, London, 1984.

Brookes, J., *Gardens of Paradise*, Weidenfeld and Nicholson, London, 1987.

Clinton, J.W., 'Image and Metaphor: Textiles in Persian Society', *Woven from the Heart, Spun from the Soul*, ed. C. Bier, Textile Museum, Washington, D.C., 1987.

Dawood, N.J., trans. of the Koran, Penguin Classics, 1966.

Day, Susan, 'Les Français et le tapis d'Orient', *Tapis présent de l'Orient à l'Occident*, exh cat., Institut du Monde Arabe, 1989.

Diba, L.S., 'Visual and Written Sources: Dating Eighteenth-Century Silks', *Woven from the Heart, Spun from the Soul*, ed. C. Bier, Textile Museum, Washington, D.C., 1987.

Diba, L.S., 'Persian painting in the Eighteenth-Century: Tradition and Transmission', *Muqarnas*, vol. VI.

Dilley, A.U., *Oriental Rugs and Carpets*, rev. by M.S. Dimand, N.Y., 1959.

Dimand, M.S., *The Ballard Collection of Oriental Rugs*, N.Y., 1935.

Dimand, M.S., and J. Mailey, *Oriental Rugs in the Metropolitan Museum of Art*, N.Y., 1973.

Donzel, B. van, Pellat, C., and B. Lewis, *Encyclopédie de l'Islam*, vol. IV, Paris, 1960.

Ellis, C.G, *Early Caucasian Rugs*, Textile Museum, Washington, D.C., 1976.

Ellis, C.G., *Oriental Carpets in the Philadelphia Museum of Art*, Herbert Press, Philadelphia, 1988.

Erdmann, K., *Oriental Carpets: An Essay on Their History*, trans. C.G. Ellis, N.Y., 1960.

Erdmann, K., 'The Art of Carpet Making', *A Survey of Persian Art*, Ars Islamica, vol. VII, 1940.

Ettinghausen, R., 'The Early Use and Iconography of the Prayer Rug', *Islamic Art and Archaeology Collected Papers*, Berlin, 1984.

Ettinghausen, R. 'New Light on Early Animal Carpets', *Islamic Art and Archaeology Collected Papers*, Berlin, 1984.

Ettinghausen, R., 'The Boston Hunting Carpet in Historical Perspective', *Islamic Art and Archaeology Collected Papers*, Berlin, 1984.

Falk, S.J., *Qadjar Paintings*, London, 1972.

Falk, T. *Treasures of Islam*, exh. cat., Geneva, 1985.

Faza'eli, H., *Atlas-e-Khat*, Isfahan, 1362 solar.

Féhérvari, G., *Islamic Metalwork of the 8th-15th Century in the Keir Collection*, London, 1976.

Floor, W., 'Economy and Society: Fibers, Fabrics, Factories', *Woven from the Heart, Spun from the Soul*, ed. C. Bier, Textile Museum, Washington, D.C., 1987.

Ghani, G., and M. Ghazvini, eds., *Divan-e-Hafez*, Teheran, 1367 solar.

Ghirshmann, R., *Parthes et Sassanides*, Gallimard, Paris, 1962.

Grabar, O., *The Formation of Islamic Art*, Yale U. Press, New Haven, 1973.

Gray, B., ed., *Shahnameh-i-Baysonghor 1430/833*, with facsimile, Teheran, 1977.

Gray, B., 'The Essence of Islamic Art', *Apollo*, April 1976.

Haldane, D., *Islamic Bookbindings in the Victoria and Albert Museum*, London, 1983.

Helfgott, L.M., *Woven from the Heart, Spun from the Soul*, exh. cat.

Housego, J., 'Eighteenth-Century Persian Carpets: Continuity and Change', *Oriental Carpet and Textile Studies I*, London, 1985.

Hutt, A. and H., Len, *IRAN I*, Scorpion, 1977.

Hutt, A. and H., Len, *IRAN II*, Scorpion, 1978.

Ittig, A., 'The Kirmani Boom: A Study in Carpet Entrepreneurship', *Oriental Carpet and Textile Studies*, vol. I, 1985.

Jacoby, H., 'Materials Used in the Making of Carpets', in A.U. Pope, *A Survey of Persian Art*, 1938.

James, D., *Qurans and Binding from the Chester Beatty Library*, World of Islam Festival, London, 1980.

Kendrick, A.F., and C.E.C. Tattersall, *Hand-Woven Carpets: Oriental and European*, 2 vols., London, 1922.

Kia'i, Al, *Chenakhte Chahkarhaye Farch-e-Iran*, Teheran, 1347/1974.

Lambton, A.K.S., *Qadjar Persia*.

Larson, K., *Rugs and Carpets of the Orient*, London, 1962.

Lentz, T.W., and G.D. Lowry, *Timur and the Princely Vision*, Los Angeles County Museum of Art/Arthur M. Sackler Gallery, Washington, D.C., 1989.

Lings, M., *The Quranic Art of Calligrapahy and Illumination*, Kent, 1976.

Lisbon, Museu Nacional de Arte Antiqua, *Oriental Islamic Art: Collection of the Caluste Gulbenkian Foundation*, exh. cat., Lisbon,1963.

Lockhart, L., *The Fall of the Safavid Dynasty and the Afghan Occupation of Iran*, Cambridge, 1958.

Martin, F.R., *A History of Oriental Carpets before 1900*, Vienna, 1908.

Milikian-Chirvani, S., *Islamic Metalwork from the Iranian World*, exh. cat., Victoria and Albert Museum, London, 1982.

Mumford, J.K., *The Yerkes Collection of Oriental Carpet*, London, 1910.

Perry, J., *Karim Khan Zand: A History of Iran, 1747-1779*, Chicago and London, 1979.

Pope, A.U., and Phyllis Ackermann, eds., *A Survey of Persian Art from Psrehistoric Times to the Present*, Oxford U. Press, London, 1939.

Rahjiri, A., *Tgarikh e Mokhatassar e Khat*, Teheran, 1345 solar.

Robinson, B.W., *Persian Drawings from the 14th through the 19th Century: Drawings of the Masters*, Victoria and Albert Museum, London, 1965.

Robinson, B.W., *A Descriptive Catalogue of the Persian Paintings in the Bodleian Library*, Oxford, 1958.

Robinson, B.W., *Persian Paintings the John Rylands Library*, London, 1980.

Sadeghi, A.A., 'Chiveh ha va Emkanat Vajehsazi dar Zaban e Farsi Mo'asser', *Nachr e Danech*, 11, vol. IV, 1370 solar.

Sarre, F., and H. Trenkwald, *Old Oriental Carpets*, trans. A.F. Kendrick, 2 vols., Vienna, 1926-1929.

Sourdel, D. and J., *La Civilisation de l'Islam classique*, Paris, 1968.

Schürmann, U., *Central-Asian Rugs*, trans. A. Grainge, Frankfurt-am-Main, 1969.

Soustiel, J., *La Céramique islamique*, Office du Livre, Fribourg, 1985.

Spühler, F., *Oriental Carpets in the Museum of Islamic Art in Berlin*, trans. R. Pinner, London, 1987.

Stierlin, H., *Ispahan: image du Paradis*, with pref. by Henry Corbin, La Bibliothèque des Arts, Lausanne, 1976.

Tanavoli, P., *Shahsavan*, trans. A. Berra, Office du Livre, Fribourg, 1985.

Tuschscherer, J.-M., and G. Vial, *Le Musée Historique des Tissues de Lyon*, Lyons, 1977.

Welch, A., *Calligraphy in the Arts of the Muslim World*, Austin, 1979.

Wlber, D., 'Heriz Rugs', *Hali*, 6, no. 1, 1983.

Wiet, G., *Solieries persanes*, Cairo, 1948.

Wulff, H.E., *Traditional Crafts of Persia*, MIT Press, 1975.

Zoka, Y., 'Arch'ar va Arhya'a', *Honar va Mardom*, Farvardikne(March-April), 1344 solar.

CHAPTER VI. CARPETS OF THE GREAT MOGHUL: 16TH-19TH CENTURY

Bennett, I., 'Jahan, Haipur, Jonquils: Some Notes on Indian Carpet Designs', exh. cat., The European Fair and Art Fair, Maastricht, March 1989. *Tapis du monde entier*, Paris, 1982.

Bérinstain, V., 'Les Tapis indiens', exh. cat., *Tapis, présent de l'Orient à l'Occident*, Institut du Monde Arabe, Paris, 1989.

Chattopadarya, K., *Carpets of India and Floor Coverings*, Bombay, 1969.

Dhamija, J., 'Carpets of India', *Marg*, Bombay, Sept. 1965.

Dimand, M.S., and J. Maley, *Oriental Rugs in the Metropolitan Museum of Art*, N.Y., 1973.

Ellis, C.G., 'The Strengths of the Textile Museum's Oriental Carpet Collection', *The Textile Museum Journal*, Washington, D.C., 1985.

Ruedin, G., *Les Tapis indiens*, Office du Livre, Fribourg, 1984.

Walker, D.S., 'Classical Indian Rugs', *Hali*, vol. IV, no. 3, 1982.

CHAPTER VII. THE CARPETS OF THE MIDDLE KINGDOM: CHINA

Boswell, R., *Antique Chinese Carpets, Masterpieces of the Te-Chan Wang Collection*, London, 1978.

Dimand, M.S.,and J. Mailey, *Oriental Rugs in the Metropolitan Museum of Art*, N.Y., 1973.

Hackmack, A., *Chinese Carpets and Rugs*, lst ed., Tientsin, 1924; 2nd ed., Tuttle, Tokyo, 1980.

Larsson, J.R., *Lennart, Carpets from China, Xinjiang and Tibet*, ed. Shambala, Boston, 1989.

Lorentz, H.H., *A View of Chinese Rugs from the 17th to the 20th Centuries*, London, 1972.

Murray-Eiland, L., *Chinese and Exotic Rugs*, Boston, 1979.

Rostov, C., and Jia Gu, *Chinese Carpets*, N.Y., 1983.

Ruedin, G., *Les Tapis chinois*, Office du Livre, Fribourg, 1981.

Several articles devoted to Chinese carpets in the review *Hali*, vol. 5, no. 2, p. 132, London.

'Tapis Chinois', *Connaissance des arts*, June 1953.

CHAPITER VIII. THE FRENCH CARPET

Le XVᵉ siècle au tapis: Aspects du tapis en France de l'Art nouveau à l'art contemporain, Centre Culturel de Boulogne-Billancourt, Éditions de l'Albaron, 1991.

Sirat, J., and F. Siriex, *Tapis français du vingtième siècle de l'art nouveau aux créations contemporaines*, Éditions de l'Amateur, Paris, 1993.

Day, S., *Carpets by Artists from William Morris to Henri Morris* (to be published).

CHAPTER IX.
THE CARPETS OF GREAT BRITAIN

Athur, L., *Embroidery 1600-1700 at the Burrell Collection*, Glasgow, 1995.

Bateman Faraday, C., *European and American Carpets and Rugs*, Woodbridge, 1990.

Bennett, I., *Rugs and Carpets of the World*, London, 1977.

Bennett, I., and M. Franses, 'The Buccleuch European Carpet and Others in the Oriental Style', *Hali*, no. 66, Dec. 1992, pp. 95-107.

Fairclough, O., and E. Leary, *Textiles by William Morris and Morris & Co., 1861-1940*, London, 1981.

Hackenbroch, Y., *English and Other Needlework, Tapestries and Textiles in the Irwin Untermyer Collection*, Cambridge, Mass., 1960.

Haslam, M., *Arts and Crafts Carpets*, London, 1991.

Jacobs, B., *The Story of British Carpets*, London, 1968.

Jacobs, B., *Axminster Carpets (Hand-made): 1755-1975*, Leigh-on-Sea, 1970.

Kendrich, A.F., *English Decorative Fabrics of the 16th-18th Centuries*, London, 1934.

Kendrich, A.F., and C.E.C. Tattersall, *Handwoven Carpets, Oriental and European*, London, 1922.

Mayorcas, M.J., *English Needlework Carpets, 16th to 19th Centuries*, Leigh-on-Sea, 1963.

Le Paradis terrestre: L'Artisanat d'art selon William Morris et ses disciples dans les collections canadiennes, exh. cat., Toronto, 1993.

Parissien, S., *Néo-classique, le style Adam*, Paris, 1992.

Parry, L., *William Morris Textiles*, London, 1983.

Parry, L., *Textiles of the Arts and Crafts Movement*, London, 1988.

Sherrill, S.B., *Carpets and Rugs of Europe and America*, N.Y., 1995.

Stanland, K., *Medieval Craftsmen Embroiderers*, London, 1991.

Swain, M., *The Needlework of Mary of Scots*, Rugby, 1986.

Synge, L., *Antique Needlework*, London, 1982.

Tattersall, C.E.C., and S. Reed, *A History of British Carpets: From the Introduction of the Craft until the Present Day*, Leigh-on-Sea, 1966.

CHAPTER X.
THE CARPET IN SPAIN AND PORTUGAL
Spain

Airie, R., *L'Espagne musulmane au temps des Nasrides (1232-1492)*, Paris, 1973.

Bateman Faraday, C., *European and American Carpets and Rugs*, Woodbridge, 1990.

Beattie, M.H., 'The Admiral Rugs of Spain: An Analysis and Classification of Their Field Designs', *Oriental Carpet and Textile Studies*, II, 1986.

Bennassar, B., *Histoire des Espagnols, VIe-XVe siècle*, Paris, 1992.

Bennett, I., *Rugs and Carpets of the World*, London, 1977.

Bennett, I., 'Splendours in the City of Silk: Part 4: The Remaining Classical Carpets', *Hali*, 1987, no. 3, pp. 32-36.

Collins, S.P., 'The Spanish Connection', *Hali*, March-April 1988, no. 38, pp. 42-44.

Descola, J., *Histoire d'Espagne*, Paris, 1979.

Dimand, M.S., and J. Mailey, *Oriental Rugs in the Metropolitan Museum of Art*, N.Y., 1973, chap. 8.

Dufourq, C.E., *La Vie quotidienne dans l'Europe médiévale sous domination arabe*, Paris, 1978.

Ellis, C.G., *Oriental Carpets in the Philadelphia Museum of Art*, Philadelphia, 1988.

Erdmann, K., *Seven Hundred Years of Oriental Carpets*, London, 1970.

Ferrandis Torres, J., *Exposicion de alfombras antiguas espanolas*, Madrid, 1933.

Gancedo Baga, J., 'Las alfombras espanolas', *Revista de las Artes Decorativas*, 1983, no. 39, pp. 36-41.

Guinard, P., *Les Peintres espagnols*, Paris, 1967.

Kendrick, A.F., and C.E.C. Tattersall, *Hand-woven Carpets, Oriental and European*, London, 1922.

Kendrick, A.F., and C.E.C. Tattersall, *Guide to the Collection of Carpets*, Victoria and Albert Museum, London, 1931.

Kuhnel, E., and L. Bellinger, *The Textile Museum Catalog of Spanish Rugs: 12th to 19th Century*, Washington, D.C., 1953.

Lamm, C.J., *Carpet Fragments: The Marby Rug and Some Fragments of Carpets Found in Egypt*, Stockholm, 1937.

Leaf, W., and S. Purcell, *Heraldic Symbols: Islamic Insignia and Western Heraldry*, London, 1986.

Lewis May, F., 'Hispano-Moresque Rugs', *Notes Hispanic*, 1945, vol. 5.

Lewis Mayh, F., *Silk Textiles of Spain: 8th-15th Century*, N.Y., 1957.

Mackie, L., 'Covered with Flowers: Medieval Floor Coverings Excavated at Fustat in 1980', *Oriental Carpet and Textile Studies*, I, pp. 23-35.

Mackie, L., 'Native and Foreign Influences in Carpets Woven in Spain during the 15th Century', *Hali*, 1979, vol. II, no. 2, pp. 88-95.

Mackie, L., 'Two Remarkable Fifteenth-Century Carpets from Spain', *Hali*, 1977, vol. IV, no. 4, pp. 15-32.

Perez, J., *Isabelle et Ferdinand: Rois catholiques d'Espagne*, Paris, 1988.

Perez-Dolz, F., *El arte del tapiz y la alfombra en españa*, Barcelona, 1952.

Sanchez Ferrer, J., *Alfombras antiguas de la provincia de Albacete*, Albacete, 1986.

Sarre, F., 'Mittelalterliche Teppiche Spanischer und Kleinasiatischer Herkunst', *Kunst und Kunsthandwerk*, 1907, X.

Sarre, F., 'A Fourteenth-Century Spanish Synagogue Carpet', *Burlington Magazine*, Feb. 1930, LVI, pp. 89-95.

Sherill, S.B., 'The Islamic Tradition in Spanish Rug Weaving: Twelfth through Seventeenth-Centuries', *Antiques Magazine*, March 1974, pp. 532-549.

Spühler, F., *Islamic Carpets and the Textiles in the Keir Collection*, London, 1978, p. 29.

Spühler, F., *Die Orientteppiche im Museum für Islamische Kunst Berlin*, Munich, 1990, pp. 118-123.

Thomson, W.G., 'Hispano-Moresque Carpets', *Burlington Magazine*, 1910, XVIII,, pp. 100-111.

Van de Put, A., 'Some Fifteenth-Century Spanish Carpets', *Burlington Magazine*, 1911, XIX, pp. 344-350.

Van de Put, A., 'A Fifteenth-Century Spanish Carpet', *Burlington Magazine*, 1924, LXV, pp. 119-120.

Tapis: Présent de l'Orient à l'Occident, exh. cat., Institut du Monde Arabe, Paris, 1990.

Portugal

Baptista de Oliveira, S., *Historia e tecnica dos tapetes de Arraiolos*, Lisbon, 1983.

Bateman Faraday, C., *European and American Carpets and Rugs*, Woodbridge, 1990.

Campana, M., *European Carpets*, London.

Stone, P. *Portuguese Needlework Rugs: The Time-Honored Art of Arraiolos Rugs Adapted for Modern Handcrafts*, Virginia, 1981.

CHAPTER XI.
THE CAUCASUS AND OTHER CARPETS
The Caucasus

Ellis, C.G., *Early Caucasian Rugs*, Textile Museum, Washington, D.C., 1975.

Gans-Ruedin, E., *Le Tapis du Caucase*, Fribourg, 1966.

Kerimov, L., *Les Tapis caucasiens*, Leningrad, 1984.

Schürmann, U., *Caucasian Rugs*, London, 1965.

Central Asia

Boenders, F., et al., *Djulchir, tissus de défense et de protection*, exh. cat. ('Djulsjir, Weefsels tot afweer en bescherming'), Brussels, 1995.

O'Bannon, G.W., *The Turkoman Carpet*, London, 1974.

Moschkova, V.G., *Die Teppiche der Völker Mittelasiens im späten XIX und frühen XX Jahrhundert (Materialien der Expedition von 1929-1945)*, Hamburg, 1977.

Kilims

Balpinar, B., and U. Hirsch, *Flachgewebe des Vakiflar-Museums Istanbul*, Wesel, 1982.

Qilima shqiptare, cat. of the F.S.E., University of Tirana, 1978.

North Africa

Giacobetti, R.P., *Les Tapis et tissages du Djebel-Amour*, Paris, 1932.

Poinssot, L., and J. Revault, *Tapis tunisiens*, Paris, 1955.

Ramirez, F., and C. Rololt, *Tapis et tissages du Maroc*, Paris, 1995.

Ricard, P., *Corpus des tapis marocains*, Paris, 1923.

NOTES

CHAPTER I.
THE ORIGINS THE KNOTTED CARPET
1. U. Hirsch, 'The Fabric of Deities and Kings', *Hali*, no. 58, 1991, pp. 104-111.
2. L. Murray Eiland, 'Evidence for Pile Carpets in Cuneiform Sources and a Note on the Pazyryk Carpet', *Oriental Carpet and Textile Studies*, vol. IV, 1993, pp. 9-18.
3. M. T. Barrelet, 'Un inventaire de Kar-Tukulti-Ninurta: Textiles décorés assyriens et autres', *Revue d'assyriologie et d'archéologie orientale*, 1977, no. 71.
4. Dynasty founded by one of Alexander's generals, which ruled Egypt from 305 to 30 bc, with Alexandria as their capital.
5. Athenaeus, Greek professor and grammarian, lived in Egypt in the 2nd and 3rd centuries ad; in the *Banquet of the Sophists*, a collection of curiosities gleaned from his lectures, he cited 1,500 works now totally disappeared. Bk. V, chap. XXVI, pp. 258-259, Sweighausen, cited in E. Müntz, La Tapisserie, Paris, 1882, pp. 37-38.
6. Xenophon (430-355 bc), *La Cyropédie*, bk. VIII, cited in E. Müntz, *op. cit.*
7. Athenaeus, *Banquet of the Sophists*, bk. XII, chap. 7, cited in E. Müntz, *op. cit.*
8. J. Ebersolt, *Les Arts somptuaires de Byzance*, Paris, 1923, p. 147.
9. O. Grabar, *The Formation of Islamic Art*, London, 1937.
10. F. Sümer, 'Early Historical References to Turkoman Carpet Weaving in Anatolia', *Oriental Carpet and Textile Studies*, vol. I, 1985, pp. 36-40.
11. 'The Fabric of Deities and Kings', *op. cit.*
12. E. Riefstahl, *Patterned Textiles in Pharaonic Egypt*, Brooklyn, 1944.
13. 'Un inventaire de Kar-Tukulti-Ninurta', *art. cit.*
14. U. Schürmann, 'The Pazyryk: Its Use and Origin. A Paper Read During the Symposium of the Armenian Rugs Society', N.Y., 1982.
15. *Ibid.*
16. M. S. Dimand and J. Mailey, *Oriental Rugs in the Metropolitan Museum of Art*, N.Y., 1973, p. 9.
17. S. Rudenko, *Kunsthandwerk im Altaï und Vorderasien*, Moscow, 1961.
18. H. Fujii and K. Sakamoto, 'The Marked Characteristics of the Textiles Unearthed from the At-Tar Caves, Iraq', *Oriental Carpet Textile Studies*, vol. IV, 1993, pp. 35-46.
19. *Tissus d'Égypte. Témoins du monde arabe*, VIIIᵉ-XVᵉ siècles. Collection Bouvier, Musée d'Art et d'Histoire, Geneva; Institut du Monde Arabe, Paris, 1993, pp. 120-122.

20. L. Mackie, 'Covered with Flowers: Medieval Floor Coverings Excavated at Fustat in 1980', *Oriental Carpet and Textile Studies*, vol. I, 1985, pp. 23-35.
21. It is interesting to note that these mosaics were still being made in the 11th and 12th centuries under the name opus *Alexandrium*, with one installed at Westminster Abbey in 1268. The carpets produced in Constantinople in the 6th century and again in the 9th were also inspired by mosaics, just as the Mamluk rugs would be at a later date (1250-1517).
22. E. de Unger, 'An Ancestor of the Mamluk Carpets', Hali, vol. V, no. 1, 1982, pp. 45-47.
23. Le rapport d'armure est de quatre fils et deux coups et la découpure chaîne est de quatre fils.
24. K. von Folsach, *Islamic Art: The David Collection*, Copenhagen, 1990; K.von Folsach and A. M. Keblow Bernsted, *Woven Treasures:Textiles from the World of Islam: The David Collection*, Copenhagen, 1993, ill. 1.
25. C. Rogers, *Early Islamic Textiles*, Brighton, 1983.
26. F. Spühler, *Islamic Art in the Keir Collection*, London, 1988 ; E. de Unger, 'An Ancestor of the Mamluk Carpets', Hali, vol.V, no. 1, pp. 44-46.

CHAPTER III.
BETWEEN A TRIBAL ART AND A COURT ART
27. J. Housego, *Les Tapis anatoliens du xiiiᵉ siècle jusqu'au xviᵉ siècle*, degree defense before the EHESS, 1988, pp. 8-9, 13-14. I wish to thank Ms Housego for having made her work available to me.
28. Tribes of Huns, very likely of Turkoman origin, had been making sporadic incursions into Europe since the 5th century.
29. The presence of 'lazy lines' is not visible on the surface of the work, which is covered by the pile.
30. K. Erdmann, *The History of the Early Turkish Carpet*, London, 1977, p. 2.
31. J. Housego, *op. cit.* (1988), p. 23.
32. *The Eastern Carpet in the Western World from the 15th to the 17th Century*, exhibition organized by D. King and D. Sylvester at the Hayward Gallery, London, 1983, no. 37, p. 71.
33. B. Balpinar and U. Hirsch, *Carpets of the Vakiflar Museum*, Wesel, 1988.
34. C. G. Ellis, 'The Rugs from the Great Mosque of Divrigi', *Hali*, vol. I, no. 3, 1978, pp. 269-274.
35. F. Spühler, 'Unbequeme Fragen zu unbekannten turkischen Teppichen der Berliner Sammlung – Uncomfortable Questions about Unknown Turkish Carpets in the Berlin Collection', *Hali*, vol. IV, no. 4, 1982, pp. 324-328.
36. W. Brüggemann and H. Böhmer, *Rugs of the Peasants and Nomads of Anatolia*, Munich, 1983.

37. Radio isotope of carbon which develops naturally in the atmosphere. The analysis of the content of carbon 14 which diminishes at a fixed rate over time allows an object to be dated with relative accuracy.
38. H. Inalcik, 'The Yürüks: Their Origin, Expansion and Economic Role', *Oriental Carpet and Textile Studies*, vol. II, 1986, p. 40.
39. Certain experts believe the term signifies *gu*, the Perisan world for 'rose'.
40. S. Day, 'Tales of Totems and Tamghas', *Oriental Carpet and Textile Studies*, IV, 1993, pp. 255-266.
41. P. M. Holt, A. K. S. Lambton, and B.Lewis, *Encyclopédie générale de l'Islam*, s.l., SIED, 1984, p. 286. We should note that the relationship between the totem and the blazon in the structure of tribal society had been remarked upon by sociologists.
42. F. Sumer, 'Early Historical References to Turkoman Carpet Weaving in Anatolia', *Oriental Carpet and Textile Studies*, vol. I, 1985, pp. 35-40.
43. W. Denny, 'Turkmen Rugs and Early Rug Weaving in the Western Islamic World', *Hali*, vol. IV, no. 4, 1982, pp. 330-337.
44. For a discussion of the importance of color in Turko-Mongol society, see Susan Day, 'Heraldic Devices of Turkish Peoples and Their Relationship to Carpets', *Oriental Carpet and Textile Studies*, vol. III, no. 2, n.d., pp. 235-249.
45. S. Day, 'Oriental Carpet Design', *World Rugs and Carpets*, D. Black, ed., London, 1985, p. 26.
46. The *tamgha* of the twenty-four Oghuz tribes, ancestors of the Turkomans, are drawn in the margin of the manuscript, next to their names. Cf. S. Day, *op. cit.*, 1993.
47. S. Day, 'Chinoiserie' in Islamic Carpet Design', *Hali*, no. 48, 1989, pp. 38-45.
48. K. Erdmann, 'Turkish Carpets: The Konya Carpets', in *Seven Hundred Years of Oriental Carpets*, London, 1970, pp. 41-46.
49. R. M. Riefstahl, 'Primitive Rugs of the "Konya" type in the Mosque of Beyshehir', *Art Bulletin*, vol. VIII, no. 2, June 1931, pp. 177-220.
50. C. J. Lamm, 'Carpet Fragments', *The Marby Rug and Some Fragments of Carpets Found in Egypt*, Stockholm, 1985, pp. 36-41.
51. Long out of sight, this carpet reappeared on the Cairo market in the 1950s. It is cut in two. One of the pieces is in the Keir collection in Switzerland, and the other in the David Collection in Copenhagen. Y. Petsopoulos, 'Beyshehir IX', *Hali*, no. 31, 1986, pp. 56-58, and *Hali*, no. 61, 1992, p. 85.
52. N. Olçer, 'Early Seljuk and Ottoman Carpets from the Collection of the Museum of Turkish Islamic Art',

Oriental Carpet and Textile Studies, vol. IV, 1993, p. 49.

53. Another fragment of the same type was auctioned by Sotheby's, N.Y., on 17 Sept. 1992 (lot 29).

54. R. Pinner, 'The Crivelli Rug and the Turkmen Connection', *Oriental Carpet and Textile Studies*, vol. IV, 1993, pp. 245-252.

55. C. J. Lamm, *op. cit.* (1985) pp. 44-46.

56. K. Erdmann, 'The Anatolian Animal Carpets', in *Seven Hundred Years of Oriental Carpets*, op. cit., figs. 39, 40.

57. It is worth noting that the woollen foundation with symmetrical knots is not characteristic of Egyptian weaving but more like the later techniques used in Anatolian manufacture. 'The "Fustat" Symposium', *Oriental Rug Review*, vol. VI, no. 9, Dec. 1986 p. 2.

58. 'An early Animal Rug at the Metropolitan Museum, *Hali*, no. 53, Oct. 1990, pp. 154-155.

59. '13th Century Animal Carpet Sold at Fine Art Fair', *Hali*, no. 68, April-May 1993, pp. 167-168; R. Pinner, 'Orient Stars', *Hali*, no. 71, Oct.-Nov. 1993, pp. 124-125. In the next chapter we will take up a fifth carpet with an engimatic design dated by Carbon-analysis to between the 13th and 15th centuries, this work too owned by H. Kirchheim.

60. E. de Lorey, 'Le tapis d'Avignon', *Gazette des beaux-arts*, July 1932, pp. 162-171.

61. J. Mills, 'Early Animal Carpets in Western Paintings: A Review', *Hali*, vol. I, no. 3, 1978, pp. 234-243.

62. S. Day, *op. cit.* (1993), p. 262.

63. Marco Polo, *Le Devisement du monde, Le Livre des merveilles*, reprint of the trans. by L. Hambis, Paris, 1982, vol. I, p. 69.

64. H. Inalcik, 'The Yürük'. *Oriental Carpet and Textile Studies*, vol. II, 1986, pp. 52 and 63, n. 75.

65. J. Carswell, 'Ceramics', in Y. Petsopoulos, ed., *Tulips, Arabesques and Turbans*, London, 1982, p. 76.

66. H. Inalcik, *op. cit.*, 1986, p. 56.

67. R. Pinner, *op. cit.*, 1993, fig. 4, p. 247.

68. J. Mills, 'Small Pattern Holbein in Paintings', *Hali*, vol. I, no. 4, 1978, pp. 325-334.

69. Others are illustrated by M. Dimand and J. Mailey, *Oriental Rugs in the Metropolitan Museum of Art*, New York, 1973, pp. 22-24.

70. C. G. Ellis, 'A Soumak in the International Style', *Textile Museum Journal*, vol. I, no. 2, Dec. 1963, pp. 3-19, and by the same author, 'On "Holbein" and "Lotto" Rugs', *Oriental Carpet and Textile Studies*, vol. II, 1986, p.169.

71. F. Spühler, *Oriental Carpets in the Museum of Islamic Art Berlin*, London, 1988, nos. 4 to 6, pp. 30-32.

72. W. Denny, lecture at the International Congress of Oriental Carpets, San Francisco, 1990.

73. Dyed lime yellow, the warps of the Egyptian carpet are made of three or four yarns of wool S-spun and then twisted Z; the woollen warps, in pastel shades, are never dyed red; finally, the pile is woven with the asymmetrical knot.

74. R. Gilles, 'Mamelouks',*Tapis, Présent de l'Orient à l'Occident*, exh. cat., Institut du Monde Arabe, Paris, 1989, p. 29. 75. F. Spühler, 'Ottoman or Anatolian? An Attempt at a Redefinition', in H. Kirchheim, M. Franses, and F. Spühler, et al, *Orient Stars*, London, 1994, p. 237.

76. B. Balpinar and V. Hirsch, *op. cit.*, 1988, pls. 15, 55.

77. Christie's, London, 20 Oct. 1994, lot 519. Carbon-14 dating has given two periods - 1413-1606 (95% probability) and 1437-1508 (68% probability).

78. Another fragment came on the German market in 1987; cf. *Hali*, no. 34, May-June 1987, p. 100.

79. J. Mills, 'Lottos in Western Paintings', *Hali*, vol. III, no. 4, 1981, pp. 279-289.

80. C. G. Ellis hypothesizes manufacturer in the Balkans within the so-called 'kilim' and 'ornamented' subgroups; cf. 'The Lotto Pattern as a Fashion in Carpets', *Festschrift für Wilhelm Meister*, Hamburg, 1975, p. 23.

81. Inv. 08.208.2. Reproduced by M. Dimand and J. Mailey, *op. cit.* (1973), ill. 175.

82. W. Denny, *op. cit.* (1986), p. 244.

83. W. Denny, *op. cit.* (1986), pp. 244-245.

84. H. Inalcik, *op. cit.* (1986), p. 56.

85. G. Paquin, 'Cintamani', *Hali*, no. 64, 1992, pp. 104-119 ; W. Denny, *op. cit.* (1986), p. 248.

86. W. Denny, *op. cit.* (1986), p. 248.

87. W. Denny, 'Dating Ottoman Turkish Works in the Saz Style', *Muqarnas*, vol. I, 1983, p. 104.

88. A. Boralevi, 'Three Egyptian Carpets in Italy', *Oriental Carpet and Textile Studies*, vol. II, 1986, p. 212.

89. The manner of spinning fiber to the right is particular to Egypt, the linen of this provenance having a natural tendency to twist in this direction. Cf. E. Kuhnel, L. Bellanger, *Cairene Rugs and Others Technically Related*, Washington, D.C., 1967, pp. 80-81.

90. A. Boralevi, 'The Discovery of Two Great Carpets: The Cairene Carpets of the Medici', *Hali*, vol. V, no. 3, 1983, pp. 282-283.

91. S. Day, *Catalogue raisonné des tapis mamelouks et ottomans du musée des Arts décoratifs*, degree defense at the École du Louvre, Paris, 1985, pp. 103-108.

92. A. Sakisian, 'L'inventaire des tapis de la mosquée Yeni Djami de Stamboul', *Syria*, vol. XII, n. 7, 1931, pp. 369-370.

93. L. W. Mackie, 'Turkish Prayer Rugs',*Prayer Rugs*, exh. cat., Textile Museum, Washington, D.C., 1974, p. 27.

94. A. Sakisian, *op. cit.* (1931), p. 369.

95. J. Raby, 'Court and Export. Part 2: The Usak Carpets', *Oriental Carpet and Textile Studies*, vol. II, 1986, pp. 178-183, 185.

96. *Ibid.*, pp. 184-185.

97. C. G. Ellis, *Oriental Carpets in the Philadelphia Museum of Art*, Philadelphia and London, 1988, pp. 77-91.

98. J. Mills, 'Carpets in Paintings: The "Bellini",

"Keyhole" or "Re-entrant Rugs"', *Hali*, no. 58, 1991, pp. 86-103.

99. H. Inalcik, *op. cit.* (1986), pp. 58-59.

100. J. Raby, *op. cit.* (1986), p. 35.

101. H. Inalcik, *op. cit.* (1986), p. 58.

102. J. Raby, *op. cit.* (1986), p. 31.

103. A. Sakisian, *op. cit.* (1931), p. 369, n. 5.

104. M. Beattie, 'Coupled Column Prayer Rugs', *Oriental Art*, vol. XIV, 1968, p. 116.

105. M. Beattie, 'Some Rugs of the Konya Region', *Oriental Art*, vol. XXII, spring 1976, pp. 60-76.

106. D. Walker, 'Oriental Carpets of the Hajji Babas', *Hali*, vol. IV, no. 4, 1982, p. 392.

107. J. Lessing, *Altorientalische Teppichmuster nach Bildern und Originalen des XV bis XVI JH*, Berlin, 1887, p. 3. no. 2, 1981, p. 130.

109. M. Beattie, *op. cit.* (1981), p. 131.

110. l. Bennett, 'Counting Knots: Some Comments on Modern Hereke Weaving', *Hali*, no. 40, July-August 1988, p. 38.

111. N. Enez, 'Dye Research on the Prayer Rugs of the Topkapi Collection', *Oriental Carpet and Textile Studies*, vol. IV, 1993, pp. 191-204.

112. W. Denny, 'Anatolian Rugs: an Essay on Method', *Textile Museum Journal*, vol. III, no. 2, 1973, p. 22.

113. R. Arik, 'Turkish Landscape Carpets', *Hali*, vol. I, no. 2, 1978, pp. 123-127.

114. P. In his article 'The Masterweavers of Istanbul', *Hali*, no. 26, May-June 1985, P. Bensoussan illustrates rugs he has attributed either to Safavid Persia or to Turkey.

115. G. F. Farrow, 'Kum Kapi Masters', *Hali*, no. 46, August 1989, p. 11.

CHAPTER IV. CARPETS OF SAFAVID PERSIA: GARDENS OF EARTHLY DELIGHTS

116. R. Pinner, 'The Earliest Carpets', *Hali*, vol. V, no. 2, 1982, p. 111.

117. T. Kawami, 'Ancient Textiles from Shahr-i Qumis', *Hali*, no. 59, Oct. 1991, pp. 95-99.

118. F. R. Martin, *A History of Orient Carpets before 1800*. Vienna, 1908, republished with commentaries by C. G. Ellis and L. Murray Eiland in *Oriental Rug Review*, vol. V-3, June, 1985, p. 13.

119. Pope has hypothesized that the carpet was only terminated after the fall of the Sassanian dynasty, which would explain why a Muslim prince was included. A. U. Pope and P. Ackerman, *A Survey of Persian Art from Prehistoric Times to the Present*, London, 1939, vol. III, pp. 22-76.

120. For a study of the tribal carpets of Persia, see J. Housego, *Tribal Rugs*, London, 1978.

121. F. R. Martin, *op. cit.* (1908), republished in *Oriental Rug Review*, vol. V-6, Sept. 1985, p. 12.

122. K. Chabros, 'The Mongol Rug', *Oriental Carpet and Textile Studies*, vol. I, 1987, pp. 106-116.

123. A. Briggs, 'Timurid Carpets: I. Geometric Carpets', *Ars Islamica*, 1940, pp. 20-50.

124. In the *Maquamat* of Al Hariri, Bodleian Library,

Oxford, ms Marsh 458, ill. by Sir Thomas Arnold, *Painting in Islam*, N.Y., 1965 (reprint), pl. XII-c.

125. Marco Polo, *Le Devisement du monde, Le Livre des merveilles*, trans. Louis Hambis, Paris, vol. I, p. 97.

126. E. Hermann, 'New Light on Ancient Designs: Within the Sign of the Great Bird',*Orient Stars*, London, 1994, pp. 343, 350-351, 361.

127. E. Hermann, *ibid.*; Gerd Gropp, 'Thus Spoke Zarathustra', *Hali*, vol. XVI, no. 74, pp. 96-101.

128. G. Gropp, *ibid.*

129. L. Mackie, 'A Piece of the Puzzle: A 14th-15th Century Persian Carpet Fragment Revealed', *Hali*, vol. XI, no. 47, 1989, pp. 16-23. It is woven with Z2S wool warps alternating in two shades of blue, two by two; two and occasionally three picks in dyed 1Z red wool, the first and third tightly pulled, creating a ribbed effect on the back. Asymmetrical knot open to the left, 1, 550 knots to the square decimeter.

130. Weaving ateliers were established in the Shirvan and Karabakh regions during the reign of Shah Abbas. C. G. Ellis, *Early Caucasian Rugs*, exh. cat., Textile Museum, Washington, D.C., 1975.

131. Marco Polo, *op. cit.*, vol. II, p. 266.

132. A. U. Pope and P. Ackerman, *op. cit.* (1939), vol. III, p. 2273.

133. *Ibid.*, pp. 2334-2335. Another expert has expressed doubt about the veracity of this report. A. C. Edwards, *The Persian Carpet*, London, 1983 (reissue), p. 4.

134. L. Steinman, 'Sériciculture et soie, production, commerce et exportation pendant le règne de Chah Abbas',*Woven from the Heart, Spun from the Soul*, exh. cat., Textile Museum, Washington, D.C., pp.12-18.

135. T. Mankowski, 'Some Documents from Polish Sources Relating to Tapis Making in the Time of Chah Abbas I', in Pope et Ackerman, *op. cit.* (1939), vol. III, p. 2431.

136. A. U. Pope and P. Ackerman, *op. cit.* (1939), vol. III, pp. 2267, 2431.

137. S. Day, 'Chinoiserie in Islamic Carpet Design', *Hali*, no. 48, Dec. 1989, pp. 38-45.

138. L. Binyon, J. V. S. Wilkinson, and B. Gray, *Persian Miniature Painting*, London, 1971 (rev. ed.), p. 110.

139. A. C. Edwards, *op. cit.*, (1983), p. 164.

140. F. R. Martin, *op. cit.* (1908), p. 69.

141. This statement comes from Yaku, one of the great Mulsim geographers († 1229), active at the beginning of the 13th century. A. U. Pope and P. Ackerman, *op. cit.* (1939), vol. III, p. 2280.

142. In *Die Denkwurdigkeit en Schah Tahmasp's des ersten von Persien*, German trans. by P. Horn, 1891, p. 54, cited by Sarre and Trenkwald, *Anciens tapis d'Orient*, 1927, vol. II, p. 27, no. 32.

143. A. U. Pope and P. Ackerman, *op. cit.* (1939), p. 2257, n. 4.

144.W. Denny, 'Ten Great Carpets', *Hali*, vols. I-2, 1978, pp. 156-157.

145. O. Ydema, *Carpets and Their Datings in Netherlandish Paintings*, Woodbridge, 1991, p. 70. It appears to be from the same workshop as the Bardini carpet discussed by Alberto Boralevi, *Hali*, 39, 1988, p. 14.

146. C. G. Ellis, 'Some Compartment Designs for Carpets and Herat', *Textile Museum Journal*, vols. I-4, 1965, p. 53.

147. Parts of it were used to repair the London carpet when they were acquired by a London dealer in the late 19th century. The carpets were part of a group of five sold by the mullahs of the Ardabil shrine to cover the cost of renovation in the early 1890s. In a publication devoted to the Ardabil carpets published by the Getty Foundation in 1974, Rexford Stead advanced doubts that the carpet came from the Ardabil shrine, on the grounds that the premises are insufficiently large to accommodate it. It was however observed in situ in 1843 by an English traveler.

148. A. U. Pope and P. Ackerman, *op. cit.* (1939), vol. III, p. 2399.

149. C. G. Ellis, *op. cit.* (1965), p. 48, illustrates Sarre's reconstitution of the Harvany fragment, which originally had a cartouche border.

150. Captured at the battle of Parkany in 1683, the carpet was donated to Cracow Cathedral by King John Sobieski III. Too large for the steps in front of the altar, it was cut up and the unwanted half sold. Y. Brunhammer, *Cent chefs-d'œuvre du musée des Arts décoratifs*, Paris, 1964, pp. 138-139.

151. A. U. Pope and P. Ackerman, *op. cit.* (1939), p. 2309.

152. Warps: Z2S ivory or yellowish silk; wefts: 3 picks of 2Z ivory or yellowish silk, alternate warps depressed; 2Z wool pile, asymmetrical knot, knot density not given, occasional *jufti* knotting. C. G. Ellis, *Textile Museum Journal*, vol. I-4, 1965, p. 55.

153. K. Erdmann, *op. cit.*, p. 164.

154. A puzzle to certain experts, it has also been suggested that this carpet is a late copy of the 'Salting' group, supposedly made in Herecke, a Turkish workshop from the early 19th century. It was however purchased by Gian Giacomo Poldi Pezzoli at auction in 1855, at a date long prior to the founding of the Hereke workshops in 1891. Cf. *Hali*, no. 61, 1992, p. 118 *et infra*.

155. Rachid ed-Din, *Histoire des Mongoles de la Perse écrite en persan par Raschid-el-Din*, trans. and ed. by Quatremère de Quincy, Paris, 1836, pp. 21-22.

156. The carpet was recently sold by the owner to a Japanese museum.

157. M. Beattie, *The Thyssen Bornemisza Collection of Oriental Rugs*, Castagnola, 1972, p. 27.

158. A. U. Pope and P. Ackerman, *op. cit.* (1939), vol. III, p. 2318.

159. M. Beattie, *Carpets of Central Persia with Special Reference to the Rugs of Kirman*, exh. cat., Sheffield, 1976, p. 41.

160. I. Bennett, 'The Marcy Indjoudjian Cope', *Hali*, no. 35, 1987, pp. 22-23.

161. A. F. Kendrick and C. E. C. Tattersall, *Hand-woven Carpet: Oriental and European*, N.Y., 1973 (rev. ed.), pp. 36, 106, pl. 30A.

162. The corner pieces in this carpet are said to have been cut out and replaced. I. Bennett, 'The Emperor's Old Carpets', *Hali*, no. 31, 1986, p. 15.

163. C. G. Ellis, 'The Portuguese Carpets of Gujarat', *Islamic Art in the Metropolitan Museum of Art*, Richard Ettinghausen, ed., N.Y., 1972, pp. 267-289.

164. A. U. Pope and P. Ackerman, *op. cit.* (1939), vol. III, p. 2274.

165. *Ibid.* p. 2276.

166. M. Beattie, *op. cit.* (1976), p. 21, has expressed reservations about the atypical structure of the Figdor carpet.

167. C. G. Ellis, 'Garden Carpets and Their Relation to Safavid Gardens', *Hali*, vol. V-1, 1982, pp. 10,14, 16.

168. M. Beattie, J. Housego, and A. H. Morton, 'Vase-technique Carpets and Kirman', *Oriental Art*, vol. XXIII, 1977, p. 471.

169. M. Franses, 'Un présent du Shah de Perse à Soliman le Magnifique', *Tapis, Présent de l'Orient à l'Occident*, Paris, Institut du Monde Arabe, 1989 (exh. cat.), p. 22.

170. *Prayer Rugs*, exh. cat., Textile Museum, Washington, D.C. 1974, no. 26.

171. M. Beattie, *op. cit.* (1976), pp. 19, 36.

172. For a translation of these verses, see Kendrick and Tattersall, *op. cit.* (1973), pp. 21-22.

173. K. Erdmann, 'Persian Carpets of Turkish Provenance',*Seven Hundred Years of Oriental Carpets*, London, 1971, pp. 76-80.

174. M. Beattie, 'Hereke', *Hali*, vol. IV-2, 1981, pp. 128-134.

175. N. Enez, 'Dye Research on the Prayer Carpets of the Topkapi Collection', *Oriental Carpets and Textile Studies*, vol. IV, 1993, pp. 192-195.

176. M. Franses and I. Bennett, 'The Topkapi Prayer Rugs', *Hali*, no. 39, May-June 1988, p. 25.

177. B. Gray, *La Peinture persane*, Geneva, 1961, p. 168.

178. A. U. Pope and P. Ackermann, *op. cit.* (1939), vol. III, pp. 2366-2367, pl. 1185.

179. A. C. Edwards, *op. cit.* (1983), p. 166.

180. Also known as the 'fish pattern', because of the curved forms of the lanceolate leaves placed around a central diamond.

181. A. U. Pope and P. Ackerman, *op. cit.* (1939), vol. III, pp. 2398-2400. On the plates, vol. VI, pls. 1158-1160, the date indicated is 1671.

182. M. Beattie, J. Housego, and A. H. Morton, *op. cit.* (1977), p. 469.

183. I. Bennett, 'Isfahan Strapwork Carpets', *Hali*, no. 41, Sept.-Oct. 1988, p. 36.

184. Cited in *Woven from the Soul, Spun from the Heart*, exh. cat., Textile Museum, Washington, D.C., 1987, p. 151.

185. D. Walker, 'Metropolitan Quartet', *Hali*, no. 76, Aug.-Sept. 1994, p. 106.

186. Illustrated by A. U. Pope and P. Ackerman, *op. cit.* (1939), vol. VI, pl. 1265. Another carpet with the same border pattern, formerly in a Kansas gallery, is illustrated in pl. 1263.

187. J.-B. Tavernier, *Les Six Voyages de Jean-Baptiste Tavernier en Turquie, en Perse et aux Indes*, Amsterdam, 1678, p. 405.

188. Typically, Z4S cotton warps, mostly ivory, but occasionally dyed blue or pink; 1st and 3rd picks in Z2S woollen yarns in natural or brindle shades, the second in Z2S silk or cotton yarns, in natural shades, but sometimes dyed pink and blue or red in the case of silk. Occasionally one thick weft in colored yarn is substituted for the three. The pile is in Z2S wool, tied in the asymmetrical knot open to the left, and the knot count is about 2,250 knots to the square decimeter. Occasionally, the underside is covered in backshag in yellowish wool, presumably for extra softness. M. Beattie, *Carpets of Central Persia with Special Reference to the Rugs of Kirman*, exh. cat., 1976,, pp. 14-15.

189. J.-B. Tavernier, *op. cit.*, p. 444. Shah Abas I was deceased by the time Tavernier visited the workshop, but it is reasonable to assume that the secret door was installed from the outset.

190. *Ibid.*, pp. 521, 528: 'Deux vénérables vieillards d'ont l'office est de tirer les souliers du Roy quand il entre dans les chambres couvertes de tapis d'or et de soye, et de les luy remettre quand il en sort.'

191. Père Raphaël du Mans, *Estat de la Perse en 1660 par le père Raphaël du Mans*, with notes and an appendix by C. Schefer, Paris, 1890, p. 186.

192. L. Helfgott, 'Production and Trade: The Persian Carpet Industry', *Woven from the Heart, Spun from the Soul, op. cit.*, p. 115.

193. J. Housego, '18th-century Persian Carpets: Continuity and Change', *Oriental Carpet and Textile Studies*, vol. III-1, 1987, p. 46.

194. I. Bennett, 'Animal and Tree Carpets: An Amorphous Group', *Hali*, no. 73, Feb.-Mar. 1994, pp. 90-99.

195. J. Housego, *op. cit.* (1987), p. 47.

196. *Ibid.*, p. 48.

CHAPTER V. POETRY AND CARPETS:
CALLIGRAPHIC ART IN THE CARPETS OF IRAN

197. There are several studies relating to the Pazyryk excavations and the earliest knotted-pile carpets; see F. Spühler, *Oriental Carpets in the Museum of Islamic Art*, Berlin, trad. R. Pinner, London, 1987, pp. 18-19.

198. The carpet fragment with knotted pile from Chahr-e-Qumes displays no form of decoration; T. Kawami, 'Ancient Textiles from Shahr-i-Qumis', *Hali*, no. 59, Oct. 1991, pp. 95-99. The excavations were carried out by J. Hansman and D. Stronach between 1967 and 1970.

199. H. E. Wulff, *The Traditional Crafts of Persia*, Cambridge, Mass., 1975, p. 212.

200. A. U. Pope, 'The Art of Carpet Making', *A Survey of Persian Art*, Oxford, 1938, vol. 111, p. 2272.

201. See G. Wiet, *Soieries persanes*, Cairo, 1948, pl. XVI, pp. 83-84: 'Glory belongs only to them…'; see the signed and dated example from the fragment of 'tiraz' in the collection of the Metropolitan Museum (31.106.27), dated AH 879-880, silk foundation, inscription woven in red, indicating the name of the commissioner, Abu Abdallah al-Hamis, at Nishapur.

202. The 'Suaire de saint Josse', in the Louvre catalogue *Arabesques et jardins du Paradis*, exh. prepared by M. Bernus-Taylor, cat. no. 97, pp. 123-124, inv. 7502.

203. A. S. Melikian-Chirvani, *Islamic Metalwork from the Iranian World*, London, 1982, figs. 40-41.

204. See the naskhi in M. Lings, *The Quranic Art of Calligraphy and Illumination*, Kent, 1976, p. 53; and in E. Binney, III, cat. of the Nasli M. Heermaneck Collection, P. Pal, Los Angeles, 1973, p. 72.

205. E. Binney III, cat. of the Nasli Heermaneck Collection, P. Pal, Los Angeles, 1973, p. 72.

206. W. von Bode and E. Kuhnel, *Antique Rugs from the Near East*, trad. C. G. Ellis, London, 1984, fig. 63.

207. R. Ettinghausen, *op. cit.*, 23, fig. 6, n. 22.

208. H. Bartels, 'Kufic or Pseudo Kufic as Anatolian Border Design', *OCTS*, vol. III, no. 2, p. 35.

209. R. Ettinghausen, 'The Early Use and Iconography of the Prayer Rug', *Islamic Art and Archaeology Collected Papers*, Berlin, 1984, pp. 282-300.

210. For the convergent medallion, see R. Ettinghausen, *ibid.*, miniature of Kalileh-o-Demneh, National Library of Egypt, no. 61, folio 3b; see also D. James, *Findings from the Chester Beatty Library*, 1980, pp. 10-11.; A. Briggs, 'Timurid Carpets', *Ars Islamica* 7, 1940, pp. 27-41.

211. V. Donzel, B. Lewis, and C. Pellat, *Encyclopédie de l'Islam* IV, Paris, 1973.

212. D. Shayegan, *Les Illusions de l'identité*, Éditions du Félin, 1992, p. 18.

213. I. Bennett, ed., *Rugs and Carpets of the World*, N.Y., 1977, p. 44.

214. See, for example, A. Rahjiri, *Tarikh e Mokhtassar é Khat*, Teheran, 1345 solar, p. 76; or yet H. Fazaeli, *Atlas é Khat*, Isfahan, 1362 solar, p. 453.

215. These rugs are analyzed in several works, but in detail by F. Sarre and H. Trenkwald, *Old Oriental Carpets*, Vienna, 1926-1929, 2 vols.

216. J. Bailey, 'The Other Ardabil', 56, April 1991, p. 138.

217. A. U. Pope, 'The Art of Carpet Making', *A Survey of Persian Art*, Oxford, 1938, vol. III, p. 2296 and pl. 29.

218. I. Bennett, 'Emperor's Old Carpets', *Hali*, no. 31, 1986, p. 14.

219. M. S. Dimand and J. Mailey, *Oriental Rugs in the Metropolitan Museum of Art*, 1973; cat. no. 8, p. 99, inv. no. 32.16.

220. M. Aga Oglu, *Safavid Rugs and Textiles: The Collection of the Shrine of Imam Ali at al-Najaf*, N.Y., 1941, p. 31, pl. III.

221. Jean Chardin, *Voyage de Paris à Ispahan*, vol. II, coll. 'La Découverte', *Maspéro*, 1982, p. 244.

222. See T. Mankowski, 'Some Documents from Polish Sources Relating to Carpet Making in the Time of Shah Abbas I', in A. U. Pope, *A Survey of Persian Art*, pp. 2431-2436; and M. H. Beattie, *Carpets of Central Persia*, London, 1976, p. 10; several French travelers, such as the Chevalier Chardin and J.B. Tavernier, as well as Portuguese, Italian, or English travelers of the period, were wonder-struck by these extraordinary carpets ornamented in gold and silver thread; among the travelers Father Filorentino de Nino Jesus in 1607-1608 and Thomas Herbert in 1627-1628.

223. K. Erdmann, 'The Art of Carpet Making', *Ars Islamica*, vol. VIII, Ann Arbor, 1941, pp. 121-191.

224. M. Franses and I. Bennett, 'The Topkapi Prayer Rugs', *Hali*, no. 39, p. 21.

225. M. S. Dimand and J. Mailey, *Oriental Rugs in the Metropolitan Museum of Art*, fig. 121, cat. no. 48, p. 113; cotton warp, silk weft, silver brocading around a silk core.

226. L. Bakhtiar, *Sufi: Expressions of the Mystic Quest*, London, 1976, p. 113.

227. C. Bier, *Court and Commerce: Carpets of Safavid Iran*, London, 1976, p. 113; see the introduction and the *dibatcheh*,

228. J. Brookes, *Gardens of Paradise*, London, 1987, p. 21 and 77.

229. A. A. Sadeghi, 'Chiveh hâ va Emkânâté Vâjehsâzi dar zabâné Fârsi é Mo'asser', *Nachr é Dânech*, 11, vol. IV, 1370 solar, pp. 13-14.

230. Y. Zoka, 'Ach'ar va Achy', *Honar va Mardom*, Farvardine (March-April), 1344 solar, pp. 23-30.

231. W. Clinton, 'Image and Metaphor: Textiles in Persian Poetry', *Woven From the Heart, Spun From the Soul*, exh. cat, Textile Museum, Washington, D.C., 1987.

232. L. Lockhart, *The Fall of the Safavid Dynasty and the Afghan Occupation of Iran*, Cambridge, 1958; W. Floor, 'Economy and Society: Fibers, Fabrics, Factories', *ibid.*, pp. 23-25.

233. L. M. Helfgott, 'Production and Trade: The Persian Carpet Industry', *ibid.*, pp. 118-119.

234. L. K. Steinmann, 'Sericulture and Silk: Production, Trade and Export Under Shah Abbas', *ibid.*, pp. 12-20.

235. J. Housego, 'Eighteenth-Century Persian Carpets: Continuity and Change', *OCTS* I, London, 1985, pp. 45-48.

236. P. Tanavoli, *Shahsavan*, trans. Annette Berra, Fribourg, 1985.

237. L. S. Diba, 'Persian Painting in the Eighteenth Century: Tradition and Transmission', *Muqarnas*, vol. VI, pp. 148-160; see also the various publications of B.W. Robinson, e.g. *Persian Paintings in the John Rylands Library*, London, 1980, p. 348. The miniatures with their small scale gave way to oil paintings in large format, often inspired by copies of Italian, French, or Dutch paintings.

238. A. Ittig, 'The Kirmani Boom: A Study in Carpet

Entrepreneurship', *OCTS* I, pp. 111-112.

239. D. L. Wilber, 'Heriz Rugs', *Hali*, vol. 6, no. 1, 1983, pp. 2-12; Heriz was a weaving center – some sixty kilometers east of Tabriz in the Azerbaijan – active during a short period: 1840-1920. Farahan was developed as a weaving center by Nader Shah Afshar in the 18th century. The Farahan rugs from the 18th century are known for their classical and refined patterns.

CHAPTER VI. THE CARPETS OF
THE GREAT MOGHUL: 16TH-19TH CENTURIES

240. Marco Polo, *Le Devisement du monde*, *Le Livre des merveilles*. Maspero, Paris, 1980, vol. I, p. 470.

241. S. Cohen, 'Indian and Kashmiri Carpets before Akbar: Their Perceived History', *Oriental Carpet and Textile History Studies*, vol. III, London, 1987.

242. The description of the life of the imperial court is given by Abul Fazi in the *Ain i-Akbari*, a complementary volume to the *Akbar Nameh*, cf. trans. H. Blochmann, 3rd ed., Calcutta, 1977.

243. There was also carpet production in southern India, particularly in the kingdom of Golconda at Ellora. However, little relevant information has surfaced, but it appears that the privileged relationship between the Sultan of Golconda and Persia resulted in the arrival of Persian weavers, who worked according to their traditions, possibly causing the rugs of Golconda to be confused with those of Persia made in the 17th century.

244. Abul Fazi, *op. cit.*, p. 48.

245. The David Collection (Copenhagen), the Metropolitan Museum, and the Louvre, to cite only a few collections.

246. This was a theme widely treated in Persia. A Moghul miniature, representing Timur (Tamerlane, 1336-1405), shows a tent canopy decorated in the same manner.

247. This may be owing to a lack of imagination on the part of painters responsible for the decorative elements. Under Akbar, a painting was not executed by a single artist but by several working in collaboration, each according to his own speciality.

248. This is particularly true of the 'Widener carpet' preserved at the National Gallery of Art in Washington, D.C. Cf. R. Skelton, *The Indian Heritage*, London, 1982, p. 75, no 196; M. Brandt and G.D. Lowry, *op. cit.*, pp. 154-155, no. 73.

249. See the catalogue of the Louvre exhibition, Arabesques et Jardins de paradis, Paris, 1989, p. 169, no. 140. The rug in question is entitled 'Peytel', and it dates from the 16th century.

250. Cf. M. Brandt and G.D. Lowery, *op. cit.*, p. 110, no. 72, concerning a carpet preserved in the Museum of Fine Arts, Boston.

251. Abul Fazl, *op. cit.*, p. 57.

252. M.C. Beach, *The Imperial Image: Paintings for the Mughal Court*, Washington, D.C., 1981, p. 205, no. 32.

253. M.C. Beach, *op. cit.*, p. 79.

254. Amber, the capital of the Rajastan from 1037 until 1728, was replaced by the new city of Jaipur, built nearby by the Raja Sawai Singh II.

255. The ceiling of the Diwan-i-Khas, the throne room for private audiences in the Red Fort at Delhi, was decorated with a trellis made of different stones.

256. L. Murray Eiland, Jr., 'The Moghul "Strapwork" Carpets', *Oriental Rug Review*, vol. XI, no. 6, Aug.-Sept., 1991.

257. Cf. R. Crill, 'Flower of the Grat Mughals', The Victoria and Albert Museum Album, no. 5, London, 1986, p. 135, fig. 9.

258. Reproduced in the catalogue *The Indian Heritage, Court Life and Arts under the Mughal Rule*, Victoria and Albert Museum, London, 1982, no. 198, p. 71.

259. Thomas Roe, the Ambassador of James I of England to the Great Moghul would have brought back from India in 1619 a carpet ornamented with escutcheons.

260. J. Irwin, 'The Girdlers' Carpet', *Marg*, vol. XVIII, no. 4, Bombay, Sept. 1965, and cf. R. Mac Allan, 'The English East India Company and Its Role in the Carpet Trade of 17th-Century India and Persia', *Oriental Carpet and Textile Studies*, vol. III, no. 2, London, 1989.

261. The delay owing to English taste, which favored very large carpets.

CHAPTER VII.
THE CARPETS OF THE MIDDLE KINGDOM

262. This term appears to distinguish between the knotted carpets, supposedly used in the winter, and the cotton rugs, employed during warm weather. In reality, both were used at the same time.

263. Even if piled, as in velvet, the rug is not knotted.

264. The donors and worshippers represented in the paintings in the Dunhuang grottoes are frequently posed on carpets, some of them ornamented with floral motifs.

265. From the 18th century date several paintings on silk by Zhen Zhuzhong (National Palace Museum, Taipei). Those illustrating the story of Wenji and, especially, the return of Wenji to China, appear on carpets whose pattern, with its geometric motifs, derives more from Turkoman sources.

266. This account and others are published by Calmann-Lévy under the title *L'Inde du Bouddha vue par des pèlerins chinois sous la dynastie des Tang - VIIᵉ siècle*, Paris, 1968. p. 267.

CHAPTER VIII. THE CARPETS OF FRANCE

267. N. de Saint-Phalle, *Jane Fillion ou la Belle d'un seigneur*, Robert Laffont, Paris, 1988.

268. J. Guiffrey, *La Stromatourgie de Pierre Dupont*, BSHAF, Paris, 1882.

269. P. Verlet, *The Savonnerie*, Office du Livre, Fribourg, 1882, p. 1689-170.

270. Published in the *Bulletin d'histoire de l'art français*, in collaboration with Jean Vitet, inspector at the Mobilier National.

271. J. Guiffrey, *Inventaire général du mobilier de la Couronne sous Louis XIV*, Paris, 1885.

272. K.A. de Piacenti, 'Un dono de re Sole a Cosimo Pitti', *Antologia di Bella Arti*, nos. 29-30, 1986, pp. 17-20. This article reports the views of P. Verlet.

273. ANO 3304.

274. P. Verlet, *Bulletin de liaison du CIETA de Lyon*, no. 27, pp. 69-84.

275. C. Aulanier, *La Grand Galerie du Bord-du-l'Eau*, Éditions M.N., Paris.

276. M. Jarry, 'Tapis Louis XIV du Mobilier national', *The Connoisseur*, Oct. 1966.

277. A.P. de Mirimonde, 'Le symbolisme musical dans les tapis de Grande Galerie du Louvre', *La Revue du Louvre*, no. 1, 1973, pp. 99-100.

278. P. Verlet, 'On cherche 38 tapis royaux', *Connaissance des arts*, Feb. 1982.

279. E. Floret, 'L'Allégorie de la 'Félicité', *L'Objet d'art / Estampille*, no. 235, April 1990.

280. AN, O2 907 (6 Ventôse VI).

281. P. Verlet, 'Les tapis de la chapelle de Versailles au XVIIIᵉ siècle, *Revue de l'art*, I-II, p. 65, 1968.

282. P. Verlet, *The Savonnerie*, *op. cit.*, sec. III, which has very detailed notes.

283. The Royal Collection of Sweden HGK 470; identical pattern, Lowengard estate, Galerie G. Petit, 20 March 1910, no. 35; identical pattern at Christie's, London, 15 June 1989.

284. P. Verlet, *The Savonnerie*, *op. cit.*, fig. 63; Royal Collection of Sweden, HGK 474.

285. 'Le destin des collections royales', Mairie (Town Hall), 5th arrondissement, Paris, Oct. 1989.

286. No. 721 delivered on 4 March 1760, woven after a design by Perrot (see Bibliothèque Nationale, Estampes HA18).

287. Bukowski (Stockholm), 3 Nov. 1989 (no. 102).

288. P. Verlet, *The Savonnerie*, *op. cit.*, p. 86-393. AN 487 AP / 1.

289. AN F12 1459b, dossier 1780-1790.

290. Cf. Duhamel de Monceau, *Art de faire des tapis façon de Turquie connus sous le nom de tapis de la Savonnerie*, Paris, 1766.

291. F12 2431, report from 9 Thermidor III.

292. F12 1458A, dossier V.

293. F12 1458A, dossier V, p. 94.

294. Central *minutier* of the notaries and / XX / 580 (21 April 1743).295. F12 1459B.

295. F12 1459B.

296. M. Jarry, 'Les débuts de la fabrication à Aubusson (1743)', *BSHAF*, 2 March 1968.

297. J.D. Ludman, *Le Palais Rohan de Strasbourg*, Istra, 1979-1980, 2 vols.

297bis. See the article 'Orient et Occident: l'influence turque à Aubusson', Élisabeth Floret, *L'Objet d'art / L'Estampille*, Sept. 1996.

298. AN F12 1458 (SV-236).

299. *Idem*, XV-240.

300. AN F12 801.

301. AN F12 1458A (XIV).

302. No. 268 in the museum catalogue.

303. Also worth citing are the following sales: Couturier-Nicolay (Paris, 20 Dec. 1988), no. 145 (former Bensimon collection); Finarte (Rome, 7 March 1989); Michèle Campana, 'European Carpets', Paul Hamlyn, 1969: see the carpet in the Tarica-Catan collection.

304. Cf. Duhamel du Monceau, *Art de faire des tapis façon de Turquie connus sous le nom de tapis de la Savonnerie*, Paris, 1766.

305. AN 01 2058: P. Verlet, Bulletin issued in relationship with the CIETA in Lyons, no. 27, pp. 69-84.

306. No. 117 in the catalogue, from the collection of Charles-Éphrussi Rothschild.

307. AN F12 1459A (dossier V).

308. AN F12 1459A (dossier V, piece 40 [letter of 9 June 1778] and piece 128).

309. AN F12 1459A (dossier V, p. 136).

310. No. 263 in the catalogue; no. 116 of the catalogue.

311. P. Verlet, *The Savonnerie, op. cit.*, p. 135.

312. The pattern is still woven, as witnessed by the sale. Étude Rollin (Limoges, 28 April 1991, no. 36).

313. Comte de Caylus (1692-1765), archaeologist, collector, engraver, and dedicated writer on the subject of antiquities.

314. P. Verlet, *The Savonnerie, op. cit.*, p. 188-119.

315. AN F12 2431.

316. M. Jarry, 'La Manufacture impériale de la Savonnerie', *The Connoisseur*, no. 778, Dec. 1976.

317. J. Coural, 'Napoléon, roi du Garde-meuble', *L'Œil*, May 1969.

318. O2524 (p. 14, art. 3), but a good number of others could also be cited.

319. M. Jarry, 'La Légion d'honneur inspire le décor des tapis impériaux', *Le Jardin des arts*, no. 173, April 1969.

320. O2555.

321. E. Dumonthier, *Recueil de dessins de tapis et tapisseries d'ameublement du mobilier de la Couronne*, Paris, plate 4.

322. O2519.

323. O2570 (mémoire no. 109).

324. O2524 (V, p. 15).

325. É. Floret, 'Une manufacture méconnue (Piat-Lefebvre)', *L'Estampille / L'Objet d'art*, Jan. 1991).

326. M. Jarry, 'La Manufacture impériale de la Savonnerie', *The Connoisseur*, no. 778, Dec. 1976.

327. O2515 (12, p. 78).

328. O2517.

329. Compare as well with no. 144, Millon-Jutheau sale, 9 Dec. 1987.

330. Dépôt Général, 105, rue du Faubourg-Saint-Honoré.

331. F12.

332. E1560: *Les Tapisseries de Tournai*, Éditions Vasseur-Delmée, Tournai, 1892.

333. 3, rue des Vieilles-Andriettes, in the Marais.

334. Roby, Debel, and Maingronnat, among others.

335. At 29, rue de la Huchette.

336. É. Floret, 'Une manufacture méconnue', op. cit.

337. The maquette for the carpet at the Mobilier National was sold at Sotheby's, N.Y., 13 January 1988 (no. 177).

338. O2721, pp. 3-4.

339. Palais Galliera, 2 March 1961, no. 132.

340. MM, no. 8023. Another example belongs to a private collector.

341. Cf. Dumonthier, *op. cit.*

342. These motifs were revived by Piat-Lefebvre, as well as by Aubusson, Braquenié, etc. Certain maquettes were sold at Sotheby's, N.Y., 18 May 1991.

343. P. Arrizoli-Clémentel, 'Le décor textile de la salle du Trône des Tuileries', 12th assembly of the CIETA.

344. Seligmann sale, Galerie Charpentier, 5 June 1935, no. 196.

345. The same pattern with a green ground appeared at the Paul Dutasta sale, Galerie G. Petit, 3-4 June 1926, no. 197; another example was sold on 19 June 1991 at Ader-Picard-Tajan, George-V, Paris.

346. O3 1884.

347. BN 8° C, Le Senne 12-487 (2).

348. *Recueil de tapis et tapisseries et autres objets d'ameublement exécutés dans la manufacture Chenavard à Paris* (pl. 15-3).

349. O3 1884.

350. J. Guiffrey, *Arts appliqués et Industries d'art aux Expositions*, Paris, 1912 (incomplete).

351. O4 1850.

352. A. Dion Tennenbaum, 'Aubusson et l'Asie', *L'Objet d'art / L'Estampille*, no. 92, June 1995.

353. O2 2180.

354. *Exposition des produits de l'industrie française, 1844. Report du jury central*, Paris, tome I. This carpet left a trail as it traveled, showing up in the Herbert Gutmann sale on 13 April 1934, Galerie Paul-Graupe, Berlin (no. 275), and then at the Hôtel d'Orrouer, Paris. Cf. *Grandes Demeures de France*, Arthaud, Paris, 1991, p. 284.

355. Bibliothèque Nationale, Exposition de 1844, 'Description des esquisses exposées par Amédée Couder (1844)'.

356. BN 8°V, piece 11434, *Exposition des produits de l'industrie*, p. 22 (1839).

357. BN.

358. AN = MC, and / XVI / 958.

359. AN = MC and / XVIII /980.

360. AN = MC and / LXXX / 938.

361. AN = MC and / XLVIII / 839.

CHAPTER IX. THE CARPET IN GREAT BRITAIN

362. This engraving is reproduced in C. Bateman Faraday, *European and American Carpets and Rugs*, Woodbridge (Great Britain), 1990, p. 146, fig. 3.

363. Several miniatures give proof of it, as in the January plate, with the Duc de Berry receiving at table, from the *Très Riches Heures du duc de Berry*, 1423-1416, 1413-1416, Musée Condé, Chantilly, folio 2; the illumination showing Jean sans Peur, Duc de Bourgogne, receiving a copy of the Vosges book by

Hayton, 1410, Bibliothèque Nationale, Paris, Grec 55; the illumination depicting Saint Matthew setting down the Tree of Jesse includes a very beautiful map covering the entire floor of the room.

364. Matthew Paris (d. 1259), British Library, MS Royal 14 C VII.

365. The Victoria and Albert Museum owns a number, including example T.101-1928, T.50.1914, W.30.1923, preserved both in the galleries and in the reserve.

366. C.E.C. Tattersall, *Handwoven Carpets: Oriental and European*, London, 1922.

367. M. Beattie, 'Britain and the Oriental Carpet', Leeds Art Calendar, no. 55, Leeds, 1964; I. Bennett and M. Franses, 'The Buccleuch European Carpets & Others in the Oriental Style', *Hali*, Dec. 1992, no. 66, pp. 95-107.

368. Pierre Norbert, alias Peter Parisot, a native of Lorraine and an ordained priest, was obliged, because of conflict with the Jesuits, to emigrate to England in 1750.

369. Reproduced in Tattersall, *op. cit.*, pl. 28.

370. *Ibid.*, pl. 18.

371. I. Bennett, *Rugs and Carpets of the World*, London, 1977, p. 286.

372. Ratiné (also spelled ratine, ratten, and rateen) is a woollen 'loops ground' material, very like bouclé, an uncut looped pile.

373. A knotted carpet made in Scandinavia.

374. Whence they brought back furniture and objets d'art.

375. The wools were dyed in Berlin, which explains the term 'Berlin Woolwork' adopted for the embroideries.

376. See the 1740 carpet at Colonial Williamsburg, Virginia, in Mayorcas, *English Needlework Carpets, 16th-17th Centuries*, Leigh-on-Sea, 1963, fig. 45.

377. Mayorcas, *op. cit.*

378. *Ibid.*, fig. 40.

CHAPTER X.
THE CARPET IN SPAIN AND PORTUGAL

379. M.S. Dimand and J. Mailey, *Oriental Rugs in the Metropolitan Museum of Art*, N.Y., 1973.

380. Al-Idrisi, *Description de l'Afrique et de l'Espagne*, ed. and trans. R. Dozy and M.J. de Goeje, Leyden, 1866, pp. 195-237.

381. Makkari, *Analectes sur l'histoire et la littérature des Arabes en Espagne*, ed. R. Dozy, Leyden, 1855-1861, vol. I, p. 123.

382. According to the chronicler Matthew Paris. The Arab and Christian sources are mentioned by various authors, among them J. Ferrandis Torres, *Catálogo de la exposición de alfombras antiguas españolas*, Madrid, 1933; E. Kühnel, L. Bellinger, *The Textile Museum, Catalog of Spanish Rugs, 12th Century to the 19th Century*, Washington, D.C., 1953; J.S. Ferrer, *Alfombras antiguas de la provincia de Albacete*, 1986.

383. Pearcy Dearmer, *Fifty Pictures of Gothic Altars*, London, 1910.

384. C.J. Lamm, *Carpet Fragments: The Marby Rug*

and Some Fragments of Carpets Found in Egypt, Stockholm, 1937.

385. L. Mackie, 'Covered with Flowers: Medieval Floor Coverings Escavated at Fustat in 1980', *Oriental Carpet and Textile Studies*, London, 1985.

386. F. Sarre has maintained that it represents the Arc of the Covenant, whereas Dimand and Mailey see the Tree of Life: F. Sarre, 'Mittelalterliche Teppiche Spanischer und Kleinasistischer Herkunft', *Kunst und Kunsthandwerk*, X, 1907; 'A Fourteenth-Century Spanish Synagogue Carpet', *Burlington Magazine*, LVI, Feb. 1930; Dimand and Mailey, *op. cit.*

387. Some fifteen examples are preserved, among them carpets with unidentified heraldry and others with the same beehive pattern but no blazons.

388. See, for instance, the animal-pattern rug depicted by the Catalan painter Jaime Huguet in *Madonna and Child with Saints*, a work of 1456 now preserved at the Museo de Arte de Cataluña de Barcelona.

389. The influence of Persian Islamic art is quite marked in Hispano-Maghrebin art, particularly in the realm of ceramics. Several surviving texts bear witness to the appearance of Persian artists in Spain.

390. For the first group, two *Annunciations* by Crivelli, one at the National Gallery in London and the other at the Städel Institute in Frankfurt. For the second group, *The Ordination of Saint Vincent* by Jaime Huguet and *The Legend of Saint Ursula* at the Accademia in Venice.

391. The pomegranate and pine-cone motifs and, to a lesser degree, because later, the pineapple and the thistle no doubt form part of a floral composition derived from the Chinese lotus.

392. The first establishments sprang up along the west coast of Africa. Bartolomeu Dias sailed past the Cape of Good Hope in 1487, which opened a sea route to the Indies. In 1494, the Treaty of Tordesillas assured Portugal a monopoly position in the Indian Ocean, water until then plied only by Arab merchants; the treaty also guaranteed that Brazil would be Portuguese.

393. See a series of rugs woven in the 17th century with a Persian-type pattern and few colors (dark as well as light blue, yellow, mustard, white) often attributed to Spain. in M. Campana, *European Carpets*, n.d., pl. 17; Sotheby's Parke Bernet, *The Robert Hirsch Collection: Furniture and Porcelain*, London, 1978, no. 506.

394. F. Baptista de Oliveira, *Historia e tecnica dos tapetes de Arraiolos*, Lisbon, 1983, p. 14.

395. *Ibid.*, figs. 16, 17.

396. *Ibid.*, figs. 18-21.

397. The first Portuguese trading post in Bengal opened in 1517.

398. The birds are the most numerous: parrots, peacocks, pigeons, storks, eagles, etc. Also present are stags, lions, dogs, dragons, serpents, mermaids, male and female figures, musicians, hunting scenes, etc.

399. J. Soustiel, *La Céramique islamique: Le Guide du connaisseur*, Fribourg, 1985, p. 183.

400. W. Leaf and S. Purcell, *Heraldic Symbols: Islamic Insignia and Western Heraldry*, London, 1986.

PHOTOGRAPHIC CREDITS

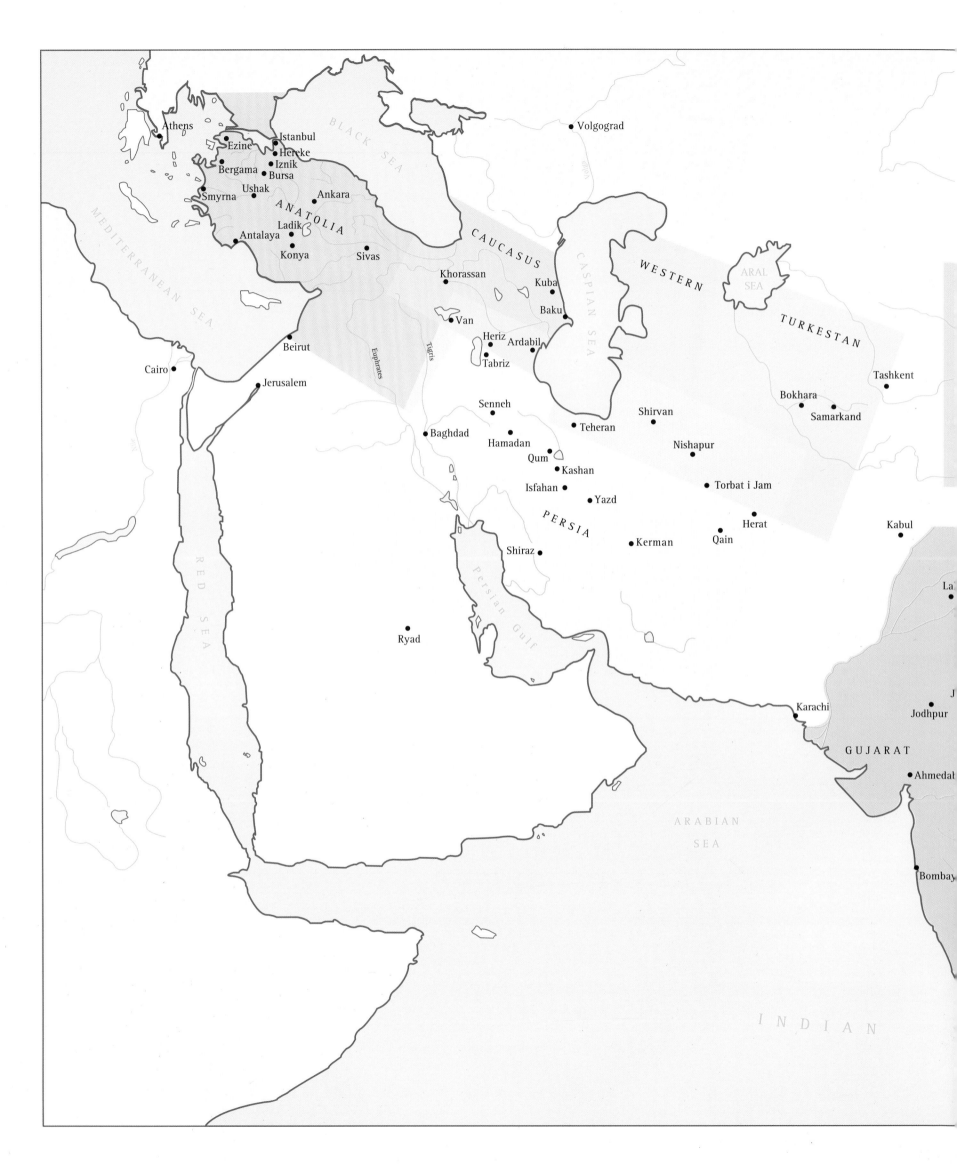

Athens

Istanbul
Ezine
Hereke
Iznik
Bergama
Bursa
Smyrna
Ushak
Ankara
ANATOLIA
Ladik
Antalaya
Konya
Sivas

BLACK SEA

CAUCASUS

Khorassan
Kuba
Baku
Van
Heriz
Ardabil
Tabriz

CASPIAN SEA

WESTERN

ARAL SEA

TURKESTAN

Tashkent

Bokhara
Samarkand

MEDITERRANEAN SEA

Beirut

Cairo

Jerusalem

Euphrates

Tigris

Senneh

Baghdad

Hamadan

Qum

Kashan

Isfahan

Yazd

PERSIA

Shiraz

Teheran

Shirvan

Nishapur

Torbat i Jam

Qain

Herat

Kerman

Kabul

La

RED SEA

Persian Gulf

Ryad

Karachi

Jodhpur

GUJARAT

Ahmedal

ARABIAN SEA

Bombay

INDIAN

Volgograd

Nile

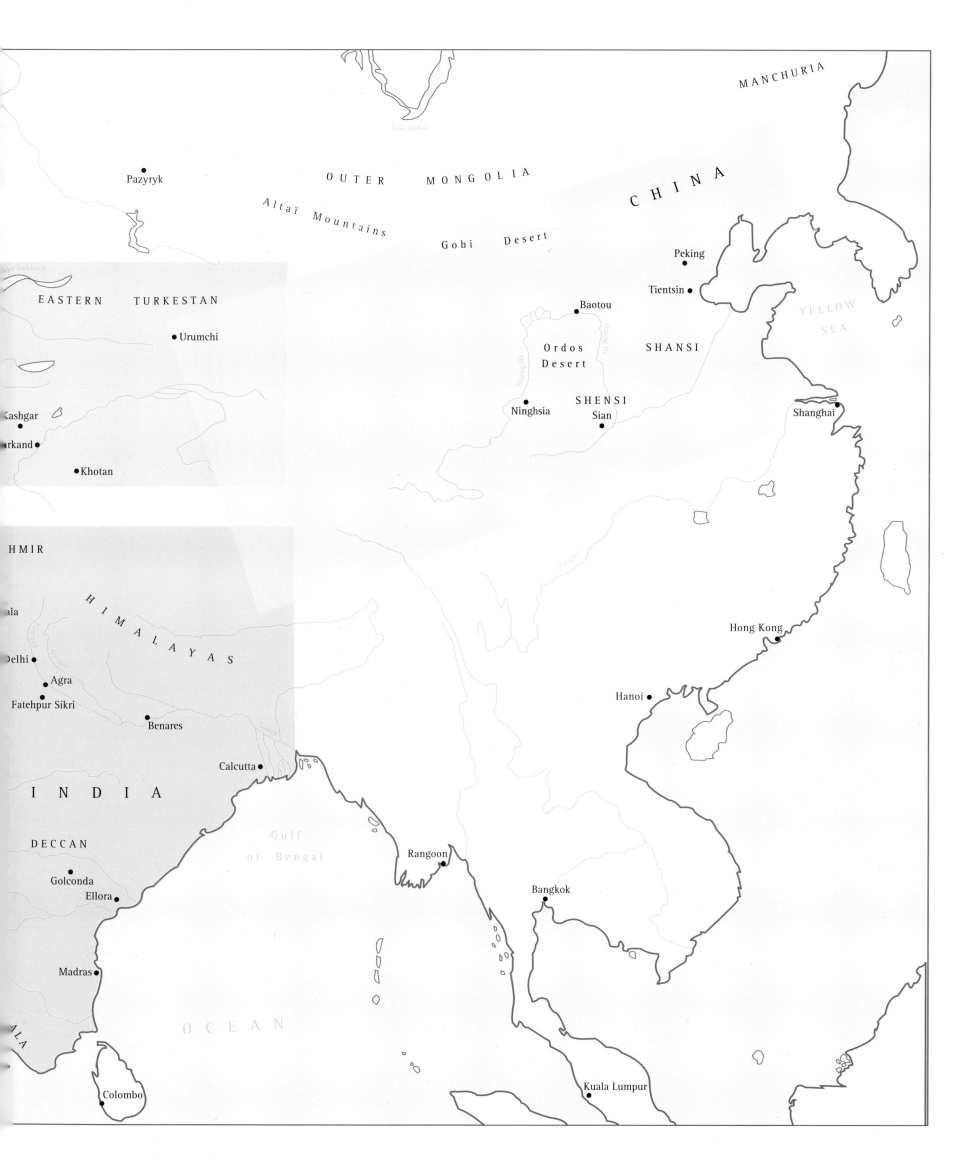

MANCHURIA

OUTER MONGOLIA CHINA

Pazyryk

Altaï Mountains

Gobi Desert

Peking

EASTERN TURKESTAN

Tientsin

YELLOW
SEA

Baotou

Urumchi

Ordos
Desert

SHANSI

Ninghsia

SHENSI
Sian

Shanghai

Kashgar

arkand

Khotan

HMIR

ala

HIMALAYAS

Hong Kong

Delhi
Agra
Fatehpur Sikri

Benares

Hanoi

Calcutta

INDIA

DECCAN

Gulf
of Bengal

Rangoon

Golconda
Ellora

Bangkok

Madras

OCEAN

Colombo

Kuala Lumpur

ALA

Riverside
County
LIBRARY SYSTEM

www.rivlib.net